Surrealist Art and Writing offers a fresh analysis of Surrealism, the avant-garde movement that, in its search for contemporary lyricism and imagery, united literature and art with politics and psychology. Examining Surrealism's main phases from a variety of perspectives, Jack Spector emphasizes the rebellion of the protagonists against their middle-class education under the Third Republic, a rebellion that later extended beyond their moral, political, and artistic background. In manifestos and manifestations, the Surrealists promoted Marxist over liberal politics, Freudian psychoanalysis over French psychiatry, Hegelian dialectics over Cartesian logic, and the outmoded, psychotic, or childish over modernist art. This study offers an overview of the exciting and important interwar period in Europe. In particular it places avant-garde ideas and imagery within the historical and political contexts of the 1920s and 1930s, integrating them into contemporary artistic and ideological currents.

Surrealist Art and Writing, 1919–1939

CONTEMPORARY ARTISTS AND THEIR CRITICS

General Editor

Donald Kuspit, *State University of New York, Stony Brook*

Advisory Board

Matthew Baigell, *Rutgers University*

Lynn Gamwell, *State University of New York, Binghamton*

Richard Hertz, *Art Center College of Design, Pasadena*

Judith Russi Kirshner, *University of Illinois, Chicago*

Udo Kultermann, *Washington University*

This series presents a broad range of writings on contemporary art by some of the most astute critics at work today. Combining the methods of art criticism and art history, their essays, published here in anthologized form, are at once scholarly and timely, analytic and evaluative, a record and critique of art events. Books in this series are on the cutting edge of thinking about contemporary art. Deliberately pluralistic in approach, the series deals with the complexity of contemporary art from a wide perspective, in terms of both point of view and writing.

SURREALIST ART AND WRITING, 1919–1939

THE GOLD OF TIME

JACK J. SPECTOR

Rutgers University

CAMBRIDGE
UNIVERSITY PRESS

CAMBRIDGE UNIVERSITY PRESS
Cambridge, New York, Melbourne, Madrid, Cape Town,
Singapore, São Paulo, Delhi, Tokyo, Mexico City

Cambridge University Press
32 Avenue of the Americas, New York NY 10013-2473, USA

www.cambridge.org
Information on this title: www.cambridge.org/9780521657396

First published 1997

Printed in the United States of America

A catalogue record for this publication is available from the British Library.

Library of Congress Cataloging in Publication Data
Spector, Jack J.
Surrealist art and writing, 1919–1939 : The gold of time /
Jack J. Spector.
p. cm. – (Contemporary artists and their critics)
Includes bibliographical references and index.
ISBN 0-521-55311-3 (hardcover)
1. Surrealism – Europe. 2. Arts, Modern – 20th century – Europe.
I. Title. II. Series.
NX542.A1S68 1997
700´.94´09041 – dc20 96-5179
 CIP

ISBN 978-0-521-65739-6 Paperback

CONTENTS

ILLUSTRATIONS

ACKNOWLEDGMENTS

It is a pleasure to acknowledge having received help, information, and/or encouragement from the following scholars: in the United States, Robert J. Alexander, Dore Ashton, Mary Ann Caws, Jonathan Fineberg, Haim Finkelstein, Peter Gay, John and Mary Gedo, the late J. van Heijenoort, George Kubler, Donald Kuspit, Gene Lebovicz, Pat Leighten, Barbara Lekatsas, Steven Levine, Pat Mainardi, Henry Millon, Francesco Pellizzi, Theodore Reff, and the late Meyer Schapiro (who knew Breton, Masson, and Bonnet personally); in France, Adam Biro, the late Marguerite Bonnet, Pierre Broué, Gérard Legrand, Gérard Roche, and Claude Schvalberg; and the faculty and graduate students at various universities where I presented some of my material as lectures or workshops – Illinois University (Carbondale); Emory; Columbia; CUNY Graduate Center; New York University; Hebrew University (Jerusalem); Rutgers; and, in Australia, a number of excellent universities including ones in Brisbane and Melbourne. Over the decades my graduate students at Rutgers University have both stimulated and encouraged my work.

A Senior Fellowship at the Center for Advanced Study in the Visual Arts (CASVA) (National Gallery of Art, Washington, D.C.) during 1985–6 permitted me to develop my project "Hegel, Trotsky and Freud as Sources for the Early Surrealism of Breton (1924–32)," on which part of this book is based. As Visiting Professor at Brisbane University in the spring semester of 1989 I had an opportunity to ripen my ideas, as I did at the Rutgers Center for Historical Analysis in 1990–1 in exchanges with John Gillis and the fellows. The Rutgers Research Council provided a subvention in 1995.

The library staffs I consulted at CASVA, the Library of Congress, and Rutgers provided valuable assistance. Through the kind permission of Elisa Breton and the cooperation of M. Chapon, librarian of the Bibliothèque Doucet, I had access to an important collection of Breton manuscripts. Although, as noted by M. Chapon, Breton's will forbids their publication until fifty years after his death (2016), examining certain documents helped modify, clarify, or corroborate my views. Finally, I thank my production editor at Cambridge University Press, Mary Racine.

For Helga, "or du temps."

INTRODUCTION

> [I have] sometimes the illusion of setting out on a great adventure, somewhat like a gold digger: I seek the gold of time. / I seek the transcendence of time [Je cherche *l'*(h)*or*(s) *du temps*].
>
> André Breton (1924; emphasis added)

I

These courageous precursors, whether painters or poets ... knew this fascination with hieroglyphs on the walls ... they express the fate of an age.

Aragon, "On Decorations" (1918)

1966. André Breton, founder and longtime leader of Surrealism dies, and apparently the movement with him. A colloquium held that year at Cerisy only seemed to corroborate the loss of its old vitality and notoriety: Surrealist scandal was replaced by a scholarly polemics both sophisticated and civil.

1968. A student movement erupts in Paris intent on liberalizing the policies of the university system. In order to upset established routines and to create disorder, the students take their dispute out of the classroom and into the streets, and inscribe their arguments not just in their private *cahiers* but on the public walls of the university buildings, where – echoing Aragon's remark of fifty years earlier cited above – they smear graffiti "manifestos" and certain curious slogans: "Soyez réalistes / demandez / l'impossible"; "Cache-toi, / OBJET"; "L'imagination prend / le pouvoir"; "la vie est ailleurs"; "Vive l'union libre"; "Plus je fais l'amour, plus j'ai envie de faire la Révolution, / Plus je fais la Révolution, plus

j'ai envie de faire l'amour." "L'art c'est de la merde" (Figure 1). (The suppression by the police of the students coincided with the cleaning up or purging of the walls, an act of political "hygiene." One should note that a collection of graffiti on the toilet walls of public institutions in Paris during the late sixties shows clearly that even the rare "political" allusions serve as discharges of pique and contain no serious ideological content.) Significantly, the students – interested in the street façades rather than the interior spaces – mounted prominent blowup photos of Trotsky, Mao, Castro, Marx, and Lenin, but not of Stalin; and they ignored the Mur des Fédérés, that monument to the Communards of 1871 revered alike by the Communist Party and the Third Republic.[1]

In both years what we might call educational processes occurred, with the opposite effects of drying up a vital movement and of revitalizing a stagnant institution. To my mind these processes have significant parallels to and bearings upon the history of the avant-garde that emerged in the first decades of this century (comparable also to the literary processes of deformation, estrangement, and rebarbarization of the language of normative discourse discussed by the Russian formalists). Indeed, it is a

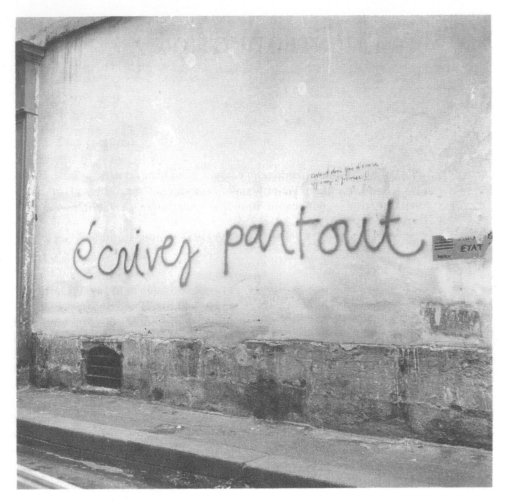

Figure 1. "write everywhere"; "before writing, learn to think!" Graffiti by two different hands inscribed on a Paris wall during the May 1968 revolution. Photo: Roger-Viollet, Paris.

major thesis of this book that by examining the responses of the young Surrealists to the educational system under the Third Republic that formed their generation, we can gain insights into the mentality, motivation, and artistic productions heretofore unavailable to students of the movement. It also seems to me that we can best approach those productions by starting from the texts, published and unpublished, created by the major participants in the movement.

As some protagonists in the 1968 events already noted, the behavior and the violently imaginative language of the students echoed those of the Surrealists. In fact, the uprising for a moment infused new life into Parisian Surrealism: many young intellectuals, even anti-Surrealists like Philippe Sollers (admirer in 1967 of the Stalinist Aragon) who wrote for *Tel quel*, now equated writing and revolution after the manner of the Surrealists. Indeed, the sentiments expressed by the student rebels demonstrate an unmistakably Surrealist character – they evidently identified with the great Surrealist truants of the twenties and thirties. Some graffiti actually cited Breton's and Péret's names. A decade earlier there had been a less dramatic political parallel to Surrealism in the "Situationist international" founded in 1957 by former

Lettrists, who adopted mottoes like "The revolutionary movement can tolerate neither prophets nor guides," and "All power to the imagination."[2] But more commonly, prominent Parisian intellectuals like Robbe-Grillet conformed to the mood of political disengagement of the fifties and separated their writing from political activism.[3] The intrinsic polarity (that will emerge later in this book) between revolutionary graffiti and Cartesian orthography is beautifully epitomized in a clash of slogans on one of the May walls: "write everywhere"; and beside it in much smaller characters: "before writing learn to think!"

This detachment of pronouncements from historical meanings has had a long and continuous tradition in the land of the French Academy and its *Dictionnaire.* Something like that may have happened in 1968 to the great rhetorician President Charles de Gaulle, whose political destiny, it has been observed, depended greatly on words; ruling by radio and television, he kept in touch by words alone with the "fickle mob." Unfortunately, in 1968 de Gaulle, used to preaching a daring international chauvinism, misread the tensions within France reflected in the loud and confusing demands made by the students and their allies among the workers. He faltered, left Paris for Germany at the height of the unrest, and later failed to win a plebiscite. He died within two years.

With the subsiding of the student revolution, and the void left by the death of Breton, Surrealism seemed destined to pass once more into the rarefied regions of esoteric literature and scholarly research. However, general interest in Surrealism received a major boost after 1968 from "French (Lacanian) psychoanalysis," and more recently from "postmodernists"; as a result Surrealism continues to inspire some artists, to provoke challenges by Marxists and feminists, and to stimulate art critics to "surreal" theorizing (there is even a "Surreal mathematics"). But these trends and the theories associated with them have sometimes cast as much

shadow as light on Surrealism. I hope to demonstrate the weaknesses of such an approach.

In the United States a theory of Surrealism that would disengage the movement from its history and from the political context of its productions (a reductionist version of Tel Quel's theory of writing and revolution) and reconstitute it as an autonomous world of language practices has recently become highly visible. The theory has introduced a novel viewpoint and raised new questions, but also has moved in an eccentric direction and yielded idiosyncratic results. Norman Bryson's "The Politics of Arbitrariness," in rejecting a suppression of history, notes the reactionary curve traced from the May 1968 events to the rise of Le Pen.[4]

In theorizing Surrealism, Rosalind Krauss's two essays in an exhibition catalogue, *L'Amour fou* (1985), are typical of recent attempts to overthrow received opinions: in the first essay, with the brash enthusiasm of the convinced collector or tendentious theorist, she confines herself to a select group of photographs in the exhibit (mainly of misogynistically distorted images of women) – but presumably in order not to fall into the trap of the "connoisseur" of photography (into which she believed both Benjamin and Barthes fell) signaled in 1980 by her colleague Douglas Crimp, she focuses on photographs of a repulsive "marvelous." From this group of photos, which she regards as "the best" works of Surrealism, she spins out a theory based on the "relationship between photography and writing."

Krauss announces that "surrealist photography . . . is the *great* production of the movement," a remark that leads to the paradox that the " 'greatest' of surrealist images are not really by 'surrealists.' " Essentially, she develops a pseudosemiological translation of Breton's definition of Surrealism as convulsive beauty into a "theory of photography" (which appears to amount to a theory of pornography): she skillfully deploys certain statements of Bre-

ton in order to make him into an unwitting exponent of her theory, a mongrel bred from conjugating the semiotics of Saussure's sign (without naming him) and Peirce's index and icon (she artfully frames a distinction between painting as icon and photography as index that draws on Peirce, but collapses Peirce's third category, the symbol, into Lacan's dyad of Symbolic and Mirror phases). Thus, to her mind photography is not only a sign, a writing, but an appropriately postmodern "index" like "palm prints, death masks ... the Shroud of Turin," whereas Surrealist drawing and painting – disdained like passé modernist art – fall into the category of "icons." But in her own terms the most "indexical" process in Surrealism occurs in Ernst's painting: frottage produces textures on a canvas placed on an irregular surface by rubbing over it with chalk or brush.

In a second essay, a dirge on the death of Breton's Surrealism, Krauss promotes more forcefully her postmodern/structuralist interests and, following Denis Hollier, includes interesting but comparatively neglected individuals, many associated with the now-fashionable figure of Bataille. Before applauding this apparently generous expansion of the Surrealist "canon," we must realize that she does not so much wish to expand the field by complementing the roster of established artists as to narrow it by surgical revision: she expunges Breton's and Aragon's writings on painting, drives all the painters from the temple, and enthrones the marginal figure of Bataille, placing him at the center of the movement's vitality and emphasizing such highly personal notions as the "informe." Breton and Bataille had battled over the issue of Bataille's "low materialism": Breton helped suppress Bataille's early novel *W.C.*, whose setting was a toilet, and continued in the Second Manifesto to criticize Bataille's predilection for filth evidenced in his periodical *Documents*. Krauss illustrates her article with some scatological and pathological photography that fills the pages of that periodical (Boiffard, prolific

in such photographs, later turned to the profession of medicine). In contrast to the slogans inscribed on the public walls of 1968, Bataille, Surrealism's "old enemy from within," has inspired Krauss's exhibition of intimate toilet wall graffiti, for in her catalogue, as though touched both by scholarly voyeurism and by revulsion at reproductive heterosexuality, she exhibits photographs of fetishistic details showing mainly females with dripping genitals, sick and deformed body parts, and naked behinds – an anal display that arguably equates photographic inscription to an "indexical" impression on toilet paper.

The Surrealism of Breton's circle, which has survived many vigorous attacks, from within and without, as well as premature announcements of its "death," remains vital and controversial in this "postmodern" period, though not as an organized movement. Critics of Surrealism – who intended only Breton's group – like Sartre, Camus, Adorno, and the Tel Quel group considered it dead.[5] Camus dismissed Surrealism as a negative revolt, a "metaphysical rebellion"; Clement Greenberg called it "bad art"; Habermas asserted that Surrealist desublimation failed to liberate and that Surrealism was limited to the aesthetic sphere. At a symposium held in Rutgers in March 1977, "The Posthumous Life of Surrealism," the critic of modern art Harold Rosenberg, himself an ex-Surrealist, provocatively asserted that Surrealism had long since "died"; he pointed out that the (English) Surrealist periodical *This Quarter* acknowledged this already in 1930. Paradoxically such terms as "the outmoded" and "dead" have been adopted recently by a postmodern critic bent on redefining the current importance of Surrealism.[6] Examples of the continued interest in Surrealism are easy to find.[7]

Why, despite severely critical attacks and periodic lapses into obscurity, and in the face of changing political and ideological currents (and the spate of rival movements), has Surrealism managed to survive? It owes this survival, I believe, to the

extraordinary range of its imagery, its involvement with theory torn between political engagement and artistic autonomy, and its tolerance of technical nonconformity to the point of crudeness in the interest of an uninhibited imagination. Moreover, the Surrealists by their mockery of their childhood education in the schools of the Third Republic won over the sympathy of others who, like them, had successfully passed through the system, but rejected its bourgeois rewards of comfort and perfunctory esteem. In my view, much of the Surrealist antiacademicism and its raw lyricism took shape in response to that education and the professional dead end that it led to. The educational factor admittedly cannot answer nagging questions such as why these particular individuals, educated like their contemporaries in those schools, should evolve toward Surrealism, and how they became creative poets through what has been called their "vocational choice."[8]

The complex "slippages" of the Surrealist position have been especially attractive in this period of "postmodernism": the Surrealists fought first as part of the modernist avant-garde to make art autonomous; then saw the need to reintegrate art and society; and seem finally to have envisioned a place for art as moral leader and guide of society – hence, not completely in or out of it. We find an index of these different positions in their varied use of the image, from the artistically autonomous Surrealism of automatic writing and dream image, to a compromise formation involving sociopolitical revolution, with its claims to "change life" (Rimbaud) or society (Marx).

These qualities still inspire many artists, filmmakers, and advertisers. An abundance of important documentation has been published, notably by French scholars like Marguerite Bonnet, André Thirion, Elisabeth Roudinesco, Henri Behar, José Vovelle, René Passeron, Françoise Will-Levaillant, and José Pierre. Moreover, Surrealism has been the object of studies not

only by documentary scholars of twentieth-century art, but by a diverse group of writers: in England, Dawn Ades and Robert Short; in Israel, Chaim Finkelstein and Milly Heyd; in Germany, Peter Bürger; and many in the United States, including J. H. Matthews, Anna Balakian, and Mary Ann Caws. They reexamined persistent questions involving Dadaism, the dream, and automatism (Freud vs. Janet), and entered new scholarly territories like book illustration. Bold speculations and suggestive theoretical perspectives have been developed by others: the "Barthesians" and the semioticians, a host of literary Lacanians, feminist art historians (some of them Lacanians), the post-Stalinist Maoist critics of Tel Quel, Foucault, Derrida, the Marxist literary critic Jameson, literary anthropologists like James Clifford, and writers in the circle of the journals *Screen, Block,* and *October* (including Rosalind Krauss and Hal Foster). And the effort by Surrealism to unite psychoanalysis and Marxism still interests some students of radical movements.

We cannot comprehend this vitality by limiting ourselves to the distorted forms and bizarre fashions that have, ironically, nourished the popular consumption mocked by the Surrealists. Rather, it seems to me, its current importance and relevance have mainly to do with the moral and political issues raised by Western forms of acculturation (education) that Surrealism addressed, and which, though transformed, seem to persist even today. Almost alone in their own time the Surrealists embraced most of the crucial issues for the culture of late capitalism: the opposition between consumption and production (the place of desire), and the linked problem of the relation between work and creativity (alienation); the need – earlier noted by Romantic utopians like Fourier, then by Nietzsche, and later by the Decadents of the fin de siècle – for new mythologies or "religions" to replace an ossified and reactionary clericalism; the problematic relation between word (the poem) and image; colonialism in

art as a reflex of bourgeois racism; the problem of incarnating or representing the revolutionary ideals of society by a small group (the Bolsheviks, the artistic avant-garde); and the contrary demands made on the artist, particularly during the thirties, on one hand to create freely and autonomously and on the other to try to improve society, goals that entailed political responsibility. Their political position has achieved a particularly forceful resonance for intellectuals in Western democracies, which since the sixties have faced a growing challenge to the authenticity of their values of liberty and equality. Like their later counterparts – and on the stable model of socialist and communist elitism – the Surrealists lived in culturally privileged isolation from the society they dreamed of changing. As Breton wrote, in response to Eluard's question, "Are you capable of changing a text in order to get someone to read it?": "Yes, I believe myself capable of it, as I do not wish to give any sustenance to aristocrats or bourgeois, I pretend to write for the masses."[9]

If, as I maintain, Surrealism is an "unfinished project" – an adventure for those still seeking "the gold of time" – then we can expect further revisions of our understanding of this rich and complex movement in the years to come.[10] Such revision would fit into the radical reeducational enterprise now shaking Western civilization: firm clichés, stereotypes, and rituals are now being undone as new claims to representation are posed by feminists, multiculturalists, and proponents of decentered power – advocates of a shift from totalitarian to local hegemony.

II

A crisis in the writing of history, especially of that of the avant-garde, poses particular difficulties for the student of a field like Surrealism, which embodies a labile mixture of the visual and verbal or the syntactic and the semantic, and in which interdisciplinary scholarship ("intertextuality") has made the centering on single texts or issues a controversial matter.[11] A further muddying of the water comes from "theoretical" interpretations that replace the factual (social, historical, documentary) material and context of the movement with big hypotheses that make broad theoretical claims for single aspects of the movement – for example, the "photography" theory of Krauss and the "uncanny" theory of her follower Hal Foster.

How can one write history in the context of a postmodernism that (as in "postmodern ethnography") insists that discourse replace mimetic description, emphasizes reception, and claims that science does not represent but rather "evokes"?[12] In fact, one can no longer write with the placid assurance of earlier historians who believed in an objective causality and the scientific value of chronological sequence. Discourse – including the "narrative" of causality – muddied by intervention and ideology, eschews claims to clarity and "transparency" of language, and regards truth claims as either delusion or hypocrisy. When the signifiers of history do not indicate but "play" autonomously and with open-ended intertextuality (Barthes, Derrida), the old grounds of "objectivity" tremble.

This crisis has extended to art history, particularly modernist art history, internally challenged by feminist art historians (who have begun to extend their critique to earlier periods) and externally by the postmodernist leanings of scholars bent both on distending the canonical boundaries of established disciplines so that they seem to dissolve, and on challenging the practice of scholars who believe in "truth" and in the consensual validation of judgments.[13]

Many of the same cultural conditions that fostered Surrealism still persist in Western culture; perhaps the very nature of Surrealism repels or even threatens scholars by recalling the ideological issues currently pervading education from the elementary grades to the academic fields of the adult ("political correctness," multi-

culturalism). This might in part explain the recent avoidance of Surrealism by American art historians – except those intent on "sublimating" the recalcitrant materials by a "theoretical" rather than historical approach.

The neglect of context and history by formalists favoring particular "great artists" (Greenberg's Matisse, Rubin's Picasso) diminishes the value of their approach for comprehending Surrealism both in its own context and as part of ours.[14] Such analysts typically separate the veristic imagists (Tanguy, Dali, and Magritte) who are rejected from the valued automatists (Masson and Miró), creators of "absolute" Surrealism, and ignore both the pre-Surrealist contribution of Symbolism and the debt of postmodernism to Surrealism.[15] Since they usually make the material conform to their theories, they tend either to distort or to simplify the richly historic dimension of Surrealism, collapsing the manifold time of Surrealism into a theoretically manageable atemporal model such as semiotics. The Surrealists themselves, tormented over paradoxes of time in art – the timelessness within time – eventually adapted their thought to Trotsky's paradoxical (and anti-Stalinist) dream of "permanent revolution." But presumably even theories of art do not exist autonomously or escape the logic of Kuhn's paradigm shifts (the claim that the imagination occupies a space outside time was already made by the Surrealists); and understanding their changes demands a formulation in historical terms. (This does not entail a search for causal sequences or "origins.") The point becomes clear from a brief consideration of a debate within the field of the semiotics of art.

Recently, historians of twentieth-century art who have centered their interest on formal questions have found an attractive model in the semiotic system of Saussure, with its emphasis on a systematic and synchronic *langue* distinct from a diachronic *parole*.[16] The Swiss linguist, in a formulation almost identical with that of his contemporary, the French mathematician Poincaré, insisted that form, not substance, constitutes the subject of the linguist.[17] Art critics influenced by Saussurean semiotics have tended to consider art as autonomous, as largely independent of context and history.

A number of thinkers have taken issue with the attempt to make Saussure's linguistics a master pattern for understanding visual art.[18] Peirce proposed an alternative semiotics that makes a place for the visual in terms of an iconic sign.[19] Margaret Iversen observes that, compared with Saussure, "Peirce's system offers a much richer potential for . . . formulating a semiotics of visual art. This is because Saussure believed that linguistics should serve as the master pattern for the study of semiology in general, a view which has the consequence of treating all signs as though they are fundamentally arbitrary and conventional like linguistic signs. . . . It is clear that visual signs are not arbitrary, but 'motivated' – there is some rationale for the choice of signifier. The word 'dog' and a picture of one clearly do not signify in the same way."[20] (It seems that some American art critics interested in Surrealism have begun to replace the old Saussurean jargon with a Peircean vocabulary.)

Another critic, Francis Frascina, notes that "the Saussurean model of explanation (as well as the Modernist model) is unhelpful in accounting for the significance of [an individual work of art] as a *social* 'utterance,' a specific sign, within what we might call the 'rhetoric' of the visual representation."[21] What is needed, Frascina maintains, is a "social semiotics" as proposed by Bakhtin and the Marxist Valentin Voloshinov (author of *Marxism and the Philosophy of Language,* 1929) who criticize Saussure's *Cours* for leading us away from the "living, dynamic reality of language and its social functions." Voloshinov's Marxist position evidently avoids the idealism of Jameson, who overvalues the formal component of semiotics.[22]

The position of social semiotics – which

finds support in the later thought of the best formalists – corroborates my assumption that the intellectual and cultural context of the Surrealists (including their education and politics) is relevant to their mature art and thought, which in turn are not autonomous productions independent of or even intelligible outside that context.[23] Almost concurrently with the dispute of the semioticians, art historians like Warburg and Panofsky faced the comparable question of integrating into their "iconological" interpretations the concretely visual aspect of artistic phenomena.

Historians of Surrealism who acknowledge the urgency of these issues must ask themselves how they can historicize and contextualize art and writing without ignoring the valid critiques forwarded by deconstructionists. On the other hand, deconstructionists have been unable or unwilling to write histories that presume any sense of coherent narrative about an objective "reality"; instead, they take up one another's themes and, with an eagerly incestuous rhetoric, verge on an infinite regress of comments on the comments of their predecessors.[24]

Surrealism presents an especially complex case to writers of art history; at once sympathetic and hostile to modernism, it adopted features of modernist practice only to put them to their own distinct use (the formal syntax of Cubist collage transformed into a semantics of fantasy; Apollinaire's "surprise" sifted through the chance of Dada and turned into the marvelous); it returned again and again to narrative even as it disintegrated it, transgressing with explosive impact the limits between art and writing, spontaneity and madness, text and author, individual and collectivity. The unstable boundaries marking these interactions account for many of the interesting "dialectical" problems in Surrealism: between genres of verbal or visual "texts" (poetry and prose, including advertising, but above all the political manifestos, photography and cinema, narrative and dream sequence); between visual and verbal imagery; and between levels or spaces of reality (psychological and parapsychological vs. physical reality).

The complexity of Surrealism's relation to "reality" discourages simplistic analysis; we could not, for example, apply to it Jakobson's paradigm, which, like a Wölfflinian polarity, equates metaphor with Romanticism and metonymy with Realism.[25] We are compelled to consider seriously the somewhat obscure framework of a "dialectical" synthesis adopted by the Surrealists themselves in their efforts to resolve these and other tensions or paradoxes. For example, Breton's description of Surrealism as the "prehensile tail of Romanticism" suggests a chimerical synthesis of Romantic immateriality and Realist tangibility. In fact, the Parisian intellectuals who made up the avant-garde of Surrealism resembled the Romantics of the period from Napoleon I to Louis Bonaparte at least in one important respect: both came from a middle class evolving amid complex social, political, and economic tensions. Uncertain about their social class, they oscillated between incompatible social values, at once sharing the egalitarianism of the revolution and the ambition of a bourgeoisie for which they felt contempt. (Nineteenth-century Romantics like de Vigny actually invented an aristocratic lineage.) Understandably, contradiction, irony, paradox, and mystery (including detective thrillers) were important for them.

While Surrealism from 1920 on subverted the modernist concept of stylistic progress, it sympathized with utopian notions of social progress (from the late twenties to World War II when it shared the goals of Marxist Communism, and after World War II when it developed an eclectic program of "myth" blending socialism, anarchism, Fourierist utopianism, and occult philosophy).

The most productive approach to Surrealism seems to me not to compartmentalize its political and formal developments, nor to see everything solely from the viewpoint of one of the great figures like

Breton: we have to complement the loyal exposition of Breton's views by faithful Trotskyite cronies in the circle of Marguerite Bonnet, not only by the hostile criticism of ex-Surrealists and Stalinists, but by figures on the margins of Surrealism (Bataille) and Trotskyism (Souvarine).

The perplexing combination of obscure poetry and intelligible prose of Surrealism derived in part from its unique and paradoxical mixture of "political" and "spiritual" content. I will try to show that even when not publicly visible, the political manifested itself in internal conflicts with external implications, and in external conflicts with internal implications; and that a quasi-religious (and ferociously anticlerical) dimension runs through the whole Surrealist enterprise under guises that changed with time: from the pale desires of Symbolism to the vocalized dream séances; from the oracular utterances of seers and mediums to the unexplained validity of the unfathomable Nadja's predictions; from individual creativity to convulsive and ecstatic eroticism; from the vague hopes and images of a revolutionary transcendence to the radiant fog of utopian myth. This "religious" aspect – another reaction to their early education – has often been overlooked owing to the Surrealists' vociferous anticlericalism.[26]

The notion of the political adopted here has ramifications for many aspects of Surrealism, particularly when connected to the large social context that includes the Surrealists. In the writing of this book a number of inconsistencies and incoherences surfaced: the linguistic chauvinism of French Surrealist writing (non-French texts only appear in translation) as opposed to the cosmopolitanism of Surrealist art; the "political" dimension that inhered within seemingly asocial and individual activities; the Surrealists' search for forebears to their poetry as far back as the eighteenth century, while acknowledging no precursors for their art before the twentieth century (except perhaps Moreau); the redefinition by the Surrealists

(without overt acknowledgment) of the term "revolution" in different periods to mean a general urge to change "life," class warfare against "the bourgeoisie," Marxist social change, and the quasi-anarchistic liberation of humankind through an art in touch with the unconscious. Moreover, one finds inconsistencies between declared policy and actual practice: the complex juggling of commitment to the Communist Party while insisting on the autonomy of the movement; the dilemma that resulted from rebuking Miró and Masson, but not Picasso for doing ballet decors; the inconsistent censoring of obscenities in certain works by Aragon and Bataille while approving of the unlimited sexual liberties promoted by de Sade. Finally, the complex and unresolved tensions between verbal and visual imagery, and between automatism and the dream, resulted in interminable debates over the definition of a Surrealist painting and in the effort – intermittent but never wholly rejected – to transfer the technique of the *Champs magnétiques* into "automatic" drawing. My book, in addressing such issues, will probably provoke more questions than it resolves in this controversy-laden field of scholarship.

We can get to understand much of their practice, in my opinion, only by considering the historical context, the "reality" the Surrealists maligned – for example, the social, economic, and political conditions between the wars, as well as concurrent artistic activities. No movement more easily defeats the attempt to see it autonomously: without taking into account social and political as well as stylistic considerations, we have little chance to understand the meaning of the Surrealists' obscure and enigmatic productions, or their ideology of revolution. It was in part because political considerations intruded at each phase of Surrealism that attempts to produce a comprehensive definition limited to writing and painting have fared so poorly. On the other hand, surveys of Surrealist history like Nadeau's or of Surrealist politics like Helena Lewis's, by marginalizing

the artistic productions, offer us schematic shells of the rich interaction between art and politics.[27] By arguing for the revolutionary implications of their practice, the Surrealists justified their remaining within the Communist movement.[28] An effort will be made in this book to demonstrate that the (anti)formal impulses in apparently unintelligible works actually have a semantic component.

To reformulate our question as to how one can write a history of Surrealism in a period of postmodernism: Is Surrealism devoid of any narrative cohesion, and is its recent adaptation to postmodernism merely a symptom of a change in late capitalism?[29]

An indispensable first step toward answering this question is to analyze in their historical context the writings (poetry, political prose, art criticism) and actions of André Breton, the critical figure always at the center of the conflicts and collaborations of the major group of Surrealists. In the words of Masson (by no means a close adherent of Breton at the time), "As we used to say, Surrealism existed before its definition. But all the same the definition and site of Surrealism is André Breton."[30] In order to avoid reducing the history to a static configuration like a solar system in which a central, dominating individual attracted creative personalities, we must take into account the presence of the other "stars" – Aragon, Eluard, Artaud, Bataille. Studying the group dynamics as a constellation – the interaction of these ambitious individuals among themselves and in relation to the "outside" worlds in which they lived and worked – leads beyond poetry to politics and beyond a mere expounding or praising of the movement by taking into account the criticism of former colleagues as well as rivals.

Obviously, an exclusively laudatory discussion of Breton would distort the larger historical picture of Surrealism; yet much otherwise good scholarship by defenders of Surrealism suffers from taking an apologetic stance to this embattled personality. The huge Breton exhibition at the Pompi-

dou (1991), the latest major production of official (mainly French) Surrealist scholarship, is a pure exaltation of Breton, demanding the obeisance one would expect in Lenin's mausoleum. The essays in the Pompidou catalogue render unqualified praise (supported, happily, by valuable documentation, much of it previously unpublished) and, though some of them (notably Bonnet's) offer useful observations, they nowhere deal with controversial aspects of Breton's career, like the recurrent tensions and splittings within the group, the tangled relations with the Communist Party and Trotsky, the conflicts and reconciliations with Bataille, and the criticisms of the movement (Bataille, Benjamin, Adorno, Sartre, Camus, Clement Greenberg, H. Rosenberg, Habermas and Bürger, Baudrillard, and certain feminists). The focus on love of the Pompidou exhibition (and a rather tepid one at that, for neither de Sade nor Lautréamont has much to do with it) obscures the lively tensions within Breton's group.[31] A more recent trend derives as a mutation from the Tel Quel group of the sixties, an adversary of Surrealism, among writers associated with *October*. These writers first insisted on the superior importance of Bataille (a figure greatly admired by Foucault) over Breton, and later attempted to pigeonhole Breton's group by theoretical stratagems based largely on Lacan and semiotics, and more recently on quasi-mathematical notions, completely ignoring their political intentions or agenda.

When one looks at the full range of the Surrealists' experience one concludes that Breton and his friends were tossed between an individualism forever on the hunt for unusual and disturbing images, and a "solidarism" that conceived collective actions evolving over time; consequently, their often incongruous activities included secular séances, adolescent girl chasing, intense bouts of writing, scandalous manifestations, and public critiques of artistic events deemed bourgeois from a quasi-Marxist viewpoint.

This confusing congeries of activity mingles social, artistic, and political intentions in a remarkable way; consequently, the political behavior of the Surrealists considered in this study will not only be defined by or limited to the familiar patterns that emerged during the period of their party membership. Indeed, before and after that period they applied "political" tactics to art and literature as a form of criticism by picketing, publicly censoring, threatening[32] or praising individuals or performances, collectively publishing or signing manifestos, and expelling and admitting members.

To engage these issues, it seemed useful to work from a broader definition of politics, however difficult for me to implement, involving the group dynamics of the Surrealists and considering their evolving utopian visions as political reflexes. I have found helpful the approach promulgated by political anthropologists like Victor Turner, who study the relations of legitimacy and power within social groups.[33]

The word "politics" thus has two main senses in this book: the first sense concerns the power plays of dominance and submission and ideological divisions within the group of artists and poets that, as we'll see, may resonate with similar tensions experienced in their educational formation; and the second concerns the normal meaning of the word to designate the public positions taken, for example, within the worlds of radical politics and of the artistic avant-garde, and communicated in manifestos and tracts.

The interplay of these senses underlies the discussions in Chapter 2 of the "politics of dream," and in the chapters on Marxist politics of the tensions between creative individuality and group loyalty. I maintain that there is a "politics of dream," a political dimension to Surrealist poetry, and a dialectical relationship between the imaginary aspect of dream and the concreteness of selected features of the social context from which their poems emerged. We find this relationship manifested in the fruitful interplay between dream *récits,* poetry, and art on the one hand, and a militantly political prose (as in the manifestos) on the other. While the Surrealists initially opposed the dream to poetry, they later for a time tried to make the dream the core of poetry and a model for art. Moreover, the dream – particularly the published dreams of the early Surrealists – had political significance that can be interpreted from close examination. Examining the early debates about how to realize the dream first in art and then in politics can help us understand the history of the movement and the succession of figures who dominated Surrealist thought and discussion – Lautréamont, Hegel, Freud, Trotsky, and Fourier. Ignoring the conflictual history of Surrealism by singling out whole periods and designating them by honorific labels such as "the Heroic Years" reifies dynamic processes; consequently, they are bound to fail as history and to reveal themselves as simplistic and arbitrary.[34]

Interpreting Surrealism in terms of this definition of politics, while taking into account the social, intellectual, and material contexts of Surrealist activity, will allow us to grasp more easily the continuity and disjunction between the artistic phases of the movement (the twenties and thirties), and within the movement at any given moment – we notice that each expansion of imaginative activity is followed by a compensatory shift: from the automatism of 1919 to the dream séances of 1922; from the anarchic radicalism of 1924 to the political revolutionism after 1925. (Ignoring this evolution seriously mars studies of Surrealist painting.)[35] Moreover, it will help us, I believe, to clarify and explain the bizarre and often obscure works of these painters and poets.

The evolution of Surrealist "political" attitudes is well illustrated in the changing uses made of Hegel and Freud; for one notes significant differences between their influence in the twenties and thirties, corresponding to the ideological needs and emphases of the two periods. During the

transitional *epoque floue*, Breton evidenced ambivalence at best toward both Freud and Marx.[36] Indeed, while after the mid-twenties Breton's Surrealists frequently expressed admiration for both Freud (but not the Freudians) and Marx, they only cited passages from a few of the works available even in translation, and never explored the original German texts (with the exception of Ernst, whose role for Breton's Surrealism has been misconstrued by recent theorists). Compared with writings by Lenin and Engels (and later Trotsky), those of Marx were virtually ignored, and different texts of Freud's attracted their attention in terms of polemical needs of the moment: up to the mid-thirties Breton usually cites Freud on the unconscious, on sublimation, and on the verbalization of unconscious thoughts. The prompt response to the foreign thinkers Hegel and Freud by restive French youths makes sense as a facet of their resistance to conservative middle-class culture initiated during their school days.

This book suggests a new approach to the Surrealists in terms of their life-long interaction with an educational system, both institutionalized and noninstitutionalized, that formed their minds and spurred their rebellion against many social values and conventions. I believe that we can gain insight into the intentions and implications, the politics and the artistic productions of Surrealism by considering them in relation to the education – early and late – of the participants. Ignoring the early education of the Surrealists has, for example, resulted in making Freudian ideas the sole source for Surrealism and ignoring that of French psychiatry[37] and sociology.[38]

Considering the work of a group noted for its mockery of institutionalized learning in terms of educational background makes sense when we see that the Surrealists, like all their contemporaries, were intimately involved with the bourgeois values transmitted by family, church, and peer group, at once absorbing and rejecting them. Two major crises marked the

imaginative individuals destined to become Surrealist poets: leaving behind a comparatively carefree childhood to enter the *école maternelle,* and the passage into the elite *lycée* – both changes bringing or renewing disciplinary rigors.

Their education in the schools of the Third Republic exposed them to conventions and practices, ideas and attitudes that shaped their mature thought even while provoking their nonconformity and dissent toward an educational system that Althusser called an "appareil idéologique d'Etat."[39] I think that we can gain fresh and valuable insights into Surrealism by placing it within the context of a French intellectual, cultural, and social history extending from the seventeenth century to the present.

The Surrealists, children of the middle class during the Third Republic, had suffered (and thrived) under the disciplinary education promoted by academic rhetoricians in France.[40] Those educators resolutely tried to reduce all obscurity to clear expression, to codify the mysterious and domesticate the strange; for example, Cournot, a mathematician influential as inspector general of public education, wrote in his *Traité de l'enchaînement des idées fondamentales dans les sciences et dans l'histoire,* echoing the dogmatic insistence of Comte: "Progressive civilization is not the triumph of mind over matter but the triumph of the rational, general principles of things over the energy and distinctive qualities of the living organism." Since everyone agreed – even the nonconformist Rousseau – on the great importance and formative power of education, any literary battle implicitly involved questions about the aim and means of education. The Surrealists, inverting the classical design of achieving clarity and taste, explored a poetry of dream and image.[41] In their adolescence – a portent of their mature union of love and revolution – they simultaneously distanced themselves from their middle-class families and the schooling they had excelled in, and turned with

passionate excitement to poetry and sexual adventure. In their quest for alternatives to the classical analytic logic and the Cartesian clarity emphasized in their early education, the Surrealists looked to very different alternatives like Hegel's union of contradictories.[42] The same aspect of Hegel had already appealed to the Dadaists: R. Poidatz, in a letter to the editor of the *Revue de la Quinzaine* of July 17, 1920, associates Dada and Hegel, and points out that "it was Hegel who created . . . a new logic based on the identity of contradictories. For him, to affirm is to deny."[43]

III

When we turn from questions of politics and semiotics to literary and visual productions, other questions arise: Are the latter supposed to shock? If so, why, how, and by whom? What was the Surrealist position with regard to commercial activities (publishing; exhibiting in galleries and selling; advertising)? How did they reconcile the diverse senses they gave to beauty (the faces in Moreau's paintings and Man Ray's photographs; the convulsed bodies of hysterics); and what was the meaning of the "portraits" in games of mislabeling and in various group photographs like those around Magritte's *Je ne vois pas . . .* (discussed later)? While I am better able to raise than to answer most of these questions, I do hope to suggest the kind of material and analysis needed to approach them profitably.

The interaction between writing and art proved immensely fruitful as a vehicle for the Surrealist ideology of "revolution": the artists, while working within the domain of literary imagery and ideas, felt freed from the restrictions on their imagination imposed by considerations of material and craft, and could develop an "aesthetic" without ties to formalism; on the other hand, the writers subverted narrative logic and descriptive realism through collages that daringly ingested visual imagery or through word and picture games evoking the group play of children.[44] My project is to write this ideology into a historic context by analyzing the content expressed (often with tensions or even contradictions) in the verbal and visual works. Such an approach allows us to see that as it evolved and changed, the movement, for all its limitations, faced moral and intellectual issues with a seriousness and highmindedness often missing among its contemporaries.

Various questions arising from the connection of the visual and verbal can only be posed in this book: How successfully can dream content be translated into a visual medium? Can the unsettling qualities of Surrealist writings and pictures affect social mores, ideas, and feelings of the potentially revolutionary segment of a middle class who had similar early experiences, or do they simply convey the quirks of bizarre individuals and turn into a spicy variant of *épater le bourgeois?* Finally, a fundamental question posed from the mid-twenties on – can there be a Surrealist painting (or collage or photography) comparable in its authenticity to automatic writing?

There are serious difficulties in attempting to answer the last question; for in contrast to the apparent ideological coherence of the Surrealist writers (as in the signing of manifestos), the artists present a confusing heterogeneity: crucial figures like De Chirico, Miró, and Picasso belonged at most peripherally to the movement; some like Duchamp and Man Ray skirted the border between Dada and Surrealism; some belonged intermittently (Ernst and Masson) or were merely included occasionally (Klee, Kandinsky, Chagall); and Dali, once exalted as a paradigm of Surrealism, suffered after his expulsion a severe retroactive demotion. Moreover, Surrealism had so pervasive an influence during the thirties that one can often not tell whether many artists "belonged" or were only "fellow travelers."

The Surrealists attached great importance to images as instruments for exploring the unconscious, as vehicles through which to communicate their findings, and as a means to "change life"; hence, it is

important to explore their circulation of images through illustrations to their books and pamphlets. In addition to such illustrations, they exhibited pieces to the public in small and sympathetic Parisian galleries like the Galerie Surréaliste and the Galerie Pierre or even in shop windows; moreover, collectors like Breton and Eluard who followed Apollinaire's example extolled approved works in catalogue entries and advised collectors outside their circle to acquire them. Their resistance to exhibiting in established spaces like those of the museums or major galleries led to a dilemma for many of the artists, who desired exposure to a larger public (as we know, the best works of these artists eventually found their way precisely into such spaces).

IV

As already noted, a major role in the intellectual and cultural formation of the Surrealists who came to maturity after World War I – the generation of the 1890s – was played by the education in the schools of the Third Republic, which perpetuated the tradition of French "discipline."[45] It was the values conveyed by these schools (which were consonant with those of their middle-class families) against which at the moment of adolescence they instinctively reacted.[46] This education was very like that received by their immediate predecessors, admired modernists like Apollinaire and Mallarmé; but two factors made a difference: socioeconomic developments and the fact that a new tradition, a modern establishment, shaped a different target for rebellion than that of the "masters."

Demographically (and educationally), the major Surrealists formed a cohort – the inaugural group of writers were all French, all born within a decade of one another: Paul Eluard, 1895–1952; Jacques Vaché, 1895–1919; Breton, 1896–1966; Aragon, 1897–1982; Desnos, 1900–45. The artists, who formed a less coherent group,

were born slightly farther apart: Picasso, 1881–1973; Duchamp, 1887–1968; De Chirico, 1888–1978; Ernst, 1891–1976; Miró, 1893–1983; Masson, 1896–1987; Magritte, 1898–1967; Tanguy, 1900–55; and Dali, 1904–89. Moreover, in contrast to the writers, of the nine artists only Duchamp, Tanguy, and Masson were French. Not surprisingly, these middle-class Europeans also exhibit analogies in their education, social milieu, means of livelihood, and sexual attitudes, as well as in the literary and artistic conditions from which they started and against which they rebelled.

The Surrealists like other middle-class intellectuals and artists lived on the tenuous margins of their community: seeking as adolescents to revolt or escape from an unsatisfying educational formation, they were always lured back to the culture they fled. The breakdown and secularization of religious values – part of a larger crisis of the middle class – created an enabling condition for Surrealist rebellion. Reactionary authors like Sedlmayr expressed regret for the loss of religious values in his *Verlust der Mitte* (1950) and found in Surrealism "eloquent testimony" of modern art's "world of dissolution and disintegration."[47] Artists who faced this crisis often resolved it by flight: into the autonomy of art; into the unconscious; into a variety of "others" (what once was called "deviance," but what has become now merely one among many alternative life-style options); into radical, revolutionary resistance to the dominant culture, or – a favorite ploy of the Surrealists like the Dadaists before them – to mock all authority, including even their own masters of rebellion.[48] The roots of this dissatisfaction of Western intellectuals with their models and even with themselves cannot be explored here, but merely noted. Surely it has a forerunner in Rousseau, who connected his analysis of social inequality with the value of revolution.

We might compare the Surrealist group to a fraternity like that of the Jacobin

revolutionaries of 1793 after their regicidal act; for this generation also escaped the authority of their fathers and mentors through their camaraderie.[49] Although such behavior might suggest an interpretation in terms of the Oedipal complex, the Surrealists themselves infrequently turned to such psychoanalytic concepts. Dali, at once versed in psychoanalytic terminology and preoccupied with patricidal motifs, was the exception: as a by-product of the eccentric artist's eternal preoccupation with fathers – his own, influential artists, William Tell, Lenin, Hitler – equivalents of the Oedipal theme entered Surrealist painting.[50]

Following in the tracks of the movement, one discovers the history of Surrealism in the debris of poetry and letters, as well as public statements left after these splits. A major task of this book will be to follow the continuous evolution of these problems, above all the quixotic quest to insert poetic imagination directly into one or another dimension of "reality" – psychological, interpersonal, political, or psychic. Although the Surrealists explored very different aspects of reality, or antireality – dream, the unconscious, the convulsion of beauty, objective chance – one thread connected them all: the paradoxical location of the poetic image in an ambient space and time it wished to escape or undermine.

The approach adopted here, which assumes the constant presence of the "real" in the "surreal" (a presence Breton himself liked to minimize), faces the challenging task of finding the thread of historical reality that winds through the fantastic productions of the Surrealists. A strong and, I believe, misleading current of thought about Surrealism detaches its fantastic imagery from the actual purposes or meanings underlying most of the best works. "Surrealist" thus becomes an intransitive attribute, a semantic dead end signifying the unintelligible.[51] Admittedly, the attempt to situate the Surrealists in their time while maintaining that they are still interesting to us involves a problem, al-

ready known to Hume and Kant, that has long hobbled even Marxist art criticism, namely, the difficulty (known to Baudelaire) of reconciling the fashionable or transitory with the enduring. Marx faced the problem with regard to Greek art, which has won appreciation from new audiences over a long time and through changed socioeconomic conditions. The whole question of historical time in Surrealism falls within the complex issue of disjunction between present and past that underlies the radical avant-garde. By drifting into revery during business or school hours the Surrealists manifested the purposeful daydreaming of politicized bohemians; implicitly this defiance of bourgeois complacency aimed at undermining a social order grounded in rational and sequential time. This intention helps us understand the Surrealist attraction to atemporal images and convergences across time, to the photographic freezing of movement, and to the conversion of cinematic motion into unsequential dream narrative. A problem arises here for any history of Surrealism: Can one do justice to the seemingly contrary needs of conveying the disjunctive and irrational aspects of Surrealism and of structuring the material to make sense of it historically and psychologically? This book is an effort to do so.

V

A major thesis of the book is that the formation of the Surrealists and their eventual resistance to it provided an enduring condition of their mature synthesis of poetic individuality and revolutionary social vision. The tensions between theory and practice, ideals and everyday realities that nourished the anxieties no less than the enthusiasms of the Surrealist intellectuals were conditioned by the vagaries of the formation of middle-class adolescents as they moved through the educational institutions of the Third Republic. These institutions insisted on rational discourse and obedience within the public context of family, church, school,

and job. A pervasive Cartesian logic guided the "disciplines" of science and ethics, and provided academic rules and guidelines even for the arts – metrical regularity for the temporal arts of poetry and music, the rhetorical "analyse de textes" for literature, and mimesis for the spatial arts of painting and sculpture.

In a defiance bordering on anarchism, the young poets cultivated the lyrical, irrational, and antibourgeois, and they felt drawn to experiments that blurred the boundaries between the verbal and visual arts. One particularly wonders about the role that popular visual materials accompanying their early education – like the illustrated children's books that influenced Ernst, or the rebus puzzles in the Parisian weeklies that persisted into the twentieth century – played in their conception of adolescent visual/verbal games.[52]

These group or individual games seem to anticipate the *cadavre exquis* (a transformed parlor game) and the collage novel. These formative educational experiences – in part absorbed, in part rejected – when coupled with their later encounters with social, political, and artistic developments, provide an explanatory power, I believe, whose cogency can be enhanced by formal analyses of major works and psychological studies of significant individuals. At the very least such an explanation might help us understand the constant and impassioned urge for a vaguely defined "freedom" of these relentless critics of the bourgeois society that had shaped and nurtured them.

VI

The chapters of the book address the following topics.

1. Breaking the Institutional Codes: Revolution in the Classroom

The Surrealists can be considered within a vast framework of educational polemics as representing an attempt to resolve the split between self and object, a problem engendered by Cartesian dualism, reproduced within the seemingly rational academic models that prevailed in the school systems of the Third Republic that educated them, and embodied in various intellectual frameworks like Saussurean dualism.[53]

That the "rational" Cartesian tradition was associated with everything French, patriotic, and middle class helped to define for the Surrealists the targets of their revolution. Contention between dogmatic exponents of philosophies that were oriented to either Descartes or Rousseau and that had important implications for the methods of education remained sharp right up to the twentieth century; for example, Bergson (much appreciated by Breton up to 1924) militated against Cartesian rationalism in the name of organism and intuition.[54]

Imaginative and verbally gifted, the Surrealists felt stifled by a prosaically rational, positivist, and progressive milieu; but while on one level they wished to escape from or destroy these values, paradoxically (or dialectically!) on another they in fact embodied them. Thus, the Surrealists, perpetually preoccupied with the critique of petit bourgeois values, tried to replace those values with their opposites: logic and reason with the unconscious, alchemy, the "supreme point" of convergence, or chance; French middle-class progress first with anarchic then with proletarian revolution;[55] literary modernism with the apparently timeless and styleless productions of automatism, psychosis, and dream: the commercial materiality of products salable to the bourgeois with *épatants* objects, or ones either too intangible or too enigmatic to appeal to any but initiates. Their attraction to German idealist thought (Fichte and above all Hegel) meant both a foreign evasion of an oppressive nationalism and a means to bypass French rationalism.

Breton and his colleagues, having experienced the cataclysmic transformation of the appearance of reality in modern styles of art, increasingly doubted the value of

depicting a "reality" that – divesting itself of its bourgeois connotation of comfortable regularity and predictability – had become problematic: they questioned the reality presented or represented in their own poetic texts; and they worried over the tension they perceived between the flux of motion and the crystallized stasis of spatial images. In their quest of timeless images paradoxically expressed in the temporal mode of writing, they forged metaphorical puns like Breton's "l'(h)or(s) du temps." And they turned passionately to a collective experience of dream.

2. The Politics of Dream and the Dream of Politics

Guided by the automatism of the *Champs magnétiques* and the unrelenting negation of Dadaism, the young poets gathered around Breton began turning from their former models, Gide and Valéry, whose modernism seemed less and less interesting and whose works eventually became the targets of their sarcasm. Breton, doubtless recalling his experience treating mental patients during the war and in search of realities untainted by bourgeois values, encouraged colleagues gifted with the power to generate fabulous images while asleep (Desnos, Crevel, and Péret) to do so in the presence of the group and to report their dreams as they occurred. It was as though they transferred the daydreams and rebellions of their classroom days to the "séance" room. Their dream performances convinced the Surrealists that they had uncovered a new and limitless resource for the imagination; for the texts produced by these somniloquous male poets seemed to their audience (other males, except for a female stenographer) immediate and authentic documents, at once real and magical.[56] Through such texts they sought to preserve individual sensation threatened with bourgeois clichés and to make manifest unconscious desires and impulses latent within social intercourse. Dreams and hallucinations, especially when accompa-

nied by scribbled drawings (adumbrations, perhaps, of the automatic drawings) offered a domain without firm boundaries between the real and the imagined. But as the meetings got more and more unruly, the threats of madness and suicide gradually but inexorably imposed limits. The maneuverings, bickerings, and manipulations among the dreamers and with their audience amounted to an unacknowledged politics of dream: leaders and followers, rebels and conformers emerged, all jockeying for position. During this period the poets, following the example set by the Futurists, attempted to establish a collective self-image through jointly signed lists distributing praise or blame of celebrated personalities.

The conflicts just noted developed within the group of dreamers threatened a disintegration that Breton averted by channeling his friends' energies into a more public domain of scandals and manifestations: the *epoque des sommeils* evolved into the period of unspecified revolution, of a utopian political dream. This began to change radically after Breton, attracted by the charisma of Lenin and Trotsky and their rhetoric of revolution, led the Surrealists into the public arena of radical politics.

3. In the Service of Which Revolution? An Aborted Incarnation of the Dream: Marxism and Surrealism

The dream sessions, which ended in internal tensions that threatened to split the group, were replaced by a collective political outlook directed against bourgeois society as a whole and expressed publicly in numerous publications, including the periodical *La Révolution surréaliste*. A generalized interest in "revolution," already in Breton's First Manifesto, was extended from Western manifestations (the French Revolution) to the "Orient," which vaguely included the Russian Revolution. An important step toward concrete political engagement occurred in 1925 when Breton read

Trotsky's biography of Lenin, a book whose inspired polemical rhetoric made the abstract notion of revolution tangible, showing how powerful minds had transformed reality. Breton published along with a review of the book a manifesto jointly signed by the Surrealists and two radical groups. There then began a long history of tangled engagements with the French Communist Party and the Third International in which accord alternated with dissension. Most significantly, the Surrealists avoided to the extent possible compromising their artistic integrity in order to serve the revolution.

As Breton's group of Surrealists became more politically active they felt a growing need to justify their art as relevant to the revolutionary goals they shared with the Communist Party. Breton's political turn provoked resentments from opposed factions within the movement – on the one side from dedicated artists like Artaud and Desnos, who refused to compromise their art, and on the other from engaged radicals like Naville, who demanded total commitment to political action. But none of them conceived politics outside the polarity between Trotskyism and Stalinism that dominated the controversies of French Communism.

The Surrealists soon realized that their newfound political concerns involved an inconsistency with their ideas of "work" and their goal of overcoming the division between work and leisure: the equation developed in the First Manifesto between creative "work" and dreaming contradicted the definition by Marxist theoreticians of work as the production of use value. Moreover, they rebelled against the bourgeois work ethic that their education had attempted to inculcate in them and which the Surrealists believed prepared students for the routines of wage labor. Without having a practical grasp of the anxieties that unemployment and hunger caused for workers, they aspired with utopian enthusiasm to surmount the division between work and leisure. They val-

ued activities that fell outside the economic nexus – unpaid creativity (including that of the *flâneur*), naive (Henri Rousseau) and psychotic (Nadja) art, the work of indigenous peoples – and they criticized whatever seemed like bureaucratic oppression, whether imposed on inmates in mental institutions by the psychiatric establishment, on *lycée* students by the teachers, on factory workers by the bosses, or on soldiers by the officers.

After the cataclysmic upheavals of 1929, Breton and those who remained in his circle anxiously reexamined their lives, looking for signs of coherence between their sexual desires, their poetic imagery, and their political hopes. During what we might call the paranoid thirties, themes of sadism, voyeurism (the gaze), and defensive "armoring" (Wilhelm Reich's term) became commonplace in Surrealist circles.[57]

During the thirties Breton, adrift, as always, between his preoccupation with the poetics of love and with politics, was continually frustrated in his efforts to contribute to what he still believed were the radical political intentions of the Third International. As hope within the public sphere diminished, he turned more and more to the private domains of poetry (except for their periodicals Surrealists' poetry mainly circulated among friends) and love. Breton adopted two key metaphors during the thirties – the *pont*, or bridge, and the "supreme point" in support of his long-standing effort to overcome the Cartesian dualism of mind and body, of rational and irrational. These metaphors acquired a new significance during this period of increased tension between the artistic and political aims of the movement.

The flimsiness of the political discussion in *L'Amour fou* adumbrates Breton's later disappointment with the Third International experienced in 1935–7 (the Moscow trials; the renouncing of class warfare in favor of a united front; the accommodation with the liberal, bourgeois French government). During the thirties the erosion of a

French democracy constrained by the global economic crises (inflation, overproduction, and unemployment), evoked moral and political challenges from the Right (Nazism, Fascism) and Left (Communism): Léon Blum's government fell in 1937. The Surrealists sided with the Third International, but the idea of revolution espoused by Surrealism remained tied to the idea of class conflict and did not conform to the latest turn of the Comintern against a conflictual model, and the adoption of the notion of a united front against Fascism.

In a final grand attempt to keep Surrealism free of intellectual and moral compromise, the Surrealists looked not to Marx and Engels but once more to Hegel — particularly his dialectics and his notion of objective humor[58] — and Freud (the analysis of dreams and humor and the theory of the superego). Breton now evolved his ideas of *l'humour noir* and *le hasard objectif,* which played a major role in his thinking about art of the late thirties.

Lacking its own official journal after 1933, Surrealism attached itself to the plush art magazine *Minotaure* (inaugurated after an idea by Bataille), which it gradually took over. This magazine never directly addressed the fateful political events of the time, except for one editorial on nationalism in art, which was published in 1939 in the last issue, just before the outbreak of World War II.

The Surrealists, skeptical and pessimistic in the face of chauvinist rhetoric and a universally dwindling artistic freedom (especially in the Soviet Union and the Fascist nations), courageously adopted the oppositional stance of a Trotsky or even of the anarchists, and insisted on the absolute right of the artist to liberty of expression. The famous manifesto by Breton and Trotsky, "Towards a Free Revolutionary Art" (1940), though still imbued with Marxist conceptions, above all embodies an affirmation of artistic liberty. It marks only a late moment in the long and hectic debate within Surrealist circles about the possibility of realizing a Surrealist art.

4. Surrealism and Painting (The Ineffable)

The Surrealists began early to look at artworks outside the pale of the familiar styles of Parisian modernism. And these poet-critics began to consider the question of whether artists could create a Surrealist painting with an authentic voice comparable to that of automatic writing.

The texts of the *Champs magnétiques* established the importance of the technique of verbal automatism, and the First Manifesto emphasized sound as the creative initiator for visual as well as verbal images, but the crucial idea was the "omnipotence of dream." Breton states that his dream image of a man cut in half by a window started out as a phrase (sound) "rapping on the window," thereby adding to the old image of the window as an eye (perspective) a new auditory one of a tympanic membrane. In their criticism the Surrealists said little about the visual aspects of the work, preferring to exercise their verbal talents; for example, they often named paintings they admired (e.g., the early works of De Chirico); they never describe the literal or formal contents of a painting, preferring either to produce "automatic" metaphors or their own poetic tributes. Yet visual imagery, as in a dream, circulated just below the verbal surface.

Inevitably, the Surrealist poets encountered considerable difficulty in their attempt to find a parallel in painting to automatic writing. This difficulty arose naturally from the fact that the medium of painting demanded craft skills and experience with which the poets were usually unfamiliar, skills that the quick, effortless automatic writing seemingly did not require. In attempting to overcome this difficulty, some Surrealist artists dedicated themselves to inventing (after the "velocity model" of the *Champs magnétiques*) rapid "hands off" techniques that seemed to

minimize craft and premeditation, and others made use of photography or cinema. Above all, De Chirico's powerful and enigmatic Metaphysical paintings up to about 1918 stimulated the creation of new subject matter by turning dream images into concrete visual ones with their own "metaphysical" reality.

In the wake of De Chirico's enigmatic allegories Masson fleshed out the scaffolding of analytic Cubism with mythological and psychological allusion, and also explored automatic drawing; and Ernst brought collage into the Surrealist domain as an instrument of fantasy rather than as a technique relevant to certain branches of modernist design. But however much they valued the work of these artists, the Surrealists remained uncertain how to realize a visual counterpart to their texts, and major independent artists like Picasso and Duchamp remained beacons for the Surrealists, transcending momentary polemics. The anxious writers and critics – Morise, Breton, Eluard, and Naville – debated in the pages of *La Révolution surréaliste* the possibility and the hypothetical nature of authentic Surrealist painting.

Breton rose to the challenge in his *Surrealism and Painting,* a collection of essays (some previously published as catalogue entries), in which he designated several painters as "Surrealist" – Picasso, Braque, De Chirico, Picabia, Ernst, Man Ray, Masson, Miró, Tanguy, Arp. Instead of presenting a definition, as he had done for Surrealist writing in the First Manifesto, he arrays the artists' works, accompanying them with allusive and lyrical texts. Neither here nor in his other writings on art of the twenties does he make the case for Surrealist visual art as a revolutionary weapon in the vulgarly propagandistic sense of social realism.

The Surrealists' exhibitions served as a major vehicle for communicating their ideas to the educated public. And the publication of books and periodicals could also reach a considerable audience among sophisticated Parisians. Careful consider-ation of the illustrations to Breton's "novels," *Nadja,* the *Vases communicants,* and *L'Amour fou,* can cast considerable light on the relation of visual image to text in Surrealism as it evolved from the twenties to the thirties.

Other media contributed significantly to Surrealism, notably photography (which Breton compared at one point to automatic writing) and a form of "sculpture" – the production of three-dimensional objects (including found objects, Giacometti's work, and *poèmes-objets*). These media seemed to some to spell the "death of painting" for the Surrealists, but in fact painting remained central to Surrealism.

5. The Surrealist Woman and the Colonial Other

Consistent with the middle-class home life of their childhood and their early education, the Surrealists saw women in subordinate roles, not as leaders or policy makers, or (at first) as artists. Women filled familiar roles as lovers, seers, and hysterics, which complemented the main activity of the fraternity: they were gazed at as beloved objects, were made to utter enigmas for the benefit of attentive poets, and to perform charming choreographies. While remaining on the periphery as wives and mistresses, women sometimes participated in the group activities during the twenties and performed secretarial tasks in the Surrealist Bureau.

The segregation of the woman corresponded to an idealization of her as a mysterious and potent Other, often in the form of a mythical being (Melusina, Gradiva); in particular Breton and his fellows were obsessed with the representation of female beauty, which they defined alternatively as convulsive, as incorporeal hallucination, or as a sadistically reconstructed "exquisite corpse."

Yet, compared with all the other contemporary avant-garde movements, Surrealism came closest to addressing its intrinsically patriarchal attitudes – with Engels

they criticized the patriarchal family and sometimes admitted women as equal participants in their meetings and games. Indeed, during the thirties and forties the term "Surrealist woman," which had signified an objective condition, took on a subjective connotation when applied to certain strong women artists (Toyen, Oppenheim, Carrington, Sage). For most, in contrast to the major male Surrealists, the central issue was not adherence to an ideology, but the construction of a well-defined identity that would yet remain in touch with the Surrealists' images with their strange associations and fertile condensations. This project often meant that the women produced self-representations concerned with adolescent fantasies and erotic tensions. Yet, in images dealing with powerful animals and women, many also seem to have expressed, however veiled, feelings of regret and anger; and a few were able to channel these impulses into paintings uniting the personal to the political. Leonora Carrington, detaching herself from the vision of Ernst, with her friend Remedios Varo opened up a whole new domain: they experimented with everyday materials they found in the markets of Mexico City and transformed the daily domestic rituals of the kitchen into their own magical and alchemical imagery.[59]

The Surrealists' dilemma about women – accepting them as equal, creative subjects or reducing them to dependent objects – reflects their deep-seated ambivalence as white, male, French middle-class revolutionaries whose enemies were in a sense themselves; for in opposition to the values of their class, they theoretically extended their sympathies to the non-white, the female, the non-French, and members of the working class. They manifested a similar ambivalence toward the colonial other – they cultivated only Francophone intellectuals and poets who accepted features of the Surrealist program, and never showed much interest in or sympathy with the fate of the unfortunate populace as a whole.

The abstract nature of the Surrealists' opposition to racism and war was revealed in their stand against the Moroccan War, for they had little interest in or knowledge about the Riffs themselves or the specifics of their plight. The Surrealists, suburban adolescents in revolt, presumably arrived at their views of colonials first through their school texts and then through viewing African and Oceanic objects in ethnographic contexts. They concentrated their interest largely on outstanding Francophonic writers of the Third World like Léopold Senghor and Aimé Césaire, with whom they had profitable exchanges of a literary rather than a political importance.

Educational questions were deeply inscribed within the ambivalence and anxiety of the avant-garde, and particularly affected the Surrealists in their poetry, art, language, and politics. The joint ambitions of the Surrealists to "transform the world" (Marx) and to "change life" (Rimbaud) disposed them at moments to move from their self-centering to a concern for the well-being of others expressed in their political engagements, and to transform the conservative institutions that had shaped them – school, family, work. Believing that miseducated adults had lost the best part of their childhood, they offered their productions as paradigms or at least stimuli for the realization of a repressed imagination and spontaneity – as though they would spread their slogans in graffiti on the walls of the world. However, limited by a linguistic and cultural imperialism and a patriarchal rigidity they could not transcend, their efforts fell far short of their ambitions, which in any case were utopian. Still, they had the merit of sharpening the problem of the reeducation of themselves and of their society as inseparable from the hopes for the future of humanity. In fact, the survival of the planet may depend on the ability of rich "advanced" nations not only to provide technological information and material to the Third World, but to learn forgotten lessons from those "colonial" nations.

1

BREAKING THE INSTITUTIONAL CODES
Revolution in the Classroom

For me, [Surrealism] was the incarnation of the most beautiful youthful dream of a moment in the world.

Marcel Duchamp, interview with André Parinaud after the death of André Breton in 1966

Let us not refuse to pay attention to this new school whose present members have an irritatingly excessive self-confidence, but who also have the fertile confidence and lively passion of youth.

Georges Rency, *L'Indépendance belge,* cited in *La Révolution surréaliste,* no. 5 (October 15, 1925)

But in reality, we encounter the tyranny of good-will, the obligation to think "in common" with others, the domination of a pedagogical model, and most importantly, the exclusion of stupidity.... We must liberate ourselves from these constraints.

Michel Foucault, "Theatrum Philosophicum" (1970)

France has two passions: equality and the selection of elites.

Le Monde (10 June 1993), on the annual ordeal of the baccalauréat exams

I

At first sight the idiosyncrasies of Surrealist art and writing might seem to detach the movement from its own time and place. However, Surrealism, in its characteristic paradoxes and incongruities, did not abruptly emerge as a full-fledged monster (even out of the chimerical bowels of Dada), but passed through a number of stages, successively assimilating and modifying or rejecting a variety of influences, including the Surrealists' early education.

Many of the earliest texts to which the Surrealists were exposed – their schoolbooks – displayed in conventional images the "reality" of national history and promoted chauvinism along with the dusty clichés of an academic education. The *école maternelle* and the *lycée* both nurtured and oppressed them, both stimulated them with great classic texts and provoked their irritation by a routinized pedagogy founded on a system of authority against which they would revolt as adolescents. However, as schoolboys they were more

compliant: Breton and Eluard, for example, won prizes as exemplary students. Thus, their education provided the Surrealists a rich intellectual background, as well as material for revolt and resistance.[1]

From their earliest years the Surrealists evidently felt impatient with their schooling and were in constant revolt against it. This and rebellion against the educational system that formed them manifested itself in such diverse topics as art and writing, politics, dream, time, work and leisure, love, and family.

I maintain that the restless youths who became Surrealists in general resented and suffered from the underlying philosophy that guided their early education (even as they digested essential elements from it) – for example, a Cartesian logic that emphasized clarity and simplicity of communication. Nor did this rationalism disappear after their adolescence: in the twenties and thirties there occurred a "Cartesian reaction" among writers like Alain and the once admired Valéry (Breton praised his "La Soirée avec Monsieur Teste" of 1896, with its ironic Cartesian dream) against the irrationalism of a Bergson. The Surrealists adopted a tone of ironic seriousness toward standard instruments of education like dictionaries; for example, Breton, in the First Manifesto, the founding statement of the movement, offered a carefully pedantic definition of Surrealism (in contrast to the earlier example of the Dadaists, who "discovered" their name by randomly pointing into an open dictionary).

Indeed, the generation of youths in France restive with their Cartesian mentors preferred to dream (or daydream) or to doodle rather than perform exercises like the *analyses du texte* universally demanded in the *lycées*. It is no accident that under the combined impact of psychoanalytic and Surrealist ideas, progressive French educators have in recent decades aimed at a reform that would emphasize originality for the student. The psychoanalyst Didier Anzieu, for example, wrote (just before the graffiti explosion in the Paris student uprising of 1968): "Automatic writing, the techniques of group creativity, education through play and free drawing, projective tests, psychodrama . . . are variants or derivatives of this goal [discovering the pathways of phantasy]."[2]

This is, however, not the whole story. While Descartes's method engendered a rational tradition well suited to the academies, one must not forget a second less rational tradition that owes much to Descartes, the "egotistical" geometrician whose metaphysics seemed interesting to Valéry only as an expression of his personality. Indeed, one might paradoxically maintain that the antirational Surrealists themselves, with their programmed spontaneity, produced a quasi-Cartesian calculus of the irrational. Nor should we forget Descartes the philosopher who wrestled with a mind–body duality (opposing a *res cogitans* to a *res extensa*) that to this day remains unresolved, nor Descartes the troubled dreamer at once finding in dream a source for knowledge and delusion;[3] moreover, the split that developed in his metaphysics between subject and object, and that has plagued philosophers and psychologists ever since, provided a context for the Surrealist fascination with the psychoanalytic unconscious. At its upper levels the intellectual rigor and emotional restraint of the French educational system was comparable to the German and English systems, but in the wake of the 1789 Revolution there resulted an unusual alternation between revolution and conservation, freedom and rigidity, experiment and codification. The potential for revolutionary change was built into the system.[4] Throughout his mature years Breton retained a spirit of rebellious negation and a reverence for the memories of his own childhood.[5]

A similar resistance was engendered in most European writers and artists confronted by the emphasis on discipline and reason. Parisian Surrealism was, however, a special case, expanding the range of its

targets beyond the arts (they even faulted fashionable modernist styles) and school to a whole range of social institutions like the military, religion, and the family. The Surrealist experience might be considered the type of the political struggles of other young mischief makers and truants in school.[6] Breton for one as an adult liked composing his wholly unorthodox and provocative poetry in school *cahiers,* as though he recharged his creativity through scribbling and drawing over the parallel lines intended as calligraphic aids: in the optic of nostalgia he probably saw his preschool childhood as an era free of the dessicating restraints of an institutionalized education.[7] Though no longer a rebellious adolescent schoolboy, Breton continued to use the same kind of school notebooks, as he recalls in "Saisons"; in fact he used them to sketch out the *Poisson soluble* section of the First Manifesto.[8] I conjecture that, as career choices began to loom, he spent time daydreaming in class (like Picasso, Dali, and others who recorded their early experiences). He then would sometimes create images he later recalled, like his playful allusion to Cartesian coordinates: "white coordinates on the blackboard, crossing its great hands *OX* and *OY.*"[9] Perhaps the practice of classroom doodling inspired in Breton and Soupault the idea for automatic writing; in fact Breton almost seems to recapture the early experience in the first words of his essay "The Automatic Message" (December 1933): "Oh no no I wager Bordeaux Saint-Augustin. . . . That's a notebook (*cahier*) that."[10]

Doubtless Breton and Eluard, capable students presumably already restless in the *école maternelle,* eluded with irony the rigidity of the *lycée,* the rote learning of literature and the rigorous demonstrations of Euclidean geometry and arithmetic, logic and grammar. Like Jarry before them they felt particular antipathy to the dogmatically positivist attitude foisted on the educational system by a seemingly self-assured and triumphant French scientific community (who assuredly felt anxious before the looming power of German research). We should note that both Aragon and Breton studied medicine, a profession toward which they felt ambivalence; for they felt at once sharply critical of the humanistic shortcomings of doctors and proud of their own bit of expertise, which they incorporated into their writing, especially at the beginning of their careers. It has been observed that, in the late twentieth century, students "protected" themselves from the excessive discipline and authority of the teachers, and they admired their classmates who flouted both.[11] In turning from the lucidity claimed by the Cartesians the Surrealists discovered the dark counterworlds of alchemical magicians (rather than the orthodoxy of the major religions) and above all of female seers and clairvoyants, heroines of the occult.[12] I believe that their interactions with women, as well as with poets from Francophone colonies, also repeat features of their education.

They commemorated their rebellion in poems, and Breton, as already noted, never tired of composing his wholly unorthodox poetry in school *cahiers,* as though charging his creativity by imposing his handwriting on the pedantic regularity of the ruled lines. In a similar vein perhaps, Eluard wrote in "Liberty," a poem created in the midst of World War II (1942): "On my school notebooks (*cahiers d'écolier*). . . . I write your name" (i.e., liberty's). Breton's *Poisson soluble* alludes humorously to his "attendance" at the "école buissonnière." This significant phrase refers to cutting classes in order to roam about idly (*flâner* in the liberty of "la Clé des champs") on the lookout for adolescent adventures. Aragon used the phrase to express a carnival mood in a poem published in June 1919.[13] Such a stand clearly prefigures their later contempt for the wage-earning labor that they were supposed to engage in as adults.[14] Breton devoted the entire section 15 of *Poisson soluble* to recalling the "école buissonnière" replete with chalk, black-

boards, and children.[15] Breton's "école" clearly had nothing to do with conventional schools.[16] The view of the Surrealists toward normal education was expressed on March 25, 1925, by Boiffard: "There is a work that would consist in taking account of all the courses offered in the Faculties, the Collège de France, the Ecoles Normales in Social Science, etc. . . . in order effectively to work [substituted for "fight"] against any mind, future or present, who would act (according to those schools). This work has been assigned to Pierre Naville."[17]

Middle-class youths in the late nineteenth and early twentieth centuries in France received from the Third Republic an education in which – on the model of Napoleon's codification of the Revolution – academic achievement provided access to professional advancement. The *lycée* faculty often included productive scholars who brought their students into touch with the major intellectual issues in their fields. Judging from textbooks of the period it is certain that in their *lycée* studies the future Surrealists could first encounter the heady intellectual issues that would later engage them – the Cartesian dualism of mind and matter, the tension between scientific determinism and subjective liberty, and the oppositions between the conscious and the unconscious and between prosaic truth ("reality") and poetic imagination. Such an education could have a transforming effect on pupils who came typically from homes whose highest goals were financial security and respectability.

II

Since the Surrealists owed so much – positively as well as negatively – to their early schooling, it will be useful to summarize relevant aspects of the Third Republic's art policies and educational philosophy.[18]

At the level of the elementary schools, the Third Republic fostered the education of rational and orderly citizens through an association of "les mots et les choses,"

following "Pestalozzi's techniques of having students draw objects and then write the identifying word, to have them make a connection between words and things, between the natural order, manual processes, and thought."[19] This technique incorporated the unintended potential of stimulating the imagination and emotional expression of the pupils; for its underlying pedagogical concept derived from Pestalozzi's teacher and fellow-Swiss Rousseau, whose ideas in turn attracted and influenced Breton.

Reading books like Rousseau's *Emile* (1762) that promoted liberation from the constrictions of civilization, the deeply affected Breton exclaimed, "Rousseau: I would even say that it is on this branch – in my opinion the first to achieve the height of man – that poetry has been able to flower."[20] His most extensive allusion to Rousseau (in 1952) expressed the depth of Breton's sympathy with his philosophy of education by citing a passage from Rousseau.[21] Without mentioning Rousseau, but with a view of education not unlike Breton's, Eluard wrote in 1932: "Man can never completely destroy the walls put up around him in infancy. In order for him to develop freely, he would, as a child, have to be raised by children."[22] The ideas of Rousseau were quite current among radical intellectuals in Paris during the twenties.[23]

It is likely that the ideas of Rousseau provided a context that enabled the Surrealists to welcome Freud's ideas early on,[24] and it is no accident that two Swiss psychologists were among the first to introduce psychoanalytic ideas to the French: Maeder, who wrote the first exegeses of psychoanalysis in French, and Claparède, who first introduced Freud's books.

Favoring economic individualism and desiring above all security and peace, the administrators of the Third Republic disregarded the conflictual model implicit in the Marxian class distinctions between labor and capital, proletarian and bourgeois. Moreover, evidently the Third Re-

public maintained the Hausmannian logic of the Second Empire that put city planning in the service of antianarchist, antirevolutionary ends: the spider web of wide symmetrical streets radiating from centers marked by monuments was intended to limit the possibility for erecting effective barricades (a tactic recommended by the anarchist Blanqui) like those of the July Revolution. Like all colonialists at the turn of the century, they projected social conflict outward and asserted that the opponent of all society was raw nature, an obstacle presumably to the innate human impulse to lead an ordered existence. The laborer had a moral and progressive role, and like the capitalist exercised willpower in controlling and refining nature; indeed, as the laborer transformed an undeveloped nature from disorder to order, his consciousness was presumed to be altered toward increasing rationality.

Republican educators perceived the work of art as a symbol of their social system[25] and as a means of diffusing an ideology of social balance through the mechanism of the marketplace. Art as taught in the public schools served the Republicans as a means to cultivate the perceptual and organizational faculties of French citizens and provide them with a common, preverbal system for perceiving, communicating, and satisfying their needs.[26] Moreover, art was closely associated with science, and form in art was defined in visual terms derived from contemporary physics. Drawing, largely reserved to copying from plaster casts, was regarded as a rational process that focused the student's attention on concrete entities before his or her eyes and away from mental chimeras or visions of realms outside human experience. Seeking to convey the "constitutive principles of human reason" and to provide young children with a rational conceptual framework that would bring human nature and the external world into conjunction, the Republicans turned also to the Greeks (e.g., Plato and Euclid) and trained students to draw geo-metrical figures in order to clarify the logical patterns underlying nature. The Director of Fine Arts in 1879 emphasized contour drawing to reinforce the identification between visual and written language ("les mots et les choses") and the "reading and writing of forms." (The Surrealists' desire to extend automatic writing to drawing surely has roots in this program.) A true scion of Rousseau, the director argued that contour drawing is at once "the instinctive procedure of primitive man and of the infant, while at the same time being perfectly rational." The Republicans, long before Trotsky and Breton's manifesto, expressed sanguine opinions about the ability of the ordinary worker; for example, one critic speculated that on seeing the machines at the 1878 Exhibition, workers might be inspired to create their own inventions and utter a cry analogous to Correggio's "I too am a painter."[27]

Finally, the Republicans, who were opposed morally, aesthetically, and economically to the separation between art and work, seem to have located a utopian region where the psychology, if not the interests, of labor and capital coincided: consumption. Here, the connection of the visual arts with science was crucial; for by grounding the advertised image of the consumer object in science, the image would not only appear, but seem to be "real": visual art became the perfected commodity, apparently proffering solutions to all problems from physical need to psychological alienation. The emphasis on consumption rather than production made particularly good sense for Paris, whose major industries were culture and entertainment.[28] Moreover, the movement of commercial entertainments like cafés, café-concerts, and music halls into the working-class neighborhoods paralleled the emergence of a consumer mentality susceptible to advertising. Here, the nineteenth-century issue of the psychological equality of hallucination and reality meets the twentieth-century move to advertising and consumerism, and ultimately to the

Surrealist encounter with "reality" through art and hallucination.[29]

Considering the aims just outlined, the education provided by the Third Republic's schools, particularly in art, was more likely to irritate than attract the independent youths. In 1952 Breton gave one reason for his antagonism to this education in his letter cited earlier to a young French girl at school in the United States. Recalling the dully disciplined copying to which he was subjected as a child, Breton observed: "It is so much more agreeable to imagine a child drawing and painting according to its phantasy than being obliged as here in France to become engrossed in copying a sauce pan or a lousy plaster cast! In complete contrast to these exercises, of which I have retained such an unpleasant remembrance . . ."[30]

The frustration of a restrictive education is not new for French youth, and we must ask why this particular moment at the end of the nineteenth century may have favored the emergence of such a radical departure as Surrealism. Part of the explanation comes from the anarchistic and libertarian thought that permeated the Symbolist writings to which the most literate members of Breton's generation were exposed.[31] The Surrealists later made special use of the educational material available in many European schools. (The German Ernst, constantly preoccupied with his own childhood, integrated images from children's books in collage novels like *Histoire naturelle*.) The pupils generally encountered impressive or amusing images first in picture books for teaching the alphabet, then in Christian texts, and later in the puzzle pictures (rebuses) of the weekly magazines. Other French students, like the young Sartre, recalled similar experiences. Breton often related the associative power of visual images to words, perhaps recalling also childhood rebus games; indeed, in his last year of life, as though returning full circle, he again and again combined pictures and words in his *poème-objets*.[32] Despite waging lifelong war

against organized religion, the Surrealists, fascinated by the ritual displays of the church, seem to betray a certain ambivalence reminiscent of the sacrilegious interest of Rimbaud (whom they much admired) in Christian dogma and ritual, expressed in juvenile pranks that evolved in adulthood as anticlericalism (Breton once mockingly dressed up in a Christian initiate's white garb), misdemeanors (Aragon in France and Breton in Mexico stole cult objects from churches), or the making of ironic art objects (the poets included images from religious history in some of their collages).

It is little wonder that these poets, revolting against technical skill and aesthetic purity, responded to modernist innovations in art that shocked their elders. But avant-garde art had another liberating aspect especially important for these somewhat "provincial" Parisian poets: the painters tended to be cosmopolitan (the French Fauves and Cubists; the German Brücke), to speak a universal language, whereas the Surrealist poets, though they burlesqued and distorted language, refused to speak or write in any language but French (their coolness to Joyce was perhaps an instinctive recoiling from his polyglot macaronics). As Breton succinctly put it in response to the question whether he could make love to a woman who did not speak French: "Insupportable. I detest foreign languages."[33] In theory the Surrealists believed in international revolution; in practice they were fortunate to have the school of Paris art as a counterweight to their linguistic chauvinism.

Escaping from the straitjacket of their education meant assigning a high value to "liberty" and the transgression toward the marvelous – a concept of long standing in France – in art and love.[34] It also meant defiantly turning (like their Romantic forebears searching for exotic thrills) to the non-French "East," especially to Germany, still suspect in a France that had during the war years read constantly of German atrocities and was only too willing to

station soldiers in the Rhineland. Hence, the "unconscious" analyzed by the Austrian Freud intrigued them, as did the ideas of philosophers like Fichte and Hegel, and German Expressionist movies like *Nosferatu* (they probably did not know that the painter Heckel in 1914 said that "the unconscious and the unwilled are the sources of artistic power").[35] Still, one detects traces of their educational formation even in their mature writing.

No figure looms larger in their intellectual background than Descartes, the source if not in fact the paradigm of a detested rationalism.[36] Although they often simply ignored Descartes when they did not oppose Cartesian rationalism, the Surrealists actually found certain notions of Descartes appealing – for example, that of the pineal gland, a "third eye" that Descartes believed could resolve one of his philosophical difficulties.[37] It has been noted that as late as 1931 philosophy in the French universities, bound to the rationalism and determinism of the physicists, "remain[ed] almost entirely Cartesian in the most traditional sense of the word."[38] But this does not refer to the most recent theories of physics. Breton, in his essay of 1921 on Ernst, already speaks of escaping "from the principle of identity," a view supported by radical developments in mathematics and physics as well as by Hegelian logic.[39] The First Manifesto called for replacing the prosaic constraints of logic with the concept of the union of contradictories; in this context Breton alludes to the Freudian unconscious, which he opposes to the positivism of French psychiatry. Paradoxically, the union of opposites in nature was one resolution of the impasse into which the exclusionary logic of Descartes was forced (but which was not consistent with the demands of that logic).[40]

The positions of Breton and Descartes in a number of cases stand directly opposed: Descartes contradicted the scholastic explanation of physical phenomena on the basis of occult forces, such as attributing white color to an activating quality of whiteness, whereas Breton, with an exquisitely sophisticated and ironic intelligence, was "enchanted" by medieval philosophy, notably Ramon Lull's (1235–1316) "immortal propositions," circular definitions such as "Digestion is the method by which the digestion digests the digestible" and "Shadow is the habit of the loss of light."[41]

German philosophers who diverged considerably from the Cartesians like Fichte and Hegel interested Breton as more suited to the demands of poetic imagination. French students of Breton's generation came first to know Hegel completely outside the Marxist context: the obscure and dense ideas of Hegel that would eventually help liberate the poets from the tight linearity of French Cartesian logic entered their awareness already as students.[42] When Taine applied Hegel in his social psychology he followed the example of Victor Cousin, who earlier interpreted Hegel *à la française*, and turned German softness into French solidity (as Paul Bourget observed).[43] A textbook much used in Parisian schools by Emile Boutroux contrasted the logics of Descartes and Hegel.[44] Histories of the presence of German philosophy in France generally ignore allusions in *lycée* textbooks to Hegel (and Fichte!), in the 1890s and after, that indicated his opposition to Cartesian logic. In contrast to the philosopher Hamelin, who aimed to reconcile Hegel and Descartes, the well-known Boutroux, like other conservatives (Barrès, Henri Poincaré, and Bergson) opposed everything German and advocated during World War I and later a competitive birth rate; and the major French Catholic scholar Jacques Maritain upheld as an axiom the principle of identity of noncontradiction, precisely in opposition to Hegel's identification of contraries.[45] Nineteenth-century critics of Hegel, such as Bourget (and rather like French musicians from Debussy to Satie), also contrasted the succinct and scientific positivism of Taine with the vague and verbose German philosopher Hegel whereas sym-

bolists like Villiers de l'Isle-Adam valued Hegel's notion of an absolute reality.[46]

Hegel's dialectic, evidently quite accessible to the Parisian art circles, was already cited familiarly by an exponent of Cubism in 1910, and the identity of contradictories was sufficiently well known to lead a critic in 1920 to publish his view linking the antilogic of Dada to Hegel.[47]

One notes that the differences between the early and late phases of Hegel's (or Freud's) influence on Surrealism satisfy the different ideological needs and emphases in the two periods. In their early phase while struggling with Symbolism, the Surrealists felt attracted both to Hegel's logic of the union of contradictories and, in a general way, to Freud's theories of dreams, against the linear clarity of Descartes and as polemical counters to the lessons in classical reasoning received in the schools.[48] As noted earlier, the irrationalist aspect of Hegel had already appealed to the Dadaists, whereas in the twenties and early thirties chauvinist intellectuals in both France and Germany, even among the liberals who appealed to reason and order, praised Kant as an example of Platonic and Cartesian logic above Hegel.[49]

Critics of oppressive discipline in French institutions have usually come from outside the system and followed advocates of a more "natural" and less regulated approach in the tradition of Rousseau, which would allow uninhibited display of emotions and free play to the imagination. Critics of Surrealism (as of Romanticism) have noted how often such planned spontaneity resulted in simulating emotion and in placing the imagination paradoxically at once in the service of the irrational and the academic.

Is it farfetched to see in the anger of imaginative youths anxious to liberate themselves from dull and burdensome school conventions (like the schoolboys in the lyrical film of the thirties, *A nous la liberté*) their first incentive to produce the scribbled and uninhibited outpourings of automatic writing and drawing?[50] Or might

we consider the aimless scribbling of Surrealist automatism in part (albeit unintentionally) a retrospective campaign against the purposeful sketching of Republican schools? – in other words, a form of revolt.[51]

While the Surrealists seem to share with their petit-bourgeois ancestors in the French Revolution the desire to rebel against authority,[52] there are differences. The changing attitudes toward the father within the French family parallel the historical changes of secularization and the uprooting of the old paternal European dynasties. One consequence of changes within paternalistic society may well have been a greater influence on the public behavior of culturally rebellious youth by their mothers; indeed, one study supports the point that mothers had a crucial influence on the taste of children attracted to modern art.[53] On the other hand, a classic form of patricide was projected into the public domain; indeed, one might compare the traumatic assassinations of public figures in the old orders to the popular perception that venerable scientific paradigms had been overturned by thinkers like Freud and Einstein. And the work of these thinkers, disseminated in popular form by the French press, in turn strengthened the assault in the cultural domain on positivism and rationalism launched at the end of the century by writers like Bergson and Proust; indeed, rationalists like Julien Benda (1867–1956) defended their version of intellectual discipline against "le bergsonisme."[54]

Placing the intellectual ferment we have mentioned into a global context, the Marxist historian (and "Hegelian sociologist") Henri Lefebvre, erstwhile collaborator with and later critic of the Surrealists, has noted that around 1910 "Euclidean and perspectival space disappeared as referents along with the other commonplaces (the city, history, paternity, the tonal system in music, the moral tradition, etc.)."[55] The Surrealists, hostile to the temporal and spatial continuities they regarded as consistent with bourgeois rationalism, welcomed all those in science or the arts who under-

mined conventional ideas of time and space.

III

The youthful Surrealists could call on impressive forerunners as corroborators of their position – "authoritative" subverters of authority, poets who rejected the poetic establishment. (For a slightly later generation the Surrealists themselves became the model for rebellion.)[56] But before they could appreciate these outsiders, they had to pass through a somewhat less challenging initiation: in their efforts to breathe in a less stifling intellectual atmosphere, Surrealists like Breton turned first to the esoteric and precious views of the Symbolists (returning to favor at the end of the war) and Decadents, who had animated the literary scene of their childhood and who validated their opposition to the tedium of petit-bourgeois life.[57] More than this, the Surrealists found endless material in Symbolism to engage them: the notion of the symbol as the clothing of an inner idea; the emphasis on esoteric matters like the void and the infinite, the enigma and parapsychology, or the unconscious; and in art paradoxical mixtures of flatness and depth that raise doubts about the location and even the meaning of depicted objects.

The young poets emulated the Symbolist fascination with dreams,[58] but perhaps they gained most from the ambition of the Symbolists to do away with conventional aesthetics, to investigate mediums and extrasensory phenomena (magnetism, hypnotism), and to suggest a new society freed from the dross of materialism.[59] The Surrealists naturally rejected the Symbolist flights into mysticism and commitments to esoteric doctrines that often became cults (albeit highly unorthodox), and coupled their antinaturalism with a curiosity that kept them alert to ordinary and concrete details.[60] But the Surrealists also assimilated from the nineteenth-century Symbolists their perversely iconic image of Woman (fatal, hysterical, Sphinx-like):

they stared open-eyed at Moreau's richly embellished Salomé, seduced by her frozen eroticism.[61]

They soon discovered, however, a cumbersome artificiality in the Symbolists, a fin-de-siècle preoccupation with sickness, neurosis, and genius that took itself too seriously. (Not surprisingly, when these Symbolist materials resurface in Surrealism, they either take the form of ironies, are transformed into the banal terms of clinical and medical praxis, or are adapted to Sadist scenarios.) Happily for the young writers, French nineteenth-century poetry offered several eccentric geniuses who could support their revolt – Lautréamont, Baudelaire, Rimbaud, Mallarmé, Jarry, and Saint-Pol-Roux. Lautréamont expressed hostility toward his education, which closely resembled that of the Surrealists: "When a boarding student in a *lycée* is ruled for years that seem like centuries, from morning to evening and evening to morning, by an outcast of civilization who constantly keeps an eye on him, he feels tumultuous waves of hatred rise like a thick steam to his brain, which seems about to explode."[62] One scholar has noted that for Lautréamont "class is a hell and hell is a class,"[63] another that he has "elevated a schoolboy's rebellion against the junior master to a revolt of man against his Creator.... But to destroy God, isn't it the most efficient way to strike Him in His works?... That is why he relentlessly attacks man and human reason, of which the Creator is so proud."[64] Jarry as a rebellious schoolboy had already created Ubu, a Rabelaisian character who exposed the id-like underbelly of middle-class propriety.

In their preference for the ferocious satire of Lautréamont and Jarry the Surrealists attacked the Symbolists' bourgeois complacency and their affectedly idealistic worldview with its presumption of aesthetic autonomy – and implicitly subverted their own predilection for Symbolism. Moreover, they infused their work with a shockingly unliterary realism so banal or vulgar as to bring them at some points

closer to Naturalism, a school whose adherence to the narrative logic of the novel they detested.[65] For a while they looked for support and encouragement to the most daring writers of the older generation, Gide and Valéry; but these modernists lost their influence when the ardent revolutionaries, undergoing the traumatic experiences of war, confronted their passivity and moral inertia (Gide's nothingness, as in his *Voyage d'Urien;* Valéry's excessive intellectualism) that, still steeped in the Baudelairean tradition of correspondences, was tinged with a passé Symbolism.

The cataclysmic transformation of the appearance of reality in modern styles of art (exemplified in painting by Cézanne and later in philosophy by the thought of Merleau-Ponty) corroborated doubts about the value of depicting a "reality" that Symbolism had already made problematic. However, modernism went much further. In the decade 1910–20 the emphasis of modernist schools (Fauvism, Cubism, Abstraction) on raw immediacy over tradition, on witty invention and on the discovery of new figurations, demolished the pale and reveried narratives of Symbolism and surely had a resonance with Breton's peer group. As opposed to the delicate vagueness of their Symbolist forebears, the Surrealists experimented with self-induced hypnosis, explored paranormal phenomena, and, with a complex mixture of paternalism and libertarianism, transformed the abstract and ethereal woman of the Symbolists into concrete heroines with case histories – as seers (Helen Smith, Nadja), as hysterics (Charcot's), and as assassins (who acted from personal as well as from political motives).

Service in the military during World War I – disturbingly akin to the regimentation of the schools – provoked the proto-Surrealists' revulsion and helped complete the first and decisive phase of their education.[66] They likewise rejected the formalist "schools" that grew out of Cubism and Fauvism, preferring an ill-matched congeries of art modes, including the enigmas and literary allusions of De Chirico, the allusive and protean oeuvre of Picasso, and the experimental photography of Man Ray. A book like Breton's *Nadja* places illustrations of a psychotic's drawings beside those of De Chirico and Picasso, primitive art, and objects found in a flea market.

IV

Warring against convention in art as in poetry, Breton turned, as we have seen, from the delicate reveries of Symbolism to the shocks of Fauvism (at first he admired certain works of Derain and Matisse) and then of Cubism, and to the disturbing clarity of De Chirico's enigmas. In particular he understood the importance of Picasso, the first "to break away from conventional representation," followed by Picabia and Duchamp, who "shared his conception of an art that has ceased to be derivative."[67] Though he may well have gained something from critics in Picasso's circle, Breton early on perceived the gulf separating the genius of Picasso from "Cubists" like Ozenfant and Metzinger, who, in fact, attempted to turn Cubism into an academic exercise. By 1916 the proto-Purist Ozenfant, and the future founder of an Apollinairean "Surrealism," Dermée (who then called himself a "dadaïste cartésien" and later published a poem by Breton), sought to surpass Cubism by using a Platonic theory of the beauty of geometric forms as the basis for a new and more rigorous style.[68] In fact, this goal echoed the values of the Third Republic discussed earlier, against which Breton's peers rebelled. These movements seemed to register the urgencies of international tension and conflict at the beginning of the century (the Boer War, Germany's ominous industrial expansion that seemed to dwarf France's) and the upheavals in the nature of daily life upon which a number of observers commented; for example, the British author Philip Gibbs, viewing prewar society in Europe, saw the breakdown of economic and social classes and neigh-

borhoods, including suburbia. Modern rest-lessness, he noted, penetrated homes "like microbes through open windows" breeding chaos in the families within.[69] And the War of 1914–18 created a new "French Revolution" in the workforce: operatives of mass production (many of them foreigners), herded into the big towns, displacing the prewar individual worker. Liberal intellectuals among the poets and artists abhorred these developments, as did the Surrealists, who felt somewhat ambivalent when they adopted (submitted to) the program of the Soviet Union advocating a revolution of the proletarian masses. The ideas of Einstein and Freud (and in France the Curies, Poincaré, and Charcot) in different ways contributed to the new intellectual, scientific, and cultural climate of revolutionary innovation from which emerged the explosion of Cubism and its varied offshoots. The inaccessibly complex mathematical physics of relativity was popularized in the paradoxes of "space-time," and psychoanalysis reformulated the concept of literary space long ago discussed by Lessing and others.[70] Breton, a pragmatic dreamer, tried to turn current scientific theory to poetic use; as he remarked in 1921, "Surrealism, psychoanalysis, [and the] principle of relativity ought to lead us to the construction of instruments as precise and as well adapted to our personal needs as wireless telegraphy."[71] Einstein and Freud were only the foremost of their generation to question the relation of space to time, an issue that art movements from the Futurists to the Dadaists and Surrealists would confront in different ways.

By 1920–1 (the years in which Freudian dream interpretation became the rage in Paris, as we shall see), the vogue for Einstein inspired humorists and cartoonists working for the popular press and made his name a household word throughout the world.[72] And in 1923 Jacques Rivière had already speculated on the influence of relativity in the new literature: "Literature will face the death penalty if it tries to resist the invasion of Relativity. . . . Literature will take up the task of bringing out the relativity of all things both external and internal, material and spiritual."[73] Symbolist literature and art, concerned with allegorical content, had already wrestled with the representation of ideas in preference to the emphasis on more purely formal values by modernist art movements.

The young Parisians of Breton's generation learned much from the Futurists' attitudes toward French Symbolism: the Italians, while charmed by the Symbolists' ethereal and psychological content, repudiated its Romantic "passéisme."[74] Moreover, anticipating Ernst's collages, the Futurists expanded the classical collage of Picasso and Braque, making more extensive and dramatic transfers between media (from drawing, painting, or sculpture to "words in liberty," film, etc.); apparently they hoped to promote a fission within "reality" that could provide new psychic and physical energies. In their antiliterary attitude the Surrealists shared with the Futurists a destructive abandon toward language that was dubbed "language terrorism."[75] The Futurists also applied their version of collage enthusiastically to bringing together remote images, before the Surrealists ratified such a procedure (to which they added a taste for sadistic imagery) by the example of Lautréamont's metaphors; but in contrast to the Surrealists, the Futurists aimed thereby to achieve within their art the concords, syntheses, and analogies they rejected in "reality."[76] The youthful aggressions of the Futurists eventually yielded paintings joyously affirming the values of armed conflict and military technocracy.[77] The Futurists, who saw themselves as protagonists on a world stage, were evidently also influenced by the idea – contrary to their conflictual model – of continuity (and adaptation) implicit within Bergson's philosophy (one repugnant to the Surrealists); for example, in his concept of "psychic duration," memory linked past, present, and future.[78] The

search for such continuity in time was congruent with the nationalist ambitions that later took political form as Fascism, but the concept of painting "states of mind" – essentially a refinement of Symbolist ideas – was dropped once Futurist chauvinism turned to Fascism.[79] The Surrealists on the other hand mocked the glories of French history and the chauvinism associated with them. (Desnos, in *La Révolution surréaliste* of October 15, 1925, simultaneously mocked two bits of school information – a famous character of French history and a textbook formula: he expanded the French version of Q.E.D. – "*Ce Qu'il Fallait Démontrer*" – into the ironic "*Charles Quint Faux Défunt* [instead of *Dévot*].") Moreover, as pacifists and opponents of bourgeois commercialism they opposed French occupation of the Rhineland and the exaction of war reparations.

In the years immediately after the war the avant-garde became politically ambiguous, splitting into opposed directions, the one revolutionary, the other conservative and anti-Bolshevik. The Dada nihilists attacked everybody, including Lenin before a group of workers, and Marinetti's Futurists, with confused intentions, in April 1919 joined Mussolini's Fascists in a counter-demonstration against a Bolshevik march in Milan.[80] In December 1919, *Littérature* – by no means ready to distinguish Bolsheviks and Fascists – could still publish a statement, "Un Acte nécessaire," calling for demonstrations "in honor of the poet" Marinetti, who had been arrested in Italy for "threatening the security of the state"; but in the March 1921 "Liquidation" published in *Littérature* Marinetti received neutral or negative grades, and by 1922 Breton wrote that Futurism was less interesting than Cubism or Dada, and that "we owe it a debt of gratitude only for its intentions."[81]

One interest the Futurists shared with early Surrealism was a preoccupation with the representation of time (in terms of velocity) and space. Already in his "Les Mots en liberté" of February 20, 1909, Marinetti wrote: "We stand on the promon-tory of the centuries! ... Why should we look back, when what we want is to break down the mysterious doors of the Impossible! Time and Space died yesterday. We already live in the absolute, because we have created eternal, omnipresent speed."[82]

But the nature of that interest was very different: the Surrealists, even at the beginning, thought in terms of the psychological displacement of hallucination rather than of optical illusions based on retinal effects (they were certainly affected by Duchamp's antiretinal theories).[83] The *Champs magnétiques* advocated speed of execution as a means of escaping style and logic, and indicated several speeds – v, v', v'', a procedure only superficially akin to one proposed by Marinetti years before and that might seem to approximate the uninhibited condition of free association.[84] As observed by Breton in *Saisons:*

> The a priori adoption of a subject is not absolutely incompatible with a greatly accelerated speed of writing whereas one can, without completely ruining this subject, continue indefinitely to press on the accelerator. Perhaps one could never more concretely, more dramatically grasp the passage from the subject to the object which is at the origin of every modern artistic preoccupation.[85]

But above all they differed owing to their opposed attitudes to war: on the one side, the chauvinistic and aggressive Futurists appreciated the machines of war in spatially expansive imperialistic terms; on the other, the Surrealists, in agreement with the Dadaists, were pacifists and antichauvinists, concerned not with mechanical speed but with the metaphorical speed of the imagination.

Finally, the Futurists desired (like Kandinsky and others at the time), in the words of Bragaglia, "to define and express in tangible form the subtle ties which unite our abstract interior with the concrete exterior," ties expressed visually in the Futurist fusion of a figure with a frame.

The desire and example anticipate an interest of Surrealism manifested in Breton's famous dream of a figure in a window reported in the First Manifesto and illustrated by an engraving of Ernst.[86]

In his efforts to free himself from the excessive refinement and obscurity of Symbolism – he was still wrestling with the tension between refinement and banality he found in Rimbaud – Breton gained a certain degree of freedom through the Futurists. But a much greater and more direct influence came from Apollinaire (himself responsive to the Futurists), whom Breton, like many other young poets and artists in Paris during the period, took as a guide. This leader of the Parisian avant-garde, by his example as a twentieth-century Baudelaire, not only helped Breton to discover the "idea of modern life" in the streets of Paris, but served as a model of the poet who crossed over into the visual arts, at once criticizing and inspiring modern artists.[87] Indeed, the Surrealist poets, wandering the streets like adolescent truants from school, produced writings that amounted to the apotheosis of the *flâneur*.

The objects that Apollinaire collected prefigure Breton's own later choices: on a visit to Apollinaire's apartment Breton remembers having seen Polynesian fetishes (as well as African) and – decisive for his poetics of the visual – two paintings by De Chirico.[88] We must also not forget that Apollinaire had an interest in magic, as well as the art and writing of the insane, wrote an introduction to de Sade in 1912, and had already mentioned psychoanalysis in 1914, years before the other poets in his entourage.[89]

But Breton must have already felt serious reservations about the chauvinism and nationalism of Apollinaire, a naturalized French citizen, and his emphasis on the value of poetry as a high art. At this juncture an individual more sympathetic to his view of life, war, and poetry took center stage, one who like Jarry mocked middle-class stuffiness with the reckless insouciance of a disobedient schoolboy. Jacques Vaché, acclaimed alike by Dada and Surrealism, sent some of his famous *lettres de guerre* to Breton conveying his Jarryesque "Umour" and his ironically polite refusal to accept the ordinary. His rejection of Apollinaire certainly affected Breton, as did his disavowal of all art.[90] Aragon recalled how in 1918–19 both Breton and he condemned poetry, and since they found even the best poems clichéd, they advised their replacement by what they called the poem-happening, or event. They compared such an event that could stir reactions in a crowd to a poster that could catch the eye of passersby.

In Paris during World War I, the young poets destined to create Surrealism were, as we have seen, at first stimulated by the surprising formal inventions of modernism, both in painting (Cubism, Fauvism, Futurism) and in poetry (Apollinaire's *Calligrammes,* the Futurists' "words in liberty"), but they soon looked for more than formal novelty. Moreover, they became disillusioned when they saw commercial connections between modernism and the bourgeois society they blamed for the social ills of war and imperialism. Rebels and pacifists, they turned their efforts to the destruction of bourgeois modes of art and poetry. At first these poets criticized prominent conservatives, but as noted earlier, they eventually even attacked such erstwhile innovators as André Gide and Paul Valéry, masters who had encouraged their initial efforts.[91]

Above all, they refused to follow their famous mentors in the game of career poet or critic: to them success within the context of bourgeois society seemed reprehensible, a surrender of integrity and independence for contemptible rewards. Consequently they experimented with ways to satisfy their ambition to produce work in an unconventional mode while avoiding the path of modernism that had become fashionable among many educated petits bourgeois. A major experimental endeavor was the recording and pub-

lishing of their dreams (discussed at length in the next chapter).

The young Surrealists found in the dream a vehicle with which to escape from stultifying mimesis on one hand and the stylistic innovation of the modernists on the other: their approach to art was figurative without being natural, intelligent without being rational, liberated without subscribing to modernist plastic values. Breton and later a succession of Surrealist poets and painters discovered a marvelous paradigm in the early paintings of Giorgio De Chirico, which opened to them prospects of presenting a visionary reality at once liberated from academic art with its mimetic constraints and from a modernism devoted to the formal and decorative.[92] And De Chirico opened the prospect of escaping from the transitory surprises of modernism. De Chirico helped Breton go beyond Baudelaire's perception that "modernity has to do with disengaging from fashion (*la mode*) whatever it can contain of the poetic within history, to draw the eternal from the transitory.... Modernity is the transitory, the fleeting, the contingent half of art, the other half being the eternal and unmovable."[93] With De Chirico, Breton doubtless felt that he could transcend Baudelaire's modernism in a nonreligious realm beyond time.

De Chirico's painting also appealed to the Surrealists in its implicit rejection of Futurism, of the passion for illustrating physical movement. The artist with rare exceptions froze the movements he or she depicted into static images devoid of overt drama; yet they invite us to construct narratives on some virtual (hence invisible) plane. "Time" also exists paradoxically within the same painting both as an instant registered on a clock face and as an expanse of centuries suggested by objects from various periods: De Chirico juxtaposed allusions to the ancient world, the Renaissance, the nineteenth and twentieth centuries, all conflated into the same picture. (It is less anomalous than one might think that Carrà moved straight from Futur-

ism to Metaphysical painting.) This conflation of times arrests temporal flux, crystallizing the successive moments as by a quasi-geological layering. There results in these paintings enigmas of time and memory whose fathoming seemed possible especially through psychoanalytic "archaeology" (Freud's description of psychoanalysis). Perspective here functions not as mirror of spatial relations, but as a time frame (one that Dali well understood).

In achieving these images De Chirico appropriated the dated mythology and symbolism of twentieth-century academic predecessors like Böcklin and Klinger, and to represent classical figures and architecture he adopted the conventional chiaroscuro, perspective, and foreshortening of artists like von Stuck. But in his most impressive work he transformed these figures into personal and unsettling characters – classical actors of uncertain pedigree, featureless mannequins or masks – suspended in alien surroundings, and his landscapes with their shadowy figures and figured shadows are hermetic, airless, and uneventful except for an implicit and silent drama of dream. Furthermore, De Chirico, despite his professed contempt for modernism, adapted modernist distortions with telling effect: he undermined the plasticity of modeled figures by setting them before large areas of flat intense color, subtly distorted scale and perspective, and juxtaposed flat planes with a temerity that seems to owe something to collage.[94] Owing to these incongruities the spectators, whose first glance could lead them to expect familiar meaning and expression, would experience on further looking a tremor of disappointment and perplexity or – in the case of the Surrealists, a thrill of the impossible, an anticipation of the inconceivable.

Apollinaire's articles in *Les Soirées de Paris* introduced the young Breton to De Chirico and other contemporary artists, especially Duchamp. And Apollinaire's poetry and plays (already stimulated by the technique of collage) opened Breton's eyes to the possibility of incorporating

banal and commercial matter in his poetry.[95] Apollinaire also corroborated Breton's opposition to optically mimetic art; for example, Apollinaire wrote in "The New Painting: Art Notes" (1912) that "the young painters offer us works that are more cerebral than sensual. They are moving further and further away from the old art of optical illusions and literal proportions, in order to express the grandeur of metaphysical forms."[96] This article probably refers obliquely to Duchamp and quite directly to De Chirico, working in Paris since 1910 and mentioned often by Apollinaire in the following years; for it seems more than coincidental that just before writing the word "metaphysical" he quotes Nietzsche's remarks about Ariadne on Naxos, at the time a favorite theme of De Chirico's painting. In his article "New Painters" of 1914 he quoted Canudo's definition of De Chirico's painting "as a language of dreams," commenting that he had another way of viewing the artist, which he promised to describe in the future.[97] Breton in an essay of 1928 discussed the notion of nonretinal art as emerging in the work of Duchamp, who explicitly formulated it.[98]

The marvelous that Breton found in De Chirico's art by no means came from the "metaphysical forms" that Apollinaire had discerned. For a Breton struggling with the paradoxes of time De Chirico provided the visual "evidence" that one could arrest or even transcend the transience of life in its many manifestations (clocks at a railroad station, the hour of day defined by a sundial effect, a running girl).[99] The Surrealists – in contrast to Apollinaire and the Futurists – had little use for modern machinery or the technology of "progress": they appear to have held with Baudelaire's views on the marvelous, which had little to do with technological progress: "Parisian life is rich in poetic and marvelous subjects. We are enveloped and steeped as though in an atmosphere of the marvelous, but we do not notice it."[100]

Rather than up-to-date and efficient mechanisms (symptoms of succumbing to that "American" taste mocked by Picabia, Duchamp, and Man Ray), the young Surrealists generally admired older, secondhand objects rich with empathetic suggestion that one could transform into anthropomorphic metaphor, such as the arcades, arches, portals, or hand-held machines or implements that already had become poetic objects (Lautréamont's eroticized sewing machine and umbrella).[101] Crystals, minerals and – by contrast – the soft forms of certain organic growths rather than the geometric regularities or free-form inventions of modernist abstraction (prior to Gorky) satisfied their curiosity about the nonhuman. They liked cinema but neither airplanes nor autos, found wireless telegraphy ("t.s.f." in French) a mysterious medium, and conjured with electricity and "magnetic fields" (perhaps remembered from the elementary physics of their early education and recalling eighteenth-century animal magnetizers).

V

An important source of new ideas and a powerful stimulant to their instinct for rebellion greeted them with the arrival of Dadaism: they found useful hints in the ways the Dadaists (following the Futurists) distorted words and meanings, ejaculated meaningless sounds, or gave synchronized readings that shocked the mind of their auditors and rendered their utterances unintelligible.

During World War I many sensitive young poets and artists in Europe on both sides of the trenches became disillusioned with aspects of their culture that seemed to support military violence. The notorious Dadaists mocked the institutions of patriotism, nationalism, and religion, while vociferously assailing prominent artists and writers. Breton and Aragon, among other French writers serving in the army, independently arrived at sentiments similar to the Dadaists' and joined them in demonstrations after the Dadaist leader Tristan

Tzara came to Paris in 1919. The generation destined to become the French Surrealists hesitated to embrace Italian Futurism for the same reason that they found the subversive humor and iconoclasm of the Dadaists (who had absorbed some of the salient features of Futurism) appealing: while impatiently enduring World War I, they shared with the Dadaists an antipathy to militarism and to its accompanying machinery of power and destruction. Strong formulations of the thesis that Dadaism led to Surrealism appear in the Dada scholarship of Sanouillet, who claims that "Surrealism was the French form of Dadaism," and in the Dadaist memories of Hans Richter.[102] Admittedly, Dada and Surrealism show striking similarities: both took vigorously pacifist stands, both rejected conventionally academic along with inventively modernist art movements, and both achieved notoriety through scandal and public manifestations. In detaching himself from Apollinaire in 1919 Breton reached out to Tzara, who had also earlier submitted to Apollinaire's influence. Breton dedicated to Tzara his ironic narrative about Apollinaire ("A Shaky House"), with its ambiguous characterization of someone named "Apollinaire," who "won the medal for work, and was valued highly by his companions." One can, moreover, find real anticipations of Surrealism in such remarks by Tzara as: "Dada is the signboard of abstraction; advertising and business are also poetic elements"; "Art is a pretension heated in the timidity of the urinary basin, Hysteria born in the Studio." Aragon admired the collage method applied in Tzara's play *Cloud Handkerchief,* first produced on May 17, 1924, before Breton finished the First Manifesto.[103] Like the Dadaists the Surrealist poets had no fear of seeming amateurish or incompetent when they ventured into art making; thus, several of the future Surrealists, notably the poets Aragon, Soupault, and Péret along with Tzara, agreed to exhibit their rather crude art productions at the Salon Dada of June 1921.[104] At the same salon and in the same spirit, the artists made the catalogue entries and Man Ray wrote a piece called "Inquiétude."

But the differences between Dada and Surrealism even at the beginning were significant – anarchic Dada had an amorphous and polyglot membership, whereas the Surrealists carefully controlled their membership and spoke and wrote in French from the beginning;[105] Dada shocked and intimidated its audiences by a limitless play of "dystax," whereas Surrealism remained within the bounds of syntax (although it stretched the term), while uniting provocatively incongruous images. Tzara, prime and first transmitter of Zürich Dadaism to Paris, precisely formulated in a letter of 1922 his idea of poetry: "Already in 1914 I had tried to take away from words their meaning, and to use them in order to give a new global sense to the verse by the tonality and the auditory contrast. These experiments ended with an abstract poem, 'Toto-Vaca,' composed of pure sounds invented by me and containing no allusion to reality."[106] Clearly Tzara's remarks already diverge from Surrealism and point toward the tradition of typographical experiments that evolved into concrete poetry and the products of Isou's *Lettrisme.* Although the pre-Surrealist circle of *Littérature* in 1919 and 1920 extended a welcome to Dada, and Tzara published abundantly in the periodical during this period (issue 13 of May 1920 contained "23 Dadaist Manifestoes"), the core of editors was never expanded to include Tzara.[107] Moreover, in contrast to the Dadaists, the Surrealists consistently valued the unconscious and dreaming (and Freud's contribution to understanding them), poetic imagination and passionate love, and from the mid-twenties on spoke out for political freedom as interpreted by Leninist Marxism.

Tzara's Dadaist views of society differed radically from the collectivist position that the Surrealists adopted in the mid-twenties; for example, Tzara declared in his "Dada Manifesto 1918": "Dada was born of a desire for independence, of a

distrust of the community." Furthermore, the Surrealists' use of shocking images in support of revolutionary and oppositional values differs markedly from the Dadaists' storm of images meant to deny constant values in art or life, as revealed by Tzara's formulations: "Any pictorial or plastic work is useless.... Order = disorder; I = not-I; affirmation = negation: supreme radiations from an absolute art." This Dadaist *coincidentia oppositorum* might lead toward a mystical nihilism, but not to the synthesis of a Socialist community through a dialectical negation of which Surrealist Marxists dreamed. Likewise, Tzara expressed antagonism toward psychoanalysis and Marxism during the Dada period: "Psychoanalysis is a dangerous sickness, lulls the antirealistic tendencies of man and codifies the bourgeoisie.... Dialectic is an amusing machine which leads us in a banal manner to opinions we would have had anyway."[108]

Compared with the psychologically rich though irrational automatism of the Surrealists, the chance games of the Dadaists were empty; for example, Tzara suggested that a writer cut letters from a newspaper article, mix them in a bag, take them out one at a time, copying them in the order in which they emerge. The net effect, characteristic of Dadaist ideas in general, was a centering on the object, the work produced, to the exclusion of the subject. On this question of the subject the Surrealists held more complex, even incoherent positions. Like the Dadaists Breton engaged throughout his career in a struggle against calling attention to the "subject" of art: in his annotations of 1930 on the *Champs magnétiques,* he commented that modern art is concerned especially with "the passage from the *subject* to the *object.*"[109] A certain inconsistency plagued Surrealism with regard to the Surrealist artists who on the one hand were held responsible for their creations and for their political views, but on the other hand could be admitted to the group only if they worked automatically. Paradoxically, automatic results,

even those resulting from chance operations – could be interpreted as "resembling" their authors.

Breton, moreover, although he rejected the middle-class individualism that exalted culture heroes, made an exception when it came to extraordinary personalities from Lautréamont and Rimbaud to Picasso and Duchamp. While expressing contempt for the extollers of artistic "genius" – including the heroes of modern art – Aragon, Breton, and Eluard found their own formulas of praise.[110]

While making an impassioned plea for the irrational and unconscious of "life" against consciously crafted art, the Surrealists at first expressed themselves like the Dadaists primarily with meaningless exclamations, dialogues in which question and answer do not correspond, and simultaneous readings intended to confuse the audience. They despised the coherence of narrative and drama, and retained vestiges of character, setting, subject, and dramatic action only to mock them. With the replacement of plot by random action and pointless talk the issue of boredom surfaced, a problem that plagued Tzara and that Breton also had to face.[111] The falling of the "Fourth Wall" – the elimination of the boundary between audience and actors (an anticipation of G. L. Moreno's psychodrama and Living Theater) – enlivened performances, as did bizarre psychosexual suggestions like the umbrella and sewing machine, instruments adopted from Lautréamont, and presumably they avoided tedium also through the extramural activities of manifesto, scandal, and conflict. Such attitudes have little in common with their later solutions of boredom – first in explorations of dream inspired by psychoanalysis, and then in sociopolitical controversy.

In its early impact on Breton and his companions Dada seems to have stirred up misgivings about psychoanalysis (as well as about radical politics); thus, after a discussion of Apollinaire in "Pour Dada" of August 1920, Breton writes:

What risks harming Dada the most in the public opinion is the interpretation propounded by two or three bad scholars. Up to now they have wanted to apply a system that is fashionable in psychiatry, Freud's "psycho-analysis," an application foreseen by Freud. A very confused and especially malevolent thinker, Mr. H.-R. Lenormand, has seemed to suppose that we would benefit from psycho-analytic treatment, if one could get us to take it. It goes without saying that the analogy of the works of the cubists or dadaists to the mental wanderings of the mad is entirely superficial.[112]

Seven months later Breton (who never thought psychoanalytic therapy was needed for artists) tentatively indicated some appreciation of Freud – in the evaluation of famous names in *Littérature* (March 1921) Aragon and he gave high marks to Freud as opposed to the "0" recorded by Tzara. But after he paid a visit to Freud in October 1921, he wrote a mocking "Interview du Professeur Freud à Vienne" – perhaps in frustration over his cool reception and echoing a previous "interview" published by Tzara.[113] Even during the ascendance of Dadaism in the circle of his friends, Breton was on the lookout for something more than Tzara's nihilism could offer. In the context of a presumed defense of Dadaism, the article "Pour Dada" of August 1920,[114] he began to distance himself from Dadaist nihilism (with a slightly barbed tone he observes, "The dadaists have taken care to assert that they want nothing"), anticipating some future "irrepressible personal fantasy which will be more 'dada' than the present movement."

Breton actually began to make the first tentative moves toward what would become Surrealism, and he initially found support in the giant figure of Apollinaire (criticized in other contexts), who served as his starting point or at least as a foil from which to launch these first moves away from Dada.[115] Breton discusses Apolli-naire in terms of the unconscious and the spontaneous:

There has been much talk about the systematic exploration of the unconscious. Poets have long abandoned themselves to the natural inclination of their mind. The word inspiration, taken until recently in a good sense, has (why, I don't know) fallen out of use. Almost all the lucky finds of images, for example, give me the impression of being spontaneous creations. Guillaume Apollinaire thought rightly that stock phrases like "lips of coral" whose destiny can be considered a criterion of value were produced by that activity which he called "surrealist." Doubtless the words themselves do not have any other origin. He went so far as to make of the principle that one must never start from a previous invention the condition for scientific improvement and, so to speak, of "progress." The idea of merging the human leg in the wheel was only by accident rediscovered in the piston rod of the locomotive.

We find here an informative misquotation of Apollinaire that suggests how Breton had come close to the poet's involvement with aesthetic form. What Apollinaire actually wrote in "Les Mamelles de Tirésias" was, "When man wanted to imitate walking, he created the wheel which does not resemble a leg. He thus made surrealism without knowing it." Breton's version omits the word "Surrealism" and converts Apollinaire's wheel (his equivalent of human locomotion) to a piston rod and introduces a favorite machine of his – a locomotive.[116] Breton's revision of Apollinaire's text exemplifies the independence of his mind; in fact his notion of Surrealism will drastically depart from Apollinaire's definition, which placed under its rubric ballet, stage design, and music: "This new alliance – I say new, because until now scenery and costumes were linked only by factitious bonds – has given rise, in *Parade*, to a kind of surrealism, which I consider to be the point of departure for a whole series of manifesta-

tions of the New Spirit that is making itself felt today."[117] Apollinaire's collaboration on the project of *Parade* with Cocteau – an opportunist anxious to unite the conservative right and the avant-garde – gave a repulsively chauvinist and bourgeois quality to the project in Breton's eyes.[118]

All these issues were addressed at the extremely important occasion of the mock "Barrès Trial" in May 1921, in which Breton assaulted the egoistic individualism represented by Barrès, expressed revulsion at Barrès for betraying his early rebellious posture by becoming a successful chauvinistic writer, safely ensconced within the establishment as president of the Ligue des Patriotes, and began moving away from Dadaist nihilism and anarchism toward collectivist revolution.

Breton as a young man probably was quite impressed by the daring ideas he discovered in Barrès, but he already seems somewhat guarded when presenting him to the leader of the Dadaists. In a letter of September 5, 1919, Breton asked Tzara: "Have you read Barrès? – what do you think?" In a *carnet* of December 1920 he notes that "with regard to a brochure by Barrès ('De Hegel aux cantines du nord') Aragon told me this morning that collectivism and individualism undoubtedly are not incompatible. We only believe this to be so through relying on superficial reasoning."[119] Many passages in this brochure, which discusses Hegel, Marx, Bakunin, and Proudhon, must have stimulated Breton, about to discover de Sade and Lautréamont – for example:

> ... The Hegelian idea is first transformed into two ideas, collectivism and anarchy which contradict one another, and yet are two equally necessary consequences of his principle. (p. 20)

> If terrorists understand the identity of destruction and creation, it is thanks to the fine views of Hegel on the importance of evil ... [and] that man is naturally evil ... Evil, the blow directed at the sacred, and revolt, these are the conditions of human evolution. (p. 26)

> If the revolutionary force of the Hegelian idea, concentrated in popular milieux like those we saw in the northern canteens, is to transform the world, if the old civilization is to crumble... (p. 37)

> The impoverished young man who, thanks to a scholarship has had the benefit of a university education, is a victim of what Taine has called *the incongruity between education and life*. In the last lines he [Taine] wrote... [he] gave voice to what youth was saying to the authorities: "You led us to believe through the education you have given us ... that the world is made in a certain way; but you have deceived us: it is much uglier, duller, dirtier, sadder and harder, at least to our mind and our imagination.... Listen to these young men, these rebels.... They are going to become free men, who will accept only principles of their own making. Tomorrow they will be the enemies of society. (pp. 50–1)

In March 1921 Barrès appears still in a favorable light; for in "Liquidation" Breton rated him very highly, giving him a "13" (to Hegel's "15"), but by August 1921 a radical change occurs, leading to "L'Affaire Barrès."

The charge against Barrès accuses him of "Crimes against the Security of the human spirit."[120] As "president of the tribunal" Breton treated the matter far more seriously than Tzara, a "witness," who tried his best to undermine the whole proceeding in favor of Dadaist absurdity. Breton solemnly censured Tzara, asking whether the witness was "trying to pass himself off as a perfect imbecile." Sensing that a new wind was blowing, Tzara, in his futile effort to confound the proceedings, recited a Dadaist poem as conclusion to his "testimony." Perhaps also, Tzara divined that the serious purpose of the trial – to indict an egoistic individualist, and move on with some vaguely collective intentions – touched him as well, and paradoxically even brought him into distasteful associa-

tion with conservative poetic individualists like Barrès, Valéry, and Gide.[121]

The threatening tone of the mock trial alarmed Barrès, who remained out of Paris before and after it took place.[122] From this moment on the Surrealists, taking advantage of the freedom of the press under the Third Republic, applied the weapon of scandal with great abandon.[123]

Breton declared his independence of both Dada and Apollinaire a year after the Barrès Affair in an article on Duchamp: he criticized both of them for misunderstanding Duchamp's archly ironic productions and mock-bohemian gestures: Breton claimed that Apollinaire mistakenly believed that Duchamp would "reconcile Art and the People,"[124] and that the Dadaists had made an error in claiming Duchamp as one of their own. After admiring the transcendent elusiveness and indifference of Duchamp Breton paid him the rare compliment (bestowed on only one other – Picasso) of acknowledging that he

is beyond the questions that ordinarily engage artists: with Duchamp "the question of art and life, as well as any other question which could cause conflict among us at the present time, is not raised."[125]

As the circle of Breton first clashed with and then detached itself from Dadaism on the grounds of its nihilism and diffusiveness, it became increasingly important to discover new vehicles for the energies and ideas of these young poets. One such vehicle was their group sessions at which they dreamed aloud. The images that often swarmed into their dreams in the presence of their colleagues generated an excitement in dreamer and audience alike. The transcription of these dreams replaced for the group whatever charms writing poetry once had for them; for they now sensed that they were producing texts that provided more than the thrill of confession, and in fact seemed to them to evoke a reality not otherwise accessible.

THE POLITICS OF DREAM AND THE DREAM OF POLITICS

> I'm absolutely convinced that the political aspect of Surrealism was purely oneiric.
>
> André Masson, *Conversations with Charbonnier*

DREAMING IN THE TWENTIES: COMMUNION AND CONFLICT

Before the period of recorded and published dreams that began with the first issue of the new series of *Littérature* in March 1922, the fledgling poets revealed a preoccupation with dreams that one suspects extended back to their childhood. Breton wrote poems referring to dreams as early as 1911 ("The Dream") and right up to the automatic writing of the *Champs magnétiques* (1919–20), and Aragon wrote the poem "Sleep of Lead," which begins: "The alert sleeper looks at life with the eyes of a little child."[1]

In a grand effort to resume the state of poetic irrationality that Soupault and he had induced in their shared experience of automatic writing, Breton initiated a new experiment with his friends. He described it in "Entrance of the Mediums":

> What our friends and I mean by *surrealism* is known up to a certain point. This word is not of our invention and we might very well have left it to the most vague critical vocabulary, but we use it with a precise meaning: we are agreed it designates a certain psychic automatism, a near equivalent to the dream state, whose limits are today quite difficult to define.

He next explains how he evolved to the present experiment based on the hypnotic sleep of colleagues gifted with the power of mediums:

> To return to "surrealism," I had come to think recently that in this domain, inroads of conscious elements, placing it under a human, literary, well-determined will, made its exploitation less and less fruitful. I was losing all interest in it. Along the same line of thought I had been led to give all my preferences to *dream accounts*, which, in order to protect them from stylization, I wanted to be stenographic. The misfortune was that this new test called for the help of memory, which is subject to deep failings and remains, generally speaking, unreliable. A solution to the problem did not seem to gain much ground, mainly for lack of numerous and typical documents. This is why I expected little more to come from that direction, when a third solution offered itself (I would think that all that remains to do is to decipher it), a solution in which a considerably smaller number of causes of error intervenes, consequently a most exciting one.[2]

To the usual idea of the dream as personal and obscure, the new solution counterposed a practice in which hallucinations seemed increasingly to contain their own secret rationale, to have a transpersonal and luminous significance, and to constitute an extraordinary new mode of writing.

The interactive potential of the mind implicit in their method was developed out of the experiment of the *Champs magnétiques,* in its turn related to French psychiatry and the pseudoscientific literature of occult writing.[3] At their séances a member would fall asleep, enter a quasi-hypnotic trance, and respond to questions from his unsleeping colleagues.[4] During this period of hallucinating "seers" (Crevel, Desnos, and Péret) in which words alone did not convey the whole meaning, the poets introduced visual images, hieroglyphs of their language of dream.

In recording their dreams the Surrealists followed a practice not uncommon among contemporary writers in Paris influenced by Symbolism; however, unlike most of their contemporaries, they made an effort to expunge any taint of the sentimentality and elitism of the Symbolists, preferring a matter-of-fact stenography of their dreams. In the context of postwar Paris and after his experiences as an army medic treating emotionally traumatized soldiers, Breton was particularly impressed by Freud's sympathy with the neurotic, his refusal to categorize – as was fashionable then in French psychiatry – the abnormal, hysterical, or psychotic, whose utterances seemed to him to contain valuable sparks of imagination. At first Breton had only secondhand knowledge of Freud through translation,[5] but eventually he read French versions of Freud's major works.[6]

Freud's name did not come up publicly as an admired source among the Surrealists before the First Manifesto;[7] but by then they were applauding the *Interpretation of Dreams,* which, for all its tendency to scientific reductionism, confirmed their belief in the significance and "reality" of their dreams.

Wishing to explore their own images and the sounds of their vibrant cosmopolis, the Surrealists rebuffed not only conservative writers but, as noted earlier, the modernist poets they once admired, including innovators like André Gide and Paul Valéry, masters who had encouraged their own initial efforts. Their defiant inclusion of prosaic and commercial material in their work did not mark the abandonment of poetry, but rather the evolution of a new concept of poetry that entailed a schoolboyish evaluation and grading of famous personalities.[8] Ever the rebels against the "vocational" approach to poetry, they admired the daring manifested briefly by Paul Valéry when he gave up writing and declared that the poet should remain silent,[9] and Breton expressed first disappointment and later sarcasm when Valéry resumed his career.[10] In the introduction I explained how an individual activity such as dreaming can have an implicit "political content" and a group meaning. In the sense there discussed, we can attribute a "political" dimension to the "Entrance of the Mediums" in which Breton narrates the dream sessions.[11] Thus, the events preceding the publication of the dreams in *Littérature,* no. 6 (November 1922), reveal a "political" maneuvering for position by Breton and his colleagues as they sought alternatives to the defunct Dada.[12] As will emerge in later discussion, a realignment of adherents and opponents occurred as the new movement of Surrealism began to take form.

I maintain that not only was the publication of the dreams a decisive refutation of Dada, a public gesture showing a new direction no longer tied to the playful contradictions of Dada, but that each dream presented by a member of the group for publication implicitly proclaimed or reinforced his position within the group. This latent meaning gives the dream a coherence as a "political" statement in terms of the narrow society of the poets' group; moreover, we might consider the published dream an uncensored "confession" in which one could, without incurring criticism by the others, comment on (or merely locate) anyone's position within the group – as charismatic leader, as loyal follower, as centrist member or peripheral and eccentric participant or even a centrifu-

gal rebel; considered in their less structured moments one might see them merely as siblings squabbling among themselves or expressing disquiet over Breton's autocratic leadership. Of course, not all the dreams are "political" in the same way, although in my opinion careful analysis even of the most personal dreams can expose an element of political assertion (as happened in the group of psychoanalysts gathered about Freud).[13]

Careful interpretation of some of these apparently obscure personal dreams, and their replacement to the extent possible within the context in which they arose, reveal, I believe, that they bear on the dreamer's overt behavior to which they can more or less be related. Their very publication and editing can provide clues to the writer's intentions.[14] If, as I believe, large portions of these dreams do not belong to inaccessible areas of the unconscious, we may question why they were reported: Why go to the trouble of putting into the form of a dream what one could have stated directly? Part of the answer is that the dream allowed a rejection of familiar poetic styles without adopting the inventive fashions of modernism. But also, it seems to me, the poets, wishing to express their antipathies to their colleagues or views unacceptable to them, yet fearful of exposure, found in the dream an ideal vehicle, a language without accountability that allowed the making of innuendos. Evidently the unqualified expressions by the Surrealists of praise or blame, especially of Breton, left little place for nuance. (In the section "Before and After" appended to the Second Manifesto in 1930, Breton mockingly juxtaposed admiring remarks made earlier by his friends with their recent attacks on him in *Un Cadavre;* for example, Desnos's expression of adulation in 1924 faces this sentence of 1930: "And the last vanity of this ghost will be to stink eternally among the stinks of the paradise consigned to the imminent and certain conversion of the confidence-man André Breton.") They could use the dream report as a means to utter their feelings

without being wholly conscious of their meaning, and with diminished risk of retaliation or embarrassment; for everyone in their circle, by a common but unstated agreement, was motivated to find marvels and metaphors in dreams, not symptoms: they did not, as it were, seek the minotaur of meaning lurking in the psychoanalytic labyrinth. Thus, the dream as published antiliterature allowed them to express their feelings without having to explore them psychoanalytically or present them to their colleagues in the context of dialogue.

As the poets turned to actions within the public sphere, they converted their dreaming into projections of an ideal future (Freud was criticized for neglecting this aspect of the dream), thereby allying their utopian "dreams" to the Marxist vision of social revolutionists like Lenin and Trotsky.[15]

Certain features of the group's background can help explain the intellectual context of political dreaming. The work of the celebrated French sociologist Gustave Le Bon, who had written extensively on the social psychology of the French Revolution, is characteristic of the intellectual climate of the Surrealists' youth, and moreover bears on the social aspect of dreaming. His book, the *Psychology of Crowds* (1895), distinguished what people believe as individuals from their views in groups (ideas analogous to the hazier formulations of some Symbolists and mocked by the Surrealists):[16] groups can produce a heightened sense of power in individuals, allow them to yield to instincts repressed when alone, and thereby make them more suggestible. During the first decades of this century, in the wake of Symbolism and the attention psychologists gave to dream accounts, many poets and artists were fascinated by the content of dreams, however obscure or even occult. By about 1920 dreams were being published for their intrinsic interest and as antitheses of orthodox literary and artistic forms. A major innovation in poetry – the union of poetic sophistication and banal detail – appears to have made the

protocol form of dream narrative attractive for its disjointed presentations of prosaic accounts of intimate personal details. Other traditions or paradigms that appealed to Breton and the young poets were the dreamer as performer at séances of the group (not unlike the notorious performing hysterics that Charcot presented in his amphitheater), the poet as seer (they admired and emulated Rimbaud's attempts at voluntary hallucination), and the poetically rich but fanciful "directed dream" of Hervey-Saint-Denys.[17] Writings bearing on the dream by authors who influenced Breton's circle included Jacques Rivière's "Métaphysique du rêve" (1908), Apollinaire's "Onirocritique" (1908), and Reverdy's "L'Image" (*Nord-Sud*, 1918). The last work advocated a process of bringing distant realities together, to arrive at a pure creation of mind, and insisted that what is great is not the image but the emotion it provokes. One can compare this process to the dream work described by Freud, especially the process of condensation that brings together apparently unrelated images. But in psychoanalytic terms, as Lacan has indicated, "The doctrine behind it is false," since "the creative spark of the metaphor does not spring from the presentation of two images, that is, of two signifiers equally actualized. It flashes between two signifiers one of which has taken the place of the other in the signifying chain, the occulted signifier remaining present through its (metonymic) connexion with the rest of the chain."[18] Reverdy, and the Surrealists after him, based this process on considerations of rhetorical contrast rather than on psychoanalytic doctrine.

There is, I believe, a dialectical relationship between the fantastic *récits* produced in the dream sessions and the social reality of the dreamers. We find this relationship manifested both internally among the members of the group and externally as a fruitful interplay between dream, poetry, and art on the one hand, and the militantly political prose of manifestos on the other. The dreams published by Breton and his colleagues Desnos, Péret, and Naville can be read as documents produced by individuals interacting both in their group (and manifesting not only enthusiasm but aggression, jealousy, and emotional dependency) and within the social and cultural context of Paris in the twenties.

These political and psychological aspects of the published dream indicate an unexpected dimension of "reality" in these highly personal texts: entering into the stream of Surrealist publications they became transpersonal and helped define the group's collective being. Moreover, their "reality" served to document an exploration into the unknown and the unconscious that attempted to materialize such figments of the imagination as phantoms, ghosts, the visions of seers, as well as psychotic imagery. Like other poetic explorers the Surrealists received confirmation for their novel productions through the resistance of their critical public, which amounted to what one might designate as a "coefficient of friction."

In April 1922 the three poets destined to dominate the Surrealist movement announced that their preferred occupation was "to sleep" (Louis Aragon, Paul Eluard) or "to dream while sleeping" (André Breton).[19] In various avant-garde publications that he edited, Breton printed accounts of his dreams. He was primarily interested not in the latent content of these dreams, but rather in using them to create a new aesthetic, transforming them into uncategorizable poetry. In addition, he used his dream material to promulgate his evolving philosophy of art, a philosophy later expressed more overtly in his Surrealist manifestos.

The attempt that follows to analyze dreams without the accompanying associations seems justified because these dreams evidently constitute prime examples of what Freud called "dreams from above" whose real significance lay in the intention to make a specific intellectual point.[20] Freud reported several instances of such dreams produced by his patients with the

specific goal of disproving his evolving psychoanalytic dream theory.

The contribution of Freud's theory of dream interpretation, whether direct or indirect, to the interest in dreams of Breton and his colleagues during this period is generally accepted;[21] at the same time Freud's technique of free association, intended to circumvent the mind's censorship, especially in recounting one's dreams, appealed to avant-garde writers.[22] While, as we have already indicated, one can hardly overlook the importance of the nonpsychoanalytic dream for postwar European art and culture, by the winter of 1921–2 one already finds widespread preoccupation with psychoanalytic dream theory in Paris, even before the translation of Freud's major work:[23] Marcello-Fabri edited *La Revue de l'époque,* in which the influence of Freud was felt as early as 1920; Breton published an account of his visit to Freud in Vienna in 1921, albeit a somewhat ironic one; and the famous literary critic Albert Thibaudet circumspectly contemplated the application of psychoanalysis to literature in the April 1921 issue of the *Nouvelle Revue française.* This important periodical was influenced by the psychoanalyst Eugénie Sokolnicka, who had been analyzed by both Freud and Jung.[24] As we have already noted, the Surrealists shunned the sentimentality and overt elitism of the Symbolists. Wishing to locate their art within the images and sounds of their vibrant cosmopolis, they also rebuffed the elegant inventions of modernist poets.

The Surrealists' defiant inclusion of prosaic and commercial material in their work did not mark the abandonment of artistic production, but rather the evolution of a new concept of poetry. As Breton observed in "The Entrance of the Mediums" "I was led to give all my preference to *accounts of dreams* which I intended to be written down verbatim in order to prevent their being stylized."[25] The dream texts were often published with prose writings by the same author, and analysis reveals similar ideas, latent in the dreams, made manifest in the prose. To understand the political nature of these dream texts for the Surrealists, we must consider why they seemed so important to these youthful authors in the first place.

The Dadaist antimilitarism and mockery of institutions even including modernism affected the young avant-garde poets, as noted in Chapter 1, but they turned the wild anarchic mocking into moral issues, and the extreme individualism into coherent programs.

For several reasons Freud's theories of dreaming attracted the young iconoclasts and scandalmongers who revolted against bourgeois authority. The ideas of this German Jew provided a public platform from which to contest xenophobia and anti-Semitism among their countrymen. (The French had not forgotten the Franco-Prussian War or the bloody World War, and the name of Dreyfus – at once associated with Germany and the Jews – still embittered a considerable public.) In 1924 Henri Claude, the well-known psychiatrist, deplored the fact that psychoanalysis was "a German invention."[26]

Furthermore, these young iconoclasts insisted on confronting the general distaste in France (and elsewhere in Europe) for sexual explanations of dreams and neuroses. However, the alternative theories of the subconscious with little concern for sexuality, such as Janet elaborated in France before 1900, had a pervasive influence along with other features of French psychiatric thought and were as inescapable as Cartesianism in the schools. One must acknowledge the impact of French psychiatry on the founders of Surrealism, albeit an indirect and negative one.[27] The preference of the Surrealists for Freud's psychoanalysis can be better understood by looking at Janet's strictly symptomatic and etiological analysis of automatism, and his apparent lack of interest, compared with Freud, in the objectivity of mental states.[28] Where would the word and the notion of "automatism" come from, if not from Janet's adoption of it in

his well-known titles?[29] In fact, the term had already appeared in Maury, *Le Sommeil et les rêves* (1878), a book quoted by Taine, by Freud, and by Breton. We find the following in Taine's *On Intelligence:* "We are going to sleep. As the image becomes more intense so it becomes more absorbing and independent. . . . We seem no longer actors, but spectators; its transformations are spontaneous and automatic."[30] Indeed, already in 1909 Théodore Flournoy, a psychologist admired by Breton, associated the word "automatism" with the theories of Freud without ever mentioning Janet.[31]

Evidently the Surrealists made little direct use of the technical aspects of psychoanalysis and did not share its therapeutic[32] and educational objectives.[33] In fact, the young authors published their dreams with a complex mix of intentions – literary, personal, and "political," in the personal and social senses already indicated. The political nature of these dream texts is not obvious in either sense, especially since the proto-Surrealist texts, from the *Champs magnétiques* to the published séances, were characteristically experimental and highly subjective. Nevertheless, even the *Champs* hinted at a concern for what we may call sociopoetical issues, if not sociopolitical ones: the authors apparently subscribed to Lautréamont's (the pseudonym of Isidore Ducasse) motto "La poésie sera faite par tous. Non par un"; for in the first selection of "La glace sans tain" they referred to a "factory for producing dreams at bargain rates and department stores filled with obscure dramas."[34]

The Surrealists were of course not the first to put the dream to literary use, but they were the first avant-garde group to make the dream central to their artistic and political goals, and in their everyday exchanges. Nowhere do we find this more clearly than in the early Surrealist dream accounts. In the First Manifesto, Breton acknowledged his debt to Freud, who "very rightly brought his critical faculties to bear on the dream," and observed that "Surrealism is grounded in the belief in the superior reality of certain forms of association previously neglected, in the omnipotence of dream, in the disinterested play of thought." But he considered the image neither innocent nor mere escape in the manner of the Symbolists; in fact, in the First Manifesto he maintained that powerful images could dislocate or otherwise affect their perceiver. Breton thus sustained his old antipathy toward the strain of Cartesian thought that placed the clear and useful results of reason and logic above the obscure or irrational products of dreaming and the imagination.[35]

An important question arises here: Can one elevate so ordinary and apparently formless an activity as dreaming to an artistic product, something that Freud himself refused to do? But just such an idea made the rounds of Parisian intellectual circles before Freud came to their attention, between the 1880s and the 1920s. Dr. Emmanuel Régis, a psychiatrist whose writings Breton knew as early as 1916, observed: "Given the frequency of somnambulism, neurosis and dream hallucinations among men of talent and genius, it would be interesting to know if they were especially subject to subconscious dreaming and if so, what share the subconscious could claim in their creations."[36] Dreams also contain the imagery crucial to the antiliterary revolution of Breton's generation. We have already mentioned an important source for him in Reverdy's notion that a good poetic image, a "pure creation of mind" that brought distant realities together, had value not in itself but for provoking an emotion (Reverdy seemed later to turn to a more conventionally poetic appreciation of the image). Reverdy's knowledgeable contemporaries might readily have found in his idea of the image a parallel to Freud's concepts of dream mechanisms (e.g., condensation) and free association, both of which connect apparently unrelated images through their latent content of feelings and ideas. Breton would have appreciated both

Freud's and Reverdy's sensitivity to the emotional reality inherent in images.

Another set of suggestions emanated from Aragon, who aimed to arrive at a concrete, materialist aesthetics of poetry. Breton seems always to have had strong reservations about an aesthetic materialism, but evidently during the years of their collaboration the two colleagues suppressed this smoldering disagreement.[37]

It will prove instructive now to look at the most relevant "political" dreams published in *Littérature,* from the years preceding 1924, when the First Manifesto was published and *La Révolution surréaliste* began publication.

The first issue of the new series of *Littérature,* edited by Breton and Soupault, in March 1922 carried an artlessly "stenographed" record of dreams by Breton. In pronounced contrast, the first pages of the original series of *Littérature* (no. 1, p. 3) edited in March 1919 by Aragon, Breton, and Soupault, reprinted excerpts from André Gide's exquisite novel *Les Nouvelles nourritures.* Gide there revealed himself still in the grip of old Symbolist-Decadent notions: "I dream of new harmonies, a subtler and franker art of words without rhetoric and with nothing to prove." Gide saw himself as a voluptuous narcissist seeking individual happiness while defying conventional moral prohibitions to his homosexuality. These attitudes were rejected by the collectivist, heterosexual, and amoral positions of the future Surrealists.

Breton's "Three Dreams" appeared in the same issue as his subtly ironic interview with Freud, a fact of some significance since the two texts constitute the first of several instances of rivalry with the master analyst of dreams.[38] Indeed, in a subsequent issue of *Littérature* dedicated to poetry, a list of famous names was printed on facing pages; as already noted, among those names we find Charcot's but not Freud's. But in an earlier issue of March 1921 containing the notorious "Liquidation" list, Freud's name not only appears but receives a very high mark from Breton.[39] Breton was much more the literary dreamer than interpreter, and his efforts to explore his dreams have a different kind of value than one scholar assigns to them.[40]

The next few issues of *Littérature* reflected the struggle of the editors to move away from Dada, and no dream accounts appeared until October 1922. Then Desnos presented three dreams, perhaps a tribute to Breton, whom he greatly admired and feared. The third dream reads: "I go to bed and see myself as I am in reality. André Breton comes into my room with the official journal in his hand. 'Dear friend,' he says to me, 'it is my pleasure to announce your promotion to the rank of sergeant-major.' Then he turns around and leaves."[41] In November 1922, Desnos won star status among the vocalizing dreamers at the séances reported by Breton in "Entrée des médiums."[42] In December 1922, Desnos took as his dream identity the name "Rrose Sélavy" and published dozens of word plays uttered while he was asleep to an audience that recorded them.[43]

The leadership exercised by Breton gave shape to the group's activities, and sustained whatever coherence the group had; in fact his authoritative presence during these sessions seems to have contributed the aura of security that made the continuous outpouring of these somniloquies possible.[44] But that security did not free them from another anxiety. As Victor Crastre put it:

> Those who failed to show up regularly for the meetings – and these took place every day – ended by being suspected of being lukewarm.... A *good* Surrealist could not refuse the "communion" ... that was given every day.... The excluded Surrealist could not fail to fall into an abyss of desolation because at the same time, he lost his friends, the audience of Breton, and the gathering places they frequented together, and was forced into solitude, or into the mediocre games of the "literary life."[45]

A nucleus of writers from the defunct *Littérature* collaborated on the new periodical *La Révolution surréaliste*, which published dreams and extolled sleep as a stimulant for imaginative work. The first issue (December 1924) offered dreams by Giorgio De Chirico and Breton on the same page. The prominence of a painter's dreams marks an effort, especially by Breton, to expand the earlier interest of these poets in the visual images of painting and sculpture (as well as film and photography). Illustrations of paintings and a notice of Breton's forthcoming study of Surrealism and painting appeared there. This notice prompted a veiled polemic with Pierre Naville and Max Morise in ensuing issues of the periodical (see Chapter 4, this volume).

After culminating in the winter of 1922–3 in what is known as the "Period of Sleeps," the publication of dreams as such diminished drastically. The dream account did not disappear, but was transformed when the Surrealists turned to other concerns: visual images (collage, film, symbolic objects) became more interesting than verbal accounts of dream imagery; group games emphasizing chance and the irrational (pooling, the *cadavre exquis,* occult and parapsychological "experiments") replaced the dream séances; and revolutionary politics replaced the "omnipotence of dream."

The move from group activities involving sleep and the unconscious to radical politics makes more sense when the role of collective psychology in Surrealism is understood. The cover of the first issue of *La Révolution surréaliste* (December 1924) is a collage of three group photos of the Surrealists by Man Ray; at least one of them shows what looks like a somnolent performance by Desnos. The last issue (December 1929), in which Breton published his Second Manifesto, a polemical blast against Surrealist renegades, contains a full-page collage of a painting of a nude woman by Magritte surrounded by individual photos of the 16 leading Surrealists, all frontal, with their eyes shut and with solemn expressions on their faces.[46] Their "collective dream" evolved over the next few years into the vision of an egalitarian community of "liberated egos" after the manner of the communist ideals espoused by Trotsky that began to permeate the movement by 1925.[47]

Let us turn now to Breton's five dreams in *Clair de terre* (1923),[48] which Aragon in *Le Paysan de Paris* (1924) described as the first accounts to retain their dream character in the telling. Breton begins: "I was spending the evening in a deserted street of the Grands-Augustins quarter, when my attention was caught by a sign above the door of a house." The notice on it read "Shelter" or "For Rent," phrases then somewhat out of date. Breton entered the somber passageway and was met by a person who serves as a "guiding spirit" and leads him down a very long staircase, an action which evidently he associated to a feeling of youthful success.[49] He notes that "I have already seen this person" ["Je l'ai déjà vu," altered from the earlier version, "Je le reconnais"], a man who once tried to find him a job. On the walls of the staircase Breton sees bizarre reliefs, plaster casts of greatly enlarged mustaches. He observes, probably with irony, "Here are the mustaches of Charles Baudelaire, Germain Nouveau and Jules Barbey d'Aurevilly."[50] On the last step his guide leaves him, and he finds himself in a vast hall divided into three rooms. In the first, a young man he knows named Georges Gabory[51] is seated composing poems at a table surrounded by very dirty manuscripts.

The next room has almost no furnishing, but its lighting, while still inadequate, is better than that of the first. Breton observes someone seated in the same position as Gabory, but to this person he feels much more attracted. "I make out Mr. Pierre Reverdy." Neither person seems to notice Breton. After stopping "sadly" behind them, he enters the third room.

This is by far the largest, and its contents more valuable:

An unoccupied chair before the table seems to have been intended for me. I take my place before the sheet of immaculate paper.

I follow the suggestion [earlier he also wrote, "I understand the role that I have been called to fulfill"] and set myself the task of composing poems. But, even while allowing myself the greatest spontaneity, I succeed in writing on the first sheet only these words: "La lumière . . . "

No sooner is this sheet torn up than on the second appears the word "La lumière . . . " and on the third sheet: "La lumière."

Certain clues in these apparently disconnected texts can help us ferret out an underlying theme. As usual Breton rebels against authority: on one side this concerns the "light" of Cartesian logic – the illumination of dream displaces logic and reason. But on the other it has to do with the authority of modernism: Breton throws out a challenge to a formalized and therefore passé modernism in poetry, and proclaims his characteristic readiness to assume leadership among the young poets. The sign "Shelter" or "For Rent" (a pun on *louer,* meaning both "to praise or glorify" and "to rent," evoking the notion of art critics for hire, doubtless a repugnant activity in Breton's view), evidently set on the old house of modernism, gives a message all too vapid for the fearsomely judgmental Breton, as his associates well understood.[52]

The walk down the long stairway apparently expresses Breton's opinion of his distinguished place in history; in fact he had used the image once before to evoke memories of his achievement as a schoolboy.[53]

The oversized mustaches refer with a touch of irony to significant predecessors, paternal and powerful like De Chirico's father, who also sports a mustache in the illustration preceding Breton's dreams in *Littérature.* Although Breton wrote respectfully of these poets in the First Manifesto a year later, he showed some ambivalence toward them in his dream, since his reference to mustaches (false in the case of Baudelaire, who did not have one) contains an obvious element of burlesque. Breton's readers would immediately have associated the mustaches with the notoriously iconoclastic mustache that Duchamp added to the *Mona Lisa* – an act that deeply impressed Breton.[54]

The guide – doubtless a reference to Paul Valéry, who had inspired Breton's early efforts – leaves him on the last step, having apparently fulfilled his role. Unquestionably Breton included Valéry, as he did André Gide and Guillaume Apollinaire, among the once admired figures he now feels destined to surpass.[55] In 1919, Breton mocked the presumably dated poetry of Valéry, in the poem "Monsieur V" (in *Mont de piété*), to which the dream seems to allude.[56]

Doubtless in keeping with his readings at the *lycée,* Breton's dream suggests a secularized version of Dante's *Divine Comedy.* In his journey from darkness to light Dante is guided by his classical predecessor Virgil, whose shade departs after having brought his charge to the border between the Inferno and Purgatory.[57] Breton progresses through three rooms, passing from the obscurity of Gabory to the better light of Reverdy on the way to a room intended for him alone, where he would find his own destiny – a chair to fill, a fresh start on "immaculate" paper unspoiled by previous inscriptions, and a culminating "brilliant" triumph (*lumière*).

The theme of light that climaxes in the repeated word *lumière* represents one of the dream's essential motifs – the poet's high ambition and confidence – and points the way toward the "light of the image."[58] This dream heads the collection of writings titled *Clair de terre,* which brings the clichéd romanticism of moonlight "down to earth."[59] The poet appears as indomitable creator by assimilating the luminosity of Lucifer and the fire of Prometheus, creator of humankind.[60] Breton was aware

of the technical and metaphorical significance of light in painting, and in 1917 he praised Apollinaire's seminal importance as an art critic in these terms:[61] "Delaunay can with some elegance lay claim to this phrase from [Apollinaire's] *Méditations esthétiques* as a profession of faith: 'I love the art of today because I love above all the light, as all men love light above everything else – they invented fire.' "[62] The light of Breton's dream was that of the poetic creator and evidently concerned not the Realist or Impressionist sunlight, but rather, as he put it in *Surrealism and Painting,* "the suns of the mind."[63] One might observe, finally, that through etymology we can trace links between this preoccupation with light and the Surrealist interest in "fantasy" and dream: the Greek *phantasia* (imagination) means the power by which an object is presented to the mind, the object, or *phantasma,* being an appearance, as in a vision or dream. Kindred words like *phanos* (light) fall directly into the circle of Surrealist concerns; for the central idea of many Surrealist dreams, poems, and paintings explicitly or implicitly concerns light.

The remaining four dreams pursue a variety of themes important to Breton. The second conveys a sense of anxiety and frustration and introduces a woman – one might call her a muse of the metro – who sits facing him and says what must have seemed to the energetic and ambitious Breton like a denunciation: "Lazy life" (*Vie végétative*).[64]

The third dream concerns two birds in flight seen by people armed with rifles (including Breton) who shoot at them, wounding one and killing the other. The wounded bird had differently colored eyes, one bright, the other dull, and a member of the group, who didn't really belong, took "the marvelously colored and brilliant" one for a monocle. The dream concludes when the monocle of the fashionable bourgeois couturier, Paul Poiret, is broken while he dances before clients. Paul Eluard offers to replace it with his own monocle,

whereupon the replacement suffers the same fate. An undercurrent in the dream is the question of identity and sympathy: the bird – a Valéry? an Apollinaire? – is also Breton himself. Like the bird, he had different-colored eyes, and the two Pauls share first names if not ideological viewpoints. The dream suggests that Breton felt some uneasiness about the deadly use of critical weapons by his friends, but in the end he realized the futility of trying to help "the enemy," as the generous Eluard tried to do.

The fourth dream, first published in *Littérature* in December 1922, like a didactic exercise deals with the discovery of "a new tense of the verb 'to be.' "[65] Breton dreams that while writing a novel he feels a need for information, so he consults his library, out of which he chooses a volume at random. Since it seems to be a treatise on philosophy, he expects its title to read "Logic" or "Morality," but instead it reads "Enigmatic" and contains plates of ecclesiastical or mythological figures.[66] Now, with a feeling of exaltation, he turns to a book of "medical observations" in his possession that contains what he had sought – a photograph of a woman who utters threatening words, touches his shoulder, and disappears. The encounter gives him a "real revelation." He then looks at a dictionary, "probably" looking for the word *souris* (mouse). He opens at *Rh* and sees the word *rhéostat,* and then *réalité.*[67] Next he sees Charles Baron, "a young man whom I never recognize in reality," who is replaced by Aragon.[68] Breton and Aragon are on the avenue of the Champs-Elysées, going up to l'Etoile, each carrying an empty frame.[69] "Under the Arc de Triomphe I dreamed only of getting rid of mine"; but Aragon objected that they should shelter the frames because of a risk of rain. Breton concludes with the observation that "Aragon's frame was gilded, whereas mine was white with very old traces of gilt, and of appreciably smaller dimensions."

This dream seems to me to stand at the

turning point between the earliest proto-Surrealist publications of 1919 and the First Manifesto announcing the advent of Surrealism in 1924. The discovery of a "new tense" (*temps*) of the verb "to be" within this dream alludes to the newly sensed reality status (the place of being) within the dream – its "Surreality"? – and corresponds to an interest of French psychoanalysts of the time in the relation between grammar and the unconscious.[70] In 1926 Desnos, writing on the same issue, subsumed all tenses into the present.[71] The union of time and being in the fourth dream approaches the formulation in the manifesto (based in part "on the discoveries of Freud"): "The sum of the moments of dream, from the point of view of time (*temps*), is not inferior to the sum of the moments of reality." The "book of medical observations" (Freud) helps Breton solve his problem, and then as we have seen, he pursues his investigations in the dictionary with the series of words that construct the word "Surrealism."

Breton's "Entrée des médiums," published one month before this dream, grapples with the problem of preventing the undesirable intrusion of conscious – hence, unspontaneous and literary – elements into the domain of what had come to be called "Surrealism." He considered possibilities of automatism and the direct recording of dreams, but chose instead a third – the pronouncements of fellow Surrealists while in a state of trance in the presence of a sympathetic audience. Not only did such performances have the advantage of direct and convincing immediacy, but they gave the witnesses access to a treasure house of imagery and verbal invention, richly stimulating to their own imagination. Breton felt triumphant as he entered this new path: the walk up the Champs-Elysées toward l'Etoile and the Arc de Triomphe continues the victorious march predicted already in "Monsieur V" of 1919 and pursued in the *Champs magnétiques*.[72]

The categories ("Logic," "Morality") of the presumed book on philosophy appear in the published text with Germanic capitals; but the book denies both Logic and Morality and treats instead Enigma (De Chirico's favorite term, as Breton knew), as though sketching out the major and familiar definition of Surrealism offered in the manifesto. The notion of a link between art and life has its counterpart and antithesis in the conservative viewpoint of the Third Republic that art must indeed bear on life and vice versa, not as an agent of change, but as a reflection of "reality," and as a promoter of stasis, beauty, perfection, decorum, and decoration.

The fifth dream continues Breton's preoccupation with the development of two very unlike poetical ideas – clumsiness and the marvelous (with its strong admixture of the bizarre and comic); he attempts to unite these ideas in the botched beauty of the nude woman whose body "we see at half-length, then at half-leg." Later, in the manifesto Breton will announce, "We have no talent," and offer an analogue to the marvelous nude in his image of "the man cut in half by the window." (His Rabelaisian or Swiftian adventures with little men in blue jerseys who attack him and try to tie him up also smack of the Surrealist marvelous.)

In "Entrée des médiums," Breton reported the utterances and scribblings of René Crevel, Benjamin Péret, and – as we have already seen – Robert Desnos, produced during a hypnotic trance. Breton's dominance of these sessions, usually held in his atelier, quickly became evident. Remaining conscious (like Eluard, Ernst, and Morise) throughout the sessions, he soon assumed the role of father protector, the benign superego that allowed the "children" to perform before him and the audience. The rewards for which they competed were his approval and acceptance. Desnos in particular having won the privileged place of star performer (somewhat like Charcot's hysterical patients displaying their symptoms in the amphitheater to a select medical audience), became,

after the other contenders fell away, the chief soloist, the favored child. Crevel, his main competitor, has left an account of one of these séances:

> One evening hands are being held round a table at Eluard's. I want to fall asleep before Desnos. I am afraid I shan't succeed. So then, in order to do something, I utter the sentence of which I have failed to rid myself the whole day long. The words are weighted, they bear me away. My head bangs on the wood. I no longer exist. On waking, I am told what I have said. As my talk has not been so bad, I am delighted to learn what it has been from the lips of those who have listened to me, but only because I thus score over Desnos, my mediumistic competitor.... When I cannot stand any more, when I realize that I am going to lose my life or at least my head if I go on, I decide as a diversion to have an operation for appendicitis, though not without first having done my best so that Desnos (certainly delighted to have the field to himself) may get more strongly addicted and so go mad.[73]

Desnos's "victory" cost him dearly: lacking the boundaries set by his "sibling rivals," he apparently lost sight of all limits, and as he extended himself ever further, he became childishly autocratic and jealously guarded his favored position. In a dream fragment of June 1925, he indicated his fear of madness.[74] Desnos, craving the attention, apparently repressed any anger he felt at being manipulated by Breton. Unable consciously to accept this anger, let alone to direct it at the real targets, in sleep or simulated sleep, he "acted out" his angers by attacking those present with a knife.[75]

Desnos, the chameleon-like narcissist, having previously assumed the personality of Rrose Sélavy, now sought to become an extension of Breton, the charismatic master who had encouraged and recorded his trances.[76] Hence, his fitting recourse to the use of a knife (Breton's "pen"/penis) to attack his rivals. In 1927, just before detaching himself from the Surrealists, Desnos published his "Diary of a Phantom," where he records a series of dreamlike encounters with a spectral woman (he explicitly compares it to the *époque des sommeils surréalistes*) that occurred between November 1926 and January 1927. In one of his dreams he expresses the wish to kill the specter with a knife, but he never makes the attempt and feels ashamed of his deadly (phanticidal?) impulse. Finally the phantom leaves him, never to return, just as Desnos himself gave up his interest in Surrealism and turned to making films.[77]

In fact, the séances had lost their momentum long before Desnos's departure, for their continuation depended very much on the presence and authority of Breton. When he went to Barcelona, leaving Eluard to direct the sessions, the dreams became less interesting and the dreamers more violent. On his return Breton, presumably sensing the risk of suicide and madness involved in the séances, like a vigilant caretaker terminated them after Desnos attacked Eluard (his vulnerable replacement as authority figure) with a knife.[78] The experiment faded beside the brilliant entry on stage of the Surrealist movement and the introduction of *La Révolution surréaliste* in December 1924, six months after the last issue of *Littérature*. In that first issue the editors Pierre Naville and Benjamin Péret addressed an inquiry to their readers presumably in part with the outcome of the "period of sleeping fits" in mind, and perhaps in antithesis to the Symbolist mode sentimentally linking death and revery: "It seems that one dies as one dreams. It is not a moral question that we pose: IS SUICIDE A SOLUTION?"

On the first page of text were printed one dream of De Chirico's and three of Breton's. De Chirico imagined with oedipal awe (can this feeling have been in part stimulated by his relation to Breton?) a struggle with his powerful father who evokes the fearsome image represented in *The Child's Brain:*

I struggle in vain with the man whose squinting eyes are so gentle. Each time I grasp him he frees himself, quietly stretching his arms, and these arms have an unbelievable strength, an incalculable power, they are like irresistible levers, like those all-powerful machines the giant cranes that lift whole lumps of floating fortresses, as heavy as udders of antediluvian mammals, over the swarming shipyards. . . . It is my father who thus appears to me in my dreams. . . . And still it is he; there is something more *far-off* in the whole expression of his face, something that perhaps existed when I saw him alive and that now, after more than twenty years, appears to me with all its power when I see him again in a dream. . . . Suddenly I find myself under the porticoes, among a group of people crowding at the door of a cakeshop where the shelves overflow with multicolored cakes; people crowd and look inside the shop, as they would do at the door of a pharmacy when a passerby who has been injured or has fallen sick in the street is brought in; but there, when I look inside also, I see my father from behind, standing in the middle of the shop and eating a cake; yet I do not know if it is for him that people throng there; a certain anguish seizes me then, and I feel like fleeing westward to a more hospitable and newer land, and at the same time I search under my clothes for a poniard, or a dagger, for it seems to me that some danger threatens my father in this cakeshop, and I feel that if I enter it, the dagger or the poniard will be indispensable as when one enters the lair of bandits, but my anguish increases and suddenly a whirl of the throng presses me hard and carries me away toward the hills; I have the impression that my father is no longer in the shop, that he flees, that he will be chased like a thief, and I wake up with this anguishing thought.[79]

Breton recounts his first dream as follows:

The first part of this dream is dedicated to the fashioning and exhibition of a costume. The face of the woman for whom it is destined is supposed to play the role of a simple ornamental motif somewhat like those that are repeated in a balcony railing or in a cashmere. The features of the face (eyes, hair, ear, nose, mouth and various wrinkles) are very delicately composed with lightly colored lines. One thinks of certain masks of New Guinea, except that it has a far less barbaric execution. The veracity of the human features is nonetheless attenuated and the repetition in several places on the costume, notably in the hat, of this purely decorative element no more allows considering it alone and attributing life to it than to a collection of streaks in a uniformly veined marble. The form of the costume was such as to allow nothing of the human silhouette to appear. For example, it could be an equilateral triangle.

I lose myself in contemplation . . .

Lastly at Pantin I follow the Aubervilliers road toward the town hall. Then, before a house that I once lived in, I join a funeral procession which, to my great surprise, is going in the opposite direction from the Paris cemetery. Already I find myself abreast of the hearse. On the coffin sits an older man, extremely pale, in deep mourning and wearing a top hat, who can be none other than the dead man who, turning alternately left and right, returns the greetings of the passers-by. The procession enters into a match factory.[80]

The second, more complicated dream of Breton reads as follows:

I arrive at Paris and descend the staircase of a train station very like the Gare de l'Est. I experience an urge to urinate, and get ready to cross the square, on the other side of which I know I'll be able to relieve myself, when a few steps away on the same platform I discern a urinal of small dimensions, in a new and very elegant model. I am no sooner there than I ascertain the mobility of this urinal and become aware, as I am not alone there, of the inconvenience

resulting from this mobility. After all it is a vehicle like any other, and I decide to remain on the platform. From that place I observe the disquieting maneuvers, not far from us, of a second "flying-urinal" similar to ours. Failing to draw the attention of my fellow travelers to the disordered movement and the consequent risk to pedestrians, I step down and succeed in persuading the imprudent conductor to give up his seat and follow me. He is a man under thirty who, on being questioned, proved quite evasive. He lets on that he is a military doctor in possession of a driving license. Being a stranger to the city where we are, he makes it known that he comes "from the back country" (*de la brousse*) with no other details. I try to convince him that although he is a doctor that he may be sick, but he enumerates the symptoms of many illnesses, starting with the different fevers. He shows none of these symptoms, which anyway belong to the simplest clinical category. He concludes his explanation with these words: "At worst I have general paresis" [the most malignant form of syphilis]. The examination of his reflexes that I at once undertake, is not conclusive (normal patellar ligament, feeble Achilles ligament, called *tendinous* in the dream). I forgot to say that we have stopped at the threshold of a white house and that my interlocutor constantly goes up and down a flight of steps one story high. Following my examination I try vainly to learn how he spent his time "in the back country." While making a new ascent of the steps he finally recalled that he had put together a collection there. I insist on knowing the contents of the collection. "A collection of five shrimps" [he says]. He descends the steps again: "I swear to you, dear friend, that I am very hungry," and so saying he opens a straw valise I had not noticed before. He profits from the occasion to let me admire his collection, made up of five shrimps of very different size and looking like a fossil (the hardened carapace is empty and absolutely transparent). But innumerable intact carapaces fall

to the ground when he raises the upper part of the valise. He answers my astonishment, "No, there are only five – those over there." From the bottom of the valise he takes out a roasted back of *rabbit, and with nothing but his hands* he sets about eating by scraping with his nails on its vertebral column. The flesh is distributed in long filaments like that of rays [fish] and seems to have a pasty consistency. I can hardly stand this disgusting spectacle. After a rather long silence my companion says to me: "you will always recognize criminals by their immense jewels. Remember that there is no death, only reversible directions [or senses]."

Breton reported his third dream as follows:

It is evening at my house. Picasso sits at the end of a couch in the corner between two walls, but it is Picasso in a middle state between his present condition and that of his soul after death. He draws distractedly on a notebook. Each page is comprised only of a few strokes and the figures indicating the enormous asking price of 150 francs. He hardly responds and doesn't seem at all affected by the thought that I have succeeded in getting information about his schedule at Beg-Meil, where I arrived shortly after his departure. Apollinaire's ghost standing upright against the door is also in this room. It seems gloomy and full of ulterior motives. The ghost agrees that I may go out with it. Its destination is unknown to me. On the way I burn to ask a question, one of importance, since I can't carry on a real conversation with it. But why was it important for me to know? Besides it would only satisfy my curiosity once. Of what use was it to inform myself from Apollinaire as to what had befallen his political views since his death, to assure myself that he was no longer patriotic, etc.? After mature reflection I decide to ask him what he thinks of himself as we knew him, the more or less great poet that he was. It is, I believe, the second time that he was asked this question

and I apologize for it. Does he think his death was premature, does he enjoy his glory a little. "No and no." The ghost acknowledges that it thinks of Apollinaire as of a stranger for whom it feels no more than a trite [*banale*] sympathy. We get onto a Roman road, and I believe I understand where the ghost wants me to go (I feel quite proud that it will definitely not astonish me). As a matter of fact at the other end of this road is located a house that holds an important place in my life. In it a cadaver lies on a bed. Around this bed that is bathed in light, there once took place hallucinatory phenomena which I witnessed. But we are far from having arrived and already the ghost pushes open the two wings, framed with gold buttons, of a swinging door of somber red. I grasp that it is only the brothel. As I am unable to change the resolve of the ghost, I regretfully take leave of the ghost and turn back. I am soon in the grip of seven or eight young women who have separated themselves from a group that I discern poorly on the left side. *Four of them* with taut arms, bar my way. They want at all costs to head me off. I finally get rid of them by flattery and craven promises. Now I am seated in a train facing a young girl dressed in mourning who has apparently misbehaved, and whose mother is lecturing her. She can still repent, but she remains rather taciturn.

The three dreams, as Alexandrian observed, "reveal Breton's state of mind at the moment of the birth of Surrealism."[81] In my opinion Breton did several things in these dreams: as he launches a new enterprise, he recalls his rejection two years earlier of Tzara's Dadaism; he relinquishes the hallucinatory phenomena of the dream sessions; and he asserts the importance of Picasso's *Demoiselles d'Avignon* for himself as critic, even as he displaces Apollinaire, an admirer of "reason" in Picasso's art, and whose "ghost" continues to live on in the criticism of Breton's rivals Dermée and Goll.

The first dream contains several motifs – funeral marches, top hats, and matches – that turn out to have an unsuspected significance. Funeral marches had provided the stuff from which images of poetic freedom and black humor could be drawn, right down to the twentieth century.[82] The top hat and matches (which suggest transience, and allude to fashion) imply that the subject of this dream is Dada – more precisely the death of Dada; for Breton, in an article "After Dada" dated March 2, 1922, wrote about "Dada's funeral, around May 1921," "The procession, not very numerous, took the same route as Cubism and Futurism, drowned in effigy in the Seine."[83] A top hat depicted by Man Ray figured prominently on the covers of the first three issues of the new series of *Littérature* with the approval of Breton, who had become sole editor. Such defiantly absurd elegance was still somewhat in the Dada mode, while the matches obviously suggest an explosive conclusion, as noted earlier (Figure 2).[84]

Breton, it seems to me, has alluded to a defunct movement now revitalized, from which he wishes once again to disassociate himself: he designs a costume that stimulates his contemplation, and he, alive, sits beside a cadaver on the way to incendiary excitement.

The second dream sustains Breton's claim of having gotten beyond his precursors, notably Duchamp; for the main image of the dream, the flying urinal, clearly represents Marcel Duchamp.[85] Breton had already appreciated Duchamp's elusiveness, his "intellectual equivocation," and his "disdain for theses" in the *Littérature* article of October 1922, but the essence of the second dream, in my opinion, is the assertion (using the slippery Duchamp as a foil) of the superiority of Breton, who appears prudent, attentive to the safety of others who ignored the risks of the flying urinal, a good conductor, and a "real doctor" (Breton parades his army medical training and technical vocabulary, his skill perhaps suggesting also his powers as a

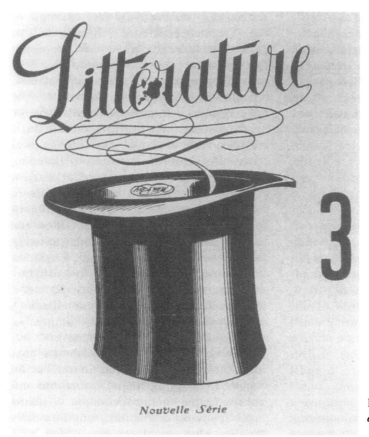

Nouvelle Série

Figure 2. Man Ray, cover, *Littér-ature,* n.s., no. 3 (May 1922).

critic superior to Apollinaire).[86] Breton's forcefulness as a leader comes through so clearly in the dream report that it stirred the admiration of the Fascist intellectual Ungaretti.[87]

Breton apparently does not admire the collection of shrimp as Duchamp wished him to, for they turn out to be empty fossilized carapaces. Here, I think, Breton implicitly takes an important new position of independence: in the section of the *Champs magnétiques* known to be entirely by him, "Le Pagure dit," his mouthpiece, a hermit crab, is a crustacean that lives in shells discarded by other creatures. Breton, having wrestled with his indebtedness to precursors in the dreams already discussed, here discards for good the very notion of a hermit crab's symbiosis. This impression is reinforced by Breton's disgust with Duchamp's greedy gesture of pulling a rabbit out of his valise rather

than a top hat – a post-Dada trick of a kind that Breton had rejected.[88] A charismatic leader, Breton increasingly accepts his position as antibourgeois revolutionary: the last sentence of "Le Pagure dit" brings to mind his identification with the glamorous role of the criminal Fantômas. The Surrealists admired this popular film character for defying the police and for his ability to slip through the net of bourgeois authority – a worthy hero for adolescent boys.[89]

Breton's third dream completes the picture of his advance beyond the respected models of his past, in this case Apollinaire, whose ghost, a third party in the dream, is asked by the dreamer to comment on the dead poet. The ghost feels only "banal sympathy" for the deceased, presumably echoing in the word "banal" Breton's own feelings.[90] Breton mocks the patriotism of the "more or less great poet," and asserts

that he is proud that the ghost of Apollinaire "will definitely not astonish" him – here referring, I believe, to Apollinaire's definition of the modern in terms of surprise, but especially to his famous play of 1917, *The Breasts of Tiresias,* which launched the term "Surrealism" and whose preface refers to "new worlds" and to "the most surprising discoveries" for the modern dramatist. To prove his acquaintance with astonishing phenomena Breton mentions a bed bathed in light, and hallucinatory phenomena, alluding to the now passé period of séances and hypnotic trances. The whole scene occurs within the context of the brothel of Picasso's *Demoiselles d'Avignon,* a painting intimately known to Breton.[91] Picasso, whose work had received eulogies from Apollinaire as early as 1905, long before Breton's "birth" as a critic, was at this time and for many years thereafter the object of Breton's more or less subtle efforts to enlist him in the Surrealist movement; consequently, to Breton the artist occupied a middle ground between his two admiring critics and was a happy choice to mediate in the dream between the living and the dead.[92] Breton's dream thus announces that he, the living, now assumes the mantle of the dead poet-critic and, in political terms, asserts his position as leader.

Implications of political positions, in terms not of leadership but of opposition, emerge from texts of other important early Surrealists, notably Pierre Naville and Max Morise. Their dreams have special interest because they concern the urgent question of developing a Surrealist style of painting. (The two diverged markedly in their later careers: Naville turned to radical politics and Morise had a successful career in the film business.)

By the mid-twenties Naville, increasingly committed to the political position of Trotsky, began detaching himself from the Surrealists, who were then moving toward official (Stalinist) French Communism. He published two dreams in *La Révolution surréaliste* (no. 3, pp. 4–5) that suggest his unrest and constitute another example of the "Politics of Dream." Though still an editor, he evidently had entered on a path that will soon take him to an active political sphere far from colleagues like Artaud, who, in the same issue (p. 13), wrote: "We have less need for active adepts than for confused ones." In the first dream he is walking with a group that encountered houses in one of which people are dancing. Women with heavily powdered faces try to get him to dance, but he refuses. He is looking for someone. "The house fills up the entire space of my anxiety." He seems to recognize the voice of "S.B." (probably Simone Breton), whose initials terminate the dream. The themes of the dream – dancing, seduction to dance, anxiety about a house – concern, in my opinion, Breton's orchestration of the Surrealist "dance," as he displaces Naville and Péret and becomes editor of the periodical in the next issue. In the accompanying dream Naville reported, "A young man ... stops me and questions me on the technique of painting." His name is Werther, which troubles Naville, who concludes the dream with these lines: "Well, how do you like that! To call oneself Werther and busy yourself with painting technique! Well, that's a bit much, you call yourself Werther and you dabble in that!" Naville, in issue no. 2, pp. 12–13, had answered an inquiry "Is Suicide a Solution?" by saying that "liberty, according to which I am bound to live, prevents me from existing in any way other than accidentally, and that is how I will die. . . . I do not believe in my existence." The relevance of Goethe's emotional and romantic Werther, who, because of unrequited love committed suicide (a major preoccupation of the Surrealists that Marxists castigated as antirevolutionary) is obvious and doubtless refers chiefly to Breton, who expressed boldly revolutionary impulses and yet remained preoccupied not only with poetry but with art (as a notice in *La Révolution surréaliste* for the forthcoming essay "Surrealism and Painting" shows).[93]

Naville contributed a dream (pp. 8–9) and an essay (pp. 54–61) to issue no. 9–10 (October 1927) of the periodical, which, implicitly or explicitly, criticize Breton's Surrealists for shirking the responsibility of avant-garde intellectuals to engage in revolutionary activism. Interestingly, the dream begins, "The *action* takes place in the garden of the house on rue de Grenelle," and the essay begins, "Surrealism is still an actor without a voice." Naville makes plain the aspect of political responsibility by ending the dream with the word *coupable* (guilty). Three generals appear, one of whom (Gouraud) Naville shoots. There is a police interrogation: Naville offers an alibi and admits his guilt, which no one believes. "This has the *consequence that even though I am inevita*bly the guilty party and everyone suspects me, nothing permits me to accuse or condemn myself." Suddenly a solution occurs: "It would seem that a Serb or Bulgarian having had a grudge against General Gouraud in the East, had taken his revenge. But how did he get into the house? Why a Serb when there are so many French soldiers? And since I know so surely that I am the *guilty one*." (Although perhaps too early for Naville's participation in Trotskyist politics, the circumstances suggest the climate of incrimination that evolved in the bureaucratic power struggle after Lenin's death.) Obviously the dream concerns the editorship of the periodical whose location had been moved to Naville's home at rue de Grenelle after Breton alone replaced the joint editors Péret and Naville (a replay of the editorial changes at *Littérature,* where the name first of Aragon then of Soupault disappeared from the masthead, leaving Breton as sole editor). Breton presumably is represented by the general whom Naville shoots. The polemical engagement latent in the dream becomes manifest when considered in conjunction with the other text by Naville published in the same issue, "Mieux et moins bien," an analysis of which we cannot undertake here.

Morise like Naville quarreled with Breton over the possibility of achieving a Surrealist painting; but unlike Naville, he felt uneasy about Breton's growing sympathy for the revolutionary East (eventually for the Soviet revolution), particularly its leader Lenin.[94] He, too, published a dream that registered his feelings:[95]

I attend a banquet given in honor of Surrealism. Numerous tables are set up on a vast meadow. Someone who plays the role of André Breton, but who resembles simultaneously Nikita Balieff, Joë Zelli and the lead violinist of the famous Spanish jazz band "Fusellas" (now on tour in Chamonix), circulates among the guests singing and dancing with southern exuberance. His *talk is continually punctuated with ex*clamations such as, "We other Russians... You're going to see how the Russians... In the Russian style... etc., etc." He roles the *r* in Russian in a menacing manner and pronounces the *u ou.* Toward the end of the meal they distributed guns to those present and conscripted them to learn military drills. But there are several recalcitrants and I see one of them draw along several of those who hesitated by making loud protests. Someone at my side says, "Always that Rigaut, he can never keep still."[96] However, the wisecracker, after explaining that Fascism will be overcome by a stronger Fascism in the "Russian" style, presents us with a new model gun, [and then is] astonished [to see] that we are distributing it to the troops. They have removed the butt as a useless accessory and replaced it with a second bayonet, an improvement whose importance one can easily understand. Then the wisecracker tries out this weapon by shooting it into the air. A beautiful mauve flare rises several meters and falls describing a graceful parabola, to the great delight of the general and his staff officer. The general is a potbellied person in a musical comedy uniform, endowed with a cardboard skull pointed in form and crowned with some red hair.

Next a cannon is brought which

launches a mauve flare more beautiful than the first. But that's still nothing. Now they bring up a superb artillery piece of gigantic size whose form is poorly defined, but in any case bizarre: the barrel has several bends in it. It has as a projectile a sphere that is transparent, and of course mauve. Like a soap bubble it rises slightly and then falls on the pointed skull of the general. "That's worth more than a cannon ball," says the latter with satisfaction. On passing before a cage in which a sheep is confined, the wisecracker exculpates himself of a false accusation directed against him by the general: "W... has died," says he. "You believed it was I who killed him. Well, not at all! The sheep did it. And do you know who caught the sheep? Well, it's the fox! And the fox? Well, the lion caught him! And the lion? Well, it's nausea!" During this discourse, the persons of the dream have been effaced, and I hear a voice which concludes: "Quite so, quite so, the general agreed, without even asking what this strange animal might be."[97]

Morise, troubled about Breton's infidelity toward his wife, Simone, expressed his disaffection with Breton and Surrealism in dreams such as the one published in issue no. 47 (July 1925), p. 6, the first issue in which Breton took over sole editorship from Naville and Péret. In it Morise tells of riding in a train with "S..." (doubtless Simone Breton, who had problems that year with her marriage, which would in a few years terminate in divorce),[98] and observing a race with three contestants mounted on "curious vehicles." They see that the two losers "have stopped themselves just in time to avoid falling into the abyss that opens at their feet." Morise finds a packet in a public toilet and is about to throw it away when S. points out that it contains drawings. In fact they're his own, along with a book dedicated by Eluard. They get out of the train and Morise sees his old regimental companions (from World War I), including Crevel. "S.... is at all times with me, but each time military

obligations come to the fore, as in the fall-ins, she is replaced at my sides by René Crevel, who is effaced in turn when we stand at ease."[99] A lieutenant he dislikes then appears, and in his presence "nothing works any more, I'll not succeed in using my rifle as I'd hoped, and the dream ends in the height of my indignation." Continuing the theme of unpleasant authority figures, in issue no. 5 (October 1925) Morise dreamed that he is held prisoner by a guardian and their leader, whom he reviles as "that old whorehouse madam" (thereby continuing the theme of sexual ambiguity of the preceding dream). One day this "master" (now compared to "a leader of the Ku-Klux-Klan") appears and

> distributes to each of us a handful of small objects: a phial of mercury, a phial of a colorless liquid, a piece of tender and unpolished charcoal.... We are all together going to swallow these unusual pills, then go to bed and our minds will experience ineffable joys.... The master counts and describes for us beforehand the phases of our delight; lastly, the drug possesses erotic properties and will provide us with an unhoped for dream of love.

This certainly seems to refer to Surrealist activities up to the mid-twenties that Breton guided, and against which Morise and others were soon to rebel.[100]

After the first issue of *La Révolution surréaliste*, Breton accepted no further dreams for publication in the journal, and became instead more and more involved with the politics of revolution. This transition from collective dream to collectivism – an elitist collectivism, like that of the Bolshevik Party, with little connection even with the radical working class – is not as unexpected as it might at first seem. We know that the Surrealists lived and worked communally in 1924–5 and that their sense of freedom and independence rested on their group activity.[101] We have seen that even earlier as pre-Surrealists they gathered for group séances not entirely unlike aristocratic literary salons but

closer to the hectic cultural gatherings of Romantic bourgeois in the nineteenth- and early-twentieth-century in France, in the wake of the traumatic group behavior during the French Revolution. Little wonder that the epithet that Gustave Le Bon, in *The Crowd* (1890), applied to France of the turn of the century – "the epoque of the crowd" – gained currency.[102] In France collective psychology remained close to the tradition of medical pathology, and conservative members of the profession easily associated it with the psychology or pathology of revolution. Theories of collective behavior such as Le Bon's were rooted in *the French tradition of hypnosis and psychiatric observations of the contagious* nature of certain mental states among the inmates of asylums, and they involved a pathology of the collective ego related to the studies of split personalities by French psychiatrists.[103]

A *strong current in French aesthetics* derived from the sociological analyses of Proudhon, Taine, and Guyau, and Breton's former mentor Valéry formulated the notion that all ideas emerge from a group.[104] Many of the progressive literary movements of the first two decades of the twentieth century were concerned with collective integrative solutions – synchronism, synthetism, integralism, unanimism – and the unanimists welcomed Bolshevik Communism in the belief that they had a common viewpoint.[105]

From these considerations we can understand the importance of the group in the period of sleeps. We also gain some understanding of the transformations of the primarily antiliterary group first into the broadly antibourgeois, dream-oriented Surrealism of the First Manifesto, and then into the politically engaged revolutionary movement of the mid-twenties and later that associated itself with the goals of Communism.[106] Dream accounts were already called obsolete in 1922 in "Entrée des médiums," which presented hypnotically induced productions before observers.[107] By 1924 the climate had so changed

that Breton actually speaks of having had a "purely political dream."[108]

The overt political involvement and the concurrent quest for a Surrealist painting that would externalize their images gave the Surrealists an impetus to move toward a new psychic reality integrated into the external world of the visible and the social, and away from what they saw as the autism of trance and dream alike. While the irrational juxtaposition of unconnected bits of everyday events, objects, and personages and their insertion into absurd milieus still formed a major source of the marvelous, more room was made from the *mid-twenties to the early thirties for the* expository prose of politics.

Even with the turn to Marxism Breton's Surrealists continued to insist on the importance of creative individuality, and sought a framework within which to reconcile that individuality with the ambition to create a collective experience. In a development analogous to the history of the Soviet Communist Party in the early twenties, the firmer organizational structure of Surrealism that evolved in the mid-twenties (after the First Manifesto and official formation of the movement) permitted ever less ambiguity in choosing between poetry and politics. Collective dreaming, which as we have seen posed the risk of internecine competition or madness, gave way to the *cadavre exquis,* other group games – visual or verbal, literary or parapsychological – and art production. With the Moroccan War, against which the Surrealists took a stand, occurred a baptism of political fire that for a time would transform their texts, infusing many of their images with practical and potent messages about political behaviors and policies they publicly opposed.[109]

"DREAMS AND POLITICS" IN THE THIRTIES

After giving up the dream séances Breton's group entered a new phase of overt political activity. He has recorded his own intellec-

tual and emotional "growing pains" during this transition in the *Vases communicants*. In this book, at once a diary of dream accounts, a theoretical exposition, and a novel, Breton demonstrates the interconnections between his dreaming and waking activities. He couples the images of his dream with images he encountered in art, cinema, or simply in his daily perceptions. As we shall see, writing the book helped him face and resolve a number of problems. He moved from *eminence grise* of a group of somnambulists to presiding over the radical politics of a Surrealist "party" for whom dreaming entailed a critique of the bourgeois social order. In establishing this new political role for the dream, one not intended by Freud, Breton entered into controversy with the "master."

The most important writings of Breton in the thirties – the *Vases communicants* and *L'Amour fou* – attempt to reconcile a search for love with problems of art, psychology, and politics. (Their relation to art is discussed in Chapter 4, this volume.) Like chivalric (or Gothic?) novels they celebrate love and imagination in an unromantic time. The *Vases communicants* was especially important for Breton's dreams and self-analyses in which we discover once more rich political implications.

At the height of the involvement of the Surrealists with radical politics, dreams appeared less as independent texts than as documents of the unconscious or as testimony to freedom of the imagination. In this period of ascending totalitarianism the synthesis of psychoanalysis and Marxism offered a possibility to escape from bureaucratic routine: once again the Surrealists took up the rebellious mode of the *école buissonnière*, which received its classic formulation in Breton's the *Vases communicants*.

Breton noted two relevant features to the metaphor of the communicating vessels: the fluid when in equilibrium stays at the same level in both containers, and that level is independent of the form of the vessels. He had used it in *Surrealism and*

Painting in 1928: "What I envisage is almost a communicating vessel between the container and the contained." This metaphor had already served writers as diverse as Freud, Marinetti, and Leiris.[110] He now used it to suggest among other things the connection between dream and reality, individual and social group.

The *Vases communicants* makes a valiant effort to oppose the tide of vulgar materialism pervading leftist circles, to counter the plebeian and prudish "reality" of Social Realism with the poetry and sexuality of Surrealism, and to promote an imagery free of narrowly tendentious content. Breton attempted to realize these aims through the dreams reported and analyzed in the book.

The first dream reads:

Dream of August 26, 1931. Immediately recorded on awaking at three in the morning: An old woman, seized by an intense agitation, is on the lookout not far from the metro station Villiers (which rather resembles the station Rome). She has sworn a violent hatred toward X (my girlfriend, once), with whom she wants to get into contact at any cost. Because of this X's life seems to me to be in peril.

Breton then describes X's taking taxis for fear of stepping in the street, presumably to avoid the old woman.

As I arrive with a friend, who must be Georges Sadoul, at the upper end of the street . . . we cross the old woman and I observe that she is closely watching my every gesture. To see what she will do, and to put her off the track, I write on a paper something that I'd like her to believe I'm going to bring to my old residence. But, since she can read, I modify the name by inverting the letters which to my surprise give the word Manon, which, in an extra effort of precaution, I interlace again with those of a word of endearment such as "my dear." The old woman, who seems mad to me, [a fusion of the mad Nadja who was replaced by the "X" Suzanne Mu-

zard, with his overbearing mother?] thrusts her way into the apartment, from the interior of which the hardly visible person guarding it signals that I should not enter. I fear some nasty affair, perhaps involving the police – or internment – in which X was once supposed to have been involved.

At the home of my parents, at dinner time, in a house with which I am unacquainted. I am armed with a revolver, for fear of the mad woman's breaking in, and I stand before a quite large rectangular table covered with a white cloth. My father, whom I must have told about my encounter, delivers some incongruous reflections. He makes trivial objections: not being acquainted with X, he doesn't know, he says, and doesn't have to know whether she is "better or less good" than the old woman. These remarks irritate me and, taking those present as my witnesses, I request that if possible he speak normally and without intending to offend me by comparing a woman of twenty to one of sixty-five.... Next, abandoning myself to my own thoughts, I think that X will never return....

Here I am in a shop where a boy of twelve ... shows me some neckties. I'm about to buy one that I like when he finds another in a drawer, that I allow him to force on me: it's a dark green tie, quite ordinary, with very thin white diagonal stripes, quite like one I own. But the young salesman assures me that it harmonizes especially well with my red shirt. As he digs once more into his stock of ties, another salesman, middleaged, tells me of a "Nosferatu" tie which sold well two years ago, but of which, he fears, none remain.[111] I am anxious to show this tie to my friends.

It is I who forthwith discover this tie among the others. It is a garnet tie on whose tips stands out ... the face of Nosferatu in white, a face which is at the same time an empty map of France, and in which the Eastern frontier is traced summarily in green and blue, so that, I believe, rather than rivers, it represents surprisingly, the make-up of the vampire.[112]

I have turned one hundred eighty degrees to the right. At the other counter stands a member of the C.P., physically resembling Cachin. He converses with me with certain reserves about a trip to Germany which I would soon undertake. Vaillant-Couturier arrives, who acts at first as though he did not see me, then shakes my hand. . . . He gives me more precise details about this voyage. I will first go to Berlin. He explains rather craftily that "really, the subject of the conference to be given, it seemed to them, might very well be surrealism." I scoff within myself at this manner of presenting things. We leave tomorrow. I think that happily I found a bit of money a little while ago. The pseudo-Cachin states precisely that they will take B . . . and, I believe, René Clair (he names B . . . twice). I think of using as theme of the lecture, if I'm the one to give it, parts of the book that I propose to begin at once to write. (It concerns the present book.)

At this point Breton presents a "Note of Explanation about the year 1931, with its somber outlook" – X, with whom he had hoped to establish a permanent relationship was gone, probably for good. "Thus vanished a certain conception of unique and reciprocal love" he had held since youth. He was having great difficulty convincing others of this sincere belief that "there was no poetic, philosophical or practical outlet to the activity of my friends and me apart from the social revolution in its Marxist-Leninist form." Because of such considerations "purely Surrealist action . . . had lost its best reasons for existence." He concludes the note with a parenthesis: "Some time has passed. I determined the following summer while on the Breast Island, whose name should endear it to psychoanalysts, that ships are neither more nor less stable on the sea.[113] They are more or less always in distress, like everything. Around the world communist action pursues its course. At Castellane, where this dream surprised me last year, already the impossible has

come back to merge in the possible.... A bright light bathed the plane trees of the public square."

In a 26-page analysis Breton took up part by part of the dream in sequence: the mad old woman was Nadja, with whom he had had a brief, intense affair two years before, and whom he abandoned when she was institutionalized, after visiting her at the mental hospital. He felt anxiety about the possible return of Nadja after she read his novel about her and defensive about the possibility that he was unintentionally involved in Nadja's psychosis (X had accused him of wanting to make her *mad*); in fact years before Nadja, Breton wrote in *Poisson soluble:* "It is when she is asleep that she really belongs to me; I enter her dream like a thief and I truly lose her as one loses a crown." The name Manon he had given as a child to a cousin for whom he felt a sexual attraction that he had taken for love.[114] He wished, by this association, defensively to reduce the importance of X and the exclusiveness of their love. With regard to the rectangular tablecloth, Breton notes that he usually sat at such a table, but that this table was occupied on August 24 by an attractive young woman apparently writing verse. He had to sit at a round table, where, inattentive to its shape, he placed a decanter of water where there was no support, and "it broke with a crash, bespattering at my feet the copybooks on which I had taken some general notes on dreams. This miscarried act already reveals my wish to sit outside at the rectangular table with the young woman.[115] The table is rectangular in the dream for the same reason and also large enough so that what is put on it will not be broken. (In sexual terms we know that the table when set symbolizes the woman; one should notice that in the dream they are only *getting ready* to serve.)" The ages 20 years and 65 years Breton associates with the loss of 20 and 65 francs by Sadoul and him on August 25 to a one-armed bandit. He notes that if you get three pictures of fruit in a certain order the sign marked (in English) "Free Play" comes on, indicating that one can play gratis.

"Twenty" also concerns an experience that happened to X at that age. In a long explanation Breton again tells how his dream was helping him overcome the "conception of love limited to one person... I can now pass on to a different conception without losing all value in my own eyes." Of the red shirt he merely observes that "presently I'm wearing (*j'arbore*) one of this color." The long entry on "Nosferatu" begins: "On the evening of the 25th there was, at quite a distance to my left, a diner to whom I called Sadoul's attention.... I thought on the one hand of the type of reactionary philosopher about whom Lenin constantly complains in *Materialism and Empiriocriticism* and ... on the other hand, of Mr. F., director of the laboratory at the Institut Pasteur whose outward appearance always seemed to me singularly irresolute for a man of science."[116] His mind had been playing games with names and faces recently, and he even thought that one of the hotel's customers "could be named Riazanov, though I don't recall ever having had the opportunity of picturing him to myself." Breton associates the scientist with a notebook entry about giraffes he made as a schoolboy, and the selection of the notebook plus the long neck leads to the choice of ties and to discussion of the sexual element they have in common.

All these ingredients were fused in the character of Nosferatu, whose presence was suggested even by such details as the landscape and the bat. Breton then thought of a phrase from the movie that always inspired him with "a mixture of joy and terror: 'When he was on the other side of the bridge, the phantoms came to meet him.' " Breton notes that the bridge is "a very clear sexual symbol."[117] After his allusion to the tie, Breton talks of the woman of the rectangular table. Sadoul and he saw her again, this time in German costume, and they agreed she must be an engineer's wife. She walks off, probably to

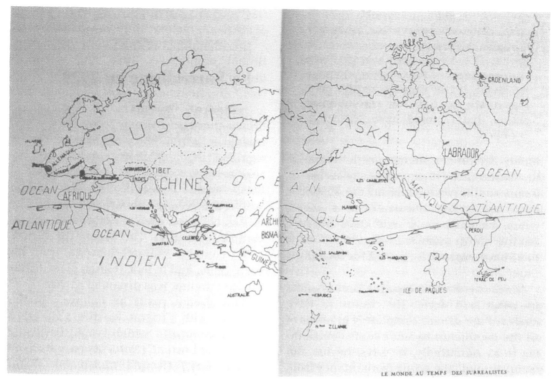

Figure 3. Anon., Surrealist map of the world, from *Variétés*, hors série (Brussels, June 1929).

meet her husband, and disappears around the corner of a little bridge. The dream realizes two wishes through her: to talk freely to this woman and to remove all causes for incomprehension between France and Germany, "the marvelous country full of thought and enlightenment, where in one century were born Kant, Hegel, Feuerbach and Marx. The substitution of rivers, with a particularly vague line, for the eastern frontier on the map can only be interpreted here as an invitation to *cross the bridge.*"[118]

For the Surrealists, location (and paths to the location) and scale held moral and emotional significance: in their imaginative map of the world, desire, admiration, and contempt rather than objective proportion governed the comparative size of nations and continents (Figure 3). Obviously Left and Right held in these circles (as for the psychoanalysts) immense power of moral and political suggestion;[119] thus, Breton interpreted his phrase about the

"half-turn to the right" as "a real rectification of position ... the right road." He then compares the "pseudo-Cachin" to the "false Riazanov." The "voyage to Germany" has to do, he says, with his

wish to cross the bridge. Apparently [I am] on the verge of waking up, and with the awakening arrives a sense of practical realities. The proposal of the subject of the lecture, and the bantering it provokes, the entry of Vaillant-Couturier with whom, last winter, I had a long conversation on the possibility of the P.C. finding a use for the Surrealists, a conversation in which he was very circumspect, evidence to some extent of a return to critical awareness.

Of his taking along "B ... and René Clair," Breton says:

René Clair (if it is he) comes in because he is mixed up in a superficial way with the production of a film whose sce-

nario, by Aragon and myself, was to be taken from an opera theme, which we thought at first we would present in Berlin. The dream here borrows from the organizers of the trip the intention, by giving it the vaguest artistic plan, knowingly to limit the revolutionary action that I would have wished to conduct.

Finally Breton comments on the theme of the conference: "It expresses my desire... to succeed in reconciling on the objective level my varied occupations, a desire which becomes more and more intense, inciting me to undertake urgently a work that I have regretfully put off for too long a time."

On the next twelve pages Breton sums up what he's done. He claims to have analyzed the dream completely in terms of all the significant recent events contributing to it. Admittedly, he says, he has not reconstituted "the scene from infancy from which (the dream) probably in part derives," but, he asserts, this would at this point "only be of secondary interest." The dream has served its main function, the salutary "crossing of the bridge," which freed him from paralyzing emotions derived from painful experiences of the recent past (with "X"), and thus allowed him the (sexual) freedom to act. Evidently the metaphor of the bridge, which recurs in his writings on art and poetry, could serve like the communicating vessels as a link between the very different spatial realms of reality and imagination.[120]

There follows a discussion of the logic – or, better, the dialectic – of dream, the role of time and space, the theatricality of dream, its poetics and the condensation of modern poetry that resembles the dream process. Breton's poetic analyses achieve a degree of distinction by uniting two models: Freud's autoanalyses in *The Interpretation of Dreams,* and an automatist play with visual images. (See the discussion of Surrealist criticism in Chapter 4, this volume.) His method has little to do with Freud's therapeutic and metapsycholog-

ical concerns or with the academic pursuit of style and history in the *analyse de texte.*

In concluding the analysis of this dream, Breton emphasizes that "the world of dream forms a unity with the world of the real," and he demonstrates this point with a rhetorical procedure in the second dream through distinguishing dream and reality by letter types: the dream text is signified through italics and reality by regular characters. The intermingling of these types – especially in the dream within the dream – illustrates the unity he claims between dream report and critical comment (reality). The dream (of April 5, 1931) contains intimate material from his early years, and in fact, though placed after the first dream, was dreamed *earlier.*

This dream reads as follows: "In the evening, with a friend, we direct our steps toward a *château* which would be in the suburbs of Lorient. (Note: My parents lived in this city.) Ground moistened. Water already half-way up our legs, this water cream-colored with traces of water green, suspicious looking, yet very agreeable." He sees an "admirable fish" that eludes his pursuit and goes rapidly toward the château. "I fear falling into a hole. Drier ground. I throw a stone at it which misses.... In its place is now a woman-bird who throws the stone to me. The stone falls between my feet, which frightens me into giving up the pursuit."

"The château's annexes. A refectory. In fact, we've come 'for the hashish.'" Breton wonders whether it is real hashish, then takes two spoonfuls "in two little round breads similar to those served for breakfast in Germany." He has served himself awkwardly, and the servants around him display an ironic attitude toward him as they offer him an unfamiliar kind of hashish.[121]

At home, morning. Room similar to mine but which keeps on getting larger. It is still dark. From my bed I can distinguish in the left corner two little girls of about two and six years of age, in the act of playing. I know that I have taken hashish and that their existence is hallucina-

tory. *Both girls are nude, forming a white block in movement, very harmonious.... I speak to the children and invite them to come to my bed, which they do.* What an extraordinary impression of reality! I observe to someone, *who must be Paul Eluard,* that I am touching them . . . that it is not at all like a dream where the sensation is always more or less dull, lacking . . . an indefinable something specific to real sensation.... Here . . . there is no difference. It is . . . absolute reality.[122] The smaller of the children who was seated astride me, weighs down on me. . . . She therefore exists. In determining this I experience the most marvelous sensation (*the strongest I have felt in the dream*). *Sexually, however, I take no interest in what is going on. A feeling of warmth and dampness on my left side draws me away from my thoughts. One of the children has urinated. The two disappear simultaneously.*[123]

Entry of my father. Scattered on the floor of the apartment are little puddles that are nearly dry and shiny only at the edge. In case anyone might make a remark to me on the matter, I intend to accuse the little girls.[124] But what if they don't exist . . . ? How shall I justify the "real" existence of the puddles? *How can I make myself credible? My mother, very displeased, claims that not long ago all her furniture had been soiled by me at Moret. (A city in which she never lived.) I am once again alone and in bed. All reason for disquiet has disappeared. The discovery of this château seems to me a stroke of good luck. What a cure for boredom! I think, with delight, of the astonishing precision of the image of just before. All at once here are the little girls who take shape again at the same point.* They quickly take on a terrifying intensity. I think that I am becoming mad. At the top of my voice I demand that someone turn on the lights. No one hears me.

Commenting on this dream Breton cites Stekel's observation (quoted by Freud) that the dream within the dream serves to "deprive a part of a dream of its too

authentic reality.... That is the formal negation of something that has actually happened, but which must at all costs be overcome, the product of a real dialecticization of the dream thought."[125] The dream within a dream and the mixture of dream and reality allow Breton to take a parting shot at crass materialism that would deny the connection between dream thought and the sensations of reality. He also takes a position diametrically opposed to Freud's view that only consciousness was equipped with the ability to confront reality.[126]

Evidently the *Vases communicants,* which owes so much to the *Interpretation of Dreams,* displays an "oedipal" challenge to the great "Professor Freud," a powerful father figure.[127] He took aim at a vulnerable aspect of Freud's personality – his sensitivity to questions of his originality and priority, a foible Breton claims to have detected.[128] The opening section criticizes Freud's suppression, among the list of the precursors of the *Interpretation of Dreams,* of the name of Volkelt, whose work he had used, and of the important but neglected French theorist of dream Hervey de Saint-Denys, and his "apology" for Freud's omission – that it was not deliberate but rather attributable to Freud's own principle enunciated in the *Psychopathology of Everyday Life* that "in all cases forgetting is motivated by a disagreeable feeling," in this case Freud's failure to overcome, as he claimed, the "unbounded ambition of infancy."[129] Breton praised Hervey, who before Freud demystified dreams that he controlled by imposing his desires on them, by dreaming what he wanted to dream – precisely the "advance" Breton would claim to have made on Freud's method of interpretation. This view constitutes a profound change from the ideas of the manifestos in which the "omnipotence of dream" meant the passivity of the dreamer, just as the automatist practice implied creative passivity.[130] Now Breton had ground for a criticism of Freud, who maintained the passivity of the dreamer, and after the

Second Manifesto the Surrealists expected to control the imaginative content of both their dreams and – as proposed by Dali's paranoiac criticism – their waking perceptions. Moreover, with competitive acuity he faults Freud for failing fully to expose the sexual content of his own dreams.[131] Breton, competing with the founder of psychoanalysis, offers his own dreams and a self-analysis to match Freud's; indeed, he goes him one better (he claims) in the frankness of his self-exposure.[132]

I have given Breton's text of the last dream in extenso so that we can note the gaps in his interpretation: we never understand why family characters come on stage or depart, or why certain characters appear. Breton, for all his allusions to politics and psychology, fails to explain the political and psychological sources of his dreams. Yet there is a subtext that, read politically, like the earlier dreams already discussed, allows us, I believe, to fill in some of the apparent gaps. For example, in his dream of August 26 and his comments on it, he mentions several people: Georges Sadoul, his father, Cachin, Vaillant-Couturier, René Clair, Lenin, Aragon, and Riazanov, all of whom (except perhaps his father) are associated in one way or another with the polemics generated by the Communist Party in France and the Soviet Union.

The ever-grimmer political situation in Europe before World War II diminished the once sanguine political expectations of independent radical groups like the Surrealists, who turned increasingly to utopian, erotic, and artistic pursuits. After *L'Amour fou*, discussed elsewhere, Breton edited (in 1938) an anthology of dreams from Paracelsus to Péret, *Trajectoire du rêve*, in which he explored the relationship of dreams less to politics than to literature, art, and the foretelling of the future. In his own contribution to the anthology, titled "Oneiric Accomplishment and the Genesis of Animated Painting," Breton describes how he watched Oscar Dominguez paint a picture of a grill of knotted pipes, which

become the rear ends and heads of lions. The rears become a sun, the painting becomes an aurora borealis. Here occurs a break, a forgotten section of the dream. Then Dominguez changes his methods and makes the lions with something taken from a fiery basin in the room. Breton tries to extinguish the fire by throwing water on it, with the result that Dominguez falls in. Breton flees, and goes high up into the house. While descending, his wife stops him, saying, "What! You're forgetting your little girl!" Breton returns and takes the infant with him. People below wonder who is responsible. Breton consults a doctor, afraid his baby is more burned than he, but the doctor is concerned mainly to know whether Breton has other children. Breton becomes impatient. The doctor tells him that Léon Blum[133] was there shortly before and cannot be far away. Breton tries to see and talk to him, then wakes up. Breton's interpretation is entitled "On the Field of Fire, of the Tree Tied to the Aurora Borealis by a Fire-grate of Fellating Lions." Breton himself notes the immediate source of the dream: a chimney pipe of a heater in his apartment, full of holes and needing repairs. He had patched it with a rag that looked like a bloody bandage on a wound, which caused laughter on the part of X (Suzanne Muzard again!). He points out other sources for the details: Breton saw a picture of a penguin and chicks resembling an erect phallus, leading to the chain of association lions–zoo–memory of seeing lions copulating in a zoo; the crayfish associated with the Aurora borealis came up in his reading.

Breton, I believe, has left unstated important allusions in the dream that place his thought in relation to three persons on his mind especially toward the end of the thirties: Magritte (the pipes), Dali (the lions), and Bataille (the rears associated to Bataille's "solar anuses"). The existence of his daughter Aube/Aurore allied to Breton's great model, Lautréamont's character Maldoror, allows him to defy Bataille's threatening suns (only later in

the dream does Aurore suffer a homonymous fate, when the *mal d'Aurore* is to burn);[134] and Dominguez, a recent recruit to Surrealism, metamorphoses images of fellating lions and anuses that remind one of Dali (as though replacing Breton's enemy, a source in 1929 of rivalry with Bataille). The fire suggests the urgent need to repair Surrealism, and Suzanne, always an independent and outspoken observer, mocks him for confusing the rags of art with the blood of life.

Breton's prosaic, factual interpretation of the first part sticks to recent events, making no references that might expose the feelings and ideas underlying the reported details. The second part, following the significant gap of the forgotten section,

is left uninterpreted, and with deceptive "innocence" Breton offers us a poetic transformation, as though to demonstrate that the metamorphic power of the dream work is independent of psychoanalytic dynamics. He seeks above all to distinguish the "processus de la création poétique ou artistique" from what has an "erotic and psychological origin" – in a word, "the functions of desire and knowledge."

The constant aim to link desire to knowledge and dream to reality followed a different direction, especially during the thirties, when urgent political considerations invaded the most private domains of art. It was above all then that the Surrealists sought to realize their dreams in political revolution.

3

IN THE SERVICE OF WHICH REVOLUTION?

An Aborted Incarnation of the Dream: Marxism and Surrealism

Even sleepers are workers and collaborators in what goes on in the universe.

Heraclitus, Fragment 124

The mission of poetry is difficult. It does not mix into political events, in the way one governs the people, allude to historical periods, coups d'état, regicides, court intrigues. . . . It discovers the laws that bring to life political theory, universal peace, . . . human psychology. A poet should be more useful than any other citizen of his society (*tribu*).

Lautréamont, "Poésies," *Littérature,* no. 3 (May 1919)

The ferment stirred up by the private séances of the group (discussed in Chapter 1), and the subsequent dissatisfaction with the exciting but unfocused individualism of group dreaming, led the Parisian fraternity into more public activities, like regular meetings in cafés and the publication of a periodical. The youthful rebelliousness and imaginative daydreaming of the erstwhile "schoolboys" fed their fervor for some kind of revolutionary change. As already mentioned, Aragon summed up their disdain for all authority – akin to Dada's irreverence – in a mocking "Manifesto" published in 1923:

SCANDAL FOR THE SAKE OF SCAN-DAL – There you have the last formula you'll need, young morons. Repeat it to your gouty examiners, after you've finished with the dates of the French defeats in battle from Julius Caesar to Marshal von Hindenburg.

There you have the title of a chapter that you'll have to add – in order to be COMPLETE – to your manuals of literature, [you] professors full of idealism and impartiality.[1]

The intellectuals around Breton, perceiving the futility of such posturing, were seeking a more directly political vehicle through which to express their rebellion. At this juncture the Marxist group Clarté proposed a joint plan with the Surrealists "to demonstrate to our proletarian readers the ignominious ruin of what is pompously called French thought and to expose the insidious influence of the writings of counter-revolutionary intellectuals [practically all of them are]."[2]

Morise reported that "the Ideological Committee will have a meeting on March 30, 1925, at the Central, to see whether the

idea of the Revolution should take precedence over the Surrealist idea, if one will be realized at the expense of the other, or if both can work together in harmony."[3]

To prove their support of proletarian revolution, the Surrealists published in the French Communist organ, *L'Humanité*, a declaration on November 8, 1925: "Only a semantic confusion has allowed the persistent misunderstanding that there was a *Surrealist doctrine of Revolution. . . .* There never was a Surrealist theory of Revolution." Consequently the Surrealists accepted the tenets of Communism and came out for the dictatorship of the proletariat.

At the very outset Breton, tying the new direction of his intellectual/anti-intellectual friends to the old wish to explore the strange "realities" of dream and hypnosis, dubbed his movement "Surrealism" and produced a manifesto as a rallying cry, apology, and guide. He even provided a quasi-academic definition (on the model of mock definitions of the Dadaists), which has become in fact a didactically useful cliché:

> SURREALISM, noun. Pure psychic automatism, by which one proposes to express – verbally, by means of the written word, or in any other manner – the actual functioning of thought. Dictated by thought, in the absence of any control exercised by reason, without any esthetic or moral concern. ENCYCLOPEDIA. *Philosophy.* Surrealism rests on the belief in the superior reality of certain forms of previously neglected associations, in the omnipotence of dream.[4]

Breton has clearly drawn on the automatist "parallel play" practiced by Soupault and himself when they created the *Champs magnétiques* (Breton on his own continued the automatist research in *Poisson soluble,* written just before but published with the manifesto), in which "words and images serve only as springboards to the mind of the listener." But as pointed out in Chapter 2, he adumbrated

elements of this formal definition in a dream, first published in *Littérature* in December 1922, containing allusions to a treatise on philosophy, a dictionary, and the term "réalité."

The formulas "omnipotence of dream" and "actual functioning of thought" mark a departure from the unruly productions of the dream sessions and a move toward psychology; for they stem directly from Freud's discussions of dream in *The Interpretation of Dreams* and his concept of the "omnipotence of thought" of primitive magic in *Totem and Taboo.*[5]

The center of gravity has shifted from dream to poetry and language, and Breton acknowledges the first glimmerings of a new trend within Surrealism by placing emphasis on dialogue: "It is to dialogue that the forms of Surrealist language best adapt themselves." However, he does not mean a conventionally communicative dialogue, but rather "dialogue in its absolute truth." The image provides the key to this new dimension of language that aims at unconventional "truth." The combination of allusions to psychology – especially Freudian, and a new "reality" provoked a hostile response in the counter–"Manifesto of Surrealism" by Breton's rival Yvan Goll, inventor of a "Cubist Surrealism." Goll rejected Breton's emphasis on psychic mechanisms such as the dream, claiming that it would "turn Freud into a new muse . . . [and] confuse art and psychiatry." In many places Goll implicitly contravenes Bretons' manifesto by claiming that his (Goll's) Surrealism "is international . . . signifies health . . . finds its way back to nature, and moves toward construction."[6] On the cover Goll claimed among his "collaborators" Apollinaire (deceased, but cited as the originator of "Surrealism," who, in a letter of 1917 to Dermée, said the word was "not yet in the dictionaries" – a remark quoted as a cut at Breton's quasi-official definition), Crevel (alienated from the group between 1923 and 1925 after disenchantment with the "period of sleeps"), Robert Delaunay (cited in a two-

page article "The Painter Speaks"), Pierre-Albert Birot, Paul Dermée, and Pierre Reverdy. Birot contributed an article, "Mon bouquet au surréalisme," in which he claimed to have collaborated on finding the word "Surrealism" with Apollinaire (who wrote a preface in 1917 to Birot's first published poetry).

Breton's assertions in the First Manifesto did more than take aim at conventional psychology or aesthetics: they had a strongly polemical intention directed against Yvan Goll. There resulted a battle around the definition of Surrealism – the one modern and formal, the other imagistic and psychological. Still, Goll's remark, "Beautiful images are those that bring together elements of reality the furthest removed from one another," comes straight from Reverdy, and at least here brings him into agreement with Breton, who also cited it in the manifesto. (Despite some qualifications, he continued to admire Reverdy.)[7] But Breton went much further than Goll in seeking to transcend the immediacy of sensory images.

As he describes it, Breton struggled fruitlessly to realize images in the terms he found in Reverdy as juxtapositions of distant realities. At last a solution came to him in a dream image that he had experienced several years earlier and that united the aural and the visual.[8] He writes in the manifesto:

> One evening, therefore, before falling asleep, I perceived, so precisely articulated that it was impossible to change a word... a quite bizarre phrase... *which was knocking on the window-pane.* In truth the phrase astonished me; unfortunately to this day it has eluded me, but it was something like: "There is a man cut in two by the window." But there could be no question of ambiguity, accompanied as it was by a faint visual image of a man walking and cut half way up by a window perpendicular to the axis of his body. Doubtless it had to do with the simple representation in space of a man who was leaning out of a window. But

since the window moved with the man, I realized that I had to do with a rather rare kind of image, and I could think of nothing else but to incorporate it into my material of poetic construction.[9]

This realization led to "a whole series of phrases," and he decided to pursue Freud's

> methods of examination which I had some opportunity to use on patients during the war. I decided to obtain from myself what we tried to get from them, that is, a monologue spoken as rapidly as possible, without judging it from a critical point of view... and which would reproduce as exactly as possible *spoken thought.*

However, in a footnote to this text Breton refers not to Freud but to a novel by Hamsun in which such "revelations" came about through hunger. In fact, Breton's procedure has little to do with psychoanalysis; for example, it stipulates neither the presence of an analyst nor a therapeutic intention.

One might characterize the First Manifesto as a quixotically romantic quest for the marvelous in the ordinary (a psychoanalyst would see this as a morbid pursuit of poetry in the psychopathological or of artistic symbols in symptoms) – an absolute reality born in dross but untainted by it, embedded in time but out of it – all of whose contradictions could be realized, condensed and overdetermined, in a concrete image.[10]

The manifesto credited Freud's discoveries with enabling "the human explorer to carry his investigations much further," to go beyond prosaic reality: "The imagination is, perhaps, about to reassert itself." The Surrealists (in the spirit of Rimbaud) declared that dreams and imagery could change the world. As late as May 1925 Breton declared in "Le Maître de l'image," a eulogy of the poet Saint-Pol-Roux, "It seems more and more the case that the most powerful generator of the new world with which we intend to replace the old, is no other than what the poets call the

image. . . . It is by the force of images that, with time, *true* revolutions could be achieved."[11]

A critical problem that would persist throughout their engagement with Marxist revolution arises here: how can the image, apart from its rhetorical impact, produce revolutionary effects? Already in the manifesto Breton seems to have sensed that he would have to choose between a form of passive dreaming such as the Symbolists indulged in or somehow to "act." A "Poem" published in the manifesto asserts, "I do / while dancing / What people have done, what they are going to do." Characteristically, this idea recurs as a prose statement just before the end of the manifesto: "Of greater importance, as I have often enough suggested, are the applications of Surrealism to action." The issue of action and its relation to a despised and commonplace reality that Surrealism first ignored, then aimed to change, became crucial in the intensely political phase between the mid-twenties and World War II. Breton's manifesto does not make clear how the amoral "Surrealist acts" differ from Gide's *actes gratuits,* and in the years following he would struggle to reconcile Surrealist acts with Marxism. However, the promotion of such acts decisively distinguishes the Surrealists from utopian theorists like Mondrian or Kandinsky, whose ideas at some points seem to approach the theory and ethics of Surrealism but which never descend from the spiritual clouds to a revolutionary praxis (beyond formal change).[12] The dream account did not disappear, but it lost its place as the mainstay of Surrealist activity: visual images (collage, film, symbolic objects) shared more and more space with verbal accounts of dream imagery; group games emphasizing chance and the irrational (pooling, the *cadavre exquis,* occult and parapsychological "experiments") replaced the dream séances; and revolutionary politics took its place beside the chimerical principle of the "omnipotence of dream."

The economic and political context of the mid-twenties with its seesaw between depression and prosperity favored the Surrealist assault on the bourgeois establishment. In 1924 there occurred in France in the war's aftermath a tentative economic recovery, and few Frenchmen regretted that it depended on squeezing concessions from a defeated Germany. The League of Nations supervised with strong moral assertions but feeble policing the assurance of the postwar territorial agreements. The League was for the Surrealists an abomination of the idea of true internationalism, which the Soviet Union alone seemed to represent. Aristide Briand, the premier of France intermittently between 1925 and his death in 1932, apparently leaned to the left – he favored an internationalist position for France and supported the League of Nations, cooperation with Great Britain, and rapprochement with Republican Germany, but he also sustained the policy of keeping Germany tied down by the French army, to ensure the payment of reparations. Briand's name, symbol of bourgeois bureaucratic insensitivity, was a target in Surrealist polemical writings several times between 1931 and 1933. During the world economic crisis of 1929 France remained comparatively well off: since it relied less on foreign trade, it was less affected by the crisis than Germany or Great Britain. Another authority who guided that militant peace, Raymond Poincaré, stabilized the franc (which had remained rather shaky after the war) in 1926.[13] Execrated as a World War I militarist, Poincaré – nicknamed "Poincaré-la-Guerre" by Eluard and called "l'homme-des-cimetiéres" (the Cemetery Man) by Crevel – was the butt of numerous insults in the Surrealist publications.

The move from group activities involving sleep and the unconscious to radical "collectivist" politics makes more sense when the role of collective psychology in Surrealism is understood. Between 1923 and 1924 the Surrealists, those defiantly antipoetic poets, met again and again to define the meaning of their activities. Re-

placing the prophetic utterances of sleepers with an excited dialogue about a need for some unspecified change, they rushed forward on the road from *rêve* to *révolution,* naming their first official periodical *La Révolution surréaliste.* As noted earlier, in his poem dedicated to Valéry, "Monsieur V" (1919), Breton included the phrase "Rêve de révolutions"; indeed, one of the Surrealists' most revealing word plays reads, "Révolution: évolution d'un rêve." The First Manifesto expresses a yearning for an absolute reality born in dross but untainted by it, embedded in time but out of it. One might characterize the project as a quixotically Romantic quest for the marvelous, whose "reality" depends on the concrete content of the images.[14]

This generalized approach to revolution suggests a vague and romantic resistance to institutional orthodoxy, and even smacks of anarchism, a viewpoint that in fact colored all the phases of Surrealism.[15]

But the clearest tendency of the emerging movement was toward collective public action. The cover of the first issue of *La Révolution surréaliste* (December 1924) features a collage of three group photos of the Surrealists by Man Ray, and at least one of them shows a somnolent performance by Desnos like those from the period of trances; for Desnos had returned to a central place among the Surrealists.[16] The nucleus of collaborators on the new periodical came largely from the defunct *Littérature,* which, particularly at its beginning, published dreams and emphasized the condition of sleep as a stimulant for imaginative work.

Breton's writings of 1925 evidence the movement from private dream to public politics. In "Le Bouquet sans fleurs,"[17] after discussing criticisms of his earlier proposals to commit violent actions, Breton insisted "on the purely revolutionary nature of our enterprise," which puts the Surrealists "always on the side of those ready to give their lives for liberty." He made clear his hopes for renewal from the East near the end of the article: "Let us turn toward the Orient, from which we are beginning to get immense encouragements. Poetry is getting ready to pass over a bridge. [The bridge] is Paris!" And slightly later, in response to the inquiry conducted by *Cahiers du mois* concerning "East vs. West," he exclaimed, "Let the Orient of the dream, the dream of every night, pass more and more into the West of the day. It will dissipate that somber politics of the last days of our decadence."[18] One week later, in his "Intervention" at a meeting of the group on January 23, 1925, Breton demanded responsibility of members for the consequences – "political, social, religious, anti-religious" – of their actions and criticized two obstructions of Surrealism's development – inertia and formulations couched in obscure poetry rather than in an "objective style." He proclaimed a readiness "to place all our force in the service of the East (Orient) against the West (Occident)." The East at this point remained for Breton – as for the German Expressionists – a vague idea, signifying either "the Jewish question" or "Bolshevism."[19] In his essay "Le Maître de l'image" of May 1925 (cited earlier) he listed some of the miscellaneous elements of "the debate that at this time impassions us: order or adventure, reason or divination, West or East, slavery or liberty, non-dream or dream."[20]

The acknowledged point at which the Surrealists turned toward politics occurred when the French government waged war against Abd el-Krim and the "Republic of Confederated Tribes of the Riff" in Morocco. The move began inauspiciously with a slap on Aragon's wrist by *Clarté,* a periodical sympathetic to Communism, edited by Jean Bernier and Marcel Fourrier, for having referred sarcastically to Soviet Communism in his diatribe against Anatole France (in the collective pamphlet *Un Cadavre* of 1924).[21] But a common revulsion at the colonialist war soon led the Surrealists to cooperate with the Clartéistes and the group associated with the journal *Philosophies* (Lefebvre, Politzer, Guterman).[22] In June 1925 *Clarté* asked, "What Do You

Think of the Moroccan War?" to which the major Surrealists responded by expressing their outrage. The French Communist organ *L'Humanité* on July 2, 1925, and *Clarté* on July 15, 1925, published the declaration written by Henri Barbusse, "Appeal to Intellectual Workers: Yes or No, Do You Condemn the War?" which the Surrealists signed. Before that, Breton expressed his dislike of Western nationalism with vaguely orientalizing ideas, as in the "Introduction au discours sur le peu de réalité" (1924), which decries the mediocre reality of the bourgeois West with overtones of Condillac's troubled sensationalism.[23] In that essay he wrote "Orient, Orient conqueror . . . permit me to recognize your measures in the Revolutions to come."[24]

Breton first led the Surrealists to the revolutionary East not out of concern for the Russian workers' struggle for improved conditions, but initially out of disgust with the high value placed by the French bourgeois on colonialism as the material possession of "reality": political revulsion merged with aesthetic critique. And second, the turn toward political revolution owed much to his admiration for the two brilliant heroes of the Russian Revolution, the Bolshevik stars who had arisen in the East – Lenin and Trotsky. It seemed clear to Breton that the powerful rhetoric of these Bolshevik giants had "changed the world," and that they had succeeded in materializing their dreams and visions and thus in creating their own version of poetry from real events on a world stage. Here art became life and life art.

He came to appreciate the charismatic personality of Lenin after reading and reviewing the French edition of Trotsky's *Lenin,* a magisterial book paying tribute to his dead comrade, with a rich and intimate portrayal of Lenin the man. The review was published in October 1925, but Breton might already have come to know Trotsky's writing through *Clarté,* where he would also have learned of the criticism of Trotsky by the official Soviet Communist Party.[25] Breton was "transporté" by Trot-

sky's book which showed Lenin the human being in relation to the superhuman politician, thereby imbuing his ideas with a great power of attraction.[26] A wide range of Parisian contemporaries in the avant-garde – excluding some, like the perceptive Picabia – shared a similar fascination with the Soviet leader to the point of apotheosis.[27] Thus, through a complex association of dream, hero worship, and theory, Breton managed to juxtapose the reality of the Russian Revolution and the imagination of poetry (which, like Reverdy, he still valued).[28] The initial impact on the Surrealists of the review was to inspire a change of attitude – Eluard, for example, had actually been contemptuous, even hostile, to the Revolution.[29] This led to a search for a new vocabulary, as recorded in the minutes of their meetings; the participants at the meeting of October 23, 1925, proposed the following word replacements: "bourgeoisie, bourgeois" for "arrivisme, arriviste"; "Prolétariat, prolétaire" for "art, artiste"; "France" for "La Terre"; "U.S.S.R." for "the horizon"; "Marx" for "Malebranche"; "Lenin" for "Leibniz"; "Trotsky" for "Taine."[30] The equation of artist and proletariat, echoing the Third Republic's attempt to enlist the artists as workers in a craft tradition (repugnant to the Surrealists), soon disappeared.[31]

Breton published his review of Trotsky's book at the end of a period of uncertainty and unrest in France, but the situation changed considerably that same year with the stabilizing of capitalism in France and the West generally.[32] The prosperity of capitalism had an adverse effect on the morale of radicals and the integrity of avant-garde writers, put under stress by the seduction of professional careers. Breton's effort to synthesize political revolution, the psychology of the unconscious and avant-garde antiaesthetics did not sit well with all his colleagues. *L'Esprit* attacked the cult of introspection and subjectivity in writers like Barrès, Gide, Rivière, and Valéry and urged a return to the object in France. The futility of bourgeois ideal-

ism struck especially young Marxist intellectuals like Henri Lefebvre, Georges Politzer, Norbert Guterman, Georges Friedmann, and Pierre Morhange, who, like the Surrealists, published a series of periodicals (*Philosophies* from March 1924 to March 1925, *L'Esprit* from May 1926 to January 1927, *La Revue Marxiste* from February to September 1929, and *La Revue de psychologie concrète* in 1929).[33]

Breton later asserted that his review of Trotsky's book "marked the first and decisive step" toward having a better grasp of the ideas and ideals of the Russian Revolution. As the leader of a small group of avant-garde poets challenging the establishment, he would perhaps have thrilled to such remarks as the following by Trotsky: the rhetorical question, "Isn't there a monstrous contradiction between the condition of a 'little group of propagandists' isolated from all others, and their proudly stated claim that they will take over the power in an immense country?" (p. 73); Lenin's formulas, "What matters are acts and not words" (p. 117) and "His scientific works [those based on dialectical materialism] are only a preparation for action" (p. 230); or the question, especially meaningful to an ex-pacifist, "Do you imagine that we will emerge the victors in the struggle without the most pitiless revolutionary terror?" (p. 134) After describing Lenin's "immense creative imagination," Trotsky observed that "Lenin's force was, in great measure, that of a realist imagination" (p. 141), and called him "a tough realist . . . a destroyer of romanticism" (p. 184). Chapter 8, "The Philistine and the Revolutionary," assaults H. G. Wells, the Fabian progressive and evolutionist, for his article on Lenin, "The Dreamer in the Kremlin" (London, 1920), which exposed the bourgeois Englishman's mistake in judging Lenin by the standards of a man of letters. Speaking for Lenin, Trotsky states: "If we must destroy the valuable things of the past, let us destroy them without tears of sentimentality; we will later reerect them and create new ones, infinitely more

beautiful than the old" (p. 206).[34] Breton did not seem to notice (or to mind) Lenin's hostility to the avant-garde, which, considered an "infantile disorder of Leftism," was crushed during the New Economic Policy period.[35] Consequently, in regard to the arts, we must question Trotsky's eulogizing summary: "His genius consisted above all in overstepping the bounds" (p. 200).

Thus, through a complex association of dream, hero worship, and theory, Breton managed to make place both for the reality of the Russian Revolution – or at least that of its outstanding historical figure – and for the imagination of poetry.

But a difficulty that would nag over the years emerged for the Surrealist would-be revolutionaries – the difficulty of accepting the party's leadership without loss of aesthetic and moral autonomy; indeed, at the high tide of their interest in the Communist International, the Surrealists themselves verged on offering to submerge their identity in the party.[36] But this momentary impulse subsided owing on the one hand to the hesitation on the party's part to put the talents of these anarchic personalities to use, and on the other hand to the unwillingness of the Surrealists to perform the monotonous tasks demanded of them. In the December 1926 issue of *Clarté* Breton explained: "In the revolutionary sense, just as on the social and economic plane, one can honorably claim to be Marxist, in the same way, on the spiritual plane, I affirm that it is always permissible to uphold Lautréamont and Rimbaud."[37] In a development analogous to the history of the Soviet Communist Party in the early twenties, by the midtwenties (after the First Manifesto and official formation of the movement), Surrealism had developed a firmer organizational structure that restrained internal divergences and resisted the distractions of political activism.

Naville, uneasy about the aesthetic preoccupations and self-centered effusions of Desnos and Artaud,[38] disengaged himself from any version of Surrealist politics that

included them; and while rejecting such a hybrid, he expressed disaffection with Breton in *La Révolution surréaliste,* no. 3, the last one he edited jointly with Péret, before Breton took over sole editorship. For several years he kept up his contact with the Surrealists, but urged those who tried to unite poetry and politics to concentrate exclusively on the revolutionary goal.[39] He demanded of his fellow Surrealists: "Is the desired revolution . . . linked to Marxism, or to contemplative theories, to the purifying of interior life?" Taking aim at the metaphor of the "East" he added, "Wage earning is a material necessity to which three-quarters of the world's population is subject, independent of the philosophical concepts of so-called Orientals or Occidentals."[40]

In his reply, *Légitime Défense,* Breton denied any opposition between "contemplative theories, the interior life" and the world of facts, and he insisted on their reconciliation in the "marvelous."[41] He defended using the word "Orient," "which must correspond to a particular anxiety, to a secret wish, to an unconscious anticipation of these times . . . reactionaries of our time know this well, and lose no opportunity to raise doubts about the Orient."

He also explained that he had not joined the French Communist Party, even though he agreed with all its political stands, because he found the editor of *L'Humanité,* Henri Barbusse, "if not reactionary, then at least behind the times." The party organ had become under this editor "puerile, declamatory, useless and stultifying, an unreadable paper, entirely unworthy of the task it has claimed for itself of educating the proletariat." Breton also felt irritated that the party rejected the Surrealists' offer to write for it, while employing hacks to grind out the pabulum of Socialist Realism. (One might compare the denial to these talented writers of the chance to create a genuinely revolutionary lyricism to the hostile attitude toward the great poet Mayakovsky by the Soviet literary establishment.) As a consequence, after an uneasy period (1927–31) of rapprochement, Breton and his closest associates broke definitively with the French Communist Party and adopted an independent stance that looked sympathetically toward the leader of the opposition, the exiled Trotsky.

Pressed by Naville to show that their demand of autonomy accorded with the struggles of the proletariat against the bourgeoisie and with support for the Russian Revolution, Breton's group excluded Artaud and Soupault for not treating social issues seriously. The new radicalism appears also in the "Protestation" by Breton and Aragon against Ernst and Miró's "participation in the forthcoming performance of the Ballets Russes, which entails the abandonment of the idea of Surrealism": "It is not admissible that thought should follow the orders of money." Surrealism is "subversive" of such "enterprises, whose goal has always been to domesticate dreams and tame revolts induced by physical and intellectual starvation, in the interest of the international aristocracy."[42] Evaluating particular money-earning activities by a Surrealist in terms of a revolutionary code of morality raised complicated issues, too often brusquely resolved for ideological or personal reasons. Thus, Breton condemned Artaud for acting in a "commercial" production of a Strindberg play, while lauding Palau's *Les Détraquées,* a non-Surrealist play, interesting perhaps for its subject matter of a depraved pair of women (one of them an opium addict) who were sadistic infanticides. Most strikingly, Ernst and Miró were excluded for doing exactly what Picasso had already done with impunity.

Breton's rejection of artists close to him for agreeing to work for money was by no means an impulsive gesture. With almost Calvinist fervor Breton's Surrealists inveighed against any participation in capitalist exchanges. But the Surrealists, as we shall see, refused allegiance equally to the positive value of proletarian labor theorized by the Marxists. Both systems offered objectionable versions of an "emploi du temps" reminiscent of schoolboy sched-

ules: Breton, on the contrary, dreamed of a world without chronological and mechanical time available for military as well as economic purposes.[43]

The ambition to create a lyricism that would rise above the mundane level of any time-bound activity meant for Breton a quest for a "reality" both marvelous and enduring. This idea is implicit in a striking phrase of the opening paragraph of his "Introduction to a Speech on the Lack of Reality":[44] "Wireless. . . . There are feeble references of this sort which sometimes give me the illusion of setting out on a great adventure, of ever so slightly resembling a gold-digger: I am seeking the gold of time." Gold and the search for it recurred as a theme throughout Breton's career, from the philosopher's stone of the alchemist Nicolas Flamel to the chimerical search for gold by Rimbaud.[45]

To understand more fully the implicit meaning of Breton's phrase we must, I believe, interpret it as a paradoxical pun: "l'or" is homonymous with "l'hors," which means "the outside"; consequently the treasure sought in "l'hors du temps" by Breton is both inside and outside time, the essence of time (as in "l'air du temps") and timeless.[46] In a notebook of 1920–1 Breton noted that in writing the *Champs magnétiques* with uncontrollable speed, Soupault and he intended "extracting the gold in its pure state."[47] An unexpected stimulus for this idea can be found in the thought of Bergson, rejected or ignored by Breton after 1924, but much admired up to 1924.[48] Bergson, well known for his cinematic theory of knowledge, remarked:

> [The philosophy of Forms or Ideas] establishes between eternity and time the same relation as between the gold piece and small change – change so small that payment continues indefinitely without ever paying off the debt: one is freed of the debt at one stroke by the gold piece. That is what Plato expresses in magnificent language when he says that God, being unable to make the world eternal, gave it Time,

"the moving image of eternity." (*Timaeus,* 37 D.)[49]

In 1929 Breton and Aragon collaborated on the anticlerical scenario of the "Trésor des jésuites," which contains a brisk dialogue between time and eternity: "Time: Bah! everything passes away. / Eternity: No. / Time: What persists, then? / Eternity: that which finds in life a marvellous echo."[50] An excellent visualization by an artist of the "gold of time" is Dali's *The Persistence of Memory* (1931), which suggests that biological time (memory) has overcome mechanical time: the gold of a watchcase covered by ants has apparently metamorphosed into amber, and other watch faces display bent, dysfunctional hands. (Unfortunately gold later became for Dali a more commercial value, hence Breton's anagram on his name – "Avida Dollars.")

Breton so clearly indicated the importance of this phrase that his friends, believing that it summed up his life's quest, prepared this succinct obit: "André Breton / 1896–1966 / *Je cherche l'or du temps.*"[51] In 1924 Desnos commented that Breton "finally poses the question close to the heart of Apollinaire . . . [the relation of] eternity and modernism."[52] Desnos showed his mocking interest in a religious theme in *La Liberté ou l'amour!* (1927 [1925], which includes a rewriting of Christ's imprisonment and crucifixion as a battle between two advertising emblems: the smiling "Bébé Cadum" (displayed on billboard ads for Cadum soap that were everywhere to be seen – a photo of a worker demonstration showed a Cadum baby looming on a billboard above them) playing Christ, against his adversary the Michelin tire man.[53]

Immediately after the phrase on time, Breton ruminates: "What do these words that I have chosen evoke? Merely the sand on the seashore . . . an antenna . . . some islands . . . Crete, where I must be Theseus . . . forever enclosed in his labyrinth of crystal. / Wireless telegraphy, wireless telephone, wireless imagination."[54]

Breton's search for the timeless, the gold of time, recalls his years as a schoolboy longing to escape from the routines of the classroom and his later revulsion at the bourgeois formula "time is money." But despite their claim to reject bourgeois commercial values, the Surrealists themselves could not always claim moral superiority: at the *marché aux puces* the bartering poets apparently acted often out of ordinary pecuniary motives, and on several occasions they were known to have stolen objects they admired, an act they even bragged about, like misbehaving schoolboys.[55]

Of course, Breton and Aragon did on occasion manage to make money by shrewdly bartering and brokering art objects, and even – however unwillingly and rarely – working for a salary. In seeking gold, Breton, like the alchemists seeking through the sublimation of gross matter to distill a pure and ultimate element (Breton admired the alchemist Raymond Lulle from at least 1922 on), obviously hoped to find the one "color" (or substance) embedded in but potentially independent of circumstances, of the "couleur du temps."[56] And the attempt to "escape" from experienced time, the quest for a paradoxical eternity of the immediate (understood in different terms by Goethe and Nietzsche), brought Breton back to a version of the Romantic search for Woman, ultimately for the mother.[57] The phrase cropped up again in the fifties in a radio interview when he characterized Ernst's work in terms of a "mythique hors du temps."[58] The idea of a mythical state outside time was regularly conveyed to students at the *lycée* like Breton, exposed to Greco-Roman art and literature – with the crucial difference, of course, that the twentieth-century poet had no intention to create in enduring materials.[59] Perhaps Breton also had in mind the phrase of Saint-Pol-Roux's that he admired, "Breast of crystal": the vitrification of the maternal breast signifies a way to get out of or to stop time and, by transforming opacity

into transparency, to "sublimate" the material flesh.[60]

The implicit pun on the "(h)or(s) du temps" belongs among Breton's efforts to unite the contradictory attributes of time and timelessness, movement and stasis, perhaps culminating in the oxymoron of convulsive beauty (*explosante-fixe, magique-circonstantielle, érotique-voilée*). Doubtless he hoped that this union of contraries would yield feelings of orgasmic pleasure that would not quickly subside, but endure like spiritual elation or ecstasy (the desire of Goethe's Faust).[61]

He expressed his desire (in the manner of Reverdy) to unite opposites in other images such as the supreme point where all things converged (like the "coincidentia oppositorum" or Descartes's pineal body where mind and matter meet), the bridge, the communicating vessels, and arrested motion.[62] Clearly there was more than imagery in the pun: underlying the poet's desires was a concern to escape from the bounds of a "bourgeois time" centered on the regularities of work and profit.

The Surrealists shared with their opponent, the Marxist Sartre, the wish to escape from the temporal constraints they associated with Cartesian dogmatism, and like Sartre they found in Hegelian Marxism the possibility for such an escape.[63] But eventually, realizing that even Marxism might circumscribe the imagination, he turned toward the idealist side of Hegel's thought that Marx had assimilated (and "inverted"), and even skirted the suggestive obscurities of occultism.

Breton's project of extracting meaningful images from the past without remaining tied to the "passé" or to a linear progression of memories has as much to do with fin-de-siècle Symbolist concerns as it does with Marxist or Hegelian ideas; indeed it constitutes a transformation of late-nineteenth-century concerns with time and memory exemplified by the writings of Proust and Bergson.[64] Bergson's notion of the image (in *Matter and Memory*) stands midway between "thing" and

"representation." His confusion of subject and object, of a mind that creates images and the objects thought about or imaged, has analogies to Breton's view of mind and image, but Bergson shared with the fin-de-siècle Symbolists the temptation to act without a coherent will to change and in this crucial regard provided support for (without espousing) two distinct visions of the world: the painless (quasi-religious) contemplation of the petit bourgeois, and the sadistic violence of the terrorist (a favorite theme of Sorel).

George Poulet comments in *Proustian Space,* "Proust's novel has ceased to be temporal; exactly like a history of France 'in images,' it is no longer a history; it is a collection of images, which, brought together, furnish a place and form 'an illustrated space.' "[65] The search for an essence outside history in Breton and Proust parallels the quest for an absolute by Fichte and Hegel, and also the spatial aesthetics of modernism, which one critic has linked to the rise of Fascism.[66]

The conclusion of the *Vases communicants* makes oblique allusion to Breton's concept of the "hors du temps," in speaking of certain men (alchemists?) whose manipulations "retain eternity in the instant and the general in the particular" – a remark with affinities both to Bergson and Lulle. Breton doubtless meant to link "out of time" to "eternity" (an idea some Symbolists found in Hegel) when he cited Lulle's remark: "Creation in Eternity is the idea: creation in Time is the creature."[67] In the same year that World War II started Breton envisaged another way to escape from time – the Einsteinian space-time continuum – which he believed he discerned in the works of Matta, Onslow-Ford, and Dominguez. He praised Dominguez further for creating "lithochronic surfaces" that produced a "solidification of time."[68]

Breton's attempt to extract the timeless and imaginative from the drab flux of quotidian existence was not shared by all the Surrealists: Naville, followed by Aragon, less interested in a private and poetic revolution, immersed themselves within their own time and engaged public political issues. Although the two groups shared aesthetic concerns, tensions between the political and the apolitical artists intensified over the decade following the First Manifesto, culminating in a split between those with visions of a communist "collective dream" and those who conceived of an anarchist egalitarian community of "liberated egos." The Surrealists around Breton hoped to preserve the integrity of the movement through accommodating individual temperaments in group activities like games in which each could express himself or herself (often anonymously) and in the publication of manifestos bearing their signatures. But after the mid-twenties another "game" – revolutionary in a more practical sense – attracted some Surrealists, that of radical politics, as conducted by the great personalities of the Russian Revolution.

The appeal to Breton of both Communism and psychoanalysis depended, as we have seen, in good measure on his admiration for the charismatic figures of Freud and Trotsky. He remained steadfastly attached to these powerful father figures in their final years of tribulation; moreover, he was drawn exclusively to these gigantic personalities rather than to their followers (perceived as sibling rivals?) – he had little to say about Freudianism or Trotskyism in France or elsewhere.[69] But even these admired figures did not escape criticism: as we have seen, Breton had a major disagreement with Trotsky over the poet Mayakovsky, and he came close to joining the Stalinists at one point; moreover, as shown in Chapter 1 the *Vases communicants* displays an "oedipal" challenge to the father of psychoanalysis.

Pressed by the example of Naville to show that their independence accorded with the struggles of the proletariat against the bourgeoisie and with sympathy for the Russian Revolution, Breton's group, as we have noted, expelled Artaud and Soupault, explaining in their tract "Au grand jour" of

Figure 4. Jacques-André Boiffard (?), photomontage portrait of Breton as Christ (January 15, 1930).

April and May 1927 that the exclusively aesthetic commitment of the two men did not allow them to treat social issues seriously.[70] The excommunicated men produced a flurry of retorts to "Au grand jour," realizing that the spirit of schoolboy rebellion that had initially attracted them was being superseded by an unwelcome discipline. Artaud quickly wrote "A la grande nuit ou le bluff surréaliste" (June 1927), defending the place in Surrealism of fantasy and of mental disturbance and rejecting the move into politics. Asserting his "point of view of complete pessimism" (a rebuff of Naville's Marxist criticism of the self-indulgence of Surrealist pessimism), Artaud derided the pretensions of his fellow Surrealists of engaging in action on the social and political levels; for he felt convinced they were incapable or at least disinclined to enter the arena of public action. Consistent with his political indifference, Artaud defended a "pure cinema" that rejected any admixture of verbal material.[71]

During the following months the tensions kept growing until a number of dissidents who had given up Surrealism published a joint pamphlet, *Un Cadavre*, in which they ridiculed and execrated their former leader. The illustration on the cover, by Boiffard according to Bataille (Figure 4), cleverly enlarged the photo of Breton in "Je ne vois pas" – his closed eyes could suggest a cadaver as well as a sleeper – and sarcastically circled his brow

Figure 5. Francis Picabia, cover, *Littérature,* n.s., no. 4 (September 1, 1922).

Figure 6. Anon., "Le Passé," cover, *La Révolution surréaliste,* no. 5 (October 1925).

with thorns, thereby assimilating Breton, then 33, to the Christ crowned with thorns. This may have been suggested to Boiffard by the cover of *Littérature,* n.s., no. 4 (September 1922), the first issue edited solely by Breton, with Picabia's drawing in red of a bleeding heart of Jesus "crowned" in the center by intertwined thorns and surmounted by flames above which in turn rises a cross (Figure 5). Picabia's cover was recycled in a collage of Dada and Surrealist publications that included covers to "Le Mouvement Dada," *Littérature,* no. 4, and – ironically inverted and placed just above "Le Passé" – "La Vie Mod[erne]". This collage was put on the cover of no. 5 (October 1925) (Figure 6) and titled "Le Passé." This irony about the past interests of the Surrealists was sharpened by the recursive repetition of a miniaturized version of the whole cover. It fitted well in issue no. 5 containing Breton's review of Trotsky's *Lenin:* together they mark an initial turning from past nonpolitical con-

cerns now considered regressive. One year later the cover of *La Révolution surréaliste,* no. 8 (December 1926), showed a drawing of a profile head filled with a miscellaneous collage of images; it intends to suggest a typical bourgeois and carries these words beside it: "CE QUI MANQUE A TOUS CES MESSIEURS C'EST LA DIALECTIQUE (*ENGELS*)" (Figure 7).

The effort to move toward overt politics while retaining the characteristic features of Surrealism irritated members for opposite reasons: Artaud, insisting on aesthetic autonomy, rejected the contamination of the dream by politics, whereas Naville, demanding social engagement, rebuked the shallow and ineffectual politics of the dreamers. An unavoidable dilemma loomed before those who wavered between dream and politics; the Cartesian moralist Julien Benda summed it up in 1927 when he condemned "the betrayal of the clercs" –

Figure 7. Anon., "Ce qui manque à tous ces messieurs c'est la dialectique (*Engels*)," cover, *La Révolution surréaliste,* no. 8 (December 1926).

intellectuals who engaged in political activity but "who should essentially concern themselves not with practical goals but . . . with timeless values" like justice, truth, reason, freedom.[72]

The differences among the Surrealists threatened the integrity of the group and led to a purge accompanied by the defections of dissenters, phenomena reflected in Breton's response to *Un Cadavre,* the Second Manifesto. The crisis entailed changes in direction and membership: the last issue of *La Révolution surréaliste* (December 1929), which contained the Second Manifesto, took a new tack with regard to visual art that veered away from automatism. Surrealism found fresh support among artists like Magritte and especially Dali, whose carefully crafted enigmas and bizarre imagery differed sharply from the

earlier apparently spontaneous effects of automatism. Dali's claim to an "activity of mind" opposed to the passivity of automatism echoed the rhetoric of political activism and, however ambiguously, helped justify the claim that Surrealist art was now – as the title of its new periodical asserted "au service de la révolution."

After the crisis of 1929 the restructuring and restoration of the movement posed difficulties to Breton and his colleagues. Like an informal admissions committee, they groped for criteria for acceptance into the Surrealist "University." But they faced harder questions: Can the expelled members still produce acceptable work? How can one revise the list of sympathetic artists and writers? Do the old categories and definitions of the two manifestos still hold? Can one sustain independent, individual creativity – automatism – and still adhere to the collective ideals of a Surrealist politics of revolution? Why meet as a group? Does one need a single leader like Breton or should the more democratic form of a committee guide the group?

These questions were not always formulated and rarely answered satisfactorily, but responses to them implicitly shaped the Surrealist world of the thirties. As we shall now see, moving from dream to published statement and concrete act, like participating in Marxist revolution, raised profound questions concerning the nature of poetic and social time, the definition of revolution and the place of intellectual and creative work within it, and the validity of Surrealism's claims both to independence within the politically engaged art of the revolution and to an autonomous position within a society it wished to change.

Each of the two manifestos was in a sense a political declaration, the first a general one against bourgeois society and its traditional means of expression, the second a diatribe directed at members who had defected from the movement, with a sideswipe at psychiatrists for their medical treatment of Nadja and their hostile atti-

tude toward the Surrealists. In coming to grips with nonconformist behavior, Breton seems drawn at this point not to psycho-analysis or to party politics, or even to Marxist dialectical materialism, but to He-gel, who proposed a concept of mind that includes its "Other."[73]

Criticisms of the move to Marxist politics came from individuals targeted by the Second Manifesto – notably René Daumal of the group Le Grand Jeu and Georges Bataille. Daumal insisted that Breton hadn't gone far enough in fighting materialism and had not adequately grasped Hegel's idea of the perfectibility of the human mind.[74]

Bataille, on the other hand, criticized the Second Manifesto for being too idealis-tic; in fact, his theory of revolution from below, a "bas matérialisme," had provoked sarcastic remarks in the manifesto, includ-ing comments on Bataille's neurasthenic condition. Bataille's idea belongs actually within an old rhetorical tradition contrast-ing high and low strata of society.[75] But in opposing Breton's idealism, Bataille goes much further beyond the traditional bounds of good taste.

To Breton's concept of hysterical yet chivalric love (shared by Breton's "oldest and dearest comrade in arms," Péret), Bataille opposed an earthy version of Marx-ist materialism that featured a raw sexual-ity, sadistic and bestial, devoid of Breton's sublimations that Bataille characterized as "Icarian" for its failed aspiration (like that of the mythological Icarus) toward an idealist "sun."[76] The adversaries of Breton generally perceived his need to rise, to show his virility, as an aspect of his authori-tarian personality, and sometimes opposed their anal to his phallic vision.[77]

Bataille found Masson interesting even during the period when the artist associ-ated chiefly with Breton's group, for Mas-son's explicitly sexual and violent and orgiastic scenes actually fitted Bataille's taste more than Breton's. Masson claimed that several Surrealist painters and poets met in 1925 and "proposed eroticism as the origin of a Mythology of desire."[78] What-ever the attractions of these erotic scenes for some Surrealists, their thrust diverged from the increasingly political interests of the group, and evidently this proposal failed to enter the mainstream of Surrealist concerns.[79]

Combining a quasi-Marxian revolution-ary goal (but with as little interest in proletarian labor as Breton) with Freudian notions about orality and anality (always with the excesses of de Sade in mind), Bataille explored a dialectic between the appropriation and excretion of objects – like Breton he had little interest in their production. He envisaged human emanci-pation to result from the passage from an orgiastic and destructive phase of political and social revolution to a postrevolution-ary one involving separation between so-ciopolitical organizations and an "antireli-gious and asocial organization."

In the "Notion of Expenditure" (1933), Bataille expounded more a Hegelian than a Marxian dialectic of class struggle as a master–slave conflict, based on a funda-mental human need to destroy (an echo of Freud's death instinct) – the negativity of a destructive orgiastic drive – that leads the workers to the final revolution. Now the "lower" classes surge with a Nietzschean force (an idea that briefly attracted him to a concept of "Superfascism" superior to decaying democracy) comparable to the force not of a Superman but of an *Untermensch* (if I may so dub Bataille's revolutionary masses, a political counter-part to Groddeck's *Es* or Freud's id). Bataille's radicalism and his *bas matérial-isme* has much in common with the views of his contemporary, the novelist Céline, whose petit-bourgeois rantings against the big bourgeoisie brought him to the verge of Fascism, yet whose savage exposure of the failings of capitalist society elicited widespread admiration – even including Trotsky's.[80] Bataille, the grand decadent of the twentieth century, virtuoso of "Entar-tung," seems to have confronted the Fas-cist aestheticization of politics not with (in

Benjamin's formulation) a politicization, but with a perversion, of aesthetics.

The Surrealists' fascination with the id – and metaphors of the unconscious as a labyrinthine intestine – was embodied in Jarry's Ubu, whose huge belly and intestines resemble those of Rabelais's Gargantua and a corresponding figure, a headless creature in Bataille's periodical *Acéphale* depicted by Masson as a Theseus with a sword who carries the labyrinth in (or as) his guts.[81] While the earlier Surrealists played scandalous parlor games, Bataille, obsessed by a "nostalgie de la boue," dreamed that his revolutionaries would engage in excretionary orgies, which he presumably thought to be salubrious in the sense of Bakhtin's carnivals. His idea of expenditure, modeled on the potlatch described by Mauss, ignores Marxist theories of production as much as Veblen's theory of conspicuous consumption (1899) had, and instead emphasizes consumer activities.[82] The attitudes of Bataille and Breton in the darkening years leading to World War II show surprising parallels despite their almost constant dissension: both opposed the production of works intended to have beauty or utility; neither reacted very strongly – as did, for example, other left-wing groups in England – to the onset of Nazism in 1933;[83] both maintained antipathy toward productive work, placing the pleasure (also, in Bataille's case, pain) principle far above the reality principle; and each had only a remote sense of what the working masses were like (although both professed sympathy – inspired by a theoretical communism – for the proletariat).[84]

As we have seen, Naville, who shared the Marxist-Leninist insistence on the fundamental importance of work, addressed such views in 1926, taking aim at his fellow Surrealists. He raised the point that Surrealist quarrels about intellectual matters – including distinctions between East and West – seemed trivial in the face of the "material necessity of wage earning" that underlay the workers' condition every-

where.[85] Breton replied in "Self-Defense," denying that wage earning could be considered "the efficient cause of the state of things we endure" and insisting that he opposed simple materialism, not historical materialism. He also denied any opposition between "contemplative theories, the interior life" and the world of facts, and he insisted on their potential reconciliation in the "marvelous."[86]

The issues raised were relevant to the current polemics about the definition of the "intellectual worker." In an essay of 1930, Breton voiced his objections to artists or writers prostituting their imagination – a concept Freud would have understood – by making objects with commercial salability (in fact the prostitute became a metaphor for the notion that "time is money" – the ultimate debased embodiment of Kant's *Lohnkunst*).[87]

First he distinguished

the two principal modes of "intellectual" production: 1. that whose object is to satisfy the *desire of the mind,* which is as natural to human beings as hunger; 2. that whose object is to satisfy extrinsic needs of the producer (money, honors, glory, etc.). . . . The intellectual producer . . . I want to consider is one who, by his product, seeks to satisfy above all the personal need of his mind. Marx says: "A thing can be useful and a product of human labor without being merchandise. The man who, through his product, satisfies his personal need, creates indeed a use value but not merchandise. To produce merchandise, he has to produce not a simple use value, but a use value having the ability to serve others, a social use value."

Breton insists that the professional regulation of intellectual work is impossible because the qualitative judgments of contemporaries often differ from those of posterity (he cites the case of Baudelaire), and also because of the incommensurability of the time involved: while a poet may take the same amount of time – a day – to write a poem as the shoemaker to make a

pair of shoes, "the items are hardly ex-
changeable, and whereas the shoemaker
begins anew next day, the poet is not
necessarily capable of doing the same
thing." While he opposes taking "ineffec-
tual steps" to form guilds or unions of
intellectuals, he concludes his essay with a
rousing expression of sympathy for all
workers who suffer from the "present
order" and a call to intellectuals "to serve
without reservation as their own, the admi-
rable cause of the proletariat."[88]

The attempt to find a common ground
with the French Communist Party beyond
the vague though passionate interest in
figures like Lenin and Trotsky was fraught
with difficulty for creative and intellectual
workers like the Surrealists. While they
refused to compromise their imagination
by tying it to either bourgeois commercial
or communist propaganda interests, they
wanted their productions to be relevant
to the great social revolution they saw
taking place without being considered
"engineers."[89]

Breton explained the Surrealist position
in *Clarté,* no. 79 (January 1926), pp. 380–
7.[90] "In the revolutionary sense, just as on
the social and economic plane, one can
honorably claim to be Marxist, in the same
way, on the spiritual plane, I affirm that it
is always permissible to uphold Lautréa-
mont and Rimbaud."[91] Curiously, in a de-
fensive development analogous to the his-
tory of the Soviet Communist Party, by the
late twenties Surrealism itself had devel-
oped a firmer organizational structure that
restrained internal divergences and inte-
grated political activism with less fear of
submerging in the party.

As we have seen the party rejected
collaboration with the Surrealist avant-
garde. In the Soviet Union, where a split
developed early between the literary and
political avant-gardes,[92] the "establish-
ment" (Gorki, Lunacharsky, Blok) harshly
judged innovative poets like Mayakovsky,
who refused to write versified propaganda,
as bourgeois – not revolutionary – talents.

Between 1924 and 1929, *La Révolution*

Figure 8. Man Ray, "Et guerre au travail,"
cover, *La Révolution surréaliste,* no. 4 (July
1925).

surréaliste published articles critical of
work; its cover in the month Breton took
over the editorship announced a "War
against Work" – meaning regular wage la-
bor (Figure 8).[93] Socially, the Surrealist
position fell somewhere between an adoles-
cent immaturity and the petit-bourgeois
claim of intellectual elitists to aristocratic
leisure. However, what they aspired to was
a new form of "work" uniting love and
creativity, and they were willing to work
hard at that. In 1925 Aragon, echoing old
Dada demands and in agreement with
Breton's derision of normal wage earning,
exclaimed: "Ah! bankers, students, work-
ers, civil servants, domestics, you are the
cocksuckers of the useful, the jerkoffs of
necessity. I will never work, my hands are
pure.... I curse science, twin sister of
work."[94] Several years later the Surrealist

André Thirion, in "A bas le travail!" while arguing against both the bourgeois apology of work and the phony images of "Russia at work," defended the right not to work.[95]

In a manifesto denouncing a project for a monument to Rimbaud, the Surrealists quoted sympathetically the poet's exclamations against work: "JAMAIS JE NE TRAVAILLERAI . . . CELA DEGOUTE DE TRAVAILLER, etc."[96] Moreover, they defined "work" very differently from Soviet theoreticians who placed physical labor at the heart of social productivity; for they included poetry in the category of intellectual work. Indeed, by the Second Manifesto, presumably in an effort to accommodate Surrealism to Marxist Socialism, Breton wrote: "The problem of social action is . . . only one of the forms of a more general problem that Surrealism has taken on itself to raise; viz., that of human expression in all its forms. Whoever speaks of expression first of all speaks of language."[97] Breton imbued economic terms with very personal overtones: he despised the money of labor or profit (as a poet he even once proposed paradoxically to maintain a golden silence), and he wanted to transmute the regulated time of the workplace into a fabulous "gold of time."[98] The Surrealists proposed a regression from a capitalist market economy to the kind of bartering they practiced at the flea markets. Evidently they preferred to middle-class consumer pricing and shopping the practice of "l'hasard objectif" – for example, the surprise of discovering *objets trouvés* in a bazaar. (Breton and Aragon occasionally made money by shrewdly bartering and brokering art objects.) Their attitude to work freed the Surrealists from the insidiously exploitive mentality that climaxed in the mid-thirties in Stakhanovism, a counterpart to capitalist incentive labor, and it inspired their criticism of the Soviet Union's idolizing of work. Thus, in 1933 Alquié very unfavorably reviewed the Soviet film *Road to Life,* which moralized about work as the only worthwhile goal.[99] The position of radical gadfly allowed the Surrealists considerable intellectual independence, though one more limited than the German Dadaists, who had openly criticized Marxist and bourgeois alike.[100] But their independence diluted their commitment to Marxist praxis, and despite the intention of supporting the Revolution, after a long series of disagreements it brought about a withdrawal from organized political engagement.

The questions raised by the Surrealists concerning wage labor grew out of their rebellion against the link between time and work in general (a link important in Hegel's *Phenomenology of Mind*). One finds a moment in 1927, when, seeking approval of the Communist Party, they maintained – inconsistently with their opposition to wage-earning – a defense of pay and of the struggle against unemployment, but this issue had to do with the proletariat and not with writers and artists.[101] However, they were always consistent with regard to intellectuals and artists, for whom they favored leisure, albeit an active and productive one. Here they agreed with radicals close to the anarchist Bakunin.[102] But they also favored the idea of Paul Lafargue (1842–1911), considered by Breton to be "an enlightened determinist," who – in contradiction of workers who demanded a right to labor – championed the "Right to Be Lazy."[103]

The Surrealists, one might say, hoped to overcome the polarity between work and leisure, in the dialectical synthesis of play (including sexual play). (This was a natural idea for a Parisian intellectual, since Paris played a special role in the nineteenth and early twentieth centuries as art and culture leader to the world, a city whose "industry" depended on entertainment rather than industry.)[104] Naturally they only advocated play that was not coerced or codified (at least in bourgeois terms) and did not intend it as relaxation for tired bourgeois.[105] Consequently Breton excluded prostitution from play as no less institutionalized than the family, while extolling *l'amour fou* and the chance encounter in love.[106] Here they seem to

associate themselves to a tradition that included Schiller's ideas about art as play, Fourier's *phalanstère,* and Marcuse's notion of the "performative principle."[107]

Another alternative to work was the strike, an action that Breton believed would unite manual and mental workers (he was, perhaps, inspired by Trotsky's advocacy of the strike as a revolutionary means).[108] On the first page of *La Révolution surréaliste,* no. 2 (January 15, 1925), he published a note entitled "The Last Strike" in which he asserted that the Surrealists' aim – liberty – is incompatible with both bourgeois and proletarian work (a view analogous to Duchamp's model of laziness and energy conservation and to the German Dadaists' stand against work, as well as antithetical to Ozenfant's views).[109] While acknowledging with a touch of humor that intellectuals are no more workers than Hercules (mythic labors), Columbus (the lucky discovery), or Newton (the apple story), Breton suggests that he and his fellow writers could join with workers in the action of the strike (ceasing to publish their revolutionary journal): "Why not the strike? It has been up to now the only recourse of our friends the true workers and it has the advantage of presenting a most objective and symptomatic value." The ideas are not very clear and fall short of the concept of the strike as Marxist instrument of class warfare, anarchist agitation, or even the revolutionary theater conceived, for example, by Sorel.[110]

Breton's mixture of notions about work and leisure, free love play and paid prostitution, imagination and communication, found a partial embodiment in his book on Nadja. But it was in his defense of a poem he actually detested – Aragon's "Front Rouge," a heavy-handedly political poem singing the praises of the USSR – that Breton clarified his views on the relation of art and politics. The ideological conflict between the Stalinists and the Trotskyist opposition that started in the twenties and the emergence in the thirties of Socialist Realism as the official vehicle of Stalinist

propaganda against Fascism (and ironically, the stylistic counterpart of Fascist propaganda) caused some confusion and uncertainty among the Surrealist avantgarde still sympathetic (like Trotsky) to the Soviet experiment. While sustaining an interest in radical politics, the Surrealists now sought other ground for their energies that would not compromise their dedication to artistic freedom. A preliminary skirmish in the battle of styles occurred during the "Aragon Affair."

Aragon had changed dramatically since defining Surrealism in *Le Paysan de Paris* as "the disordered and passionate use of the stupefying image." "Front rouge" lays out a rhetoric on class lines: the attributes of the wealthy – champagne, "aristocratic bottoms," "a Louis XVI bed" – are hostilely counterposed to the sufferings and martyrdom of the Bolsheviks and their worker allies. Rhythmic variations on the letters USSR mingle with the chant "Kill the cops."[111] Having named specific places, political heroes (Lenin, Marty) and enemies (Garchery, the associate of Souvarine), Aragon defiantly adds "for those who claim this is not a poem" a paragraph of reportage describing a political incident. His taste in art during this period had shifted to straight political message, especially as carried in the collage. (He expresses this interest in his essays in 1930 on collage and in 1935 on Heartfield.) Aragon above all displayed his rejection of Surrealist values in his hostility to metaphor. The Surrealists might well have associated the factual aspect of Aragon's poem with the naturalism of a Joyce's interior monologue, which Breton rejected.[112]

Aragon's poem, with its explicit call to violence against the government, provoked threats of legal action. Breton wrote a defense of Aragon against the French state's efforts to prosecute him, but his article "Misère de la Poésie" (March 1932; an echo of Marx's "Poverty of Philosophy") shows little sympathy for this flagrant exposition of Stalinist values. However, he confined his criticism of "Front rouge" to

artistic questions. It remained for others to call attention to Aragon's shameless – and very successful – efforts to ingratiate himself with the Soviet bureaucracy.[113]

The style of this poem reflects a profound shift in Aragon's political and artistic values, a change that contributed to the hardening of positions in the dispute between the supporters of Surreal fantasy and those of Socialist Realism. The differences between the parties can be clarified by staging a hypothetical confrontation between Aragon's "Front rouge" and Breton's "Union libre": the one an aggressive political exhortation in poetic form, the other a lyrical and poetic expression of desire.

Aragon, displaying a newfound party loyalty, rejected the "frivolousness" of Surrealist poetry and its automatist practices, summed up in the excessive use of metaphor and image by the Surrealists: "With me, after a certain moment, you'll always find metaphor in abundance . . . ; and then, suddenly, entire poems appear in which there is not a single image. That resulted from my having grown tired of making the poem recognizable through its images. This 'anti-poetry' was never so violently manifested as in 'La Grande Gaîté.' " This poem of April–May 1929 was one of the "two works usually considered as the end of my Surrealist period."[114] In keeping with his shifting taste Aragon expressed interest in Emile Savitry (1930–67), a realist who had flirted with and then rejected Surrealism.[115]

Looking back at the twenties, Aragon, taking sly aim at Breton's inadequacy as a revolutionist for preferring formal quality to social content, observed:

At that date [1926] our respective positions were not what they would become later; e.g., André Breton, who at that time was to my left, reproached me for expressing myself with flippancy compared to the communists, and recommended to me that I read Lenin, etc. I even remember the approval he gave – against Trotsky – to the celebrated speech of Stalin on "the construction of Socialism in one country." It is true, in my opinion, that Breton was above all carried away by the *style* of [Stalin's] speech, which had the character of a litany with its repetition of the expression, *the construction of Socialism in one country,* a character resembling Péguy's prose [a sarcastic allusion to the Christian Socialist Péguy].[116]

And in fact before the Moscow Trials Breton showed little sympathy for the alert enemies of Stalin in the Left Opposition; for example, he berated Riazanov, a great Marxist scholar and a genuine hero of the Opposition, with considerable harshness.[117]

Surrealism in the early thirties bifurcated along two edges – the high edge of psychology and madness (Artaud) and the low edge of politics and materialist philosophy (Aragon) – but both edges met in their rejection of metaphor. They did so for opposite reasons: the one, loathing allusions to or embellishments of the self-satisfied middle-class world from which they came, wished to create things never seen before; the other, aiming to reproduce richly didactic pictures of the everyday existence of the working class, rejected what did not smack of straightforward prose statement.

In contrast to Aragon's poem, "Union libre" abounds in metaphors. Its "meaning," like the body of the mistress, is lost in the confusion of its descriptions: loading the body parts with automatist images obscures both sense and anatomy; its images succeed one another in open-ended associations that endlessly ramify. Yet the poem, composed of a collage of images, retained at least a sequential order in both the visual (the anatomical arrangement) and verbal (syntax), as Breton suggests in a long note to the Second Manifesto.[118]

Whereas Aragon proceeds from image to image by what one might call a metonymy of collage fragments (tied together by the percussive reiteration of "U.S.S.R."), creating the impression of journalistic rhetoric, Breton explores the po-

etic potential of collage: in passing from head to toe of the woman's figure Breton collapses the verticality of verbal metaphor (in Jakobson's sense of selection on a vertical axis) onto the horizontal metonymic axis of juxtaposition and translates the body into a verbal equivalent of the exquisite corpse.[119] Generally the methods of the Surrealist artists and poets were complementary and depended on the relation of the visual to the verbal, in which the visual constituted – in the terms of Piaget and Freud – the more "primitive" level.[120]

Breton's lyrical poem, devoid of overt political messages like the poetry of Péret and Eluard, nevertheless represents implicitly (it was not given public circulation) two "political" positions of Surrealism in the early thirties. First, the word "Union" makes topical allusion to the campaign of the Communist Party to form a broad-based coalition with Surrealism and other parties of the Left against the growing power of Fascism, and "Free" indicates the Surrealist insistence on the independence of their involvement (one might say they proposed a union modeled on free love rather than on marriage). Second, its difficult imagery challenges the trend toward mass marketing promoted by the Communist Party and addresses a sophisticated audience. It contrasts graphically with Aragon's "Front rouge," which also contains a quasi-musical repetition of a phrase in is rhythmic chanting of "U.S.S.R."; however, Aragon, unlike Breton, who assigns only the generic name "femme" to the object of his poem, indicates through the recurrent acronym a concrete political entity. Aragon defuses any poetic tension by massive dosages of journalistic prose and an insertion of trivial news items. The best of Aragon's later poetry (the love poems to Elsa) eliminates the incongruous prosaic element and, while remaining within the conventions of French lyrical poetry, tastefully spices it with a sprinkling of surreal imagery, but most of his art criticism amounts to a Stalinist hack's effort to make a plausible case for bad Soviet art, emphasizing in 1933 like Stalin that "technique decides everything."[121] Aragon, loyal to the simplistic party line, contrasted the revolutionary virtue of proletarian literature to "apolitical works [which] are militant weapons for the preservation of the regime in power."[122]

The preference for an aesthetically weak realism intended to simulate the condition and viewpoint of the proletariat over a radical literary style was not dominant at the beginning of the Russian Revolution, when political considerations did not restrict the cultural avant-garde. Thus, the Revolution in its expansive first years welcomed an inventive materialism: in 1920 Konstantin Umansky praised the constructions of Tatlin in these terms:

> A triumph of the intellectual and the material, the negation of the right of the spirit to isolated autonomy, a quintessence of contemporary reality, of sovereign techniques, of victorious materialism – it is thus that we must define the counter-reliefs which have relegated within quotation marks all such sacrosanct words as Art, Painting, Picture.[123]

But with the establishment of a new order the political definition of cultural limits became a major point of contention between advanced writers and artists and the party hacks who professed what the official Communist bureaucracy called Socialist Realism. During the twenties the issue took the form of a concern about the relation of reality to lyricism in art; for example, the manifesto of the exhibition "Art d'aujourd'hui" held in Paris in 1925 declared: "The purpose of this new technique [is] to relieve art of the weight of reality, which is essentially anti-lyrical. Mankind needs an escape from reality." This leads essentially to Breton's "marvelous," which goes beyond the purely poetic definition of Reverdy. The Surrealists detected in Reverdy confusions about the link between dream image and thought – on the one hand he acknowledged that

the two were "different sides of the same thing," and on the other that "dream is an isolation," "dream is to flee," and "dream is a tunnel that passes beneath reality. It is a sewer of clean water, but nevertheless a sewer." He obviously rejected the notion of a sur-reality, in which the image represents a reality beyond the perceived one.[124]

While Aragon substituted Soviet propaganda and Socialist Realism for the avant-garde, the Surrealists during the thirties rejected all explicit political art that smacked of propaganda. They struggled on bravely, maintaining the supreme value of individual liberty, but only finding appropriate responses in the wildly imaginative evasions of Dali's paranoiac-critical misperceptions and in the amorous poetics of individual passions. Considering their goal of putting their work in the service of the Revolution, dream and automatism seemed to some of questionable political relevance, a self-indulgence that entailed a dangerous political vulnerability; so while Breton made favorable critical allusions to them, the practice of both declined steeply during the thirties, and paranoiac criticism replaced them.

"Socialist Realism" was not identical with objective realism, in the nineteenth-century sense, nor with the naturalism of a Zola intended to hold a mirror to society. Instead it was "revolutionary romanticism," as Zhdanov put it. Given the conditions in general among the economically lower classes, such naturalism could easily be seen as pessimistic, and the Social Realists preferred to depict a glowing future and to encourage the downtrodden with heroic themes. From the Surrealists' point of view the "dream" of Socialist Realism amounted to a hypocritical worship of pie in the sky by credulous masses who repelled the unsettling fantasies of the Surrealists.

The concreteness of the visual image eventually created problems even as it offered the fascination of a mirage. For in the sinister climate pervading the early thirties – as Nazis spread their terror, Stalinists in France as well as in Russia throttled the voices of opposition, and Nazi counterfeits of patriotism (the "Fifth Column") battled Stalinist counterfeits of socialism (the United Front) – only the path of the political collagists like Heartfield and Hannah Höch seemed to offer a valid political mode for visual art. The political environment of the thirties was dominated by mindless herds like Ionesco's rhinoceroses. Vulnerable to criticism from the Right and Left, the Surrealists "occulted" (Breton's phrase in the Second Manifesto) their practices of dream and automatism.

The possibility and desirability of an autonomous art became during the thirties compelling issues for the Surrealists, who felt constant intellectual and moral pressure to side actively with the French Communist Party against their bourgeois enemies. Their efforts to define their dissatisfactions with the bourgeois society that had acculturated them dramatically changed in the two decades between the world wars. But now they faced a dilemma: on the one hand, they continued their efforts to "unlearn" the compulsive time schedules imbedded in the routines of middle-class society, always with the hope of finding liberation in the politics of revolution; on the other hand, they repudiated the party's commitment to discipline and regularity. While they were trying to escape from the party's discipline, they needed the party as a forum in which to perform their polemics and give substance to their dreams.

A quarrel over the autonomy of art flared up between Eluard and Breton in 1926 (the same year that the Prague circle, which attacked the notion of an autonomous art, was founded).[125] Eluard wrote a note for an anthology of his work, *The Dark Sides of a Life*, which explains his position at the time concerning such aesthetic issues:

It is extremely desirable that we not establish a confusion between the differ-

ent texts of this book: dreams, Surrealist texts and poems.

No one can mistake dreams for poems. To a mind preoccupied with the marvelous, they are living reality. But concerning poems ... it is indispensable to know that they are the result of a quite definite intention, the echo of a hope or an expression of despair.

The uselessness of poetry: the world of perception is excluded from Surrealist texts and the most sublime and chilly light illuminates the heights where the mind plays with a freedom that it does not even dream of verifying.

Breton considered this text clear proof that Eluard had reservations about the fundamental concepts of Surrealism. As he remarked in an interview, "This division by *genres* with a marked predilection for the poem seemed from the first moment ... in flat contradiction with the spirit of Surrealism."[126] But by 1927 the two poets were reconciled once more, and they joined with Aragon to criticize an edition of Lautréamont by Soupault, now considered a renegade.

Naville, repudiating the quarrels among his colleagues about art's autonomy and the place of fantasy and mental disturbances in the context of political action, had already given up his adherence to Surrealism in 1927 and entered into the Left Opposition.[127]

With the final issue of *Le Surréalisme au service de la Révolution* in May 1933, the Surrealists lost their last major periodical, and when they collaborated on the luxurious *Minotaure* in May 1933 and later, theirs became one voice among several, without any clear-cut political focus other than disillusionment and pessimism. Part of the difficulty in sustaining a Surrealist revolutionary politics derived from the decline of radical vision internationally, led by the insidious Stalinists, but the success of Surrealism in the fashionable world of European and American modernism also undermined its earlier Communist libertarianism. In a March 1935 lec-

ture in Prague, "Surrealist Situation of the Object: Situation of the Surrealist Object," Breton with grim humor addressed the latter difficulty:

Perhaps the greatest danger threatening Surrealism today is the fact that because of its spread throughout the world, which was very sudden and rapid, the word found favor much faster than the idea and all sorts of more or less questionable creations tend to pin the Surrealist label on themselves.... To avoid such misunderstandings or render such vulgar abuses impossible in the future, it would be desirable for us to establish a very precise line of demarcation between what is Surrealist in its essence and what seeks to pass itself off as such for publicity or other reasons. The ideal, obviously, would be for every authentic Surrealist object to have some distinctive outer sign so that it would be immediately recognizable; Man Ray thought that it should be a sort of hallmark or seal.

Thus, to help the amateur, objects would bear the mark "A Surrealist Object." (Unfortunately, he may have meant the last prescription more than mock-seriously.)[128] Already in the October 1927 issue of *La Révolution surréaliste,* Naville, in his article "Mieux et moins bien," had warned against the vulgarization of the name "Surrealist," to which Breton apparently responded in the Second Manifesto with a demand for the "occultation of Surrealism."

Surrealism now found that its capacity to "épater le bourgeois" had become domesticated into a middle-class entertainment, performed above all by the renegade Dali. In 1936 an anxious Breton, revolted at the threat posed by the rationalism of a universal totalitarian bureaucracy to engulf artistic imagination, wrote the "Crise de l'objet." In it he proposed the production of objects to disturb and confuse, not to please or display a "Cartesian" logic and consistency: "The Surrealist procedure tending to provoke a *total revolution of the object,* an

action of diverting it from its proper ends by assigning it a new name and by signing it." He envisaged reconstructing a piece from scratch with scattered parts, "taken as immediate data (a Surrealist object properly speaking). Perturbation and deformation are here sought out for themselves."[129] In spite of this intention, he probably sensed the risk that for a jaded bourgeois public, the objects would serve not as a provocation to think, but as a diversion.[130]

At the same time that the Surrealists were sinking in the web of their own success (either as entertaining novelty or as fashion statement) among a middle-class audience, they found themselves alienated from totalitarians on the Left and Right: the Surrealists insisted on a concept of the "whole" person that had little to do with the loss or fragmentation of self in a bureaucratic totality.[131] They steadfastly scoffed at the facile and compromising policy that attracted many liberal "pinks" during the mid-thirties to the Popular Front. Their ideological allies were Trotsky and a handful of intellectually open and generous liberals (Dewey, Russell) and intelligent and courageous Marxists (Souvarine) who defended Trotsky's right to expound a variety of non-Stalinist Marxism, even though they did not agree with his Leninist dogmatism.

In these circumstances Surrealism became enmeshed within the paradox that its need for autonomy was inseparable from its need for engagement; for its very autonomy was a highly engaged gesture necessary for defending its freedom from totalitarian dogma, as well as from the conformism and rigidification of contemporary art, whether fashionable modernism or popular Socialist Realism. Surrealism shared this moral stance with a very different movement that espoused an aesthetic of beauty: the journal *Abstraction-Création* expressed belief not only in an independent, pure creation, but in an "art social et collectif universel" (1935).[132]

The heroic dimensions of the Surrealist position could easily be overlooked by retrospective critics like Adorno, who, as already noted, criticized Surrealism for trying to produce "a dialectic of subjective freedom in a situation of objective unfreedom."[133] Habermas, in a similar vein, criticized Surrealism for attempting to overcome only the autonomy of the art sphere while ignoring the cognitive and moral spheres. He relies on Peter Bürger, who characterizes the political phase of the avant-garde – Surrealism – from World War I to the late twenties:

> The historical avant-garde movements negate those determinations that are essential in autonomous art: the disjunction of art and the praxis of life, individual production, and individual reception as distinct from the former. The avant-garde intends the abolition of autonomous art by which it means that art is to be integrated into the praxis of life.[134]

In fact, the Surrealists did not ignore the cognitive and moral spheres, but attempted to undermine the first through the irrational (dream, automatism) and the second through assaults on bourgeois morality (appeal to de Sade's libertinism and to Engels's attack on the family). The Surrealists, acutely aware of the failure of liberalism, spent much time in quixotic tilting at the patriarchal and racial rigidities of their own class; but they did not see the extent to which they reproduced those problems within themselves: evidently before their insecurity prodded them to seek psychological or psychoanalytic counseling, they could discharge their anxiety by some artistic or political "acting out."

Breton in 1947 – still concerned with the social responsibility of the artist – deplored the fact that signs should survive the things they signified and, perhaps with the experience of Fascism in mind, observed that this fact leads to intolerance and dogma.[135] Breton's remark made poignant sense in the late forties, in the wake of Hitler and Mussolini, and at a time when Stalin supported seductive emblems and "signs"

to cover the brutalities of his regime. But in the following decade of suffocating stalemate and Cold War, disillusioned with political activism, he encouraged a free rein to the imagination to the point of advocating a "play of signifiers," with little concern for the limiting factor of the signified. He opposed any limitations on artistic freedom; thus, he criticized the Existentialists' *art engagé* and finally (in 1966) even the Trotskyists' efforts to recruit artists into their movement.[136]

The advancing "autonomy" of the arts in bourgeois society apparently followed in the wake of the sciences, which constantly narrowed their focus and detached themselves from one another and from the arts in general. Mimesis, which had provided a stable link among painting, poetry, and "reality," as well as between art and science, was challenged by a technology increasingly capable of creating artificial "realities." As Max Weber (and Habermas after him) noticed, cultural modernity separated substantive reason into the autonomous spheres of science, morality, and art, leading to "de-magicization" – the elimination of the unpredictable and irrational, the sensuous and the mysterious from the theory and practical conduct of life.[137] A seemingly inevitable consequence of the diminished and isolated place of the humanities in society was that the "modern system" of the five major arts began to disintegrate. By the end of the nineteenth century, painting, less and less tied to narrative structures, diverged from poetry and came closer to music.[138] Specialization and the ideal of the purity of medium imposed itself on all aspects of modernism, forcing an ambivalence on a Surrealism torn between artistic introversion and political responsibility.

The question of the social and revolutionary potential of the form or content of Surrealist writing and art became crucial in the thirties, when the alternatives were the Realism of Nazis and Stalinists or decorative abstraction. The Surrealists – with the Promethean hubris of the Western

intellectual – hoped that their art and writing, by making contact with repressed desires, could have an impact on psychological or social reality and thereby, ultimately, lead to "freedom" (variously defined as psychological and personal, poetic, or sociopolitical). But the audience they addressed remained the cultural elite, who, like them, emerged from the middle classes, and not the proletariat presumably addressed by Marxism. In retrospect it appears that the "workers" not only remained an abstract entity for Breton and his fellow poets – despite their rhetoric of involvement and identification – but never became more than an abstract force for Trotsky and his fellow Bolsheviks, including both Lenin and Stalin.

In its last years as a movement, Surrealism instinctively and crucially attempted to recover precisely the magic lost to Western society. To do so it turned to "sciences" untouched by modern technology – the occult, alchemy, art as ritual, and psychoanalysis. Breton had from the start credited Freud's discoveries with enabling "the human explorer to carry his investigations much further," to go beyond prosaic reality: "The imagination is, perhaps, about to reassert itself."[139] The Surrealists extended Rimbaud's empowerment of poetry, claiming that dreams and imagery could change the world. In fact, the Surrealists could change no more than the content of their poetry and painting. Caught as a generation between the wars in a world of military and technological expansion and narrowed human horizons, the Surrealists could do little more than turn inward, seeking futilely in art and love solutions to enormous social problems. One such problem that marked their thought and action was the place of the woman – the indispensable center who paradoxically remained on the margin, an "Other." A second problem, at once acute and chronic, was the place of visual imagery in a movement founded by poets. The next chapter will consider especially the place of painting in that movement.

4

Surrealism and Painting
(The Ineffable)

A similar limitation applies to the plastic arts . . . as compared with poetry, which can make use of speech; and here again the reason for their incapacity lies in the nature of the material which these two forms of art manipulate in their effort to express something. Before painting became acquainted with the laws of expression by which it is governed, it made attempts to get over this handicap. In ancient paintings small labels were hung from the mouths of the persons represented, containing in written characters the speeches which the artist despaired of representing pictorially.[1]

Freud, *The Interpretation of Dreams*

The attempt to define a "Surrealist painting" provoked questions early on, not only among the Surrealists themselves but among the critics and historians interested in them: Is painting or photography or cinema the essential Surrealist visual art? How can one unite the seemingly incompatible political engagement and artistic autonomy? How can one finance art and its illustration without succumbing to the very commercial pressures one criticizes?

There was no question at first of a specifically and novel Surrealist painting: in their writings up to 1924–5 Breton, Aragon, and Eluard discussed and praised without reservation artists like De Chirico, Picasso, and Ernst. We can follow Breton's changing priorities as the movement evolved, from post-Symbolism to Dada collage and photography, and his efforts to base such painting first on automatism – automatic drawing held some promise as a counterpart (even of the instrument) to automatic writing – and then on the dream. But something more than drawing or pho-

tography was wanted, and after the First Manifesto placed emphasis on the poetic image, the Surrealists had to face the question whether there could be a Surrealist painting.

One of the first artists mentioned by Breton, right in the midst of his enthusiasm for Dadaism, was Ingres, a surprising choice proving that Breton had not yet seriously considered linking his poetic interest to his taste in visual art. In a letter to Tzara in January 1919, Breton expressed enthusiasm for Ingres, placing his name at the head of a list of artists interesting to him that included Derain.[2] But in a second letter to Tzara dated April 4, 1919, Breton wrote with youthful hyperbole: "What seems to me the most urgent thing is to kill art," adding, "but we must not operate openly."[3] Nevertheless, he would soon write extensively on art and artists like De Chirico and Ernst.

The art attractive to the adolescent

POÈME

Un éclat de rire
de saphir dans l'île de Ceylan

Les plus belles pailles
ONT LE TEINT FANÉ
SOUS LES VERROUS

dans une ferme isolée
AU JOUR LE JOUR
s'aggrave
l'agréable

Une voie carrossable
vous conduit au bord de l'inconnu

le café
prêche pour son saint
L'ARTISAN QUOTIDIEN DE VOTRE BEAUTÉ

MADAME,

une paire
de bas de soie
n'est pas

Un saut dans le vide
UN CERF

L'Amour d'abord
Tout pourrait s'arranger si bien
PARIS EST UN GRAND VILLAGE

Surveillez
Le feu qui couve
LA PRIÈRE
Du beau temps

Figure 9. André Breton, collage poems published in the First Manifesto (1924).

Breton before his exploration of either modern art or automatism had to do with images of women whose mysterious and compelling beauty reminds us of those conjured up by the French Romantics and Symbolists. His taste for female beauty was equally accommodated by the cold elegance of Ingres's women and the pensive femmes fatales of Moreau, and later by the enigmatic creatures of De Chirico, but he never seems quite comfortable with the paroxysmal females of Masson or the sadistic maenads of Picasso (he illustrated *L'Amour fou* with a painting of a woman from Picasso's Blue Period).

We can reconcile the apparently conflicting views expressed to Tzara as responses to two different moments – the first was written exuberantly, with little knowledge of Tzara. The second letter evidences awareness of Tzara's recent hostility to art and with tactful deference seconds it.[4]

Breton's willingness to accommodate Tzara's view probably also owes something to his impression that the verbal automatism of the *Champs magnétiques* had much in common with the iconoclasm of Dada. However, at the time of the Barrès Affair the profound divergence in philosophy between the Parisians and Dada became clear: the Parisians rebuffed Dada's nihilism in favor of some sort of revolutionary change. Breton, who, despite his remark, never wholly abandoned painting (nor poetry, even though he once proclaimed that he would never write again), turned to visual imagery as a means to expand the boundaries of poetry (e.g., in the collage poems of the First Manifesto; Figure 9) and to explore the enigmas he

believed were hidden behind appearances. Freud's interpretations of dream imagery, as noted before, helped inspire his declaration of the "omnipotence of dream" in the First Manifesto.[5] In fact, not all the Surrealists agreed with Breton about the importance of dream – in the controversies of 1924–7 Naville and others insisted that Surrealist painting would have to model itself on automatist writing.

Automatism, an important means to liberate the poets from classroom routines, initially concerned only verbal material (they seem unaware of nineteenth-century investigations of automatic drawing as a manifestation of the unconscious) and did not at first attract Surrealist artists.[6] It later did inspire Surrealist artists, perhaps as an alternative to the stylistic skill of modern art – a means of associating the artist's gesture primarily to the unconscious,[7] rather than to planned abstraction or decoration.[8] Artists in Breton's circle, like Ernst, Masson, and Miró, would soon challenge the formalist Cubism that had influenced them, both through experiments with automatism and through reviving interest in mythological and poetic themes rich in psychological overtones. Their subjects did not derive directly from psychoanalysis (except perhaps to some extent in Ernst's case), but through an adaptation of themes drawn from current Surrealist literature dealing with the erotic, magical metamorphoses, and inner vision. Other artists, affiliated with Dadaism, mingled texts with their Cubist images.[9]

For the early Breton, automatism guaranteed fidelity in the transcription of the voice without implying a conventional connection between artist and expression; and years later, during paranoid and duplicitous moments of the thirties, he returned to automatism as a source of authenticity.[10]

Breton's hope of discovering hidden meaning within uttered texts led him to explore other avenues including silence and the possibility of automatic visual imagery, sometimes mixed with words. However, automatism, which served the authors of the *Champs magnétiques* in their search for fresh images apparently free of rational control, proved more difficult to apply in art, where the question arises: Does the requirement of technique in painting inevitably obstruct Surrealist access to the unconscious? One might even wonder whether automatism actually negates individuality (as some photographers at the end of the century believed).[11] Romanticism, aware of the old issue of talent versus genius, raised the question whether the raw and unfinished might not yield a greater art, and the Symbolists even attacked easel painting for its excessive refinements.[12] The Ecole des Beaux-Arts faced the issue in a new form later in the century – the distinction between "generative" (sketching) and "executive" (refining, finishing);[13] one writer has generalized the issue for nineteenth-century modernism as "whether one could deliberately *make* an art of finding, an art of the discovery of origins, a 'technique of originality' "; and Barthes and postmodernist theorists of photography (and "doubling") have called the whole idea of "originality" into question.[14]

In a remarkable preface to a Dadaist exhibition of Ernst's photomontages, doctored photos, and drawings in May–June 1921, Breton claimed that such work – above all the photomontages – was the equivalent of automatic writing, which he characterized as "a true photography of thought" (the idea of photographing mental "fluids" had a currency dating back to the nineteenth century);[15] but this thesis, which was advanced in the context of Dadaism – and which Cocteau, favoring Man Ray, rejected in 1922 – was dropped by Breton during the following years when he and the Surrealists tried to find the equivalent in painting of automatic writing.[16] Ernst later applied photomontage-like effects in a complex technique of printmaking that blended cutouts from science periodicals, academic drawings with realistic subject matter, and his own monstrosities – for example, in his collage novels that show unruly creatures crawl-

ing from the walls of middle-class houses. Photography provided Breton with an argument not against painting as such, but against its use for imitation (an argument elaborated on by Malraux). Indeed, he insisted as late as 1935:

> Photography was to deal [realist painting] a decisive blow by mechanizing to the extreme the plastic mode of representation.... The only domain left for the artist to exploit became that of *pure mental representation,* such as it extends beyond that of true perception without for all that being identical with the hallucinatory domain.... The important thing is that recourse to mental representation (outside of the physical presence of the object) furnishes, as Freud has said, "sensations related to processes unfolding in the most diverse, even the deepest levels of the psychic mechanism." In art the necessarily more and more systematic search for these sensations works toward the abolition of the *ego* by the *id,* and consequently it endeavors to make the pleasure principle *hold clearer and clearer* sway over the reality principle.[17]

The rejection of imitation was intended to lead not to abstraction or decoration but to a new kind of imagery, an "imitation" of reality perceived not by the physical eye but by the mind's eye, in memory or dream. In May 1925, one year after publishing the manifesto, Breton declared: "It seems more and more the case that the most powerful generator of the new world with which we intend to replace the old, is no other than what the poets call the *image.* ... It is by the force of images that, with time, *true* revolutions could be achieved."[18] And in 1926 Aragon wrote, "The image – the stupefying image – up to now celebrated for its magical properties of metamorphosis and its power of transformation, now becomes an instrument of knowledge ... the greatest possible consciousness of the concrete."[19] Breton later repeated Stendhal's phrase, "The imaginary is that which tends to become real."[20] Already in its post-Dada

phase Surrealism encouraged an imagery that would trouble its middle-class audience, and in this respect it ran counter to those modernists aiming to relieve tension and to provide sensual "comfort" (Matisse) or mystical balance (Mondrian).[21]

De Chirico's images touched the early Surrealists' imagination more than any other artist's: even more important than De Chirico's depiction of females was his provocative mythology that seems to have inspired in Breton visions of alternative worlds beyond the physical constraints of a mundane reality. De Chirico's offbeat style fitted neither into academicism nor into the latest stylistic trends (Apollinaire called De Chirico in 1913, "an awkward and very gifted painter"), but unlike *le douanier* Rousseau he was never idolized by the modernists.[22]

Breton's interest in De Chirico's myths had already appeared in an article, "Giorgio de Chirico," first published in 1920:[23] "Representing the Sphinx as a lion with a woman's head was once considered poetic. I believe that a truly modern mythology is in formation. It falls to Giorgio de Chirico to fix it imperishably in our memory. / The nature of his mind above all inclines him to overhaul our fundamental perceptions of time and space." Perhaps he felt that his own dreams (e.g., those recounted in *Littérature* of December 1922) had a kinship to the art of De Chirico. Aragon arrived at the comparable idea of a "modern mythology" in his *Paysan de Paris* and linked it to the geography of the nocturnal wanderings of his fellow poets: for him, new (and concrete) myths are born beneath each step taken among the "sacred" paths and arcaded passages of the capital. (Aragon's Paris reminds us of Joyce's Dublin and its modern Ulysses.)

De Chirico's art gave added impetus to the quest of Breton and his Parisian friends, who, as we have seen, never ceased to seek a way to overcome the prosaic reality of their early education. Already in a poem of 1913 Breton spoke of "undermining the walls of the Real that encircles us."[24] It was

chiefly De Chirico's "incomparable works achieved between 1910 and 1917" that offered, in Breton's opinion, one of the two points (the other was Lautréamont) that determined this line of Surrealist development. Breton came to consider De Chirico to have transcended the material concerns of ordinary, commercially successful artists. These extravagant expectations help account for the subsequent disappointment with De Chirico among the Surrealists for having "sold out" to the art market.

In a footnote to the First Manifesto Breton cited Apollinaire's opinion that De Chirico painted his first works while suffering from migraine, colic, and other "cenesthetic disorders," and just before this Breton claimed that his own dream of the man cut in half by a window was stimulated by his impoverished diet, and in this context quotes a long passage from Hamsun's novel *Hunger*. Several years later, in *Surrealism and Painting* Breton returned to the theme citing Hippolyte Taine's argument for the reality of hallucinations or mental images, a subject of interest to Freud as well. Taine – considering psychologically what the Symbolists considered poetically – maintained that hallucinations can be generated from internal sensations and yet seem as vivid as mental images based on an external object (a position that Freud later adopted with regard to dream images).[25] Taine reported the case of a patient who, in a fever and hungry, had a hallucination in which a beautiful girl brought him a cup of soup. After he drank the cup and became satiated, she disappeared.[26] Breton gave the story the moral weight of a cautionary tale criticizing vulgar materialism among artists who destroy an illusion worth more than bodily sustenance: the suffering artist risks sacrificing creativity on the golden altar of success. Breton applied it directly in judgment of the recent mercenary interests of De Chirico, who lost his hunger for poetically rich images owing to his appetite for bourgeois broth: "The devil take his tiresome hunger and this absurd bowl of broth. . . . Certainly I would not have drunk

the poison." Breton would have agreed completely with Taine: "The image, like the sensation it repeats, is, in its very nature, *hallucinatory*. Thus the hallucination, which seems a monstrosity, is the very fabric of our mental life."[27] He implies that as in De Chirico's case, the poison of reality killed the beautiful hallucination; indeed, recalling the early De Chirico's belief in ghosts, Breton applies to him a phrase from "that marvelous film *Nosferatu*: 'When he reached the other side of the bridge the ghosts came to meet him.' "[28]

In 1928, as a rebuke to De Chirico's recent style, which they found devoid of the qualities of oneiric imagination they valued, the Surrealists organized an exhibition, "Ci-gît [Here lies] Giorgio De Chirico," to commemorate De Chirico's earlier painting and to mark his more recent artistic "death."[29] Aragon's review of this exhibition of early work was vitriolic. His first words, "Properties for sale," insinuate the artist's venality, and he continues with barbed remarks: "Out of the early painting of De Chirico a mythology is born while De Chirico himself dies. . . . The Sphinx devours the one who has opened the cage."[30] As an ultimate insult Aragon announced that he has changed the titles of the paintings exhibited, and he lists the new titles.

De Chirico's "fall" happened after he succumbed to "vulgar temptations" – commercialism, the display of craftsmanship, and the ambition to reproduce reality; concomitantly – and his worst sin – he gave up the enigmatic and imaginative style of his first works (although he was willing to make copies of them for sale to interested collectors). In the eyes of poets concerned with the unconscious and automatism, De Chirico's return to craft meant his acquisition of a salable skill as a means to commercial success. The Surrealists in general rejected efforts to produce art with any commercial utility in mind. In "Au bout du quai, les Arts Décoratifs!" Aragon denounced the useful decoration of architecture, "pure convulsion of pragmatism, a sort of deification of work," and positivism

(he names Comte).[31] Perhaps he had in mind Apollinaire's discussion of Duchamp-Villon and his brother Duchamp's celebrated mockery of the useful.[32] He appeals to the modernist decorators: "Henceforth let us agree on the pecuniary sense of the word *modern,* and leave us in peace with our painting devoid of the useful." This "useless" art comes close to art for art's sake; and the Surrealists, who refused the solution of Socialist Realism, never fully resolved the dilemma between engaged and "useless" art.

Yet one detects a trace of ambivalence in their excessive fury at the disappointment they felt over De Chirico's selling out: while rejecting the commercial, they themselves had to make a living and were constantly on the lookout for profitable art. Their purchases at the Hôtel Drouot auction house did not always reflect their critical views[33] and in some cases were presumably intended for resale to collectors like Jacques Doucet, who at one point regularly paid several Surrealists for advice about art.[34] They also established the Galerie Surréaliste and the Gradiva Gallery, but these were not very successful.[35]

In various ways Picasso, at home in gallery, studio, and café, might have helped solve the dilemma: he above all eluded, even transcended, the usual criticism of the Surrealists;[36] thus, while Breton and Aragon overlooked Picasso's ballet decorations, they inveighed against Ernst and Miró's "participation in the forthcoming performance of the Ballets Russes, which entails the abandonment of the idea of Surrealism": "It is not admissible that thought should follow the orders of money." Surrealism is "subversive" of such "enterprises, whose goal has always been to domesticate dreams and tame revolts induced by physical and intellectual starvation, in the interest of the international aristocracy."[37] Presumably they lay down their arms before this unique giant who bewilderingly straddled Left and Right banks, avant-garde and fashion. (The dispensation to Picasso was soon extended to other creative collaborators.)[38] The Surrealists may have felt that Picasso's playful approach to commercial and consumer culture had something in common with Duchamp's ironic posture, and that his distortions were compatible with their own program for subverting a world that at once attracted and repelled them.

Picasso's mock-serious mixture of high art and low (advertising), as in his collage containing the name of the great Parisian department store Au Bon Marché (1912–13), appealed to the Surrealists. *La Révolution surréaliste* reproduced it on the same page as Aragon's "Chronique," a review of the famous Exposition Internationale des Arts Décoratifs et Industriels Modernes held in Paris. Without once directly alluding to Picasso's collage Aragon presents a Surrealist context for it.[39] This collage displays fragments of advertisement: beneath a cutout ad bearing the store's name appear the words *lingerie broderie,* which allude to women's clothing; and the cutout letters "SAMA" next to a fashionably dressed lady may be a clipped ad for the Samaritaine, Paris's other great department store. To the left and right are Cubist versions of a perfume bottle and a wine glass. Here, in contrast to the straightforward commercialism of De Chirico's academicism, artistic invention confronts and subordinates the commercial, and undermines – especially for the contemporary audience – an advertising message.

In his review Aragon conducts a diatribe against the commercial utility of decorative art, of the

> deceit of the markets (*marchés*) where in turn a table ceases to be a table and is deified, and then again becomes a table proud of its legs and extensions. In this great fair there is no one who would claim to be working at the same time for eternity and for everyday commodities.... From now on let's agree on the pecuniary sense of the word "*moderne,*" as long as you leave us in peace with painting that lacks util-

ity.... Great Art: Dada has given you something to think about. But Decoration! Well, as for me, I prefer Great Art after all.

Yet Aragon left room in other writings for everyday items like the bits of advertising inserted into Picasso's collage. In *Le Libertinage* (Paris, 1924) Aragon observed that contemporary decor becomes

> the place of magical metamorphoses where one will experience Surreality; but one also divines that certain objects possess the unusual and seem endued with latent powers. That's the case with toilet accessories of a surgical character that fascinate by their look of cruelty. These same objects will appear in certain shops in the Passage de l'Opéra, but there transfigured by a triumphant animism.

One of the characters in this novel notes the mysterious influence such objects have on her imagination.[40] And in *Le Paysan de Paris* of 1926 he notes approvingly that everyday life has been permeated by advertising, and says: "The wondrous is contradiction appearing in the real," a remark made at the same time or even earlier than *Nadja*.[41]

The disaffection with De Chirico from 1925 on was exacerbated by the growing need felt by the Surrealists for the kind of suggestive imagery that his art at first embodied. As their revolutionary ambition grew, the Surrealists largely turned from kinesthetic automatism to an art of visual images. While agreeing that De Chirico's painting brought into focus the question of the "reality" of the image, they went far beyond him in attributing to the image the power to influence behavior (indeed, in the trial of Barrès they had already hinted at a form of *envoûtement,* or, to use Lévy-Bruhl's term, "sympathetic magic"). Many French psychiatrists agreed about the power of the image.[42]

Whatever impact their images might have had on the spectator, the Surrealists' large claim that images in themselves have

the power to generate a new world borders on a poetic wish fulfillment or even a childish fantasy, benign and innocuously romantic: the utterance of this idealistic concept, which Naville and others challenged, gives little hint of the Surrealists' later adherence to Communist revolution and the espousal of class warfare. (Perhaps we can trace this paradoxical union of individual creativity and radical commitment once more back to the epoch of the "Ecole buissonnière.") After the debates about the relation of Surrealism to Marxism, the Surrealists became active promulgators of political revolution and supported the Communist Party not only by signing its manifestos, but by demonstrating in public.

To accomplish their aim (not always clearly thought through) of affecting political attitudes, the Surrealists had to convey their messages to the uninitiated spectator with something more than obscure visual imagery or decoration. Breton's Surrealists held the view that the visual could serve political purposes in a way inaccessible to abstract art. As Masson, who had been a prime exponent of automatic drawing, remarked, "In answer to your pertinent question whether abstract painting can be in the slightest degree subversive, I say: no, because there is no image!"[43] The very first issue of *La Révolution surréaliste* (December 1924) contains an automatic drawing by Masson, and for the second he submitted another in response to the question, "Is suicide a solution?"

The issue of a Surrealist painting arose with increasing frequency after the First Manifesto as Breton, Aragon, Naville, Eluard, Desnos, and Morise tried to define a visual counterpart to their writing without legislating to the artists or conforming to the aesthetic prescriptions increasingly proffered by the Communist Party. They could not escape the complex ramifications of the questions: What subjects would Surrealist artists treat, considering Surrealism's insistence on the autonomy of its "revolution," while "serving" the

social revolution? Should Surrealist imagery draw on automatism, the dream, or both? What happens to the immateriality of words and ideas when they are interpreted in the material medium of easel painting, which demands a laborious technical preparation (Picasso was again the exception)? How could the Surrealists write about art without using the vocabulary of traditional or modernist criticism?

The controversy over Surrealist painting first reached the public in *La Révolution surréaliste,* no. 3 (April 15, 1925), when Naville published a note entitled the "Beaux-Arts" (p. 27), presumably responding to Breton's announcement in issue no. 1. Naville, who was then engaged in a power struggle with Breton,[44] questioned the possibility of Surrealist painting:

The only taste I know is distaste (*dégoût*).[45]

Master-singers, extortioners [a pun on *maître chanteur*], smear your canvases.

No one is unaware any more that there is no *Surrealist painting.* Neither the random marks of the pencil, nor the image retracing dream figures, nor imaginative fantasies, of course, can be so characterized.

But there are *shows.*

Aesthetics is nothing more than memory and the pleasure of the eyes . . .

How is it that literature is nourished almost uniquely by love, and gets so much from passionate surrender to love, whereas the plastic arts are deprived of it, or show it in a very ambiguous manner? There really is no equivalent of the *nude* in books.

The cinema, not because it is life, but the marvelous, the arrangement of chance elements.

The street, kiosks, automobiles, their doors screaming, their lights flashing in the sky.

Photographs: Eusebius, the Star, Morning, Excelsior, Nature . . .

Get dressed – get undressed.[46]

Breton soon responded to Naville's challenge. The first installment of Breton's series on Surrealist painting appeared in issue no. 4 (July 1925). The article begins, significantly, "The eye exists in its savage state." With these words Breton takes up the challenge of his literary friends of defining what he means by Surrealist painting and confronts Naville's rather classical definition of aesthetics as visual pleasure. Breton indicates a preference for the visual over the auditory (he never expressed much interest in the "musical" side of poetry): "Auditive images . . . are inferior to visual images not only in clarity but also in strictness, etc."; but this point arose as a polemical response, and some writers have exaggerated the importance placed on the superiority of sight.[47] He seems to be trying with some awkwardness to sidestep the problem of a visual automatism.

Breton argues that while the Surrealist painter can perhaps not achieve the level of automatism of the writer (we note that in the First Manifesto, which strongly advocates automatism, Breton included many examples of automatic writing but none of paintings, drawings, or photographs), they do have access to the marvelous. In fact, he believes that the artist's eye, freed from craft and training (a subject presented by Morise in the same issue) can return to its "savagery" and see beyond the superficial – the visual and real – toward the deep, the "unreal"; for paradoxically, "through the looking glass" of the visual lies the marvelous invisible (Breton cited Lewis Carroll's book of 1872, translated as *La Traversée du miroir,* in the *Anthologie de l'humour noir*). Visual images, produced in states of dream or hallucination, in darkness or with closed eyes, can have a "clarity" missing in auditory images. Such images have a language of their own: unburdened by the need to conform to codes for "describing reality," they yet demand the apparent tangibility of hallucination. Strange and unreal visual objects in an imaginary or irrational space seem to him to have a power of provocation missing in the real world: "It is impossible for me to envisage a picture as being other than a window, and my first concern is . . .

to know what it *looks out on* . . . nothing appeals to me so much as a vista stretching away before me and *out of sight.*"[48] Again and again he formulates aesthetic questions as value judgments, opposing the enchantment of the street to the dullness of the museum and the lyrical beauty of dream to the bourgeois values of fame and fortune.

Rejecting the imitation of external "reality," Breton insisted on an art grounded in an "internal model,"[49] as already suggested by the poets Lautréamont, Rimbaud, and Mallarmé, as well as the Symbolists, including Mallarmé's friend Gauguin. The difficulty of applying a poetic internal model to *visual art, which had prompted Naville's* skepticism, resulted in painting with no distinguishably Surrealist character, especially during 1923–4, when would-be Surrealist painters had few means to interpret the cues of verbal automatism. Indeed, unable to visualize "the true functioning of thought," they had difficulty eluding the dangerously contrary attractions of "reality" and abstraction. For Breton as well as Aragon, both the imagery of De Chirico and the very different one of Picasso succeeded here.[50] But De Chirico's light pales *in comparison with that of Picasso, who* follows the internal model of the poets that allows our eyes

> to reflect that which, while not existing, is yet as intense as that which does exist, and which has once more to consist of real visual images, fully compensating us for what we have left behind. . . . For fifteen years now, Picasso has been exploring this path, advancing deep into unknown territory, bearing rays of light in each hand.[51]

(After the manifesto, Breton rejected Braque, who had come out – like a latter-day Descartes – publicly in favor of discipline and order.)[52] Without applying the "ridiculous word 'cubism'" he expresses admiration for paintings after 1909 in which the figures have been dematerialized, except for their scaffoldings. (He em-

braces Picasso "as one of us" without daring to label the uncategorizable genius "Surrealist.") In this context, and doubtless with De Chirico in mind, he makes a counterproverbial example of La Fontaine's fable mocking the dog that exchanged a shadow for a reality; for Breton approves of the action of the Picassoid dog that "seeing its prey represented in the water, lets go the prey for the image." Breton underscores this idea at several points in alluding to caves: those of prehistory with their animal paintings, marvelous images much more valuable than any "real" animals, and what I consider the Platonic cave whose shadows he infinitely prefers to the sunlit reality *beyond the entrance.*[53]

Breton's notion of the marvelous (and later of objective chance) created by the artist from an internal model owes nothing to Marx's historical materialism, but much to Hegel's sense of the timeless absolute. Hegel wrote:

> Whereas wonder only occurs when *man, torn free from his most immediate* first connection with nature and from his most elementary, purely practical, relation to it, that of desire, stands back spiritually from nature, and his own *singularity, and now seeks and sees in* things a universal, implicit, and permanent element. In that case for the first time natural objects strike him; they are an "other" which yet is meant to be for his apprehension and in which he strives to find himself over again as well as thoughts and reason. . . . Now the first product of this situation consists in the fact that man sets nature and objectivity in general over against himself on the one hand as cause, and he reverences it as power.

The "beginning of art" occurs through contemplation.[54] Breton's art criticism reflects this subjectivity, and in particular his discussion of specific works often constitutes a poetic evocation. He seems to work from the verbal to the visual and back to the verbal, an ekphrastic procedure that develops metaphors from selected features

of the painting – sometimes visual details, sometimes nothing more than the title of the picture.

Hegel above all offered Breton a vehicle for transcending the meanness of middle-class desire. Owing to his hatred for the "stinking beast named money" and for bourgeois possessiveness, Breton, for example, found himself able to praise Picabia despite their disagreements, since the artist experienced "feelings of disgust at the commercial transactions to which every work of art is subject today." Breton, remembering with distaste the "excessive contact with existing things" that prevailed in the postwar years 1919–20, affirmed that the way out of the miasma that he and his friends discovered was to "plunge into that strange adventure in bewitchment and exorcism," that is, Surrealism. He admired Ernst for having transcended even the residues of the object left in Cubism: "The day of the pipe, of the newspaper which is not even tomorrow's issue, of the guitar was almost over."[55]

Morise also hoped for a Surrealist art that could escape from materialistic illusionism, but unsure what that art would be, he wavered between automatism and photography. In the "Beaux-Arts" section of issue no. 5 (October 1925),[56] he wrote an article – "Les Yeux enchantés" (a title responding to Breton's "eye in a savage state") – in which he discovers parallels to the practice of automatic writing in the rapid or uncontrolled painting or drawing of psychotics, seers, and Surrealist artists:

> What surrealist writing is to literature, surrealist plastic art should be to painting, to photography, to everything made to be seen.
> But where is the touchstone?
> It is more likely that the succession of images, the flight of ideas are conditions fundamental to every surrealist manifestation. The course of thought cannot be considered statically. Now if we understand a written text in time, we perceive a painting or sculpture only in space, and their different re-

gions appear simultaneously.... But even supposing that the figural representation of time is not essential to a Surrealist production... nevertheless, to paint a canvas, one must begin at one end, continue elsewhere... a process very subject to chance, arbitrariness, taste, tending to interfere with the dictation of the thought.

> The comparison of surrealism to a dream does not give us very satisfactory guidelines. Painting and writing are both capable of representing a dream. A simple effort of memory will easily achieve this. The same is true for all apparitions: strange landscapes appeared to Chirico; he had only to reproduce them, trusting to the interpretation his memory offered him.
> ... In the sort of waking dream that characterizes the Surrealist state of mind, our thought is revealed to us, among other semblances, as words and plastic images. A word is soon written, and the idea of a star is not far from the word "star," from the symbolic sign written STAR. I am thinking of Picasso's decor for *Mercure* (a ballet), which represented night: in the sky, no star, only the written word twinkled now and then.

The early paintings of the Cubists had the necessary absence of preconception, but after that Morise finds this condition only in the productions of the psychotic and of seers.

> One could formulate an algebraic equation: this kind of painting [by psychotics or seers] is to x as a medium's account is to a Surrealist text...
> But who will provide us with the marvelous drug that will allow us to realize x?... For the whole difficulty is not in starting, but in *forgetting what was just done*, or to put it better *ignoring it.* ...
> Today we can imagine what a surrealist art might be only by considering certain apparently chance meetings which presumably are due to the omnipotence of a superior intellectual law, the very law of surrealism.

The "x" of Surrealist painting Morise finds (like Cocteau and others before him) in photography:

> Who then is this man [*homme*] whom we see . . . mount with a lazy movement the steps of a staircase that leads nowhere? Who is this Man Ray, our friend, who, using photosensitive paper turns highly necessary objects into objects of the highest luxury? Who is this white woman who passes by in an automobile among men in top hats?[57]

Thus, Morise, less emphatically than Naville, expressed doubts about the possibility of Surrealist painting, particularly considering the defection of De Chirico from the imaginative early style that appealed to Surrealism. Aside from the issue of medium (painting vs. photography), Morise had already questioned the importance of technique in his review of a De Chirico exhibition, where he states that "there is no Technique, no science of how to paint well."[58] Perhaps Morise's target is not painting per se, but the teachable technique associated with academic and/or commercially successful painting.

Responding to Morise's allusions to automatism, Breton apparently made sure that issue no. 5 of *La Révolution surréaliste* contained the largest number of automatic drawings ever published there (none appeared in no. 6), but one month later, the first Surrealist exhibition in November 1925 was dominated by painting rather than automatic drawing (or photography) and included works by Arp, De Chirico, Ernst, Klee, Man Ray, Masson, Miró, Picasso, and Pierre Roy. Moreover, by 1926, in his response to Naville, "Légitime défense,"[59] Breton quoted the following with approval:

> The entire activity of the Surrealists does not reduce to automatism alone. They employ writing in a manner that is quite voluntary and in contradiction of automatism. Quite simply one can assert that their actions and the painting that corresponds to their actions belong to that vast enterprise, to which

Lautréamont and Lenin have wholeheartedly given themselves, of recreating the universe.

In 1926 Desnos, who had collaborated with Breton on the introduction to the catalogue of the Surrealist exhibition at the Galerie Pierre in November 1925, entered the fray with an article entitled "What Is Surrealist Painting?"[60] Doubtless with his own experience in the dream sessions in mind, he wrote:

> A frequent criticism of Surrealism is that it is not applicable to painting. In fact the great problem for a Surrealist painting has been the application of the definition of Surrealism to pictorial processes. This fruitless problem has for *several months paralyzed us. In effect,* only the drawings of mediums, drawings produced in a trance, the drawings of madmen can, and to some extent only can correspond to this definition.[61] Doubtless the error consisted in the excessive importance unwittingly given to craft. The Surrealist poet makes use of known words and writes with familiar letters. Painters can paint, in terms of craft, as they wish. What counts is the first conception, whether they have a vision of the whole painting and record this vision, or, being venturesome, they allow the inspiration to renew itself by fits and starts and to get stronger with each brushstroke until the painting is completed.

In fact, one must note that in the thirties when Breton called on Surrealist automatism to combat the illusionistic imagery of Dali, inventive painters did make interesting efforts to achieve automatism in art, and in 1939 Breton stated that his call for automatism in the manifesto had at last been realized in painting "with the advent of Dominguez's 'decalcomania without preconceived object' and Paalen's 'fumage.' "[62]

As noted earlier, the one modern master who seemed to transcend the issue of skill was Picasso, who continually steeped his consummate virtuosity in a mudbath of childish play. Among the artistic "stars" in

Paris only Picasso had some sympathy with Surrealism (and not only Breton's, but also Max Jacob's version of Surrealism): the very first issue of *La Révolution surréaliste* contained illustrations of his work. Breton cited Picasso at the outset of his book *Surréalisme et peinture* in support of his claim that there could be a Surrealist painting:

> It has been said that there could be no such thing as Surrealist painting. Painting, literature – what are they to us, O Picasso, you who have carried the spirit, no longer of contradiction, but of evasion, to its farthest point. From each of your pictures you have let down a rope-ladder, or rather a ladder made of the sheets of your bed, and we, and probably you with us, desire only to climb up into our sleep and down from it again. And they come to talk to us of painting, of that lamentable expedient which is painting![63]

He is charmed by the breakdown of the media in Picasso's synthesis of word and image in his paintings (*Le Jour-* and *Vive la*) and in the curtain for *Mercure,* and he attributes the form of some of his own poetry to Picasso's collage. But Picasso's "support" remained tenuous and ambiguous, owing to the wide range of his styles and – especially in the thirties – of a leftist politics dependent more on friendships than understanding (Aragon helped bring him ultimately into the Stalinist camp).[64] Indeed, Picasso was never officially named a Surrealist, and only a small portion of his work actually conformed to Surrealist taste (in the thirties, some poetry and some painting with female hybrids and mythological themes).

As early as November 6, 1923, Breton, who had long admired Picasso, wrote to the collector Jacques Doucet advising him to buy the *Demoiselles d'Avignon*

> because with it one enters fully into the laboratory of Picasso, and because it is at the center of the drama and all the conflicts generated by Picasso and which I strongly believe will immortal-

ize him. This work alone, in my opinion, goes beyond painting, it is the theatre of all that has happened for the last fifty years, the wall before which Rimbaud, Lautréamont, Jarry, Apollinaire and all those we still admire have passed.[65]

The Surrealists collectively wooed Picasso on June 18, 1924, in the tract "Hommage à Pablo Picasso," signed by Aragon, Breton, Desnos, Ernst, and Morise. It ascribes to Picasso the creation of *l'inquiétude moderne* and – before Morise's October 15, 1925, article – praises his curtain for *Mercure:* "It is here with MERCURY that he once again provokes general misunderstanding by presenting the full measure of his daring and genius." This tract, written by Breton, marks a turn from Duchamp and Picabia, to Picasso, who now exemplifies the ideal Surrealist painter.[66]

But Picasso and De Chirico were not the only artists interesting to the Surrealists. The 77 illustrations to the first edition of *Surrealism and Painting* (1928) indicate clearly the range of painting (and collage and photography) then accepted as Surrealist. The artists appeared in the following order, with the number of illustrations after each name: Picasso (15), Braque (2), De Chirico (15), Picabia (1), Ernst (10), Man Ray (6), Masson (8), Miró (8), Tanguy (6), Arp (6). However different their individual styles, all these artists rejected the daylight tradition of Realism, Impressionism, and Fauvism in favor of an arbitrary and subjective "nocturnal" illumination more suited to the dream world of the Surrealists (a marked symptom of De Chirico's postmetaphysical period was its Courbet-like lighting).[67] There were no illustrations of Duchamp, Dali, or Magritte (*La Révolution Surréaliste* introduced the latter two artists in 1929).[68]

Breton responded in his book to the issue of technique with a discussion of collage, the Cubist alternative to easel painting. What repelled the Surrealists was the adaptation of collage either to modern machine design or to a formalist aesthetics

in the Cézanne line.[69] The mechanomorphism of the modernists, reversing the comic botching of the Dadaists, was tied to the elegant finish of the craftsman. The Purists Le Corbusier and Ozenfant, in good beaux-arts style, advocated "un art conscient" and placed the human figure at its center; and even the remarkable Léger, who saw "chance alone presiding over the birth of beauty in the manufactured object" and considered the street "one of the fine arts," remained attached to a tradition that could assimilate and offer to "teach" Poussin and Cézanne.[70] In one of his articles of 1930 for the *Cahiers* on recent painting, E. Tériade, as though speaking *ex cathedra,* deplored the literary emphasis of the Surrealists, whose anti-Cubist attitude annoyed him. He found in them "not a trace of that sculptural ability" (*faculté sculpturale*) or of "réalisation plastique."[71] Unlike the nuanced appreciation of the Surrealists, he unequivocally admired commercial art; consequently, while both were fascinated by window displays and the giant ads for "Bébé Cadum" children's products, each saw such things from a profoundly different viewpoint.

It was Ernst's novel version of collage that had particularly stimulated the Surrealist poets, with its disjointed visual "poems" often accompanied by enigmatic texts and poetry (Eluard). In a passage prefacing one of his own collage "Poems" included in the First Manifesto, Breton wrote:[72]

> Everything is valid to obtain the suddenness desired from certain associations. The *papiers collés* of Picasso and Braque have the same value as the introduction of a platitude into the most polished literary style. It is even permitted to entitle POEM what we obtain by assembling as randomly as possible (let us, if you will, adhere to the syntax) of headlines and scraps of headlines cut out of newspapers.

The "poem" consists of striking phrases, complete in themselves (words are not cut in half like the Cubist "Le Jour"), that take on a curious brilliance through their juxtaposition. Breton found the collage valuable as a means analogous to automatism to avoid conventional artistic expression.[73] Only the evolving Masson (and Miró) in the mid-twenties still had to work through traces of Cubist influence. Moreover, the collage introduces disjunctions in space well adapted to rendering the character of dream imagery and to implying a new narrative type that Aragon compared to cinema.

Aragon recognized early on the value of Ernst's collage and, even before the artist's appearance in Paris, wrote in his essay "On Decoration" (1918):

> Before the appearance of the cinematographic projector, very few artists had dared make use of the false harmony of machines and the haunting beauty of commercial inscriptions, of posters, of evocative capitals, of very ordinary objects, of everything that sings about our life, and not some artificial convention that fails to take into account corned beef and tins of shoe polish. These courageous precursors, whether painters or poets . . . knew this fascination with hieroglyphs on the walls. . . . These letters proudly displayed on a bar of soap are worth as much as the characters on the obelisks or the inscriptions of a book of black magic: they express the fate of an age. We have already seen them as elements of art in the work of Picasso, Georges Braque or Juan Gris. Before them Baudelaire knew how to put to account a shop sign. The immortal author of *Ubu Roi,* Alfred Jarry, had made use of some bits of this modern poetry. But only the cinema that speaks directly to the people could impose these new sources of human splendor.[74]

And by 1923 in his well-known essay, "Max Ernst, Painter of Illusions," Aragon distinguished between "collage as practiced by the Cubists" and that of Ernst from 1921 on:

> For the Cubists the postage stamp, the newspaper, the match box that the

painter glues to his picture, had the value of a test, of an instrument to control the very reality of the picture.... With Max Ernst things are different.... Collage becomes with him a poetic process, in its purpose completely opposite to the Cubist collage, whose purpose is purely realistic.[75]

Here Aragon agreed with Breton's distinction between Cubist collages, which served as "compensation" for conventional painting (paper for canvas, scissors for brush) or to enhance novel compositions, and Ernst's collages, which expanded his visual vocabulary to include "everything."

The Surrealists – welcoming Ernst's emphasis on images, rather than on formal or painterly qualities, and his integration of verbal elements – invited him to illustrate their texts (he had already illustrated poems by Eluard in *Littérature*), including the First Manifesto. This is not accidental, for Ernst shared both taste and technique with the poets: like them he enjoyed rummaging among dated and vulgar art objects and inserting bits of nineteenth-century prints into his collages to achieve disjunctive effects of a bizarre or comical nature.

Breton attributed the charm of Ernst to his poetic quality:

His methods are well known by now. Proceeding from Rimbaud's celebrated love of the decorative panels over doors, for silly refrains . . . from the systematic taste that Lautréamont is supposed to have had for a sort of spiritual trench extending from Edward Young's *Night Thoughts* to certain medical reports, from Jarry's taunting knowledge of heraldry, and even from the inspiration which Apollinaire sought in catalogues, Max Ernst seems unquestionably to have inherited the sense of a culture that is extraordinary, captivating, paradoxical and priceless.[76] In the "collages" that are the first works by Max Ernst that we know of he did not use materials aimed at an effect of compensation, as had been the practice hitherto (painted paper for painted canvas . . .), but, on the contrary, elements endowed in their

own right with a relatively independent existence – in the same sense that photography can evoke a unique image of a lamp, a bird or an arm. . . .

There is no reality in painting.[77] Virtual images, corroborated or not by visual objects, more or less fade away before our eyes. The idea of painting should be viewed in the same light as hypnagogic visions such as that recorded by René Guyon. . . . After having revolutionized the relationship of objects considered initially in their most elementary aspects and "rendered" almost according to their dictionary figuration, with the same good faith as Rousseau enlarging a postcard, and with no other ambition than to induce a child to point at this blot and say "lion" or "cloud"; . . . Max Ernst has now begun to examine the substance of objects, with complete freedom to determine new shadows, attitudes and shapes for them.

Ernst's enterprise consisted of nothing less than to reassemble these disparate objects according to an order which, while differing from their normal order, did not seem on the whole to do them violence . . . to assert *by means of the image* other relationships than those generally or, indeed, provisionally established between human beings on the one hand and, on the other, things considered as accepted facts.[78]

He calls Ernst's dream "a dream of *mediation,*" a concept that will be resumed significantly in the *Vases communicants.*

The appeal of Ernst's interpretation of collage as a reassembled order and of the project of gathering the *disjecta membra* of earlier productions – like the work of admired avant-garde authors (Lautréamont, Rimbaud, Jarry) – derives in good measure, I believe, from its relevance to the old educational rebelliousness. Ernst's collage – exceeding the dry routines of Picasso's academic descendants – defiled orderliness and revived happy memories of the rebus and other diverting childhood games in which words and images were freed from their conventional sense.

Ernst's ability to generate visual from *verbal imagery using seemingly unassimilable materials* particularly impressed Breton, who had asserted that a new value could come from the juxtaposition of two "absurd ready-made realities." Ernst apparently developed such a composite from a famous image of Lautréamont: he tells of a canoe and a vacuum cleaner displaced to a forest, where they make love. This seems – like so many other Surrealist works – indirectly inspired by that founding image of Surrealism, Lautréamont's umbrella and sewing machine that make love: the canoe's concavity resembles an open umbrella's (though inversely related to water), while vacuum cleaner and sewing machine share the category of domestic appliance.[79]

In contrast to Ernst, Masson, after a successful debut, was assigned a secondary rank among the artists. Perhaps this occurred because he, more than any other Surrealist, embodied the discarded ambition to create an "automatic painting." Evidencing his struggle to extricate himself from Cubism – paintings like *Woman* (1925) still largely conform to the style – Masson translated Cubist fragmentation into the scribbles of automatism without giving up the location of a figure in a flat Cubist space. Even beyond his Cubist period and well into the thirties he seems to have kept an eye on Picasso's work: early in 1928 Picasso made two versions (plaster and bronze) of a weird cephalopod titled *Metamorphosis,* reproduced later that year in *Cahiers d'art,* and Masson followed suit in 1928 with a very similar sculpture likewise called *Metamorphosis.*

Masson, whose automatic drawings and paintings were included in all but the last issue of *La Révolution surréaliste,* received a nuanced criticism that was sufficient to provoke the artist to a long-lasting estrangement from Breton. The tepid praise was particularly galling to Masson, who believed that his ambition to be a "painter-poet," which he shared with Miró, should have made him particularly attractive to

the Surrealists in the period after the First Manifesto.[80] In fact, for a number of years Bataille, more than Breton appreciated, supported and collaborated with Masson, who found more sustenance in Nietzsche and Heraclitus (neither of them important to Breton's group) than in Freud.

Breton's rejection of Masson may have come from his fear that Masson's successful and abundant production of automatic drawings might lead to an academic formula; as he put it, "[Poe's] words 'chemistry of the intellect' that agree so well with Masson's science would tend to suggest to us far more than those reactions of which we wish to be only distant witnesses." The slightly obscure allusion to "chemistry" (another dig at the lycée curriculum?) presumably refers to Masson's painting *Les Quatre Eléments* of 1924, which Masson and Breton in their reminiscences agree launched their acquaintance (Breton bought it). Breton linked the depiction of air, earth, fire, and water to the metaphysical ideal of universal elements that Masson says he got from Heraclitus by way of Nietzsche. Such an idea would assuredly have put Breton off, by suggesting a narrow and mechanical vision. Indeed, in the discussion of Miró that follows he turns his praise of the "pure automatism" of Miró into an implied disparagement of Masson (whose well-known automatism is never mentioned): "[Miró] could perhaps pass for the most 'surrealist' of us all. But how far we are from this 'chemistry of the intellect' that we have just discussed!"[81]

The section of *Surrealism and Painting* on Miró seems intentionally inserted as much to sharpen the criticism of Masson as to appreciate Miró – the same rhetorical trick of contrast he had used for De Chirico – and Miró for a long time failed to receive a deserved attention, owing, perhaps, to his standing in the shadow (like Braque, Gris, and others) of Picasso.[82] Still, this section contains some of Breton's most lyrical evocations of paintings. To the beguiling praise, Breton, following a carrot-and-stick model, appended a somewhat

bullying invitation to the artist to join his group:

My most fervent wish is that . . . Miró should not think in terms of a delirious pride, should not rely on himself alone, however great may be his gifts. . . . Pure imagination is the sole mistress of what she appropriates to herself from one day to another, and Miró should not forget that he is simply one of her instruments. Whether one likes it or not, the fact remains that his work tackles a certain number of general ideas which others as well are concerned to reform.

Breton especially approved of Miró's intention to do away with painting in any traditional sense.[83] Miró remained permanently on the sidelines of the movement, and although he exhibited with the Surrealists (e.g., in the Galerie Pierre), he rarely signed group manifestos.[84]

The last sections of the book – those on Tanguy and Arp – came unchanged from their original publication as prefaces to exhibitions.[85] The suggestive nature of Tanguy's subjects seems to have allowed him, more than the other Surrealists, to become the sport of psychological interpreters; hence, Breton fended them off, starting with a comparison to the Phoenix rising from the ashes – a metaphor for a transcendent sublimation that rises far from its origins and turns more to alchemy than to the sexual hypotheses of Freud or Nietzsche. He refuses to see Tanguy as the product of "childhood impressions" retained in memory (like a bad early education):

It must be said immediately that subliminal memory – that vengeful hypothesis through which the positivists, neo-Kantians and even psychoanalysts have attempted to burden Tanguy with the weight of his childhood impressions, attributing to him a rare faculty of auto-suggestion and even going to the ludicrous lengths of supposing that his work is the expression of deeply rooted feelings of remorse – is totally inade-

quate to explain the diversity of his images.[86] The sensory verbs: to see, to hear, to touch, to taste, to feel, demand to be conjugated from the others, a necessity proved by their astonishing participles, already seen, already heard, never seen, etc. To see, to hear, means nothing. To recognize (or not to recognize) means everything.[87]

Tanguy's painting *He Did as He Liked* (1927; ex-coll. Breton, and illustrated in all editions of *Surrealism and Painting*) sums up for Breton the unboundedness of the Surrealist's mind and seems to me a brilliant extension both of Picabia's placement of mechanomorphic elements on a marbled ground (*Parade amoureuse,* 1917) and of Miró's insertion of geometric or Synthetic Cubist forms into blurred and vague spaces (*Birth of the World,* 1925; Figure 10). The title and the visual details of Tanguy's painting signify a mind ready for an endless reeducation: the solid geometric forms matched to organic or automatic scribbles, and the numerals that grow out of a "number tree" evoke the conditions of a Platonic world (or a Pestalozzian kindergarten!) in which the building blocks of a mental order emerge from a chaotic reality. Above, the celestial equine creature seems to constitute an astral projection of the figure below. The phrase "a fabulous submerged city to which he [Tanguy] has found the key" (which recalls an image of Rimbaud) possibly alludes to this painting as well as to a favorite phrase of Breton, "la clé des champs," which signifies freedom. This defense of the image maker's freedom from determining preconditions could be extended to Lautréamont, de Sade, seers, Charcot's hysterical performers, and even psychotics like Nadja or the infanticidal heroines of Palau's play *Les Détraquées.*[88] And Breton, while willing to play psychoanalytic games promising him access to the unconscious, refused any suggestion of a medical diagnosis: for him the Surrealists did not produce neurotic symptoms, but marvels demanding contemplation.

At the end of his discussion of Tanguy,

Figure 10. Joan Miró, *Birth of the World* (1925), 250.8 × 200 cm, Museum of Modern Art, New York.

Breton elaborated the idea of projection (an idea first realized in Ernst's frottages and later in Dali's paranoiac imagery): "Poor Hamlet's clouds, that looked so like animals: but they *were* animals, of course. There are no landscapes."[89] Breton failed to discuss the important application of the frottage in a series of Ernst's works – the engraved series *Histoire naturelle* (1926), the group of "Forest" paintings (1927–8), and a related group of paintings like *Black Sun* (1927–8) and *The Total City* (1935–6) – where, as chaotically overgrown areas, they contrasted with clean circular areas as unconscious to conscious. (In the twenties Klee also explored the antithesis of celestial clarity and terrestrial chaos, and Adolph Gottlieb made this polarity the principle of his mature style of the mid-fifties.)

Breton concludes the book with a discussion of Arp that poses subtle questions about the very nature of Surrealist art, and that once more raises a voice against (Cartesian) dualism:[90]

Everything I love, everything I think and feel, predisposes me towards a particular philosophy of immanence according to which surreality would be embodied in reality itself and would be neither superior nor exterior to it. And reciprocally, too, because the container would also be the contents. What I envisage is almost a communicating vessel between the container and the contained.[91] Which means, of course, that I reject categorically all initiatives in the field of painting, as in that of literature, that would inevitably lead to the narrow isolation of thought from life, or alternatively the strict domination of life by thought.[92]

For Breton, Arp's work bears directly on crucial issues: his reliefs "represent for me the most effective summing-up of the degree to which particular things can achieve generality." Arp escapes narrow isolation by suggesting the verbal in the visual; for example, Breton playfully commented on Arp's *Still Life: Table, Mountain, Anchors and Navel* of 1926: "The word table was a begging word: it wanted people to take a meal, to rest their elbows or not, to write."[93] Breton was especially enchanted by Arp's punning "conjugation" of "un nombril" (a navel) in the plural as "des ombrils" (a neologism meaning shadows). Breton himself indulged in visuoverbal games, like the rebus-pun "Silence" (discussed later) and in numerous poème-objets.

THE DALI "CASE"

From 1929 to the mid-thirties Dali remained the central – and most controversial – figure in the development of Surrealist painting. Dali carried his independence to the point of anarchic rebellion, an intention that he made clear in a remark about Picasso, whose painting, both Neoclassic and Cubist, had strongly influenced his early work. In 1927 he called Picasso's recent work "the most uncontrollable extension of Surrealism."[94]

Dali was well aware of Breton's writings before coming to Paris and even based a painting of 1928, *The Spectral Cow,* on an account of a dream published in *Clair de terre* (1923).[95] After having kept himself at an informed distance, Dali, now ready to move into the orbit of Surrealism, painted *Le Jeu lugubre* in 1929 (Figure 11), which became the center of a vitriolic contest – in an article on the painting in November 1929 Breton, aware of Dali's position, wrote, "Dali is here like a man hesitating ... between talent and genius." In the same article, employing a favorite image, he claimed that with Dali the "mental windows were for the first time opening wide,"[96] though he did not appreciate the feces provocatively smeared on the under-wear of the man in the foreground with his back to the spectator.

In alluding to feces Breton was more than expressing a sense of propriety (he did not take de Sade to task for his scatology): implicitly he was attacking the taste and thought of Bataille, and his recurrent preference for the golden flow of urine over the brown matter of feces may owe something to this contest. (On February 5, 1933, in a "recherche expérimentale" on the irrational knowledge of objects, published in *Le Surréalisme au service de la révolution,* no. 6 [May 15, 1933], Breton answered the question, "What happens if you immerse a seer's crystal ball in urine?": "According to the prediction, the dung [*fumier*] is transformed into gold and the gold into dung.") A few years earlier he had read and sharply criticized Bataille's manuscript for a novel titled *W.C.* centered on a toilet, and the hostility felt between them surfaced in Breton's derogatory remarks in the Second Manifesto about Bataille's "low" materialism.

Many of the rebels of 1929 refused to fall in line with Breton's insistence both on a vigorous anticlericalism and atheism close to the Marxists' and on developing the poetic imagination instead of serving the party with a drab but easily understandable political prose. Bataille, on the other hand, rejected Breton's materialism for having the puritanical quality of a Lenin, and Breton castigated Bataille's *bas matérialisme* as obscene and disgusting. As though to purge himself of filthy materialism without neurotically excluding all contact with reality, Breton, in a footnote to the Second Manifesto[97] cited Freud's discussion of sublimation, which concludes that the artist can "transform his dreams into artistic creations. Thus he escapes the fate of the neurotic and finds via this detour (the sublimation of art) a relation to reality." While Breton could hardly deny that Surrealist artists made use of waste materials assembled without harmony or decorum, he drew the line on actual excrement

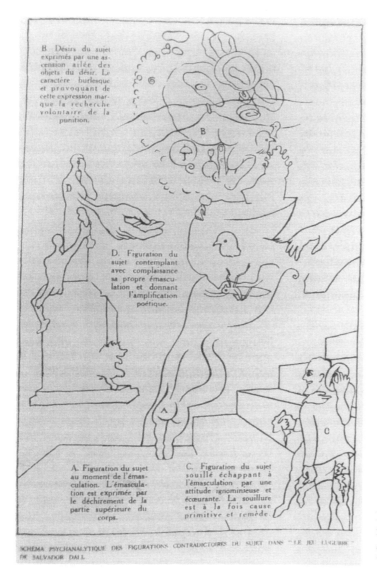

Figure 11. Georges Bataille, drawing after Salvador Dali, *Le Jeu lugubre* (1929), in *Documents,* no. 79 (December 1929), p. 371.

(he did not comment on Miró's humorous image of excrement in a painting).

Breton associated the element of "excretion" with the gathering of random "junk" by Surrealists inspired by Picasso's collage. But writers like Rudolf Arnheim who criticize the Surrealists while admiring Picasso have compared their productions not to collage but to unprocessed arrangements of refuse. This applies even to images in paintings. Speaking of the lack of pictorial imagination among "pedestrian Surrealists," Arnheim (a Gestalt psychologist who valued the "Aha! Erlebnis") singles out

Magritte's notorious painting of a tobacco pipe on an empty ground that bears the inscription "Ceci n'est pas une pipe": "Unfortunately a pipe is all it is. A similar problem arises from the unskillful use of *objets trouvés* in collages or sculpture. The beholder is confronted with the untransformed presence of refuse."[98] While such criticism ignores the poetry and intellectual subtlety of a Magritte (appreciated in Foucault's little book on the painting), admittedly Surrealist exhibitions during the thirties, with their diverse and *dépaysés* objects mingled with near excreta, sometimes

113

seem to have been modeled on the *marché aux puces*. Still, in recycling refuse as aesthetically (hence, ultimately commercially) valuable, Surrealists who selected "found objects" in flea markets provided a minor loop in the cycle of capitalist economy. Their "sublimation" – the transmutation of junk into art (often by an intellectual reframing à la Duchamp) – seems closer to the alchemists, Hegel, or Nietzsche (in Bataille's interpretation) than to the psychoanalysts.[99] Ernst's definition of collage for the *Dictionnaire abrégé du surréalisme* (1938) sums up the Surrealists' view: "It is somewhat like an alchemy of the visual image. The miracle of the total transfiguration of beings and objects with or without modification of their physical or anatomical aspect."

In their ensuing quarrel both parties literally threw dirt at one another as acts of anal aggression (Breton commented on his critics with the word "shit") – a mode of insult not uncommon in the history of French radicalism.[100] A running battle in print between Bataille and Breton resulted in unacknowledged borrowings from one another and implicit criticisms: Breton kept an eye on *Documents* (his discussions of the sunflower and mandrake root "sublimate" the earthy interpretations of these plants in Bataille's article "The Language of Flowers" in issue no. 3 of June 1929), and Bataille and the Surrealist heretics around him wrote scathing commentaries on the Surrealist books and periodicals, especially in *La Critique sociale*.[101] In rejoinder to Breton's criticism of his base materialism, Bataille, who coined the term "Solar Anus," described the sublimating Breton as a pretentiously high-flying Icarus ripe for a catastrophic fall.

The antithetical viewpoints of Bataille and Breton were dramatically expressed in their heated contest to recruit Dali, the most important new arrival in Paris, who had features attractive to each: to the one, a fascination with putrescent matter and "low materialism" of long standing,[102] to the other, a luxuriant imagination grounded in the images of De Chirico and Tanguy. Breton rightly sensed that Dali's brash iconoclasm and his "paranoiac-critical" method could help resuscitate Surrealism's ability to capture the public's attention (which he desired, even as he called ambivalently for Surrealism's "occultation"). After 1930, with his affair with Gala on the ascendant, Dali laid decreasing emphasis on scatology, which may in part account for why Dali turned to Breton rather than Bataille, who encouraged his scatological tendencies.[103]

Dali, who knew how to express his ideas scandalously so as to force open an uneasy space around him, noted that the Surrealists "did not like anuses! I tried to trick them by giving them lots of anuses, carefuly dissimulated, and preferably Machiavellian ones. If I constructed a Surrealist Object in which no fantasy of this type appeared, the symbolic functioning of this object would be anal."[104] But Dali not only teased the Surrealists: he did not hesitate to integrate their images into his own art, and aside from well-known borrowings from De Chirico and Tanguy, he may well have drawn on Surrealist texts for images in his films.[105]

Breton, although doubtless repulsed by the more outrageously scatological aspects of Dali's – as of Bataille's – aesthetics, not only at first expressed admiration for Dali, but even found something positive to say about excretion. However, he was able to circumvent the issue of excretion in Dali, whose wilfullness and plays for power and prestige nettled him, by writing about excretion in Picasso:

Artistic creation, whose aim is to affirm the hostility which can actuate the desire of all living beings with reference to the outside world, has reached the point where it is capable at last of making the external object synonymous with this desire and so, to a certain extent, reconciling this outside world to the living being. . . . It must not be forgotten . . . that the body of work accomplished in this sense should be

considered as the product of a particular faculty of *excretion*.[106]

Dali's preoccupation with anuses in 1929–31 perhaps marks his anxiety about the nature of his sexuality (he had recently broken off his long and productive friendship with the homosexually aggressive Garcia Lorca – with whom he had engaged in scatological banter – on grounds of artistic and sexual preference). At this time Dali made a clear-cut heterosexual choice in his affair with Gala, which generated a further anxiety over his father's severe disapproval of Gala and produced a heady mix of guilt and elation over winning her from Eluard, another authority figure nine years older than he. It seems that Dali resolved all these problems by an improbable blend of anal aggression and oral cannibalism that he felt was uniquely his own.

Dali insisted on his individuality within the avant-garde: he defied socialist orthodoxies and embraced charismatic authority, while demanding unlimited freedom of speech and action. He concocted a formula corresponding to these contrary tendencies in "The Terrifying and Edible Beauty of 'Modern Style' Architecture": "The contradictory and rare *collective sentiment of ferocious individualism.*" He concluded the article with a travesty of Breton's definition of beauty as convulsive: "Beauty will be edible or it will not be." In rejecting modernism along with the populist chauvinism and productive aesthetics of Social Realism, he instinctively developed a late capitalist interest in consumption and a revisionist passion for nineteenth-century academic art (Meissonier). Creative activity for Dali paralleled the digestive process – ingestion, consumption, and excretion (the soft precipitation of fecal matter) – an idea he drew perhaps from his reading of Lacan's thesis of 1932.[107]

Dali quickly found echoes of his obsession with simulation in Surrealism; he particularly enjoyed the simulated madness presented in the text of Eluard (who perhaps initiated the project) and Breton, *L'Immaculée conception* (1930), for which he prepared five illustrations: "Conception," "Intra-uterine Life," "Birth," "Life," "Death." The section called "The Possessions" contained their famous poetic simulation of various forms of psychosis: "Mental Deficiency," "Acute Mania," "General Paralysis," "Delirium of Interpretation," and "Dementia Praecox." Doubtless this provided a model for Dali as he developed his own artistic version of "possession."[108]

Dali's frank and noisy claims to a paradoxically creative imitation exposed a weak spot of Surrealism – its forced spontaneity. Dali soon boasted that he could control the production of his own dreams.[109]

Bataille wrote a sarcastic rejoinder in *Documents* to Breton's article on Dali, mocking the irrelevance of Breton's talk of "mental windows" in such a painting. He noted that he had wanted to illustrate the painting, but Dali refused (evidently in order to cement his position with Breton's group), so Bataille has to settle for a diagram. Bataille interpreted the painting as a comment on emasculation and tried to turn it into a criticism of Surrealism.

In at least one respect *Le Jeu lugubre* may very well have been Dali's "reception piece" in which he echoed current Surrealist attitudes. For as I read it, it contains a coded attack on the pariah De Chirico: by adopting the Surrealists' critical posture toward De Chirico he doubtless hoped to win their approval. Unfortunately most of the Surrealists apparently missed his intention.[110]

Major details of the painting allude to De Chirico and – in keeping with current Surrealist credo – implicitly criticize his venality. It is well known that the embracing figures in the lower right derive from the father and son in De Chirico's *Return of the Prodigal Son* (of 1922; therefore, from a period of the artist rejected by the Surrealists), but in addition, the effeminate and "ashamed" statue seems a parody of the Victorian man on a pedestal in *The Enigma of a Day* (1914; Figure 12), a painting that

Figure 12. Giorgio De Chirico, *The Enigma of a Day* (1914), 185.5 × 139.7 cm, Museum of Modern Art, New York.

may have suggested the idea of masturbation first to Dali and then to the other Surrealists.[111] Dali appears to link the sexual shame to Breton's account in *Surrealism and Painting* of Taine's man who disgraced himself by accepting a real bowl of soup, which cured him at once of his hunger and of the hallucination of a beautiful companion.[112] Instead of soup the black man offers right over the genital area a large, ambiguous object that could be a soft penis or a piece of meat (or a turd?).[113] Dali's version of Taine's moral might read: the stony statue has an unwarranted success in being exhibited to the public (and carrying a metrical scale on the base). It reaches its gray, swollen hand inconclusively toward its antithesis, the facing head of Dali, who, though asleep, displays an imagination that, creative, vigorous, and colorful (literally, the only colors are on Dali's side), gestates sexually potent things like the "liberated" phallic finger inserted into pubic hairs.[114] The abundance of images streaming into and out of this sleeping head (used also for the Great Masturbator) remind one of Freudian dream associations governed by a code of sexuality; for example, the hats and open umbrella stand, respectively, for female genitals and for orgasm. The "shame" of the statue for its commercial success (signified by the units of metric weight that increase as they ascend toward the statue) is echoed in its androgyny (short "masculine" hair coupled with female breast and skirt, and the meaty penis) and in the travestied symbol of paternal strength, a

scraggly maned lion below – all epitomized in the missing phallus.[115] The unmonumental quality of the ashamed statue echoes the unstable "Leaning Tower of Pisa" at the center of the *Ci-gît* collage of Aragon and Breton that symbolized De Chirico's decrepit art.

Dali's obsession with grandiosity and its subversion in *Le Jeu lugubre* manifested itself also in his poem "Le Grand masturbateur" with its antimonumental column of "free verse," in his project for an *Imperial Monument to the Child Woman,* and in his irreverent treatment in *William Tell* (1931) of Lenin, the Surrealists' political hero. Essentially, Dali discovered how to subvert the dignity and patriarchal power attributed to classical figures by creating monumental turds (an anticipation of Claes Oldenburg's absurdly scaled trivia), soft fecal erections, and impotent authority figures propped on crutches. Perhaps Dali, with his infantile fantasies of power, intended to mock with his soft penises yet another authority figure – Breton, who once said that he wished never to be seen naked by a woman unless in a state of erection.[116] Always self-centered and arrogant, Dali even believed at one point that he could replace Breton as Surrealist leader.[117] But this was hardly a realistic possibility for a tactless megalomaniac like Dali, who refused to conform to the political views of his Surrealist colleagues and who, in direct contradiction of orthodox revolutionary opinion, treated Lenin irreverently, while expressing an irritating, even scandalous, sympathy for Hitler. However, the self-centered insouciance of the artist fascinated the Surrealists; for example, they quoted his definition of the crutch, illustrated with his drawing of a limp penis propped on a crutch: "Support in wood deriving from Cartesian philosophy. Generally employed to support the tenderness of *soft structures.*"[118]

Dali's frank commercialism and increasingly anti-Leninist and quasi-Fascist themes (suggesting, as already indicated, less a serious political stance than an Oedipal provocation toward Breton and others) embarrassed Breton.[119] Dali may have felt the authoritative Breton's demand that the Surrealists engage in radical politics as an encroachment on his independence. Moreover, the matriarchal Gala's assumption of ever greater control over his moral decisions presumably empowered Dali to test Breton's power to the limit, and ultimately to break away.

Breton wrote an approving piece on Dali in 1936, "Salvador Dali: The Dali 'Case'," which attributes Dali's "great originality" to his ability in his paranoiac-critical activity to be at once actor and spectator or – in terms he uses without mentioning Freud – ego and superego (which he labels a "stage").[120] Restating an old idea of his in a quasi-Freudian vocabulary, Breton praises Dali's humor in terms of a withdrawal of "psychic accent" from the ego to the superego, and for "the denial of reality and the splendid affirmation of the pleasure principle."[121] And Dali, second to no one in praising himself, traced his method directly to Leonardo.[122]

With Aragon playing an ever diminishing role in Breton's circle Dali became during the period of 1929 to 1934 Breton's most important collaborator and the most notorious Surrealist. However, his self-centered exhibitionism posed an ethical dilemma for Breton even more threatening than Artaud's had been; for Dali's scandalmongering fantasies tested the tolerance of the avant-garde, as when his subtle ironies blurred his actual opinions about Leninism on one side and Nazism or Fascism on the other. In *The Enigma of William Tell* (1933) Tell has Lenin's face and holds the baby Dali in his arms. With a certain comic sweep Dali subsumed the political Lenin to his own psychological lucubrations. According to Dali the cutlet on his head signifies the cannibalistic intentions of his father and the baby will save Dali from his own superego.[123] For all its self-serving absurdity, the painting does capture an aspect of Lenin the dictator unthinkable at the time to liberals about to

join a united front against the Fascist dictators – the only thinkable enemies.

Perhaps his last significant collaboration with the Surrealists occurred in December 1933. For their collective brochure, *Violette Nozières,* Dali contributed a phallically long-nosed "Portrait paranoïque de Violette Naziere (Nazi . . . Nez)" – an obviously provocative association at a time when most of the French Left was uniting in alarmed response to the surging power of Nazism. As though to disengage himself from his past support for the "active" paranoiac criticism with which Dali had displaced "passive" automatism, Breton in the same month wrote "Le Message automatique," once more exalting automatism as the major technique of Surrealist art. This is contrasted to "the so-called 'paranoiac-critical' activity [which] had always maintained a certain ambiguity between the involuntary and the voluntary and had consistently emphasized their rational aspect."[124] Still, Dali's importance for Surrealism was so great that only later was he formally expelled from the movement.

In the years just before World War II it became increasingly difficult to tell whether Dali's assault on bourgeois complacency produced a social impact of any consequence or merely added the spice of scandal to advertising campaigns in the interest of self-promotion. Breton's article of 1939, "The Most Recent Tendencies in Surrealist Painting," observes that "Dali's influence has declined very rapidly," owing to revulsion at his reactionary and racial politics and to the Surrealists' turn to automatism, rejecting the overly rational control of paranoiac criticism. Dali's further political deterioration, which kept step with the military and political progress of Nazism and Fascism, as well as his self-serving pronouncements, evoked a hostile response by Breton: in the "Artistic Genesis and Perspective of Surrealism" of 1941 he modifies the judgment of 1939 by calling Dali an academic who owed his paranoiac criticism to "borrowings and juxtapositions" above all from Leonardo's

wall and Ernst's frottage.[125] By the time that the avaricious Dali (Breton called him "Avida Dollars") and Surrealism parted ways, Dali had turned the convulsions and the marvelous of Surrealism into a salable exhibitionism.

THE ILLUSTRATIONS OF *LA REVOLUTION SURREALISTE*

The most important vehicle of the Surrealists for attempting to reach, if not to influence, the public was not the exhibition of paintings but the illustration of their publications: periodicals (after the pre-Surrealist *Littérature*) like *La Révolution surréaliste* or *Le Surréalisme au service de la révolution;* books like *Nadja,* the *Vases communicants,* and *L'Amour fou;* Ernst's collage novels; Dali's illustrations to his own and others' texts; Magritte's word and image "lessons"; and numerous flyers (*papillons*). (The illustrations of such works in non-Surrealist publications in Europe, the United States, and Japan offer a big, largely uncharted domain for research.) On the flat textureless surface of the page, reproductions of photographs had an impact equal to those of paintings or drawings.

Moreover, illustration could incorporate a polemical message and through multiplication communicate it to an interested public that was potentially limitless. For example, *La Révolution surréaliste* published an "Extraits de presse" by a writer hostile to the periodical, in issue no. 5 (October 1925), p. 25: "In this potpourri, this wastepaper basket, a subtle psychoanalyst discovers what the main preoccupations of an individual are, what he does not know or admit about himself, which would be very interesting. Robert Kemp, *Liberté.*" The Surrealists followed up on Kemp's sarcastic suggestion with a demonstration of the value of the wastepaper basket as a research instrument in the very next issue of March 1926: Aragon on pp. 15–17 presented a photomontage of illustrations of the blotters of the Council of Ministers

from photos of their desk tops, where they scribbled during deliberations. Aragon declares: "So the unconscious of these Guardians of the State have no more secrets from us." He concludes with a mock-serious question: "Can one distinguish the drawing of one minister from that of another? That's the question."

These illustrations, with their flagrant polemical implications, were an integral part of the periodical literature circulated by the Surrealists. Illustration, common practice in children's books and popular periodicals (recalling the old *Biblia pauperum* or the *images d'Epinal*, as well as popular science magazines), hardly seemed appropriate to a primarily literary publication treating topics like psychoanalysis and Marxism, but its ability to unsettle and provoke the reader through strange or comical effects made visual illustration all the more useful for *La Révolution surréaliste* (as for *Littérature* before it). Indeed, Breton made it quite clear in issue no. 2 that "Surrealism is not a new literary school."[126] And once again the adoption of incongruous and even tasteless material echoed the old subversion of middle-class values. Along with dream texts, automatic writing, and burlesque deformations of novels and poetry, the Surrealists produced curious combinations of poetry and image – all means to escape from or, rather, to challenge what they saw as the prosaic and rational domain of French literature.

But as we have seen, the Surrealists also pondered the question of a serious Surrealist painting, so many of their illustrations represented art works with which they sympathized. The writers themselves often explored drawing and painting, and some even tried to emulate the collaborative procedure of Breton and Soupault in their automatic writing; for example, Desnos and Naville, both of them amateur painters, collaborated on a technically crude collage for issue no. 2, evidently a narrative about a man who appears to be committing suicide by jumping from a balcony. This image presumably was their contribution to the inquiry on suicide published in the same issue.[127] We see the prospective suicide only as a reflection on a bottle of wine, placed at the edge of a table. Tiny in the distance appears a ship tilted on its side, with Romantic implications of shipwreck and drowning (in and out of the bottle). We detect the influence of the collage spaces and themes of Miró, who, by the end of 1923, was in touch with Desnos. The writers may have been interested in Miró's integration of words into his images, a development, like Ernst's transformation of collage (or his collaboration with Arp on the FATAGAGA collages [the fabrication des tableaux garantis gazométriques]), out of but beyond the more formalist practice of the major Cubists Picasso, Braque, and Gris. They could have found direct visual stimulation in Miró's oil painting *Bottle of Wine* (1924), which bears the letters "VI (N)" on the label and has waves beside the bottle (in Fundacio Joan Miró, Barcelona).[128]

An important synthesis of word and image derived from Apollinaire's "calligrammes," complex condensations of verbal and visual signs with the texts of poems shaped into images. Calligrammes provided models for some of the early work of the Surrealists, and versions appeared in several issues of *La Révolution surréaliste* – for example, to no. 5 (October 1925), p. 7, Michel Leiris contributed "LE SCEPTRE MIROITANT" (Figure 13), a calligramme in which the interlaced words "amour," "miroir," and "mourir" constitute the shape of a hand mirror, with a subtext provided by capitalized letters spelling "ROI" and "MOI." The image apparently subtends a psychoanalytic message concerning the narcissistic themes of self, omnipotence, and death – themes attractive not only to Dali ("The Great Masturbator," "Narcissus") but to Masson.[129]

In their efforts to escape from the purely literary, the Surrealists transformed the verbal game of *cadavre exquis* into the visual one of assembling an "exquisite"

LE SCEPTRE MIROITANT

Figure 13. Michel Leiris, "Le Sceptre miroitant," *La Révolution surréaliste*, no. 5 (October 1925).

female body. The *cadavre exquis* game produced all the body parts in correct anatomical position more or less, with head, torso, thigh, and legs done by three or four different persons each in turn starting from the sheet so folded that only the tip of the lines of the previous player was visible. Usually the sections retained anatomically relevant details (eyes, hips, feet) of the monstrous "cadaver."[130]

The convergence of writing and drawing in the *cadavre exquis* suggests first that the concept of a "line" had become richly bivalent for the Surrealists, uniting the visual and the verbal, and second that a "syntactical" equation existed between the sequence of performance (the time of narrative) and the location of anatomy. Thus, in the drawings we can speak of the "syntax" of head, torso, legs (cf. subject, verb, and object), and the fleshing out of the segments with a "vocabulary" of bizarre nouns of incongruous adjectives (e.g., the

use of irrational epithets attached to nouns in Eluard's famous "La Terre est bleue comme une orange," in *L'Amour la poésie* of 1929, in Breton's "the roses are blue" in the First Manifesto, or even in a whole poem like "Union libre" or in certain paintings of Miró).[131] On the other hand, the invention of novel figures, or "personnages," made startling through collaged juxtapositions, as in the *cadavre exquis* drawings, corresponds to Surrealist poetic usage. Compositions of such figures relate tentatively if not illogically to their ambient space, much like Surrealist sentences that have an uncertain relation to other sentences within their "paragraphs." Surrealist lines, both visual and verbal, undergo metamorphoses analogous to the disjointing of the sequence in Surrealist novels: the automatist scribble of a Masson by being transformed from undefined mark to soft figures of exploded architecture comes to resemble Shandyesque texts like *Le Paysan de Paris* that meander from lyrical nonsense to philosophical excursus.

The Surrealists' preoccupation with the uncontrolled irrationality implicit in the fragmented anatomy of the exquisite corpse was accompanied by a predilection for a fluid and boundless or indefinite space. Psychologically, we might interpret this aspect of Surrealism as a projection of a self "liberated" from the middle-class goal of coherence and integration (the goal of Freudian therapy that they repudiated), as well as from its artistic counterparts of compositional unity (found not only in abstraction, but even in classic Cubism). The Surrealists evidently reveled in the impossibility of visually representing mental space in rational terms: after subverting rationally coordinated space, they would happily regress to a pre-Cartesian "unconsciousness."[132]

The first illustrations of exquisite corpse drawings were published in *La Révolution surréaliste*, no. 9–10 (October 1927), though such drawings had already been produced privately in the house at rue du Château in 1925.

The union of image and word is nowhere so visible and effective as in the covers to *La Révolution surréaliste,* which subtly guide the reader to the contents of the issue. Every cover of the 12 issues contained an eye-catching illustration set below the name of the periodical and accompanied by a text. And all are photos (except for the eighth issue, a profile head with collaged details), as though to play off the documentation of photography against the reveried imagination of Surrealism.

The cover of no. 1 displays beneath the large title letters a montage of three group photos by Man Ray of the Central Office for Surrealist Research, accompanied by the text from Aragon's *Une Vague de rêves* (p. 119): "Il faut aboutir à une nouvelle déclaration des droits de l'homme" (What we have to do is arrive at a new definition of the rights of man).[133] This new French Revolution, in keeping with the slogan, is still dominated by "Fraternité" – all are men, except for the wives of Breton (who helped with stenography and the "permanence") and of Soupault, neither of whom published in the journal. This first issue contains photos of works by Man Ray and drawings or paintings by De Chirico, Desnos, Ernst, Masson, Morise, Naville, and Picasso.

The covers of the issues from no. 2 to no. 7 attack with sarcasm a series of sacred cows of the French middle class.

Number 2 ridicules French art prior to Fauvism and Cubism: the cover, chosen by Breton, shows an image of a scarecrow labeled by an accompanying text as "Art français, début du XXe siècle" and was supposed to have beneath it as an ironic accompaniment the phrase of the inquiry "Is Suicide a Solution?"[134]

Number 3 has a cover photo of ghostly religious sculpture resembling a Pietà superimposed on city buildings (apparently reflected off the window of a store selling religious objects) with the legend, "1925: End of the Christian Era"; this indicates the contents of an issue that is devoted to criticism of the decadent West and praise of the vital East from which come two antagonists of Christianity – the Russian Revolution and Buddhism.

Number 4 asserts a favorite theme of Breton (see Chapter 2, this volume) – "War on Work," an opposition to regular employment and wage earning. It shows a Poiret-style dress mannequin on an art nouveau staircase, an image of a bourgeois doubtless linked to Breton's prefatory note, "Why I Am Taking over the Direction of *La Révolution surréaliste,*" in which he denounces "sacrificing remote concerns for the immediate. It is the very mannequin of Giorgio De Chirico, descending the staircase of the Stock Exchange."

Number 5 has a montage including old covers of Dada periodicals and *Littérature,* a letterhead of *La Révolution surréaliste* when Naville and Péret were the directors, an open letter to Claudel (a tract of July 1925), and the inverted title of the periodical "La Vie moderne." The text below – "Le passé" – seems to comment sarcastically about these journals, but the irony is undermined by including a reflexive image of the cover. The latter raises the question whether the present is not equally passé, especially since temporal perspective is absent (all the covers are spread out on the same two-dimensional surface).

Number 6 reproduces Man Ray's Dada photo "Moving Sculpture" (1920; anticipating Duchamp's designation of Calder's "mobiles"?), of wind-blown wash hung out to dry. The caption "La France" mocks the country by associating it to "le vent" (perhaps the idea was suggested by Ernst's ironic painting reproduced in issue no. 5, *Vive la France*), hence to ideas of instability, vanity, even drunkenness. Although there is "wind in the sails" there is no movement, since the sails are "anchored" to the washline.

Number 7 shows a photomontage of a crowd of onlookers – middle class to judge from their clothing – standing before buildings presumably in Paris, all looking up to the same point in the sky. The cap-

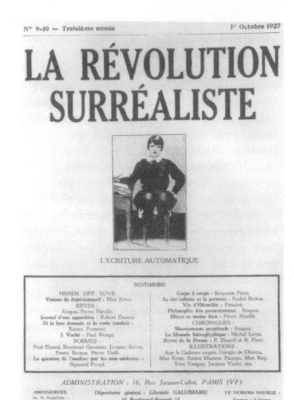

N⁰ˢ 9–10 — Troisième année 1ᵉʳ Octobre 1927

LA RÉVOLUTION SURRÉALISTE

L'ECRITURE AUTOMATIQUE

SOMMAIRE

Figure 14. Anon., "L'Ecriture automatique," cover, *La Révolution surréaliste*, no. 9–10 (October 1927).

"L'ECRITURE AUTOMATIQUE," suggests that like a muse or seer (and not merely the stenographer of the "Entrée des médiums" mentioned in Chapter 1, this volume), she is a visionary medium, and that automatism still presides over Surrealist writing.[135] The sexual aspect of creativity is implied by the raising of her skirt to reveal a dark area between her highlighted and frontally placed knees. In terms of the controversy then raging about the nature of Surrealist painting and drawing, it is significant that her activity is not designated "Le Dessin automatique."

Number 11 shows two workers bent over staring into the dark circular cavity exposed by the removal of a manhole cover. The caption, "LA PROCHAINE CHAMBRE," compares a coming bourgeois political assembly to a sewer viewed by the proletariat. (Perhaps the two ideas are linked by the phrase "pot à chambre.")[136]

Number 12, the final issue, has a photo of a lightning flash striking toward a dark silhouette of houses and trees. The caption – "What sort of hope do you put in love?" – fits this issue, which includes an "inquiry into love." (At this time Breton experienced the height of his passion for Suzanne Muzard, but the allusion to hope recalls an incident of *Nadja*.) Text and image are linked by the proverbial "coup de foudre," which means both stroke of lightning and sudden, irresistible love. (There seems to be some continuity with no. 9–10, which included Aragon's article, "Philosophy of Lightning Rods," and an illustration of Tanguy's *Second Message*, which features a giant lightning flash.)

The format for illustrations changed in no. 12. This issue included the Second Manifesto, in which an embattled Breton expelled dissident members and demanded the "occultation" of the movement. This word meant not only a turning away from public view (this was not the first time they did that), but literally an interest – albeit with skeptical reservations – in the occult. Indeed, he observes in a note that an expert on horoscopes has observed a rare astrolog-

tion – "LES DERNIERES CONVERSIONS" – mocks religious faith (is it conversion or just idle curiosity?) and like no. 3 suggests the end of religion.

Number 8 captions the interior of a head in profile with Engels's remark, "What all these gentlemen lack is dialectics." Collaged into the brain space is a jumble of (mainly female) heads and bodies and other details. This type of caricature, already practiced in the eighteenth century, suggests that the "gentleman" would be able to sort out his confused state of mind if he applied dialectical logic to it.

Number 9–10 has a photo of a primly dressed young woman, seated on a stool, who stares off to her left, while her right hand writes on a pad placed on a school desk (another instance of a transfigured memory of school, Figure 14). The caption,

ical conjunction of Uranus and Saturn, an occurrence that augurs well for the "engendering of a new school." Breton evidently assumed that this applied to him and his friends Aragon and Eluard, all of whom had birthdates under that conjunction.[137] Indeed, the new periodical – *Le Surréalisme au service de la révolution* – not only "occulted" its contents by making all its covers identical in color and format (only the issue number was changed and no date appeared), but revealed an "astral influence" in its prominent display of a zodiacal emblem uniting Uranus and Saturn. A new format for the illustrations, perhaps reflecting a new revolutionary discipline that aimed to exclude distracting intrusions, permitted few drawings or engravings in the body of the text, but confined photos, collage, and paintings to a section at the end of the issue.

The difficulty of converting their texts into images that could affect spectators without descending to propaganda or to Socialist Realism produced tensions between those dedicated to art and those involved in political change, and in part motivated Breton's desire for the "occultation" of Surrealism in 1929. Characteristically, after the crisis of 1929 Breton recharged faltering Surrealist writing through a fresh start in the visual domain. This disappearance from view corresponds to Breton's veering toward the verbal in his discussion of the "automatic message" (1933), where he speaks only of writers like Rimbaud and Lautréamont, or the mediums, and makes no reference to Surrealist artists or automatic drawings.[138] And the occultation anticipates the alienated and paranoid thirties in a prewar Europe overrun with Fascist fifth columns, double agents, and Stalinist moles, when the visual image, blending persuasion and manipulation, did not always convey reliable information. In another medium the Surrealists remained, as always, very much in the public eye – the novel, particularly those of Breton, continued to irritate cultivated readers on the Left and Right

and spur the prurient curiosity of a larger audience.

THE ILLUSTRATIONS FOR THREE NOVELS BY BRETON

Breton alone among the Surrealists made abundant use of illustration in his "novels." His three major efforts in this genre – *Nadja,* the *Vases communicants,* and *L'Amour fou* – deserve careful consideration for the light they cast on the relation of visual image to text in Surrealism as it evolved from the twenties to the thirties.

Nadja (1927)

Nadja was written in the midst of Breton's struggle to define Surrealist painting in terms of an "interior object." The book, consisting of sections without narrative connection and in which the central events conform to the calendar of a psychiatric case study rather than to a dramatic plot, mingles the subjective experiences of the author with documentary reports. Photography and art served to mediate between "subjective" interior and "objective" exterior. The disturbed productions that Nadja made during her affair with Breton suited his purposes particularly well, because they represented a vivid point of contact and communication between them; indeed, Breton, an intimate participant in the improbable events, had helped engender the drawings through his encouragement. Nadja's drawings, which one might view as psychiatric protocols or pathetically romantic gestures, represented to Breton mysteriously prophetic signs associated with himself or images that approach the marvelous like certain works of De Chirico or the drawings of seers. Breton evidenced his long-standing interest in psychotic art (which he doubtless encountered as a psychiatric orderly during World War I, even before meeting Apollinaire) in his essay "Characters of Modern Evolution" (1923), when he observed that Ernst "also takes the point of view of psychotics, and there is a

remains the graphic symbol that gave to Nadja the key to all the rest."[149] Nadja drew two symmetrical pairs of eyes and two hearts, all radiating from a center like the leaves of a flower. The stem turns into a sinuous arrow that points into the open mouth of a fanged serpent.

He called the next drawing illustrated (dated November 18, 1926), which he considered one of the best, "a symbolic portrait of the two of us." In it he points out a siren ("which is how she saw herself") whose tail seems to interlace with that of a monster and another "monster with flashing eyes emerging from a sort of vase with an eagle's head, and filled with feathers that represent ideas."[150] In my opinion the vase resembles a fountain (the "feathers" correspond to splashes of water – an association confirmed by the siren), and thus constitutes a visualization of her earlier remarks about the fountain on October 6: "They are your thoughts and mine."[151] The tail that clearly belongs to the siren penetrates a loop made by the monster's tail: one can compare this to the doubly phallic forms of "the Lover's Flower" – the fanged open mouth of the serpent receiving the love shaft (one thinks of the spears of St. Theresa's angels) suggests a *vagina dentata*. Presumably these ambiguities evidence Nadja's tragic insecurity over her femininity and her attraction as a woman. The figures Breton associated to Nadja – Melusine, the Gorgon, and the Sphinx – carry the same implication of deformed femininity.

The artworks reproduced just after Nadja's drawings – a mask from New Britain, an Easter Island figure, paintings by Ernst, De Chirico, and Braque – take their relevance entirely from Nadja's mysterious, even "marvelous," reactions to them. Like the drawings, a little collection of phrases she uttered – "With the end of my breath, which is the beginning of yours"; "Before the mystery. Man of stone, understand me"; etc.[152] – reflect their intimacy and, Breton suggests, her powers of divination. Some items in her drawings resemble

and may derive from details of the artworks (the hand in the De Chirico, the nail and rope in the Braque).

Nadja's "language" consists not only of cryptic utterances and drawings, but of gestures imputing significance to the paintings by De Chirico, Ernst, and Picasso, and to the objects of New Britain and Easter Island. This language, an accompaniment to her acts and the embodiment of her thoughts and desires, was often an attempt to reach out to Breton by visually interpreting his words. One suspects that with a certain cunning she informed herself beforehand by reading Breton's publications, so that she was prepared for their encounter; for example, she seems to have known Section no. 24 of *Poisson soluble* with its refrain, "A kiss is so soon forgotten." This section concerns lovers and takes place near Breton's favorite haunts, the Pont-Neuf and the City Hotel, where Nadja and he will later walk. Again, Breton had written: "My eyes were the flowers of a hazel tree, my right eye the male flower, my left the female flower"; and Nadja drew what Breton named "The Lovers's Flower," which shows four eyes (as in another illustration showing a repeated detail of her eyes in a photo by Man Ray) like the petals of a flower, with matching dark and light pupils, clearly her eyes and his. Finally, an idea of Breton's apparently inspired her poignant self-portrait, a collage in which a drawing of her head emerges from a glove, presumably traced from her hand.[153]

The paradox of gloved intimacy exquisitely expressed in the red rubber glove of De Chirico's *Song of Love* (probably named by the Surrealists rather than the artist) as a lifeless envelope around sensitive flesh anticipates the metaphor of insect eroticism (the brittle chiton encapsulating the vital juices) that fascinated the Surrealists in the thirties. As in other drawings, Nadja spontaneously produced figures in a private language constituting a cryptogram requiring interpretation. She signed "Nadja" in her hair and on a heart form that covers her nose and mouth; and

philosopher Berkeley: Boiffard, Eluard, and Vitrac in their joint preface to *La Révolution surréaliste,* no. 1 (December 1924), quoted Berkeley's remark, "The idea of movement is above all an inert idea," and they appended an oxymoron – "the tree of speed."[212] (Perhaps – as stated earlier – Breton's reading of this preface and Lenin's *Empiriocriticism* with its allusions to Berkeley brought him to the fountain text of *Nadja.*) One might compare this to the painter Dominguez's notion (somewhere between lithography and photography) of "lithochronism," or "the solidification of time," much appreciated by Breton in "The Most Recent Tendencies in Surrealist Painting" (1939). Breton finds magic in "this monument to victory and disaster,"[213] and perhaps also a reminder of the alchemical transmutation of metals from soft to hard and from base to noble. In seeking to expand the associations to *amour fou,* Breton made important and innovative use of photographs; in *Nadja* no photographs accompanied the text about convulsive beauty.

The photos concern Breton's quest to fill the void he still felt, to turn his dreams into something tangible, and they have more to do with sublimation than with the fetish (an obsession of Bataille and his admirers who fault Surrealism for not dwelling on the fetish). Indeed, what the photos have in common is their visualizing of processes of metamorphosis whereby form emerges from the formless or concreteness from the vague – all this achieved through what I would call the alchemy of the Surrealist photograph.[214] The capturing of forms in motion and the crystallization of objects in transformation turn the temporal into the spatial and make possible a romantic triumph over a painful reality and the escape from his unsettling memory (of the loss of Suzanne) within the framework of a sublimating *hors du temps.*

The photos in different ways reveal these motifs: the motionless whirl of Man Ray's dancer; the vital process of ossification in the Great Barrier Reef; the discovery within a mandrake root of an episode from Virgil's *Aeneid* (the figure of Aeneas and his father carried by him); the streets of Les Halles, where his eyes pass from "magnificent cubes" to "the pavement with its gleam of horrible garbage" – merchandise dumped by the truckload at night; the half-formed structure of the Tour Saint-Jacques under a scaffolding as tenuous as that of an Analytic Cubist painting; the "amphibious" figure of a nude swimmer under water (Jacqueline), whose head and breasts are clear, but whose legs blur into the depths; bunches of roses crowded next to one another, overgrowing the florist's stall at night – a strange bouquet offered to "the unknown woman, the woman to come"; a shoreline whose edge is lost under sand and plants; a building with dark windows on large, solid white walls set above a shadowy mass of trees crowded into the lower half of the photo – the "starry chateau on the edge of an abyss"; the sad reality of war, with lively children playing among the signs of death – buildings ruined during the Spanish Civil War; and the last illustration (discussed later), a photo of a sand-clock by Man Ray. The few paintings illustrated make the same point: there is a soft-focus painting of Picasso's Blue Period; Ernst's *Garden Airplane Trap* (modeled perhaps on the praying mantis),[215] in which vegetable forms nest "seductively" within a loose structure of slats luring machines to their destruction; and the *Maison du pendu,* a work of Cézanne (an artist usually rejected by Breton, who like Picabia judged him superficial), whose presumed "halo" of a hanged man fascinated Breton.

Three photos concerning a statue of Giacometti's in progress, *Mains tenant le vide* (*l'objet invisible*) (Figure 17), are of great relevance to Breton's quest for a new amorous adventure. At the very beginning of chapter 3 (which we might call the "Giacometti chapter") Breton cites familiar phrases about the proverbial shadow and prey, emphasizing that one must not "*allow the paths of desire behind one to become covered over with bushes*" (p. 38).[216]

the number 13 – suggesting the letters AB – appears at the heart's center.[154] Breton convinced the anxious and compliant Nadja to simulate what he wished her to be, a free spirit and a seer who could play a role in his own self-discovery. To achieve this he converted her word salad into poetry and prophecy, and played games with her name. After alluding to the character "Hélène" in *Poisson soluble* and to his long-standing fascination with the English seer Helen ("Hélène") Smith, Breton reports that Nadja (who had probably read the text in which Helen appears) said to him, "Hélène, c'est moi." Nadja had told him that one of her boyfriends had insisted on calling her "Lena" after his dead daughter, and Breton probably associated the consonantal structure of Lena – L N (pronounced in French like Hélène) to the name (He)lena of Hélène.

The purpose of this play of identities was – following a mixed model of psychoanalytic and psychic research – to capture a domain on the border between the ordinary and the extraordinary, the normal and the paranormal (an interest not uncommon at the beginning of the century in France even among scientists).[155] Breton reports two examples in *Nadja* that occurred on the same day, October 6 (1926) – "the window," in which Breton witnessed Nadja's paranormal performance and reported it to his readers, and "the fountain," in which he actively participated, since presumably a form of mental telepathy had passed between Breton and Nadja.

Breton considered these episodes so important that from the whole book he published only the October 6 entry as a separate piece in *La Révolution surréaliste,* no. 11 (March 1928). The window episode occurs as the two walk the Paris streets toward evening. Suddenly Nadja asks:

"Do you see that window up there? It's dark, like all the rest. Look hard. In a minute it will light up. It will be red." The minute passes. The window lights up. There are, as a matter of fact, red curtains. (I am sorry, but I am unable to do anything about the fact that this may exceed the limits of credibility. Nevertheless, in dealing with such a subject, I should never forgive myself for taking sides: I confine myself to *granting* that this window, being black [dark], has now become red, and that is all.)

(The text specifies no particular hotel, and offers no photo.) Although Breton claims not to "take sides" he at no point even suggests hypotheses that, for example, a psychoanalyst might advance to explain such events.

It is no accident that a window should serve as the central image of the episode, for Breton understood its significance for a hated optical aesthetic of mimesis that defined art as a window onto reality;[156] we have already suggested that the image in the First Manifesto of a man cut in half by a window launched Surrealism. Against the realistic point of view, the Surrealists followed the Symbolists, faithful adherents of Baudelaire's notion that there is more to be seen when a window is closed than open.[157] However, the events described in *Nadja* are more than ominous or mysterious – they raise questions about the normal nature of our "vision"; in fact, the exercise of Nadja's prophetic powers – her "seeing" beyond what was visible in the window – implies a denial of normal cognition and causation, and challenges rational explanation. In attempting to reaffirm the omnipotence of dream or desire, Breton allows Nadja's magic to support his poetic narcissism and fantasy, at times almost in the manner of a *folie à deux,* but he refuses to formulate what he regards as the marvelous in ordinary realistic prose.[158] Breton seems to formulate a retort to Descartes when he asserts, however ambiguously, the existence of phantoms and other imaginary productions. Descartes in *Meditation I* maintains (like Horace in the *Ars Poetica*) that

painters themselves, even when they study to represent sirens and satyrs by forms the most fantastic and extraordi-

nary, cannot bestow upon them natures absolutely new, but can only make a certain medley of the members of different animals; or if they chance to imagine something so novel that nothing at all similar has ever been seen before, and such as is, therefore, purely fictitious and absolutely false, it is at least certain that the colours of which this is composed are real.

Scholars sympathetic with Breton's Surrealism tend to defend the mysterious aspect of the event.[159]

At the outset of the book, before meeting Nadja, he passes the statue of Dolet, which "always caused me an unbearable malaise [discomfort]" (the Latin *dolet*, which means one "suffers" or "laments," presumably suggested the mood), then walks along "Boulevard Bonne-Nouvelle" (recalled later in *L'Immaculée conception*, and which here represents a mundane and accidental allusion to the "good news" of the Annunciation). An unstated etymology of place names attributes hidden or forgotten meanings to these Parisian sites and transforms them into intensely personal experiences:[160] Evidently, the Surrealists enjoyed investing the public spaces of Paris with private, mysterious meanings, as though recovering the genius loci (analogous to Benjamin's "aura"?) from Haussman's overpowering banalizing network of "grands boulevards." The names of sites have an "overdetermined" significance, or in Breton's terms they are "haunted" by invisible presences, like the insular and brilliantly obscure squares represented by the early De Chirico.

With no plan, and as unconcerned about a destination as they were about the dramatic conclusion of one of the grade B films the Surrealists enjoyed seeing, the distracted *flâneur*, Breton, set forth on a voyage of discovery of the unfamiliar within the well-known. Breton had less grandiose aims in his walk than Aragon, who made a nebulously philosophical event out of his walks in Paris.[161]

He begins his walk at the "Hôtel des Grands Hommes" in the Place du Panthéon, passing, as he and his comrades so often did, the statues of famous men in the public squares (one of the photos in *Nadja* shows the bronze statue of Jean-Jacques Rousseau subsequently melted down by the Nazis and replaced by one in stone). Subsequently he mentions several of the "great men" in his personal Pantheon: Apollinaire, Paulhan, Eluard, Desnos, and Péret.[162] In 1951 Breton and Péret, in their humorous proposal of statues they'd like to see erected in Paris, stated: "We think that the secret of the mystery inherent to the first paintings of De Chirico, which outclass in our eyes the whole of modern painting, resides in the apparition of statues unknown to us on deserted squares where the sun casts their shadow."[163]

Several pages after the window episode in *Nadja*, Breton describes the fountain episode apparently involving a telepathic communication between Nadja and him. They were seated side by side toward midnight in the garden of the Tuileries and, as Breton narrates it:

> Before us there surged a fountain whose curve she seemed to follow. "Those are your thoughts and mine. Look from where they all start out, to where they rise, and how it is even prettier when they fall back. And then, as soon as they merge, they return with the same force, again that gushing interrupted (*élancement brisé*), that fall . . . and on and on forever." I cried out, "But, Nadja, how strange this is! Where did you get just this image, which appears in almost the identical form in a book that you cannot know and which I have just read."[164]

The book he had been reading was Bishop Berkeley's *Three Dialogues of Hylas and Philonous*, significantly dated 1713.[165]

In the relevant passage Berkeley finds an emblem for the movement of thought in "the water in the fountain that the two interlocutors" see "rise to a certain height and fall back afterwards in the basin from which it first rose." An illustration showing the two before the fountain (reproduced in

Nadja) carries a Latin text that means " 'The same force that spurted the water skywards causes it to fall again.' "[166]

The *Three Dialogues* were already known to Breton, since the very influential book by Lenin, *Matérialisme et empiriocriticisme* (translated into French in 1925), refers to it.[167] Although presumably in agreement with Lenin's criticism of Berkeley's spiritualistic metaphysics, Breton, always hostile toward both vulgar materialism and positivism, would have listened with sympathy to the criticism by Berkeley's philosopher (identified as Philonous, "lover of mind") of the materialist Hylas and his demonstration that all reality is mental, a view to which the "omnipotence of dream" (as presented by Aragon in 1924 as well as himself) could resonate.[168] Breton, an experimental poet fascinated by parapsychological phenomena, presumably welcomed (without buying into any religious pretensions) an "objective idealism" that demolished the conception of corporeal substance. The passage quoted by Lenin would have especially interested Breton for its assertion of the power of mind: " 'If something acts on us from without, we have to admit that there are forces that exist outside us, forces belonging to a different being from us. Where we part company is in our answers to the question of the nature of this powerful being. I say it's spirit; you, that it is matter.' "[169] Breton would probably have psychologized the question, choosing as examples of "powerful beings" the disturbed Nadja, or some seer, or a passionately loved woman.

The emotional upheaval after Nadja's hospitalization, Breton's divorce from Simone in 1928, a turbulent love affair, and the crisis of 1929, when several Surrealists became belligerent opponents on personal as well as on political grounds, caused Breton to rethink fundamental positions. The metaphors of the window and the fountain had brilliantly epitomized the experience Nadja and Breton shared, but the discursive assertion that concludes the book – "La beauté sera CONVULSIVE ou

ne sera pas" – does not apply to Nadja, but to a genial personality capable of sharing more than mental games and sex. What Breton now needed was a metaphor able to express his ambition to find a common ground for his private and political, his artistic and his intellectual concerns.

He found the appropriate metaphor in the physical instrument of communicating vessels in which a fluid in a system of connecting glass tubes rises to the same level in the different tubes. Breton saw in this an expression of the idea that individuals can unconsciously share a collective existence and, while remaining independent, can find a common level. He engaged this idea in the *Vases communicants,* a novel that represents the transitional period between the late twenties and the mid-thirties.

Les Vases communicants

The painful as well as happy experiences in politics and love in the years after 1929 brought the Surrealists a new maturity concerning the "reality" against which they had so vigorously protested. The old aim to sustain a tension between elements of metaphor as far removed from one another as possible began to wear thin in the thirties. A subtler intention modeled on Hegelian dialectics seemed more appropriate for the turbulent decade in which the Surrealists had to confront tensions between free love and family, individuality and social commitment, the public expression of an unconstrained fantasy, and the need to seek allies against the encroachments from the Left and Right of totalitarianism. A major vehicle, a clear parallel to the dialectical model, was that of the "communicating vessels."

In the *Vases communicants,* as in *Nadja,* Breton continued to explore external events or "objective chance," in adventures along the borderline between fantasy and reality. The book is stamped with the trauma of his breakup with Suzanne Muzard, who shared with him perhaps the

most intense intellectual and emotional experience of his life. Suzanne actually provided the link among the three novels – she was the new "convulsive" love ("X") that appeared in the last part of *Nadja;* the subsequent breakup with her plunged him into a morass of contrary ideas and impulses that impelled him toward that consoling dream of synthesis and reintegration, the *Vases communicants;* and in a final effort at release and recovery, he converted his old passion into a new one, recorded in *L'Amour fou.*

After his solo "performance" in *Nadja* – even the dialogues with Nadja seem staged and manipulated – Breton, in his next ventures into abnormal psychology, collaborated with friends. First he wrote with Aragon a note on hysteria, then with Eluard he produced a remarkable study that rather convincingly simulated the "rhetoric" of various psychotic mental states. But with the increasing pressure of political events it became apparent to him that such writing, however fascinating, fell short of the project to change the world, rather than expressing or describing it – hence, the attraction to political revolution and the search for a common ground between the Surrealist interest in the dream and Marxist-Leninist materialism.

The role of dream for Breton cannot be separated from his quest for a new "dream girl" to fill the void left by Suzanne; the book introduces a number of potential substitutes, real and imaginary. And Breton refuses to reduce his need to mundane psychoanalytic terms. At the outset of the book Breton criticizes bourgeois dream interpretation – Freud is faulted for keeping apart "psychic" and "material" reality – and he proposes to radicalize them "dialectically" by finding a way to unite the dream and reality (through the dream's interpretation), to go "from the abstract to the concrete, from the subjective to the objective." The epigraph to the first section cites a passage from Jensen's *Gradiva* (a novel about which Freud had written, perceiving in it certain quasi-psychoanalytic ideas),

that epitomizes the theme of the intermingling of dream and reality: " 'And lightly gathering up her skirt with her left hand, Gradiva Rediviva Zoé Bertgang, enveloped in the dreamy looks of Hanold, with her supple and tranquil step in full sunlight on the marble slabs, passed to the other side of the street.' " The key to the passage is the group of four words – the first two designating a classical figure in marble about whom the archaeologist Norbert Hanold has dreams, the third and fourth referring to a German woman of flesh who eventually displaces the phantom so avidly sought by the archaeologist. The passage to the other side of the street, which corresponds, as Freud noted, to philological parallels intended by the author between the epithets *Gradiva* (in Latin "she of the Martian step") and its German equivalent (*Bertgang*) and similarly between *Rediviva* (in Latin "the living, the reborn") and *Zoe,* the German woman's name (meaning in Greek "life"). The crossing also symbolizes Hanold's ambivalence toward Zoé: in his dreams and hallucinations, when he feels that Zoé threatens to become a being of flesh and blood, he metamorphoses her into the stone figure of Gradiva. This oscillation between dream and reality constitutes a major theme of the book. As important as *Gradiva* was for Breton and all the Surrealists, the really imposing monument of psychoanalysis remained *The Interpretation of Dreams.* Breton seems to have aspired to create his own form of interpretation to apply both to his dreams and poetry.[170] While borrowing Freud's methods from the *Interpretation of Dreams,* Breton claims he will go much further than Freud in terms of self-analysis:[171] he faults Freud for censoring too much of the "material reality" of his sexual experience.[172] (There resulted a heated exchange of letters between the two on the subject of Freud's originality and frankness.) And even more important, Breton rejected Freud's firm separation between material and psychological reality, and his insistence that fantasy – a form

of illusion or fiction – is grounded in desire and the unconscious.[173]

Breton never discusses in this book Freud's interpretations of older masters like Leonardo, and conversely he evidently believed that he could not usefully apply orthodox psychoanalysis to significant contemporary art (including Man Ray's photography and the sculpture of Giacometti) or poetry. He feels that no account along traditional historical or comparative lines could do justice to such works as Dali's *The Great Masturbator,* Picasso's *Clarinet Player,* De Chirico's *Seer,* Duchamp's *Bride,* and Ernst's *Femme 100 têtes.* What was needed was a psychoaesthetic analysis such as he had already applied to his own dreams and poems.[174] In the *Vases communicants* he demonstrates his method by analyzing not a Surrealist poem or painting, but a "phantom-object"[175] that evokes an emotional crisis in a love relationship that ends, like *Nadja,* in a failure of communication. (In *L'Amour fou* he analyzes his poem "Sunflower," which played a role in his adventure he called "The *Night* of the *Sun*flower"; my emphasis.)

The rebus image of a "silent envelope" epitomizes, as we shall see, Breton's failure to communicate any longer with Suzanne Muzard, the "X" of *Nadja,* after the termination of their passionate affair. Breton's refusal to reduce the "poetic level" of a rebus to the terms of a mundane psychoanalysis in my opinion has as much to do with his resistance to a painful realization and its exposure as with his aesthetic choice. This "letter," which betrays his unfulfilled erotic desires, has no inscribed message and is not intended for delivery – except to the reading public that will only partly grasp its meaning. Despite its link to his painful recent breakup, the envelope, as we shall see, refers as well to earlier moments; and by releasing it from a transitory misadventure, Breton hoped to elevate the envelope to the marvelous category of the *hors du temps.*

Breton explains the origin of the image

Figure 15. André Breton, "L'Enveloppe-silence," *Le Surréalisme au service de la révolution,* no. 3 (December 1931), p. 21.

with considerable detail. He tells how he recently conceived an object "during a game called 'Exquisite Corpse.' . . . This *fantom-object* . . . can be described as follows: an empty envelope, white or very light, with no address, closed and sealed in red, the round seal without any particular stamp [gravure], the edges dotted with eyelashes [cils], with a handle [anse] on the side allowing one to hold it" (Figure 15).[176] The object embodies visual and verbal paradoxes: it is a visible phantom (with eyelashes but not eyes), a rebus based on the word "silence," and an *impresa* or emblem signifying a vase that communicates (the letter) nothing (silence).[177] The poor drawing of the object in the magazine piece is absent from the novel, but with little consequence for its effectiveness, since, as Breton noted, it is a *"poetic* object, which has value only on the level of poetic images, and on no other."[178] "The object," he says, "constituted a rather bad pun, *Silence,* which it seemed to me could either accompany the object or designate it."[179] He compares this object to the powerful image of Lautréamont, "beautiful as the chance encounter on a dissecting table of a sewing machine and an umbrella" – an image that inspired an inquiry by Eluard and him: "Can you tell what the principal encounter of your life was? To what degree did this encounter give you, does it give you, the impression of being fortuitous? necessary?"[180] The "obvious" sexual connotations of these objects (already in Lautréamont's time one could speak of "l'immoralité du parapluie")[181] lead him to

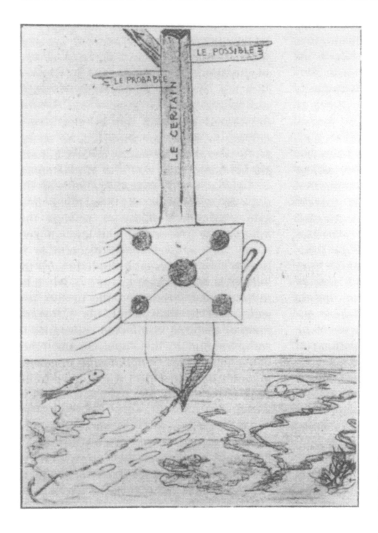

Figure 16. André Breton and others, *Cadavre exquis, La Révolution surréaliste,* no. 9–10 (October 1927).

question his earlier notion of the innocuousness of his *enveloppe-silence.* He denies any major latent significance to the object, except to state that the "silence," the paper vase, and the red seal all passed through a process of "condensation and displacement, products of the censor" to signify mentally placing "the phantom envelope in the hand of a phantom who would hold it properly."[182] Breton adapted these Freudian dream mechanisms to his own purposes, without getting past the censor to see the painful content within it.

This object appeared earlier as part of a *cadavre exquis;* for, as he states in his article on the "phantom object": "I drew it, for better or worse, in the form of a torso, on the middle third of the paper" (Figure 16).[183] The collective experience of the *cadavre exquis* at the origin of this object places it in the line of group dream sessions and "pooling" games – another analogy to the "dialectics" of communicating vessels. In the final version of the envelope, four dots disappear, whereas the diagonal creases and the handle at the side are delineated more clearly.

The second edition of the book uses visual illustration to support its thesis of communication between various pairs of "vases." Not only do the reproductions provide tangible documentation of his mental adventures and his speculations, but they help the reader follow the virtuoso

interweaving of his own dream imagery and works of art. The eight illustrations chosen for the *Vases communicants* all correspond to portions of the text; they include several types of photograph (a movie still, a close-up of an object, a landscape view, and a photo of Breton before a bizarre architectural structure), as well as reproductions of three paintings. These illustrations do not merely reflect the text, but contain, as it were, nonverbal implications, providing a spatial context for the reader's imagination as it engages Breton's puns, analogies, and rebus-like associations. Significantly, Breton illustrated one of three letters in German from Freud to him (all given in the text in French translation). Freud was one of those "father figures" Breton at once admired and faulted, and in this novel he entered into an amicable competition of dream interpretation with the master. (Freud's analysis of Jensen's text inspired Breton's fascination with Gradiva.)

Apart from the "silence envelope," the *Vases* contains, mixed into the speculative, whimsical, and bizarre material, personal hints that border on "true confessions." Breton reported several dreams in the novel in which we sense a latent resentment toward his parents (usually deflected into diatribes against the family in general), but he seems especially to have resented his mother. Presumably he felt a blend of guilt and desire experienced as anger on account of his mother's coldly domineering and unappreciative attitude toward her only child. To get her son into a comfortable bourgeois career as engineer (one that doubtless conformed to her maternal vanity), she censored his "wasteful" reading of literature (he had to spend most of his time studying for his exams and not playing) and induced a defensive secrecy in his correspondence – in a youthful letter to a friend he asked that no allusion be made to a book he had bought. Certainly there persisted into his maturity an elusiveness and a capacity for defensive "occultation," as he put it. Though master of a

clear expository prose, in his poetry he evidenced a desire to address an elite audience in a style impenetrable to laypeople that assuredly included his mother. Both his refusal of a conventional career and his atheism (his mother was devout) constituted rebellion against her and a rallying to his father, who had no steady profession and who was an atheist. But one job his father held was that of policeman, so André enjoyed an identification with the unlikely combination of atheist and policeman.[184] Breton's character reflects this mingling of irreverence and law enforcement. This is particularly discernible in Breton's own paternal attitude toward his Surrealist "sons," both in 1922–3, when he initiated and terminated the dream sessions, and in 1929, when his autocratic manner inspired disaffected colleagues to compare him to the Pope. On the other hand, in the *Vases communicants* questions of authority and control were linked to his own rivalry with the paternal figure of Freud.

Although they rarely name the Oedipus complex (Ernst, creator of a mythical autobiography, whatever his knowledge of Freud, evidently intended to limit his imagery to Oedipus the myth), the psychological interactions – rivalries, jealousies – of the Surrealists among themselves and with external authorities – seem pervaded by what one might describe as Oedipal motives and behavior (at least the paternal side), and the Surrealists' harsh critic Camus described them as being in a state of adolescent revolt.[185] Sartre, in his "Situation de l'écrivain en 1947," characterizes Surrealism in Oedipal terms that Breton, the "Pope of Surrealism," could not have missed, as a "revolt against the Father" and notes its "spirit of negativity." He argued that "Surrealism joins the destructive tradition of the writer-consumer. These young turbulent bourgeois wish to ruin culture because they are cultivated, and their principal enemy remains the philistine of Heine, the M. Prudhomme of Monnier, the bourgeois of Flaubert, in brief, their Pa-

pa."[186] (This sociology of the Oedipus complex is psychoanalytically incomplete, of course, since it takes no account of the desire for the mother that corresponds to the rivalry with the father.)

Actually, the pattern of relations within Breton's family – his warm father and his somewhat cold mother – can only obliquely be called Oedipal (or a negative Oedipus complex); furthermore, his closeness to his grandparents adds another complication. Breton expressed an aspect of the complex relation to his father in the symbol of the crystal in *L'Amour fou*. Breton's father provided a much more attractive model to his son than his doctrinaire mother, whose strict Catholicism must early on have oppressed him (and prepared the ground for his blend of skepticism and occultism). His father became an official in a crystal manufacturing company in Pantin, where the family moved around 1900 and where, for want of a nursery, André was placed in a religious school.[187] These displacements apparently caused resentments and anger in the child, judging from the fact that one of the rare memories preserved from that period has a markedly sadistic character.[188] In what seems a conflation of parental attributes in his famous "praise of crystal," Breton equated paternal crystal with maternal home, as though registering the wish to find softness and warmth beneath the hard personality of his mother in a domain whose hardness was softened paradoxically by association to the crystals of his father.[189] (He never seems to have come to terms with his father's role as a cop.)

The association of verbal and social rebellion against a paternal authority is characteristically French, extending from the "Querelle des anciens et des modernes" to the Lacanian "Non(m) du père" and even to Barthes, who in 1966 wrote, "At all events, without wanting to strain the phylogenetic hypothesis, it may be significant that it is at the same moment (around the age of three) that the little human 'invents' at once sentence, narrative, and the Oedipus."[190]

The use of a mythical rather than psychoanalytic framework for an Oedipal theme had already occurred in Apollinaire's ribald comedy *Les Mamelles de Tirésias* (1917), which introduced the term "Surréalisme." Apollinaire made Tirésias the blind, androgynous seer of the Oedipal story – or "his" breasts (as Thérèse) – his central character. In painting, among the major precursors only the work of De Chirico evidently involved his father, usually as a latent though ubiquitous presence. But even he, in his explicit themes, concerns himself with the deserted Ariadne and the labyrinth (and the triumphant Theseus, deserter of Ariadne), and never significantly represents Oedipus. Except for the complicated case of Ernst, Surrealist writing and art up to the mid-thirties circumvented any notion of filial dependency: the Surrealists largely ignored their parents, replacing the father by a variety of antiheroes and the mother by mistresses, seers, and assassins. Without acknowledging it, they secreted the maternal within such monstrous and powerful females as the Sphinx and Melusine, or in Salome (for the Surrealists as for the Symbolists an instrument of her perverse and sinister mother Herodias). But for the *Vases* Breton, rival of Freud, chose the theme of Gradiva in a provocative manner: he deliberately cites only the name of Jensen, author of the novel, without mentioning Freud's study of the novel, recently translated into French, and his real inspiration: Jensen's novel in German was not accessible to the Surrealists; evidently, Freud's interpretation alone made this undistinguished novel interesting.

The epigraph quoted from Jensen's *Gradiva* that stands at the beginning of *Vases* contains, as already mentioned, the metaphor of "passing to the other side of the street." This passage from one side to the other amounts to the book's leitmotiv of the communicating vessels. We can follow the elusive thread of this idea in seven of the illustrations to the book (omitting the facsimile of Freud's

letter), each of which treats pairs of ideas.

1. Love and Death. The still from Murnau's *Nosferatu le vampire,* a film of 1922 based on Bram Stoker's novel (1897), shows the visage (and the contour) of the vampire Nosferatu. In association with his text, Breton offers us an array of overdetermined elements. Reappearing like a rebus figure in and out of dreams, it links certain details (as Breton himself points out): a cravat (Aragon); the delineation of the eastern frontier of France (and Germany); a bridge that, like a communicating vessel, connects phantoms and reality; and the contour of Dali's *Great Masturbator.* The dying vampire faces out the window to the devastating light,[191] his left hand clutching his heart, his right arm fading as though blanched by the acid rays of the rising sun – a disintegration of matter strikingly represented in some of Man Ray's photographs (e.g., "Primacy of Matter over Thought," 1929).

2. Freedom and Mechanical Probability. The photo of a one-armed bandit in the Eden Casino (p. 43) shows a machine for gambling, which bears the inscription (in English) "Free Play" (defined as freedom of choice on p. 47). The amount of Breton's gambling loss at this machine is ironically converted into years on the Freudian principle that dreams can represent the proverb "Time is money" – a contradiction of free play and free love that plainly alludes to Breton's bête noire prostitution. Later Breton, agreeing with Lenin's bold claim in repudiation of neo-Kantian philosophy that time and space are "essential conditions of existence," concludes that "the time and space of dream are thus real time and space" – a notion applicable to certain works of Arp, Dali, and others.[192] The conception of a space-time that transcends the linear determinism of Cartesian and Newtonian principles made available to the public in popular accounts would have relevance to the issues addressed here by Breton. As noted in the Introduction, this volume, Breton early on sensed the importance of Einstein's theories, in contrast to Lenin, who polemically bludgeoned Russian scientists who adopted a neo-Kantian philosophy (one that Einstein believed consonant with relativity), and refused to welcome recent theories of physics.[193] Breton quotes (p. 62) with approval Engels's view that "beings outside time and space (*en dehors du temps et de l'espace*) created by the church and nourished by the imagination of ignorant and oppressed masses are only the products of a sick fantasy, subterfuges of philosophic idealism, *the evil products of an evil regime.*"

3. Bridging Desire and Reality. In the photo "At the Bend of the Little Bridge," the shadowy background foliage and the foreground tree shadows form a horizontal parenthesis around the wall that thrusts into the concavity bounded by the three straight sides of the sunlighted surface of the bridge. After describing the phantoms crossing Nosferatu's bridge, Breton defines (p. 50) bridges in general as "the clearest of sexual symbols."[194] He then mentions seeing an attractive young woman in a German peasant costume taking tea: she "could only be the wife of the engineer building the dam over the Verdon river" (p. 50); she then leaves, presumably "to meet her husband, and I lost sight of her at the bend of the little bridge . . . on which I had never walked." He understands that she symbolizes his twin desire to speak freely with her ("free play") and to find a way to link France to an enlightened Germany (a sexuocultural "passing over the bridge"), the "marvellous country of Kant, Hegel, Feuerbach and Marx" (p. 53). The face of Nosferatu and especially the makeup around the eyes remind him of the eyelid with its long lashes in *The Great Masturbator,* and also of a drawing of a map of France he contributed to a game of *cadavre exquis.* (The general metaphor of the bridge – between conscious and unconscious or between two individuals, lovers – was formulated by Paulhan in 1922.)[195]

4. *Sexuality (Solitary and Social).* Although Breton mentions several works by modern artists (Picasso, De Chirico, Duchamp, Ernst, and Giacometti), as usual he illustrates only the two paintings about which he plans to speak – Dali's *Great Masturbator* and the De Chirico. Here (p. 53) he repeats elements of the discussion of the *Nosferatu* still:

> The quite unexpected representation of the face of Nosferatu on the points of the tie makes me think that it is more or less copied from that of a personage that is found frequently in the paintings and drawings of Salvador Dali, I mean the *Great Masturbator* ... that resembles my *ex-libris*. The outline of the vampire's head seems to be confused with the edge of the eyelid with its long lashes. ... On the other hand, in the paper game called the "*Cadavre exquis*" which consists in having three persons successively draw the parts of a person, such that the second doesn't know what the first did, nor the third of what the first and second did, I once gave the map of France for the head of one of these hybrid beings.

Dali's painting corresponds closely to an important theme of the book, the generation of reality through the (passive) activity of dream. In the painting a monumental sleeping head stands on a nose-toe, a monument with sealed or missing sense organs,[196] unaware of the ambient landscape containing tiny figures; but out of its own rubbery substance evolves a number of symbolic objects, most notably one that corresponds to Breton's notion of masturbation – the woman who with eyes closed nuzzles the soft mass of a male's genitals.[197] Dali, who at that time often turned male and female mouths into genitals, suggested her absent sexual parts with red lips.[198] Dali's character the Great Masturbator appeared originally in his book *The Visible Woman* of 1930 and announces a new open-eyed woman with her sexuality on view rather than covered ("invisible") as it had been in Magritte's painting at the center of a Surrealist group portrait of 1929 (to be discussed at length in the next chapter).[199]

In the context of a dream (pp. 68–9), Breton, following hints in Freud, identified phantoms and parents as the night watch against young masturbators and bed wetters: in the anxious terms of Breton's dream *he* becomes the Great Masturbator of his own tie/penis.[200] Such frank interest in masturbation – Breton and his circle publicly favored it – triggered sarcastic criticisms of Surrealist activities.[201]

5. *Clairvoyance and Visual Perception.* De Chirico's painting *Seer* (an important work also illustrated in the first edition of *Surrealism and Painting*) is a mannequin with an encircled star in the middle of its forehead: this single "eye" signifies clairvoyance. As a six-pointed star (the "Seal of Solomon") it symbolizes the conjunction of consciousness and the unconscious and alchemically the principle of the immaterial (curiously akin to the function Descartes attributed to the same spot), as well as supports the claim that "the world of dream and of reality are only one" (p. 70), views reinforced at the end of the section through a quotation from the mathematical physicist Henri Poincaré on the subjective dimension of reality. Ironically, the quotation came from Lenin's book, where it is treated with supercilious contempt.[202]

6. *Passion and Fatal Loss.* The only illustration to chapter 2 of the book is of Moreau's watercolor *Delilah,* in the Luxembourg Museum, a work that, as Breton says, "for 15 years has constantly fascinated me." Together with an epigraph – "A lady I had loved for a long time and whom I called by the name of Aurelia, was lost to me" (Nerval, *Aurelia*) – this painting sums up his pain and anger at the loss of Suzanne (The "X" of *Nadja*). A variant on Nosferatu's fatal love, the painting clearly represents the theme of decapitation/castration: Samson's head lies near the center of a round plate identical to the one on which John the Baptist's head is served to Salome, or that

carries Orpheus's head in other paintings by Moreau; Delilah holds up the pair of scissors; and her eyes look coquettishly at us, while Samson sleeps. At the outset Breton explicitly states, "I was moved during this period, as far as I can tell, by the disappearance of a woman, whom I will not name, at her request." A contemporary has pointed out that chapter 2 sums up the emotional difficulties experienced by Breton and others during the spring of 1931.[203]

The whole chapter is strewn with coincidental occurrences, fragments for a potential melodrama around the sexually fascinating and castrating Delilah, whose upright form props the reclining victim's body, ominously cut off by the frame: there are repeated allusions to someone named "Samson" (Breton receives in the mail a favorable review of the Second Manifesto by someone named "Samson," who happens to be a long-forgotten acquaintance); Breton encounters a girl whose eyes he associates with those of Moreau's Delilah; finally, a reminder of Samson (and his story) by a girl casually encountered in a café who looks closely at his hair, and – recalling Suzanne's rejection and his sexual embarrassment as well – expresses a certain distrust at its length.[204] Delilah's eyes are of paramount importance in all this – Breton on many occasions stated or implied that for him a woman's eyes were her most sexual feature. The power projected onto Delilah's fascinating eyes gains a destructive leverage both from the contrast with the closed eyes of Samson and through the displayed shears. After a series of further encounters all tinged with the Samson/Delilah association, Breton perceived that he was seeking to substitute a collective woman for the real one he lost. Thinking of the relation of dream to action, he recalls admired poets who committed suicide (Mayakovsky, Vaché, Rigaut), but finds their solution worse than the problem. As we shall see, Breton will subtly pursue in two other paintings the theme of male power either turned back upon itself in

onanism or transmogrified into the power of the blinded seer.

The attempt to console himself for Suzanne's loss takes the form of intellectual sublimation: he turns to Engels's *Origin of the Family* and digresses into discussions of the evils of monogamy and – echoing the theme of the one-armed bandit – of Engels's idea of objective chance as opposed to classical causality in matters of love and art. He struggles with the idea of chance encounters and random distractions, and wishing to triumph over such sexual satisfaction without love, he announces a Hegelian negation of the negation (as though in a belated response to Suzanne's rejection) and declares that his one possibility to recover the being he has lost "consists in going from [her individual] being to [her collective] essence." Perhaps with a touch of hypocrisy he then wanders the streets picking up girls as he used to with the intellectual gang of his youth, while disclaiming the pleasure: "I detest this sort of activity." (In 1954 he criticized a contemporary play that seemed to him to suggest promiscuity.) He concludes chapter 2 with a rousing call to men to solve the problem of the commercial degrading of love (prostitution) by "the sweeping away of the capitalist world" (p. 137).

The third and final section seeks to effect an accord between the poetry of dream and the reality of Marxist socialism as practiced not in France but in the Soviet Union – partly because remoteness diminished the visibility of Soviet flaws. Ignoring the energetic criticism in French periodicals from 1930 on of the Stalinist version of Leninism, Breton failed to grasp Lenin's perversion of Marx's notion of the "dictatorship of the proletariat." In fact, he pays a fashionable tribute to the USSR as uniquely successful in overcoming "the exploitation of one class by another" (p. 141).[205] However, in concluding the book, Breton empties the "vase" of political and social discourse and fills the "vase" of poetry and love: he quotes from Nadja in the epigraph

to chapter 3 and concludes the chapter with a paragraph on the poet of the future. In the epigraph, Nadja announces to Breton: "You will never see this star as I see it. You do not understand: it is like the heart of a flower without a heart."

7. *Daylight and Nightlight; Building and Cave.* Breton is portrayed in the photograph "In the 'Ideal Palace' of the Postman Cheval (1931)," anticipating perhaps the crystal house of *L'Amour fou.* Breton reveals his intimate rapport with the subject by enclosing his image in the space, as he had done before in his famous self-portrait (wearing makeup) before De Chirico's *Enigma of a Day* (where a raking light cast over his features aligns the chiaroscuro in and out of the painting, thus coordinating Breton's space with that of the picture). He complicates the meaning of the photograph by situating himself partly inside and partly outside the Palace's mysterious portal.[206] Cigarette in hand, the critic Breton turns his head away like a distracted Cerberus, a poetic Sphinx guarding the irregular biomorphic pile of Cheval's Palace and – like Ingres's famous Sphinx – stands in the light before a cavernous shadow.

Breton's mediating position in the photo repeats the theme of the communicating vessels in the first illustration, the movie still of the convulsed Nosferatu disintegrating in the light at the window (Breton in "Recherches sur la sexualité" (January 26, 1931), said he "would love to be a vampire");[207] moreover, in both images the loved one is missing. But in contrast to the dying vampire, Breton concludes on the optimistic note that there can be a regenerating contact between the two worlds; for, as expressed in the last paragraph of the book:

The poet of the future will overcome the depressing thought of the irreparable divorce of action and dream.... The poet will rise up in protest against this overly simple interpretation.... Then the poetic operation will be car-

ried out in broad daylight.... [Certain men] will not hail a beautifully colored precipitate as a miracle each time they succeed in obtaining it by mixing, in doses more or less involuntarily calculated, the two colorless substances that are existence submitted to an objective connection of beings, and existence concretely escaping this connection. They will already be outdoors, mingled with the others right in the sun, and no gaze will be more understanding and more intimate than theirs when Truth comes and shakes her hair streaming with light at their dark window. (pp. 170–1)

(Compare this oxymoronic phrase with the "Night of the Sunflower.") Breton's vision of himself as it were turning around in the Platonic cave to face the sun without blinding, of creating a synthesis of action and dream, of love and life, persisted almost down to World War II. Of course, much of this amounts to an erotic ontology – a world to be filled by the missing lover – and the program for political action amounted to a digression, particularly ineffective in the poisoned political climate of the thirties. In fact, he achieved his most powerful realizations elsewhere, in the domain of poetry and love – and in the images and forms that incarnated them – that became the subject of Breton's last major novel, *L'Amour fou.*

L'Amour fou

The sanguine prediction concluding the *Vases communicants* had little chance of fulfillment, as just noted; indeed, its subjective underpinning would have obstructed that fulfillment. The ambition to mediate between individual love and Socialist solidarity, between Surrealist art and Communist ethics, faded in the mid-thirties, a time of disenchantment and frustration. Breton centered his next novel, *L'Amour fou,* on a love at once passionate and cool, offering a utopia of desire not merely to replace bourgeois banalities, but to shore up the faltering sense of purpose in the Surrealist

avant-garde. He still lay under the pall of his traumatic loss of Suzanne Muzard, even at this greater distance, and he still felt insecurity and a need to work out the painful memory: consequently the impassioned poetry and the political excurses in this novel constitute efforts to come to terms with that trauma.

Evolving out of the convulsive beauty of *Nadja* and the *Vases communicants,* this novel presents as its subject climaxes of ecstasy that are in and out of time (*hors du temps*) and that allude as much to death as to life and as much to desire as to love.

The first image, a photograph by Man Ray called "Explosante-fixe," shows a whirling fandango dancer caught in such a way that we cannot make out her face or that it even represents a woman (all we recognize is one of her raised arms). Certainly Man Ray has succeeded in finding the still center of an exploding vortex, much as he had done in his closeup of a sunflower, in which the configuration of petals around a stamen resembles that of arms reaching from a hairy center.

The photo acquired its title from the crucial definition at the end of chapter 1: "Convulsive beauty will be erotic-veiled, exploding-fixed, magic-circumstantial or it will not be (at all)." Obviously this refers to the disjunctive correlative proposed in the last words of *Nadja:* "Beauty will be CONVULSIVE or it will not be." The sentences differ: the earlier looks toward creating the entity of convulsive beauty as the consummation of a sexual union with Suzanne, whereas the later assumes this entity but makes its realization contingent upon having three attributes. This difference, I believe, corresponds to the change in Breton's fortunes and to his ongoing search for a woman to share the experience of convulsive beauty.

Breton returns here to fin-de-siècle Symbolism; for those moments of frozen intensity – what one might call convulsive *tranches d'amour* – are represented by images uniting biological growth and mineralogical form, summed up in Breton's favor-

ite image of the crystal, particularly as "crystallized" on a film. And we find the crystal among other places in Gide's Symbolist *Traité du Narcisse* (1891): "For the work of art is a crystal – a partial paradise where the Idea flourishes in its superior purity.... Such works only crystallize in silence" (p. 25).[208]

The second photo in the book – by Brassaï – of crystalline cubes concerns Breton's "praise of crystal" for its hardness, rigidity, and regularity, for the luster on all its facets, exterior and interior, and especially for being paradoxically the perfect expression of "spontaneous action." The photo in particular illustrates this text: "The house in which I live, my life, what I write: I dream that all that might appear from afar the way that cubes of rock salt appear close up" (p. 17).[209] The crystal – in stark contrast to the French scientific view of the crystal – was also important in connection with transparency and light, characteristics of the Great Transparents, phantoms that signified a sort of secular angel.[210] Breton's association of the crystal with sentiments of love and desire recalls the image of the crystal in the writings of Romantics like Stendhal and Vigny, and the early Gide.

"Crystallization" as the site where arrest and motion, time and the timeless intersect, inheres within the key notion of convulsion:

> The word "convulsive"... would lose in my eyes all sense if it were conceived in movement and not precisely at the expiration of the movement itself... convulsive beauty can only be achieved through affirming the reciprocal relation linking the object in movement and the object at rest. I regret not having been able to provide as an illustration to this text a photograph of a very fast locomotive that has been abandoned for years to the untouched forest. (p. 15)[211]

Curiously, the Surrealists found the paradox of arrest in motion (which the Dadaist Tzara also noted) already articulated by the eighteenth-century idealist

philosopher Berkeley: Boiffard, Eluard, and Vitrac in their joint preface to *La Révolution surréaliste,* no. 1 (December 1924), quoted Berkeley's remark, "The idea of movement is above all an inert idea," and they appended an oxymoron – "the tree of speed."[212] (Perhaps – as stated earlier – Breton's reading of this preface and Lenin's *Empiriocriticism* with its allusions to Berkeley brought him to the fountain text of *Nadja.*) One might compare this to the painter Dominguez's notion (somewhere between lithography and photography) of "lithochronism," or "the solidification of time," much appreciated by Breton in "The Most Recent Tendencies in Surrealist Painting" (1939). Breton finds magic in "this monument to victory and disaster,"[213] and perhaps also a reminder of the alchemical transmutation of metals from soft to hard and from base to noble. In seeking to expand the associations to *amour fou,* Breton made important and innovative use of photographs; in *Nadja* no photographs accompanied the text about convulsive beauty.

The photos concern Breton's quest to fill the void he still felt, to turn his dreams into something tangible, and they have more to do with sublimation than with the fetish (an obsession of Bataille and his admirers who fault Surrealism for not dwelling on the fetish). Indeed, what the photos have in common is their visualizing of processes of metamorphosis whereby form emerges from the formless or concreteness from the vague – all this achieved through what I would call the alchemy of the Surrealist photograph.[214] The capturing of forms in motion and the crystallization of objects in transformation turn the temporal into the spatial and make possible a romantic triumph over a painful reality and the escape from his unsettling memory (of the loss of Suzanne) within the framework of a sublimating *hors du temps.*

The photos in different ways reveal these motifs: the motionless whirl of Man Ray's dancer; the vital process of ossification in the Great Barrier Reef; the discovery within a mandrake root of an episode from Virgil's *Aeneid* (the figure of Aeneas and his father carried by him); the streets of Les Halles, where his eyes pass from "magnificent cubes" to "the pavement with its gleam of horrible garbage" – merchandise dumped by the truckload at night; the half-formed structure of the Tour Saint-Jacques under a scaffolding as tenuous as that of an Analytic Cubist painting; the "amphibious" figure of a nude swimmer under water (Jacqueline), whose head and breasts are clear, but whose legs blur into the depths; bunches of roses crowded next to one another, overgrowing the florist's stall at night – a strange bouquet offered to "the unknown woman, the woman to come"; a shoreline whose edge is lost under sand and plants; a building with dark windows on large, solid white walls set above a shadowy mass of trees crowded into the lower half of the photo – the "starry chateau on the edge of an abyss"; the sad reality of war, with lively children playing among the signs of death – buildings ruined during the Spanish Civil War; and the last illustration (discussed later), a photo of a sand-clock by Man Ray. The few paintings illustrated make the same point: there is a soft-focus painting of Picasso's Blue Period; Ernst's *Garden Airplane Trap* (modeled perhaps on the praying mantis),[215] in which vegetable forms nest "seductively" within a loose structure of slats luring machines to their destruction; and the *Maison du pendu,* a work of Cézanne (an artist usually rejected by Breton, who like Picabia judged him superficial), whose presumed "halo" of a hanged man fascinated Breton.

Three photos concerning a statue of Giacometti's in progress, *Mains tenant le vide (l'objet invisible)* (Figure 17), are of great relevance to Breton's quest for a new amorous adventure. At the very beginning of chapter 3 (which we might call the "Giacometti chapter") Breton cites familiar phrases about the proverbial shadow and prey, emphasizing that one must not *"allow the paths of desire behind one to become covered over with bushes"* (p. 38).[216]

produced paintings on the subject of invisibility, notably *The Invisible Man* (1929–33), an androgynous figure reaching out to us with hands as prominent as those of Giacometti's figure, and also the painting *The Invisible Sleeper* and the book *The Visible Woman* (both of 1930).

Giacometti's statue seems to offer, like the poetry of the Romantics Browning and Hugo, a rebuff of possessiveness and grasping:[217] this creature – one of Giacometti's last Surrealist sculptures – with its predatory grasp and features of a praying mantis, anorexically feeds on nothing, thereby suggesting the futility of its gesture. It also may have suggested to Breton his erotic void and his painful and empty-handed search for a new love; presumably he empathized with Giacometti's struggle – like a modern Pygmalion – to render femininity: the statue apparently "resisted" the artist's efforts to make it concretely feminine and to endow it with specifically human features. (Other objects that were found in a flea market and that have to do with Giacometti and his statue also bear on Breton's anxious quest and will be discussed later in the section "Surrealist Objects.")

The blank inhumane expression and the sense of a void toward which the figure reaches remind us that Giacometti's standing figures will soon evolve toward those groups of nearly fleshless verticals – parallel personnages devoid of human convergence – that seemed to Sartre consonant with the Existentialist dialogue between Being and Nothingness.

Man Ray's photograph titled "Explosante-fixe"[218] may be considered the "crystallization" of the potential motion of a cinematic frame into a "pregnant moment" – before the image was "fixed."[219] It suggests, too, the convulsion of a sexual climax and the photographs of the *attitude passionnelle* of Charcot's hysterics shown in *La Révolution surréaliste* in 1928. Conversely, one might observe that Breton based his idea of the crystal "on its definition by Hegel as 'the moment when the

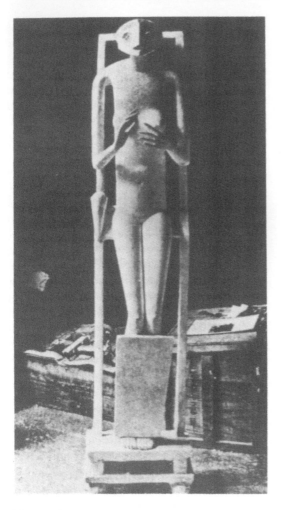

Figure 17. Photo of Giacometti's *Mains tenant le vide* (*l'objet invisible*), *L'Arc*, no. 37.

Then he turns to a statue, a *construction du personnage féminin* by Giacometti of which he says he "never lost interest in the progress of this statue which from the very first I considered to be the very embodiment of the *desire to love and to be loved* and in a quest for its true human object of which it is painfully ignorant" (p. 40). The statue's title cited by Breton – *Mains tenant le vide* (1934) – or "Hands Holding the Void," bears homonymic resemblance to *Maintenant le vide,* or "Now the Void." Another title of the piece, perhaps the original, was "The Invisible Object." Giacometti – and Breton, who knew the work of both artists – seems to owe much to Dali, who earlier

restless activity of magnetism attains complete rest,' which is in fact the prototype of hard and radiant beauty, the beauty of 'explosante-fixe.' This proves that the convulsive nature of this new beauty depends on a whirling motion and not on a grimace."[220] In terms of the photo, the fandango dancer's head and body mingle with the dress and lose their human delineations in the whirling motion, and recall both Renoir's description of Delacroix's sketches for his *Lion Hunt* as "bouquets" and representations of Loie Fuller lost in her swirling skirts (e.g., Toulouse-Lautrec's lithograph); but Man Ray's image has undergone a strange metamorphosis into another sort of creature and belongs with Picasso's discovery of a bull's head in a bicycle seat and handlebars.

The photo by Man Ray captioned "An endless trickle of milk dripping from a glass breast" illustrates the concluding chapter dedicated to Breton's daughter Aube. The glass spheres or "breasts" that hold the sand are placed one above the other and are open at top and bottom to permit the sand to flow as in an hourglass.[221] In its allusion to endless time (the chapter also discusses the word "forever" and the phrase "a long time") and to the flow of "milk," the caption makes implicit allusion to the domestic crisis in which his wife Jacqueline, apparently without giving him notice, had left husband and child on September 6, 1936, and gone off to Ajaccio.[222] Breton, hitherto (and after) opposed to the engendering of progeny, had allowed Jacqueline to convince him they should have Aube; but now, deserted and anxious, he could no longer make this last chapter a testimony to their joyous *amour fou.* Instead, he might have had in mind Nietzsche's "the eternal hourglass of existence."[223]

The last chapter of *L'Amour fou* reveals a less theoretical and more personal aspect of the problem of the family than in the *Vases communicants,* which tried to rise above his own sufferings as a lover (the loss of Suzanne) to the broad sociopolitical vision he saw in Engels (the notion of the future of love freed from economic necessity). Now Breton, having discovered a replacement for the lost Suzanne (Jacqueline), represents his own predicament as a father, an unwilling "bachelor" (as in Duchamp's *Big Glass*) obliged to replace an absent mother, and also lays claim to equality with Jacqueline in nurturing (his image of a glass breast suggests a milk bottle to replace for Aube the absent breast of the mother). Perhaps in his resentment he even dreamed of a male version of parthenogenesis; indeed, in an earlier passage of the book he wrote that it is "impossible not to associate the idea of mother's milk and that of ejaculation."[224] (One must be careful not to exaggerate the significance of the androgynous character of these images and to take them with too heavy-handed a seriousness: Breton did not suffer Bataille's obsessions, and he always retained a sense of humor about social intercourse.)

SURREALIST OBJECTS

Breton's article "Phantom Object," discussed earlier, was one of several in issue no. 3 of *Le Surréalisme au service de la révolution* devoted to the production of Surrealist objects that were intended to excite sensations of desire and lead to an expansion of the field of the imagination. Dali wrote "Objets surréalistes: Objets à fonctionnement symbolique" (which included an object by Breton), and Giacometti wrote "Objets mobiles et muets," which he illustrated with seven drawings. We have already suggested that Dali's *Great Masturbator* may have contributed to the conception of the "silence" object. Perhaps Breton (and Dali as well) was aware of a well-known lecture given in Paris in 1929 linking sexual disequilibrium to masturbation.[225] In an aside Breton comments on the erotically provocative objects of Dali and claims that he considers them actually less stimulating than ordinary objects found by chance, which have a special, latent meaning comparable to that of his *enveloppe-*

silence – for example, the hanging gold leaves that separate at the approach of an electrostatically charged stick, which "help to inspire in children a passion for the study of physics."[226]

In its efforts to render the dream concrete Surrealist painting turned from abstraction toward a plastic figuration that deviated from beaux-arts academicism by techniques that recall the characteristics of Freudian dream interpretation: distortion, bizarre juxtapositions and doubling of objects, and irrational arrangements of perspective, lighting, and atmosphere. Such techniques could add to the element of subversion that the Surrealists attributed to some painting.[227] A three-dimensional figure really signified for Surrealism what one might call a phantom one wants to touch like the hallucinated girl in Taine's story. With the right lighting, photography (still life, the figure), which could look "sculptural" in its hallucinating concreteness and plasticity, without the laborious bulk of actual sculpture, came close to offering a solution to the problem (one might compare this to recent holograms and electronic "virtual reality"). Dali, dedicated to creating "handpainted dream photographs," composed a photomontage mainly of heads to illustrate sexual ecstasy.[228]

The objects displayed in Man Ray's photos belong to a class of symbolically functioning objects produced by the Surrealists in the thirties. Such objects acquire value from their exposure of raw sexuality or aggression unearthed from the unconscious, as opposed to the presumably conscious procedures that yielded a pleasing and relaxing *objet d'art*. The latter, valued as a product of human hand, is defined as the "work of man, to whose value artistic merit contributes the most."[229] Before Surrealism antiaesthetic artists like Duchamp had slyly subverted both "work" and artistic merit, for example, by playing on the *objet d'art* in an *objet dard* that has the aggressive value of a primitive projectile, and long before the photos for *L'Amour fou* Man Ray made curious assemblages and photo-

graphed them. A catalogue of antiaesthetic objects made by Futurists, Dadaists, Russian Constructivists, and Surrealists would easily demonstrate aggression against the tradition of fine art and its place in bourgeois society.[230] There is a continuity between this refusal to allow their objects to serve an aesthetic use and the moral stance of the Romantic critics – either the autonomy of Gautier's *l'art pour l'art* or the animism of a Gérard de Nerval.[231]

Objects found or significantly encountered could acquire a mysteriously symbolic function. This occurred in *L'Amour fou* with regard to the metal mask (provided to soldiers in World War I to protect their eyes, as Breton later learned, but which Breton compared to the masks worn at a ball) and a wooden tablespoon made by some peasant with a slipper carved into the end of the handle. Both were acquired in a flea market by Breton accompanied by Giacometti. Breton associated them with Giacometti's statue *Mains tenant le vide*, on which he was then working. Moreover, each had special relevance to Breton's search for a new love, since Breton attributed to them roles in the story of Cinderella, discovered by the prince at a masked ball – and lost. The prince then searched his kingdom for her and identified her through the glass slipper that she'd left behind at the ball and that fit only her foot. Breton recounts a phrase that came to him on waking, a few months before finding the spoon-slipper: "the Cinderella ashtray," which so gripped him that he asked Giacometti to make a piece based on that phrase. Giacometti never did, and Breton says that "the *loss* of this slipper, really experienced, caused me on several occasions to have long daydreams, concerning which I believe that I find traces in my childhood." Loss and ash (echoes of the "death" of Suzanne's love) both link Cinderella to death, as Freud had done in his article of 1913 entitled "The Theme of the Three Caskets" (in *Standard Edition*, vol. 12). The alliteration of "le cendrier Cendrillon" fits the homophony of "pantoufle

en vair" (the slipper made from squirrel fur of Perrault's fairy tale) and "en verre" (glass). Breton appreciated the "euphonic ambiguity" of "vair" and "verre" (perhaps he also considered "envers" and "en vers") that led to the popular and well-known mistranslation that converted a fur slipper into a glass one.[232] Breton indicated the sexual intent of all this in a long analytical footnote added in 1934 in which he states: "My thought started from the objective equation: slipper = spoon = penis = perfect mold for this penis."[233] (The idea of the sexually charged slipper may owe something to Dali, who produced an *Object of Symbolic Function* in 1931 containing a series of images of women's shoes.)[234] Clearly these objects suggest fetishes, but the play on meanings is too consciously literary and psychoanalytic to warrant speaking simplistically of Breton's "fetishism." The straight-on angle of the photographs of the two objects also has nothing of the provocative raking angle of the photos (Boiffard's, for example) used by Bataille for *Documents.* The latter conform to the viewing angle of Freud's fetishizing patient, who as a child looked up and was fascinated by the "Glanz auf der Nase."[235]

The Surrealists rejected the figural aesthetics of sculpture – the beauty or drama or monumentality of the human figure – even as evolved by modernists (Brancusi; Cubists like Lipchitz, perhaps with the exception of Gonzalez):[236] from among those working in solid materials they approved only of the small, witty pieces of Arp and the nightmarish objects of Giacometti. Evidently the medium with its demands of conscious craft and long and patient preparations was ill-suited to the representation of dream imagery and antithetical to the scribbles of automatism. Consequently, the idea of an automatic sculpture never came up;[237] nor did the Surrealists attempt to translate the "plastic solitude" of the mannequins or statues in De Chirico's paintings into sculpture. Small and portable collages like the *poème-objets* of Breton were better suited to convey the peculiar union of intimacy and the shock of disjunction produced by bringing unrelated things together. Hence, too, the appeal of ready-made solid objects (like mannequins, dolls, toys, and obscure tools), incongruous collections of things juxtaposed by chance, and the myriad objects "found" anywhere from flea markets to beaches.

Years after these objects were produced or assembled Breton gave his version of the steps leading to them:[238] Duchamp's objects of 1916, Breton's own proposal to make objects in his *L'Introduction au discours sur le peu de réalité* (1923), and Giacometti's constructions of 1930. Breton's account (see later for Crevel's earlier observation) does not do justice to the range of pieces or to the prehistory in the twenties of Giacometti's mobile objects. One would have to consider film and photography and even modern sculpture. After the rotoreliefs of Duchamp, the films of Man Ray and Picabia displayed objects in unusual motion, and Léger's *Ballet mécanique* (1923) invested inanimate or abstract forms with a "personality" and set them into suggestive intercourse with one another.[239] During the twenties Miró studded his landscapes with "personnages" whose paths of movement he designated by lines of dots or dashes; and a few years later Magritte envisaged skeletal creatures in suspended motion like prehistoric pterodactyls (similar to the creature in Giacometti's *The Palace at 4:00 A.M.*), Tanguy explored the "life of objects," and Buñuel and Dali represented the slicing of a woman's eye in *Un Chien andalou.* By 1930 Calder was setting those little toys into motion that Duchamp called mobiles. This corresponds to what Breton had in mind when he remarked in *Surrealism and Painting,* "One day, perhaps, we shall see the toys of our whole life, like those of our childhood, once more." The "toys" of Bellmer – those violently distorted *Poupées* – remained an exception marginal to the Surrealist approach but attractive to some recent critics.[240]

Giacometti was the first to find a way to

transform his sources in collage and painting into a plastic version of Surrealism. Breton shared with Bataille an enthusiasm for the new work of Giacometti of the early thirties in which solid forms, often in wood, seemed caught in a movement winding up or expended. The potentially cyclical movement of these inanimate but troubling figures suggested an endless sadistic ritual like Lautréamont's operating table and sewing machine.[241] It is more than a coincidence that Giacometti approached Surrealism soon after the appearance of Breton's idea of convulsive beauty. Perhaps the early pieces of Giacometti already embodied this idea, which was passed on to other Surrealists.[242]

The same issue of *Le Surréalisme au service de la révolution* contained illustrations of Giacometti's drawings of anthropomorphic forms with sexual and aggressive gestures and an article in which Crevel summed up the aim of these objects: "The Surrealist objects . . . make love." (He might have qualified it as "sadistic love.")[243] After citing Breton's "beauty will be convulsive or will not be," Crevel quotes Hegel:

> "The true is the bacchic delirium in which all the participants (*composants*) are drunk and since each participant by placing himself apart from the others immediately dissolves, this delirium is at once simple and transparent."
> . . . Transparence that reveals and protects the liberty of images, which play, but not at hopscotch; for the verb play (*jouer*) is no longer the poor relation, the mere doublet of the verb enjoy, have an orgasm (*jouir*), since Breton, in the Epoch of Sleeps said: "words at last make love."
> The Surrealist objects (whose idea originated in an animated sculpture of Giacometti) also make love.[244]

Arp, after a strong Dada period, created objects that hovered on the border of Surrealism, but his playful genius (like Klee's) refused to conform even to the loose program of the "omnipotence of dream." Both artists later diverged from Surrealism: Arp turned to biomorphic abstraction and Giacometti, as already noted, to an expressionism in which the ambient void makes cancerous incursions on the flesh of isolated standing figures.

Breton, who had no interest in modern sculpture, chose to ignore in this context the production of pieces made by Surrealists, or by those near them, that, despite their strangeness, exhibited a degree of formal coherence. Though such pieces – including the biomorphs of Arp or the configurations of Miró – belong to the history of sculpture in a way that the Surrealists' "symbolically functioning" objects do not, they could, of course, also evoke "unconscious" thought. This touches on an important, neglected issue – the incorrect assumption implicit in Surrealist writing that there is one Unconscious, generally resulting from processes of repression. In fact, other paths can lead to an "unconscious" not necessarily as troubled and charged with the sexuality and aggression as the one Freud and the Surrealists explored – other versions of the dream (Jung, the Australian bushman), complex mathematical thinking (Henri Poincaré, Einstein), the imagination of some abstract artists (Abstraction-Concrétion), the chance actions of the Dadaists, the proposals of other "Surrealists" (Goll, Max Jacob), or the "optical unconscious" (Walter Benjamin).

Perhaps the most characteristic objects produced by the Surrealists (though not the best known), notably by the poets, were, apart from the symbolically functioning objects already discussed, the *objet-poèmes* that draw on very diverse phenomena: the collage poems of the twenties, the calligrammes of Apollinaire, rebus puzzles in popular magazines, and hints from psychoanalysis (condensation). Breton made a number of them with amusing texts and unusual imagery, and from this potpourri of different moments past and present Breton, much like the non-Surrealist poets, attempted to forge a psychic continuity. This amounted to fulfilling his vision of the "(h)or(s) du temps" – a site where percep-

tion and memory meet, and where the image *déjà vu* becomes a *souvenir-trouvé;* that is, the place where the object once met becomes in memory the phantom of an *objet-retrouvé.*

We can partly understand Breton's desire to make subjective coherence out of external objects through a remark of Hegel about a man who

> satisfies his need to make external to himself the subjective feeling of something higher, essential, and universal, and to contemplate it as objective. In this unification ... the single natural objects ... are not accepted just as they are in their separation, but, lifted into the realm of our ideas, acquire for our ideas the form of universal and absolute existence.[245]

Breton only partly subscribed to Hegel's view; for he constantly thought about but could not unequivocally accept the notions of the higher and the universal: his desire at once to enter and to get out of time has shown us this ambivalence. This relation to time appears above all in the *rêve-objets.*

In 1935 Breton made one such object,[246] while intensely involved with Jacqueline Lamba. Breton offered this description of the object:

> A *judas* put into the last door (*porte*) lets us catch a glimpse of the solution to the enigma: a water fountain speaks: "It's I, the water – (*l'eau huppée*)!" (Let us note in passing that the joyous note of this last exclamation clarifies the earlier condemnation in the dream of the o with a circumflex accent, an o whose *huppe* is turned upside down, an o falsely hupped.)[247]
> Nothing is more manifest than the persistence of the idea of water throughout the representations that I made one after the other in the interiors of the five rooms: edge of the carpet in the corridor, green color of an houppe, view of an animal in a mirror, sound of the vowel O, quotation of Lautréamont, Neptune, etc. My poem "L'Air de l'eau" had just been published and it is the very person who inspired it [Jacqueline

Lamba] who offered to stage the present dream according to my indications.

The piece contains a detail representing the fountain from *Nadja,* thereby associating Nadja's fountain and Jacqueline's swimming act (a photo of her swimming illustrates *L'Amour fou*); and because Jacqueline actually helped Breton realize the piece, she came closer to him than Nadja could despite the ecstatic moment of their union represented by the fountain. Thus, with this object Breton finally closed the door on the Nadja story – as his affair with Suzanne had prematurely promised to do.[248]

THE EXHIBITIONS

The objects that the Surrealists made eventually reached a larger public through gallery exhibitions (Galerie Pierre Colle, Galerie Surréaliste), which ever since the twenties, served as a kind of manifesto, as in the days of Futurism and Dadaism. But collections of admired artworks from the beginning had been displayed in the writers' studies, in the artists' studios, or at the Centrale. These exhibitions had an informality very distinct from the businesslike order of the regular gallery entrepreneurs. And the big international exhibitions that they put on in the thirties also defied the Cartesian architectural regularities of commercial display: their settings were not intended to seduce customers into buying, but to unsettle them. Duchamp was a past master of such installation – for the exhibition at the Galerie Beaux-Arts in Paris, 1938, he suspended right over the viewing spaces a simulation of heavy and threatening sacks of coal; and for the "First Papers of Surrealism" in New York, 1942, he stretched twine at the level of the paintings, offering a cobwebby encumbrance to the visitor.[249]

Duchamp's exhibition designs, along with his early Dadaistic constructions like the ambiguous doors that open by shutting and shut by opening, seem to suggest a

Surrealist formula for "architecture," but Duchamp's conceptions remained those of a painter working in a two-dimensional space (his objects were workups of schemata or verbally generated wit). Tzara, with his usual flair for the pertinent shock, wrote an interesting article in 1933 that could serve as a program for a Surrealist architecture. Using catchphrases from psychoanalysis (especially Rank's formulations about prenatal sensation), Tzara advocated an intrauterine architecture of "prenatal comfort" as opposed to the "aesthetics of castration" of functionalist architecture.[250] It remained for Frederick Kiesler, compatriot of the Austrian Hundertwasser (a painter who imagined fantastic architecture), to realize a Surrealist "architecture." Of course, the Surrealists did not intend to modify space or structure for normal use: they roomed in antiquated buildings "haunted" by former inhabitants and dreamed about "found" spaces like the old arcades, while ignoring the new, like the Eiffel Tower (that Apollinaire's generation of modernists admired). Kiesler, hostile to normal functional architecture, preferred the liberties admissible in stage design: in 1924 he staged two plays bordering on Surrealist fantasy, Goll's *Methusaleh* and Tzara's *Mouchoir des nuages,* whose set was conceived as a closed space.[251] The latter anticipates his unique egg-shaped room for the Hall of Superstitions at the "International Surrealist Exhibition" (1947). His architectural vision culminated in the biomorphically shaped Endless House (1958–9). The seamless continuity of the closed spaces conveys a sensation of claustrophobia as though one were walking through an eerie womb elongated like a labyrinthine intestinal tract with sphincter windows and doors.

The exhibitions show how little interest the Surrealists – working with subjective scale and perspective – had in large easel paintings – and they had of course even less in mural decoration. Their brochure, "Il faut visiter l'Exposition Surréaliste," for their exhibition of June 1933 proposed a list of the items exhibited, mainly small ones, that were produced by their *recherches expérimentales:* "Disagreeable objects, chairs, drawings, sexual organs, paintings, manuscripts, objects to be sniffed . . . intrauterine memories . . . ear perversions . . . atmospheric spoons, pharmacies, failed portraits, breads, photos, tongues." (The knowing spectator would have picked up the allusions to the work of Dali, Duchamp, and Man Ray.) Perhaps in the years when big meant propaganda for the regimes of Hitler, Stalin, and Mussolini, making small works served as protest, a mark of independence, or at least as a manifestation of distaste for the magniloquent. The megalomaniac Dali in those years usually went along with making small canvases, but with ironic distortions, as in his panels of over-life-size personalities like Lenin and Hitler. (An exceptionally large painting of 1933 on the William Tell theme provoked the Surrealists by mocking Lenin.)

In 1936 the Surrealists set up three major exhibitions – in Paris, London, and New York – all of which included a rich variety of objects.[252] Breton published a commentary on the Paris exhibition, "Crisis of the Object," in *Cahiers d'art* (May 1936).[253] In it he claims that the growing dominance of conventional, systematic, and rational thought poses a threat to the imagination in art and science. Breton's preface to the catalogue for the "Surrealist Exhibition of Objects" held at the Galerie Charles Ratton in May 1936 concludes: "These objects are particularly enviable in their sheer power of evocation, overwhelming us with the conviction that they constitute the repositories, in art, of that miraculous charm which we long to recapture." The Ratton exhibition included an astonishing number and range of things – "natural objects," "interpreted natural objects," "interpreted *objets trouvés,*" mathematical objects, and so on. But the real emphasis in the exhibitions was on consumption and sexuality: the edible works of Dali, and the hit of the Ratton show, Meret Oppenheim's celebrated *Luncheon in Fur* or *Fur-lined*

Teacup, which blazoned to the world an image of fashionably fetishistic obsession (see Chapter 5, this volume).

During the years when he associated with Dada, Breton publicly declared that the medium of painting was passé, and his later defense of Surrealist painting did not quite conform with the aim of the Marxist years to change the world materially as well as morally. During the thirties he seemed to favor three-dimensional objects over two-dimensional images even as he preferred photographs over lengthy verbal description. Photography, on the border between image and object, deserves renewed discussion.

PHOTOGRAPHY

Photography and its relation to painting entered our discussion earlier in this chapter. But the preceding section introduced a different question – the relation to objects – one important enough to warrant consideration; for the ability of the photograph to simulate an object seemed so convincing in the twenties that the public often equated the photographic image and the object. But its importance for Surrealism went beyond its astonishing realism that had seemed for decades to have marked the death of representational painting.

In an early essay on Ernst (1921) Breton seems to suggest that photography rather than painting is linked to automatic writing:[254]

The invention of photography [Breton also alludes to film] has dealt a mortal blow to the old modes of expression, in painting as well as in poetry where the automatic writing that appeared at the end of the nineteenth century is a real photography of thought.[255]
... The belief in an absolute time and space seems ready to disappear. Dada does not present itself as modern. It considers it useless also to submit to the laws of a particular viewpoint. ... But the marvelous faculty ... of bringing together two distant realities and to produce a spark from their rapprochement, of bringing within reach of our senses abstract figures ... and, by depriving us of a frame of reference, to confuse our own memory – that is what for the time being holds its attention.

Further, in another pre-Surrealist essay, "Characteristics of the Evolution of Modernism" (1923), he states:

[Ernst] takes as critical a look as Man Ray at the new conditions created for the plastic arts by the introduction of photography, and he winds up with an almost total subjectivity, which no longer even respects the general idea of the object, and actually affects how we see the external world.
Man Ray, after whom we will no longer have to concern ourselves about painters, can above all pass for a photographer, in the sense that he has quite often chosen to express himself with this modern instrument, and, if I may dare say so, revealing [*révélateur* means both an adjective (revealing) and a noun (photographic developer)] instrument – sensitized paper.[256] The mystery of the photographic print is intact in the sense that the artistic interpretation is reduced in it to a minimum. I admit, strictly speaking, that one might take a relative interest in the arrangement on a table of some fruits or that one might find beauty in a bunch of keys.[257] That's no reason to paint them, and how grateful I am to Picasso for giving up painting, and for fabricating for his own amusement little objects out of sheet metal and bits of journals! Man Ray, by a process of his own, gets a similar result on a piece of paper.

Breton's exaltation of photography did not survive the years after the manifesto, and by 1935 he credited photography chiefly with dealing a decisive blow to realism, so that painting could turn to "pure mental representation." In 1938 he even characterized Man Ray as a painter rather than as a photographer.[258] Moreover, together with the two essays just

mentioned he published two others (on the painters Derain and De Chirico), which did not dismiss their medium; and in the arguments concerning a Surrealist painting, photography, while important, was not the main subject. Neither Breton nor the other Surrealist writers themselves bothered to take their own photographs (they relied on experts, a concession to craft they generally abhorred), though they often made collages and photomontages; and they preferred to discuss painters and painting rather than photographers (except for the photographer-painter Man Ray) and photography. Nevertheless, photography (and cinema) had a profound importance for Surrealism (as it had for the Bauhaus and other movements), and not only as illustration.

As a complement to his discussion of Ernst and photography Breton turned to the work of Man Ray, who achieved results comparable to Ernst's by "stripping (photography) of its positive nature, forcing it to abandon its arrogant air and pretentious claims."[259] The Surrealists had long admired the photographs of Man Ray, and after the twenties they found increasing value in his photographs as illustrations of their books and journals. Probably with Man Ray in mind Breton asked the rhetorical question, "When will all the books that are worth anything stop being illustrated with drawings and appear only with photographs?"[260] One must not exaggerate the importance of the question: he chose Man Ray for being not exclusively a photographer, but also an "outstanding painter" able to "assign to photography the exact limits of the role that it can legitimately claim to play." Among the rich variety of photographic techniques Man Ray employed none seems more important than his photomontages, mingling pieces of his photographs with other objects; for example, the eyes in a "portrait" of "Monsieur... Inventeur, Constructeur, 6 Seconds," are a photograph of breasts with "eyes" scratched over the nipples, and a fragment of his photograph "Tears" (1930)

is placed in a complicated Surreal photomontage of objects reproduced as a colored frontispiece for *Minotaure*, no. 3–4 (December 1933).[261]

Man Ray was admired by Breton for turning photography away from positivism, but he did so as a post-Dadaist, with wit and inventive manipulation (his portraits, which focus on the face and homogenize the background, belong in a category apart) – and with none of the Surrealist ideas of the unconscious. Like Duchamp he penetrated into dark regions of the mind by pushing his *consciousness* to the limit. The concept of a photographic unconscious emerged in the late twenties from an unexpected quarter: Dali. Before becoming a Surrealist, Dali, a well-informed reader of Surrealist literature, perhaps in response to Breton, wrote on photography as the "pure creation of mind" and called photographic fantasy "more agile and faster in discoveries than the murky subconscious processes!"[262] And in February 1929 Dali declared, "The mere fact of photographic transposition means a total invention: the capture of a SECRET REALITY. Nothing justifies Surrealism better than photography."[263] One has only to look at the dramatically deforming lighting in the photographs of Art Nouveau sculpture and architectural decoration to see the origin not only of some of Dali's most florid images (his insectoform Metro entrances), but of many photographs by Surrealists like Man Ray.[264]

Dali's remark about a secret reality reminds us of the manifold potential of photography. Its notorious ambiguity with regard to the "real" provided Surrealism with weapons for the subversion of middle-class (and ironically their own) complacency. The photography practiced on or by the middle class – in advertising and as a hobby – was a means of preserving and celebrating the past. Surrealist photography was intended not only to confound positivism and normal mimetic expectations, but, as what I would call a "psychophotography of everyday life," to reveal

to the viewer hidden aspects of the obvious.[265] Such photography attempts to look past the manifest to the latent on the model of a psychoanalytic exploration of the unconscious.

Surrealism shared with abstraction a denial that art was essentially a transcription of perception for a mimetic end; hence, for the Surrealists the eye could either go "blind" (automatism: art as kinesthetic rather than visual perception) or attend to the invisible (dreams, the visions of mediums like Helen Smith and *voyantes* like Nadja). The constant "listening" for new content made the formulation of a visual style irrelevant and uninteresting. Instead what one finds are family resemblances and overlaps like those described by Wittgenstein.

Walter Benjamin, after Freud and the Surrealists, formulated (as noted earlier) the idea of the "optical unconscious," which he applied to both cinema and photography, as follows:

> We thus understand how the nature that addresses the camera differs from the nature that addresses the eye. Above all different because in place of a space elaborated by consciousness, it is a space elaborated unconsciously that intervenes.... We know something of the optical unconscious only owing to the camera, in the same way that we only know something of the instinctual unconscious owing to psychoanalysis.[266]

Benjamin seems inadvertently to have picked up hints about the connection between psychoanalysis and the optical unconscious from Freud, who, in discussing the relation of perception to memory in the *Interpretation of Dreams,* already characterized the perceptual system as unconscious.

The Surrealists found a use for photography not only for its mechanical "unconscious" but for a certain temporal ambiguity: a photograph could be considered either as a single piece, a "still," or as a moment of a potential cinematic sequence.[267] Film meant a dreamlike procession of silent images in a darkened theater (the talkies restricted the Surrealists' ability to conjure up sounds and to project their own thoughts onto the screen); and in viewing films they liked to converse during the showing, as well as to walk in after the beginning and before the end so as to savor special photographic moments deprived of their intended narrative significance. Their own films proceeded like a psychoanalytic dream account with a series of graphic images that succeed one another in a stream of associations. In some cases Surrealist writing may have influenced cinematic images.[268]

The photograph conceived as a still, as a static image with potential for movement, allowed the sense of being at once in and out of time. No one has given a more relevant account of this paradox in terms of the cinema than Barthes (who radically contrasts film and photograph), although he does not refer to Surrealism in this context: "The 'movement' regarded as the essence of film is not animation, flux, mobility, 'life,' copy, but simply the framework of a permutational unfolding and a theory of the still becomes necessary."[269] Barthes's theory of the still bears directly on Breton's "(h)or(s) du temps," which would transform the "pregnant moment" of events into a complex essence at once beyond the fluctuations of time and immersed in it – for example, in photomontages illustrating the novels of Breton and the poems of Eluard, in the collage novels of Ernst, in paintings like Dali's *The Persistence of Memory* (1930) with its petrified watches capable of telling biological rather than mechanical time, and in the work of Oscar Dominguez, who as mentioned earlier invented in 1934 *lithochronie,* or the petrification of time.[270]

In Surrealist book illustrations the photograph-as-still suggested the "genius loci" of a site or implied that it was a moment in a *flâneur's* trajectory through the city. This conception of the cinematic still, as we have seen, links Surrealist photography to the notion of "timeless time" (the *hors du*

temps). A discussion in the periodical *Minotaure* in the thirties raised the question of the object's "presence" in art, which bears on Barthes's and Derrida's discussions of presence in photography.[271]

Once again old questions persist: Can the time of school schedules or work routines be transferred to the time of the street or of the studio? Can the photograph signify a "pregnant moment," a framed slice of life (or dream?), as the Surrealist window metaphor suggests spatiotemporal continuity, a secular transcendence of the immediate? As we began to see in the discussion of the photographs illustrating *L'Amour fou,* questions of photographic time seem to lie close to the center of Surrealist thinking about perception and prediction, presence and absence, as well as convulsive love.

POLITICS AND SURREALIST ART

No less vexing than the question whether a Surrealist painting could exist was another one that emerged later: Could Surrealist art convey a "revolutionary" content or at least be relevant to the Revolution, without compromising its own values? The Surrealists tried to answer this question by taking a radical stance toward the art world and rejecting all forms of bourgeois art, including modernism, which they considered as much a commercial enterprise as the fashion industry. The Surrealists did not criticize modernism from the *retardataire* perspective of Stalinist Social Realism: Surrealist visual art emerges within and against the context of modernism, above all rejecting the planar coherence and architectonic purity of classic Cubism.

These antitheses to modernist claims to purity and autonomy, and the verbal allusion to a world outside the picture frame, became a constant feature of Surrealist art, especially during the thirties, and were intended to produce an unsettling response in the sophisticated viewer: the breaking up of space without abstract restructuring or synthesis served as a metaphor for irreality;

its strange and grotesque imagery was meant to subvert the pleasure and calm of middle-class beauty; and the awkward doodling or collages of the poets (Desnos, Breton, Eluard) repudiated concern for craft. These gestures share a "figurative metaphor" for artistic subversion.[272]

The Surrealists believed implicitly that somehow the image had an intrinsic potency, that one could affect the viewer through the visual material, that one could *changer la vie* with art as well as with poetry. Admittedly, critics who regard Surrealism as a literary movement, and theorists quick to transmute objects into ideas, would deny significance to the relation of verbal and visual texts to image and reality. Some of these writers choose to ignore figurative painting because of its subject matter;[273] others regard as absolute the gap between the products of Surrealist fantasy and the real conditions – social, psychological, and material – in which they arose.[274] Indeed, the role of the image seemed utopian and deceptive even to some of the Surrealists themselves – for example, to Aragon, and not just after he adopted the pedestrian position of Socialist Realism. This book has attempted to show that such denial fails to do justice both to the political and moral significance of Surrealist practice as opposed to Socialist Realism and Fascism, and to the intense emotional (and "political") life embedded in those texts.

Up to the mid-twenties the shock of Picasso's work and the provocation to dream of De Chirico's painting (and later of the art of Masson and Ernst) seemed in themselves adequate examples of Surrealist art. After the mid-twenties the Surrealists intended to affect society by sending out some form of political message in which criticism of bourgeois society was coupled with optimism and a utopian vision (and in which they sought, without acknowledging it, their own equilibrium and fulfillment). The turn after 1930 to the active and overt politics of the Communist Party generated the need for a more elaborate rationale that could support the claim

for the social relevance of their unusual imagery. However subtly and indirectly, this certainly affected the nature of the art they appreciated and produced. Yet they always provoked critics from the Left to dismiss them for having no positive political message; above all, they never convinced the party of the relevance of their art to the needs of the unsophisticated Communist workers.

The paradoxical stillness in motion in Surrealist photography mentioned earlier, coupled with the Surrealist collages or assemblages of *disjecta membra,* or fragments of reality, and a fascination with sadistic imagery, suggested to some critics of the Left that Surrealism had mostly to do with death and unfreedom. Thus, the Frankfurt school critic Adorno (whose critical view of Surrealism was mentioned earlier), writing in the thirties, claimed that "the dialectical pictures of Surrealism are those of a dialectics of subjective freedom in a situation of objective unfreedom.... Its montages are the true still lifes. Inasmuch as they arrange the archaic they create *nature morte.*"[275] He also maintained that "Surrealism is anti-organic and rooted in lifelessness."[276]

Adorno's criticism, however much it misses the humor of Surrealism, indicates an important feature of the thirties: thoughts about death preoccupied the Surrealists like many in the French Left, perhaps reflecting their grim and defeatist mood when, after the Nazi Reichstag fire, the confused and divided German Left was crushed (the Stalinists offered noisily militant rhetoric while increasing the fatal confusion), and the French Communist Party followed the Stalinist line and let the situation evolve without firm engagement. It became increasingly clear that the USSR was guided not by Communist principles but by pragmatic political concerns; for example, the pacifist policy of the thirties was a propaganda maneuver.[277] Blum's Socialists failed constantly to take decisive positions about Fascism, and their United Front with the Communist Party (strongly approved by Trotsky) was doomed to failure, since the Stalinists joined the Socialists with the intention of destroying their party and absorbing its members. What Adorno misses is that the Surrealists refused the hypocritically optimistic and promotional imagery about land, production, and fertility, manufactured alike by the bureaucracies of Stalinist-Leninist Russia and Fascist Germany and Italy.

Not surprisingly, in the mid-thirties, sadistic and morbid fantasies like those of Dali recurred among the Surrealists. A series of articles appeared in *Minotaure* that brought into contact notions about a version of the Freudian death instinct and mimesis (especially insect mimicry and simulation), drawing on the writings of artists, anthropologists, psychologists, and entomologists. The problem of rendering believable as well as marvelous the phantoms and invisible beings that obsessed them made the issues of simulation and the simulacrum along with fetishism and magic highly relevant to the Surrealists and those near them who wrote for *Minotaure.*[278] In 1933 Lacan described a "fundamental tendency" associated with the creation of poetry and of style that he called " 'repetitive identification of the object': the delirium produces ... doubles and triples of the same persons, sometimes with hallucinations of doubling or tripling of the delirious person."[279] (Eventually Lacan applied a more elaborate analysis to Dali's paranoiac imagery.)[280] And A.-M. Petitjean, "Analyse spectrale du singe," discussed in 1935 the "dialectic of resemblance and imitation" and concluded: "The ape before the mirror does not recognize itself: if it were to do so, that act that belongs properly to Narcissus would at once metamorphose it into a human being. Man, capable of representing death, infinity and himself, is an 'ape that laughs.' "[281]

The growing importance of psychological and parapsychological concerns of the Surrealists in the mid-thirties corresponded to the dwindling possibilities for a meaningful revolutionary politics. This

condition is manifest in the bewildering hodgepodge of objects the Surrealists now put before the public (discussed earlier) and their taking over of a periodical conceived by their "enemy" Bataille.[282] At this time propaganda and fashion publicity appear to converge, especially in the mass spectacles of totalitarian leaders. Surrealism, which once mainly attracted an elite audience of savvy collectors, was now the rage of the haut monde. In the work of the artists approved by the Surrealists one hardly finds more comment on the political tensions in Europe than one would find in abstract art; but they registered their anxieties in nightmarish imagery, and their fantasies of depersonalization and cannibalism in images of insects.

The anxiety about loss of individuality that intensified so strongly during the thirties had roots in the development of the middle class in France from the nineteenth to the twentieth century. Insect imagery cogently registers that loss. The image of the bee, long a symbol of industry and light (contrasted by Swift to the spiders of poisoned sloth and darkness) suggested the beehive to the 1848 Revolution. The early Third Republic, caught up in industrial and economic progress, made the cogwheel the symbol of work; and in the 1830s Victor Hugo could write in *Les Contemplations,* "I have told words: Be a republic! Be an immense anthill and work!"[283] But the militantly nationalistic Europe of the thirties concerned itself chiefly with political rather than economic questions, and a new collectivist image dominated – the robot, uncanny simulacrum of the human worker. Assimilated to such a mindless group, even the bee falls from favor; Ortega y Gasset, in the prologue to his *The Revolt of the Masses* (Madrid, 1929), states, "Europe is really a swarm, many bees on a single course." Particularly in Germany, those shaped by classical culture recoiled before the loss of individualism; and the humanist Panofsky sarcastically referred to the mass idolization of dictators as "insectolatry," a metaphor real-

ized with particular clarity in a film of 1939 *The Sun Never Sets;* an eccentric scientist presumably resided in a British colony in Africa to study the behavior of ant and bee colonies; in fact, the "science" served as a cover for his political machinations. By secretly dispensing propaganda and mind control through a powerful radio transmitter and by achieving economic hegemony through cornering the market on several strategic minerals, he hoped to become a world dictator. When challenged by two Englishmen of the ethics of absolute power, he argues from analogy by comparing insect to human society (to the advantage of the former): totalitarian colonies by ants have an ideal political organization conducive to a productivity unimpeded by the confusions and contradictions inherent in liberalism and democracy. No wonder that, according to the biographer Albert Zoller (*Hitler privat* [Düsseldorf, 1949]), *der Führer* dreamed approvingly of the future as a "termite state."

Wilhelm Reich called the rigidity of individuals under Fascism "character armoring," a form of emotional chiton, and similar analyses of the Fascist personality were made by the psychoanalyst Fromm and later by members of the Frankfort school. In 1934 Brauner painted *The Strange Case of Mr. K,* a caustic satire on the uniformed body of the middle-class Fascistic patriot, which Breton praised as being superior to "an art of supposedly revolutionary propaganda." In general, he described Brauner's paintings as "armed . . . always celebrating the latest episode in a street-battle, etc." In 1936 Lacan described the mirror stage in terms of "armor."[284]

In France in 1933 a psychoanalyst sympathetic both to the USSR and to Surrealism could – like the more radical German psychoanalysts before him – announce the advent of a new collective phase to psychoanalysis.[285]

The Surrealists, contemptuous of the "softness" within the shell of middle-class morality (analogous to Communist contempt for the "pinks"), depicted several

kinds of insects, including the female praying mantis, notorious for its nuptial habits. No one thrived better in this climate than Dali, who relished arthropods with hard shells over pulpy insides (ants, crustaceans) and who elaborated a humorously reductive "morphological aesthetics of the soft and hard."[286] Tanguy, who exhibitionistically ate live spiders – perhaps savoring the succulent interior as Dali did that of crustaceans – produced soft melting forms against hard rocks in *Promontory Palace* (1930) and *The Armoire of Proteus* (1931). Kafka earlier expressed the idea of a soft and delicate subjectivity encased in a disgusting vermin's chiton in *Metamorphosis*.

But the praying mantis held the most significance. In 1934 Caillois published his article "La Mante religieuse," part of a larger study of "the mechanisms of overdetermination in automatic and lyrical thinking, and the development of affective themes in individual consciousness."[287] In his Dalinian connection of sexuality and nutrition Caillois alludes to oral aggression and teeth, as well as Freudian analyses of castration and masturbation, and cites Freud's *Interpretation of Dreams*. He also mentions Dali's "paranoiac-critical study of the Angelus of Millet" in *Minotaure*, "an impressive and complete document on the relation of love and cannibalism."[288] Caillois treats the mating habits of insects with pronounced anthropomorphism: he makes significant parallels between "the habits of the mantids (which he calls "a feminine android") and "human anguish in the face of love," drawing on texts by the poets Baudelaire, Mallarmé, Breton, and Eluard, but not by Symbolists Rémy de Gourmont or Maeterlinck.[289]

The most familiar insects such as ants or bees exist in colonies maintained by hordes of seemingly identical workers; hence, they have often served as a metaphor for the working class and its "associations" (as the French workers in the nineteenth century called their organization). The image of the productive bee appealed to the Saint-Simonians, whose working-class journal called itself *La Ruche populaire*.[290] Breton, who hoped to restructure the community so as to eliminate bourgeois competition, found in Fourier the congenial concept of a new organization of production through association, which did not entail a submerging of artists and intellectuals into the working class.

But the Surrealists of the thirties exhibited the old ambivalence of middle-class intellectuals before the collective mentality of organized workers: their paradigm was not the productive pollen-gathering bee, but the individualistic, solitary female praying mantis, an aggressive carnivore and cannibal that devours the male at the very moment of intercourse.

A mood close to resignation and echoing the pessimistic political outlook of the mid-thirties pervades Caillois's discussion of nondefensive mimicry and its relation to cannibalism in 1935. Rather than recalling the simple and successful military use of camouflage during World War I suggested by Cubism, he based the study on Dali's "assimilations of the animate to the inanimate":[291] "The simulation of the leaf being a *provocation* to cannibalism in this kind of totem feast" (p. 7), and he speaks of an "instinct of renunciation" (p. 9, apparently inspired by an earlier article on sleep and the death instinct).[292] Caillois states that "morphological mimicry could then be, after the fashion of chromatic mimicry, an actual photography, but of the form and the relief, a photography on the level of the object and not on that of the image, a reproduction in three-dimensional space with solids and voids: a sculpture-photography or better *teleplasty*" (p. 7).[293] Breton expressed his disdain for the mimetic (bourgeois or Social Realist) as a socially defensive maneuver in a contrasting pair of object-"heads" Jacqueline and he made in 1936 – "The Great Paranoiac" and the "Petit Mimétique." An accompanying text by Claude Cahun explains: "In our present society we are not all of us always able to make ourselves ductile, good conductors of liberating forces, and sometimes we are

surprised that we have a closer resemblance to the *pétit mimétique* than to the *great paranoiac.*"[294]

In 1935 Breton's *Position politique du Surréalisme* clearly defined the Surrealists' break from the French and Soviet Communist Party, thereby releasing them from whatever constraints they still felt toward the party. This rupture corresponds to their concern to set up larger exhibitions and to show internationally. The Surrealists up to 1935 had mounted several small exhibitions, mainly of work by the group in Paris.

Without the context (however tenuous or even unfriendly) of the French Communist Party, the Surrealists no longer had a coherent social "platform" from which to oppose bourgeois society. They retained the old slogans "revolution" and "liberation," but they became increasingly utopian and anarchic: the Marxist-Leninist notion of an ascending social "progress" measured by material indices lost its grip; thus, for a preface to the catalogue of the "Surrealist Exhibition of Objects" in 1936 Breton cited Heraclitus: "The path towards the heights and the path towards the depths are identical." Thus, the dream of Marxist Communism yielded to that of Fourierist utopianism and – another side of the collectivist zeitgeist of the thirties – to "collective myths" (concerns shared with Bataille and Leiris's *Collège de sociologie*). Breton knew of social utopians in the nineteenth century who had already formulated the idea of a myth of collectivity internalized and projected into dream and poetry. By 1920 Breton, in "Giorgio De Chirico," could exclaim: "I think that a true modern mythology is now forming. It rests on Giorgio De Chirico to fix the memory of it imperishably." And in 1926 Aragon defined myth as "a reality and necessity of the mind... the road of consciousness, its moving platform."[295]

Shocking the bourgeois art consumer increasingly carried no more than an aesthetic intention. In fact, the public reached by the Surrealists, once a homogeneous, culturally sophisticated group, had, through the popular press and advertisements not exclusively addressed to the haut monde, expanded to the point of diffuseness. Ambivalent – wanting both to change or at least to reach the larger society and to create for an informed public – they engaged simultaneously in "occultation" through esoteric doctrines and in more and larger exhibitions and increased publications during the thirties: in 1935 in Belgium and Spain, and in 1936 in England, Surrealist periodicals calling themselves "international" were founded. And their influence now extended beyond their own journals: from the mid-thirties on their antics (especially Dali's) became items for the newspapers, and important periodicals like *Cahiers d'art* carried articles by and about the Surrealists. This erstwhile radical movement, whose critique of bourgeois society was largely perceived as simple irrationality, now became a paradigm for high- as opposed to "middle-brow" fashion.[296] They were not unhappy with the comparatively modest format of periodicals, and they generally exhibited small paintings in small galleries: introspective landscapes viewed as through a peephole occupy much less physical space than perspective landscapes viewed as through a telescope. They often made their political points indirectly through manifestations and through their comments on exhibitions put on by others; for example, in May 1931 they protested the chauvinistic and commercial values promulgated by the big colonial exhibition held in Paris. As a critique of French capitalism's exploitation of colonial "slave labor," they circulated a manifesto, "Ne visitez pas l'Exposition Coloniale" (see Chapter 5, this volume).

Running consciously against the tightening grip of militant nationalism, the Surrealists held large international exhibitions – in London (1936), Paris (1938), Amsterdam (1938), Mexico (1940), and New York (1942). In his introduction to the catalogue

of the first of these, the "International Surrealist Exhibition" held in London in June 1936, "Limits Not Frontiers of Surrealism," Breton presented a view that was at once revolutionary and international (a view that had repercussions decades later).[297] It contains a valiant effort to recover a revolutionary position free of Stalinist dogmas (the theory of Communism in one country, the priority of production, Socialist Realism), but unfortunately, like the other exhibitions, its high-minded intention went unperceived by most spectators.[298] Breton insists – in the face of the Stalinist Third International – on the integrity of the international revolutionary effort in Spain and praises the revolutionary acts of the French proletariat; he asserts that "as Marx and Engels have proved, it is absurd to maintain that it is only the economic factor which is decisive in history, the determining factor being 'finally, the production and reproduction of life itself.' " Despite this expression of sympathy, Breton did not actively participate in the Spanish Revolution; however, he did join with the few high-minded intellectuals (including old opponents like Bataille, Jacques Baron, Jacques Prévert, and Gérard Rosenthal alias Francis Gérard, and the recently disaffected Eluard) and signed the declaration of August–September 1936, "The Moscow Trial: Appeal to Men" (as distinguished from "Comrades"), which demanded that the truth of the accusations against the Old Bolsheviks should be examined impartially and publicly. And in a lucid statement (mainly written by himself) that he read at a meeting of September 3, 1936, addressed to "Comrades," he proposed a fundamental shift of revolutionary goals, declaring that the watchword "Defense of the USSR" should be replaced by that of "Defense of the Spanish Revolution." Eluard did not sign this time, but joined Ernst, Aragon, Desnos, and Tzara in sending from Barcelona a "telegram of congratulations" to the USSR for its role in the Spanish Civil War.[299] On January 16, 1937, in Paris Breton addressed a "discourse à propos the Second Moscow Trial" in which he explicitly defended Trotsky against Stalin.[300] Eventually Breton came to see the trials in Jarryesque terms as *humour noir*.

Without radical politics on their horizon the Surrealists adopted theoretical if not utopian positions culminating in that last stand of individual liberty, the artist not tied to artistic or moral conventions. Breton, in *Situation surréaliste de l'objet* (1935), defended the liberating quality of avant-garde art (meaning mainly Surrealism), a point others made for abstract art (Mondrian, Kandinsky; later Gorky). Breton drew the line at decorative abstractions or the elegant figural art of Matisse (intended to please the "tired businessman"). Explaining how photography made obsolete the artist who faithfully represented "reality," he writes:

> The only domain which the artist can still exploit became that of pure mental representation, insofar as it extends beyond true perception, without for all that turning into hallucination. . . . What is important is that the recourse to mental representation (without the physical presence of the object) provides, as Freud said, "sensations having a relation to processes unfolding in the most diverse, indeed in the deepest layers of the psychic mechanism." In art, the search, necessarily more and more systematic for these sensations, works toward the abolition of the ego by the id, and consequently tries to make the pleasure principle dominate ever more clearly over the reality principle. The search tends more and more to free the instinctive impulses and to break down the barrier raised before civilized man, one which the primitive and the child do not have to face.[301]

One might be reminded here of the totalitarians' barbaric appeal to the unconsciousness of the masses against the mind of the individual; but the similarity is deceptive, for Breton retained the high-minded goals of international peace and

removal of barriers to freedom – goals directed against the inhumanity of the dictators (Hitler, Mussolini, Franco, Stalin). Still, one must wonder how seriously he meant to integrate his values with the uninhibited desires of the id. The failure despite his passionate verbal support to join the Loyalists and fight in Spain against the Fascist Franco points to a certain moral confusion. The excuse that he could not bear being separated from his daughter Aube overrode the moral commitment to solidarity with the Loyalists that he had subscribed to in manifestos.

Breton's failure to respond publicly to Picasso's *Guernica* is another act or lapse that one can best explain from personal motives. One would have expected enthusiasm on the part of Breton's group for Picasso's *Guernica,* whose grotesque figures at least conform to the ideological spirit of Surrealism. Although Breton knew the work – he and several others had visited Picasso's studio to see the painting in its early stages – there is no mention of it in Breton's article of 1961 on the artist that gives as the dates of Picasso's "Surreal" work "1923 and 1924 ... from 1928 to 1930 ... 1933 ... 1935 and, more recently, 1943." Doubtless at first glance one could account for the elimination of *Guernica* on grounds of form and content, Picasso's creation of a coherent composition out of a chaos engendered by brutal and aggressive forces. Contrary to Surrealist irrationality Picasso subordinated the centrifugal forces of destruction within a triangular form resembling a classical pediment, and the whole work suggests, however vaguely, moral indignation. Moreover, its commemoration of a specific event in a monumental size was alien to Surrealism.

More important, I believe, were personal and political associations of *Guernica* repugnant to Breton during the years when it was conceived, finished, and exhibited. The Stalinist Aragon, Breton's ex-colleague, had, with Josep Lluis Sert and Lluis Lacasa, "asked [Picasso] to paint a mural for the Spanish Pavilion" in Decem-

ber 1936 and January 1937.[302] Eluard, who had definitively and virulently broken with Breton in April 1936,[303] got very close to Picasso after 1936. He wrote "The Victory of Guernica" in 1937 while Picasso painted his monumental work. Eluard's poetic response to a real event was for Breton's Surrealists as unacceptable as Aragon's politically motivated poem "Front rouge" had been. However, cut off from the bureaucratic Left and repelled by the chauvinist Right, they had no political outlet that suited their needs.

After the great disillusionment, Surrealism, while constantly rejecting political forms of totalitarianism, emphasized internationalism with renewed vigor, as we have seen, and, with the default of the Third International (and with little interest in the Trotskyist Fourth International), placed its hopes in a chimerical international proletariat. More pertinently, the Surrealists fought against nationalist restrictions on art. Breton, always more sympathetic to modern art than to Social Realism, signed an open letter on August 7, 1937, to the Fine Arts Administration that had organized in the Jeu de Paume an "Exposition d'art international indépendant" in which he questioned the exclusion of major foreign artists, for example, some of the Russian Constructivists and Italian Futurists.[304] Then, in a collaboration surprising to some observers between Trotsky, the advocate of reason, and Breton, the advocate of the irrational, on July 25, 1938, there appeared over their two signatures the famous tract "For an Independent Revolutionary Art," which calls for the formation of a "Fédération Internationale des Artistes Révolutionnaires Indépendants" (FIARI), and which concludes with the slogan: "The independence of art – for the revolution; the revolution – for the definitive liberation of art."[305] Trotsky wrote to Breton on December 22, 1938: "The struggle for the ideas of the revolution in art must recommence with the struggle for artistic TRUTH, not in the sense of this or that school, but in the sense of the UNSHAKABLE FAITHFUL-

NESS OF THE ARTIST TO HIS INNER SELF."[306] Trotsky's appeal to the artist's individuality and probity as a resource against overwhelming political forces would have had greater moral cogency if he had not continued to insist on the old Leninist dictatorship of the proletariat. Moreover, the existence of an artist's "self" had become increasingly problematic among socially conscious intellectuals in France, one of the signs that middle-class culture (echoing the collapse of the Weimar Republic) had become a void between political forces moving left and right away from the center.

SIGNS OF THE TIMES IN LATE SURREALISM

The anxiously democratic world of post-war reconstruction in the twenties mingled desperate pessimism and chimerical optimism. In such a world "shock" had a different ring to it as compared with the paranoid thirties.[307] In the face of destructive hegemonies on the Left and Right the Surrealists, disillusioned with radical collectivism, reverted to their youthful sympathy for anarchism. Insisting on the rights of the individual against a monolithic bureaucracy, they made artistic freedom their major platform. Unfortunately, this position was anathema to younger contemporaries, bent on defeating Fascism: radical intellectuals (including the politically "engaged" Existentialists) in general allied themselves to the Communist Party and paid lip service at least to Social Realism. Even old companions among his own generation turned away from what seemed an idiosyncratic opposition: Aragon had long gone over to the Communists, and by the forties Eluard and then Picasso joined him.

By the thirties Surrealist shock and scandal had become less effective to middle-class audiences through their familiarity. Frustrated politically, the Surrealists arranged fashionable exhibitions, castigated diverse injustices by govern-ments on the Left and Right, and above all explored mythologies to replace the "God that failed" (Communism).[308]

In an interview of 1948 Breton responded affirmatively to a question about the relation of Surrealism to myth, utopia, and the "tradition initiatique," suggesting that even dialectics might come from that tradition, that Trotsky had concluded that Marxism might be a utopia, and that Surrealism had always remained true to itself, drawing on occultism while involving itself with Marxism. (He insisted, however, that the Surrealists used the occult without becoming mystics.) By the fifties Breton spoke even more rarely of the "materialist" (in contrast to the Hegelian) aspect of dialectics;[309] moreover, having relinquished hope for a historically specific program, he asserted – without the nuances of *hors du temps* – the "timelessness" of the movement: "[Since] at its origins Surrealism dedicated itself to the codification of a state of mind which has sporadically appeared in all periods and in all countries, one can no more assign to Surrealism an end than a beginning."[310] The energies and ideals of the avant-garde had not disappeared, but had become submerged within the new needs and impulses of younger rebels.

For the Parisian avant-garde the most significant result of pre- and postwar socio-economic developments was the weakening of the centrist Socialists and Liberals (the anti-Fascist United Front): bureaucratic extremists on the Left and Right divided up the liberal center between them and fought to shape the lumpen forces of the proletarian "mass," a process described by a humanist as replacing "wholeness" with "totality."[311] To ward off the demise of humanism in the United States and Europe scholars insisted on education based on an unchanging curriculum; but diverse factors undermined the classical, patriarchal, and conservative or reactionary legacy of "man the center (and measure) of all things,"[312] still preserved even in Sartre's existentialist humanism: the

demands for recognition of various non-Western "minorities," the increasing calls by feminists and gays to share power and visibility, the "death of the author," and the upward invasion of the mass consumer. Surrealism contributed a lasting legacy for intellectuals disaffected with the institutional supports of realism, humanism, and rationalism – which still thrived in France even among Marxists.[313] In doing so, they proposed sadistic variations on the romantic imagination: the exquisite corpses, metamorphic creatures like the Minotaure (a model of creative destruction), anthropomorphic insects, and acephalic monsters of both genders.[314] Foucault summed up the whole catastrophe of humanism in the famous prediction concluding *Les Mots et les choses* of 1966: "Man will be erased, like a face drawn in sand on the edge of the sea."[315] In this "zero degree" of the political and social values of avant-garde intellectuals, little was left beyond irony, absurdity, or the quest for a mythical artistic freedom. At the center from which the human figure had been banished appeared an emptiness as described by Derrida in 1967: "the unnamable, bottomless well whose sign the center was."[316]

Pushed aside by the torrent of political events driving toward world war, Breton, as we have seen, increasingly emphasized the artist's freedom as a model of social liberation. During World War II that liberation became very abstract, divorced from politics: at best Breton broadcast for the Voice of America. Most of the "official" members of the group fled to the United States, where they existed marginally, uninvolved with the Anglophonic population.[317] However, unknown to Breton (who failed to acknowledge them after the war) some young adherents of Surrealism remained heroically in Paris between 1939 and 1945. After the war and even after Breton's death in 1966 the Surrealists continued to write and publish social commentary, largely from a somewhat cloistered position that emphasized artistic and scholarly matters. Breton himself sent out mixed messages

about the role of writing, on one hand demanding its autonomy, on the other urging a form of linguistic terrorism (in the words of Paulhan) intended to break down institutional conventions:[318] Breton, who had long insisted that the message rather than the form counted, stated (1928) that "the revolutionary significance of a work, or quite simply its significance, should never be subordinated to the choice of elements that the work brings into play."[319] In an essay on Ernst (1942) he designated the emphasis on the artistic signifier at the expense of the message as fetishism, and expressed his uneasiness about the pervasive contemporary faith in fetishes: "The absolute limit has been reached in the domination by the symbol of the thing signified." He thinks that contemporary poets and artists like Ernst are creating a new signification that makes "a clean break with everything that simply profited from external marks of veneration or respect."[320] Breton's words registered his bafflement and dismay precisely at a time of confusion about "the thing signified." He wrote them after the Moscow Trials had besmirched and beclouded the vision of a revolutionary future and during World War II, when totalitarianism threatened individual expression.

Breton was also tempted after the thirties by abstraction as a vehicle for the authenticity of the artist's expression. Usually, to achieve that authenticity the Surrealists either painted a vaporous deep space in "oneiric perspective" filled with ominous figures (Tanguy) or drew the flat scribbled mesh of automatic writing that suggested scrambled figural associations. But flatness could also approach surface decoration in some artists in their circle; for example, Miró sometimes verged on losing his fantastic content in abstraction. Breton also found authenticity in art deviating from the "normal": the "insane," "seers," and children produced signs that could serve as vehicles for the "transmission of a message . . . that remains obscure." He describes the signs of characteristics of this art as

the absence of perspective, the extraordinarily minute and at first glance aberrant detail... a primordial instinct for symmetry, an extreme complaisance towards decorative patterns and, above all, the knack of conveying a definite impression of contiguity with works of Far Eastern or pre-Columbian American origin. This last characteristic... endows the medium's plastic work with a quality of *sacredness* which is conspicuously absent in almost the whole of the rest of modern art production.[321]

In an essay entitled "The Art of the Insane: Freedom to Roam Abroad" (1948), he defends the seemingly paradoxical claim that "the art of those who are classified as mentally ill constitutes a reservoir of mental health.... Through an astonishing dialectical effect, the factors of close confinement and the renunciation of all worldly vanities, despite their pathetic aspect in terms of the individual, together provide the guarantees of a total authenticity which is sadly lacking everywhere else."[322]

In certain remarks by Ernst in 1925 and in Dali's paranoiac criticism after 1930 Breton discovered a basis for appreciating irregular configurations, whether produced naturally or as blots by artists following Leonardo's prescription. But this acceptance of the nonrepresentational blot did not mean that he approved of abstract art; on the contrary, he always fought against the claims that some abstract artists made to offer a purely formal alternative to a despised and chaotic reality – for example, the international exhibition of abstract art organized in Paris in 1930, and titled "L'art réaliste et l'art superréaliste (la morphologie et la néoplastique)."[323] The Surrealists, as we have noted, fought especially against the formalist line that passed from Cézanne to the Cubists.[324]

Breton strained to discover a content in the "abstract" artists he valued: he admired Kandinsky not for his color but for his "philosophical undertones," Gorky for creating "a great gateway open on to the analogical world," and he even found a

"naturalistic significance" in Mondrian.[325] In fact, Breton welcomed the Rorschach "psychodiagnostic" because he believed that as a union of psychoanalysis and the Gestalt "theory of form," it was applicable to abstract art and could refute the "exorbitant claims" for autonomous form by "so-called abstract painting." He described in 1936 a technique, which seems to combine features of Rorschach's ink blots with Ernst's frottages, that he admired and himself practiced.[326] He claimed that by pressing gouache between sheets of paper anyone could create marvelous landscapes at will that express the creator "in the most personal and valuable way": "What you have before you is not, perhaps, the old paranoiac wall of da Vinci, but it is the wall *brought to perfection*."[327] Perhaps Breton would have acknowledged as a "perfect wall" the graffiti inscribed in 1968 on the university walls in Paris.

CONCLUSION

In 1966, the year of his death, Breton and his followers expressed skepticism concerning the value of political revolution for the artist: "The independence of art has in large measure been established. The independence of the artist... is a matter of personal conduct; it measures clearly the revolutionary will of each person. What counts for us is less the idea of a Revolution that we may very well never see than the justification of our own existence in our own gestures."[328] However, two years later, the Parisian student uprisings reignited the old enthusiasm for political revolution. Indeed, only during the 1968 student rebellions did Breton's followers find a vital issue capable of rousing them to action, however belated and slight, and they were thrilled to discover that their old anti-institutional slogans became relevant once more to the radical youth who took to the streets. The students' graffiti seemed like reincarnations of automatic writing and drawing projected onto the walls of Paris,

Figure 18. Marcel Arnac, caricature, *Le Rire*, no. 271 (April 12, 1924).

or like adolescent defacements of political posters (see Figure 18, in which "Votez" becomes "Rotez" [Belch] and "Urne," the voter's ballot box, becomes "Urine"), and, as noted in Chapter 2, many of their slogans recalled those of Surrealist flyers of the twenties and thirties.[329]

Like the Surrealists, the students intended their slogans and drawings to affect the spectator – encouraging the students, unsettling the educators and administrators of the establishment. The gra[...] these students smeared on t[...] an element of Surreali[...] spite their awkwar[...] expression, th[...] liberation and e[...] belief that writin[...] nificance. Like the[...] seem to have pr[...] century version of th[...] cal idea of the world [...] that impressed Derrida[...] this case is Paris, and [...] universities are signs to [...] ents of their intellectual confineme[nt] (like Fou-

cault's hated "discipline") against which the Surrealists had already fought; hence, rewriting the biblical "Mane Mane Thecal Upharisim" in quasi-Surrealist terms, the youths filled the walls with their slogans. As though repeating the Surrealists' revolution against literature, their barbaric *écriture* replaced the literature offered within the academic walls. One of the many cogent posters that were circulated demanded the replacement of a bourgeois by a popular university (a concern continually raised throughout the nineteenth and into the twentieth century).[331]

A Surrealist statement on May 5, 1968 – the year of the "Prague spring," which once more (after Hungary) exposed the parallel between the USSR and all repressive states – declares: "The Surrealist Movement is at the disposal of the students for any practical action intended to create a revolutionary situation in this country."[332]

In connection with the June disorders the Surrealists published their "swan song,"[333] even though they then seemed more relevant for the youth than Sartre's fading Existentialism.[334] Philippe Sollers of the Tel Quel group came to a conclusion that echoes at once Surrealist thought and the famous *mot* of von Clausewitz: "Writing is the continuation of politics by other means."[335] Like the Surrealists of the twenties, he thought writing not only does not reproduce reality, but can bring a new reality into being. But the Surrealists of the late sixties seem to have lost touch with these ideas and treated the reinterpretation of *écriture* with contempt, as when [th]ey criticized in 1967 the neglect of the [poe]tic side of Lautréamont by the Tel Quel [group]: "Glory to Mr. Derrida, who has [discov]ered 'the absence of the subject and [ab]sence of the object' in the spacing [...]"[336]

[Surreal]ism, which assaulted so many [midd]le-class institutions, seems now to lie safely buried as a moment in art history and as a teachable example in art schools. But its irreverent spirit continues to engender excesses among the young who fret

over institutions better able to restrain than inspire. While most of the old institutions still stand, the resistance to them continues – the latest incarnations of that resistance have appeared in deconstruction and postmodernism. Their goals reverberate with echoes of the assault on the artistic and educational walls of its own time by Surrealism, an "unfinished project" that remains a relevant dream.[337]

5

THE SURREALIST WOMAN AND THE
COLONIAL OTHER

What role could women play in a movement whose productive personalities were all male? Not that women were entirely excluded even at the beginning: they were present behind the scenes as mistresses and on the scene as typists. Yet their absence from public view before the mid-thirties compels us to question the commitment of Surrealism to changing society in the direction of unlimited creative freedom. And other questions arise about the stereotypical roles imputed to women in the occult and marvelous, in convulsive beauty, in the timelessness of time, in chance and dream.[1] These are, of course, passive roles useful for the male creators who, moreover, spilled much ink and semen in their passionate quest of (mainly) Parisian women, while insisting on the right to love uncontaminated by commerce and unconfined by law or convention. Breton offers us a clear picture of these activities in the late twenties:

> Works like *Le Paysan de Paris* and *Nadja* give one a quite good idea of this mental climate in which the taste for wandering about was carried to its furthest limits. We gave free rein to a continuous search: to see and reveal what is hidden under the surface. The unexpected encounter which always tends, whether explicitly or not, to take the features of a woman, marks the culmination of this quest.[2]

Concerned above all with their own freedom, they never criticized the violent and exclusively sexual treatment of women by de Sade, an author they, like Apollinaire and Bataille's group, unconditionally admired.[3] Recurrently, Woman seemed to offer the poets a bridge between poetic enchantment, sexual convulsion, and political enthusiasm, usually under the sign of male manipulation. In the First Manifesto we read, "What matters is that we be masters of ourselves, the masters of women, and of love too."[4]

One must be careful to distinguish the reality from the mythology of the actual women in the Surrealist men's lives. The notion of the Woman, supported by metaphors for unity – the bridge and the point of union – suggested the possibility of a place (her body), an occasion (orgastic intercourse), and an ideal (a figuration of liberty).[5] The Surrealists saw in Woman two essentially passive powers: her convulsive beauty could inspire the imagination and tempt their pursuit of adventure,[6] and her capacity as a seer enabled her to predict the future and unravel labyrinthine knots. Although the Surrealists hung on to the old metaphorical equation between Woman and Nature (expressed with such terrifying clarity in an abstract artist like Kandinsky), the relentless dichotomy between real women and the imaginary Woman (the Other) must have troubled them.[7] Their obsessive imagery suggests an inspiration grounded in an ambivalence toward beings regarded at once as ideal and as symbols of disruption and the unrepresentable.

The attitude of the Surrealists toward women in large measure reflected the

viewpoint of a patriarchal society – for these male writers and artists, women could serve as instruments of the imagination or of pleasure, but could not easily transgress these bounds and make independent contributions, and one must reject recent claims that Surrealists were not antifeminist.[8] This patriarchal attitude defined their views of the appropriate dress of men and women. After the Dada interlude, when even Breton in mockery put on the unmasculine garb of a priest, the Surrealists (with the exception of Ernst) returned to the plain suits of middle-class males while their women often dressed in unusual, even outrageous, costumes. It was a commonplace that while women had no political power, they were "omnipotent" in the domain of clothing and furniture.[9] This development of gendered clothing recalls what the psychoanalyst Flügel called the "Great Masculine Renunciation" that occurred at the end of the eighteenth century, when men surrendered the gayer and more elaborate forms of ornamentation to women.[10] The Surrealists saw their mistresses (as distinct from their *régulières,* their wives) not as whole and present individuals, but from a distance as fleeting but provocative images, as creatures of street affairs, or more intimately as seers (at their dream séances) or gifted psychotics (Nadja).

Inevitably by "exalting" these disturbed women to their special status, the Surrealists in fact denied them a claim to be treated as real, suffering human beings, and they may not have had women in mind (despite Nadja) when they advocated reform of the mental hospitals and the institution of psychiatry. Thus, when Breton and Eluard created their remarkable simulations of psychosis in *L'Immaculée conception* (1930), they did not include female patients.

The Surrealists defended the right of the talented male to uninhibited passion against the limiting boundaries laid out by the laws pertaining to bourgeois marriage in their manifesto, "HANDS OFF LOVE" (1927). In it they took the side of Charlie Chaplin against what they considered his moralizing and accusatory wife (mother of their two sons), who was suing him for divorce on grounds of infidelity and for his perverse sexual demands on her.[11]

It is easy to see the distortions that the Surrealists, with their own agendas in mind, imposed on the women they loved and used. Even before the *cadavres exquis* and mannequins of the thirties, the acrobatic dreamer Desnos in *Deuil pour Deuil* (1924) wrote about white and rose women whose decapitated bodies were cut up into pieces – bloody and milky and edible. But the other side of the woman emerges in the same text – the hope, the symbol of freedom. Somehow Desnos's woman survives her victimization. Surrealist fetishism cannot be reduced to a neurotic symptom, for it fitted into their troubled discourse about Woman – at once the prime instrument of love and liberation and the target of sadistic assault. Evidently the Surrealists, caught up in meshes like those of the old Romantics, wanted more than the body of the Woman-Other; indeed, one might well characterize their eager pursuit and efforts to visualize the Other in terms of Hegel's notion of *Begierde,* or desire, the "manifest presence of the absence of a reality" (an objectifying view of woman that one feminist critic rebuked).[12] Finally, the dream of convulsive beauty and passionate love, the ultimate union of desires, meant at least relaxing the ideal of masculine control.

Feminist critics have nevertheless not tired of pointing out the patriarchal attitudes of the Surrealists. (One thinks, for example, of Breton's remark in 1924 that "the sleep of woman is an apotheosis.")[13] Yet, however justified their evaluation, these critics sometimes fail to consider the complexity of the Surrealists' position – one would have to distinguish their views in the twenties from those of the thirties and to see them in their historical context.[14] In retrospect the Surrealists seem today less patriarchal than most of their contemporaries, although they held un-

realistic views, as in their passionately Romantic conviction that love held a solution for the important social problems, a view variously held by Lamartine and the admired Fourier.[15]

At least in orgastic convulsion the Surrealists seem to have recognized gender equality: the section "Love" in *L'Immaculée conception* of Eluard and Breton begins: "Reciprocal love, the only one that could interest us here . . . "[16] They then describe thirty-two varieties of sexual positions.

Like the Marxists, the Surrealists ignored Comte's proposal to unite the goals of proletarian revolution and woman's emancipation.[17] (In his later writings Breton leaps over the obstacles to gender equality and assumes the "superiority" of women.) Still, beyond their distorting adoration of Woman as an ideal creature, they came gradually to respect individual women – by 1930 female acquaintances participated in intimate discussions of sexuality and in various games, and by the forties the male Surrealists displayed an openness rare at the time by admitting several brilliant women artists into their midst. And in the post-Cubist period of "virile" purism and rectilinearity, the Surrealists remained open to the soft and formless (without descending to Bataille's chaotic *informe*), qualities contemptuously categorized as "female."

An apologist for the Surrealists' views of women, Gérard Legrand, while admitting that the Surrealists remained almost exclusively a male group, claimed that they always saw women in a favorable light.[18] As proof of this claim he cites Breton's remark in *Arcane 17* expressing preference for the ideas of women over the flawed ones of men (a remark that comes straight out of Fourier) and asserting the need to rethink the psychology of women.[19] (But he wrote this in a defensive moment when Camus, Sartre, and other prominent postwar writers were battering Surrealism. Among the women praised in general, Breton certainly did not have in mind his severe critic, the Existentialist Simone de Beauvoir, colleague and companion of Sartre.)

Yet one must acknowledge that the Surrealists only partially escaped from patriarchally (en)gendered perceptions and attitudes, and that Breton manipulated women and their image for his own poetic and creative purposes, as certain feminists have suggested.[20] For example, in 1922 Eluard and Ernst created a series of images of *la femme* treated as an object posed in various positions; evidently the series addressed an audience assumed to be male.[21] For most of its history Surrealism used Woman as an object, an Other on which to project male desire, and her image filled up the spaces left vacant when the Surrealists as it were emptied the landscapes of reality.

The Surrealist woman – a compound of a manipulable body with the inspired secretarial mind of a seer or medium ("mediating" between universal energy and the poet) – served as an adjunctive inspiration to male genius, a modern version of the Muse, but in practice the relation between poet and seer evolved in complex ways. A clue to this complexity is provided by Breton's description of his affair with the gifted psychotic Nadja. Nadja's performance as a medium and her crude drawings – tantalizing like rebuses that defy deciphering – charmed Breton and served as a screen on which to project his own ideas until he understood them as cries for help, whereupon he recoiled from what he probably perceived as a dependence threatening to his own freedom.[22]

The Surrealists' behavior toward the women among them involved several self-serving aspects: the refusal to beget children had the egocentric purpose of satisfying their need to receive the undivided attention and care of their wives; their awe of certain women as special creatures gifted with supernatural qualities really attached these women to their poetic enterprise; and the Surrealist theories of absolute and convulsive love made their women convenient rationales for certain sexual

and moral preferences and even justified otherwise questionable behavior. Thus, Breton's elaborate exposition of convulsive beauty in *L'Amour fou*, which culminates earlier discussions of love, in part provided him with a rationalization for his entry into fatherhood (despite his theoretical objections to parenting): he was only inadvertently inconsistent since he begot his daughter Aube in a moment of convulsive love – he sees Aube's future purely in terms of her enjoying *amour fou*. Aube's need for her father's presence in turn excused his not fighting with the Loyalists in Spain against Franco. The convulsive love of women even helped justify his return to automatism against the defecting Dali's paranoiac criticism: automatism is one of the conditions of convulsive beauty. (The topic was known outside Surrealist circles, and André Beuclor published his novel *L'Amour automatique* in Paris in 1927.) By focusing on love for both his wife and daughter Breton deftly avoids the issue of woman's creative equality: the fact that Jacqueline Breton, a strong personality, was a Surrealist artist (who would collaborate with Breton) never emerges in *L'Amour fou* (her independence led eventually to his disaffection and their separation and remarriages).

When not fascinated by women's sexuality (as in the case of their early ideal Musidora), the Surrealists treated women as emissaries of nature, mediums capable of communicating the marvelous:[23] as a matter of fact, they were less concerned with the psychology of women than with their parapsychology. Consequently, those women closest to the Surrealists around Breton often remained shadowy creatures without names.[24] The names of some women celebrated in case histories or newspaper reports and whom he admired do occur in his writing – for example, Germaine Berton, a political assassin whose murder of a reactionary the Surrealists approved (the political antithesis of Charlotte Corday, who stabbed Marat, a radical hero),[25] and the patricidal victim of incest, Violette Nozières, condemned by the bourgeois court and press. But even their names often turn into word plays that shift away from the person (Violette – *viol*).[26] Aragon (and perhaps Eluard) expressed a yearning for a more concrete image of women (which indeed his post-Surrealist writings on his wife Elsa realized). He wrote in the third part of *Le Paysan de Paris* of 1926:

> From now on we have to advance toward the concrete: the object of metaphysics is not the problem of the divine but concrete knowledge. . . .
> There again, "salvation" comes through love, woman is the new mediator. But it is no longer an abstract or ideal woman. . . . Just as there is only concrete love, so there is only poetry that is concrete.

Aragon seems to have sought the company of powerful women right up to his falling in love with the Soviet sympathizer Elsa Triolet, who had indefatigably courted him; thereafter, as though "jilting" Breton (the very choice of a non-French woman seems in this context significant), he turned to her for support and comfort – against Breton and his former comrades – and assimilated her sympathies for the Stalinist regime.[27] But he had already expressed admiration for the act (but not the anarchism) of the assassin Germaine Berton, stating that he felt impelled "simply to prostrate myself before this woman who is *in all ways admirable,* who is the greatest challenge I know to slavery."[28]

Like his fellow Surrealists Breton in his novels names many male characters major and minor, whereas his mistresses remain anonymous sources of desire, and with Aragon he extols hysteria as the erotic "poetry" of Charcot's hysterics – beings at once remote and unknown except for their case names (e.g., "Augustine") and exposed in intimate photographs.[29] The Surrealists were countering a pejorative use of the

term "hysteria" both among artists wishing to stigmatize modern art, especially Cubism, as "sick" and mentally disturbed (Delaunay in 1917), and by Dadaists (Tzara in 1920) eager to slander all art.[30] In his review in 1920 of a new edition of Louis Bertrand, *Gaspard de la nuit* (first published 1842), Breton had already lauded hysteria as "one of the finest poetic discoveries of our times."[31] He intended not to praise patients (mainly women) exhibiting symptoms but productive men who used hysteria to enhance their creativity.[32] It is interesting that one psychoanalyst, responding perhaps to the Surrealist faculty to convert their anger into images, claimed that Desnos and other Surrealists were hysterics.[33]

Breton gave eloquent expression to this image of the nameless woman: "The eternal woman on a bench in the square / The nameless woman with a pendulum around her arms / Instead of a muff / The woman who kills work . . ."[34] The coherence *Nadja* achieves derives partly from its insistently autobiographical subject matter – even Nadja's existence depends primarily on Breton's speaking her name, and one could argue that the egocentric writer collected the marvelous debris of her mind as specimens useful for his real subject, already posed in the opening question, "Who am I?"[35] One might further argue that the namelessness of the Surrealist woman covers an unavowed vestige of the maternal – the eternal (m)other; indeed, feminists like Cixous and Kristeva claim that they detect the mother behind woman's namelessness.[36]

Women as a subject appeared only as an adjunct of the Surrealist men's own needs and desires: the Surrealists pursued the mistress but ignored the mother. Their wide-ranging images of the woman in poetry and art hardly included maternity (Ernst's painting mocking the Virgin spanking the infant Jesus proves the rule both by its rarity and by its subject) even when they explored ancient myths. Perhaps as an extension of their intrinsic revulsion of maternity, they refused in their creative

practice to suffer the gradual process of maieutic education. Their craving for instant inspiration led them to their concepts of objective chance, automatism, and the found object. These concepts implied an "immaculate conception" that would seem to justify Sartre's comment on Surrealism's abhorrence of "genesis and birth; it never regards creation as . . . a gestation." (One might compare the Surrealist aversion to genesis to Foucault's version of Nietzsche's "genealogy of morals.")[37] In spite of all this it seems to me that all their women, like those of the Romantics, incarnate aspects of a tantalizingly elusive and invisible mother; hence, their conflicted (convulsive) feelings toward the desirable young women they frequented.

A contrary position with regard to the mother was taken by the dissident Surrealists who had rejected the authority of Breton and gathered around Bataille (Masson, Leiris, Caillois) in 1929. As though to shift from his patriarchal dominance they welcomed images and myths of the mother, including Bachofen's theory of matriarchy (which perhaps they also discussed with Rank, who was in Paris from 1926 to 1935 and who owed much to Bachofen's theory). It is striking in this context to note that Engels's book *The Origin of the Family* is based on Bachofen's *Das Mutterrecht* (1884) with its theory that the origin of class society and the overthrow of mother-right occur simultaneously in prehistory. (In the Marxist utopian model, they will end simultaneously in a Communist society that abolishes "the absolute domination of the male over the female sex" that is the "fundamental law" of class societies.)

Although Breton quotes Engels's book in several places, he studiously avoids its clear assertions of Bachofen's thesis; for example, "The rediscovery of the original mother-right *gens* as the stage preliminary to the father-right *gens* of the civilized peoples has the same significance for the history of primitive society as . . . Marx's theory of surplus value for political economy."[38] Breton's group, uninterested in the

mother, was more attentive to the changing values of creative women: the increasing presence of women outside the domestic and maternal scene, too visible to be ignored, led increasingly during the thirties to a revised perception of them.

The image of the sublimely "useless" woman steeped in the extraordinary and the hidden – a secular version of Dante's Beatrice – inspired the Surrealists' efforts to escape from the prosaic confines of middle-class marriage.[39] The extolling of woman's uselessness meant especially to Breton (Eluard and Aragon were less dogmatic) a refusal to value her sexuality either as mother (a point noticed by their alert critic Sartre)[40] or prostitute.[41] Breton claimed, "I've *never* gone to bed with a prostitute."[42] However, some Surrealists (not only the dissidents) both visited prostitutes and openly valued them.[43] The Surrealist rejection of maternity and prostitution apparently echoes the then current Communist view expressed by Riazanov in 1929 and well known in Paris that monogamy and prostitution were opposite sides of the same bourgeois coin.[44] In the same year, Thirion wrote for *La Révolution surréaliste* a discussion of the ideas of Marx on gold and money, and caustically noted how money can pervert girls, transforming "desire into commercial dealing and passion into vanity."[45]

The claims for individual love over the bonds of marriage by Engels, Lenin, and other Communists, and echoed by the Surrealists, originated in their polemics against bourgeois society rather than from a commitment to the cause of women's liberation. Moreover, a tradition existed even among otherwise progressive nineteenth-century thinkers like Proudhon that compared women intellectuals to prostitutes for having given up their "true" or natural vocation as homemakers and mothers and having entered the public sphere of business and commerce.[46] (The association of women and "commerce" had an old sexual connotation in the Latin "commercium" and in the postmedieval French word

"commerce.") The suspicion that the working woman was inclined to prostitute herself (the phrase "working woman" itself has a shady connotation) appeared even in sophisticated circles, as in a drawing by Duchamp dated 1907, titled "Woman Hack Driver," which evidently renders the theme "Time is money": a cab stands empty before a hotel with the meter running.[47] Breton, refusing to place prostitutes in a Marxian framework of proletarians and bourgeois, simply divided the profession en bloc into high-class and low-class prostitutes.[48]

Though the refusal by the Surrealist men to beget children (supported by the arguments of Engels) seems to represent a step in the direction of feminism, in fact it had to do with their opposition to the bourgeois family. Rejecting the connection between child bearing and patriotism (well entrenched in France at least since Napoleon Bonaparte),[49] they mocked fertility in the manner of a Jarry and of a Germain Nouveau. One must distinguish their view from Apollinaire's spoof on fertility in his play about androgyny, *Les Mamelles de Tirésias;* for while ridiculing "the excesses of feminism" (according to Victor Basch, his contemporary), Apollinaire went further and maintained patriotic sentiments repugnant to the Surrealists. Like most of their male contemporaries the Surrealists evidence little concern for the woman's point of view.

Needless to say none of these writers felt any sympathy with the homosexual rejection of reproduction. The Surrealist revolt against having been brought into existence within a bourgeois family was consonant with the Marxist goal of ending the capitalist reproduction of property (hence, Surrealism's opposition to modernist novelty and invention). Ultimately it became clear that the Surrealist position stood in stark contradiction of the Leninist-Stalinist insistence on material productivity (a logical consequence of the theory that Communism already existed in the Soviet Union).

Breton never resolved the relation of work and pleasure revealed by prostitution (the case of Nadja) – an aporia as compro-

mising for his view of women as incest was for Lévi-Strauss's structuralist anthropology.[50] Prostitution in nineteenth- and twentieth-century Paris, which meant commercializing the visible in the spirit of Baudelaire's *filles* with their *maquillage,* was not easily distinguishable from the entertainment business. This was especially true for Paris, which was less an industrial than a fashion and entertainment center, and some modern artists felt at home in the brothel with its "artists" skilled in the artifices of sex. But Breton abhorred any shadow of commercial transaction that might compromise the purity and "freedom" of love, a view fully shared by Benjamin.[51]

He rejoiced, therefore, in his discovery of Nadja, an insouciant spirit who received money and provided sexual favors, apparently without the usual motivations of the entrepreneur. Nadja had a tenuous and ambiguous relation to both the real and the rational, for in her existence as a detached "free spirit" she eluded all clear-cut social definitions as wife or wage earner. In fact, she lived a wretched existence, essentially surviving through odd jobs and streetwalking. But one might confuse her "work" with romantic escapades, for it consisted of her meandering through Paris as a streetwalker – not as a *flâneur,* a category reserved for males – having intermittent affairs of short duration with men she called "friends."[52] Breton wrote two pages in *Nadja* criticizing work, a "material necessity" having little to do with poetic revelation; and he joined Surrealist friends in praise of Rimbaud, who had exclaimed: "I shall never work. It is disgusting to work . . . I loathe all trades, masters and workers are all ignoble peasants."[53] In an essay of 1930, "Relations between Intellectual Work and Capital," Breton voiced his objections to artists or writers "prostituting" their imagination by making objects with commercial salability, and perhaps responded to the current polemics about the definition of the "intellectual worker." His discovery in later

years of Fourier might have offered Breton the means of reconciling pleasure and work, for the central idea of Fourier's socialist utopia is "the transformation of labor into pleasure."[54] Certainly he might have found in Fourier the basis for his exaltation of woman; for example, Fourier wrote, "In summary, the extension of the privileges of women is the fundamental cause of all social progress."[55]

The Surrealists, and Breton in particular, while accepting all noninseminating heterosexual "perversions," drew the line at homosexuality, but they revealed tolerance, if not full acceptance or comprehension, when they welcomed the uncloseted homosexual Crevel into their ranks. (In an issue of the *Disque vert* dedicated to psychoanalysis Crevel paid homage to homosexuality while implicitly acknowledging his sexual orientation.)[56] Publicly proclaiming their heterosexuality (the referent of a "loved one" could only be a woman), the Surrealists were unabashedly patriarchal: like their cohort of middle-class contemporaries, they generally wore business suits as emblems of their sexual straightness.[57] Adolf Loos, who perceived the gendered significance of clothing, associated ornamentation with economic oppression and made the observation that apparently draws equally on Darwin and Marx that women resort to ornament because they lack economic power and must attract a "big, strong" man in order to survive.[58]

Within the issues of male power and dress occurs a discourse on homosexuality that Breton never explicitly addresses,[59] but in *Arcane 17* written in 1944, as though transported by a Platonic version of *amour fou,* he came close to Plato's allegory of the hermaphrodite (without ever transgressing to the dangerous ground of the phallic mother or alluding to Freud's theory of original bisexuality):[60] "Every human being has been tossed into life in search of a being of the other sex, a sole individual made for him in every respect, to such an extent that the one without the other seems the product of the disruption, of the dislocation of a

single block of light." He presented a version of what one might call sentimental hermaphroditism by unconditionally subscribing to the response by his mistress Suzanne Muzard to a questionnaire on love.[61] He echoes this exaltation of Suzanne a year later: "The lightning-woman and you go past / you are the din of thunder . . ."[62] But this subordination veiled a patriarchal maneuver, a feeling that as a male he was older and held the real authority; even late in life Breton imagined the woman as the *femme-enfant*,[63] as Suzanne recalled, "Breton overflattered his loves; he molded the woman he loved so that she could correspond to his own aspirations and thus become, in his eyes, an affirmed value."[64] And in a poem of 1931, perhaps in a generalized reminiscence of the tensions in their relation, he spoke of a "sex of gladiolus," a term applicable to the "phallic woman."[65]

None of the Surrealists pursued seriously Breton's hints about bisexuality, but the structuralist critic Barthes, who had a personal stake in the issue, does advance toward that discourse. Barthes develops from a Platonic notion of fulfillment and memory toward what I would call a truncated homosexual theory of the simulacrum/fetish resembling Plato's explanation of sexuality in terms of an original split of human beings into halves. Each being would consequently be motivated by a desire for completion (with the other half) and guided by a vague reminiscence of wholeness. Barthes's fetish involves a comparable idea of a desire that achieves satisfaction through the simulacrum – an idea that he implies has a connection to Surrealism.[66]

The repression of a homosexual discourse seems to correspond to the Surrealists' difficulty in integrating tenderness and sexuality and may have contributed to their violent images of women. As we shall see presently, when the verbal (the vocal male) failed to represent, sometimes the male Surrealists stuffed the visual (the silent female) into the gap formed.

Breton and the other Surrealists liked to dismantle conventional forms and make polemical sense or lyrical nonsense of the random, trivial, or illogical; thus, they wrote burlesque deformations of the conventional genres of novel and poetry, made art out of dreams and other phenomena on the fringe of consciousness, and applied Apollinaire's "calligrammes" – poems with texts shaped into images. But their transformation of the verbal game of *cadavre exquis* to the visual one of assembling an "exquisite" female body went beyond lyricism and amounted to an assault. Almost all the *cadavres exquis* were female, and major paintings by Ernst, Masson, Tanguy, Dali, and Magritte center on the bodies of women, whereas these same artists often represented their male colleagues in integral portraits either descriptive or symbolic.

In the game of *cadavre exquis* the nude body became the theme of a ritualized dismemberment and assemblage in which head, torso, and legs of diverse creatures are put together in correct order.[67] Lyrical dismemberment had already occurred in poems like Desnos's *Deuil pour deuil* (1924), which presents the decapitated bodies of women, cut into pieces and turning white as blood pours from them. In general, the sadistic dissection of the image of the female by the Surrealists results in a sexually charged monster, the *disjecta membra* signifying a dismissed integrity (a male fantasy of female "castration"). In the thirties this imagery, removed from its cogent Surrealist context, served to highlight products associated with body parts, thereby enlivening many commercials and fashion designs.

Ironically, during the thirties, just as women were establishing themselves among and increasing the number of the Surrealists (who needed whatever support from productive artists they could find), the men concocted alienated female images ranging from sadistically violated objects to disjointed mannequins – plastic realizations of the exquisite corpses devised in

their drawing games. And more important, they developed and popularized the image of the *femme-enfant,* a creature at once worldly seducer and naive ingenue, so appealing that it survived as a mythical reality in later literature and art (Nabokov's *Lolita,* Bellmer's *Dolls*); Joyce himself seems to have alluded to it.[68] The Surrealists' fascination with the *femme-enfant* may have arisen as a defense against the fear that women, satisfactory as passionate but passive lovers – or as studio models – would, on becoming liberated, make their own demands, turn into active desirers as well as creators, and invade the male space: the charm of the girl as lover is precisely that her immaturity renders her innocuous to her Daddy.[69]

The "apotheosis" of the female body as exquisite corpse appeared in Breton's poem of 1931, "Union libre," whose verbal images have a strongly visual flavor and raise the question again of the woman's integrity as well as visibility as a person. Nominally "about" a woman's body, it describes his girlfriend ("ma femme") by enumerating her body parts. The title also alludes to "concubinage" or a "free" marriage of a couple living together permanently but without signing a legal contract of marriage.

"Union libre" seems on first encounter to be a version of a lover's litany of body parts, which undergo a sea change into an astonishing variety of farfetched objects. The recurrent phrase "ma femme" ties together with rhapsodic metonymy the disparate collage of images that proceed from her head ("wood-fire hair," "heat-flash thoughts," teeth, mouth, tongue, eyes) to her trunk and limbs ("champagne shoulders," "matchstick wrists," "fingers of chance," "armpits of marten," "seafoam arms") to her lower limbs, and then back to her head (throat and neck) and torso ("coracle hips," "buttocks of soapstone"), before turning to verses about her eyes and concluding with an evocation of the four elements: "With eyes of water level of the level of air of earth and of fire."

The associations to the body parts suggest the erotic locale of a boudoir, a horizontal space ("fallen" woman) into which the vertical man – *Homo erectus* – enters. A semiotic analysis formulated along gender lines would not seem farfetched: in passing from head to toe of the woman's figure Breton collapses the verticality of verbal metaphor (in Jakobson's sense of selection on a vertical axis) onto the horizontal metonymic axis of juxtaposition where the body parts of the exquisite corpse are laid out. (To the extent that the distinction between metaphor and metonymy has only limited validity, especially for Surrealism, such an analysis would have limited application.)[70]

The violated daughter who killed her father, appropriately named Violette Nozières, became the subject in 1933 of a collective pamphlet by Surrealist artists and writers. The fact that her name suggests the rape that motivated her act fascinated the Surrealists, some but not all of whom took a perverse pleasure in the subject (none even dreamed of the possibility that a rape victim could be male).[71] Female victims who murdered their abusers posed no threat to the Surrealist ego, since the women's behavior, being a reaction to a man's aggression, did not evidence independence; moreover, in the cases usually reported the women were somewhat deranged and, at any rate, never close to the Surrealist circles.[72] In general, the woman's gaze lacks phallic potency: the Gorgon, seemingly an exception, in reality is held captive to the patriarchal agent Athene. On the other hand, the fearsome power of a father's gaze as perceived by his son was already represented in a portrait of his father by De Chirico who tempered it by shutting the eyes.[73]

Magritte illustrated the 1933 pamphlet and later painted *Le Viol;* Péret wrote a poem playing on the name Viol(ette); and Alain Jouffroy wrote a novel, *Un Rêve plus long que la nuit,* thirty years later that repeats the identical pun on Violette, "who killed her father because he wanted to rape

her: there was *rape* (*viol*) and violet in her Christian name." Her aggressive ("masculine") manner of getting even was most strikingly illustrated by Victor Brauner, who drew a creature with a female pubis, but with an elongated head shaped like a phallus and two spheres that ambiguously signify breasts or testicles.[74] One year later Magritte created his own version of Brauner's treatment of the theme in *Le Viol* (1934), whose impact is evident: Breton used an engraving of it for the cover of his pamphlet published in Brussels in 1934, "Qu'est-ce que le Surréalisme?"[75] Magritte "phallicized" the victim by elongating her neck (much as Brancusi had done in *Princess X* of 1916). Here the breasts double as eyes, and – adopting a motif used by Picasso and Dali – she has a mouth described by a triangle of pubic hair.[76] The woman is "raped" through transmogrifying her naked torso into a face – a collagelike process already applied in his painting *Les Jours gigantesques* (1926) in which a self-conflicted ("self-raping") woman struggles with a male figure superimposed on and contained within the contours of her body. He accomplished this by placing a head of hair around the torso and superimposing on it a triangular "mouth" of pubic hair (probably, like Dali, here influenced by Picasso). The result – comparable to the revealing protocol of a thematic apperception or another projective test – amounts to an unintended confession, long before feminist analysis of the gendered gaze, of what the male paranoiac-critical gaze can do.[77]

Sometimes women associated with Surrealism actually acquiesced to the sadistic imagery; for example, Elisa Breton, André's wife, developed her own variant on the Lautréamont image in an undated painting of a sewing machine.[78] But no woman contributed to or signed the tracts on the raped Violette Nozières (1933) or on Jarry's Rabelaisian boor, Ubu (1937).

Not all Surrealist images of women were dismembered or violated: the offices of the Bureau de Recherches Surréalistes had

on its walls plaster "pinups" – casts of women's bodies;[79] and a photomontage illustration of a painting of a nude figure with body intact surrounded by photos of the Surrealists apparently epitomized the movement for the Surrealists – it appeared, for example, on the front cover of Nadeau's popular *History of Surrealism* (1945). The following discussion will dwell on this photomontage because of its significance.

The photomontage (Figure 19), reproduced on a page of the twelfth and last issue (December 1929) of *La Révolution surréaliste*, shows a generically Caucasian woman in a painting by Magritte surrounded by sixteen portrait photos (uniform in size and format) of the following men, all frontal, with their eyes shut and with solemn expressions on their faces, in alphabetical order: Alexandre, Aragon, Breton, Buñuel, Caupenne, Dali, Eluard, Ernst, Fourier, Goemans, Magritte, Nougé, Sadoul, Tanguy, Thirion, Valentin. (The arrangement was apparently inspired by a similar one published in an issue of 1925 with Germaine Berton in the center.) In most of these group portraits the woman, absent among the photographed onlookers (or rather "nonlookers"), occupied a central position as an erotically magnetic icon – an object for the male gaze. One notes that even when women were photographed, they remained "special," different from the simple reality of these portraits of men.[80]

The nude stands with head averted, enshadowed eyes closed (but ambiguously, unlike the men's), her frontally displayed body a cynosure to *our* eyes but "unseen" by the men. This tension between her visibility and their unseeing poses an anomaly, since normally the male gaze regards the body of the woman, whose visibility, even existence, is played out in the men's eyes. The "unseen" nude woman directly raises the issue so often advanced by feminists of woman's "visibility" to this or any group of males.[81] (Magritte had already made a variant of the paradox of the invisible/visible woman in *La Femme introuvable* of 1927, in which a nude woman with left hand

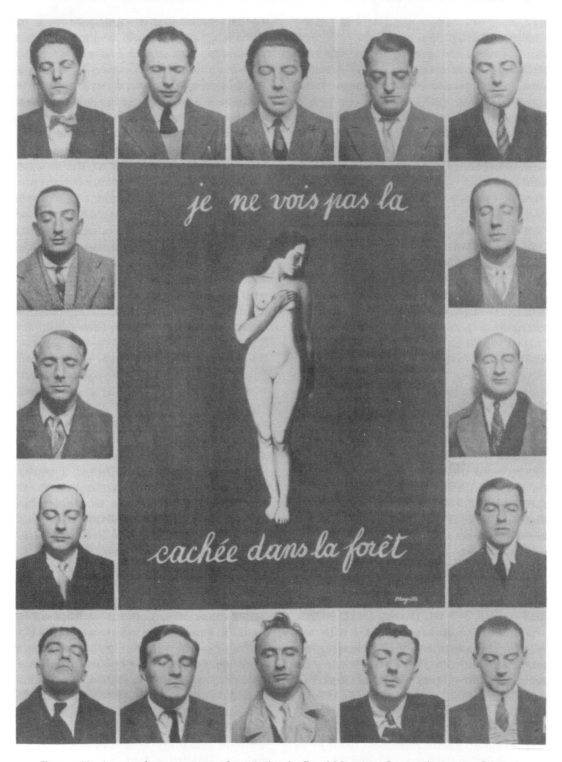

Figure 19. Anon., photomontage of a painting by René Magritte, *Je ne vois pas . . .*, framed by portraits of the Surrealists, *La Révolution surréaliste*, no. 15 (December 1929).

over one breast and open eyes is placed against a wall surrounded by four big left hands that are open as if seeking to touch or "find" her.) An accompanying text declared "Je ne vois pas . . ." – a negative assertion that allowed Magritte to play with paradox, as he did in his famous painting of a pipe bearing the inscription "Ceci n'est pas une pipe." The closed eyes of these men are seeing the nude – and beyond the nude – with the open "eyes" of the imagination. The nude moreover becomes the ground for an implicit communion of the men.

This iconic cluster of the photos of group members around a painting of a female nude is politically significant for Surrealism at that moment of crisis within the Surrealist group – and semiotically complex – like other combinations of photo and painting – and word and image:[82] issue no. 12 contains the Second Manifesto, a polemical blast against Surrealist renegades. Like a manifesto directed against schismatics, the image declares the group's coherence both through the integrity of the nude's body and through the text framing her that seems to inspire the dreamers to their silent communion: Breton and his faithful fraternity, grouped as in an altarpiece, present a phalanx of dreamers to confront the hostile world of the prosaic and the disloyal. Framing the nude above and below are the phrases "Je ne vois pas la" and "caché dans la forêt" – a variant on "not to see the forest for the trees" (l'arbre qui cache la forêt) and "not to see the town for the houses," phrases echoing nineteenth-century Romanticism and Symbolism (and perhaps recalling Baudelaire's "forest of symbols").[83] The image of the nude signifies the noun that links the definite article to the adjective[84] and fills in the missing object of the verb "see."[85] The closed-eyed Surrealists can presumably "see" what the profane cannot, in accordance with the declaration made in the Second Manifesto published in the same issue: "I demand the profound and veritable occultation of Surrealism": unsight = insight.

An illustration in the same issue (no. 12)

of Dali's painting *Illumined Pleasures* (p. 29) and of a detail (p. 64) allude to the theme of occultation, with voyeuristic overtones: the detail of Dali's painting faces the beginning of the questionnaire on love that contains *Je ne vois pas* . . . and shows the torso of an unclothed (presumably male) figure seen from the back peeping into a box. His body is covered from the waist down by a painting of many bearded bicycle riders. One month before the appearance of Magritte's painting, which equates "nature" or "reality" with the nude woman (as Alquié, a philosopher of Surrealism suggested), Breton, in an essay on Dali, enunciated the general principle of searching for hidden meaning beneath surface reality.[86] Demanding that we eliminate physical objects that "prevent us from seeing clearly," he exclaims:

> If only we could get rid of those famous trees! And houses, and volcanoes, and empires. . . . The secret of Surrealism lies in the fact that we are persuaded that something is hidden behind them. Now, we have only to examine the possible ways for this suppression of trees to see that only one way is left to us, that in the last analysis everything depends on our capacity for *voluntary hallucination.*[87]

This congregation of males presumably exhibiting feelings of somnambulistic eroticism in the presence of an "unseen" female nude was set in the midst of texts recording responses to a questionnaire about love (as one might expect, of the fifty-four responses only three are identifiable as being from women, and two of the women were closely associated with male participants).[88] The posture of the figure supports the sense of an amorous quest (albeit a purely mental one) in its similarity to the classical Aphrodites of the *Venus pudica* type, later emulated in works like Botticelli's *Birth of Venus.*

The sexuality of Magritte's nude is reinforced by the word "forest" – the forest constituting a symbol, as Freud noted, of *crines pubis* (pubic hair), which is dis-

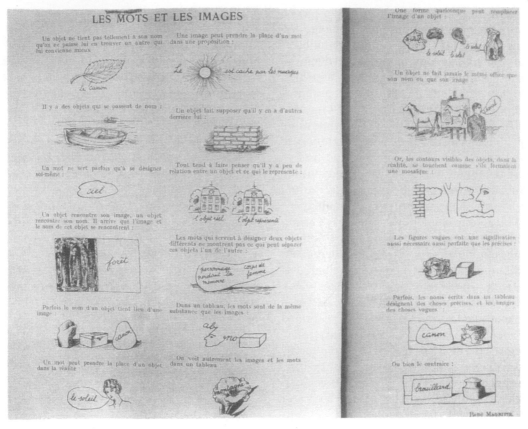

Figure 20. René Magritte, *Les Mots et les images, La Révolution surréaliste,* no. 12 (December 1929).

placed away from the nude, who shows no pubic hair, a feature evident in almost all of Magritte's nudes.[89] A similar suggestion occurs in Magritte's image not of a female nude but of her face, titled "Forest" with the word "amour" written across her lips.[90] The rebus principle of substituting images for words (discussed in *The Interpretation of Dreams*) is expanded by Magritte in the illustrated article "Words and Images" also published in the December 1929 issue (Figure 20). One relevant sentence of the article reads, "An image can take the place of a word in a proposition: The ___ is hidden by the clouds." Here the meaning is completed by a drawing of the sun, something comparable to the image of the woman (in *Je ne vois pas*) that completes the written phrases above and below her.

Corroboration that at least Breton would

have understood the sexual connotation of the image comes from his discussion in the *Vases communicants* of his dream of "the choice of ties": "Doubtless I have a 'complex' about ties. I detest this incomprehensible accessory to male dress." He knows from Freud that just as a machine's slot into which coins are put can symbolize the vagina (the idea of Fortuna or Lady Luck may also bear on female symbolism), so the tie can symbolize the penis. Freud's interpretation of the forest as pubic hair occurs in the same section on dreamwork where Breton would have found the discussion of ties ("Representation by Symbols in Dreams," in chap. 6, "The Dreamwork"). The hairy forest appears in an image from *L'Amour fou* (pp. 15–16), where Breton defines convulsive beauty in terms of "the reciprocal relation that unites movement

and rest in the object." And – with unmistakably erotic imagery – he suggests as an example "the photograph of a high speed locomotive abandoned for years to the delirious [overgrowth] of the virgin forest."[91]

The counterposing of these men to a woman follows the classic Western rhetorical tradition that distinguishes the spatial and temporal media (understood in terms of rules of decorum) according to what ultimately are gendered contrasts. The characteristic and influential example is Lessing's *Laocoon,* whose gendered oppositions W. J. T. Mitchell has usefully tabulated:[92]

Painting	Poetry
Space	Time
Natural signs	Arbitrary (man-made) signs
Narrow sphere	Infinite range
Imitation	Expression
Body	Mind
External	Internal
Silent	Eloquent
Beauty	Sublimity
Eye	Ear
Feminine	Masculine

It is astonishing after two centuries how closely these contrasts still correspond to our reading of the page. One would have only to add the gendered opposition of figure (male) to ground (female) – analogous to Freud's remark, "The Male Organ is symbolized by Persons, the Female by a Landscape" – and note the interchangeable placement of eye and ear (cf. Narcissus and Echo).[93]

The nude woman, suggestively veiled and exposed at once – inadvertently evoking Freud's theory of women's invention of weaving – reemerged in Breton's notion of the "érotique-voilée," which formed an integral part of his concept of convulsive beauty, as noted in Chapter 4, this volume.[94] Breton illustrated his article on convulsive beauty with Man Ray's photograph titled "Érotique voilée," for which Meret Oppenheim posed.[95] The wheels that teasingly "veil" part of her breasts and pubis also enhance the eroticism with their metallophallic complement to her flesh, implying an embrace along the lines of Dadaist mechanomorphic sexuality or of Léger's mechanical elements.[96] One might compare this to Man Ray's Dadaist collage *Coat Stand* (1920), which showed a woman's body with genital hair partly covered by a vertical pole placed suggestively before the pubis. Meret's pubic hair is "veiled" or cropped out in the illustration for *Minotaure,* and only the hair in her left armpit shows. In the uncropped version a frontal handle on the big wheel suggestively points toward her pubis.[97] The photo was staged with the printing machine in Marcoussis's studio, so the grease smeared over her raised left hand (which shades out – "eclipses" – her left eye) and forearm metonymically suggests at once publication (printer's ink) and occultation. The facing photo (p. 14), a Chiricoesque composition, also by Man Ray, titled "En pleine 'occultation' de Vénus" (At the full eclipse of Venus), resembles still-life groupings he often photographed. It concerns the same subject of the covering of the erotic (in this case, the "Venusian"); indeed, one can link the photographs by noting that erotic: veiled = Venus:Moon. The facing photo shows a classical female bust with open glass eyes (in contrast to Meret's nearly closed eye) above and behind the volute of a stringed instrument and a fruit with a stem resembling a nipple mounted on a (phallic?) cylindrical base. The corresponding text by Breton reads, "On April 10th 1934, at the moment of the full 'occultation' of Venus by the moon ... I dined in a little restaurant located quite disagreeably beside a cemetery." Perhaps lunar occultation refers to the moonlight that seems to illuminate the forms. The girl serving him wears moonstones in her necklace (the simple string around Meret's neck recalls this necklace), resulting in a coincidence with the lunar eclipse that he "greatly appreciated." Ever willing to discover myth within

the everyday, he mishears the dishwasher's call *"L'on dîne!"* (We're dining!) as "Ici, l'Ondine!" (Here is Ondine! – an allusion to Jacqueline, who had a diving act). All these details reflect on death and occultation: the cemetery; Ondine, who is a seductive nymph associated with water and death (a Wagnerian theme popular in the late nineteenth century with artists like Gauguin); and the moon that symbolizes at once death (or the passage of time) and fertility. But the meaning of the details of the composition of the eclipse of Venus is not clear (perhaps there is an allusion to menstruation – the menses marking a suspension of coitus).[98]

As already noted, this eliding of the pubic hair was quite general among the Surrealists; and the prominence of hirsute pubes in Bataille's *Documents* presumably as forms of *bas matérialisme* must have seemed an intentional irritant to Breton. Breton's group conformed to the canon of the beautiful, smoothly shaven pubis, and until Delvaux the Surrealists tended to displace female pubic hair onto fetish objects, as in *Le Viol,* or onto the mocking vaginal mouths that Dali inserted into the beards of patriarchal males. (The attraction of males to the frontal display of female pubic hair in pornographic photography has posed a problem for feminist theorists following a psychoanalytic line.)[99] Breton generally alluded to the vagina (literally the *pudenda*) and to intercourse in metaphors so subtle as to border on Victorian delicacy; for example, the image of the bridge could signify not only social or psychological union, but the pubis[100] and even sexual intercourse.

A celebrated image involving the sexualized bridge occurs in Breton's poem "Compared to the Gods" (1923):[101] "Above the bridge, at the same time, / the dew with the pussy head was rocking" (Sur le pont, à la même heure, / Ainsi la rosée à tête de chatte se berçait). The phrase alludes to several intensely sexual metaphors – the bridge-pubis, the rocking of intercourse, the simultaneous orgasm, the dewy secretions of coitus, and the cat's head-vagina.[102]

The sexual content, is, as always for Breton, allusive and hard to extricate from the play of associated imagery; consequently, its raw sexuality has often been missed even by French commentators.[103]

Like Breton's poem, "Je ne vois pas" suggests subtler erotic interpretations overlaying the ones we have so far offered. One might speculate that what is represented is a symbolic version of group sex (as in a "gang bang") not only upon, but – paradoxically – by a figure at once a female body and a penis: standing erect and bright, the nude constitutes the "gang penis" surrounded by the dark background signifying the forest of pubic hair. The paradoxically phallic function of the nude suggests the Lacanian notion of the copula.[104]

That Magritte, however dimly, might have conceived of this nude in terms of a symbolic penis gains credence from his painting *L'Océan* of 1943, in which the seated allegorical deity sports an erection in the form of a tiny standing female nude. This figure practically duplicates the nude of *Je ne vois pas* (except that her head is turned the other way).[105]

Two reciprocal and opposed processes collaborated to produce for the Surrealists this image of a woman: the emptying of a space at the center of these desiring males, and its filling with a fetish that in keeping with an observation by Binet and Krafft-Ebing, served as an "icon."[106] This anxious oscillation between word and image belongs to a group of manifestations that decades later would be attacked by deconstructionists on one side and feminists on the other.[107]

Considering the context of the turbulent and defensive period associated with "Je ne vois pas," and the pronouncedly phallic overtones of this remarkable page, a Freudian interpretation of the group behavior displayed does not seem unwarranted. In this light the Surrealists would at the time have comprised a fraternal order united defensively against the threat of castration by the group around Bataille, who in fact characterized Breton as "castrated."[108]

Thus, the Surrealist group constituted an "academy" (however unconventional) that offered a reassuring sense of solidarity in the face of hostile critics and of their own alienation.

Here one would need to take into account the apotropaic role (a magical warding off of danger or, in this case, of castration anxiety) of the penis represented symbolically both by the nude's body[109] and by the men's ties:[110] each man sports a tie (except for Maxime Alexandre), letting his symbolic "penis" hang out beside the others' in a phallic phalanx before the nude female (in fact, at one of the meetings for sexual research held about two years earlier, Jean Genbach explicitly connected tie and penis).[111] Indeed, as already pointed out, Breton once noted (in terms that fit Wilhelm Reich's "phallic-narcissistic" character) in answer to a questionnaire on sexuality that Benjamin Péret and he "were the only ones to declare that we would avoid as much as possible being seen nude by a woman without having an erection, since this would entail for us a sense of indignity." (There is a curious parallel to this avoidance of the woman's glance in a text by De Chirico.)[112]

Although the Surrealists themselves did not consciously equate primitivism with Woman and scorned the bourgeois conception of the exotic with its implicit (or explicit) chauvinism toward Woman-as-odalisque and toward colonials as emasculated, happy children, they remained bound by their white middle-class education. The Surrealists often inadvertently associated the magical qualities they found in Woman with the Primitive, which could serve a magical function for the Surrealists, offering perhaps an exorcism comparable to Picasso's experience at the Trocadéro early in the century, or like Tzara's recourse in the period after his emotional crisis of 1916 to pseudo-African phrases in order to escape his feeling of confinement.[113] And the exaltation of convulsive beauty in women parallels the praise of tribal fetishes at the expense of canonical Western "masterpieces." In addition to these personal and aesthetic concerns, the Surrealists turned to primitive cultures as an aspect of their quasi-Marxist criticism of French Colonialism; and the group around Bataille saw primitivism in sadistic and violent terms.[114]

The comparison on the last page of *Le Surréalisme au service de la révolution,* no. 4 (December 1931), of the juxtaposed photographs of a Christian icon and a non-Western fetish – both female – contained an implicit political-anthropological argument against French imperialism stimulated by the major international exhibition of native art in Paris (discussed in Chapter 2, this volume) by the colonialist government. These photographs illustrate the counterexhibition (organized under the auspices of the Ligue Anti-impérialiste of the Communist Party by Aragon, Eluard, and Tanguy), which they called "La Vérité sur les colonies" (with no allusion to the party) and which had a minuscule attendance (4,226 visitors) compared with the major exhibits (8 million visitors to the reconstructed Temple of Angkor).[115] Breton's group, unlike Bataille's, did not have a real anthropological interest in primitive art in the context of its culture.[116]

Rather, the Surrealists were responding to the long-held colonialist values grounded in part on deeply held prejudices maintained in the Third Republic even by progressives like Larousse, whose *Grand Dictionnaire* accepted the analogy between "savages" and infants as contrasted with "civilization,"[117] and who anticipated a benevolent extinction of the inferior "indigènes" through progressive fusion with the "more civilized" races (which will be thereby invigorated).[118] These values were still championed in France during the twenties by a bourgeoisie that claimed indifference to politics.[119] French business, confronted with drastically reduced manpower after World War I and a low level of production in most sectors, rallied to the Redressement Français, an organization founded in 1925 with the slogan "Enough

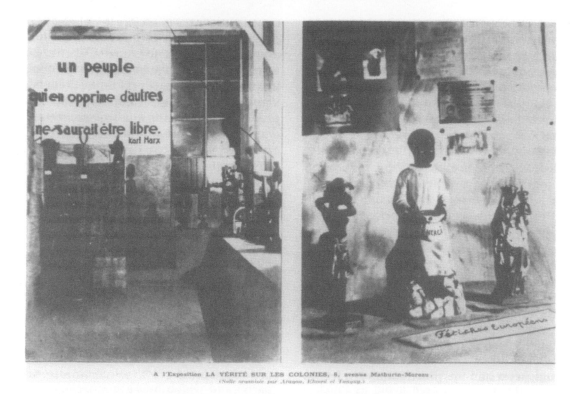

un peuple
qui en opprime d'autres
ne saurait être libre.
karl Marx

Figure 21. Anon., photograph of an exhibition arranged by Aragon, Eluard, and Tanguy, titled "La Vérité sur les colonies," *Le Surréalisme au service de la révolution,* no. 4 (December 1931), last page.

politics: We want results!" This consortium of business and industrial leaders, headed by electrical mogul Ernest Mercier, promoted modern technocracy, advocated an economy geared to mass production, and envisioned a government run by apolitical experts. In these circumstances the colonies offered undeniable advantages to French industry and – collaterally – to intellectuals seeking opportunities abroad.[120] While the climate had somewhat ameliorated since the eighteenth- and nineteenth-century glorification of French culture – there was more tolerance of difference, as well as appreciation of and sensitivity to other cultures – national power and business profit still guided foreign policy.

The Surrealists had already declared an anticolonialist position in the last issue of *La Révolution surréaliste* (especially Crevel's article "Le Patriotisme de l'incon-scient") and expressed themselves even more forcefully in the first one of *Le Surréalisme au service de la révolution* (July 1930), containing a telegram to Moscow that "declared war on imperialism."[121]

While they regarded their gesture as revolutionary – and the background of one illustration to "La Vérité sur les colonies" (Figure 21) quotes Marx on colonialism[122] – it seemed to an anonymous writer (presumably someone in Bataille's circle) in Souvarine's *La Critique sociale* that the Surrealists had simply conformed to the Stalinist viewpoint then dominant within leftist circles; for they had emphasized unduly "French atrocities in the colonies" while ignoring "the millions of workers abused, deported, starved, in Russia."[123] One might note in this vein that the Surrealists, wishing to curry favor with the Communist Party of the Soviet Union, at this time

echoed the official Soviet hostility to Freud: in the article just mentioned Crevel chided the psychoanalyst for insidiously supporting imperialist oppression of non-Caucasian races.[124] And Breton published in this issue a note stating his reservations about the value of psychoanalysis and the originality of Freud.

Still, in marking their protest, the Surrealists, like Picasso before them, went beyond the purely aesthetic preferences and formalism prevalent in the sophisticated circles that shared their taste for non-Western art (from fin-de-siècle Symbolism to Apollinaire and the Cubists).[125] The anonymous photographs serving as illustrations blur the details of the figures, depriving them of their aesthetic quality, whereas the accompanying political texts are distinct and legible.

One of the photographs for "La Vérité sur les colonies" significantly juxtaposes Christian and tribal figurines to make the ironic point that they are all equally cult objects. It shows a display that positions the figure of a young black African postulant tendering an alms pot labeled "Merci" between two much smaller statuettes – an African carving of a bare-breasted woman and a black Madonna and Child in Gothic style. The implication is that in comparison with the authentic carving, the two black Christian figures constitute a colonial seduction devoid of genuine religious feeling; indeed, before these figures lies a plaque inscribed "Fétiches européens."[126]

The fact that the "fetishes" disposed symmetrically on either side of the boy are both female, one from metropolitan, the other from colonial culture, bears on the theme of the Otherness of difference: what we have found in the Surrealist attitude to Woman we find in the colonial view of the "primitive" culture – the creative woman artist's uniting of the two (like the German Hannah Höch's) ironically did not occur in France.[127] (But in linking fetish and female, the Surrealists did not have in mind Freud's theory of the fetish, and certainly not Marx's theory of the fetishism of the commodity.) This is reinforced by comparing the Surrealist appreciation of the woman to then-current anthropological evaluations of the primitive. Lévy-Bruhl, for example, defined the "primitive mentality" as having occult properties, as not distinguishing natural and supernatural or not separating visible and invisible, and as being "prelogical" rather than antilogical or alogical – as feeling no compulsion to avoid contradiction.[128] And the definition by the Comtean Ribot of "primitive man" – "he for whom sensuous data and images surpass in importance rational concepts" – might also apply to notions about the "nature" of women.[129]

A duality pervades Western responses to the primitive fetish: fascination with its unassimilable streak of barbaric sorcery, and smugness toward the presumed inferiority of the minds that produced it. Up to the twentieth century, such productions could still be contained as curiosities within ethnographic classifications; however, with appreciation of their formal qualities, they entered collections of Western fine arts, where they caused uneasiness to observers forced to rethink the limits of art. With familiarization and expansion of canons of beauty, the threatening magical potency of the fetish verged on domestication – just as minorities began to move out of ghettos in token numbers and to move up the social scale (especially in sports and show business).[130] The Surrealists resisted this banalization, even though one of their weapons was an ironic banality. The objects desired (and sometimes stolen) by the Surrealists – whether parts of the woman's body, objects found in the flea market, or religiocultural artifacts[131] – acquired for them something of the magical value of the commodities displayed in the Oriental shop of Balzac's *Peau de chagrin* (1832), something of the "aura" that Benjamin attributed to artwork, and some of the psychological significance Freud discerned in dreams about everyday objects.

In the twenties the Surrealists had already recuperated from modernism the

power of the fetish by detaching it from its new, aestheticized frameworks (a Brecht-like defamiliarization of the ordinary being the converse of the found object's startling familiarity). In the wake of *The Psycho-pathology of Everyday Life* and *Totem and Taboo* they linked fetishes and ritual activities to sexuality and aggression. Like some Freudian dream-objects metamorphosed under the processes of condensation and displacement, these objects suggested occult meanings and an unsettling rearrangement of the everyday that came uncannily close to the psychotic.[132]

Averse both to the fetish of bourgeois merchandise and to the productions of proletarian labor, the Surrealists stumbled toward alternative ways of valuing or exchanging objects: they favored barter and the flea market. They proposed either the making of objects automatically (rather than through craft skills) or the random encounter with found objects after the manner of Duchamp. These concerns brought them to the fault lines of their culture, the site of the "others," Woman, and the colonial. Not accidentally an issue of a Surrealist periodical edited in 1929 by Aragon and Breton shows under "Fétiches" a female automaton (we may recall that a female symbolized the "muse" of automatic writing in 1927) from the Musée des Arts et Métiers beside a totem figure from the Pacific Northwest coast.[133]

The Surrealists insisted that while they *used* the fetish, they were not fetishists. At the first meeting of the Bureau de Recherches Surréalistes in January 1928 discussing sexuality, Breton said: "In a general way I have a completely fetishistic concept of love. I have a highly cerebral taste for fetishism with regard to objects; but in the end I do not at all give in to it." He later exhibited this taste when he characterized a piece of rose velvet as feminine and linked it to the "perversion of fetishism."[134] At the second meeting on sexuality Aragon stated, "I consider myself a fetishist, in the sense that I carry on me a great number of objects to which I attach importance and that I constantly need to have at hand"; and in response to a question from Raymond Queneau, Marcel Noll said, "I am in large measure a fetishist. At home I have all sorts of objects." On this Breton commented, "That's not fetishism, that's collectionism."[135] Still, as Barthes, in an interesting comparison of photograph and artwork noted, a painting can serve in the capacity of a Freudian fetish that "denies the existence of the very thing to which it refers."[136] Feminist film critics have elaborated the link made by psychoanalysis between the male gaze at the woman and castration anxiety.[137]

After the publication of "Je ne vois pas" there followed several works on the theme of the (in)visibility of the woman. We have already mentioned Dali's book *La Femme visible* of 1930, which includes the poem "Le Grand Masturbateur,"[138] and discussed Giacometti's *The Invisible Object* (*Mains tenant le vide*, a play on "maintenant"). Breton now united the theme of invisibility to that of phantoms and transparency (the crystal house). Up to the late thirties the female nude that pervaded Surrealist imagery and that Breton himself admired had a very material body, represented in the work of Ernst, Arp, Masson, and Giacometti, usually as deformed or disassembled, anonymous, often faceless, even headless.[139] However, Breton, who in 1928–30 equated women's eyes with their breasts as a sexual feature (and who must have felt a special *frisson* watching the woman's eye being cut in the opening scene of *Un Chien andalou*),[140] had long dreamed of rendering the body dematerialized and transparent. Invisibility became in Breton's later writings the basis for a new exaltation of Woman, a sublimation of her materiality: *Arcane 17* (1947) represents Woman divested of her body's material opacity, which is transmuted into light and spirit and becomes the source of life itself.

Despite their efforts to achieve freedom, even equality within their love relationships, Breton and the group around him after 1929 – the very ones whose photos

surrounded Magritte's unseeing nude woman – were saddled with the burden of their early training and education. These middle-class sons, while feeling restive within the patriarchal family structure into which they were born, could not help reproducing that structure in terms of male prerogatives in the artistic and political spheres.

Breton, as he became disillusioned with the realpolitik of social change, sought from the thirties on to make Woman the path toward some vaguely revolutionary future. The ideal muse would offer a conduit between "communicating vessels" in a dialectical movement: the "vase" of individual love communicates with the "vase" of bourgeois marriage and family through the overarching medium of the social revolution (a "bridge" to cross from the water of one vase to the other's). The Surrealists seemed ready to accept women as more active participants in the movement, to march beside them.

The woman depicted as an erotic object was, however much she writhed seductively (like Salome), usually considered to be rooted to a place; mobility and "progress" were reserved for men.[141] Desnos's "Deuil pour deuil" (1924) ascribes to a woman vainly pursued a perverse union of Oedipal limp and Gradiva-like mobility: "The woman whom I followed limped slightly. Still, she outran me."[142] More typically, Breton observed (with reference to women), "Convulsive beauty can only exist through affirming the reciprocal relation that unites movement and rest in the object."[143] As late as 1935, the de Sade expert Maurice Heine wrote in *Minotaure* on the foot fetishism of a notorious eighteenth-century pornographer.[144] Eighteenth-century engravings illustrate Heine's article: a woman reclines with spread legs, displaying her tiny foot to her lover; another woman trips on her excessively high heels and – seducing her seducer – falls into bed.[145] The scale of the body parts of these ideal women is in keeping with the ancient erotic canon embodied in the Latin saying

"parvus pes magnum barathrum" (the Latin *barathrum* from the Greek *barythron* means chasm or cleft, and in slang it signifies the vagina;[146] the Greek notion may bear on diverse allusions direct or indirect to the vagina, from the Sphinx's cave to the *abyme* of Derrida): their feet are invariably tiny, their pubic region very large. The eighteenth-century "swinger" – the unstable woman who oscillates in playful, erotic rhythm, without purposeful direction or threat – provided a recurrent model for Surrealists such as Ernst. But another model, inspired by the incipient struggles by women for equality, began to compete with it.

The growing mobilization of production throughout Europe that culminated in the war brought an ever larger number of women into the workforce; by releasing men they complemented the armed forces. Yet even in totalitarian countries opportunities opened for some women not incorporated into the system for the mass (re)production of babies. And in the democracies the postwar surge in applied technology brought home appliances to middle-class women that would educate them to contemporary mechanization. The public place made available to women, though often token and generally impermanent, significantly strengthened the self-confidence of the female population drawn out of domesticity, especially in the metropolitan centers. This new empowerment of women, however incomplete, seemed to pose a threat to the stable configuration of the middle-class family, with its established partnership between the male breadwinner, an apparently independent agent moving between home and job, and the dependent mother fixed in the home with children.

The "new woman" seemed unwomanly in her newfound activity; closer now to male creativity than to the mother-producer, she had become "aggressive." In fact, in keeping with the etymology of the word "aggression," the most "forward" of the women might resemble Delacroix's

celebrated allegory of Liberty in the Revolution of 1830, who advances her foot onto the barricades while carrying her complements of phallic rifle and banner.[147] Significantly, the most pervasive representative of social and political change in the nineteenth and twentieth centuries – the avant-garde – assumed the metaphor of a militant march. Women's marches demanding equal rights appeared to conservatives as a transgression of conventions, whereas the regimented march of soldiers expressed the maintenance of national tradition. In this period of militant nationalism under the shadow of the threat of war, a prominent French sociologist made a study of national styles of marching. He compared (1934, 1936) the marching of the French army with that of the English and the Germans (the goose step).[148]

The image of the forward march, the "progress" of women, inspired the fascinated Surrealists above all with an interest in the mythological figure of Gradiva. Breton described her in the epigraph to a chapter of the *Vases communicants,* a quote from Wilhelm Jensen, *Gradiva:* "And lightly picking up her robe in her left hand Gradiva Rediviva Zoe Bertgang, enveloped by the dreamy look of Hanold, with her supple, tranquil step, in the full sunlight on the flagstones, walked to the other side of the street."[149]

As previously noted, the Surrealists knew Jensen's novel from a book Freud wrote about it,[150] and they read it in the French translation by Marie Bonaparte in 1931 (only Ernst might have read it earlier).[151] The novel gave the Surrealists a heroine freer and more active than their old seers and mediums. It recounts the "case" of the inhibited German archaeologist Norbert Hanold, who, in studying a classical bas-relief, became obsessed with the figure of the stepping woman it represented: he dreams of her and names her "Gradiva" (so named because her bold step resembled the stride of Mars Gradivus).

Hanold yearns to find her counterpart in reality, and in a dream he does find her; but unfortunately it is in Pompeii at the moment of Vesuvius's eruption, and she disappears on the steps of a temple. He then decides to travel to Italy, where he has on several occasions the delusion of seeing her in the flesh. At last he finds her again in Pompeii in the form of a living girl he actually knew in his hometown. Freud regarded the novel as rather mediocre – an opinion that may have influenced most critics to prefer Freud's analysis to the original text.[152] But Freud credited Jensen – who himself denied in correspondence with Freud any psychological intention – with presenting a correct psychiatric study in which an intelligent girl applied therapeutic techniques and insights remarkably like those of an analyst to free a young man from the delusion that she was the Gradiva of his dreams.[153] She understands the erotic repression at the root of his delusions and helps the archaeologist to break through his defenses and denials, to find his way back from the safe remoteness of the past to their tense but sexually alive present, and to turn stone representation to living flesh. We later learn that Hanold has confused Gradiva with his childhood sweetheart Zoë Bertgang (a name analogous to Gradiva), the memory of and desire for whom he had repressed. Zoë, though in the background, accompanies Hanold throughout the story, but he is aware of her only as a hallucination or in his dreams. Just as it had in Pygmalion, that other story of flesh and stone that interested Surrealists like Delvaux, love's power brings about a conventionally happy ending, although, as one writer has noted, the therapy was in fact incomplete in psychoanalytic terms.[154]

Breton epitomized the dynamism of this aggressive Muse of the avant-garde in a phrase that Freud cites from Jensen – "Celle qui avance." The Surrealists perceived in Gradiva a guide to personal, if not social change, the being who could break the ritual confines of bourgeois family life. This transformation of the Muse of the unconscious into the insightful analyst doubtless entailed anxiety for the Surreal-

ists. Precisely owing to her independence and activity the woman represented by Gradiva held a certain ambivalence for the Surrealists: how to reconcile the free woman, boldly stepping forward, and the hysteric convulsed by love, or to progress side by side with the eternal image of the mothers that lead us forward (Goethe's *Faust*). One might appropriately put such questions to Breton, who in 1936, doubtless with some ambivalence, urged Jacqueline to paint and observed that her watercolors were tied together "by a touch of sadism."[155]

This ambivalence about women's equal rights touched most of the treatments of the subject of Gradiva as the unfettered marching woman; for Gradiva was a male invention, like Pygmalion's stone a simulacrum of a woman who came alive, in both cases a thing whose human existence in the flesh depends on the desires of men.[156] They expressed their ambivalence in deformations of the image of Gradiva. Pierre-Jean Jouve punned on her name and turned Gradiva into a pregnant woman in his poem "Gravida" (weighted, pregnant as in Raphael's famous painting) published in *Minotaure*.[157] Giacometti deformed Gradiva's "face" (composed – somewhat along the lines of Magritte's *Le Viol* – of breasts for eyes and an umbilicus for a nose) and conflated her head with her chest in his *Nude (Femme qui marche)* of 1933–4, a wiry figure anticipating his mature sculpture; and Dali, who equated the names Gala and Gradiva, differentiated them in his paintings: he reserved distortions for Gradiva (into whom he presumably projected the dark side of Gala), while painting Gala realistically. (Curiously, while extolling the maternal authority of Gala/Gradiva, he remained obsessed with the *femme-enfant*.) Bataille did not have a concept of the freestanding walking woman, which he probably considered romantic or sentimental. The texts and images of *Documents* ignored the woman's foot in motion and instead emphasized foot fetishism and the seduction it produced as a function of base materialism.[158] And Breton, who appreci-

ated the bold step of Gradiva, nevertheless endorsed placing her name on the storefront of the Surrealist Gallery, a business selling paintings and books that Jacqueline and he conducted in 1937 without much success. Under the word "GRADIVA" on the façade of the gallery appeared several women's names: Gisèle, Rosine, Alice, Dora, Inès, Violette, Alice (twice), allusions to Gisèle Prassinos, Alice Paalen, Dora Maar, Violette Nozières, and perhaps to the Alice of the Wonderland.

The major Surrealist version of the subject was André Masson's painting *Gradiva* of 1939 (Figure 22). The metamorphosis of female bodies had long fascinated Masson (*Apollo and Daphne* of 1933), who painted his own version of *Pygmalion* in 1939. The transformation of Gradiva from a relic of the dead past into a vital female companion interested Masson as it had Freud, but the psychoanalyst's interpretation failed to interest him (he preferred Nietzsche's "psychology" and the philosophy of Heraclitus). Masson drew entirely on vivid details (based on Hanold's dreams and hallucinations, as well as on his "real" experiences) he found in the novel – the prominent stepping foot of Gradiva, the juxtaposition on her body of marble and flesh, the erupting Vesuvius, bees, and the cleft in the wall. Masson has ignored the boldly striding woman, the insightful guide to Hanold, and instead given us fetishistic foot fragments and a body in metamorphic transition between flesh and stone.

The Surrealists never appreciated a female figure bolder or more independent than Gradiva. However, Gradiva was a character created by a man (Jensen), developed by a man (Freud), and exploited uniquely by male artists and poets; in fact, they did not attribute such a role to any woman of their acquaintance, since they habitually saw women as erotic creatures, delightful or mysterious. The gender tracking of French education, still in place in the Third Republic, meant that one expected the girl to be mother, nurturer of man and child, and expected the boy to become

Figure 22. André Masson, *Gradiva* (1939), 36½″ × 51¼″, Collection Nellens, Knokke, Belgium. Photo: Galerie Louise Leiris

creative and a participant in public life, but sometimes the artificiality of these predestined roles was sensed: a caricature of 1924 ridicules a boy's straining to realize the prescribed "empowerment" of his gender.[159] In theory the democratic revolutions and the Napoleonic reforms had practically mandated the equality of all persons regardless of color or gender; however, in practice one finds that primarily white males were intended by such reforms. Thus, a statement by Jules Simon (1867) begins: "The lowliest scholar in the lowliest school, the least capable, the most ignorant, the one with the fewest intellectual gifts . . . ," and it concludes, ". . . is after all a *man,* and since he is a man he has the capacity to know the truth and to understand and live by it" (emphasis added).[160] The Marxist concept of class conflict has performed a useful service in exposing (in terms of race and class interest if not of gender) the repression and exclusion hypocritically smoothed over by this image of a universal and reasonable individual (man). Still, believing in a universal equality at the level of dream and the unconscious (a level irrelevant to Marxist class conflict), the Surrealists developed a vision of humanity beyond divisions of gender, class, or race, albeit as theoretical and poetic as the Romantic Hugo's.[161] This, more than Marxism, guided their opposition to racism, as in the leveling of Western and colonial "fetishes" in their anticolonial exhibit of 1931.

Owing to this social partition and the consequent exclusion of women from higher posts and from the professional cadres, few women escaped from being stereotyped as imitators with manual rather than intellectual skills. The enormous amount of work by women exhibited in the annual salons from the eighteenth century on meant in terms of the male art critical apparatus not that women were "creative," but that they were good at

decoration, imitation, and the "minor" arts. The Surrealists only partially break out of this mold.

Although the Surrealists at first did not expect their female acquaintances to share their creative ambitions as poets and artists, women undeniably made a major contribution to Surrealism, right from the beginning; but generally they did so behind the scenes, as wives or mistresses, so they did not appear as officially contributing members. For example, Denise Levy (the cousin of Simone Breton and wife of Pierre Naville) was highly cultured and intelligent, and her knowledge of German, unusual in Surrealist circles (except for Ernst and some ex-Dadaists), enabled her through letters and conversation to stimulate the interest of the Surrealists in German Romanticism.[162]

During the thirties a few women became more visible contributors to the movement, stood beside the men, and – either as revolutionists or as artists – signed the Surrealist tracts.[163] Women now participated in the sessions of *recherches sur la sexualité* (apparently as equals to judge from the transcripts), and more important, a number of women artists entered the Surrealist circle and produced work whose quality could not be ignored; for example, Breton, having written a preface, asked Valentine Hugo to illustrate an edition of Achim von Arnim's *Strange Tales* (Paris, 1933). Of the sixteen artists participating in an exhibition of Surrealist drawings in December 1935, three were women.[164] Unfortunately, despite the Surrealist rhetoric of equality and freedom, women artists, whatever their merits, were rarely publicized individually like their male counterparts and – in keeping with "Je ne vois pas" – had less claim to exhibition space although they participated in some group exhibitions.

Not accidentally, a gifted *femme-enfant* discovered by the Surrealists, the fourteen-year-old writer Gisèle Prassinos, was among the first creative women to receive great visibility.[165] The constraints imposed on Surrealist women, first in their separation from the goals and activities of their male cohorts during their early education and later as perpetuated in the group of Surrealist men, led to the apparent paradox that some of these ambitious and independent women mirrored in their subject matter the male image of woman as *femme-enfant*:[166] driven into private self-explorations, they often represented the world of their childhood as young girls gifted with a magical imagination (Toyen, Carrington, Sage). And owing to a hostility toward the bourgeois family and a distaste for begetting children that the women shared with their male colleagues, they suppressed without apparent difficulty whatever maternal impulses they may have had.

Perhaps they, like other disadvantaged women professionals, salvaged a feeling of self-worth by rationalizing their incomplete integration as independence and subversion; it seems that in relation to the Surrealists the women occupied a position analogous to that of the men as youthful rebels. Indeed, paradoxically, their very "inadequacy" might have enabled them to be not only receivers of artistic influence but also givers.[167] Curiously, their defensive self-centering (understood either as mirroring their male counterparts' endless fascination with woman or as seizing the male gaze for themselves), though in fact a reflex of their professional isolation, seemed to corroborate the standard diagnosis of female narcissism.[168]

Even more curiously, it seems that the most creative women Surrealists began to pass through this "narcissistic" self-centering, this psychological Pilgrim's Progress, and thereby to find independence. They discovered or created their own mythology, drawing especially on ancient myths of witches, "others" who did not serve as helpmates or inspirers of men (like Breton's supernatural Melusine). The French feminist journal *Sorcières* of the seventies devoted itself to a mythology of the feminine. In its first issue the militant lesbian critic Xavière Gauthier (who wrote

a book condemning the Surrealists as patri-archal) insisted on the sexual pleasure of "lunatic women, struck ... with periodic madness." "Periodic" here suggests less Delvaux's somnambulists erotically parad-ing under the moon before unseeing men than the comparison by highly conscious feminists of menstruation and "écriture féminine"; for example, Madeleine Gagnon wrote in *Body One* as though calling for female graffiti: "All we have to do is let the body flow, from the inside; all we have to do is erase, as we did on the slate, whatever may hinder or harm the new forms of writing; we retain whatever fits, whatever suits us."[169] Gauthier promoted the work of Léonore Fini, creator of a self-portrait, *The End of the World* (1944), that mingled death and narcissistic eroticism. It shows, floating half-immersed in a deluge, her nude torso and animal skulls, with their reflections. The image suited the MTV personality Madonna, who recycled it, together with images from Kahlo, in "Let's Get Uncon-scious" from *Bedtime Stories* (1994–5).

Certainly their self-images must be dis-tinguished from their representations by the men, which alternated between com-pleteness (formal beauty) and sadistic dis-mantling (convulsive beauty). Paradoxi-cally, while the Surrealists often treated women's beauty as existing *hors du temps* (rather than aging or deteriorating, women – except in some paintings of Dali obsessed with the decay of female beauty – passed directly from youth to invisibility as phantoms or were reintegrated into mat-ter), they did not hesitate to disconnect and reconnect the limbs of healthy young women. To some extent this negation of bourgeois canons of beauty anticipates the feminist artists' attack on stereotypes of beauty.[170] The female mannequins made by men for the 1938 Surrealist exhibition in Paris were (in contrast to many images in paintings) often loaded with bizarre accre-tions, but not sadistically mutilated or de-formed; however, in the interest of fetish-ism or of an arcane symbolism they were rendered unattractive, even grotesque through the attached objects. And, as though at once in awe, fascination, and disgust at the reproductive female powers, some Surrealists made models that dis-played their internal organs. (The sadistic curiosity of young males often expresses itself in tearing open toys to see their insides.) Thus, even though women artists participated in the show, the men contin-ued to represent Woman as the Other.

Did the women artists tend to have a recognizable iconography or subject mat-ter? I think this can receive a loosely affirmative answer, without risking firm generalizations or an "essentialist" stand. This resulted from their political position within the movement: the men took charge of the production of images dealing with the theoretical formulations – they fought the battles with Cubist formalism, abstrac-tion, and Social Realism. (Many feminists now feel compelled to formulate their own theories.) When a male artist worked auto-matically he made art with ideological implications, whereas when a woman (Nadja, Helen Smith) did so, she served as a conduit for the prophetic or the marve-lous; in like manner the one used collage to dismantle and violate form, the other to fashion elegant textures.

As we have seen the men who, through their domestic and public education, be-came the Surrealist cohort were a creative fraternity that, like adolescent *flâneurs*, peeped at women and dreamed about their bodies. In Freudian terms the collec-tion of photos in "Je ne vois pas" would carry a burden of male-bonded narcissis-tic sexuality (the "je" was unmistakably male). Their self-involvement had little impact on the Surrealists' criticism of bourgeois society, but it did create for them an ambivalence toward the Others for whom they theoretically or ideologi-cally felt sympathy – workers, colonialized peoples, and Woman. However, the en-coded symbolic self-representations of the male Parisian Surrealists left no place for "others" – women or non-Westerners – at the center.

Pressed to the movement's periphery, the women could either become (as many did) reflective satellites or through introspection – either individually or in a "sorority" – define an ambiguous place on the borderline of the movement. In the best of their work they represented the female as a coherent heroine, rather than as a victim cut up sadistically. If their images of women sometimes seem strange, they are also potent; but they did not create a feminist counterpart to Gradiva, the male emblem of political aggression and liberation.

Women began to recuperate from the male Surrealist writers the "madness" (Gauthier's word) on their own bodies, which now became a site of contest. The extraordinary sculptor Germaine Richier, who was not a Surrealist, actually represented a large *Mantis* (1946), thereby appropriating an image of woman that had terrified and fascinated the male Surrealists. Surrealist women especially achieved control of their "look" in the fields of maquillage and fashion, realizing what Apollinaire had earlier only imagined in his chapter entitled "Mode":[171] no one could deny Coco Chanel's genius for dress design nor the daring imagination of Schiaparelli's inventions of hats (upside down, lamb cutlet, shoe hat) and gowns with lobster prints, developed in collaboration with Dali. It may well be that careful rethinking of the Surrealist images of women (photographs of women artists and photographers especially) will reveal a more active participation by the women in their production than has been recognized. When feminists recuperate the best art of women working in the circle of Surrealism, they find an intimate eroticism centered on touch and caress rather than penetration or tearing.[172]

Two women who transformed their sensual experiences into the "public intimacy" of their art within the Surrealist context were Meret Oppenheim and Toyen. Oppenheim is best known for her *Luncheon in Fur,* the highlight of the great 1936 Surrealist exhibition in Paris and a work that apparently owed its scandalous meaning to the Surrealists rather than to her.[173] Its success seems to derive from an ironic tension between its subtly metonymic allusion to pubic hair (cunnilingus) and the potential sexuality of the act of drinking repressed through etiquette. Many visitors to the exhibition would already have known the "pubic mouth" of Magritte's *Le Viol* of 1934, as well as the Freudian interpretation of fur as pubic hair;[174] hence, for them the thrill and repugnance at the idea of drinking tea not from hard, clean porcelain but from a fur-covered cup would easily have induced an association with a perverse performance with the mouth.[175] Oppenheim made powerful works that seem to allude to the woman's treatment as an object to be eaten: in a Surrealist exhibition of 1960, placing fetishism under the sign of black humor (and hinting at the Christian rite of communion), she served up a female body as a collection of edible parts on a table.[176] Oppenheim's refusal to adhere to any political line may account for the reticence about her among male Surrealist writers: in his writings on art Breton at most names her in passing, without discussion.

Though Breton did not do justice to the independent Oppenheim, he did praise highly the Czech painter Toyen, an important participant in the group Devetsil with Karel Teige and Jindrich Styrsky; together with these friends (and Jindrich Heisler) she engaged in the political and artistic battles of Czech Surrealism. Still, in his major article on her Breton noted above all her quality of introversion (not accidentally he dwells on Rorschach), which she transcended above all as a seer. Admiringly, he noted that like a seer she had predicted the future in her justified forebodings (reminiscent of Nadja's) about her city of Prague "on the eve of the Hitlerite putsch";[177] Breton and his fellow Surrealists contributed poetic evocations for two exhibitions in Paris of Toyen's work, one held on May 5, 1953 (twelve wrote mainly one-liners), and another on April 30, 1958 (seven prose poems, each on a different painting), for which a

line of Apollinaire's served as epigraph.[178] A far larger claim for her contribution was made by another Czech Surrealist, Vitezslav Nezval, who wrote – but not in a Surrealist periodical – that "it is the creations of Toyen, above any other, that seem to correspond to André Breton's expression 'explosante-fixe,' and it is thanks to them that I have grasped the ultimate sense of the phrase 'beauty will be convulsive.' "[179]

The issue of self-representation by Surrealist women artists – the ability to legitimate themselves as subjects and to gain recognition both for their art and for their political concerns – continues to preoccupy feminist artists, who still seek (in Althusser's terms) to be "hailed" like the male members. In his article "The Most Recent Tendencies in Surrealist Painting" (1939), Breton failed to name any woman. One can conclude from this that when, less than a year later, he and Trotsky spoke of the freedom of the artist, they did not have women vividly in mind.

THE SURREALISTS AND COLONIALISM

Surrealism is allied with peoples of color, first because it has sided with them against all forms of imperialism and white brigandage, as the public manifestoes in Paris against the Moroccan War, against the colonial exhibition, etc. demonstrate; and secondly because very profound affinities exist between Surrealism and "primitive" thought – both aim to do away with the hegemony of the conscious and the everyday, in order to bring about the conquest of *revelatory emotion*.[180]

Although most French women, like persons from non-Western countries, belonged in the vague domain of the Other, certain individuals crossed the boundaries separating male, female, and colonial. The art and personality of Frida Kahlo (1907–54) – who fascinated the Surrealists, but who denied being a Surrealist – in particular raise crucial questions for the relation of Surrealism to women and to colonialism. Breton, who – in the wake of Artaud's trip in 1936 and before Wolfgang Paalen's in 1939 – saw Mexico as a place of primitive mystery and revolutionary ferment, was irresistably drawn to visit Mexico when Trotsky found refuge there.[181] Trotsky resided at the home of Kahlo, who took him in at the urging of her husband Diego Rivera. It was at their home that Breton visited the great revolutionist. Kahlo became the centerpiece of an amorous rivalry between Trotsky and Breton, who flattered Kahlo with an article on her in 1938, which concluded with the phrase, "The art of Frida Kahlo is a ribbon around a bomb."[182] This metaphor (which has gained a certain notoriety in feminist circles) with phallic and sadistic allusions belongs with the old adoration of women not as real individuals but as larger than life beings capable of terrifying acts of destruction, like the assassin Germaine Berton or the murderous Papin sisters. Breton's appreciation of her art as Surrealist – a point firmly supported by the great Mexican poet Octavio Paz – did not survive his departure from Mexico and, presumably, his realization of her Stalinism: he never again mentions her by name in his writing (while he alludes to her in his *Entretiens*, he does not name her).

Until recently critics have seen Kahlo's art in terms of anguished autobiography or as created by a female exotic or – especially among the Surrealists – a violently imaginative artist. Diego Rivera, who relates Kahlo's painting *My Birth* to Tlazoteotl, Aztec goddess of filth and childbirth, calls Kahlo "the only woman who has expressed in her art the feelings, functions, and creative power of woman."[183] Paz on the other hand placed her in a European context: "Frida passionately wanted to be Mexican, but her Mexicanism is a mask; what counts in her case is not folklore (as is likewise true of Diego, another cultivated academic painter) but poetic genius."[184]

A searching essay accompanying an exhibition of her work in 1982 attempted to

synthesize the several aspects of her career: "Though Frida Kahlo was not herself a 'history' painter like Rivera, she worked from the point where 'avant-garde modernism,' 'popular historicism' and 'mythic nationalism' met – in her own favourite genre – portraiture."[185]

Her dual Indian and Catholic heritages enabled her to translate her experiences of injury, her emotional wounds as a woman rendered sterile by physical injuries, into Mexican parables and images of deities: she *lives* her psychic traumas through them, and she recuperates her present through her country's past. Feminists insist that having reconfigured her sufferings into the political terms of resistance and social critique, she has achieved importance as a model of the "survivor" (in a patriarchal "holocaust"?); Lucy Lippard writes, "Between the poles of populism and avant-garde, Indian and European, cultural revival and modernism, Kahlo sowed the seeds of a new vocabulary for the expression of female experience."[186]

Aside from the special circumstances that involved him with Frida, Breton's interest in Mexican art – as in that of all Third World countries – centered either on a local Surrealist movement or on primitivism. The Surrealists welcomed only Rufino Tamayo, singled out as an example counter to the "art engagé" of Mexican muralists like Siquieros and Orozco (Breton ignored even the painting of his friend Rivera, an erstwhile sympathizer of Trotsky's).[187] They also appreciated the brilliance of Octavio Paz both as a critic of Duchamp and of Mexican art, as a poet who understood automatism, and as an essayist who associated his rich interpretations of pre-Columbian mythology and of Buddhism to Surrealism.[188] The interest remained rather limited (e.g., to what Breton designated as the "humour noir" of Posada),[189] since Mexico was not Francophone; hence, he ignored the work of major contemporary non-Surrealist artists. And he did not recognize in Frida's work political intentions that transcended both the personal side (her accidents that mutilated her body, without diminishing her uncanny ability to attract men) and the unusual features that Breton regarded as "Surreal." (It is just these features of her art that feminists now emphasize.)[190]

Breton like the other Surrealists was caught within an ideology that supported sexism and racism as transparent truths, thereby making it doubly difficult to perceive the strength of a Mexican woman of mixed blood – as seductive to them as Jeanne Duval was to Baudelaire. They never wholly escaped from an ambivalent attitude toward the odalisque, the beautiful female slave created by Romantic exoticism, whose boundless sexual generosity obviously posed no threat to the power or vanity of patriarchal males.[191] Baudelaire hardly shakes off the tradition in "Parfum exotique" with it Gauguinesque "lazy isle where nature produced / Unusual trees and tasty fruits; ... And women whose eyes astound us with their frankness."[192] And Gauguin himself saw, through the Symbolist filter of his modernism, the Tahitian women as candidates for his sexual aggression, thus uniting in his art the impulses of a French colonialist to his male chauvinism.[193] In the twentieth century the insidious and debased association of woman and colonized "primitive" appeared nowhere clearer than in a news item of 1902. Parisian reporters designated as "Apaches" – an argotic term derived from the name of an Amerind tribe – one of the gangs of rival pimps fighting over rights to an attractive prostitute.

Although the limits of their compassion and comprehension were the deranged patient and the Francophone intellectual (outside France Surrealism always had the quality of an import),[194] to their credit the Surrealists struggled to transcend the limiting horizon of their bourgeois culture toward both the female and colonial "Others": they encouraged passionate and equal love unbounded by law and custom, and they opened the way to discovering and promoting new dimensions of beauty and imagination in non-Caucasian poets

and artists. In the thirties Surrealism attracted new recruits among those ignored by the dominant culture in France including women artists and students from Francophonic countries of the Third World.[195] This interest was limited, of course, to outstanding activists of the Third World – for example, Aimé Césaire (b. 1913)[196] and Léopold Senghor (b. 1906).[197] Surrealism helped to liberate both these major writers from the academic literary models of the *lycée,* in a sense legitimating their indigenous imagery and rhythms; and they in their turn enriched French poetry, thereby becoming "classics" themselves. Senghor found a way to use Surrealist imagery as a critique of the colonials: he called the Portuguese ladies in Senegal sitting in the shade of their verandahs, "Les signares aux yeux surréels comme un clair de lune sur la grève" ("Chants d'ombres" [1945]). Whatever headway the Surrealists made against colonialist prejudices, it required independent action and thinking by Third World intellectuals educated in French culture to begin the writing of a genuinely social critique of colonialism.[198]

Surrealism provided artists and poets of the Third World with a "vase communicant" that facilitated their move outside the confines of the provincial and helped make their imaginative creations available in France. The best example of the liberating influence of Surrealism appeared in Francophone Martinique – generally characterized in France as a site of the irrational and marvelous,[199] where the celebrated poet Aimé Césaire and his wife Suzanne edited the richly imaginative review *Tropiques* (1941–5). Césaire developed the notion of *Négritude* (in his *Cahier d'un retour au pays natal* of 1939), which Senghor made the basis for official policy in Senegal and which expanded beyond French culture when American blacks living in Paris encountered it.[200] All the great issues surfaced in the Césaires' writing – the relation of *langue* (French) to *parole* (Creole dialect), of the colonial to

metropolitan culture, and of the racial outsider (the "native") to the hegemonic "civilization." Breton at once recognized the power and originality of their contribution to Surrealism when he met the couple in Martinique in 1942.

During the early thirties the Surrealists were particularly exercised by French colonialist practices as they had been in 1925 by the Moroccan War and again in 1930 by the colonial exhibition in Paris.[201]

And anticolonialism of the Surrealists, like that of most radical intellectuals, was encouraged by the Comintern's propaganda. It was primarily generated in response to actions by the French government (which had before World War I and after the defeat by Germany in 1870–1 attempted to recruit the colonials into their campaign for a "Greater France"):[202] they supported the Moroccans in their war with the French "imperialists," even though they had only a vague idea about the Moroccans or their culture, or about the war for that matter. A major collective manifesto against the war was signed by members of the groups *Clarté* and *Philosophies,* as well as by the Surrealists. These groups were less concerned with the specifics of the Moroccan War involving France, Spain, and the Riffs than with a generalized pacifism and rejection of French chauvinism and patriotism.[203]

Having placed colonialism in the context of the drift of Western imperialism toward Fascism, the Surrealists expressed their political sympathies during the thirties by engaging in street politics, participating in radical party meetings, joining worker protests, and disseminating manifestos that they wrote or signed or both. Their hostility to a colonialism linked to French imperialist ambitions and naked profit seeking was accompanied by mixed sentiments of awe and empathy for the exotic. What sustained them, as I have tried to show, was an old disgust for French nationalism (and rationalism) rather than a sympathy with the proletariat and a Marxist-Leninist analysis of the links between imperialism and

industrialization.[204] In this context one might describe the Surrealist revolutionaries as premodern rather than postmodern.

The Marxist interpretation of imperialism current in the Parisian Left in the twenties and thirties was based not on Marx's own positions on colonialism but on Lenin's book *Imperialism: The Highest Stage of Capitalism* (1917), also regarded as essential for understanding colonialism.[205] An article published in *Clarté* (1923) cited Lenin's five characteristics of imperialism: concentration of production (monopolies), fusion of finance and industrial capital in a financial oligarchy, exportation of capital, formation of multinational monopolies, and world conflict for possession of markets.[206]

In retrospect, and with the publication of previously hidden archives, we can today understand (as the generation of the thirties could dimly at best) how the crafty Leninist-Stalinist line attributing imperialism (and colonialism) solely to capitalism could convince the Left. By skilled propaganda and rigorous concealment, attention was diverted from a "domestic colonialism" in the Soviet Union to the very public actions of an expanding Western capitalism that sought fresh colonial outlets and sources of raw materials, while trying to subvert the Soviet experiment. But for all its claims to an egalitarian "Communism," the constituent republics of the Soviet Union remained as before subjugated by a Mother Russia in proletarian clothing: the minority states lay subject to what amounted to an "internal imperialism" and were no less exploited than the African colonies. (The Georgian Stalin brutally suppressed the efforts of his fellow Georgians to gain their independence.)

It was left to the marginal Surrealist, Bataille's friend Leiris, who would later visit Africa on ethnological expeditions, to suggest in 1929 a mechanism whereby persons in different cultures might find a common ground of understanding, of mutual empathy – the fetish, apparently devoid of psychoanalytic content, but inevitably bearing associations to sexual and magical practices.[207] He defined "true fetishism" in terms anticipating the fascination with insects and space in *Minotaure* as "a love – truly *amoureux* (infatuated) – of ourselves, projected from inside to outside and clothed in a solid carapace which imprisons it within the limits of a precise thing and situates it, like a piece of furniture (*meuble* [a movable property]) which we can use in that strange, vast room called space."[208]

Nothing casts more light on French colonialism before and during the Surrealist period than the big exhibitions that took place, especially in Marseille, a port with a strong North and West African trade. Breton and Aragon attended and commented on a colonial exhibition held in Marseille in 1923;[209] other such exhibitions took place in Paris in 1925 and 1931.[210] The 1931 show, clearly addressed to French bourgeois businessmen and their families, provided a context apparently suited to advertising along gender lines: on the one hand an appeal to female taste (corsets, perfumes, pianos), on the other to the aggressive ambitions of middle-class businessmen (articles urging industrial exploitation of colonial raw materials and ads for guns and cigars).[211] The manufacturer or businessman could expect to find a complete inventory of "resources suited to your activity." The artist too is addressed: "You will find in the exposition new lines, new colors, new harmonies." Indeed, the section "BEAUX-ARTS" refers to "works of art whose inspiration has been drawn from our colonies," to new motifs that can lead the European spectator to "a renewal of the decoration of our modern life." Incredibly, on the page following these remarks appears a drawing of a classic female figure in the form of a caryatid – cousin of the odalisque – supporting a bowl of fruit.[212]

The preface to the catalogue with unintended irony emphasizes France's greatness as a colonial power waging a war for peace (this slogan, reminiscent of Orwell's *1984,* was common during the twenties

and thirties, when a benign hypocrisy cloaked the Franco-German rivalry for colonies): "The colonies will thus become new fields of battle 'where the nations of the twentieth century ... can rival each other ... in working for peace and progress.' "[213] It also unctuously claims that "our protection has delivered millions of men, women and infants from the nightmare of slavery and death." At the present time to "colonize" means to "exchange ideas and materials, not with creatures burdened with physical and moral misery, but with well-to-do, free and happy folk."[214] The section entitled "Afrique equitoriale française" concludes that "our Africa" will be a "magnificent extension of our French humanity." (One has only to read the observations of Lévi-Strauss to discover the depressing conditions prevailing in the Third World, often precisely as "extensions" of European culture.)[215]

Such language rankled the Surrealists and nourished their opposition to French colonialism. Even their interest in African art was strongly qualified by their hesitation to accept the vogue for it among the Parisian avant-garde through the joint influence of Apollinaire and Paul Guillaume, and both their collections and later critical appreciations reflect their preference for Oceanic and Native American art. Economic often displaced political motives for the Surrealists, who collected, along with modern Western art, Oceanic, African, and Amerind sculpture, which they occasionally bartered.[216] Above all in Haiti, where Breton's visit in 1945 precipitated a strike and political commotion, Surrealist art and politics have more than a token significance.[217]

Non-Western, non-Caucasian men like the half-black, half-Chinese Wifredo Lam were hardly accepted into the group before the mid-thirties (as late as 1934 a montage of twenty photos of the major Surrealists by Man Ray contained not one non-Caucasian); consequently, we do not find before the forties non-French or non-Caucasians in the inner circle of the movement.[218] Presumably these outsiders shared with the women artists an urge to reconcile their "Otherness" with their need for group solidarity; this would have meant redefining their identity within a Surrealist context. It would also have entailed ultimately a denial (transgression) of Western white male categories of creativity and the assertion of a beauty outside the Caucasian canon. Challenges to the Western canon of beauty had already been mounted by artists like Picasso (and later, of course, the Surrealists), who appreciated a tribal imagery that was hard for the museums to assimilate.[219] But Western colonialism has recently found insidious support by "theorists" intent on denying the realities of historical process. In the fifties Barthes had already uncovered hidden ideologies secreted within Western images of colonial types, in which the historical reality is denied, but others have gone beyond him and indicated the ethnocentric limits of such an approach – Norman Bryson in general referred to "disremember[ing] the brutal era of European colonialism," and the Nigerian writer Wole Soyinka argued specifically against European critics, including Barthes, who misread Senghor and construct false pictures or "fictographs of an African world-view."[220]

The Surrealists, suburban adolescents in revolt, presumably arrived at their earliest views of colonials through their school texts and then through viewing African and Oceanic objects in ethnographic contexts. Some French intellectuals close to Surrealism apparently did wish to affiliate themselves with the races oppressed by European culture and to criticize half-hearted efforts (already made by Rimbaud) to understand or identify with the colonized, but they themselves never got beyond their factional rhetoric.[221]

As another fin de siècle approaches, apparently insoluble dilemmas within Western culture have threatened humanism and liberalism with extinction and covered the human face with the inexpressive postmod-

ernist mask of the multinational corporation. Unfortunately these problems have descended on developing nations that have known neither humanism nor liberalism: Senghor's efforts – no doubt a variant of the universalizing vision of the Enlightenment he understood so well – to define in Africa a cultural core common to all blacks (and to combat the colonialist disease of racial self-hatred) have so far failed owing to hitherto irreconcilable dissensions both religious (between Christians and Muslims) and cultural (between the Arab-Berbers of the north and the Negro-Africans of the south) that have incited racism and religious fanaticism and led to terror, even to genocide. Not the least important contribution of Surrealism's outrageously libertarian rhetoric and scandalous provocation may well have been to facilitate the move of creative personalities and intellectuals situated on the margins of Western culture – women and the colonized – into the center. This move, which owes as much to feminism, neo-Marxism, and radical psychoanalysis as to Surrealism, has recently developed considerable momentum in the West not only in Francophonic but in Anglophonic cultures.[222] Does this potential shift of the political center justify the hope that after so many man-made and natural catastrophes we can end the nightmare of recent history and educate the next generation to dream creatively – together?

NOTES

The following abbreviations are used: *LSASDLR, Le Surréalisme au service de la révolution; OC, Oeuvres complètes; SE, Standard Edition* (Freud).

INTRODUCTION

1. Allusions to graffiti and writing on Parisian walls recur in Aragon's *Poysan de Paris* (Paris, 1926; English version, *Nightwalker*). Useful discussions of the Paris events and parallel manifestations in Germany (especially by Beuys) are published in German in Karin Thomas, ed., *um 1968. konkrete utopien in kunst und gesellschaft* (Düsseldorf, 1990). For illustrations of posters see the catalogue of the exhibition held at the Bibliothèque Nationale in February–March 1982, "Les Affiches de Mai 68 ou L'Imagination graphique." Also Julien Besançon, *Les Murs ont la parole* (Paris, 1968), and A. Agache, *Les Citations de la révolution de mai* (Paris, 1968).

 For graffiti on the walls of public institutions in Paris and elsewhere see Ernest Ernest, *Sex Graffiti* (Paris, 1979), especially pp. 194–5, "Politique," with such utterances as "Capitalisme et Marxisme / deux inséparables pédérastes" (Paris, 1971). For the relation of wall façade to interior see "Losing Face," in Anthony Vidler, *The Architectural Uncanny: Essays in the Modern Unhomely* (Cambridge, 1992), pp. 85–99. Victor Burgin developed an approach to graffiti that attempted to unite Freud and Foucault in *Graffitification* (1977).

2. Their leader, Guy Debord, wrote the Situationist text *La Société du spectacle* (Paris, 1967). Cf. Alfred Willener, *The Action Image of Society: On Cultural Politicization* (New York, 1970).

3. Robbe-Grillet, "Sur quelques notions périmées" (1957) in *Pour un nouveau roman* (Paris, 1963), p. 35, argues against all engaged art, both existentialist and social realist: "From the point of view of the revolution, all must converge directly on the final goal: the liberation of the proletariat. . . . Everything, including literature, painting, etc. But for the artist, on the contrary, and despite his firmest political convictions, even despite his determination as a militant, art cannot be reduced to serving or being subordinated to any cause whatever, even the most just or exalted one." See also "Nouveau roman, homme nouveau" (1961), in ibid, p. 120: "The only possible involvement for the writer is literature. . . . Consequently it is not reasonable to pretend in our novels to serve a political cause, even one that appears just to us, even if in our political life we fight for its triumph."

4. Norman Bryson, "The Politics of Arbitrariness," in N. Bryson, M. A. Holly, and K. Moxey, eds., *Visual Theory* (New York, 1991), pp. 95–100.

5. See Camus, *The Rebel* (New York, 1956), p. 96.

6. Hal Foster applies the term "outmoded" (borrowed from Benjamin) to "Bretonian Surrealism," in *Compulsive Beauty* (Cambridge, Mass., 1993). Many of Foster's ideas appeared earlier in Jean Clair, "Nouvelle Objectivité et art National-Socialiste . . ." in *L'Art face à la crise* (Saint-Ètienne, 1980), pp. 58–9. Cf. Walter Benjamin, "Surrealism: The Last Snapshot of the European Intelligentsia" (1929), in *Reflections,* ed. P. Demetz (New York, 1978), pp. 181–2; and my review of Foster's book in *Art Journal,* 53, no. 3 (Fall 1994), pp. 108–11.

7. Sartre, who thought that the Surrealist "rebels" merely provoked scandals, not revolution, acknowledged in *What Is Literature?* (New York, 1965), p. 191, that Surrealism "is the *only* poetic movement of the first half of the 20th century; I even recognize that in a certain way it contributes to the liberation of man. But what it liberates is . . . pure imagination." As

discussed later, we could apply the truth of this remark to much of the best writing of the contemporary avant-garde, Sartre's included.

8. See Ernst Kris, *Psychoanalytic Explorations in Art* (New York, 1964), p. 20. He adds that the same mystery faces those who attempt to answer the question why someone becomes great or even successful.

9. See José Pierre, ed., *Tracts surréalistes,* 2 vols. (Paris, 1982), vol. 2, p. xvi, n. 17.

10. At the 1993 College Art Association meeting in Seattle, I conducted a session entitled "Surrealism – The Unfinished Project."

11. This difficulty has not yet pervaded fields sustained by connoisseurship like Renaissance studies; moreover, in the latter field, models descended especially from the Warburg school (including Panofsky) have kept, as it were, a permeable membrane between the formal and conceptual level of the iconological and the concrete imagery of the iconographic level. Such an interactive model forestalls attempts to reinterpret iconographic content in terms of an autonomous "language of pure form."

12. This is a term used by the anthropologist Stephen Tyler in "Post-Modern Ethnography: From Document of the Occult to Occult Document," in James Clifford and George Marcus, eds., *Writing Culture* (Berkeley, 1986), pp. 122–40.

13. For a sense of the crisis in art history (sometimes denied), see the series of reviews of the state of research in the *Art Bulletin* between the late eighties and June 1991 (the issue on semiotics). The radical dichotomies between genesis and structure, diachrony and synchrony are themselves being deconstructed or – especially among feminists who see the dichotomies as patriarchal – purposely tangled in mazes of intertextuality.

14. For an argument against the validity of thinking contextually, see "Semiotics and Art History," Mieke Bal and Norman Bryson, *Art Bulletin,* 73 (June 1991), pp. 174–208.

15. The recent efforts of the New York Museum of Modern Art to escape from Rubin's dogmatic vision of Surrealism has resulted in a befuddling and chaotic grouping of Giacometti, Wyeth, Hopper, and Jacob Lawrence.

16. This distinction appeared earlier in the writings of the scholar H. Paul. Saussure simply places his name in the first chapter of the *Cours de linguistique générale* (Paris, 1971) among a

number of German "neogrammarians" who preceded him. Unfortunately he fails to mention Humboldt, who directly anticipated his ideas. Nor does he mention his contemporary, the French philologist Michel Bréal, who had published in 1913 an equation of words and signs, an idea he found already in Condillac (also ignored by Saussure).

17. See Saussure's *Cours,* p. 157: "Linguistics thus works in the limited domain in which the elements of two orders combine; *this combination produces form, not substance.*" Henri Poincaré wrote in *Science et hypothèse* (New York, 1905), p. 32: "Mathematicians do not study objects, but relations between objects. . . . Matter is not important to them, only form interests them." Among English-speaking philosophers an analogous position has emerged as a solution to certain problems in the area of intention – for example, the idea of "semantic ascent" proposed by the logician Willard Quine.

18. David Summers, following W. J. T. Mitchell, criticizes "linguistic imperialism." See his "Real Metaphor," in Bryson, Holly, and Moxey, eds., *Visual Theory,* p. 234. And Eco (Bloomington, Ind., 1976), already denounced "verbocentric dogmatism" in his *Theory of Semiotics.* In his quarrel with Nelson Goodman's semiotics of visual art Richard Wollheim makes points that bring him close to their position.

19. Peirce defines three signs: an icon that provides meaning by resembling; an index that has an intrinsic relation to the referent, like a fingerprint; and a symbol that has an arbitrary relation to the referent (like Saussure's sign).

20. See "Saussure versus Peirce: Models for a Semiotics of Visual Art," in A. L. Rees and Frances Borzello, *The New Art History* (London, 1986), p. 85.

21. See Francis Frascina, "Art and Semiotics," in *Primitivism, Cubism, Abstraction: The Early 20th Century* (New Haven, Conn., 1993), p. 121; Valentin Voloshinov, *Marxism and the Philosophy of Language* (Cambridge, Mass., 1986).

22. See Jameson, *Marxism and Form* (Princeton, N.J., 1971).

23. For perception by formalists of the need for sociological and philological analysis, see the paper by Y. N. Tynianov and R. Jakobson, "Problems in the Study of Literature and Language," *Novy Lef,* 12, (1928), pp. 36–7, and V. Erlich, *Russian Formalism* (The Hague, 1955). Foucault, whose thought underwent a major shift in 1968, reconceived the problem

of language in a Nietzschean framework as political and ethical. See also the criticism of the decontextualization of art by radical semioticians like Goodman and Barthes in Norman Bryson, "The Politics of Arbitrariness."

24. See, e.g., Barbara Johnson, "The Frame of Reference: Poe, Lacan, Derrida," in R. Young, ed., *Untying the Text* (Boston, 1981), pp. 225–43. She "rereads" Derrida's reading of Lacan's reading of Poe. Barthes seems to have provided the seminal model in his *S/Z*. For a cogent exposition of the opposing view that "texts are worldly," see E. Said, "Secular Criticism," in *The World, the Text, and the Critic* (Cambridge, 1983), pp. 1–30. Postmodernist art historians for all their alleged opening up of the narrow orthodoxies of traditional scholarship, paradoxically return again and again to a canonical selection of works by, for example, Velasquez, Manet or Courbet.

25. Cf. Barthes, "Rhetoric of the Image," *Image – Music – Text* (New York, 1977), p. 50, n. 2: "We prefer here to evade Jakobson's opposition between metaphor and metonymy for if metonymy by its origin is a figure of contiguity, it nevertheless functions finally as a substitute of the signifier, that is as a metaphor."

26. In the "Procès Barrès" Breton dressed up in quasi-religious costumes that demonstrated the appeal to him of mock solemnity and mock pomposity. Of course, as a natural ham, he put on a worker's cap when he first became enthusiastic about the apotheosis of the worker, Lenin.

27. Problems of accuracy pervade Maurice Nadeau's *History of Surrealism*, recently reprinted, which has become standard fare in U.S. universities. Breton sharply criticized Nadeau's history and his accompanying collection of "Documents," in *La Clé des champs* (Utrecht, 1967), p. 175, calling it "a mediocre work of compilation with serious gaps." Nadeau's inaccuracies and incompleteness were spelled out at greater length by José Pierre in the introduction to the important collection of *Tracts surréalistes* (1980) that he edited. The problems are compounded by poor translation of the book; for example, the 1965 New York edition, p. 240, translates from the "Declaration of Jan. 27, 1925" the phrase "la fragilité de leurs pensées," referring to the thoughts of the public as "the fragility of thought," an epistemological epithet that would contradict Breton's "omnipotence of thought."

28. A central problem for the twentieth-century avant-garde, and not just for Surrealism, concerns the relation of verbal text to image. An important recent trend in art history, for example, in the study of Picasso by Robert Rosenblum and Patricia Leighten, involves the "reading" of sociopolitical meaning in seemingly autonomous works. This trend follows the detection of "space" within literature by literary historians like Georges Poulet and Joseph Frank.

29. As Foster has observed, "In a sense, Surealism (according to Baudrillard) has come home to roost in the commodity-filled landscape of late capitalism – fragmented yet fluid, coded yet *informe*." See his review of *Art in America* of the Corcoran exhibition *"L'Amour fou,"* p. 128. Whether large-scale socioeconomic changes in time imply a narrative development remains a controversial issue for historians.

30. See André Masson, in Georges Charbonnier, *Entretiens avec André Masson* (Paris, 1985 [1958]), p. 42.

31. Moreover, its subject recalls that of the "Amour fou" exhibition held at the Corcoran in 1985; but instead of walls of often kinky photos (mainly of women sadistically contorted and exposed) rendered innocuous (or Minimalist?) by a hygienically tidy display, the Pompidou overdosed the spectator with stuff from all media in a volume rich as a *marché aux puces,* but almost as disorganized (despite its chronological framework) – which might have offered a relevant experience to the spectator if the director of the exhibition had agreed to hold with the subtitle of "André Breton La Beauté convulsive" and to present it coherently to the spectator. Both exhibitions dwelled on aesthetic questions and ignored ideological ones – not merely about Marxism, but about the power plays that determined many of Surrealism's policies and tastes both artistic and erotic.

32. Cf. Breton's threat to Joseph Delteil in a note published in *La Révolution surréaliste,* 4 (July 15, 1925), p. 32, to "take the measures necessary to reduce your activity to its proper proportions, which you don't sufficiently realize, is in my power." In other episodes, he used physical assault as a mode of "criticism."

33. Aside from Victor Turner's many writings, see M. J. Swartz, V. Turner, and A. Tuden, eds., *Political Anthropology* (Chicago, 1966). The introduction, pp. 4–5, defines politics in terms of public goals of war and peace, indepen-

dence, gaining prestige, and – most relevant to this study – the relevant standing within the group. Page 10 describes legitimacy as a type of support that derives from values held by individuals who are affected by political ends, and p. 14 argues that power rests on legitimacy, a view that has some affinity to those of Foucault and Gadamer. Another useful concept is offered by Erving Goffman, who defines a "focused gathering" as a set of persons engrossed in a common flow of activity and relating to one another in terms of that flow. Jameson's idea of the political unconscious is also relevant for the textual analyses.

34. The label had so little substance that writers defined different years as "heroic"; for example, William Rubin, *Dada and Surrealist Art* (New York, 1968), p. 151, designates the "five years between the first and second manifestoes"; Robert Goldwater, 1919–23; and Maurice Nadeau, 1923–25.

35. This flaw occurs, for example, in a work by the Breton specialist José Pierre, *Position politique de la peinture surréaliste* (Paris, 1975). For many scholars Surrealism implicitly constitutes a homogeneous entity; see, for example, J. H. Matthews, *The Surrealist Mind* (Selinsgrove, Pa., 1991), which presumes that constant "principles" within Surrealism permit making stylistic generalizations.

36. See section 31 of *Poisson soluble,* in which Breton makes somewhat ironic allusions to both Marx and Freud.

37. Bonnet and her circle follow Breton and insist on the exclusive importance of Freud; naturally, they dismiss claims by Starobinski and others that non-Freudian influences also contributed to Surrealism. A recent unpublished dissertation shows the limitations of Breton's grasp of the psychoanalytic unconscious: see Ariel Remy, *Beau comme la rencontre fortuite... entre Breton et Freud,* thesis (Strasbourg, 1991). Soupault's reminiscence that Janet's writings inspired the idea of automatic writing in the *Champs magnétiques* (a view strongly contested by Bonnet) was transmitted to U.S. audiences by Meyer Schapiro (who maintained it in 1991 in phone conversation with me) and Balakian. Soupault kept repeating this reminiscence; for example, he told Bernard Robert that he remembered that Janet was important in 1918 for the authors of the *Champs.* See Robert, "Pour une définition du surréalisme," *Revue de L'Université d'Ottawa*

(April–June 1973), pp. 297–306. Probably Soupault (though an unreliable witness, as Bonnet has shown) is correct for himself – in 1918 he labeled one of his own works "automatic" – but not for Breton or for their collaboration. Other scholars have added little; see, for example, the article by Laura Rosenstock, "De Chirico's Influence on the Surrealists," approvingly published by William Rubin in the catalogue he edited of a De Chirico exhibition (New York, 1982). She writes on p. 111: "Surrealism, as evolved by Breton, was largely inspired by Freud's research into free association and dream imagery. Breton, who had visited Freud in Vienna in 1921, recognized the import of the scientific application of psychoanalysis and free association to the recollection of dreams and the revelation of their meanings." This misses the mediation of psychoanalysis by the first French interpreters and translators, and the complexity introduced by the contributions of French psychology from Charcot to Janet, and of French Symbolism; moreover, she ignores Breton's reservations about psychoanalysis and misinterprets his Dadaist sarcasm after his meeting with Freud. It now seems most probable that Breton drew on Freud, whereas Soupault – whose memory in this respect was correct – drew on Janet. See Henri Béhar, "Philippe Dada, ou les défaillances de la mémoire," *Europe,* no. 769 (May 1993), p. 744. On p. 10 Béhar says that Soupault was really faithful to "l'esprit Dada." Soupault "found, in June 1917, a copy of the *Chants* (of Lautréamont]" and loaned it to his friends especially to Breton in June 1918. On p. 11 he notes that Breton at the Centre Neurologique de Saint-Dizier familiarized himself with "the Freudian technique," whereas Soupault was "more sympathetic to the views of the psychiatrist Pierre Janet, as published in his treatise *L'Automatisme psychologique....*" On p. 12 the author asserts that the *Champs magnétiques* did not derive from Freud, but still uses hypnosis (which psychoanalysis had given up), and confuses subconscious and unconscious.

38. Some of the most influential social scientists of the turn of the century in France puzzled over the relation between the individual "ego" and society, and developed notions of collective representation and group consciousness. Durkheim's social psychology, which analyzed moral behavior in terms not of individual

consciousness but of social causes, reached the Surrealists through his follower Mauss (who in "Hommage à Picasso," *Documents,* no. 3 [1930], p. 177, equated the creative imagination in primitive art to that of Picasso). The Durkheim–Mauss line of myth/ritual analysis leads to Bataille, Leiris, and Caillois's *collège de sociologie,* which emphasized topics explored by Mauss – consumption, gift, and excess – and eventually to Lévi-Strauss. Durkheim started using the concept of *Réprésentations collectives* about 1897, in *Le Suicide* to characterize states of the *conscience collective* that are different in nature from the states of the individual *conscience* and that express the way in which the group conceives itself in its relations with the objects that affect it. Durkheim contributed as much as Freud to Leiris's study of myth and totemism.

39. Like French Catholic educators, Durkheim believed that the school should supplement the family and inculcate into the child the spirit of discipline. See his *L'Éducation morale* (Paris, 1938), p. 168.

40. The great stronghold of academic thought in France was L'Academie Française, which originated in the 1630s. The aim of this conservative institution was the governance of French literature, grammar, orthography, and rhetoric, its chief functions the establishment of a dictionary of French and the awarding of prizes. Descartes's great influence on it had to do not with his questioning of received tradition, but his systematic methodology. This rational methodology permeated the arts as well as the sciences, and became in the hands of a Lebrun or a Boileau as rigid a conservatism as that of the Académie.

41. Antoine A. Cournot, *Traité de l'enchaînement des idées fondamentales dans les sciences et dans l'histoire,* 3rd ed. (Paris, 1922), sec. 330. This transformation of the classical *ut pictura poesis* anticipated theories such as Lacan's language of the unconscious and Jameson's notion of a "political unconscious."

42. Bonnet follows Naville, who says Breton got to know Hegel about 1924 first through Croce (1910), then through Vera's translations. In 1922 Aragon and Breton advised Doucet on an ideal library, saying that he should acquire Hegel, whose *idéalisme absolu,* they said, had had an enormous influence, for example, on Mallarmé's *Un Coup de dès,* on Villier's *L'Eve future,* and on *la vie de Jacques Vaché* (see *André*

Breton, OC, Marguerite Bonnet, ed. [Dijon, 1988], vol. 1, p. 632).

43. For a liberal defense of Cartesianism against systematic philosophies like Hegel's see Karl Popper, *Conjectures and Refutations* (New York, 1968), p. 11, on "the two diametrically opposed philosophies of the state and of society: on the one hand, an anti-traditionalist, anti-authoritarian, revolutionary and Utopian rationalism of the Cartesian kind, and on the other an authoritarian traditionalism."

44. Cf. Clement Greenberg, a formalist critic hostile to Surrealism who wrote in the forties that "Surrealism never had a style of its own," and that the Surrealists abused Cubist collage by "producing not works of art, but montages," whose "literary shock effects have become unspeakably stale." See Clement Greenberg, *The Collected Essays and Criticism* (Chicago, 1986), vol. 2, pp. 55 and 262; cf. vol. 1, p. 230.

45. See Foucault, *Discipline and Punish,* esp. pp. 141ff., on the confining régimes of the *collèges;* this was based on the writings of Philippe Ariès on French education.

46. Discipline in Breton's home was abusively reinforced by his mother, if we accept his remark to Gérard Legrand, *André Breton en son temps* (Paris, 1976), p. 152: "Oh, well, my mother (and I must say that he hammered out these syllables with a real fury), made me stand before her so that she could coldly slap me." More than once as an adult Breton – who in some ways reminds one of his coldly disciplinarian mother – himself would slap the faces of his opponents. The persistence of a "disciplined" approach to education beyond the turn of the century is shown in the remark of André Michel of the Institut de France, who wrote in "L'Art français sous la 3ème République," *Journal des Débats* (November 11, 1920): "The greatest service that the Third Republic can render to the future of French art ... is first of all to assure, to facilitate, to provoke, to orient everywhere good education – that is, to found and disseminate the best 'disciplines': this would place at the fingertips and in the minds of artists-to-be the basis for a well-mastered profession." I have found useful bibliographic and other information in Theodore Zeldin, *France: 1848–1945,* vol. 1, "Ambition, Love and Politics" (Oxford, 1973), and Miriam Levin, *Republican Art and Ideology in Late 19th Century France* (Ann Arbor, Mich., 1986). Cf. also Molly Nesbit on Duchamp, in "Ready-Made Originals," *Octo-*

ber 37 (Summer 1986), pp. 53–64. For the general history of French educational discipline see the writings of Philippe Ariès and Foucault's book *Discipline and Punish.*

47. See the English edition *Art in Crisis* (London, 1958), pp. 165–6. Sedlmayr abundantly cites Ernst Jünger (called by H. P. Schwarz "Der konservative Anarchist") in support of his own views. Like Jünger, a novelist obsessed with themes of power, death, and ruin, Sedlmayr sympathized with the Nazis and flourished under their regime. Sedlmayr sharpened and expanded his attack on the nihilism of modern art and on the perversive "absichtliche Verrücktheit" of Surrealism in particular in *Die Revolution der modernen Kunst* (Hamburg, 1955).

48. Not only the avant-garde mocked the establishment. Cf. Jules Romains's *Les Copains* (Paris, 1961 [1913]), a farcical tale that evokes the bonds that unite seven friends who are determined to shock communities with their practical jokes.

49. Cf. Lynn Hunt, *The Family Romance of the French Revolution* (Berkeley, 1992), especially chapter 3, "The Band of Brothers."

50. The major psychological study of Dali's art is by Haim Finkelstein, *The Metamorphosis of Narcissus* (1996). Carlos Rojas has written imaginatively on the psychoanalytic grounding of Dali's art. And Whitney Chadwick, *Myth in Surrealist Painting, 1929–1939* (Ann Arbor, Mich., 1980), p. 23, speaks of the Surrealist painters' "filial relationships ... played out under the symbolic guise of Oedipus." The disguising of references to Freud's Oedipus in their art (with the exceptions of Ernst and Dali) and writing, even when discussing psychoanalysis, poses a question interesting both historically and psychologically.

51. Some scholars retain the old view that only art with "style" has a history; for example, the formalist William Rubin (former director of the Museum of Modern Art in New York), a good modernist scholar, in his *Dada, Surrealism and Their Heritage* (New York, 1968), pp. 123–4, placed Surrealism into the same category as fantasy art (as Barr his predecessor had done) and – curiously adumbrating the postmodern take on Surrealism – distinguished both from art that shares an art historical continuity with the "masterpieces" of the past. He believes that naïve, primitive, and psychotic artists equally lack a history; for their work is determined not

by an awareness of art, but by "immutable" psychological laws! The ignoring of continuity between such work and its historical context matches his indifference to material history.

52. Siegfried Giedion, *Mechanization Takes Command* (New York, 1948), pp. 362–3, reports that "I once asked Ernst about the origin of his novels, and he replied: 'They are reminiscences of my first books, a resurgence of childhood memories.' "

53. A strong criticism of Saussure's semiotics for its Cartesian dualism appears in Voloshinov, *Marxism.*

54. Bergson would have interested the young Surrealists in the *Essai sur les données immédiates de la conscience* (Paris, 1889), where he emphasized hypnosis and the dream. However, they later turned against his notion of the passivity of art – for example, p. 11: "Art aims to lull to sleep the active powers of our personality and bring us to a state of perfect docility." His ideas were developed by Paul Souriau, *La Suggestion dans l'art* (Paris, 1893) (cf. p. 72).

55. On their anarchism see Theda Shapiro, *Painters and Politics* (New York, 1976), pp. 114, 222.

56. For our purposes "text" will refer to both visual and verbal material and to such mixed modes as *poèmes-objets,* collage poems, and paintings with writing in them like certain Mirós. I maintain that the Surrealists, with the production of such texts, constituted a "political" weapon for cultural subversion of the disdained prosaic bourgeois perception in art and the correspondingly dull and predictable narrative in writing.

57. Cf. Hal Foster, "Armor fou," *October,* no. 56 (Spring 1991), pp. 64–97.

58. Cf. the essay, "L'Affaire Aragon" (1932) in Pierre, *Tracts,* vol. 1, pp. 204–5, in which Breton cites the cyclical concept of styles – symbolism, classicism, romanticism – in Hegel's *Aesthetik.*

59. See the catalogue of the Mexican Museum, *Leonora Carrington: The Mexican Years, 1943–1985* (San Francisco, 1991).

1. BREAKING THE INSTITUTIONAL CODES

1. For Breton's opposition to all disciplinary formulas in art see note 5. For a discussion of the relation of nineteenth-century drawing instruction to the adult Marcel Duchamp, see Nesbit,

"Ready-Made Originals," and her "The Language of Industry," in Thierry De Duve, ed., *The Definitively Unfinished Marcel Duchamp* (Cambridge, Mass., 1992), pp. 351–84.

2. See "Le Moment de l'apocalypse," *La Nef,* no. 31 (1967), p. 132.

3. Valéry observed that "in every connection [Descartes] had taken this so powerfully experienced Me as the starting point for the axes of his thought . . . it is the use of the *I* and the *me* in a work of this sort, and the sound of his human voice." See Paul Valéry, *The Living Thoughts of Descartes* (New York, 1947), pp. 36, 37, 113. In the First Meditation Descartes compared "the objects which appear to us in sleep" to "painted representations which could not have been formed unless in the likeness of realities, etc." His distinction at the end of the meditation between perceived and true reality anticipates the issue of the hallucinated hand of Taine's patient, discussed in Chapter 4, this volume. In the First Manifesto Breton opposed "the obstinate mania indulged in by minds that consists of reducing the unknown to the known and classifiable" (Breton, *OC,* vol. 1, p. 315), and he asks, "When will we have sleeping logicians, sleeping philosophers?" (ibid., p. 317).

4. For the underlying similarity of academies throughout Europe, see Pevsner, and for the place of modernism within the academy, see Albert Boime.

5. Breton wrote in "Seconde arche" (1947), in *La Clé des champs,* p. 130: "No political-military imperative could be accepted or promulgated in art without treason [to art]. The sole responsibility of the poet and artist is to oppose an unshakeable NO to all disciplinary formulae. The ignoble word 'engagement,' . . . evidences a servility horrifying to poetry and art."

6. Cf. Roger Vailland, *Le Surréalisme contre la révolution* (Paris, 1947):

> At the Lycée of Rheims, in 1925, several of us were students of rhetoric. Coming from the provinces, we were completely unaware of Apollinaire, of Dadaism and the Ballets russes, we were not even initiated in the writings of Rimbaud; still, we gave ourselves up spontaneously, not only to exercises of *automatic writing* (and drawing), but even to the systematic practice of scandal, to which at the same time new-born Surrealism attached so much importance. We were not particu-

larly bowled over when we first came across, at the Michaud bookstore, issue no. 1 of *La Révolution Surréaliste.* . . . Later we learned that *agitations* (*troubles*) of the same sort had surfaced at the same time in the cities of Cambrai, Nancy, Clermont-Ferrand.

> So – between 1919 and 1930, for the sons of the middle class – Surrealism was indeed in the air.

H. S. Gershman, *The Surrealist Revolution in France* (Ann Arbor, Mich., 1969), p. 85, notes that Surrealism at first drew writers from a number of non-Surrealistic journals that folded between 1922 and 1924 (*Paris-Journal; Adventure; Action, cahiers de philosophie et d'art;* and *L'Oeuf dur*).

7. Breton wrote in the section "Saisons" of the *Champs magnétiques,* in Breton, *OC,* vol. 1, p. 59: "From my school days I see only certain collections of notebooks. The picturesque scenes with this rare rag picker, the great Cities of the World (I loved Paris)." And in "A Propos du concours de littérature prolétarienne organisé par L'Humanité," *LSASDLR,* 5 (May 1993), pp. 16–18, he suggested a course in Marxist literature that would include non-Marxist writers like Balzac, whom Marx – in contrast to many orthodox Marxists – appreciated: "Such a course would have the advantage of counteracting the influence of the *lycées* where the teaching of literature emphasizes bourgeois conceptions of the family, religion and patriotism." Cf. also his remarks in the First Manifesto: "The mind that plunges into Surrealism relives with exaltation the best part of its childhood. . . . Memories of childhood . . . [a period] that I consider the most fertile that exists. It is perhaps childhood that comes closest to 'true life.' " Breton, *OC,* vol. 1, p. 340.

8. See ibid., p. 1366. *Poisson soluble* in several sections makes tangible allusion to school things such as chalk and blackboards; when describing classroom experiences Breton doesn't fail to mock pedantry.

9. In *Poisson soluble,* sec. 30, p. 97.

10. "The Automatic Message," in *OC,* vol. 2, p. 375. Whereas the Surrealist poet attributed value and significance to automatic writing, twentieth-century novelists, even an experimental one like Proust, would regard them as valueless doodlings; for example, Proust suppressed as superfluous the scribbles on the marginalia of his manuscripts, which ex-

pressed his homosexual impulses and allowed a cathartic release. See Claude Gandelman, "Proust's Draft Copy-Books: Sketches of his Dreams," *American Imago,* 34, no. 4 (Winter 1977), pp. 297–312, and "The Artist as 'Traumarbeiter': On Sketches of Dreams by Marcel Proust," in "Boundaries: Writing and Drawing," *Yale French Studies,* no. 84 (1994), pp. 118–35.

11. This defiant attitude was "organized into a formidable institution by the formation of cliques and gangs.... In these cliques, the pupils developed rules of their own, which neither parents nor teachers could influence much. One of these was exclusiveness: the claim to superiority, hostility to the *externes,* the day-boys.... Often these groups would choose leaders who would have precisely the opposite characteristics of the teachers – brutal ones if the teacher was weak, or cordial ones if he was severe; and with effective leaders, they could wage veritable wars of attrition against selected victims." From Theodore Zeldin, *France, 1848–1945,* vol. 2, *Intellect, Taste and Anxiety* (Oxford, 1981), p. 6. "Privilege and Culture," pp. 265–6, citing Jacques Fontanel, *Psychologie de l'adolescence – Nos Lycéens* (Paris, 1913). Gaston Bachelard, in *La psychanalyse du feu* (Saint-Armand, 1989 [1949]), p. 29, calls the "skillful disobedience" of youth a "complexe de Prométheé," noting that "like a little Prometheus he [the child] steals matches [from his father]. He then runs into the fields and in a hollow ravine, aided by his companions, he founds the *école buissonnière.*"

12. Admittedly, for many French writers clairvoyance meant something quite rational. Roger Martin Du Gard, in *Les Thibaut* (1922–40), tells about a young doctor just before World War I who found his center in "une certaine clairvoyance." Camus, perhaps to contradict the Surrealist notion of clairvoyance, writes in *Le Mythe de Sisyphe. Essai sur l'absurde* (Paris, 1942), p. 123: "We call virile what is lucid, and we want no force that is separate from clairvoyance."

13. See "Pour Demain," *Littérature,* no. 4 (June 1919), p. 5: "Playing hooky was my only school (*La Seule école buissonnière*)." A note states that the poem was in Valéry's possession.

14. In section 15 of *Poisson soluble* Breton describes a class "on the highest branches of the twisting, between the greenfinch and the

frost. It is the *école buissonnière* in the full sense of the word." The collaborative poem "L'Ecole buissonnière" by Breton, Char, and Eluard appeared in *Ralentir travaux* (Nîmes, 1930), in Breton, *OC,* vol. 1, p. 763; and in the section "On ferme," p. 770, Eluard wrote: "We have retained / nothing of the lessons of routine and mistakes / in rhythm and arithmetic." In 1932 Breton wrote a "Poème genre scolaire," targeting the school meter master ("mètre-maître"): "Le Mètre d'école est conservé aux Arts et Métiers." (The schoolmaster/meter is preserved at the Arts and Métiers.) The last sentence of "Lewis Carroll" in Breton's "Anthologie de l'humour noir," in *OC,* vol. 2, p. 963, reads: "All those who preserve the sense of rebellion acknowledge in Lewis Carroll their first master of the *école buissonnière.*" As late as 1945, the year he married Elisa (soon after he divorced Jacqueline), Breton dedicated to Elisa a manuscript for *Arcane 17* on a school notebook: "à toi ce cahier de grande école buissonnière, mon amour." See the Breton exhibition catalogue of 1991, p. 359.

15. See Breton, *OC,* vol. 1, pp. 368–9.

16. See Breton, *Entretiens* (Paris, 1969), p. 288: "Let us not speak of a 'Surrealist school.' The notion of a Surrealist 'school' or even 'group' is misguided."

17. See *Archives du surréalisme,* vol. 1, p. 99.

18. This whole discussion owes much to the valuable book by Miriam R. Levin, *Republican Art and Ideology in Late Nineteenth-Century France* (Ann Arbor, Mich., 1986). Also see Zeldin, *France: 1848–1945.*

19. See Levin, *Republican Art and Ideology in Late Nineteenth-Century France* (Ann Arbor, Mich., 1986), pp. 106–7.

20. See Breton, *Entretiens,* p. 30.

21. See Breton's "Lettre à une petite fille d'Amérique" (February 9, 1952), in *La Clé des champs,* p. 330, citing this passage from Rousseau: "Children, enthusiastic imitators, all try to draw: I wish that my child would cultivate the art, not exactly for the sake of the art itself, but to sharpen the eye and make the hand flexible; and in general it matters little whether he can do this or that exercise, provided he acquire sharpened senses and good habits. I would therefore not provide him with a drawing master who would only have him imitate imitations.... I wish that he had no other master than

nature, and no model but things, I would like him to have the original itself under his eyes and not the paper that bears a representation of it, that he make a pencil drawing of a house right on a house, of a tree on a tree, of a man on a man, so that he will get used to observing well bodies and appearances, and not mistake false and conventional imitations for true imitations ... my intention isn't so much that he learn how to imitate things but to recognize them; I'd prefer that he show me an acanthus plant and that he draw with less skill the foliage of a capital." Parenthetically, we note a decided change in the rhetoric of gender between Rousseau, who refers invariably to a young male, and Breton, who, corresponding with a young girl, refers to the experience of his own daughter, and employs the phrase "he or she."

22. See Paul Eluard, *Le Poète et son ombre* (Paris, 1963), p. 22.

23. In his article, "Pestalozzi, éducateur du peuple," in *Clarté* (1923), pp. 375ff., Célestin Freinet noted Pestalozzi's emphasis on work and that the Swiss educator based his ideas on Rousseau's *Emile*. Célestin Freinet (1896–1966) was himself a radical with interesting ideas about education. His *méthode naturelle* paid attention to the emotional life of children and recommended (like John Dewey before him) teaching reading and writing only when the experience of the child makes them seem necessary. Children – in cooperation with the teacher – actually participated in writing, editing, and publishing texts. Freinet's classes fitted poorly into the traditional school system of urban centers but have found a place in schools in marginal and disadvantaged areas. The psychoanalyst Maud Mannoni was inspired by Freinet. See Roudinesco, *Histoire de la psychanalyse en France* (Paris, 1986), vol. 2, p. 499.

24. Freud, like Rousseau, believed in the importance of education and felt that among the determinants of the Oedipal complex was "the influence of authority, religious teaching, schooling and reading." See *The Ego and the Id, SE,* vol. 29 (London, 1961), p. 34.

25. Cf. L. Goldmann, *Structures mentales et création culturelle* (Paris, 1970).

26. As Levin points out in *Republican Art and Ideology*, p. 251, n. 109, "Interest in teaching drawing as means of perceptual and moral education in the schools continued into the twentieth century, according to H. Gossot, F. Brunot, and S. Herbinière, *L'Enseignement du premier degré de 1887 à 1962: De la théorie à la pratique* (Paris, 1961?), p. 526." For discussion of the evolution and purpose of drawing instruction, see Zeldin, *France,* 2:443–51.

27. See Levin, *Republican Art and Ideology,* pp. 87, 161–2.

28. The Republicans separated work and pleasure, maintaining that work provided the means to pay for the pleasure, which thus became an escape from and reward for daily drudgery. Comte earlier proposed art as an escape for the popular imagination, and Matisse later did so for the tired businessman.

29. See Taine, *De l'intelligence* (1870). Cf. Richard Shiff, *Cézanne and the End of Impressionism* (Chicago, 1984), pp. 45–6 and notes.

30. See Breton, *"Lettre,"* p. 330.

31. See Bonnet, *Breton,* pp. 51–5. Jerrold E. Seigel, *Bohemian Paris* (New York, 1986), discusses the youthful anarchism of Breton, who knew the "artistocratic" group based on the ideas of Max Stirner and the periodical *Action d'art* (1908–13), which rejected collectivity. The "illegalism" of the Bonnot gang was notorious, but not without support by the intelligentsia: Durkheim regarded crime as a sign of social health, and Georges Sorel, an admirer of Nietzsche, noted in his *Reflections on Violence,* (New York, 1941, [1906]), p. 9: "We are thus led to ask ourselves whether certain criminal acts could not be considered heroic, or at least meritorious, if we were to take into account the happy consequences for their fellow-citizens anticipated by the perpetrators, as the result of their crimes. Certain individual criminal attempts have rendered such great services to democracy that the latter has often consecrated as great men those who, at the peril of their lives, have tried to rid it of its enemies."

32. For examples, see André Breton, *Je vois, j'imagine* (Milan, 1991), and Jean-Paul Sartre, *Les Mots* (Mayenne, 1987 [1964]): Sartre describes the notion of progress instilled in himself as a child: "The grown-ups recounted to us the History of France: after the uncertainty of the First Republic there came the Second, and then the Third, which was the good one ... we found out that our individual development mirrored the progress of the Nation" (p. 195); he observes, "Through an outmoded concept of culture religion was

made to appear as a model: being infantile, nothing could be closer to the infant [than religion]. They taught me the Scriptural History, the Gospel, the catechism, without providing me the capability of believing in them: the result was a disorder that became my own special order" (p. 207). In the *lycée* and in the course of their earlier scientific education the Surrealists were doubtless also exposed to instructive "dioramas" – tangible lessons that did not make excessive demands on credulity. These glass-covered shallow boxes with labeled specimens were commonly used in the nineteenth and early twentieth century for teaching botany and biology, and their glued-down cutouts seem to anticipate on a nonaesthetic level the collages imported into art by the Cubists. As mature poets the Surrealists would collage "dioramas" displaying their own incredible marvels. In fact Breton fit his *poème-objets* into diorama-like boxes, which he produced from the thirties to the end of his life.

33. See "Recherches sur la sexualité," *La Révolution surréaliste*, no. 11 (March 1928), p. 36.

34. An old and seemingly paradoxical attraction to the marvelous occurs within French classicism as an urge for variety. Cf. Boileau, the fifth of the *Réflexions sur Longin*. The writer Desmarets, *Défense de la poésie et de la langue française* (1675), tried to show the superiority of the Christian over the pagan marvelous.

35. See Heckel, "Das neue Programm," *Kunst und Künstler*, 12 (1914), pp. 299–314.

36. See Arnaud Dandieu *Anthologie des philosophes français contemporains,* 5th ed. (Paris, 1931). In the preface (p. 12) Arnaud Dandieu notes that in contrast to recent German and Anglo-Saxon trends, "French academic philosophy ... [in its rationalism and determinism] remains almost entirely Cartesian." On the first page of his *Paysan de Paris* (Paris, 1926), Aragon, mocking rationalism, says: "Certitude is reality. The well-known Cartesian doctrine of evidence stems from this basic belief to which it owes its success. We have yet to discover the full extent of damage done by this illusion."

37. Breton and Aragon, in the famous list of books for Doucet, make no mention of Descartes, but speak of the rationalism of Leibnitz, and of Pascal's *Pensées*. In a letter to Breton of December 1918, Aragon, commenting on Breton's "Monsieur V," wrote that "Descartes had an

inner eye – the pineal gland." See Breton, *OC,* vol. 1, p. 1094, n. 7.

38. See Dandieu, *Anthologie,* p. 12.

39. Non-Euclidean geometry dispensed with what had seemed like the logically indispensable parallel axiom, and Einstein's relativity subsumed Newtonian physics into a structure that no longer seemed accessible to common sense. See Breton, *OC,* vol. 1, p. 246, and the editor's note on relativity.

40. See note 41. Alquié in his *Philosophy of Surrealism*, p. 126, claims that Breton adopted a "theory according to which imagination is a 'realizing' faculty, images presenting ... themselves as real. This theory [is] an offshoot of Cartesianism." He claims that the Surrealists adopted the "psychological schema" of the Cartesians, but he has to admit that the Surrealists, in contradiction to the Cartesians, favored "the invasion of images" over reason and clarity. Alquié makes Breton a Cartesian who misunderstood Hegel, but I agree with G. Legrand, who sees Breton as a Hegelian opposed to Descartes. And in rejecting the rigidly rational Valéry, Breton doubtless was aware of that poet's admiration of Descartes. For Breton's hostility to Descartes, see his "Le Mécanicien" (1949), in *La Clé des champs,* p. 258, in which he cites Malcolm de Chazal: " 'French thought has come to an impasse. Since Descartes, two paths have been open to it, to which it was equally suited: reason and intuition. ... The atomic bomb was conceived in the brain of Descartes.' "

41. See Breton, *Surrealism and Painting,* p. 32. In the advisory letter Aragon and he wrote to Doucet in 1922, Breton already recommended highly Lull's work on alchemy. Ades, *Dali and Surrealism,* p. 34, unaware of Lull's importance for Breton, states that after separating from the Surrealists, Dali "replaced the accepted 'surrealist ancestors' with Gaudí and Lull."

42. We have one clue to Breton's early knowledge of Hegel in his *Entretiens,* p. 153: "... depuis que j'ai connu Hegel, voire depuis que je l'ai pressenti à travers les sarcasmes dont le poursuivait, vers 1912, mon professeur de philosophie, un positiviste, André Cresson, je me suis imprégné de ses vues." Hegel was appreciated by other future Surrealists as early as October 1923; his name appears in capital letters on the chart "Erutarettil" on p. 24 in *Littérature,* no. 11-12 (October 1923). (The reversed spelling of "littérature" manifests an

enduring resistance to the belletristic tradition; cf. "Papillon V," published in 1924: "LE SURREALISME / c'est l'écriture niée." See Pierre, *Tracts,* vol. 1, p. 32.)

43. See Bourget, "M. Taine," in *Essais de psychologie contemporaine* (Paris, n.d. [1885]), vol. 1, p. 229: "The vague and nebulous formulas (of Hegel's metaphysics) solidify in the hands of the perspicacious Frenchman." For Cousin as developer of a *hégélianisme rationnaliste* by 1818, see Roudineco, *Histoire,* vol. 2, pp. 150–1.

44. Boutroux wrote the widely used text *De l'idée de loi naturelle dans la science et la philosophie* (lectures at the Sorbonne given in 1892–3), new ed. (Paris, 1925): see especially pp. 8 and 25. This is long before the thirties, when Kojève delivered his celebrated lectures on Hegel in Paris. On p. 43 he speaks of the preference for the unconscious over the conscious in idealist philosophy, adding that "*Fichte,* under the conscious ego (*moi*), places the absolute ego, for which activity precedes intellect, and it is this activity which, suffering an inexplicable shock, explains the ego as the non-ego (*non-moi*). For Schelling, the absolute will become the identity of ego and non-ego; for *Hegel,* the identity of contradictories, which is a scandal for thought. Thus, increasingly, the ego is forced to go out of itself, and return to some principle of incongruity [heterogeneity]." On p. 135 he says – perhaps with Hegel's identity of contradictories in mind – that Descartes formulated the fundamental idea that there is "a point of coincidence between the sensible and the mathematical, between becoming and being." We are not far from Breton's famous point where all opposites meet, which in turn resembles Schopenhauer's union of the individual and the universal, well-known in France since the 1870s (and perhaps to recent dallyings of some postmodernists). Conceivably Breton knew before writing the *Champs magnétiques* that Hegel used magnetism – in which positive and negative poles unite within a field – as a metaphor for the concept of the dialectic in nature.

45. See Kenneth E. Silver, *Esprit de Corps* (Princeton, N.J. 1989), p. 93, on Boutroux, and pp. 281–2 on the Exposition Nationale de la Maternité et de l'Enfance, held in Paris in 1921, and on Boutroux's joining Bergson, Barrès, and others to advocate French *fécondité* and *maternité* to help against Germany in the war. Barrès

paraded his chauvinism in his book *The Undying Spirit of France* (New Haven, Conn., 1917). (It seems to me that during and after the centennial celebrations of the French Revolution, reactionaries countered the revolutionary slogans with their own of "religion, hierarchy and maternity" – terms detested by the Surrealists.) Breton, in his *Entretiens* (p. 268), alludes to Croce's *Ce qui est vivant et ce qui est mort de la philosophie de Hegel* (Paris, 1910). Bonnet, who never disputes a statement by Breton, in *OC,* vol. 1, p. 1348, quotes Naville's claim that Croce's book initiated Breton into the study of Hegelian dialectics in 1924. Admittedly, although Breton never expressed much admiration for Croce's book, he may well have profited from it; for in several passages Croce expounds Hegel in terms relevant to Breton's thought. Octave Hamelin (1856–1907) attempted to synthesize Cartesian logic and the law of contradictions with Hegelian dialectic in *Système de Descartes* (Paris, 1911, posth.), *Essai sur les éléments principaux de la représentation* (Paris, 1907), and "L'Union de l'âme et du corps d'après Descartes," *Année philosophique* (1904). Perhaps the neutering of sensuous quality by Cartesian intelligence most appalled the Surrealists. Léon Brunschvicg's text *Relation entre mathématique et physique* (1923) spells this out: "Cartesian idealism cleaned out the world of sensible qualities and substituted an intelligible universe for it." Bergson's *La Pensée et le mouvant* (Paris, 1934, p. 146) contrasts the worlds of sense and of the intelligible.

46. See Paul Bourget, *Essais de psychologie contemporaine,* vol. 1, p. 228. On Villiers see Henri Chapoutout, *Villiers de l'Isle-Adam, l'écrivain et le philosophe* (Delesalle, 1908). Villiers read not Hegel but Véra's *Introduction à la philosophie de Hegel* (2nd ed., Paris, 1864) according to E. Drougard, "L'Érudition de Villiers de l'Isle-Adam d'après Claire Lenoir," *Mercure de France,* 215 (1929), pp. 97–112.

47. Metzinger described Cubism as "the sensible equivalent of an idea," which he had already interpreted in 1910 as a dialectical interplay between "thesis, antithesis, synthesis." See Metzinger, "Note on Painting" (1910), cited in Fry, *Cubism,* pp. 59–60. In the same text Metzinger explicitly rejects "Hegelian superstition," but thereby suggests the source of his schema. On Dada, see the letter to the editor of R. Poidatz, July 17, 1920, *Revue de la Quinzaine:*

"It is Hegel who developed for his own purposes a new logic based on the identity of contradictories. For him, to affirm is to negate."

48. Taine, a dominant figure in literary criticism during the youth of the Surrealists, applied "Cartesian graphing" in his logical and positivist approach to literature. An apologist for Cubism, M. Raynal appeals to Plato, Kant, and Malebranche, and quotes Hegel's remark that artists make the Beautiful into a "sensible manifestation of the Idea," in "Some Intentions of Cubism" (1919). In Fry, *Cubism,* 151.

 John MacGregor, in *The Discovery of the Art of the Insane* (Princeton, N.J., 1989), p. 274 asserts: "The first manifesto of Surrealism of 1924 contains little that does not derive from *The Interpretation of Dreams* and other early works of Freud." Clearly this exaggerates the influence of a work that in 1924 still only appeared in fragmentary translation. Bonnet, *Breton,* p. 342, observes rightly that "although Freud had aided [Breton] to crystallize his thought . . . [Breton] never claimed to be a disciple . . . doubtless he still had [in 1924] only an indirect and inadequate acquaintance with *The Interpretation of Dreams.*"

49. On these questions see Silver, *Esprit de Corps.* The critics associated with the Cubist school looked mainly to Plato and Kant as sources of its formal concepts, and the German writer Adolph J. Fischer, in his *Zwei Männer spielen um die Welt. Roman aus der nächsten Zeit* (1932), observed that "the German Mind . . . had Kant as its first revealer of philosophical knowledge, the German Mind first saw the categorical imperative in itself, . . . and has cleared away much of mankind's old nonsense." Not surprisingly Breton rejected for similar reasons Kant and Descartes. In his introduction to the London Surrealism exhibition of 1936, "Limits Not Frontiers of Surrealism," Breton, applying a favorite architectural metaphor, claimed that a new "open rationalism" in science corresponds to "the *open realism* or *Surrealism* which involves the ruin of the edifice of Descartes and Kant."

50. *LSASDLR,* no. 1 (July 1930), p. 45, contains the elegant formula: "Désapprendre=Rèvolution." Also, see Melanie Klein, "The Role of the School in the Libidinal Development of the Child," *Contributions to Psychoanalysis: 1921–1945* (London, 1948), pp. 73–6. Derrida, *Of Grammatology* (Baltimore, 1976), p. 88 and n. 37 applies Klein's text to his discussion of graphology; and Kristeva has suggested using Klein in connection with the psycholinguistic study of the acquisition of language.

51. This is the view of Christiane Rochefort, *Le Repos du guerrier* (Paris, 1958), p. 177: "And automatism?" said Katov. "It's abstraction in writing. Automatism in itself is a joke. It's the content that Surrealism created. Look: Now that artists no longer take an official political position, in other words now that they're all officially bourgeois, automatism is pointless. Previously revolt was the right position to take."

52. See Lynn Hunt, *The Family Romance of the French Revolution* (Berkeley, 1992).

53. See Zeldin, *France: 1848–1945,* p. 455: "It is above all the young, highly educated people from cultured backgrounds who like 'modern' painting – beginning with the Post-Impressionists. The decisive factor seems to be not education as such, nor wealth, but the tastes acquired in childhood, and here the influence of the mothers has been shown to be noticeably greater than that of fathers. It is the cultured mother who passes on taste for avant-garde art." To take one example, the impact of his mother on Aragon emerges clearly in his conversations with Dominique Arban, p. 102ff. Having passed his youth in a "family of the petite bourgeoisie," with a poor and hard-working mother, he asks, "But what did my mother live on?" and answers, "You know, in the years just before World War I, my mother lived solely from what she made from writing serial novels." On the other hand Breton, raised under the cold discipline of a dogmatically Catholic mother, spent his whole life reviling religion and inventing marvels to outdo the wonders claimed in Christian literature.

54. See Dandieu, *Anthologie,* p. 19. As noted earlier Valéry and the philosopher Alain led a Cartesian reaction against Bergson.

55. See Henri Lefebvre, *La Production de l'espace* (Paris, 1974), pp. 34ff.

56. See André Thirion, *Révolutionnaires sans révolution* (Paris, 1988), pp. 83, 87. Thirion, raised in Lorraine, describes how, dominated by his mother, he was "in 1920 very pious, patriotic and republican" and how his discovery a few years later of Surrealist literature helped liberate him.

57. Breton's attachment to Symbolism in 1914 was noted by Michel Décaudin, *La Crise des valeurs*

symbolistes (Paris, 1957), p. 412. Bonnet developed the point in her *Breton*.

In "Un retour du Symbolisme," *Les Feuilles libres*, no. 3 (March 1921), pp. 117–21, the editors claimed that the young generation was then returning to Symbolism.

58. Many of the relevant texts by Édouard Schuré, Maurice Maeterlinck, Joris-Karl Huysmans, Arthur Schopenhauer (in translation), and others can be found in the extensive study of Guy Michaud, *Message poétique du symbolisme* (Paris, 1947). Themes involving sleeping or dreaming figures abound in the art of Gustave Moreau, Pierre Puvis de Chavannes, and even Gauguin. And Odilon Redon created a whole series of lithographs called *In the Dream* (1879). An advertisement for Sar Péladan's novel *Typhonia* (1892) in the catalogue of the Second Rosicrucian Salon (Paris, 1893) reads: "Demonstration of the necessity of the big city to disorient the ferocity of the French bourgeoisie." Bonnet, *Breton*, p. 30, notes that Breton read a novel of Péladan's in 1913.

59. An affiliation between Symbolism and Surrealism was already noted by Gilbert Guisan, *Poésie et collectivité 1890–1914. Le Message social des oeuvres poétiques de l'unanimisme et de l'Abbaye* (Lausanne, 1938), pp. 18: "Surrealism, logical flowering of Symbolism." Other scholars such as Marcel Raymond and Anna Balakian have enlarged on this point, but few have explored the connections between Surrealist and Symbolist painting or between their painting and poetry. An eclectic "History of Surrealist Painting" by Marcel Jean and Arpad Mezei (first published in 1959) likewise falls short, despite its useful collection of illustrations of Moreau and Redon; for it confuses the reader with illustrations of Toulouse-Lautrec, Seurat, and Böcklin, as well as works by Cézanne, mocked by Picabia and appreciated in a very limited way by Breton. Freud receives scant consideration (less than Jung!), Janet none, whereas the name of Rorschach recurs.

60. An analogous development in painting later appeared in Maurice Denis's "De Gauguin et de Van Gogh au classicisme," *L'Occident* (May 1909), in *Théories* (Paris, 1964), p. 119: "Art, instead of being the *copy*, became the *subjective deformation* of nature." Jean Moréas, leader of the Symbolists, declared in his "Literary Manifesto" (1886), in Eugen Weber, *Paths to the Present* (New York, 1963), p. 206, "Sym-

bolic poetry seeks to clothe the Idea in a perceptible form," and he concludes (p. 209) with an assertion that points toward the antinaturalism of the First Manifesto of Surrealism: "Thus, scorning the puerile methods of naturalism – M. Zola himself was saved by a wonderful writer's instinct – the Symbolic-Impressionist novel will build its work of *subjective deformation*, strong in this axiom: that art can only seek in the *objective* a simple and extremely succinct starting point."

61. Marcel Jean and Arpad Mezei, *Histoire de la peinture surréaliste* (Paris, 1959), mingle Symbolist art (including Moreau) in their survey of twentieth-century modernist precursors to Surrealism. Mario Praz, in his *Romantic Agony* (New York, 1967), p. 289, denigrates Moreau by comparing Delacroix's "fury of frenzied action" to the "sterile contemplation" of Moreau. His dislike of Moreau prevents his grasping the qualities that made Moreau rather than Delacroix relevant to the Surrealists. The modern art historian Robert Goldwater's *Symbolism* (New York, 1979), which emphasizes stylistic analysis while rejecting allegory as nonpictorial and "literary," ignores wholly the relation of Symbolism to Surrealism and plays down the importance of Moreau's art.

Despite the characteristically patriarchal attitude expressed in their attraction to the fatal woman, the Surrealists had moments in which they were unusually progressive for their time.

62. See Lautréamont, *OC* (Paris, 1940), pp. 70–1. For a different relation to Lautréamont by a younger Surrealist born in Lorraine see Thirion, *Revolutionaries*, p. 84: "Reading *Les Chants de Maldoror* did not cause either Sadoul or me to rush toward Surrealism. Rather, the works of Aragon and Breton allowed us to comprehend the importance of Lautréamont. I had read *Maldoror* at 14 and classified him as a wild romantic." Soupault loaned a copy of Lautréamont to Breton in June 1918 according to H. Béhar, "Philippe Dada," p. 10.

63. See Gaston Bachelard, *Lautréamont* (Paris, 1939), p. 101.

64. See H. Michaud, *Message poétique du Symbolisme* (Paris, 1947), pp. 96, 97.

65. The Surrealists admired the unusual Symbolist poet Saint-Pol-Roux, who in the 1890s developed the concept of *idéo-réalisme*, uniting mysticism and the experience of an incongru-

ous reality. Breton, perhaps sensing an affinity to his own concern with the transcendence of realism, praised Saint-Pol-Roux as the only one of his generation "qualified to intervene in the debate which impassions us: order or adventure, reason or divination, West or East, slavery or freedom, dream or non-dream." See Breton, "Hommage à Saint-Pol-Roux," *Les nouvelles littéraires* (Paris, 1925), p. 15.

66. Cf. Masson: "From 1914 to 1919, men live like Surrealists without knowing it. It is probable that the Surrealists themselves experienced the war." See Georges Charbonnier, *Entretiens avec André Masson* (Paris, 1985), p. 39.

67. See "Caractères de l'évolution moderne" (1922) in Breton, *OC*, vol. 1, pp. 297–8. Breton always understood the difference between Picasso's art and the "Cubism" expounded by minor artist-theorists like Lhote, Gleizes, and Metzinger. These artists turned "Cubism" into the basis for academically intellectual painting or into a mannered provocation with which to enliven traditional painting.

68. Mark Antliff, "Cubism, Celtism and the Body Politic," *Art Bulletin* (December 1992), pp. 655–68, showed that the Cubists themselves adopted an intuitive Bergsonian "classicism" as an alternative and in opposition to the logical Cartesianism of the Right (Action Française). This classicism was associated with a nationalistic Celtic movement of a very French character. Dermée, who would later propose his own version of Surrealism, founded and edited *Z,* whose first issue, in March 1920, contained Breton's poem "J'ai beaucoup connu" and writings by Aragon, Eluard, and Soupault.

69. See Kern, *The Culture of Time and Space,* p. 193, citing Gibbs's *The New Man* (London, 1914), p. 144–48.

70. See especially section 6, "The Dreamwork," of Freud, *The Interpretation of Dreams.* Cf. Patrick Mahoney, *Freud as Writer* (New York, 1982), p. 187, on Freud's "painful cognizance of the inherent inadequacy of linear exposition to render simultaneous phenomena." Klee, in his "Creative Credo" of 1920, rejected Lessing's distinction and insisted that "space too, is a temporal concept," but in his notes on modern art of 1945 he observed that "what the so-called spatial arts have long succeeded in expressing, ... this phenomenon of many simultaneous dimensions which helps drama to its climax, does not, unfortunately, occur in the world of verbal didactic expression." Quoted in

R. L. Herbert, *Modern Artists on Art* (Englewood Cliffs, N.J., 1964), p. 78.

71. In "Les 'Enfers artificiels,' " Breton, *OC,* vol. 1, p. 625.

72. See Jean Hytier, "Albert Einstein," *Larousse Mensuel,* 5, no. 177 (November 1921), pp. 620–1.

73. See Rivière's interview with Roger Vitrac, in *Le Journal du peuple* (April 21, 1923). See also Georges Ribemont-Dessaignes's review, "Einstein et l'Univers par Ch. Nordmann," in *Littérature,* n.s., no. 1 (March 1922), p. 18: "There is a new Jesus Christ, Einstein." For the relation of Dada to relativity, see Georges Lemaitre, *From Cubism to Surrealism in French Literature* (Cambridge, Mass., 1941), pp. 182–3. In the "Liquidation" list that appeared in *Littérature* in March 1921 (see Chapter 2, n. 8, this volume), Aragon and Breton gave both Einstein and Freud high marks. Earlier, in his notebooks of 1920–1 in Breton, *OC,* vol. 1, p. 616, had some impertinent reservations about both Einstein and Freud: "Show that the doctrines of Freud (and) Einstein err in placing too much confidence in logic." See also the writings of Linda D. Henderson on the interest among artists in popularized notions of the fourth dimension.

74. For the view that Symbolism led to Futurism see Tancrède de Visan, *L'Attitude du lyrisme contemporain* (Paris, 1911), and the same view in Gilbert Guisan, *Poésie et collectivité, 1890–1914* (Lausanne, 1938). See also Marinetti's early *La Conquête des étoiles,* with its allusions to "astral fortresses" and "the Babels of dream." Later he turned against Symbolism, as in "We Abjure Our Symbolist Masters, the Last Lovers of the Moon," in *From War, the World's Only Hygiene* (1911–15), in R. W. Flint, ed., *Marinetti: Selected Writings* (New York, 1972), pp. 66–68.

75. See Paulhan, *Les Fleurs de Tarbes, ou la terreur des lettres* (Paris, 1941), dedicated to the comparatively tame post-Symbolist Gide. The title refers to the sign that prohibits carrying flowers into the public garden in Tarbes – Paulhan regrets the anomaly that young girls should be forbidden to enter the garden with flowers. By analogy he deplored that modern young writers seem unwilling to enter the "garden of poetry" with roses or poppies in hand rather than weapons of linguistic terror; in fact much later in the book he turns the prohibition into the command that one must bring flowers to

the park. Paulhan defined the terrorist – his examples include Marx, Freud, and Sorel – as a "misologue," a hater of the beauty of language: "whether it concerns Symbolism or Unanimism, Paroxysts or Surrealists, not one fails to strike us with his verbal manias." Perhaps his suggestion that poets enter the domain of poetry carrying floral beauty was a response to Breton's essay of 1925, "Le Bouquet sans fleurs," which oriented poetry toward dream and politics. Of course, some poets found acts of terror inspiring, and one was said to have remarked on the eve of Ravachol's exploding his bomb: "Vague notions of humanity don't matter at all, as long as the act is beautiful." André Salmon quotes this in *La Terroire noire. Chronique du mouvement libertaire* (Paris, 1959), p. 360. Marinetti in *Poesia*, vol. 2, no. 6–8 (July–September 1906), pp. 18–20, wrote an "Eloge de la dynamite" dedicated "Aux révolutionnaires russes."

The Surrealists seem to have perpetuated the views of the Romantics on language: Victor Hugo, equating poetic revolution and the terror of 1793, wrote in "Réponse à un acte d'accusation" [1834], in Book 1, line 66, of *Les Contemplations* (Paris, 1969): "I have set a red bonnet (of revolution) on the antiquated dictionary" (p. 21).

76. Marinetti stated in his manifesto "Destruction of Syntax – Imagination without Strings – Words-in-Freedom" of 1913, in U. Apollonio, ed., *Futurist Manifestos* (New York, 1973), p. 100, that "as we discover new analogies between distant and apparently contrary things, we will endow them with an ever more intimate value." At another point (p. 98) Marinetti, sounding like a Dadaist *avant la lettre*, advises the poet to take "fistfuls of essential words in no conventional order." In such formulations some observers of Futurism have chosen to emphasize the "contrary" rather than the "analogy"; hence, the statement by Paulhan, *Fleurs de Tarbes*, p. 35: "A modern school (*Words in Liberty* led by Marinetti) allows the writer for the first time to 'dissassociate the content of sentences.'" (Of course, when the Futurists turned Fascist, they relinquished this "dissociation" and formulated their chauvinistic and militant propaganda in clear enough sentences.) Another manifesto, by B. Corradini and E. Settimelli of 1914, "Weights, Measures and Prices of Artistic Genius," *Futurist Manifestos*, pp. 135–50, speaks of the "cohesion which

unites" distant and unlike elements. The manifesto proposes some innovative ironies; indeed, in considering thought weighable "like any other commodity" and offering "12 atmospheric adjectives" for inspiration, it also introduces ideas that we find later in Duchamp's "Air de Paris" of 1919 and Arp and Ernst's "Fatagaga" series of ca. 1920. For the influence of Futurism on Surrealism see Herbert S. Gershman, "Futurism and the Origins of Surrealism," *Italica* (June 1962), pp. 114–23, and E. Falqui, "Appunti per una nota sulle 'parole in liberta,'" *Fiera Letteraria* (September 21, 1958). But work on the "Italian connection" has hardly begun.

77. Cf. Harold Lasswell, *Psychopathology and Politics* (Chicago, 1977 [1930]), p. 195: "Political symbolization has its cathartic function, and consumes the energies which are released by the maladaptations of individuals to one another."

78. See Marianne Martin, *Futurist Theory and Art* (Oxford, 1968), pp. 89–90. Bergson, in rejecting mechanical rigidity for its inability to adapt to reality, came close to the positivism of U.S. ego psychologists. Such a position would have been repugnant to the Surrealists; on the other hand, with Lacan, an opponent of ego psychology, Breton valued the "surreal" world of imagination. Marjorie Perloff, *The Futurist Moment: Avant-Garde, Avant-Guerre, and the Language of Rupture* (Chicago, 1986), argues for the importance of rupture in Futurism.

79. See Marianne Martin, "Futurism, Unanimism and Apollinaire," *Art Journal*, 28–9 (1969), p. 259, where she discusses the theory of analogies in Marinetti's *Technical Manifesto of Literature*.

80. See Ribemont-Dessaignes, *Déjà jadis: Ou du mouvement Dada à l'espace abstrait* (Paris, 1958), describing how the Dadaists criticized Lenin harshly in a session at the popular university of the lower class, Faubourg Saint-Antoine. See Robert S. Short, "The Politics of Surrealism, 1920–36," in W. Laqueur and G. L. Mosse, eds., *The Left-Wing Intellectual, 1919–39* (New York, 1966), pp. 3–25. In *Littérature*, no. 13 (May 1920), one finds many antipolitical utterances, even by Aragon (p. 2: "no more imperialists, no more anarchists, no more socialists, no more bolsheviks."); Breton, ibid., p. 17 wrote: "Cubism was a school of painting, Futurism a political movement: Dada is a state of mind." The Futurists in 1919

were by no means unequivocal Fascists in the sense that they acquiesced in Mussolini's terrorism and monarchism, and the dictator's acceptance of the support of big industry and banking. See Gramsci, "Una Lettera a Trotskij sul futurismo," in *Scritti politici*, ed. P. Spriano (Rome, 1967), pp. 529–31; and "Marinetti rivoluzionario?" in ibid., p. 395. Gramsci reported the decline of Futurism, expressing his regrets; indeed, he had still admired Futurists a year before for the destructive ardor they directed against the bourgeoisie, and which had won them worker support. But since then, he said, they had gone Fascist and lost their cohesion as a movement. It should be noted that by December 1926 in their review of the press for *La Révolution surréaliste*, no. 8, p. 2, Eluard and Péret exclaimed, "Death to Mussolini! Long live the world revolution."

81. See "Caractères de l'évolution moderne" (1922), in Breton, *OC*, vol. 1, p. 297. In "Génèse et perspective artistiques du surréalisme" (1941), in *Le Surréalisme et la peinture*, p. 57, Breton repeated his low evaluation of Futurism's "plastic quality," but on p. 59 he praised Futurism for favoring a "purely tactile" art as opposed to a "decadent" visual or optical art based on external models, and for accentuating "for the first time *need.*"

82. See R. W. Flint, ed., *Marinetti: Selected Writings* (New York, 1972), p. 41, "Manifesto of Futurism." Perhaps the notion of the "death" of time and space was suggested by the concept of space-time in relativity (which could have been known from either the French or Italian popular press: note Balla's painting *Mercury Passing before the Sun* of 1914, proving Futurist interest in observations concerning the relation of gravity to light). Marinetti presumably also knew the claim of relativity, so pertinent to their painting of motion, that matter would disintegrate at speeds approaching light. Concerning speed Duchamp remarked around 1912, "The whole idea of movement, of speed, was in the air"; indeed, he did not hide the sources for his *Nude Descending a Staircase* of 1912 in chronophotographs and motion pictures. Nineteenth-century French critics had already connected speed and originality, prefiguring the Futurists (and the *Champs magnétiques?*): Girodet (1817) defined originality as "freedom from control, independence in the use of resources . . . sure and certain signs of that swift instinct which precedes thought itself

in the invention of a theme"; in the 1863 Salon the Realist Thoré wrote: "M. Jongkind's manner . . . delights all who love spontaneous painting, in which strong feelings are rendered with originality. . . . I have always maintained that true painters work at speed, under the influence of impressions." See Boime, *Academy*, pp. 176–80.

83. There was much interest in Paris during the twenties in extraretinal vision, especially in publications of the *Nouvelle Revue française*, such as Jules Romains (in collaboration with the professor of philosophy René Maublanc), *La Vision extra-rétinienne et le sens paroptique* (Paris, Nouvelle Revue française, 1920).

84. See Marinetti's "Onomatopoeia and Mathematical Symbols" in *Lacerba* (1913), p. 105, in which he claims the ability to "control the speed of the style" by using mathematical and musical symbols; and he wants to "combat" Mallarmé's "static ideal" by impressing on words "every velocity of the stars."

For an experimental parallel to Breton's idea that greater velocity of perception will yield a less consciously controlled content in the viewer, see Tom Ettinger, "Picasso, Cubism, and the Eye of the Beholder: Implicit Stimuli and Implicit Perception," doctoral dissertation, Department of Experimental Psychology, New York University, May 1994.

85. See Breton's remarks on the *Champs magnétiques* in "En Marge des *Champs magnétiques*," *Change*, no. 7 (Paris, 1970), p. 10. For the stasis implied in modernist simultaneity see Par Bergman's essay, "Modernolatria et simultaneita," *Studia litterarum upsaliensa*, 2 (Uppsala, 1962), especially Introduction, "Le 'Mythe du Moderne' au début du XXᵉ siècle," pp. 1–33.

86. Boccioni's *Fusion of Head and Window*, 1911–12; and Antonio Bragaglia, "Futurist Photodynamism," in Apollonio, *Futurist Manifestoes*, pp. 38–45. De Chirico's *The Brain of the Child* may also have influenced Breton's window image.

87. The plasticity of some of Apollinaire's images directly inspired at least one Surrealist painting. His poem "The Windows" in the collection *Calligrammes* (1913), in *Oeuvres poétiques* (Mayenne, 1971), p. 168, describes what he saw through a window with curtains open (Apollinaire may have had in mind Delaunay's earlier painting of the Eiffel Tower framed by curtains): "Towers / The towers are the streets." This corresponds exactly to the cen-

tral motif in Magritte's *Euclidean Walks* (*Les Promenades d'Euclide*) of 1955 in which a medieval stone tower has a conical form matching the size and shape of a street next to it; indeed, Magritte endowed each with a quality of the other: the tower's apex touches the horizon like the street's converging orthogonals, and the street has a shadow on the left similar to the chiaroscuro on the right side of the tower. The ambiguity between the "actual" vista and that on the easel before the window is Magritte's invention.

88. See Bonnet, *Breton*, pp. 78–85.

89. See Katia Samaltanos, *Apollinaire, Catalyst for Primitivism, Picabia, and Duchamp* (Ann Arbor, Mich., 1984), passim. The Futurist manifesto "Weights, Measures, etc." of 1914, already quoted, declared that "it is time for madness (the upsetting of logical relationships) to be made into a conscious and evolved art." L. C. Breunig, "Apollinaire et Freud," *La Revue des lettres modernes. Guillaume Apollinaire* (1968), no. 183–8, observes that Apollinaire briefly described "psycho-analyse" as "analyse des mouvements inconscients de la personnalité" (p. 213).

90. Vaché's letter of August 18, 1917 (included in Breton's *Anthologie de l'humour noir,* whereas the last letter was not), offers the following advice to his friend Breton: "So we like neither art nor artists (down with Apollinaire). . . . We no longer recognize Apollinaire – because – we suspect him of too consciously making art, of patching up romanticism with telephone wire, and not knowing about dynamos." This probably refers to such phrases as the following from "The Windows": "We shall send it [a poem] in a telephone message, etc." In the last letter to Breton, dated December 19, 1918, Vaché suggested that they were ready to go beyond Apollinaire. At the same time he tempered his criticism, acknowledging that "Apollinaire has done much for us and certainly is not dead; he was right, besides, to stop in time. . . . *He marks an epoch.*" Vaché's phrase "stop in time" seems portentous for himself: Vaché committed suicide about two weeks later.

91. Breton and ten of his colleagues drew up a tally sheet assigning numerical evaluations of public personalities – both contemporary and historic – along with their average rating, in *Littérature,* no. 18 (March 1921). In this so-called "Liquidation" Breton got the highest

average, compared with the mediocre assessments of Gide and Valéry. Breton, however, gave both the latter favorable ratings; but eventually he rejected them, Gide first. Valéry committed the unspeakable crime of succeeding to Anatole France's chair at the Académie Française in 1927.

92. De Chirico's paintings may have suggested a number of images in the writings of the Surrealists; for example, the puzzling line in Breton and Soupault's "La Glace sans tain" of the *Champs magnétiques,* "The window hollowed into our flesh opens onto our heart" corresponds exactly to a detail of *I Will Be There . . . The Glass Dog* of 1914. Years later Breton wrote beside the paragraph containing this line: "in my opinion the most beautiful in the book. *Why?*" And he chose this very painting (*J'irai . . . le chien de verre*) to illustrate his "Lettre aux voyantes" in the first issue of *La Révolution surréaliste* (December 1924), p. 21, together with another female torso, Masson's drawing *La Naissance des oiseaux,* p. 22.

93. In *The Painter of Modern Life,* sec. 4, in Baudelaire, *OC* (Paris, 1968), p. 553. A version of this idea recurs in the structuralist Barthes, *Image–Music–Text,* pp. 98–9: "All contemporary researchers (Lévi-Strauss, Greimas, Bremond, Todorov) . . . could subscribe to Lévi-Strauss' proposition that 'the order of chronological succession is absorbed in an atemporal matrix structure.' "

94. Obviously I would not agree with Apollinaire, who wrote in 1918 (see Breunig, *Apollinaire on Art* [1946], p. 461) that De Chirico "may be the only living European painter who has not been influenced by the new French school," nor with Massimo Carra, "Introduction: Quest for a New Art," both in *Metaphysical Art,* pp. 19–20, who categorically states that De Chirico was untouched by Cubism or Futurism "as he had been by the Fauves and the Expressionists."

95. Breton published Apollinaire's poem "Banalités" in *Littérature,* no. 8 (October 1919), pp. 1–3.

96. See Leroy C. Breunig, ed., *Apollinaire on Art* (New York, 1972), p. 223. Cf. Maurice Raynal, "Conception and Vision" also of 1912, text no. 20 in Edward Fry, *Cubism* (New York, 1966), criticizing the inadequacy of external perception as compared with a "conceptualist method."

97. Perhaps Apollinaire had in mind De Chirico's word "metafisica" (the relation of *meta/sur* and

of *fisica/nature/réalité*), when he used first the word "surnaturalisme"; he adopted the neologism "surréalisme" in May 1917 for the program of *Parade* and again in June 1917 for the preface and title of *Les Mamelles de Tirésias. Drame surréaliste.* The play was performed in Paris in 1920 and reviewed in *Littérature,* no. 5 (July 1919), p. 22, by Soupault, who observed that everyone "laughed heartily," but the review did not allude to "Surrealism."

98. See Duchamp's 1946 minihistory, cited by Chipp, *Theories of Modern Art,* pp. 393–4:

> Futurism was an impressionism of the mechanical world.... I was not interested in that. I wanted to get away from the physical aspect of painting. I was much more interested in recreating ideas in painting.... For me Courbet had introduced the physical emphasis in the nineteenth century. I was interested in ideas – not merely in visual products. I wanted to put painting once again at the service of the mind.... Dada was an extreme protest against the physical side of painting. It was a metaphysical attitude. It was intimately and consciously involved with "literature." It was a sort of nihilism to which I am still very sympathetic.
>
> Brisset and Roussel were the two men whom I most admired for their delirium of imagination....
>
> My ideal library would have contained all Roussel's writings – Brisset, perhaps Lautréamont and Mallarmé.

(On Brisset and Duchamp, see my "Duchamp's Androgynous Leonardo: *Queue* and *Cul* in *L.H.O.O.Q.,*" *Source,* 11, no. 1 [Fall 1991], pp. 31–5.) Apollinaire in 1912 called Cubism "the art of painting new configurations with elements borrowed, not from visual, but from conceptual reality." He adds that Picabia started a new trend within Cubism, abandoning "the conceptual formula at the same time as Marcel Duchamp." Apollinaire's vision (based on his friend Delaunay's practice) of a new, pure art, that will be to painting "what music is to poetry," was repugnant to Breton, who despised music in any form. See *Apollinaire on Art,* pp. 260–1.

99. In the nineteenth century several writers reconsidered the relation of historical time to its transcendence in eternity – a relation already implicit in Plato's description of time in the *Timaeus* as "a moving image of eternity": Nietzsche in *The Use and Abuse of History* (1874) and *Thus Spake Zarathustra* (1883–5); and Ibsen in *Hedda Gabler* (1890), concerning a historian who does research during his honeymoon, a forerunner of Jensen's archaeologist or Delvaux's male scientists blind to erotic charms. The twentieth century abounds in works concerned with time, such as Joyce's "The Dead" (*Dubliners,* 1914), the followers of Bergson and Proust in France, Mann's *The Magic Mountain* (1924), and many works of Borges.

100. See Baudelaire, "On the Heroism of Modern Life," in *The Salon of 1846.* In Baudelaire, *OC* (Paris, 1968), p. 261.

101. The famous phrase in the Sixth Canto of Lautréamont's *Maldoror,* "beautiful as the chance encounter of a sewing machine and umbrella on a dissecting table," was richer in psychosexual overtones than Dada mechanomorphic imagery such as Picabia's *Prostitution universelle* of 1916, with its secret phallic emitter and horizontal "sexe féminin idéologique." In his collaboration with Eluard, *L'Immaculée conception,* in the section "L'Amour," Breton himself named the seventeenth position of intercourse (in which the woman alternately bends and extends her legs in turn) "the sewing machine." Lautréamont's phrase inspired all the Surrealists and, I believe, even Ernst's description (reprinted in *Beyond Painting and Other Writings* [New York, 1948], p. 13) of "the mechanism of collage": "A ready-made reality (a canoe), finding itself in the presence of another and hardly less absurd reality (a vacuum cleaner), in a place where both of them must feel displaced (a forest)... will make love." The following similarities exist between the two texts: in each, heterosexually paired objects are "placed" on a table or in a forest; the concavity of canoe and umbrella (opened) stand in inverse relation to water as below (river) or above (rain). Perhaps with some inconsistency Breton in the Second Manifesto criticized Bataille for his architectural anthropomorphism. For a discussion of the metaphor of the arcades in *Le Paysan de Paris* as related to *Passagen-Werk,* see Jacques Leenhardt, "Le Passage comme forme d'expérience: Benjamin face à Aragon," in H. Wismann, ed., *Walter Benjamin et Paris* (Alençon, 1986), pp. 163–71.

Foster, *Compulsive Beauty,* has made much of Benjamin's idea of the outmoded in his interpretation of Breton's Surrealism.

102. See Sanouillet, *Dada à Paris* (Paris, 1965), pp. 420–6. Hans Richter, in *Dada: Art and Anti-Art* (New York, n.d. [1965]), p. 94, asserted that automatic writing "had been employed by Ball, Arp ... in Zurich, both individually and collectively, from 1916 onwards," and that "Breton's methodical determination to gain deeper insight into *'écriture automatique'* ... does not make the latter a 'Surrealist' activity. It may be called so today, just as the works of Arp, Picabia, Man Ray, Max Ernst and others are called Surrealist. ... In its beginnings, Surrealism seems to me to be as like Dada as two peas in a pod."

103. In Act 9 Tzara refers to living and dying, a phrase that Breton may have controverted in the last words of the manifesto: "Living and ceasing to live are imaginary solutions. Existence is elsewhere." For these Tzara citations see M. A. Caws, ed., *Tristan Tzara* (Detroit, 1973), pp. 152, 157, 195. For Aragon's remarks, see *Les Collages,* pp. 141ff., "Petite note sur les collages chez Tristan Tzara et ce qui s'en suit" (n.d.).

104. Even before the advent of Dada Apollinaire provided a model with his own calligrammes, and he designated Picabia's paintings as "poems," in "Simultanisme-Librettisme," *Les Soirées de Paris,* no. 25 (June 15, 1914).

105. The major Surrealists never became familiar with a foreign language; indeed, even when exiled to the United States during World War II, Breton refused to learn English and insisted on conversing and lecturing in French. In 1922 a committee formed by the emerging French Surrealists, in their struggle to escape what began to feel like an oppressive affiliation, signed a public statement rejecting Dadaism as a movement that had "come from Zürich." Although Mme. Bonnet and others have tried to exonerate Breton from the charge of xenophobia, one can still detect in the phrase an odor of the "metropolitan provincialism" of writers infatuated with Paris.

106. See Caws, *Tristan Tzara,* p. 34. The editor notes that the letter "is the best possible introduction to ... [Tzara's] particular sense of Dada."

107. Breton, in his polemical response to Rachilde's chauvinistic criticism of Dada as "a German

product," signed his letter as "directeur de Littérature, revue dadaïste"; still, he maintained a discreet distance from Futurism and Dadaism, and generally minimized their influence on his movement. Scholars devoted to Breton like Marguerite Bonnet have achieved some measure of success in their efforts to prove that Breton independently and prior to the advent of Dadaism had arrived at the ideas he later expanded into Surrealism.

108. See Caws, *Tristan Tzara,* pp. 150–1, 153. One should, however, note that the views of Breton and Tzara converged at various times: in 1920–4 Breton seems to have shared the Dada antithesis to Freud and Marx (whose name did not even appear on the "Liquidation" list in *Littérature* (March 1921), which included Lenin and Trotsky). Tzara later turned Marxist (eventually he joined the Stalinists), and by 1930 wrote much more favorably about Freud.

109. See Breton, *OC,* vol. 1, p. 1129.

110. See M. Schapiro (1957) in *Modern Art,* p. 224: "Painting and sculpture ... induce an attitude of communion and contemplation. They offer to many an equivalent of what is regarded as part of religious life: a sincere and humble submission to a spiritual object, an experience which is not given automatically, but requires preparation and purity of spirit." He has not felt the need explicitly to reconcile this view with the positivism he propounds elsewhere.

111. In an exchange of unpublished letters (located at the Bibliothèque Doucet, Paris) in February 1919 Tzara confessed to Breton that the great exploit is "not getting bored." Breton well understood the challenge posed by boredom and observed, "All my efforts are directed for the moment along that line. ... I insist on seeing what lies on the other side of boredom." The First Manifesto presents the project "How not to be bored any longer when with others," adding, "This is very difficult."

112. Breton, *OC,* vol. 1, p. 239. Dada's view of psychoanalysis appears clearly in Tzara's "Dada Manifesto, 1918," in Caws, *Tristan Tzara,* p. 153: "Psychoanalysis is a dangerous sickness, lulls the antirealistic tendencies of man and codifies the bourgeois."

113. The interview was published in *Littérature,* n.s., no. 1 (March 1, 1922). An ironic echo of Breton's interview with Freud appeared in an article by the leader of the Lettrist group

Isidore Isou, who, in his *Réflexions sur André Breton* (Paris, 1948), p. 20, seems to parody Breton, claiming that an interview with Breton was a waste of time because he had nothing new to say about literature: "There remains only a rather vague gentleman with failing memory who chews over the poor fodder of André Breton." Tzara had earlier published, in a similar mock-serious tone, an "Interview de Jean Metzinger sur le cubisme." See Tzara, *OC* (Paris, 1975), vol. 1, pp. 569–70.

In his notebooks of 1920–1, portions of which he reused at the end of the First Manifesto (without mentioning any of the three names), Breton several times refers to Freud:

> Freud, student of Charcot, in our time has revolutionized the study of the mind (*médecine mentale*), while Babinski, likewise a student of Charcot, has revolutionized the study of the nervous system (*médecine nerveuse*).... From what they learned at the Salpetrière, Freud and Babinski retained that marvellous experimental method consisting of testing everything that passes through your head.... I've seen Babinski examining the sick – having them stand, sit, bend the left knee, etc., all without preconceived idea.... At about the same time Freud, a mind perhaps less independent and more systematic, struggled to formulate rules according to which we can perform with the greatest efficiency.... He began by criticizing the "Censorship" which causes repression into the unconscious of a number of mental operations at which current morality would make us blush.... One is still tempted to see in Freud only the most banal part of his teaching, pansexuality.... But I find no interest in making Freud into an erotomaniac just as I subscribe entirely to the view that considers the Marquis de Sade above all "the freest mind that has yet existed." The students of Freud, Jung, Maeder have tried, above all, literary applications of his teaching to works admired over the centuries. Shakespeare and Goethe have been the most often investigated: "The Theme of the Three Caskets" and Marguerite's song have been brilliantly interpreted. These cases are unfortunately unclear and I do not know that the psychiatrists of the School of Vienna ever dreamed of obtaining better documents. Censorship, despite everything, is very strong in these celebrated writers, so their work cannot be put to use. Other (writers) will have to find a mode of expression corresponding to the new (psychiatric) need. That mode can be developed by favoring inspiration. (It is not a simple question of cause and effect, as though one could ask whether the artist or the scientist came first.)
>
> Soupault and I, by writing *Les Champs magnétiques,* believed that we made a decisive advance toward (creating a mode of writing free of censorship). For the first time, I think, writers have renounced judging their work to such an extent that they do not give themselves enough time to recognize what they created. (Breton, *OC,* vol. 1, pp. 618–20)

Judging from his recurrent polemics Breton wanted the acknowledgment if not the recognition of the psychiatrists. In the mid-twenties Aragon shifted from a favorable view of Freud to the mocking tone of *Le Paysan de Paris* of 1924. In *Anicet* of 1921, Aragon, speaking through Mentor, a terrorist in Paulhan's sense, emphasized the disparity between reality and the language that describes it. Mentor found language useful only when Freudian errors yielded unintended revelation (p. 93): "One would make a mistake not to take words literally ... errors of language tell us much about our hidden thought." Later, in *Le Paysan de Paris* he writes: "*Libido,* double game of love and death (*l'amour, la mort*) which recently has adopted medical books for its temple and which now strolls about with the little dog Siegmund Freud at its heels" (p. 42). And in, *Traité du style* (Paris, 1928), pp. 142–3, maintains that in France Freud was received in two contrary ways, either "dragged in the mud by the nationalist Facultés," which disliked un-French thought coming from "the other side of the Rhine" (p. 143), or outrageously exploited by superficial writers, " 'pansexual sheep,' who dress up their banal fabrications with a new terminology like 'symptomatic actions, oedipal tendencies, and various complexes' and by critics who show that their favorite novelist antici-

pated psychoanalysis" (p. 146). On the following pages, Aragon heaps absurdities on Freud's partisans and on the idea of comparing this theorist of the irrational and unconscious to the French "analytic tradition" of a Montaigne, or of making him an adherent of classical psychology.

114. Breton, *OC*, vol. 1, p. 239.

115. In *La jolie rousse,* published in *Calligrammes* (1918), Apollinaire seems to approach a project anticipating Surrealism with such phrases as: "We wish to give you vast and strange domains / where flowering mystery is offered to him who desires to pick it. / There, there are new fires, colors never seen, / A thousand imponderable phantoms / to which we must give reality." In *Oeuvres poétiques* (Mayenne, 1965), p. 313.

116. Ibid., pp. 865–6. Apollinaire had probably wished to suggest the locus of movement as presented in the paintings of Duchamp and the Futurists, but also as interpreted in Duchamp-Villon's *Horse,* an elegant conversion of Watts's horsepower (the "leg") into mechanical form (the "wheel"). He admired Duchamp-Villon's work, and described (on July 3, 1914) the sculptor as having "best succeeded in giving concrete form to movement." See *Apollinaire on Art,* p. 415–16. Curiously, Breton's misquotation (mentioned earlier) comes closer to the dynamic forms of the *Horse* than the original text. The Surrealists, in denying modernist mechanomorphism, seem to approach the Romanticism of thinkers like Bergson (toward whose vitalism they expressed contempt) and George Simmel, who discovered a new phase to an old struggle, "a struggle of life against form as such, against the principle of form." See Simmel, *The Conflict in Modern Culture and Other Essays* (New York, 1968 [1914]), pp. 11–65.

117. See *Apollinaire on Art,* p. 452, "Parade" (program, May 18, 1917). He goes on to cite Cocteau, who "called this a realist ballet." Apollinaire has succeeded in uniting here several of Breton's bêtes noires – ballet, realism, and Cocteau. In March 1917 Apollinaire requested that Breton write an appreciation of his poetry, in which the author dutifully recites the poet's virtues. By the time it was published in October 1918 Breton was as we have seen already qualifying that earlier appreciation.

118. On Apollinaire and Cocteau, see Kenneth Silver, *Esprit de Corps,* chap. 3.

119. The book, *De Hegel aux cantines du Nord* (Paris, 1904), appeared originally in articles in 1894. See Breton, *OC,* vol. 1, p. 614 and n. 1474.

120. Unexpectedly, only two months earlier, in the "Liquidation" in *Littérature* (March 1921), the three main instigators of the trial, Aragon, Breton, and Soupault, assigned very favorable grades to Barrès. In his *Entretiens,* p. 73, Breton seemed to address this issue by distinguishing the early writer from the recent man: "How could the author of *Un Homme libre* turn into the propagandist of *L'Echo de Paris?*" But Breton is inconsistent, for in his "Bill of Indictment" at the trial he states, "Barrès has never been a free man. His first books accord with his present attitude." "L'Affaire Barrès," *Littérature,* no. 20 (August 1921), p. 6.

121. On the prevalence of Barrès's *culte du moi,* see Daniel Moutote, *Egotisme français moderne: Stendhal, Barrès, Valéry, Gide* (Paris, 1980).

122. Two years later, in the spring of 1923, Aragon, who had played no significant role in the published version of the trial, was granted an interview by Barrès. Aragon confronted him with disparities between his present and former values. See Bonnet, *Breton,* p. 242, n. 218.

123. Cf. Zeldin, *France: 1848–1945,* vol. 1, pp. 573–4: "The freedom of the press (in the Third Republic) gave journalists, or those who could buy them, immense power to slander reputations, with virtually no means of redress. A libel law introduced in 1894 proved virtually impossible to enforce. The Action Française was able to preach the murder of socialist politicians with impunity; and one minister was indeed driven to suicide by a press campaign." Aragon published a manifesto proclaiming "le scandale pour le scandale." On scandal, see also Aragon's "Le Manifeste est-il mort?" in *Littérature,* 10, pp. 10–13.

124. Michel Sanouillet, "Marcel Duchamp and the French Intellectual Tradition," in Anne d'Harnoncourt and K. McShine, eds., *Marcel Duchamp* (New York, 1973), pp. 53–4, interprets Apollinaire's notion to mean that the artist had an "instinctive communion with a certain vernacular style"; thus, Duchamp's *L.H.O.O.Q.* version of the Mona Lisa is "a

gesture that bypasses the normal circuits of culture, *going over the heads of the mandarins and litterateurs to meet the common people on their own ground.*" Such a meeting seems more than improbable, since the subtle gesture only used popular imagery as a weapon against sophisticated taste. Cf. Spector, "Duchamp's Androgynous Leonardo."

125. See Breton, "Marcel Duchamp," *Littérature,* n.s., no. 5 (October 1922), pp. 7–10.

2. THE POLITICS OF DREAM AND THE DREAM OF POLITICS

1. See *Littérature,* no. 9 (November 1919), pp. 12–14. The Symbolist preoccupation with dream that so affected the young Surrealists continued into the twentieth century; e.g., in Alphonse Séché, *Contes des yeux fermés* (Paris, 1905).

2. See *Littérature,* n.s., no. 6 (November 1, 1922), pp. 1ff.

3. Pierre Janet used electromagnetism as a model for thought processes, and Janet's work is cited in such popular occult books as Hector Durville, *Télépathie, télépsychie (actions à distance)* (Paris, 2nd ed., April 1919); fig. 2, "Fantôme magnétique," a woodcut, shows the pattern of energy waves flowing between two magnets. Other sections discuss the well-known occult phenomenon of the *fluide universel.*

4. Sarane Alexandrian, in *André Breton par lui-même* (Paris, 1970), pp. 40–3, observed that only a third of the manuscripts produced were actually published. He offers a description on p. 134 of the sessions of automatic writing that Breton organized always with the same five or six friends. After commenting on some poems of Hugo or of Baudelaire, or recounting their dreams, they would become silent, each going off by himself to write with great speed whatever came into his head. Afterward each read aloud what he had written.

5. In a letter to Tzara of June 12, 1919, Breton wrote: "I love the mind of Dr. Jung. Is Maeder still in Zürich?" In the context this probably refers to Alphonse Maeder, the Swiss psychoanalyst who wrote early résumés of Freud's ideas in French. The juxtaposition of these names suggests that Breton knew their articles introducing psychoanalysis to France in *L'Année psychologique* – Jung's "L'Analyse du rêve" (vol. 15, 1909) and Maeder's "Le Mouvement psy-

choanalytique" (vol. 28, 1912); and perhaps he also knew that both Swiss psychoanalysts had at about the same time severed from Freud.

6. Breton knew first mainly *The Interpretation of Dreams,* the *Psychopathology of Everyday Life,* and the *Five Lectures,* but after the mid-thirties he cites from Freud's later work, like *Beyond the Pleasure Principle, Group Psychology and the Ego,* and *The Ego and the Id,* bearing on instincts and their socialization. Breton had access to French translations of all these volumes by 1927. See Breton, *OC,* vol. 1, p. 1347.

7. See *Littérature,* no. 11–12 (October 1923), p. 25, which placed Charcot's name, but not Freud's, on a list of admired individuals. Aragon mocked "Siegmund" (*sic*) Freud in *Une Vague de rêves* (1924).

8. The "Liquidation" talley sheet (see also Chapter 1, n. 73, this volume) assigned numerical evaluations of public personalities – both contemporary and historic – along with their average rating, in *Littérature,* no. 18 (March 1921). An editorial note on p. 1 by Aragon, Breton, and Soupault demonstrates their continued application of early school practices, however reluctantly: "Ce système scolaire, qui nous semble assez ridicule, a l'avantage de présenter le plus simplement notre point de vue." Gide and Valéry received on the whole mediocre assessments, though Breton himself gave them both favorable ratings.

9. Breton knew two important poets concerned with silence: Rimbaud (who declared in *Alchemy of the Word,* "I wrote silences") and Mallarmé (who employed white as a symbol of silence and the void). But for them it served as an expansion of poetic expression, and not as a denial of poetry.

10. Even in 1929 the debate between Breton and Valéry continued. Valéry renewed it by provocatively writing an article with the title "Littérature" in the summer of 1929 issue of *Commerce.* This title restored the orthography of the reversed spelling "Erutarettil," Breton and Eluard's proto-Surrealist periodical, which in turn had been based on Valéry's suggestion to them that they cite, with ironic intent, the last word of a poem of Verlaine "... and all the rest is literature." (Soupault wrote the burlesque "Littérature et le reste" for the Dada issue of *Littérature,* no. 13 (May 1920), 7–8. Breton and Eluard responded by publishing "Notes sur la poésie" in December 1929 in *La Révolution*

surréaliste with ironic reversals of the sense of Valéry's aphorisms. For example, Valéry defined poetry as "a feast of the Intellect," and they defined it as "a debacle of the intellect"; Valéry called poetry "literature reduced to its active principle," and they called poetry "the contrary of literature." "Notes sur la poésie" contains the phrase "La Poésie est une pipe," which has rightly been compared to a work of the same date, Magritte's painting *La Trahison des images,* with its famous inscription "This is not a pipe." See Breton, *OC,* vol. 1, p. 1758.

11. The text of "Entrée des médiums" was not included among the political pieces in *Tracts surréalistes.* Helena Lewis in *The Politics of Surrealism* (New York, 1988), considers political only what involves a stand on social issues and the writing of public statements. Political anthropologists like Victor Turner have made possible a more inclusive approach (cf. Introduction, this volume).

12. Breton included in issue no. 5 (October 1922) notes by Picabia and Soupault that commented on the "death of Dada." He registers impatience with both and a wish to get on to other things. He was harder on Soupault, his old coauthor of the *Champs magnétiques* (and joint editor of *Littérature* until May 1922), for whom he still retained "some friendly feeling" (*quelque amitié*), but who failed to move on to the new domain of dreams. Breton made the latter criticism in a footnote to the "Entrée des médiums" in the November issue. Péret also wrote in issue no. 5 "A travers mes yeux," in which he exclaimed three times, "Dada is dead," and stated,

> I am giving up my Dada eyeglasses and, ready to start, I look to see from which direction the wind blows, without troubling to know it, and where it will lead me.
>
> Tomorrow, I will still be ready to jump into my neighbor's vehicle if he is inclined to take a direction different from mine.

Immediately after publishing this text Péret proved his loyalty to Breton, distancing himself from Dadaism and becoming one of Breton's *médiums* (his utterances during a hypnotic sleep were published with those of Desnos and Crevel in "Entrée des médiums").

13. In March 1925 Aragon noted that "Artaud calls on each of us to try to isolate and record everything in his dreams that appears to be subjected to a system, all the systematic unconscious in the dream" (in *Littérature,* no. 13 [May 1920]). Artaud, then director of the Surrealist Bureau de Recherches, published three dreams in *La Révolution surréaliste,* no. 3 (April 1925), pp. 2–3. A deeply troubled though profoundly original soul, unsure of his sexual identity and probably dissatisfied with the atheistic as well as quasi-psychoanalytic interpretations favored by some of his colleagues, he wrote in his third dream:

> The three of us were in monk's robes, and as a further reference to monk's robes, Max Jacob arrived in a short coat. He wanted to reconcile me to life or with himself . . .
>
> Previously we had tracked down some women. We possessed them on tables, on the corners of chairs, in the staircases. One of them was my sister. . . .
>
> Now my mother arrived in an abbess's costume. I had a foreboding that she would arrive. But the short coat of Max Jacob demonstrated that there was nothing more to hide.

Artaud's dream that mingles coats and dresses, ravenous heterosexuality, incest, the thought of castration, and associations to homosexuality and pedophilia (Jacob) indicates the uncertainty of his orientations in areas of concern to the Surrealists. Within a few years he will break with the political orientation of Breton's group and enter the incomprehensible spaces of schizophrenic dreams. Some reported dreams of psychoanalysts also contain a "political" message: just before their definitive break Jung presented to Freud dreams that he knew implicitly criticized Freud, and his request for the master's interpretation contained an implicit challenge. See chapter 5, "Sigmund Freud," in Jung's *Memories, Dreams, Reflections* (New York, 1963).

14. The word "intentions" can be given a complex definition involving the meaning context provided by the group and its members. We can learn much from F. Heider's book, *The Psychology of Interpersonal Relations* (New York, 1958), which analyzes the meaning of words from ordinary language that seem to involve social interaction (e.g., can, try, may, ought, wanting, belonging). Heider developed a system of notation for representing and analyzing

social exchange as expressed in fables, folk tales, and literature.

15. Since the late sixties more attention seems to have been paid to the political dimension of apparently apolitical disciplines. In France the obvious case is the turbulent field of psychoanalysis dominated by politically active Lacanians. For analogous tensions within Marxism, see Russell Jacoby, "Toward a Critique of Automatic Marxism: The Politics of Philosophy from Lukacs to the Frankfort School," *Telos*, 10 (Winter 1971), pp. 134ff.

16. Freud's study of group psychology published in 1921 and based on Le Bon's contains ideas relevant to our study of the Surrealist group. An ad for the French edition, *Psychologie collective et analyse du moi,* appeared in *La Révolution surréaliste,* (January 15, 1925). In his book *Le Groupe et l'inconscient* (Paris, 1984), Didier-Anzieu notes that Le Bon regarded the group as female. Aragon, in his *Traité du style* (Paris, 1928), p. 147, asserts that the Unanimists, a symbolist group, had "taken too much of Gustave Le Bon, that drug."

 Advertising in the catalogue to the 1893 Rosicrucian exhibition for Sar Peladan's novel *Le Dernier Bourbon* describes it in these terms: "study of collective progressions and of the soul of crowds (*l'âme des foules*)."

17. In Breton's article "Surrealism Yesterday, Today, Tomorrow," *This Quarter* (September 1932), he includes on a list of those who are Surrealist "in something" Hervey Saint-Denys, who is Surrealist "in the directed dream." The *Vases communicants,* first published in 1933, opens with a reference to the book of Hervey Saint-Denys, *Les Rêves et les moyens de les diriger,* published in 1867. This book explains how to overcome through dreams the resistance of any woman to sexual advances, an idea that Breton (p. 11) claims anticipates Freud's theory that "the dream is always the realization of a desire."

18. See Jacques Lacan, "Agency of the Letter in the Unconscious" (1957), *Ecrits* (New York, 1977), pp. 156–7. Foucault seems to find in Roussel corroboration of the rhetorical validity of the Reverdy–Surrealist union of distant realities. See *Death and the Labyrinth: The World of Raymond Roussel,* (New York, 1986 [1963]), p. 14, where he speaks of "words as the unexpected meeting place of the most distant figures of reality. (It is distance abolished . . . dual, ambiguous, Minotaur-like.)"

19. See *Littérature,* n.s., no. 2 (April 1922), pp. 1–2. The unsigned *enquête* conducted by the editors Breton and Philippe Soupault bore the title "Quelques préférences de." Breton's response to the question about his preferred occupation was "rêver en dormant." Aragon, Breton, and Soupault were joint editors of and contributors to *Littérature,* nos. 1 to 19. Eluard contributed pieces from nos. 3 to 19. Ironically these advocates of dream found others to take the center stage at their dream séances, while they invariably remained awake and in control of themselves.

20. John Gedo first drew my attention to the notion. Freud discusses dreams from above in his letter "Some Dreams of Descartes" *SE,* vol. 21, p. 199. For a critique of trying to psychoanalyze the Surrealists' dreams, see Marguerite Bonnet, *André Breton. Oeuvres complètes,* vol. 1 (Paris, 1988), pp. 1991–2, discussing Alexandrian, *Le Surréalisme et le rêve* (Paris, 1974). Breton felt somewhat ambivalent about recording such dreams in which he himself found traces of will and consciousness, but he continued to publish them.

21. Jean Starobinski maintains in his "Freud, Breton, Myers," in Marc Eigeldinger, ed., *André Breton* (Neuchâtel, 1970), pp. 153–71, that Breton drew on other psychologists than Freud, especially for his notion of automatic writing. Sarane Alexandrian faithfully follows Starobinski's search for non-Freudian sources of Surrealism in *Le Surréalisme et le rêve* (Paris, 1974). Marguerite Bonnet, *André Breton. Naissance de l'aventure surréaliste* (Paris, 1975), pp. 104–5, refutes this view and affirms the centrality of Freud's thought for Breton's ideas, including automatism. While basically agreeing with her, I feel that she is perhaps too exclusive and underestimates classical French psychology as a source for Breton.

22. Cf. Han Ryner, "La Psychanalyse," in the literary journal *Revue de l'époque,* no. 5 (February 1920), 231: "Freud had confidence in the free association (*association libre*) that comes spontaneously to mind; he pursued the path of ideas that pass through the mind without direction or apparent connections and make jumps like a fairy tale. Freud very soon noticed that these free associations quite simply follow laws other than those of logic and of conscious thought and that they reveal to us another world of the mind."

23. The first French translation of a book by Freud

was *La Psychanalyse* (Geneva, 1921). The first published in France was *Cinq leçons sur la psychanalyse* (Paris, 1922). In 1924 *Le Disque vert,* a periodical published in Brussels, devoted a special issue to "Freud et la psychanalyse," which included a number of important French writers interested in psychoanalysis.

For knowledge of psychoanalysis in France from 1913 on, see Elisabeth Roudinesco, *Histoire de la psychanalyse en France,* vol. 1, (Paris, 1986), pp. 269ff., and Bonnet, *André Breton,* pp. 100ff. Unfortunately, many writers still disseminate errors; e.g., Helena Lewis, a pupil of Anna Balakian, the historian of Surrealism, wrote in *The Politics of Surrealism* (New York, 1988), p. x: "Freud was almost unknown in France until the Surrealists 'discovered' him and became fascinated with his theory of dreams, and they were the first to translate some of his works into French."

24. On Marcello-Fabri, see Léon Somville, *Les Devanciers du Surréalisme* (Geneva, 1971); on Sokolnicka and the Parisian psychoanalytic scene of the 1920s in general, see the chapter by Alain de Mijolla, "La Psychanalyse en France," in Roland Jaccard, ed., *Histoire de la psychanalyse* (Paris, 1982). At the beginning of the war the *Nouvelle Revue française* published a "Lettre d'Arthur Rimbaud contenant rêve" (August 1, 1914); even earlier Apollinaire wrote "Onirocritique" (1908) and the literary critic Jacques Rivière wrote "Métaphysique du rêve" (1908). Thibaudet, in "Réflections sur la critique," *Nouvelle Revue française* (April 1, 1921), pp. 107–8, contests the reduction of literary surface to unconscious factors in the study by the Zurich analyst J. Vodoz of Hugo's *Mariage de Roland* and, in words anticipating Sebastiano Timpanaro's *The Freudian Slip,* observes that "that which Mr. Vodoz explains by means of the unconscious, we explain by word associations, assonances, alliterations, and above all by rhymes.... Every poem of Victor Hugo is based not on an idea, not on the physical associations of words and images, but on an element that combines them both, on a primary element from which neither is dissociated except secondarily and artificially, and which is a motor scheme." Breton's interview appeared in *Littérature,* n.s., no. 1 (March 1, 1922), p. 19.

25. Breton, *OC,* vol. 1, p. 274.

26. Professor Claude, in his preface to R. Laforgue and A. Allendy, *Psychanalyse et les nevroses* (Paris, 1924), contrasted the French and German "races" and wrote, "The great defect, the moral flaw (*tare*) of Psychoanalysis is that it is 'a German invention.' "

27. Breton, as late as 1932 (in the *Vases communicants*) praised psychoanalysis for emphasizing the importance of sexuality in the life of the unconscious. For the issue of sexuality in literature see "Procès-Verbal," *Littérature,* no. 17, (December 1920), pp. 3–4, in which the collaborators of the review voted against including poetry in future issues and for including sexual questions. It was commonly understood in psychiatric circles by the early 1920s that Jung had sharply diverged from Freud's emphasis on sexuality; for example, E. Régis and A. Hesnard observed that, for Jung, Freud's *élève dissident,* a generalized notion of libido, had replaced concrete sexuality. Janet also differed radically from Freud on the issue of sexuality: for Freud sexuality was the primary agent in the etiology of neurosis, whereas for Janet sexual irregularities derived from a general psychic malaise, and not vice versa.

28. See Pierre Janet, who, in *Psychological Healing: A Historical and Clinical Study* (London, 1925), vol. I, p. 597, cites Charcot, *Névroses et idées fixes* (1898), vol. 1, pp. 379ff., and *Les Obsessions et la psychasthénie* (1903), showing that the cause of neurosis is a "traumatic memory": "The symptoms were induced by a far simpler mechanism, which I have described under the name of 'psychological automatism.' The actual memory of the happening was constituted by a system of psychological and physiological phenomena, of images and movements, of a multiform character." Again, Janet admits that "the study of the relationships between the sexual instincts and the affectionate sentiments, the study of the relationships between love and the arts and poetry and religion, cannot fail to be of great interest." But, he adds, "Such problems, at any rate when discussed in the way we have just been considering, belong to general philosophy, and even to metaphysics," but not to a scientific psychology.

Breton and Aragon, in their project for Doucet's library (1922; see Breton, *OC,* vol. 1, pp. 631–6), emphasized "the immortal problem" of explaining "the objectivity of the internal data of reason," a problem that, in their view, was addressed above all by Kant, Poincaré, Freud, and Einstein.

29. The opinion that Janet inspired the basic technique used in the *Champs magnétiques* presumably originated with Breton's collaborator Soupault, who asserted it in his book *Profils perdus* in 1963. But he may have had the idea long before, since he published a "Scénario automatique" in *SIC,* no. 24 (December 1917), p. 4, and he wrote in a belittling letter in May 1920 that "Freud did not invent anything" (see the issue on Freud of *Le Disque vert* in 1924); and in a footnote to his "Surrealist Text" in *La Révolution surréaliste,* no. 4 (July 1925), p. 8, he stated that Raymond Roussel's "anecdotes" were written "in the same way that Breton and I wrote *Les Champs magnétiques.*" In 1924 Roussel was briefly in therapy with Janet (who failed utterly to appreciate the great writer). In *André Breton: Magus of Surrealism* (New York, 1971), p. 28, Anna Balakian shares Soupault's view and cites his book. Bonnet, *André Breton,* p. 107, n. 158, denies the point – Janet's name appears nowhere in any of Breton's early manuscripts – and doubts the reliability of Soupault's memory. Meyer Schapiro of Columbia University, who had the idea before Balakian, may have picked the idea up from some articles on Janet published in English in the 1940s. Since he doesn't connect Janet to the crucial case of the *Champs magnétiques,* he probably didn't get it (unless in a garbled form) from Soupault, whom he knew in New York and Paris. At any rate, guided by Schapiro, Geraldine Pelles wrote an M.A. thesis, "Psychology and the Surrealist Theory of Art" (1949), in which she objected to Freud's being considered the "original and principal inspirer of Surrealism" (pp. 1–2). She said that Schapiro "acutely suggested that . . . Janet had inspired the Surrealists in their early days, in the middle 1920s." (She seems to have been unaware that Soupault had already used the word "automatique" in 1917.) The thesis claims that Surrealism's strongest contribution to "modern art" concerns automatism (along with providing new sources of imagery); this point gives the thesis some interest as a document in the history of the criticism of Abstract Expressionism. As noted in Chapter 1, this volume, H. Behar, *André Breton,* offers the most probable account: Soupault based himself on Janet, Breton on Freud.

30. Quoted in Jean, *History of Surrealist Painting,* (New York, 1960), p. 117.

31. Flournoy, author of a perceptive review of Freud's *Interpretation of Dreams* in 1903, wrote "Esprits et médiums," *Bulletin de l'Institute Général Psychologique,* no. 3 (1909), pp. 357–90. He compares (pp. 362–3) the little "automatisms" of daily life to the phenomena discussed in Freud's *Psychopathology of Everyday Life* (*lapsus linguae* and *calami*). While he thinks that the Freudians sometimes go too far, he accepts "their general principle . . . that we have to interpret as much as possible psychologically . . . the automatic phenomena that a more superficial view might be led to consider as simple whims of chance."

32. Ferenczi wrote in 1908 (when he was close to Freud), in "Psycho-Analysis and Education," in *Final Contributions* (New York, 1980 [1955]), p. 286: "Great attention must be paid to the symbols of speech and of the higher mental systems. These have been the almost exclusive aim of present-day pedagogy. The knowledge that thinking in words means a new cathexis of the instinctual life can show teachers why the child's self-control grows parallel with his increasing knowledge. The lack of control in deaf-mute children may possibly be traced back to the lack of overcathexis by words." Once a "rational education" based on Freud's ideas replaces old methods, children will "no longer [be] tormented by day by unnecessary anxieties, nor by night by nightmares."

33. In 1920 ("Pour Dada," *La Nouvelle Revue française* [August 1920], published in *Les Pas perdus* [1924], pp. 90–1) Breton defended the Dadaists against the diagnosis that they could profit from psychoanalytic therapy, a view sarcastically advanced by the psychoanalyst H. R. Lenormand. It is worth noting that starting in the early twenties French psychoanalysts already produced literature analyzing writers and artists: the psychoanalyst A. Stocker examined Jean-Baptiste Greuze's *The Broken Jug* in *Encéphale,* 16 (1921), pp. 78–84; the literary critic Albert Thibaudet wrote "Psychanalyse et critique," for *La Nouvelle Revue française* (April 1, 1921); and the psychoanalyst Jean Pérès wrote "[Jules] Laforgue et la psychoanalyse," *Journal de psychologie* (1922), pp. 921–7. The last page of Breton's First Manifesto contains a covert criticism of Freudian psychoanalysis for its therapeutic goals, and praise for the undogmatic approach of his former teacher Babinski: "I have seen the inventor of the cutaneous plantar reflex (i.e., Babinski) at work; . . . it was obvious that *he*

was following no set plan. . . . He left to others the futile task of curing patients." And the Surrealists paid mock obeisance to one of the "holy books" of Freud, recently translated into French; as André Masson recalled in "Le Peintre et ses fantasmes," *Les Etudes philosophiques,* no. 4 (October–December 1956), pp. 634–6, "At the Bureau de Recherches Surréalistes, a copy of the *Introduction to Psychoanalysis* was ensconced. . . . The famous *Introduction* was framed by forks. . . . Was it not as an invitation to devour the Book, just like the Revelation eaten by Saint John . . . ?" For the full text and excellent notes, see Françoise Will-Levaillant, ed., *André Masson, le rebelle du Surréalisme: Ecrits* (Paris, 1976), pp. 31–3. A comparable quasi-ritual, perhaps inspired by the Surrealist one, occurred as a mockery of Clement Greenberg in England; cf. the discussion in my article "The State of Psychoanalytic Research in Art History," *Art Bulletin,* 70, no. 1 (March 1988), pp. 49–76.

34. Breton, *OC,* vol. 1, p. 54.

35. Contrary to Descartes, whose dreams produced irritating doubts, Breton cultivated dreams for their own sake and welcomed their "omnipotence." In the First Meditation, Descartes consoled himself with the certainty of mathematical truths, and in the Second proclaimed the famous "Cogito ergo sum" (a notion that may derive in part from an inversion of Cicero, *Tusc.* 5, 38: "Vivere est cogitare").

36. See Régis's preface to P. Chabaneix, *Le Subconscient chez les artistes, les savants et les écrivains* (Paris, 1897), p. i. Chabaneix himself noted on p. 9 that "the personality of men of talent and genius is constituted rather of morbid excitability than of madness, and the great creators are often not insane but daydreamers lost in their subconscious abstractions, in a word, beings apart, walking animatedly in their starlit dreams." Cf. Freud's essay "Creative Writers and Daydreaming" in *SE,* vol. 9, pp. 140–56, published in 1908.

37. At the end of his "Dream of the Peasant" section of *Le Paysan de Paris* (Englewood Cliffs, N.J., 1970), p. 163, Aragon, reflecting on Hegel, puts into question the very notion of philosophical idealism. He tries to develop a materialist theory of poetry and of the poetic image in which to reconcile Surrealist beauty and his new political attitude, and to avoid being condemned for artistic deviation. He explains that

the image is the law in the domain of abstraction, the fact in the event, knowledge in the concrete. . . . I seek the concrete. . . . Poetry is the only expression of the concrete . . .

Believe me, mockers, I lead a poetic life.

38. Breton published these dreams, with two additional ones, in *Clair de terre* (1923) as "Cinq réves." Concerning Breton's interview Elizabeth M. Legge, *Max Ernst: The Psychoanalytic Sources* (Ann Arbor, Mich., 1989), p. 18, states: " 'Interview with Professor Freud in Vienna' makes more sense when it is read as an attack on the current popular interest in Freud, rather than an attack on Freud or his ideas." She supports her point by citing Breton's phrase "Psychoanalysis is the fashion this winter." While Breton certainly spurned the fashionable, he also expressed animosity toward the taciturn professor Freud, as his allusions in the article to Freud's French competitors Charcot and Babinski suggest. He did not leave feeling antipathy merely for Freud's Parisian followers; for, as Bonnet, in Breton, *OC,* vol. 1, p. 1276, notes, "Simone Collinet [Breton's wife] reported to us that Breton came back from the visit sad and disappointed, refusing to talk about it."

39. A decade later, in the *Vases communicants,* Breton claimed to have outdone Freud in sexual frankness when he compared his interpretation of his own dreams with certain ones of Freud reported in the *Interpretation of Dreams.* See Chapter 4, this volume.

40. Sarane Alexandrian asserts in "L'Espace du rêve," *Nouvelle Revue de psychanalyse,* no. 5 (Spring 1972): "By disengaging in his own fashion the instances of condensation and displacement Breton came to this important conclusion: one can analyze a Surrealist painting as one analyzes a dream." This unqualified overstatement fails to take into account the hazards of the venture of psychoanalyzing paintings or texts rather than patients. Alexandrian also ignores the fact that an earlier observation had been made by Aragon, in his essay "Max Ernst, peintre des illusions" (1923), in *Les Collages* (Paris, 1965), p. 28: "Treat these drawings like dreams and analyze them in Freud's manner. You'll find a very simple phallic sense in them." Later, in "La Peinture au défi" (1930), ibid., p. 39, Aragon observed: "The dawn of this century rises with Siegmund

[*sic*] Freud, who turned the scandalous gaze of sexuality onto the incomprehensible. He is the first to recognize the strange mechanism of sublimation, and in the images of dream, madness, and poetry, he teaches us to read the moral claims of humanity." Moreover, Alexandrian seems unaware that at least one French analyst, Pérès, had before Breton understood the application of psychoanalysis to art. Pérès, in his study "Laforgue et la psycho-analyse" (p. 926), stated that "the value of psychoanalysis to us has seemed to be that of a working hypothesis ... a hypothesis imagined in the form of a myth. . . . Moreover, this hypothesis offers us the advantage of unifying ... different areas, such as dream, folklore, art, [etc.], the mind of the primitive and of the child." But the Surrealists published their dreams for literary and political motives having to do only obliquely with the purpose and nature of dream interpretation as understood by psychoanalysis. One contribution that Alexandrian makes in his book, pp. 244–5, is his notion of the "dream program" (*rêve-programme*) or dream narrative (*fabulation onirique*) to be found in the Surrealist dreams. Unfortunately his inadequate grasp of the history and nature of Freudian dream analysis – including the germane concept of "the dream from above" mentioned earlier – and his exaggerated emphasis on Pierre Janet and Fourier (for various reasons) have limited his contribution to the study of the Surrealist dream.

41. See *Littérature,* no. 5 (October 1922), p. 16. In his text "Pénalités de l'enfer" (September 1922), Desnos described a chalk inscription over the door of the room occupied by Breton and his wife as "terrifying." It signified something like "You had better take stock of yourself before I beat you up." In the further development of Desnos's powers as a Surrealist dreamer and "medium" Breton's presence looms constantly.

42. In *Une Vague de rêves* Aragon admiringly evoked the impromptu dream performances of his friend Desnos: "At the café, amidst the din of voices, the bright light, the jostling, Desnos had only to close his eyes" (p. 106).

43. Rrose Sélavy was the pseudonym invented by Marcel Duchamp, who with Dadaist defiance adopted the pose and costume of a woman. We can follow in *Littérature* the evolution of the Desnos-Sélavy persona in a series of significant juxtapositions of pieces by Desnos, Breton, and Duchamp-Sélavy: issue no. 5 (October), dedicated to "Rrose Sélavy," contained Breton's laudatory essay on Duchamp with an epigraph by Rrose, "Litanie des Saints," that plays on the homonyms *saint, sein* (breast), and *sain* (sound, healthy); printed prominently on the same page as Desnos's "Rêves" is a word play signed by Rrose Sélavy. In the very next issue, Breton's "Entrée des médiums" begins Desnos's session with these words written by him in a trance: "Salut angélique," which I associate with Rrose's "Litanie des seins" (see no. 7 [December]: Desnos-Sélavy writes, "Rrose Sélavy urges you not to mistake warts on the breast for virtues of saints"). Note that Leiris in his *Aurore* plays homonymously on the heroine's name: "Or aux rats," "Or Aura," "Eau RôRah," "Horrora," etc. This seems to parallel Lautréamont's Maldoror / *mal d'horror*. Homonyms recur in the writings of Roussel (greatly admired by the Surrealists) such as *Impressions d'Afrique* and *Locus solus,* where they are claimed to "*engendre l'histoire.*"

Breton's "Les Mots sans rides" implicitly raises the issues of whether Duchamp projects his ideas telepathically to Desnos via Rose Sélavy; but his "Lettre aux voyantes" in *La Révolution surréaliste,* no. 5 (October 1925), points out that what counts in the seer is the stimulus to the imagination, not the prediction. Thus, Helen Smith's visions owe their "magnificence" above all to their wealth of imagination, not their claim to delineate an unknown but actual world. All this can be compared with the hallucination–reality contrast in Taine and De Chirico, as discussed in Chapter 4, this volume.

44. We get some sense of Breton's ability to manipulate his followers from Aragon, *Je n'ai jamais appris à écrire ou l'incipit* (Paris, 1969), p. 56: "It must be remembered what were our relations almost immediately after our first meeting: André's *power* over me was increased by the constitution of a real Surrealist group consisting of the fresh recruits, younger than we were, who sought constantly to prove that they were more orthodox than Philippe, Paul or myself." In *Les Aventures de Télémaque* (Paris, 1922), p. 51, Aragon recounted the story of a bandit gang, whose leader he designated by the initial "B," an ambiguity intended to indicate at once both the notorious criminal Bonnot and Breton, but the description of the leader applies perfectly to Breton. "B" is the

uncontested chief, irresistably strong, with a "sense of grandeur," who encourages his comrades to pursue an "unnamable and unconscious goal." In his *Entretiens,* p. 165, Breton unintentionally corroborates his former dominance over Aragon when he explains that the reason for Aragon's fateful trip with Sadoul to Russia was that his girlfriend Elsa Triolet wished it. In his resentment of the power shift Breton refused Aragon any political or intellectual motives of his own.

45. See Victor Crastre, "Changer l'homme," *Almanach surréaliste du demisiècle,* special issue of *La Nef* (Paris, 1950), pp. 26–7. Cited in Lewis, *Politics,* p. 64.

46. For extensive discussion of this image see Chapter 5, this volume.

47. A characteristic text by Trotsky was already available in the review *Clarté* (November 1, 1923), pp. 426–7: "In a society disembarrassed of the crushing burden of earning one's daily bread . . . in which the children . . . will absorb the rudiments of science and art like air and sunlight . . . in which the liberated egoism of mankind – a formidable force – will tend only toward knowledge, to the transformation and amelioration of the universe, in such a society, the dynamism of culture will be comparable to nothing that we have known in the past." The Surrealists shared a number of positions with *Clarté,* as in 1924, when *La Révolution surréaliste* as well as *Clarté* attacked the late Anatole France, a liberal who had claimed to sympathize with revolutionary causes while remaining a patriot and a Christian.

48. As noted earlier, three of these dreams had already appeared in 1922.

49. Aragon, *Le Paysan de Paris,* p. 109. In a passage for the section "Saisons" of the *Champs magnétiques, OC,* vol. 1, p. 59, Breton wrote: "I walk down a monumental staircase with prize books. From school I see only certain collections of notebooks."

50. Breton made favorable allusions to Baudelaire and Nouveau in his First Manifesto (1924), and even earlier in "Liquidation." Baudelaire (the only one listed from among the three names in the dream) received extremely high marks from Aragon and Breton. In his lecture at Barcelona in 1922, "Caractères de l'évolution moderne" in *Les Pas perdus* (Paris, 1924), p. 185, he called Nouveau a "grand poète malheureusement peu connu." Still, the idea of respectable ancestors, even such as these,

did not sit well with Breton while collaborating on the antiliterary *Littérature,* and he probably would have shared Aragon's derisive attitude: Aragon wore a mustache during his Dada period as a mockery of bourgeois respectability and wrote an ironic "Triomphe de la moustache," published in *Le Mouvement perpétuel* (Paris, 1925).

51. In reply to the question, "Le Symbolisme a-t-il dit son dernier mot?" in the periodical *Le Disque vert* (February–April 1923), Breton joined nine friends who expressed their low opinion of Gabory (who was also asked to respond) by placing him among Cocteau, Radiguet, and Satie, all regarded as boring and passé. For the Surrealists Symbolism had taken on a wholly new complexion. In the First Manifesto only the comparatively ignored poet Saint-Pol-Roux (pen name of Pierre-Paul-Roux), greatly admired by Breton, is called "surréaliste dans le symbole." Gabory, choosing an author contemned by the Surrealists, later wrote *Essai sur Marcel Proust* (Paris, 1926).

52. Robert Desnos ("Pénalités de l'Enfer," *Littérature,* no. 4 [1922], pp. 7–8) described in a dreamlike narrative a house inhabited by Aragon, Breton, Vitrac, and himself. He wrote, "On the room of Mr. and Mrs. Breton is a frightening inscription written in chalk: 'Take stock of yourselves.'" The latter phrase, evoking a Dantesque Hell, warns (as in note 51, this chapter), against the presumption of critics who would commemorate a poet claimed by the avant-garde.

53. Breton, *Les Champs magnétiques,* p. 36.

54. Duchamp inscribed his mustachioed *Mona Lisa* with the letters "L.H.O.O.Q.," which represents an obscenity in French. Picabia apparently emulated Desnos, who adopted Duchamp's punning persona Rrose Sélavy; as Georges Hugnet noted (1932–6), at the first Friday meeting of the *Littérature* group, on January 23, 1920, Picabia showed paintings on which he inscribed Duchamp's slogan "L.H.O.O.Q." As one of the editors, Breton probably attended that meeting and so would have been familiar with the mustache motif; moreover, Frederick Brown, *An Impersonation of Angels: A Biography of Jean Cocteau* (New York, 1968), pp. 180–1, states that Breton appeared before an avant-garde gathering in Paris in January 1920 with one of the "L.H.O.O.Q." paintings by Picabia. For an-

other association to a work of Duchamp's, his urinal-fountain, see the later discussion of the second of the three dreams in *La Révolution surréaliste*. For a fuller discussion see my article "Duchamp's Androgynous Leonardo."

55. Breton's poem "Pour Lafcadio" alludes to his debts to writers like Gide (who is not named; Lafcadio is a character in a novel by Gide) and concludes with the phrase "André Breton / Tax Collector / devotes himself to collage / while waiting for his retirement." Breton's pseudo interview with Gide (found in Breton, *OC*, vol. 1, p. 13) pained the novelist, who referred to it in his diary. In the same issue (*Littérature*, no. 1 [March 1922]) Aragon (p. 4) discussed sarcastically an article by Jacques Rivière in praise of Gide. Apollinaire fared no better. Breton's "Maison peu solide," in *Mont de piété* (*OC*, vol. 1, p. 15), contains a mock-serious account of a shoddily constructed building's collapse. A boy in the vicinity at the time recounts how a man saved him by a timely warning. His savior, a sixty-year-old man named Guillaume Apollinaire, "had won the medal for work and his companions held a high opinion of him." (Breton always held wage-earning work in contempt.) Years later, in the *Vases communicants*, p. 11, Breton repeated the image of "the shaky house (*maison vacillante*) of the poets." Breton evoked a similar use for architecture in his essay concerned with English Romanticism, "Limites non-frontières du surréalisme" (1937), in *La Clé des champs* (Paris, 1967), p. 23: "Ruins appear charged with strong meaning only to the extent that they express visually the crumbling of feudalism, etc." In the marvel-filled Gothic novel by Walpole, *The Castle of Otranto,* the ruin of the castle anticipates that of the house of Otranto.

An open letter by the editors to the Comité Lautréamont protested the committee's presumption in commemorating the poet claimed by the avant-garde. While the editors took a firm stand against bourgeois praise for Lautréamont, they expressed complete indifference about monuments that might celebrate Apollinaire or Jules Simon. Finally, during a lecture in Barcelona in 1922 Breton mentions that Apollinaire's article "L'Esprit nouveau et les poètes" struck him "with its lack of thought and the uselessness of all its noise" (see Breton, "Caractères de l'évolution moderne et ce qui en participe," in *OC*, vol. 1, p. 293).

56. In "Monsieur V" Breton equated with subtle irony Paul Valéry's ivory tower Symbolism with a "quest of the blue fox." The poem includes the provocative phrase "Rêve de révolutions" followed by the conclusion – "Art could not describe / The trap (*engin*) with which to catch the blue fox (*renard*)." Breton plays ironically on "re-en-art" = *renard,* which mocks the makers of poetic "engines" like the redoubtable Valéry himself. On two points the dream resembles "Monsieur V": the genius leaves Breton "on the last step" (*sur la dernière marche*), and he is replaced by Pierre Reverdy (after a meaningless intervention of the minor poet Gabory). In the poem we read, "Marche / Pierre ou Paul"; although the *marche* in one case has to do with an imperative to advance ("March!") and in the other with steps, the word in both texts indicates a choice (the last step / Peter or Paul). Parenthetically Breton had already replaced both poets by a new hero, the undeservedly obscure Saint-Pol-Roux, who replaced the "Pierre-Paul" of his real name with a pen name – Saint-Pol – that condensed the saints' names.

57. In the First Manifesto Breton asserted that Dante "could pass for Surrealist . . . in his finer moments." The parallel to the *Divine Comedy,* in particular to the *Inferno* takes on added relevance from the phrase of a nineteenth-century poet much admired by the Surrealists. Lautréamont, in "Poésies II" (published during Breton's editorship of *Littérature*, no. 3 [May 1919], p. 8), declared, with his *lycée* experience in mind, "Vous qui entrez, laissez tout désespoir," clearly a variant of the forbidding words that Dante read near the beginning of his journey. In the Dada period of ca. 1920 Breton wrote on "artificial hells" – the title "Les 'Enfers artificiels' " is obviously fashioned after Baudelaire's *Paradis artificiels.* See Breton's unpublished manuscript in the Bibliothèque Jacques Doucet, Paris.

James Joyce's *Portrait of the Artist as a Young Man* (1916) contains a passage drawing on the medieval philosophy of light – he cites St. Thomas Aquinas's definition of beauty as wholeness, harmony, and light (*claritas*). Joyce's sophisticated interplay between naturalism and supernaturalism was despised by the Surrealists (see Aragon's contemptuous allusion in *Une Vague de rêves*), who rejected

his literary intent. (Joyce's friendship with their archenemy Ivan Goll also must have irritated them.) Later they do not even mention Joyce, although like him they were published in *transition.*

Dante's *Inferno,* considered as a "memory system for memorizing Hell and its punishments with striking images on orders of places," seems curiously to bear on Breton's dream, with its own orders suggesting Dante's spheres of Hell, Purgatory, and Paradise. Cf. Frances Yates, *The Art of Memory* (Chicago, 1966), p. 95.

58. Breton, apparently sensing that he was exposing his ambition in this text, edited some phrases for the version published in *Clair de terre;* for example, the unoccupied chair that "seems destined for me" originally read, "I understand that it is destined for me," and the phrase "I obey the suggestion" originally read, "I understand the role that I have been called to play."

In a discussion of the "Surrealist image" in the First Manifesto, Breton used the phrase "lumière de l'image." See Breton, *Manifestes du Surréalisme* (Paris, n.d.), pp. 48–9. Breton's discussion of the "Surrealist image" directly involves metaphors of light. Expanding Reverdy's notion of the generation of images by bringing together "two distant realities," Breton wrote, "It is by the juxtaposition, to some extent by chance, of the two terms [here Breton cited certain of Reverdy's images] that a particular light has sprung, a *light of the image,* to which we are infinitely sensitive."

Aragon already wrote rapturously of "Surrealist light," in *Une Vague de rêves* (Paris, 1990), pp. 12–23: "There is a Surrealist light: . . . that which stays up late on the Avenue de l'Opéra at Barclay's, when the CRAVATES are transformed into phantoms; the light of flashlights shining on men assassinated for love. There is a Surrealist light in the eyes of all women."

59. Breton and Soupault made clear their attitude to the romantic moon in the *Champs magnétiques,* which contains a caustic section called "Lune de miel" (Honeymoon). The old Symbolist André Fontainas, regular reviewer for the *Mercure de France,* in the issue of July 15, 1924, criticized with little comprehension what he called Breton's *Clair de lune,* thus reducing the title to a Symbolist cliché. For Breton's irritated response, in a letter to the editor, see Bonnet, *Breton,* pp. 293–4, n. 180.

De Chirico's manner of painting involved a use of planes of intense luminosity uncannily devoid of sunlight. In a volume of poetry dedicated to Breton, *Mourir de ne pas mourir* (1924), the Surrealist poet Paul Eluard included a poem, "Giorgio de Chirico," in which he wrote: "La Lumière en relief / Sur le ciel qui n'est plus le miroir du soleil" (see Eluard, *Capitale de la douleur N.R.F.* [Paris, 1966], p. 62). That bête noire of the Surrealists, the poet Paul Claudel, a Christian mystic, adopted an opposed view in his prose poem "Splendeur de la lune" in *Connaissance de l'Est* (Mercure de France, 1973 [1898]), pp. 204–5, which equates moonlight to the normally brighter sunlight. Perhaps more irritating to the Surrealists, he compared the moon to a "Sun of Dreams": "I see the whole capacity of space filled with your light, Sun of dreams! . . . like a priest alert for the mysteries, I left my bed in order to look into this occult mirror." Breton also may have had in mind the special meaning of light as infernal/divine/real in Rimbaud's *Illuminations,* a work he valued for effects that were boldly and ironically unpoetic, even banal (especially the poem "Dévotion"); and he may also have had in mind the quotidian magic of the electric lights illuminating the streets of the "City of Light," which enthralled him for years: see "L'Année des chapeaux rouges" in *Littérature,* n.s., no. 3 (May 1922), pp. 9–10, and his published "Carnet" in *Littérature,* n.s., no. 13 (June 1924), and *Nadja* (Paris, 1928), p. 153, of the 1962 edition.

60. Breton attributed a "Luciferian" light to Lautréamont in the *Anthologie de l'humour noir* (Paris, 1966), p. 176 (first edition 1939), where he wrote of "the face resplendent with black light of the Count de Lautréamont." Prometheus figures prominently as a character in section 31 of *Poisson soluble* (1924), and the punning phrase "Promethean promise" (*Prométhée,* a homonym of *Promettez*) appeared in section 29: a star spoke "in a low voice . . . and finally shouted Prometheus or Promise." Michel Carrouges, that paradoxically Catholic Surrealist, ascribed "promethean doctrines" to Surrealism in his essay "Le Surréalisme," in Eigeldinger, *André Breton,* p. 113.

61. See "Guillaume Apollinaire," *Les Pas perdus,* p. 40. Aragon, in *Une Vague de rêves* of 1924, already referred to "lumière surréaliste."

62. Delaunay wrote a well-known and influential essay, "La Lumière," and in a letter to Franz Marc he asserted, with a parenthetical aside to a poem by Apollinaire, that "painting is properly a luminous language (*Cortège d'Orphée*)." See Delaunay, *Du Cubisme à l'art abstrait,* Pierre Francastel, ed. (Paris, 1957), pp. 188, 150.

63. Breton, *Surrealism and Painting,* p. 13. One must sharply distinguish Breton's illuminated interiority from the Christian "light of Creation" (it was Dante's infernal fires, not his sunny paradise, that intrigued the Surrealists), especially as represented by the widely acclaimed writings of the patriotic and Christian poet Paul Claudel, whom they scorned. Breton would have sympathized with Marinetti's anti-Romantic imperative, "Kill the Moonlight!" while rejecting scornfully Claudel's "Splendeur de la lune." For a discussion of the Enlightenment and Materialist ideals of Breton's parental generation, see Deborah L. Silverman, "The 1889 Exhibition," *Oppositions* (Spring 1977–8), especially p. 80 on the metaphor of enlightenment and p. 82 on the "ethos of materialism in the nineteenth century."

64. This expression may also allude to the kind of psychology that Breton detested; for example, Th. Ribot wrote in the preface to *La Psychologie des sentiments* (Paris, 1896), "The thesis that I have called physiological, links all affective states to biological conditions and considers them a direct expression of the minimal biological state (*vie végétative*)."

65. Breton, *Clair de terre,* in *OC,* vol. 1, p. 152. Marinetti's "Words in Freedom," in *Futurist Manifestos,* p. 103, has a section entitled "The Infinitive Verb" in which he asserts that

> in a violent and dynamic lyricism the infinitive verb might well be indispensable . . .
>
> The infinitive in itself denies the existence of the sentence and prevents the style from slowing and stopping at a definite point. While the *infinitive is round* and as mobile as a wheel, the other moods and tenses of the verb are either triangular, square, or oval.

Breton, by choosing the static "to be" and searching for a new tense of it, seems to have given up the quest for velocity that he had formerly shared with the Futurists.

66. One might compare Breton's dream of a book

to one recounted by the psychoanalyst Charles Rycroft in *The Innocence of Dreams* (London, 1979), p. 124; in it a man dreams of seeing in the window of an antique shop an old book that he knows contains "The Truth" by Kant, written in an unintelligible language. Balzac's *La Peau de Chagrin* tells also of an obscure and potent book discovered by the hero in an antique shop.

67. This series of letters and words may have constituted an implicit progress toward the unspoken word "Surreality," as the dream moves from "s[o]ur – " to "r[h]é – " to the "reality" of the unrecognized Baron. That a medical book could aid Breton to resolve his problem seems pertinent but ironic in view of his earlier rejection of a career in medicine. Owing to his decision to become a poet, he relinquished this goal in 1919 despite the noisy imprecations of his disappointed mother.

In its etymology *rhéostat* derives like an oxymoron from contrary roots – "flow" and "stand" – resulting in an even sharper antithesis than that evoked by the term "Surrealism," in which the prefix evokes the beyond or above, whereas the root signifies the here and now. The sense of the device itself, a machine for controlling the flow of electricity, runs directly counter to the perceived romantic sentimentalism of the Symbolists' stream of consciousness and has kinship with the Dadaists' mock measurements and equations of intangibles like air and genius. Breton also dreamed about urine, a different kind of flowing in the dream of the "flying urinal" to be discussed later, and in the *Vases communicants.*

68. The replacement of the obscure Charles (not Jacques) Baron by Aragon seems quite fitting. Although Breton claims never to recognize the "young man," Aragon in *Une Vague de rêves* included him among the "dreamers," as Breton did not do in his list of dreamers in the First Manifesto.

69. The blankness that Breton notes in his frame recurs and may constitute a critical comment on Soupault's recent creative barrenness. Later, in *Littérature,* no. 10 (May 1923), Breton wrote "Philippe Soupault" with the subtitle "André Breton et Philippe Soupault: Les Champs magnétiques (1920)," which consists of pages 29–32, completely blank except for their page numbers and for Breton's name printed at the bottom of the last page. This

devastating comment on the current poetic emptiness of his erstwhile collaborator is ignored in Breton, *OC*.

70. See J. Damourette and E. Pichon, "La Grammaire en tant que mode d'exploration de l'inconscient," *L'Evolution psychiatrique*, vol. 1 (Paris, 1925). After a discussion of various grammatical modes including the "temps de verbe" (p. 243), the authors point out that the unconscious as revealed by grammatical analysis of the three tenses of the verb (past, present, and future) is quite different from what appears to the conscious. They hope that one day "the collective national unconscious" can be grasped through grammar, at last allowing writers "by their very style to offer us the story of their soul" (*l'histoire de leur âme*). This grammar of the unconscious clearly anticipates Lacan. The French have a penchant for investing grammar with epistemological or even with ontological significance; see, for example, the Existentialist Sartre's play on the distinctions between the verbs *exister* and *être* in *Les Mots* (Paris, 1964), pp. 151, 161–2.

71. See Desnos, "Confession d'un enfant du siècle," *La Révolution surréaliste*, no. 6 (March 1926), p. 20: "I came to the perception of eternity.... Prophecy-like memory is within the reach of all, and as far as I'm concerned, there is no difference between past and future. The only tense of the Verb is the present indicative."

72. The poem "Monsieur V," in Breton, *OC*, vol. 1, p. 13, begins: "A la place de l'étoile / L'Arc de Triomphe / que ne rassemble à un aimant que pour la forme" (At Etoile Plaza / The Arc de Triomphe / which only resembles a magnet in its form). This seems to contain a sexual innuendo on *aimant*, the "loving magnet" shaped like a "two-legged" arch with a space between. Klee created arch-legged figures in his *Revolution of the Viaducts* of 1937. The poem continues with phrases resembling those of the dream; e.g., "as one grows up," the imperative "March!" and the "Dream of revolutions."

Reaching the Etoile obviously implies Breton's belief that he would become a "star" himself, since the word can have this meaning in French. The geographical site of the dream in the Elysian Fields, gathering place for the shades of great individuals, strengthens this allusion to "stardom." Breton, according to Soupault, played the lead role of "Monsieur Létoile" in the second act of *S'il vous plaît*, one of the sketches he wrote in collaboration with Soupault in 1919 as part of the *Champs magnétiques*. See Annabelle Melzer, *Latest Rage the Big Drum: Dada and Surrealist Performance* (Ann Arbor, Mich., 1980), p. 183, who discussed the point with Soupault. As often occurs in the early-twentieth-century avant-garde, a vestige of Symbolist material remains in Breton's dream, albeit in ironic form; thus, Breton's march up the Champs-Elysées to the Etoile might easily remind one of Henri Rivière's *La Marche à l'étoile* (ca. 1890), a series of lithographs in which progress toward a mysterious star suggests the Christian epiphany. Of course, Breton wrenches us back from such stargazing and brings us down to a quite secular earth to confront a famous but mundane site in Paris.

73. René Crevel, *Le Clavecin de Diderot* (Paris, 1932), pp. 185–6.

74. See Alexandrian, *Le Surréalisme et le rêve*, pp. 128–9.

75. Desnos's anger was reflected during the sessions in his preoccupation with death and his insinuation of death wishes toward his interrogators; for example, Breton opened the sessions he described in *Entrée des médiums* by asking Desnos the question, "What do you see?" Desnos replied, "Death." In 1922–3 Desnos produced paintings with the following titles: *Here Lies Eluard*, *The Death of André Breton*, and *The Death of Max Morise*. All had been present at the séances observing Desnos, but not one of them performed like Desnos and Crevel. Desnos's response to the paternal figure Breton suggests the psychoanalytic transference, an idea known to the Surrealists; for example, Eluard, *OC*, vol. 1, pp. 982ff., quoted Freud, *Cinq leçons sur la psychanalyse*, on the transfer: "The 'transfer' is established spontaneously in all human relations as well as in the relation of patient and doctor. It transmits the therapeutic influence everywhere, and acts with a force proportional to the doubts one has of its existence."

76. For the last issue of *Littérature* in June 1924, Desnos wrote "André Breton ou 'Face à l'infini,'" a tribute including such praise as: "Preoccupied with morality, that is to say in the sense of life, and not of the observance of human laws, André Breton by his love of true life and of adventure, restores the proper meaning to the word 'religion'" (p. 14).

77. See Robert Desnos, "Journal d'une apparition" in *La Révolution surréaliste,* no. 9–10 (October 1927), pp. 9–11. For Desnos's history in the mid- to late-twenties, see Marie-Claire Dumas, *Robert Desnos ou l'exploration des limites* (Paris, 1980), p. 75:

> It is probably after 1926 that Desnos, spurred on by his neighbor André de la Rivière, began to smoke opium regularly. Malkine joined them.... Picabia, among others might have initiated him. But the period at la rue Blomet was particularly rich in experiences of this sort and doubtless Desnos sought a way to increase his powers as a Surrealist. Returning to everyday life was not always easy, although Desnos had an astonishing ability to resist the drug. After 1931 he was able of his own free will to give it up, almost as easily as he had taken it up....
>
> The years from 1925 to 1930 ... were marked by a "violent, painful, unflagging love" for the singer Yvonne George.

She died of an overdose on April 22, 1930.
78. Breton again demonstrated a "caretaker" mentality in his book on the psychotic Nadja.
79. See *La Révolution surréaliste,* no. 1 (December 1924), p. 3. The hostility to and fear of his father, whose power displaced the "antediluvian udders" offered by his mother, explain De Chirico's fear "for" his father coupled with anguish – his phallic dagger suggests ambivalence toward the father he wishes to protect, but whose potency he envies and fears. Perhaps the dream contains an allusion to his brother Andrea (Alberto Savinio), who was born three years after him and who presumably had once rivaled him for the "maternal nourishment" symbolized by the cakeshop. Another son born in the 1880s of a powerful and accomplished father, Kafka, expressed similar feelings – even including a geographical metaphor reminiscent of De Chirico's wish to flee to a "newer land" – to his father: "You have been too strong for me ... I imagine the map of the world spread out and you stretched diagonally across it. And I feel as if I could consider living in only those regions that are not covered by you." In Franz Kafka, "Letter to His Father," in *Dearest Father, Stories and Other Writings* (New York, 1954), p. 191. Cf. the discussion of Kafka and the chapter "Homuncu-

lus as Map" in Claude Gandelman, *Reading Pictures, Viewing Texts* (Bloomington, Ind., 1991).
80. Breton's family resided after 1900 at Pantin and moved to another location on avenue d'Aubervilliers in the city a little before the outbreak of war on August 3, 1914. Perhaps the dream occurred in 1922 and associated the dangers and excitements of 1914 to the tensions preceding the break with Dada. In 1922 the Dadaist "arsonist-matchmaker" Tzara, after the rupture with Breton, sent the organizing committee of the Congrès de Paris (of which Breton was a member) an ironic note refusing participation. His note included the following phrase: "I can only raise my top hat and place it on a locomotive which will depart at full throttle towards unexplored countries of criticism." See Breton, *OC,* vol. 1, p. 590, and note.
81. See Alexandrian, *Le Surréalisme et le rêve,* p. 255. This study proved particularly useful to me for its publication of manuscripts from the Bibliothèque Doucet in Paris and for some of its interpretations of Surrealist dreams treated in terms of their roles as programmatic texts or what Alexandrian calls *rêves programmes;* however, the author had inadequate knowledge of psychoanalysis and attached undue significance to other influences on Breton's ideas about the unconscious and automatism. For a brief critique of Alexandrian, see Bonnet, *Breton,* which, while basically sound, goes too far in its total rejection of all interpretation without the dreamer's presence. Apollinaire, in his article "From Michelangelo to Picasso," published in *Les Marches de Provence* (February 1912), and in Breunig, ed., *Apollinaire on Art,* pp. 195–6, applied Michelangelo's words – reason, art, symmetry, and proportion – to Picasso, whose *Demoiselles d'Avignon* he did not appreciate with the depth and fervor of Breton.
82. French humorists like Alphonse Allais and Alfred Jarry treated burial and funeral images with Rabelaisian irreverence, and Jules Romains, in one of the poems in his famous *La Vie unanime* (Paris, 1908), "Le Groupe contre la ville," describes a funeral proceeding to a cemetery that agrees in some details and in its overall tone with Breton's dream of a liberating funeral. In the poem the presence of the cadaver generates a "group," which in turn becomes the "hero." The city "assassinates" the procession, but there is the promise of some "future riot" by the group against

the city (anticipating Boccioni's *Riot in the Galleria* of 1910?).

His Surrealist collaborators apparently remembered Breton's dreaming of top hats. In the question and answer game, "Le Dialogue en 1928," *La Révolution surréaliste*, no. 11 (March, 1928), p. 7, occurred the following sequence: "Queneau: Qu'est-ce qu'André Breton? Noll: Un alliage d'humour et de sens du désastre; quelque chose comme un chapeau haut de forme."

83. See Breton, "Après Dada," *OC*, vol. 1, pp. 259–61. Alexandrian already noted that this dream bears on the death of Dada. Breton might have connected matches and Dada from the Dada exhibition for Ernst held in Paris in June 1921 at which he (Breton) chewed on matches. As to fashion magazines, Breton in 1930 described how he delighted to read them in 1916, at the time he wrote his poem "Façon." See Breton, *OC*, vol. 1, p. 1073, n. 1.

84. The newfangled top hat stirred controversy and curiosity among a wide audience at the turn of the century. In an amusing response to an inquiry by the journal *Figaro* in 1897 asking whether he thought the top hat would "haunt the dawn of the twentieth century," Mallarmé exclaimed, "What! It's just beginning to be broadcast with great energy, to mow down diadems, feathers, even heads of hair: it will go on!" ("Sur le chapeau haut de forme," in *OC* [Tours, 1984], p. 881). Breton's collaborator Soupault had already referred to matches in "Commandements," a section of the *Champs magnétiques* in Breton, *OC*, vol. 1, p. 102: "Matches are excellent and flourish at every turn." Breton owned Picabia's *Match Woman* (1920; Paris, collection of Breton's first wife, Simone Collinet), the second of a series of collages on the theme.

85. Alexandrian perceived the reference to Duchamp and notes that the dream affirms that "Surrealism cannot do without Duchamp, who unfortunately is elusive" (*Le Surréalisme et le rêve*). Duchamp's *Fontaine*, though exhibited in New York and sold from the exhibition to Arensberg, was widely known in Europe; for example, *391* published in Zürich (February 1919), p. 8, carried this report: "N.Y. – Marcel Duchamp has left for Buenos Aires to organize there a hygienic service for public urinals (*pissotières*)." I do not know whether Duchamp had yet the idea of placing a travelling collection of his work in a valise.

86. A mention in the dream of the Achilles reflex pays implicit tribute to Breton's old mentor, the French psychiatrist Joseph Babinski, discoverer of the reflex. Referring to Babinski in the midst of a dream presumably would demonstrate that even in matters of dream the poet remains independent of the master psychoanalyst Freud – another "dream from above." Breton put his medical and psychiatric knowledge to use later when Eluard and he attempted to simulate psychotic states, which they recorded in their volume *L'Immaculée conception* (1930).

87. Ribemont-Dessaignes, in his *Histoire de Dada*, had made hostile allusions to Breton, to which the following rejoinder was published: "Breton, with his dream of the 'conductor of men,' still moves me, It is not his ideas ... but the violence of his blood that attracts me to him / Giuseppe Ungaretti, fasciste." Reprinted in *L'Esprit NRF, 1908–40* (Alençon, 1980), pp. 787–8.

88. In his decisive critique of Dada, "Lachez tout," published in *Littérature*, n.s., no. 2 (April 1922), p. 10, Breton advised his readers, "Leave everything. Leave Dada.... Leave the quarry for the shadow." Breton naturally did not consider Duchamp either limited to Dada or uninterested in the shadows of things, but now, on the verge of increasing political involvement, he must have felt confusion about the complex ambiguities at the core of Duchamp's attitudes to life and art. Duchamp never wrote for *La Révolution surréaliste*, and his name appears only in its last issue (no. 12, December 1929), where he is mentioned in Breton's Second Manifesto.

89. A sentence published initially in *Littérature* (May 1922) and later as the last sentence of *Poisson soluble* (1924), appended to the first Surrealist Manifesto, reads: "The walls of Paris ... had been covered with posters showing a man masked with a black domino, holding in his left hand *la clé des champs:* this man was myself." The masked man is the film criminal Fantômas; the phrase "key to the fields" (humorously represented already in the nineteenth century by Grandville) means freedom figured by the daredevil escapades of Fantômas.

Alexandrian, *Surréalisme et le rêve*, p. 136, cites an unpublished entry in the manuscript "Poisson soluble," which connects "flight" and "theft" with "freedom": "He admits to having committed more than one hundred thefts

(*vols,* thefts or flights), and beats it (*s'envole,* flies away)."

90. One year after the poet's death, in the October 1919 issue of *Littérature,* the editors Breton, Aragon, and Soupault republished "Banalités," a group of poems by Apollinaire. They admired these poems precisely for their commonplace details recounted in a tone so different from the typical lyricism of their author.

91. In the sales negotiations for the painting Breton, who disliked working for a salary, had participated as an expert adviser on behalf of the purchaser, Jacques Doucet – hence the allusions to "the asking price" of 150 francs. Perhaps because he felt uneasy about his commercial dealings for the painting Breton never wrote about the *Demoiselles d'Avignon* in connection with Surrealism. Breton had a great aversion to prostitution. The word "brothel" (the locale of the painting commonly alluded to in Parisian art circles) plays ironically on the subject by associating the artist's exchange of art for cash and Breton's receipt of pay for his views on the work of art. The painting was illustrated in *La Révolution surréaliste,* no. 4 (July 15, 1925), the issue in which Breton took over sole editorship.

92. Breton wrote a number of articles on Picasso, one of which became the first installment of *Surrealism and Painting;* in this book Breton gave Picasso the lion's share of illustrations and made him a paradigm of Surrealist painting. Breton's exaltation of Picasso provoked envy in some of the Surrealist painters.

93. Naville may perhaps also have recoiled from the excessive subjectivity of Desnos, even though he had collaborated with Desnos in the previous issue on a collage dealing with suicide. Concerning Werther: In *Littérature,* no. 7 (September 1919), p. 11, Maurice Raynal had a one-page "Werther en trois petits actes," a mock treatment of death, with indirect allusion to suicide. Aragon, in a "Lettre à Françis Vielé-Griffin sur la déstinée de l'homme," *Littérature,* n.s., no. 13 (June 1924), p. 21, wrote: "A man on the threshold of old age suffers a crisis similar to that following the end of his first love. In this crisis, not everyone has the same fate. There are 50-year-old Werthers: a new era of suicides begins." And in *Aragon parle avec Dominique Arban* (Paris, 1968), p. 163, he noted: "It is not daily life, but the language of opera that is in contradiction with poetry. Reread a bit of *Werther,* forgetting

Massenet's version, and you'll see how much closer we are to Goethe than to the immediately preceding generations . . . remember that in *The Sorrows of Young Werther* there is much of Goethe and of the daily life of his youth."

94. In "Liquidation" Breton already gave Lenin a respectable grade of 12 out of 20 points. After 1925 Morise hardly participated in the political side of Surrealism, and the last manifesto he signed in 1927 had to do with Chaplin and Rimbaud. His last Surrealist writings consisted of dreams published in *La Révolution surréaliste,* no. 11 (1928).

95. In *La Révolution surréaliste,* no. 3 (April 1925), p. 2.

96. Jacques Rigaut wrote for *Littérature* from 1920 on but never declared himself a Surrealist. In a prophetic piece in issue no. 17 of December 1920, p. 7, ostensibly mocking suicide, he wrote, "The first time that I killed myself, I did it to annoy my mistress . . . (who) suddenly refused to go to bed with me." He traveled restlessly between New York and Paris, and after the failure of his marriage to an American, the vulnerable and fragile poet became addicted to alcohol and heroin. In November 1929 at the age of thirty he committed suicide. One month later as a gesture in keeping with Rigaut's black humor, *La Révolution surréaliste* gave him an obituary by reprinting his piece on suicide – the one article in that periodical bearing his signature. Breton included the same piece in his *Anthologie de l'humour noir* (Paris, 1966).

97. The Breton of Morise's dream – not present himself, but represented by a droll character who plays him and many other roles – foretokens Morise's picture of Breton in "La Marseillaise." This piece was included in the tract against Breton – *Un Cadavre* – written in 1929 by ex-Surrealists; however, Breton's rejoinder in the Second Manifesto does not mention Morise. In fact, his motivation was personal rather than political or theoretical: Morise, like Prévert and Queneau, close friends of Simone Breton, turned against Breton when he started divorce proceedings against her.

98. In the early months of 1925 Breton had become fascinated with Lise Meyer; though Simone received friendly letters from Breton, like one from Brussels on July 7 about the Moroccan War, she must have sensed his alienation. Signing "S.B.," she published a

Surrealist text in *La Révolution surréaliste,* issue no. 5 (October 1925), p. 14, just after Morise's dream, in which she describes a young girl who smiles as she "gets rid of an overzealous ladies' man," who is transformed into a starfish. But she in turn is changed into a transparent veil by the angry sea, revenging the starfish. A strange event then happens: "A gull seized the veil and was on the point of carrying it to the secret cabin of a sea captain. The latter was an austere and passionate man whose two favorite occupations were first, to cause swellings on his men's cheeks that he called 'hysterico-vernal' and second, to win over with poems expressly intended for them, the fish which were to be found in the guts of the sharks which ate them." (Breton would later write with Aragon a piece in praise of the poetics of hysteria.) She hints at the identity of the captain by linking him to his "old friends" including the chameleon, a character prominent in Section 5 of Breton's *Poisson soluble.* In the last sentence she announces the captain's death.

99. As a homosexual and transvestite, this friend of Morise could easily substitute for Simone.

100. In issue no. 11 of March 1928 Morise published for the last time with the Surrealists, and one of the dreams seems to concern Breton, suggested with characteristic indirectness when Morise speaks of "the house of (54) rue du Château," and of his friends Jacques and Simone Prévert. The latter's name, evidently associated to the name of Breton's wife Simone, has a bad foot, walks strangely, and wears shoes "at least ten times too big" for her feet. The dream is a nightmare, full of drunken stupor and fog, and may well allude to his uneasiness about "the house of Surrealism," where his friends Queneau and Prévert joined him and Breton for evenings of humor and talk. Tensions between André and Simone doubtless contributed to this uneasiness.

101. See Crastre, "André Breton et la liberté," in Eigeldinger, *Hommage à la mémoire d'André Breton* (Neuchâtel, 1970), pp. 137–52.

102. As already noted, Emile Durkheim and Gabriel Tarde published studies of group behavior that were widely circulated in France in the first decades of the century.

On the theme of the crowd, Gustave Le Bon, and literature, see the Marxist aesthetician Marc Ickowicz, *La Littérature à la lumière du matérialisme historique* (Paris, 1929), pp. 185ff. Le Bon was rarely mentioned by the Surrealists; however, they would have known his work not only from the *lycée* but, as already noted, from Freud's *Group Psychology and the Analysis of the Ego* (SE, p. 18). In that book Freud abundantly discusses *The Crowd* as a source of his ideas about group psychology. An advertisement for Freud's book appeared in *La Révolution surréaliste,* no. 2 (January 1925).

103. Cf. Le Bon, *The French Revolution and the Psychology of Revolution* (New Brunswick, N.J., 1980), p. 75: "Our ego consists of the association of innumerable cellular egos, the residues of ancestral personalities. By their combination they form an equilibrium which is fairly permanent when the social environment does not vary." Speaking of the emergence of multiple personalities under the "pathological conditions" of revolution, Le Bon continues:

> Morbid psychology has recorded several examples of multiple personality in a single subject, such as the cases cited by Morton Prince and Pierre Janet.
>
> In all these variations of personality it is not the intelligence which is modified, but the feelings, whose association forms the character. (p. 77)

For a contemporary list of studies applying the psychology of suggestion to sociology, see J. Grasset, *L'Hypnotisme et la suggestion* (Paris, 1903), p. 122 and n. 1. The connection of hypnosis to suggestion and of both to art is proposed in Paul Souriau, *La Suggestion dans l'art* (Paris, 1893), especially p. 72.

104. Valéry in his *Cahiers* proposed an analogy between group theory in mathematics and the workings of the mind or self (this comes clearly from the same spirit of system that has animated "Bourbaki," the collective name for the anonymous association of French mathematicians started in the thirties): "Every act of comprehension is based on a group" (1, p. 331); any given idea "is most certainly derived from a system that comprises also the subsequent ideas, rather than being the origin or cause of them" (7, p. 365). See Judith Robinson, *L'Analyse,* chap. 3, "Vers une mathématique de l'esprit," in her

edition of the *Cahiers* (Paris, 1973–4). An important article by Emile Durkheim and Marcel Mauss, "De quelques formes primitives de classification," in *L'Année sociologique,* vol. 6 (1901–2), proposes that the human mind thinks in groups in a fashion one might call "logical-aesthetic." One can find here an obvious analogy to Gestalt psychology.

Study of the creative individual in relation to the group occurred in Germany too; for example, Günter Ammon, "Kreativität und Ich-Entwicklung in der Gruppe," *Dynamische Psychiatrie,* 4, no. 13 (1971), maintains that ego development requires communication with the social group and that creativity demands, in Winnicott's terms, "a facilitating environment."

The pathology of groups was already interesting to nineteenth-century French psychiatry, most notably to Charcot and his school. See Pierre Janet, *Psychological Healing* (London, 1925), vol. 1, pp. 488–9, for a discussion that is critical of group séances (the type, in fact, practiced by the early Surrealists): "Charcot's pupils, and especially Gilles de la Tourette, did their utmost to promote the widespread adoption of this method [isolation] of treating the neuroses. 'We must break the charmed circle in which the patient is imprisoned; we must forcibly remove the victim from the excessive and harmful sympathy of the onlookers; we must rid the sufferer of the longing to play an unending comedy, and we can only do this by ensuring the absence of the audience whose complaisance is a perpetual encouragement to play-acting.' Thus there simultaneously came into existence in various countries 'asylums' of a new kind, 'sanatoria' no longer designed for the reception of the insane as the term is ordinarily understood, but for the 'borderland [i.e., borderline] cases,' for those patients euphemistically described as 'neuropaths.' " The Surrealists expressed outrage at the coercive "imprisonment" of the insane, and Foucault later directed his critical history of the treatment of madness precisely against such sanatoria.

105. See Alexandre Mercereau, *L'Abbaye et le bolschévisme* (Paris, 1922). The ideas developed at the Abbaye de Créteil gave rise to Jules Romains's *unanimisme* as presented in his influential collection of poems *La Vie*

unanime; and see also his "La Foule au cinématographe," *Puissances de Paris* (Paris, 1911), p. 120 on the film audience: "The group dreams. . . . They sleep . . . no longer conscious of their bodies."

Paul Eluard published an article in *Clarté* (November 1925), "Des perles aux cochons," in which he prophesied a poetry that would unite all men, give them access to the marvelous. Cited in Breton, *OC,* vol. 1, p. 1570, n. 1.

106. For an early psychoanalytic view of the First Manifesto, see A. Borel and Gilbert Robin, "Les Rêveurs. Considérations sur les mondes imaginaires," in the periodical *L'Evolution psychiatrique,* 1 (1925), pp. 191–2. The authors quote the first three paragraphs of Breton's text, with the comment, "We cite this expressive passage, where André Breton's preferences for what we have designated as 'schizoid' can be detected." This word signifies a type given to "imaginative tendencies and the creation of imaginary worlds" and was not meant pejoratively.

107. The interest in dream accounts declined after 1924, judging from those published in *La Révolution surréaliste,* and they were entirely given up after issue no. 11. None appeared in *Le Surréalisme au service de la révolution* or *Minotaure,* and they only became important again in Breton's *Trajectoire du rêve* of 1938.

108. In a notebook dated March 4, 1924, Breton wrote: "I met Clemenceau (yes, it had to be Clemenceau). Purely political dream. I questioned him about . . . (who?) and on Briand [the Minister of Foreign Affairs]. I was polite, amiable. He told me about the successive arrests of Briand, numbering three, I believe (the rest is lost)." See Breton, *OC,* vol. 1, p. 466.

109. Group assaults against the bourgeois, for example, in the mock trial of Barrès, became institutionalized when the Surrealists turned to radical politics. Such attacks against a scapegoat had the advantage of rechanneling the Surrealists' internecine, incestuous, or suicidal impulses against an external target.

110. Breton, *Surrealism and Painting,* p. 46. Experiments featured the *vases* in physics courses taught in Parisian secondary schools around the turn of the century. See *Plan d'Etudes et programmes de l'enseignement secondaire classique dans les lycées et collèges . . . Année scolaire 1896–7* (Paris). Under "Hydro-

statique et hydrodynamique," p. 142, appears "Vases communicants." Freud, who often found that the theories and practices of nineteenth-century science provided useful analogies, wrote around 1900 that the neurons of sensation and those of psychical processes function "like inter-communicating pipes." See Freud's letters to Fliess of 1887–1902, published in *The Origins of Psychoanalysis* (London, 1954), p. 373. Marinetti (as noted by Kern in *Culture*, p. 76), wrote *The Communicating Vessels* in 1916, and Leiris used the phrase in "Le Pays de mes rêves," *La Révolution surréaliste*, no. 2 (January, 1925), p. 27.

111. The German film on the Dracula theme, *Nosferatu, Eine Symphonie des Grauens* (1922), directed by Murnau, drew enthusiastic responses from the Surrealists on its public release in Paris in 1928. See Georges Sadoul, "Souvenirs d'un témoin," *Etudes cinématographiques*, no. 38–9 (Paris, 1965). More than the film itself, the titles and explanatory texts shown on screen excited Breton and his colleagues. Breton evidently knew the film before 1928, since he alluded to "l'admirable film NOSFERATU" in *Révolution Surréaliste*, no. 7 (June 15, 1926), p. 4.

112. Earlier examples of subjective mapmaking can be cited: the "précieuse" Mlle. de Scudéry's novel *Clélie* (1654–61) contained a famous "Carte" of a mythical town. This map consisted of an amorous geography complete with such allegorical details as an Inclination River, a Sea of Enmity, a Lake of Indifference, and towns like Obedience, Sensibility, and Generosity. Many caricatures involved similar maps, such as one of Europe as an epaulet of Napoleon. The Surrealists published a distorted map of the world in *Variétés* (Brussels, 1929), in which Paris designated the whole of France. In his discussion of Miró in *Surrealism and Painting,* Breton speaks approvingly of incantations that permit one to "form an opinion of France or Spain solely in terms of their contour on the map and the special image suggested by the sinuosity of the outline." Carried to a new level of seriousness the issue of correspondence persists in the "hyperreality" of J. Baudrillard, *Simulations* (New York, 1983), p. 4: "Simulation is no longer that of a territory, a referential being or a substance. It is the generation by models of a real without origin or reality: a hyperreal. The territory no longer precedes the map, nor

survives it. Henceforth, it is the map that precedes the territory . . . it is the map that engenders the territory." This seems to anticipate recent erotic experiments with virtual reality. Cf. also Gandelman, *Reading Pictures.*

113. The *Île de Sein* – located appropriately in Brittany, his maternal home, and equally interesting, the site of a romantic vacation during July and August 1929 with Suzanne Muzard.

114. Breton, *Poisson Soluble,* no. 1, in *OC*, vol. 1, p. 352. For biographical information see Bonnet, *Breton.*

115. The "acte manqué" clearly refers to the mechanism of slips Freud described in the *Psychopathology of Everyday Life.*

116. Breton's parents wanted him to become a scientist, but Breton resisted and claimed that he lacked aptitude for and disliked science. See Bonnet, *Breton,* for details. In *Materialism and Empiriocriticism,* Lenin exhibited hostility to the "reactionary" (meaning at variance with dogmas of Marxist philosophy) aspect of modern science: he criticized, with little understanding, speculations about non-Euclidean spaces, and "reactionary" neo-Kantians like the distinguished scientists Mach and Poincaré who claimed space is subjective or a form of understanding. As a loyal Leninist Breton, although sympathetic to the neo-Kantian Einstein's idea of relativity (obviously only in its popularized form), failed to question Lenin's simplistic materialist thesis of an objective material world in absolute time and space.

117. For the sexuality of the phrase "sur le pont" in his early poem "Au regard des divinités," see Chapter 5, this volume.

118. The phrase "passer le pont" recurs in the book as a leitmotif.

119. Freud, following Stekel, *Studienausgabe,* vol. 2 (Frankfort, 1982), wrote in the *Interpretation of Dreams,* p. 352, that "the symbol of the road is important: if it turns to the right it indicates the good direction (marriage . . .). To the left is the road to crime, homosexuality, incest, sexual perversions." For the moral polarization of space, see Robert Hertz, "La Prééminence de la main droite: Étude sur la polarité religieuse," *Revue philosophique* (December 1909), pp. 553–80, in *Mélanges de sociologie religieuse et folklore* (Paris, 1928), pp. 99–129.

120. Cf. G. Simmel, "Brücke und Tür," *Der Tag* (September 15, 1909), and "Soziologie des

Raumes," *Jahrbuch für Gesetzgebung, Verwaltung und Volkswirtschaft*, 27 (1903) on the function of borders in social life and the significance of objects that bridge different spatial realms. In "René Magritte," *Le Surréalisme et la peinture,* p. 270, Breton writes: "If concrete figuration, in the sense of description claimed by Magritte, were not so punctilious, it would have created the great *semantic bridge* that permits one to pass over it in the properly *figural* sense." This metaphor appears repeatedly in the twentieth century among adventurous artists like Klee and Kandinsky. The latter, in *On the Spiritual in Art* (1914 additions), said that a few artists could use combinations of pure form and color but explained that even he had not been mature enough a few years earlier "to experience the purely abstract without the bridge of objects." Cited in Long, *Kandinsky,* p. 67. The interest in the bridge metaphor continues in Breton's "Signe ascendant": "Poetic analogy has in common with mystical analogy that it transgresses the laws of deduction in order to make the mind grasp the interdependence of two objects of thought situated on different planes. The logical functioning of the mind is unsuited to throwing any bridge between these objects and opposes on principle that any kind of bridge should be thrown." In *La Clé des champs,* p. 134.

121. These allusions to embarrassment and gaucherie in the dream – even its anachronistic location – apparently serve to exculpate the young and innocent dreamer from experience with drugs. Drugs in fact do not seem to have been important for Breton himself, but others in the group like Desnos (whose girlfriend died of an overdose) were heavily involved for several years up to 1930.

122. Breton seems to have created a variant on the tension between reality and hallucination in a case history recounted by Taine, which he discussed several times, especially in connection with De Chirico. See Chapter 4, this volume. This play back and forth between the dream and the tangible exemplifies a process of "sur-realizing" characteristic of Breton's poetry.

123. Freud pointed out the antithesis between the two functions of the male genital, sexual (erection) and urinal, in "The Acquisition and Control of Fire" (1932): man quenches his own fire with his own water. In *Poisson soluble,* no. 16, in *OC,* vol. 1, pp. 369–70,

Breton wrote: "There is yellow rain, whose raindrops as large as our heads of hair fall straight down on the fire and put it out. . . . I am waiting for rain like a lamp raised three times in the night, like a crystal column ascending and descending between the sudden arborescence of my desires."

124. Again, an exculpation and a shifting of blame that may actually have an affective counterpart in his political conflicts. *Petites* applies both to the puddles and to the girls. Breton emphasized "rôle des accidents urinaires de l'enfant" in a note on the French edition of *The Interpretation of Dreams.* See the "Note préliminaire au Cahier de la Girafe," published by Bonnet in F. Hulak, director, *Folie et psychanalyse dans l'expérience surréaliste* (Nice, 1992), pp. 148–70.

125. Wilhelm Stekel (1868–1940), an original member of the Vienna Psychoanalytic Society, wrote *Die Sprache des Traumes* (Wiesbaden, 1911), which influenced Freud's views on dream symbolism. He along with Adler, broke with Freud in 1911.

126. In the *Minutes of the Vienna Psychoanalytic Society,* 1, pp. 172–4, at a meeting of March 10, 1909, concerning Adler's lecture "On the Psychology of Marxism," Freud says that Adler failed to offer evidence of psychoanalytic thought in Marx, and agrees with Rank (*Der Künstler* [Vienna, 1907]), who expressed the idea that the enlargement of consciousness is what enables humankind to cope with life in the face of the steady progress of repression. "That would be the introduction of psychology into historical studies." Cf. Adler, "Bolschewismus und Seelenkunde," *Internationale Rundschau* (Zürich), 4 (1918), pp. 15–16.

127. Breton adopted in the *Vases communicants* (*VC*) the following ideas about the mechanism of dreams from chapters of Freud's *Interpretation of Dreams* (*IOD*): calculation (*VC,* p. 41-*IOD,* chap. 6, f); secondary revision (*VC,* p. 131 = *IOD,* chap. 6, i); and the dream within a dream (*VC,* p. 74 = *IOD,* chap. 6, c).

128. In his efforts to demote Fliess's importance, Freud postdated his contribution to the idea of bisexuality in a bibliographical footnote to *Three Contributions to the Theory of Sex* (first edition, Vienna, 1905). Ernest Jones, *The Life and Work of Sigmund Freud,* vol. 1 (New York, 1953), p. 318, explains how Freud reduced the number of his precursors by ignoring the earlier publications of Fliess.

129. See Breton's letter (dated 1933) in the appendix to the *Vases communicants, OC,* vol. 2, pp. 213–15. He points out in his essay on Savinio in *Anthologie de l'humour noir* (Paris, 1939) that "Volkelt and Scherner before Freud" described the world of sexual symbolism. Breton himself appears to have used reports on psychoanalysis in French periodicals that he fails to note, for example, those cited by Hervey de Saint-Denys. In "Surrealism, Yesterday, Today and Tomorrow," *This Quarter* (Surrealist Number), 5, no. 1 (September 1932), p. 17, Breton called Hervey Surrealist "in the directed dream." However, he acknowledges that Freud's method of interpretation is more reliable and the one he prefers.

130. The later return to automatism of the Surrealists had to do with personal and ideological tensions within the movement that led finally to the expulsion of Dali.

131. Breton wrote in the *Vases communicants, OC,* vol. 2, p. 109, "Freud himself seems, with regard to the interpretation of dream symbolism, only to have revived under his own name the ideas of Volkelt, an author about whom the bibliography at the end of his book remains significantly silent." Freud, evidently upset by Breton's criticism concerning the omission of Volkelt's name, sent off two letters in two days in December 1932 to explain that he had not in fact omitted the name of Volkelt. Interestingly, he does not respond in any detail to Breton's numerous other points. Perhaps he felt this point most strongly because it touched a sore spot – his need to claim originality in all important psychoanalytic ideas. As Ernest Jones (here more reliable than elsewhere) in his *The Life and Work of Sigmund Freud,* vol. 2 (London, 1954), pp. 411–12, observed, "Whereas in his neurological work Freud's bibliographical references had been scrupulously exact and comprehensive, when it came to his analytical writings this was no longer so. Rank once jokingly remarked that Freud distributed references to other analysts' writings on the same principle as the Emperor distributed decorations, according to the mood and fancy of the moment." Cf. Paul Roazen, *Brother Animal: The Story of Freud and Tausk* (New York, 1986), especially chap. 3, "Plagiarism."

132. Breton has himself been criticized justly for restricting information about his own dreams and excluding childhood memories. See Jean-

Pierre Morel, "La Problématique du rêve," in *Breton et le Surréalisme,* special no. of *La Quinzaine littéraire* (March 16–31, 1971), pp. 14–17. In his response to Freud's letters, he pointed out that Freud had not been entirely frank in discussing the sexual aspect of his own dreams in *The Interpretation of Dreams* – though it can be argued that Freud, while not wholly explicit, was no less bold than Breton in presenting the personal implications, aggressive and erotic, of his own dreams – and as *the* pioneer in sexual self-exposure, he remains unique (a point that Breton fails to acknowledge). Freud took the bait and hastily responded in December 1932 to Breton's critical letter, whereupon Breton proudly quoted Freud's three letters in appendices to the *Vases communicants* and displayed an illustration of one of them in a photograph like a mounted trophy of the hunt.

133. The Socialist Blum figured prominently during the thirties in the thinking of most left-wing groups, who supported his politics of a united front as the sole hope for overcoming Fascism in France. It is understandable that the Surrealists signed a call to workers in February 1936 to rally to Blum, in response to a threat by the Fascists. See Pierre, *Tracts,* vol. 1, p. 295. As he mentions in his *Entretiens,* Breton met Blum in 1934 after the Putsch.

134. Bataille competed with Breton to get major artists like Dali to join him. Both also wooed the favors of Picasso: Breton extolled him throughout the twenties; and – most relevant to Breton's dream – Bataille included an illustration of a Picasso drawing of a female nude (1929) on the first page of his article "Soleil pourri," *Documents,* no. 3 (1930). Cf. Chapter 4, this volume.

3. IN THE SERVICE OF WHICH REVOLUTION?

1. See Aragon's "manifeste," "Le Manifeste est-il mort?" *Littérature,* no. 10 (May 1923), p. 13.

2. See J. Bernier, "Où nous en sommes," *Clarté,* no. 78 (November 20, 1925), pp. 5–6. Aragon wrote a series, "Le Prix de l'esprit," in *Clarté,* n.s., no. 4 (October–December 1926), pp. 122–3, attacking intellectuals as willing tools of the ruling class, calling thought a kind of merchandise, "essentially an emanation of capitalism. . . . For this reason nothing is more justified than the contempt which the oppressed

proletariat has for intellectuals." In retrospect the claims of left-wing intellectuals, including the Surrealists, to speak to and for the proletariat are astonishingly naïve: workers daily confronted with the economics of survival did not understand or care much about the rather esoteric problems facing avant-garde intellectuals.

3. See *Archives du Surréalisme,* vol. 1, p. 99.

4. Most quotations from the First Manifesto come from Breton, *OC,* vol. 1, as translated in the English edition: André Breton, *Manifestoes of Surrealism,* by R. Seaver and R. Lane (Ann Arbor, Mich., 1969).

5. Scholars have neglected the probable contribution of *Totem and Taboo* (1912) to Breton's definition of Surrealism. The French version, translated by Jankelevitch (Paris, 1923), was available at the time Breton formulated the manifesto. From Freud's book he could have adapted the principle of the omnipotence of thought, in which magic imposes the laws governing mental life on the real world, as well as Freud's conclusion that civilization has retained this principle only in the field of art. Presumably Breton, in order to bypass rational connotations, replaced "thought" with "dream" in his formulation. Freud cited the writing of Salomon Reinach, *L'Art et la magie,* an indication that the idea of the "magic of art" (an idea ascribed by Reinach to the creators of the prehistoric cave paintings) was independently available to Breton in French sources.

6. Goll's manifesto appeared in October 1924, a few weeks before Breton's, but he would already have known Breton's views from articles in *Littérature* during 1922, and especially from the excerpt of the manifesto that appeared in *Le Journal littéraire* (September 6, 1924). As long ago as 1919 Paul Dermée called the writers for *Littérature* "aliénés." Dermée, who founded with Le Corbusier and Ozenfant *L'Esprit nouveau,* had commercial interests repulsive to Breton: he wrote a treatise on the psychology of advertising, *Les Affaires et l'affiche,* based on a series of articles published in 1920–2. He also contributed regularly to *La Publicité.* Breton had a complex, in part ironic, view of advertising (*réclame*) and certainly would not have had Dermée's interest in it for commercial reasons. In a letter to Aragon on April 13, 1919, he said,

> For me, poetry and art cease to be ends in themselves and become a means (for

advertising). Advertising ceases to be a means and becomes an end. Death of art (for art's sake). Demoralization.

> Naturally we have to take the word advertising in the broadest sense. It is thus that I menace politics, for example. Christianity is advertising for heaven.

And he repeats, in a letter to Fraenkel of April 19, 1919, that *réclame* "menaces" business, politics, and religion. See Aragon, "Lautréamont et nous," pt. 2, p. 7, cited in Bonnet, *Breton,* p. 153.

7. Goll made his remark in his October 1924 manifesto (n.p.). Breton, Aragon, and Soupault sent a letter to *Le Journal littéraire* in May 1924 calling Reverdy "the greatest poet of our time." See Pierre, *Tracts,* vol. 1, pp. 11–14. Goll also shared Breton's taste for cinema (which Breton regarded as an "example of Surrealism") and like Breton admired Mayakovsky.

8. Breton told Jacques Doucet in January 1921 about the automatic writing "without a subject" that Soupault and he were producing. He explained that he conceived the project in terms close to those of the manifesto; one evening as he was falling asleep, the following sentence came to him: "A man has a window that passes through the middle of his body, etc." See Breton, *OC,* vol. 1, p. 1354, note to p. 325.

9. In the *Dictionnaire abrégé du Surréalisme* of 1938 (Breton, *OC,* vol. 2, p. 810), we read, under "Window": " 'The window opens and closes – like a tempest in a glass of water.' (Benjamin Péret)." In the same book the phrase, slightly modified, was applied to Breton, who was characterized (as already mentioned) as a "glass of water in the tempest." Breton's dream image would bear comparison to the richly symbolic window metaphors in Mallarmé's poetry, but its suggestion of a collage in movement probably owes something to the treatment of windows by artists who presumably found the window, a transparent plane bounding interior and exterior space, a suggestive analogy to their own plastic concerns: Delaunay's *Windows* were often discussed by Apollinaire after 1910, and in Goll's *Manifesto,* Delaunay stated, as though countering Breton: "At the time when I conceived 'The Windows,' Apollinaire lived in my studio. He created at the same time, and in the same vital atmosphere, his poem 'The

Windows,' in that technique that you call Surrealist." Also, Boccioni made the sculpture *Fusion of a Head and a Window* in 1912, and Gris and Picasso after 1915 explored the fusion of landscape and still life on either side of a window (Picasso already included cut limbs). The act of cutting may have had other more sinister associations for Breton, since a few pages later he mentions the guillotine. And sometime between 1920 and 1924, he put together a collage poem with the following words: "Here is someone who / Will enchant / OH! OH! AH! AH! / the woman without a head (la femme sans tête) / THE MARIONNETTE." See the "Inédits," *OC,* vol. 1, p. 574. This phrase may have been known to Ernst when he composed his collage novel *La Femme sans tête,* for he had earlier illustrated the Second Manifesto with a pair of female marionnette-like figures without heads. The cutting of the woman also anticipates the *cadavre exquis.*

10. Breton's examples of the marvelous include the Gothic novel *The Monk* by Lewis, Chateaubriand's "exoticism," Constant's "politics," Hugo "when he isn't stupid," and Rabbe "in death." In his early Surrealist writings Breton frequently used the image of the castle as a social structure and supernatural stage, and the manifesto describes a suburban castle for his friends "on a rural site not far from Paris." In *Un Cadavre* Georges Limbour mockingly states that "M. Breton invited us all, as a generous host, to a Surrealist castle," which was "unfortunately only a poetic creation." Breton's image recalls the remote and eerie castles conjured by the Romantics, like Walpole's *Castle of Otranto,* a major Gothic novel (which he doesn't mention); however, the site of the Surrealist castle remains suburban, inhabited perhaps by Aragon's "Peasant of Paris."

11. Breton, See *OC,* vol. 1, p. 901.

12. Except for neglecting the issue of Surrealist praxis, the following analysis by Green in *Cubism and Its Enemies,* p. 234, seems valid: "Mondrian ... did not put his faith in the collective solidarity of groups or political parties, he thought in terms of a revolution which would take place within the self. ... An inner transformation would lead to the transformation of the outer in the way the outer was experienced. Curiously, it is an attitude to change which comes close in its essentials to the attitude that led André Breton and the

Surrealists in 1926 to set their inner route to revolution through the imagination apart from the political route of the *Clarté* communists, and the result was comparable: an acutely uncomfortable alliance between broad social and cultural aspirations, and an actual focus on the self."

13. The Surrealists took notice of the difficulties of the franc, and Péret in *La Révolution surréaliste,* no. 8 (December 1, 1926), pp. 13–14, wrote an ironic poem entitled "The Fall of the Franc": "Once as a fat priest you officiated in the hallways of brothels / dispensing the host to thin whores ... here lies the franc a beet without sugar." See Marcel Jean, *Autobiography of Surrealism,* p. 174.

14. Marcel Raymond, *De Baudelaire au Surréalisme* (Paris, 1966), p. 291, referring to the First Manifesto, notes that "Surrealism ... constitutes the most recent attempt of Romanticism to break with *things as they are* and to substitute other things for them."

15. Breton, in "Légitime défense," *La Révolution surréaliste* (December 1926), p. 35, rejected Naville's dichotomy between anarchy and Marxism: "All of us seek to shift power from the hands of the bourgeoisie to those of the proletariat. Meanwhile, it is ... necessary that experiments of the inner life continue, and do so, of course, without external or even Marxist control."

16. Breton wrote in July 1924: "In our time, in the intellectual domain there are three fanatics of the first order: Picasso, Freud and Desnos.... Symbolism, Cubism, Dadaism have long since disappeared, Surrealism is the order of the day and Desnos is its prophet." See *OC,* vol. 1, p. 473.

17. "The Bouquet without Flowers" was published in *La Révolution surréaliste,* no. 2 (January 15, 1925), pp. 24–25. See also Breton, *OC,* vol. 1, pp. 895–8, and especially the notes on pp. 1679–80.

18. Breton, *OC,* vol. 1, p. 899. Drieu la Rochelle published a critical note, "La Véritable erreur des surréalistes," in *La Nouvelle Revue française* (August 1925), pp. 166–71, asking, "How can one prefer the East [by which he meant the USSR and Morocco] to the West?"

19. See Breton, *OC,* vol. 1, p. 484. The confusion about the East and the Soviets appears plainly in Marcel Noll's two "Rêves" in *La Révolution surréaliste,* no. 7, (June 15, 1926), p. 7, the first concerning the French Revolution, the second the Russian Revolution (Odessa). He envis-

ages a swarming revolutionary East: "I have the quite precise vision of a planispheric map: the Balkans, where I discern a swarm of shapeless things, where I sense obscure forces moving; and Asia, all white and radiant, with shadows from its mountain tops and the silver of its rivers." Breton recounts his own version of the "Yellow Peril" in his uncritical description of a grade B American film in which a Chinese found a way to produce clones and "all alone invaded New York, with several million copies of himself" (Breton, *OC,* vol. 1, p. 663). The Surrealists shared their fascination and confusion about the "East" with other Western Europeans, notably the German Expressionists.

20. See Marguerite Bonnet, "L'Orient dans le Surréalisme: Mythe et réel," *Revue de littérature comparée,* no. 4 (October–December 1980), pp. 411–24. She asserts that the theme of the Orient proved ephemeral, making its major appearance in 1925, the year of the turn toward the political East of the USSR.

21. France had supported the literary efforts of the Clarté movement begun after World War I by Henri Barbusse, an elitist, pacifist "intellectual of the mind." After 1920 young Communists gained increasing control over the periodical, and by 1924 they were attacking as bourgeois their literary founders, including Anatole France.

22. For further discussion of Surrealism and colonialism, see Chapter 5, this volume.

23. Breton and Aragon recorded in February 1922 that Doucet read Condillac's *Traité des sensations,* a work that had appeared in a new edition by G. Lyon published the year before (Paris, 1921). See Breton, *OC,* vol. 1, p. 632. It seems to me that Breton has shaped his *discours* in the spirit of Condillac's treatise; especially the famous example of a statue that is awakened to life by impressions impinging on it recalls the armor that comes to life under the light of Breton's lantern. Like Pygmalion's statue, Condillac's raises questions about fetishism and the creative powers of love.

24. This was the last paragraph in *Point du jour* (Paris, 1970), p. 28. Cf. *"Le Bouquet sans fleurs."*

25. Victor Serge, reviewing Trotsky's book (at about the same time as Breton), which he found the truest and most "prenant" of all portraits of Lenin, observed that "the work and political activity of Trotsky have been subjected by the Central Committee of the

Communist Party of Russia . . . to the most severe criticism" by Stalin, Zinoviev, Kamenev, Molotov, Bukharin, Kolarov, and Rykov; see *Cahiers du Bolchevisme, Correspondance Internationale,* etc. See also Serge, "Un Portrait de Lénine par Trotsky," *Clarté,* no. 75 (June 1925), pp. 255–8.

26. See Breton, *Entretiens,* pp. 122 and 123. A characteristic text by Trotsky was already available in the review *Clarté* in (November 1923), pp. 426–7: "In a society disembarrassed of the crushing burden of earning one's daily bread . . . in which the children . . . will absorb the rudiments of science and art like air and sunlight . . . in which the liberated egoism of mankind – a formidable force – will tend only toward knowledge, to the transformation and amelioration of the universe, in such a society, the dynamism of culture will be comparable to nothing that we have known in the past."

27. Pierre Morhange, an editor of *Philosophies* (1924–5) and an idealist who engaged in polemics with Breton, considered Lenin an "absolute revolutionary," comparable at once to Christ and Marx. See Losfeld, *Tracts surréalistes,* vol. 1 (Paris, 1980), pp. 379–80. But Picabia (writing while Lenin was still alive) in "Souvenirs sur Lénine," *L'Eclair* (August 23, 1922), p. 1, compared the ambitious Lenin, autocratic repressor of the peasants, to the old czars.

28. Despite his reservations, Breton tolerated the poetic purism of Reverdy, who published *"Le Rêveur parmi les murailles,"* in *La Révolution surréaliste,* no. 5 (October 1925), p. 19, where he wrote: "Thought, in order to make progress in the mind, needs the precision of words, whereas the dream develops in images." By 1929 Reverdy, who referred not to political revolution but to the "Revolution of the image," took an overt stand against the Surrealists' ideologizing of poetry: in a statement inserted into his volume *Flaques de verre,* he evokes a poetry "sans mots et sans idées."

29. In *La Révolution surréaliste,* no. 4 (July 1925), p. 32, the issue prior to the one with Breton's review of Trotsky's *Lenin,* Eluard mocked the call for total revolution by the Philosophies group, "Manifestation Philosophies du 18 mai 1925." He commented sarcastically on the optimism of the group that "radiated glory under the bright sunshine of the hammers and sickles of a mediocre regime that based itself on the easy and repugnant order of work." Ironi-

cally, Eluard later became a faithful exponent of Stalinism.

30. See *Archives,* vol. 2 (Mayenne, 1988), "vers l'action politique," edited by Bonnet, p. 58.

31. Cf. Levin, *Republican Art,* p. 219: "In making him a glorified worker, the Republicans offered the artist a methodology based on drawing which was empirical, analytic and synthetic; which had its roots in the craft traditions."

32. See H. Lefebvre, *Introduction à la modernité,* (Paris, 1962), p. 112.

33. Of *L'Esprit* Jean-Pierre Maxence, *Histoire de dix ans (1927–1937)* (Paris, 1939), pp. 80–1, wrote: "When they see the disintegration of fictional characters, they attack the cult of introspection.... They condemn en bloc and rather frantically all subjectivists (Barrès, Gide, Rivière, Valéry).... They want a return to the object. But that involves concentrating on France, and abandoning interior bankruptcy for an external, public bankruptcy. And there again they feel the need to put themselves in the opposition." Emmanuel Berl, *Mort de la morale bourgeoise* (Paris, 1929), like Politzer's *Critique des fondements de la psychologie* (Pittsburgh, Pa., 1994 [1928]), mocked the bourgeois taste for psychology.

34. See Trotsky, *Lénine* (Paris, 1970), preface by Marguerite Bonnet. This glamorizing of vandalism may have helped Breton and Aragon rationalize their own thefts of religious items from churches.

35. See "Lénine et les théâtres d'avant-garde," in Jean Fréville, ed., *Les Grands Textes de Marxisme sur la littérature et l'art* (Paris, 1937), vol. 2, p. 149. *La Critique sociale,* 1 (1931–2), p. 91, notes that the memoirs of Bontch-Brouiévitch described the "profound aversion of Lenin to the works of Mayakovsky," an avant-garde poet then admired by the Surrealists. Trotsky also disliked Mayakovsky, considering him, for all his talent, a bohemian in revolt. Cf. Renée Poznanski, "Intelligentsia. Trois écrivains russes confrontés aux événements révolutionnaires de 1917," unpublished doctoral thesis, Institut d'Etudes Politiques de Paris (1978). After the poet's suicide Breton defended him in "La Barque de l'amour s'est brisée contre la vie courante," *LSASDLR,* 1 (July 1930), pp. 16–22. Countering Trotsky, he praised Mayakovsky (p. 21) for proclaiming "the absolute inanity of 'proletarian art.'"

This was the period when Breton began leaning toward Aragon's Stalinism, and his defense of Mayakovsky against Trotsky conformed to the official position maintained by party apologists like Anatoly Lunacharsky (and Aragon's mistress Elsa Triolet, an old friend of Mayakovsky's). Lunacharsky's "V. Mayakovsky Innovator" (1931), in *On Literature and Art* (Moscow, 1973), p. 201, denounced the "squalid and bankrupt" politics of Trotsky and labeled him philistine for having criticized the revolutionary authenticity of Mayakovsky.

36. See "Les Intellectuels et la Révolution," Pierre, *Tracts,* vol. 1, pp. 62–3, published originally in *L'Humanité* (November 8, 1925): "There never was a Surrealist theory of revolution ... the Revolution is the group of events which determines the passing of power from the hands of the bourgeoisie to those of the proletariat, and the maintenance of this power through the dictatorship of the proletariat." Needless to say *L'Humanité* welcomed such submission to the French Communist Party and to the International.

37. See Robert Short, *Dada and Surrealism* (London, 1980), p. 165.

38. Artaud promoted his ideas of Surrealism as a state of rich confusion beyond concrete political engagements and stated in March 1925 that "Surrealism *is* life." See Breton, *OC,* supplement to vol. 1, p. 180.

39. On Naville, see Dumas, *Desnos,* p. 122: "An important event influenced the destiny of the periodical *Clarté* (in its new series), which was not without repercussions on the evolution of the most advanced Surrealists; viz., Pierre Naville's joining of *Clarté.* (It was owing to Naville's stimulus that the new series of the periodical was launched and that the review, no longer hesitant as it had been, resolutely turned toward the social, economic and political. One is struck with the regularity and importance of Naville's collaboration during the years 1926–27.)"

40. See Naville, *La Révolution et les intellectuels. Que peuvent faire les surréalistes?* (Paris, 1927, [1926]).

41. "*Légitime Défense*" (Self-Defense) was published in *La Révolution surréaliste,* no. 8 (December 1, 1926), pp. 30–6.

42. See "Protestation," *La Révolution surréaliste,* no. 7 (June 1926), p. 31, and Pierre, *Tracts,* vol. 1, pp. 64–5.

43. For a study of the effect of introducing the chronometer into the workplace, see E. P. Thompson, "Time, Work-Discipline, and Industrial Capitalism," *Past and Present*, 38 (1967), pp. 56–97.

 L'Illustration, no. 814 (April 8, 1916), carried an ad for "LA MONTRE DE LA VICTOIRE" that shows a soldier wearing a LIP watch. As he prepares to throw a grenade he says: "Good watch stores sell the line of LIP clocks, wrist-watches and chronometers.... [They] are adapted for controlling the accuracy of artillery barrages and of French bombers."

44. Published in Breton, *Point du jour*, p. 7.

45. The novelist Marguerite Duras, a friend of the Surrealists, in conversation with Jean Schuster, explained that Rimbaud replaced the search for the ineffable in poetry by the quest for gold in order ironically to equate them: "The spirit of inanity displayed here by poetry extends to and crowns every quest." See *Archibras*, no. 2 (October 1967), p. 13.

46. Symbolists like Sar Peladan already produced metaphors linking gold and time, and Blaise Cendrars wrote the novel *Or* before 1924 about the California Gold Rush. In *Entretiens*, p. 204, Breton described his visit to the ghost towns of Nevada and New Mexico, "vestiges of the 'gold rush.'" Gérard Legrand, *André Breton en son temps* (Paris, 1976) makes the issue of time central to Breton's thought and discusses "l'or du temps" but without my emphasis or my allusion to the implied pun on "hors." Cf. notes to Breton, *OC*, vol. 2, pp. 1440–1. The phrase bears comparison with "l'Air du temps" (included in "Le Mouvement perpétuel"), the title of a poem of Aragon's of 1920 – in its turn comparable to Duchamp's *Air de Paris* (1919).

47. See Breton, *OC*, vol. 1, p. 620.

48. See the joint letter from Breton and Aragon describing an ideal library to Doucet in Breton, *OC*, vol. 1, p. 633: "it is understood that we think that you should have the complete works of Bergson." However, on a list of authors to read or avoid, jointly signed by the Surrealists and published in 1931, Bergson was placed in the second group. See Pierre, *Tracts*, vol. 1, p. 202.

49. See Henri Bergson, *L'Evolution créatrice* (Paris, 1966, p. 317 [1907]).

50. Breton, *OC*, vol. 1, pp. 995.

51. Bonnet, in Breton, *OC*, vol. 1, p. 1446, n. 3, notes that his "obituary simply had after his name and date the phrase 'Je cherche l'or du temps.'" Breton had long before with black humor recorded his vital statistics: "André Breton (1896–19...)." He left the precise date of his death for others to fill in. *La Révolution surréaliste*, no. 3 (April 1925), published a translation from the German, "L'Europe et l'Asie," by Théodore Lessing, which compared the East's sense of being outside time (*hors du temps*) with the European involvement with the historical and temporal. It begins (p. 20): "The East dreams and breathes in a vital substance in which man and his conscious world are plunged once and for all: outside time (*hors du temps*) and absolutely. We Europeans, on the other hand, even think of what is behind the world, of metaphysics, as 'historical process,' therefore *temporal*."

52. See Desnos's article "André Breton ou 'Face à l'infini,'" *Littérature*, n.s., 13 (June 1924), p. 13. Baudelaire already engaged this question.

53. See Marie-Claire Dumas, *Robert Desnos, ou L'Exploration des limites* (Paris, 1980). Desnos may have found a model in Jarry's burlesque essay on the Crucifixion as a bike race. A photo entitled "Manifestation du Front Populaire, à la Bastille, en juillet 1930" shows workers in the street, with big poster portraits of Marat, Degeyter, Rouget de Lisle, Robespierre to the left and a large ad for "AVON CADUM" with the head of Baby Cadum to the right. See Roger Porteau, *Pantin* (1982), p. 152, with a photo by "Marie."

54. We may see here the thread of associations that carry Breton's imagery from one phase to another in his career: the wireless telegraph – an image already used by Apollinaire in *Zone* and by Drieu de la Rochelle in *Littérature* (January 1920), pp. 8–9 – appears at the end of *Nadja* as a message sent from Sand Island by an anonymous aviator in trouble. One might note that the aviator in Antoine de Saint-Exupéry's *Courrier Sud* (1929) links the phrases "hors du temps" and "hors d'espace." The struggle with images of time led Breton in *L'Amour fou*, p. 170, to write: "*Forever*, as on the white sand of time and by the grace of that instrument that serves to count time ... reduced to an endless trickle of milk from a glass breast." Breton also remarked (p. 75) that "true love is not subject to any appreciable alteration in duration (*durée*)." Breton's play on time and the timeless resembles Picabia's labeling as an

American girl an ad for a sparkplug marked "Forever."

55. The Surrealists attended in February 1921 a performance of *La Boutique fantasque* and *Tricorne* put on by the Ballets Russes, at which performance a fur disappeared from the loge. Aragon reports that when Eluard expressed anxiety about a possible scandal, Breton retorted devilishly (perhaps with the scandal about Apollinaire and a theft from the Louvre or the famous fifteenth-century poet-thief François Villon in mind), "I'd rather pass for a thief than for a poet." See Jean-Charles Gateaux, *Paul Eluard, ou Le Frère voyant, 1852–1952* (Paris, 1988), p. 82. In their *Notes sur la poésie* (1936), Breton and Eluard wrote an epigraph that both signed: "One must take from Caesar whatever does not belong to him." Two admired figures in Breton's *Poisson soluble* of the early twenties were Prometheus, the creative thief of fire, and the popular film character Fantômas, the master criminal (Breton concluded the last section of *Poisson soluble* identifying himself with Fantômas).

56. Breton's great mentor Apollinaire so titled one of his works. One thinks also of the golden bough brought up from the underworld in Virgil's *Aeneid,* a book known by Breton, who also knew and praised Frazer's *Golden Bough,* which was translated into French in 1924. See his essay "Autodidacts called 'Naives'" (1942) in *Surrealism and Painting* (New York, 1965), pp. 291–4.

57. Breton, in his preface to a Man Ray album, *Les Visages de la femme* (October 1933), in *Point du jour,* p. 161, speaks of "bright faces gathered outside time (*hors du temps*), faces of living women."

58. The interview was published in Breton, *Entretiens* (Paris, 1969), p. 302.

59. Cf. Andrew F. Stewart, "History, Myth, and Allegory in the Program of the Temple of Athena Nike, Athens," in H. L. Kessler and M. S. Simpson, eds., *Pictorial Narrative in Antiquity and the Middle Ages,* Studies in the History of Art, vol. 16 (Washington, D.C., 1984), pp. 63–4, who says, referring to the decoration of a classical Greek temple, "As anthropologists have long recognized, such memory-images (here fixed in long-enduring media) implicitly function not only to validate but to eternalize and mythicize the values of the present by taking them 'out of time,' as it were."

60. See "Introduction au discours sur le peu de réalité" (1924), in *Point du jour,* p. 23, for the phrase "Mamelle de cristal," which Breton interprets as "a glass decanter." The metaphor of crystal, which Breton applied to the crystal house – hence, associated with his father's former job – as well as the breast, seems to have permitted him a rare symbolic union of his father and mother! In Chapter 4 I discuss further Breton's use of the metaphor of crystal.

61. See Gregory Zilboorg, "The Sense of Immortality," *Psychoanalytic Quarterly,* 8 (1938), p. 171, and Betram D. Lewin, *The Psychoanalysis of Elation* (New York, 1950). Cf. Nietzsche's well-known thought that joy strives for eternity.

62. The circulation in fin-de-siècle France of the idea of the "supreme point" may owe something to the influence of Schopenhauer's notions of the union of subject and object, individual and universal. See Richard Shiff, "The End of Impressionism: A Study in Theories of Artistic Expression," *Art Quarterly* (Autumn 1978), p. 355, citing Charles Lévêque, "L'Esthétique de Schopenhauer," *Journal des Savants* (December 1874), pp. 785–7. But Schopenhauer's quest for a fundamental reality and his predilection for ascetic mysticism made him repugnant to Breton. Cf. the evaluations of the "Liquidation" of 1921 and the list of authors "Read/Do not read" of 1931. In *Nadja* (p. 102) Breton states that in games the other players often identified him with the dolphin. Perhaps he knew that in old allegories this animal signifies the idea of arrested motion. Even late in life Breton pursued this desire, adding to Hegelian dialectics an interest in Stéphane Lupasco's *Logique et Contradiction* (Paris, 1947), a book that influenced Ionesco.

63. Sartre opposed the "time" of "Cartesian rationalism," and argued in *Search for a Method,* (New York, 1963), p. 92: "Neither men nor their activities are *in time,* but ... time, as a concrete quality of history, is made by men on the basis of their original temporalization. Marxism caught a glimpse of true temporality when it criticized and destroyed the bourgeois notion of 'progress' – which necessarily implies a homogeneous milieu and coordinates which would allow us to situate the point of departure and the point of arrival." All this should be seen in the context of post-Kantian (Hegelian) efforts to incarnate the absolute in time. Kant had considered space the form of the outer sense, time that of the inner sense,

of self-perception (for him beauty corre-
sponded to the stasis and boundedness of
space, the sublime to motion). Breton, who
(like Kandinsky) constantly tried to "bridge"
outer reality and inner meaning, considered
Hegel's dialectic a solution of the problem of
uniting the two.

64. Proust already faced the issue of working with
time in terms that anticipate Breton's. See "A la
recherche du temps perdu," *La Nouvelle Revue
française,* 15 (1923), pp. 35–6, where he at-
tempts to transcend the contingencies of time:
he thinks that by uniting sensations in a
metaphor, he can disengage what he considers
their (timeless) essence. Proust, moreover,
anticipated Reverdy's and Breton's idea of
uniting distant realities in a poetic image or a
metaphoric moment of recollection, but unlike
them he limited the incongruity or disjunction
between those realities, since he wished
through his art to give pleasure, rather than to
shock (or "surprise" as Apollinaire put it) or
disturb.

65. See Georges Poulet, *Proustian Space* (Balti-
more, 1977), p. 105. For the view that the loss
of a temporal dimension entails a negation of
narration and history, see Robert Weimann,
*"New Criticism" und die Entwicklung bür-
gerlicher Literaturwissenschaft* (Halle, 1962).

66. See Philip Rahv, "The Myth and the Power-
house," in *Literature and the Sixth Sense*
(Boston, 1969), pp. 201–15.

67. For Breton's remark see *Surrealism and Paint-
ing,* p. 32. For Villiers de l'Isle-Adam and
Hegel, see Chapoutot, *Villiers de l'Isle-Adam,*
pp. 96ff., who quotes the following striking
passage from Hegel (based, I think, on Kant's
Critique of Pure Reason): *"L'Etre éternel n'est
pas l'être qui est hors du temps, mais c'est l'être
qui contient le temps."* Villiers was also inter-
ested long before Breton in the esoteric doc-
trines of Lulle.

68. See "The Most Recent Tendencies in Surreal-
ist Painting" (1939), in *Surrealism and Paint-
ing,* pp. 148–9.

69. Breton would have felt repugnance for the
nationalism and academicism of the French
analysts who, as they were about to constitute
in 1926 the Société Psychanalytique de Paris,
sent Freud a gift for his seventieth birthday of
the works of the detested Anatole France,
considered an enemy of the avant-garde.
Freud himself admired France, whose name
recurred after 1908 in Freud's correspondence

with Ferenczi (who praised France for his
psychological perception).

70. See "Au grand jour," in Pierre, *Tracts,* vol. 1,
pp. 67–77.

71. See Artaud "A la grande nuit ou le bluff
surréaliste," *Cahiers du sud,* 1 (June 1927), pp.
67–74. See also Artaud's "Cinéma et réalité," a
discussion of the film *La Coquille et le clergy-
man,* in *La Nouvelle Revue française* (Novem-
ber 1, 1927), pp. 561–7. Doubtless with the
Surrealists in mind, Artaud denied that pure
cinema could have a psychological basis or
reproduce dreams.

72. See Julien Benda, *La Trahison des clercs* (Paris,
1975), pp. 131, 97.

73. See, e.g., Hegel, *Ésthétique de la peinture
figurative* (Paris, 1964), p. 57, for a discussion
of Romantic art: "The mind, which rests on the
principle of self-adaptation, on the union of
concept and reality, can only find an existence
in conformity to its nature in its own world, in
the mental sphere, in its own soul with the
sentiments it contains; in brief, in its most
intimate and profound interiority. The mind
thus acquires the awareness of having in itself
its 'Other.' " Hegel's "Other" was featured in
Alexandre Kojève's lectures on the phenom-
enology of mind given in Paris between 1933
and 1939.

74. See René Daumal, "Lettre ouverte à André
Breton sur les rapports du surréalisme et du
Grand Jeu," *Le Grand Jeu,* no. 3, (1930), pp.
191–5.

75. Montesquieu, "Essai sur le goût dans les
choses de la nature et de l'art," in *OC,* vol. 2, p.
1258, (Paris, 1951 [1757]), says, "The base is
the sublime of the people, which wishes to see
things made for it and that it is capable of
understanding." And Boileau, *Art poétique,* vol.
1, v. 79, advises: "Whatever you write, avoid
baseness: / Even the least noble style has its
own kind of nobility." In this most important
document of classical French literature, "bas"
and "bassesse" are opposed to "noble" and
"noblesse."

76. Opposed to Bataille, both Breton and Péret
thought of the poetic imagination in terms of
sublimation. Péret wrote a collection of poetry *I
Sublimate* in 1938 and edited *Anthology of
Sublime Love* in 1956.

77. For material relevant to what one might call
"excremental criticism" see Freud, "The Most
Prevalent Form of Degradation in Erotic Life,"
Collected Papers (London, 1950), vol. 4, p. 215:

"The coprophilic elements in the instinct have proved incompatible with our aesthetic ideas, probably since the time when men developed an upright posture and so removed his organ of smell from the ground." See also Gandelman, *Reading Pictures*; on Bataille's scatology as a criticism of Breton, see Denis Hollier in *Against Architecture: The Writings of George Bataille* (Cambridge, Mass., 1989), pp. 109, 112. Apparently in contradiction of Breton's statement that the Surrealists are collectors rather than fetishists, Bataille wrote sarcastically in "L'Esprit moderne et le jeu des transpositions," *Documents*, 8 (1930), pp. 50–1, "What one really loves, one loves above all in shame, and I defy any amateur of paintings to love a canvas as much as a fetishist loves a shoe."

78. See "Le Peintre et ses fantasmes" (1956), in Will-Levaillant, *Masson Rebel*, p. 31.

79. A committee meeting on October 19, 1925, announced a forthcoming exhibit of Surrealist painting intended to have a revolutionary import and "to contribute to the destruction of bourgeois art." See *Archives du Surrealisme*, vol. 2, p. 49.

80. See the last chapter of Céline's *Death on the Installment Plan* (1933).

81. Freud, in his "Revision of the Theory of Dreams," in *New Essays,* interprets the labyrinth as a myth of anal birth, with the winding passages corresponding to the intestines and Ariadne's thread to the umbilical cord. We know how important de Sade was to both Bataille and Breton, and that the Marquis's writings seem dominated by anal imagery. As one example, in *100 Days in Sodom* he describes the eating of feces and placing them on the vagina in intercourse. Cf. also Chasseguet-Smirgel, who – in terms akin to Bataille's – replaces sublimation with anality as a motive for transcending the ordinary. See her "Perversion and the Universal Law," *International Review of Psycho-Analysis*, 10, (19XX), pp. 293–301. For Bataille and the labyrinth see Foster, *Compulsive Beauty*.

82. Marcel Mauss's "Essai sur le don," published in *L'Année sociologique*, 1, (1923–4), is specifically quoted in Bataille's "La Notion de dépense," *La Critique sociale*, no. 7 (January 1933), p. 10. The article following, in the same issue, by J. Dickmann, criticizes Marx's theories expounded in *Capital.* Though not an anthropologist like Mauss, Veblen, in developing his theory of conspicuous consumption,

resorted to examples of "primitive" (what he calls "barbaric") society.

83. The artists and critics associated with the English Constructivists founded the Artists' International Association in 1933 precisely in opposition to Hitler's seizure of power and to Fascism in general. See T. Rickaby, "Artists' International," *History Workshop Journal*, no. 6 (1978), p. 155. Breton was more exercised over French imperialism than over Nazi rearmament, and in his "Discours au Congrès des Ecrivains" delivered in Paris, June 1935 (*OC*, vol. 2, p. 455), he stated his agreement with the "manifesto" of the Comité de Vigilance des Intellectuels that "it is not the right way to persuade the German people [on disarmament] to claim that Hitler (alone of all governments both capitalist and fascist) intends to make war."

84. In the political disarray of 1935 the Nietzschean Bataille, fascinated by the pagan rituals of Fascism (linked more to Germany than Italy) and the independent Marxist Souvarine, produced a tract for the first issue of the periodical *Contre-attaque* against the Front Populaire and proposed a Fascism of the extreme left, a "surfascisme" (in the word of Jean Dautry). For a moment in 1935–6 Breton and the Surrealists supported Bataille's group, but they withdrew from its apparent sympathy toward Fascist-like violence and the cult of force.

85. See Pierre Naville, *La Révolution et les intellectuels. Que peuvent faire les surréalistes?* (Paris, 1927 [1926]).

86. See "Légitime Défense," *La Révolution surréaliste*, no. 8 (December 1, 1926), pp. 30–6.

87. See Breton, "Rapports du travail intellectuel et du capital" (Relations of intellectual work and capital), *Point du jour,* pp. 84–7. Originally published in *LSASDLR* (October 1930), p. 2, in response to a questionnaire in *L'Esprit français* (August 15, 22, 1930). Cf. Zeldin, *France: 1848–1945,* p. 1121: "The definition that every person whose work involves more mental than physical labour is an intellectual was adopted by the International Confederation of Intellectual Workers at their fifth congress in 1927." Ernesto Grassi, "Die Funktion der Arbeit und der Phantasie: Das Problem," chap. 5, sec. 7, of *Humanismus und Marxismus: Zur Kritik der Verselbständigung von Wissenschaft* (Reinbeck, 1973), points out the interconnection between work and mental image. For a caricature of the

mundane "salaried" aspect of the prostitute, see the depiction (1910?) by Duchamp of a female taxi driver missing from her cab before a hotel with the meter running. Kant distinguished between mercenary art (*Lohnkunst, Handwerk*) and free art. Freud connected intellectual work and sexual excitement in chapter 2, "Infantile Sexuality" of *Three Essays on the Theory of Sexuality* (Paris, 1923).

88. See Breton, "Rapports." Hegelian Marxists understood the mental aspect of all labor in terms formulated by Hegel; for as noted by Donald P. Verene, *Hegel's Recollection* (Albany, N.Y., 1985), p. 74, to Hegel "the work of the servant must have involved thinking in some sense. It must not have been simple *Arbeit* but must have also involved a mental dimension, *Gedankenarbeit.*" Hegel presumably drew inspiration from the "verum/factum" epistemological principle (the true and the made are interchangeable) advanced by Vico. See Martin Jay, *Marxism and Totality* (Berkeley, 1984), pp. 34–5, 54. Bergson's equation of *Homo faber* and *Homo sapiens* seems to belong to this tradition. "To him the role of intelligence is first of all to fabricate solid tools to be used on other solids; that is why it can apprehend only discontinuous and inert beings and is unable to understand life in its continuity and progression; drawn naturally to inert matter, it gives rise to a mechanistic physics to which it tries in vain to relate biology." See Emile Bréhier, *Contemporary Philosophy* (Chicago, 1969 [1932]), pp. 126–7. The Dadaists had a different view of intellectual work; for example, see Huelsenbeck's manifesto of 1920, "En avant Dada," in Motherwell, *The Dada Painters and Poets* (New York, 1951), p. 42: "The Central Council demands ... the most brutal struggle against all ... so-called 'workers of the spirit' ... against their concealed *bourgeoisism.*" For tensions between intellectuals and workers see Alvin Gouldner, *The Two Marxisms: Contradictions and Anomalies in the Development of Theory* (New York, 1980). The idea that the intellectual was also a worker was common in Left circles; cf. the Socialist Charles Hotz, *L'Art et le peuple* (Marseilles, 1910), p. 44: "The true artist is not the worker's enemy.... They are brothers in pain. If one is a manual worker, the other is the proletarian of thought." Simone Weil found in their common need for contempla-

tion a similarity between intellectual and manual labor; in 1934–5 she ruminated over Marxism and proletarian revolution as she worked in a factory. While she perceived the demeaning nature of the labor, she identified deeply with and respected her fellow workers. See E. Piccard, *Simone Weil* (Paris, 1960), especially chap. 4, "Le Travail manuel et la condition ouvrière," pp. 127ff. Already in 1920, at the height of Dadaism, Jacques Rivière, in "D'une organisation du travail intellectuel," *La Nouvelle Revue française* (March 1920), pp. 317–20, cited in P. Hebey, ed., *L'Esprit NRF* (Alençon, 1990), pp. 278–9, wondered whether, considering "the tendency toward the progressive socialization of human activities ... the moment had arrived when the average intellectual worker will have to remove all private concern (*dessein*) ... and reduce the part played by the unknown and chance."

89. Stalin called writers "the engineers of the soul," an analogue of "social engineers."

90. This appears in a footnote to "La force d'attendre," in Breton, *OC,* vol. 1, pp. 917–21. Breton (p. 921) also explicitly contests the need "for greater specification by certain of us" (presumably meaning avante-garde intellectuals).

91. See Robert Short, *Dada and Surrealism* (London, 1980), p. 165.

92. See Poznanski, *Intelligentsia,* p. 234.

93. See the cover, "Et guerre au travail," *La Révolution surréaliste* no. 4 (July 1925). Jean-Michel Pianca, "Et guerre au travail," *Mélusine,* 5 (1983), p. 37, claimed, with some exaggeration, that the Surrealists opposed work "because they are perfectly aware of the central role played by work in the organisation of industrial, bourgeois and capitalist society and in the disposition of ideology."

94. See Aragon, "Fragments d'une conférence," *La Révolution surréaliste,* no. 4 (July 1925), p. 24. A manifesto by Huelsenbeck, "En avant Dada" (Hanover, 1920), demanded "the introduction of progressive unemployment through comprehensive mechanization of every field of activity. Only by unemployment does it become possible for the individual to achieve certainty as to the truth of life and finally become accustomed to experience." Cited in R. Motherwell, *The Dada Painters and Poets,* (New York, 1951), pp. 41–2.

95. See *Variétés,* special issue (Brussels, June 1929), pp. 43–6.

96. See their letter of October 23, 1927, "Permettez!" Bataille's circle was equally antagonistic to work, and his *Documents*, 2 (1930), p. 103, quotes sympathetically under the rubric "Travail" a remark by the artist Kees van Dongen that work is a "thing as ostentatious, ugly and false as Justice." For resistance to work during this period see Michael Seidman, "Towards a History of Workers' Resistance to Work: Paris and Barcelona during the French Popular Front and the Spanish Revolution (1936–38)," *Journal of Contemporary History*, 23 (April 1988), pp. 193–219.

97. Breton opposed the bourgeois notion of morality formulated, for example, by Pierre Janet in *De l'angoisse à l'extase,* vol. 1, p. 229: "Work and effort are tendencies superior to reflection.... The value of a man is measured by his capacity to perform drudgery."

98. On April 7, 1923, Breton wrote: "André Breton n'écrira plus." In *OC*, vol. 1, pp. 1214–6. He added: "I do not want to work... I believe that work brutalizes. The mind functioning in a vacuum creates the best results. Evidently the mind requires a bit of input [from the world] which it will get particularly from love, indeed the most disordered love."

99. See Alquié's letter to Breton published in *LSASDLR*, no. 5, (May 1933), p. 43. Though pressured to disavow this letter if they wished to remain members of the radical artist and writer group, the Association des Ecrivains et Artistes Révolutionnaires (AEAR), the Surrealists refused to do so. Paul Nizan presented the official view of the letter in *Commune*, no. 1 (1933), pp. 85–6, organ of the AEAR: "The profound separation between Surrealism and the revolutionary masses is increasing. Social and political themes are being abandoned in favor of premature experiments on 'the irrational knowledge of the object.'" Still, he praised the publication in the same issue containing the notes of Lenin on dialectic and excerpts of a lecture by Breton on proletarian literature. However, he criticized Breton's contribution to *Le Minotaure*, a "slick magazine in which the politics of picture dealers is quite cynically put on display."

100. See "Manifeste art prolétarien," *Merz*, 2, no. 1 (Hanover, April 1923), signed by T. van Doesburg, J. Arp, K. Schwitters, and T. Tzara. This remarkable and precocious manifesto asserts that art has no relation to a specific class and asks, "What is proletarian art?" It notes that the proletarian who produces art thereby ceases to be proletarian and becomes an artist. Religious art, patriotic art, or scenes showing "the red army led by Trotsky or the imperial army led by Napoleon" have little to do with artistic value and are all alike; indeed, "Proletkult" is equivalent to "Bourgeoiskult." "The art we want is neither proletarian nor bourgeois, because it develops forces powerful enough to influence the whole culture instead of being influenced by social relations. The proletariat is a condition that must be surpassed, as is the bourgeoisie."

101. In a letter of April 2, 1927, addressed "aux communistes," in "Au grand jour," in Pierre, *Tracts*, vol. 1, p. 76, the Surrealists stated their concurrence with objectives of the Communist Party, among them "defense of workers' pay... complete respect for the 8 hour [day]... [and] the struggle against unemployment."

102. For the position that the Surrealists were in fact anarchist, see Annie Kriegel, *Les Communistes français: Essai d'ethnographie politique* (Paris, 1968), and James Joll, *The Anarchists* (Boston, 1964).

103. Lafargue's *Droit à la paresse* (1883) was discussed in 1931 by Tristan Tzara in his article "Essai sur la situation de la poésie," *LSASDLR*, 4 (1931), p. 23. The idea had already been formulated by Fourier, an author equally admired, at a later date, by Benjamin, Bataille, and Breton. On Benjamin and Fourier, see Susan Buck-Morss, who, in *Walter Benjamin et Paris*, p. 400, cites the *Passagenwerk*, p. 456. On Lafargue, see Breton's "The Political Position of Surrealism" of 1935, in Breton, *OC*, vol. 2, p. 412. See also the Lassallean writings of Charles Longuet in the 1880s. William H. Sewell, *Work and Revolution in France* (Cambridge, 1980), p. 249, observes that in 1848 "the RIGHT TO LABOR" was demanded by workers: "The fundamental premise of workers' discourse in 1848 was that labor was the source of all wealth and happiness." Richard Shiff's article on nineteenth-century studies in *Art Bulletin* (March 1988) relates art historical questions to bourgeois conceptions of leisure. Cf. Margaret Mead, "Work, Leisure, and Creativity," *Daedalus* (Winter 1960), pp. 13–23. The bohemian label attached to the artist ever since Romanticism was applied again to the Impressionists, as in Daumier's caustic litho-

graph *Au Travail*, which shows two artists reclining on the grass beside their easels, while the sun "works" on their canvases. For the complexities of expectations and constraints on leisure and recreational activities, see S. Hollis Clayton's dissertation *Venal Love and Modern Paris: Prostitution in French Art, 1876–1886.*

104. For the development of a metropolitan culture in France independent of "any generalized development of industrial capitalism," see Nicholas Green, "Circuits of Production, Circuits of Consumption: The Case of Mid-Nineteenth Century French Art Dealing," *Art Journal,* 48 (Spring 1989), pp. 29–34.

105. It has been claimed that "Surrealism, the sublime joke of the arts, amused people more in the desperate days of the 1930s than in the post–World War I years of its conception." Michael Batterberry and Ariane Batterberry, *Fashion, the Mirror of History,* 2nd ed. (New York, 1982), p. 319. The modicum of truth in this remark suggests the loss of critical tension that marked the decline of Surrealism as a radical movement.

106. Surrealism's critics have wondered whether through formulation in poems and manifestos and through routinized scandal, even the anti-bourgeois erotic reflex did not yield its own codification.

107. In his *Anthologie de l'humour noir* (Paris, 1966), pp. 64–5, Breton cites Marx's comparison of Fourier's *séries passionnelles* to the *méthode hégélienne,* and Engels's praise of Fourier as "un des plus grands satiriques." For Marcuse, *Eros and Civilization* (Boston, 1966 [1950]), chap. 2, the irreconcilable conflict is not between the reality principle and Eros (pleasure principle), but between *alienated* labor (performance principle) and Eros. To Marcuse loosened sexual taboos do not mean liberation of Eros, but its channeling, for programmed leisure is not freedom. This view, and his admiration of Fourier's *phalanstère* as a social organization that could make pleasure and end repression, bring Marcuse (and the German Sexpol movement of the sixties he contributed to) close to the viewpoint of the Surrealists. The radical youth of 1968 in America and Europe found such ideas sympathetic. Marcel Duchamp once said, "You paint because you claim you want to be free. You don't want to go to the office every morning." See Pierre

Cabanne, *Entretiens avec Marcel Duchamp* (Paris, 1967), p. 37. In this remark he approaches close to the creative laziness or schoolboy dreaming of the Surrealists already presented in some passages of the *Champs magnétiques.*

108. In "1905. La Grève d'Octobre," published in *Clarté* (1924), pp. 129–30, Trotsky wrote: "The general strike creates favorable conditions for this shock. The method is brutal, but history knows no other."

109. See Breton, "La dernière grève," *La Révolution surréaliste,* no. 2 (January 15, 1925), pp. 1–3. For Duchamp see his writings on the *delai en verre.* Huelsenbeck and Hausmann wrote in their Dada manifesto: "Dadaism demands . . . the introduction of progressive unemployment. . . . Only by unemployment does it become possible for the individual to achieve certainty as to the truth of life and finally become accustomed to experience. . . . II. The Central Council demands . . . the most brutal struggle against all . . . so-called 'workers of the spirit' . . . against their concealed *bourgeoisism.*" The Purist Ozenfant asserted in 1918 under the heading of "L'Esprit moderne," in Charles Jeaneret-Gris and Amédée Ozenfant, *Après le Cubism* (Paris, 1958), p. 26, that "the current evolution of work is leading through the useful to synthesis and order."

110. Breton, *OC,* vol. 1, p. 894. On Sorel see Kern, *Culture,* p. 103: "A pioneer of social psychology, Sorel conceived of political action as theater and believed in the necessity of creating a sense of urgency, a movement toward climax, that would give the workers a profound and lasting impression of revolution. He drew from Bergson's theory that intuitive knowledge was superior to analytical knowledge and worked out a plan by which workers would intuit socialism as a whole, instantaneously, in the drama of a general strike." See Georges Sorel, *Reflections on Violence* (New York, 1961 [1906]), pp. 124–5.

111. Aragon already in "Pour arrêter les bavardages" of 1924 approved of the expression "A bas les flics" attributed to him.

112. In *Du Surréalisme en ses oeuvres vives* (Paris, 1953), in *André Breton: Manifestoes of Surrealism* (Ann Arbor, Mich., 1960), p. 298, Breton wrote: "In opposition to the illusory stream of conscious associations Joyce will present a flux which finally tends toward the closest possible *imitation* of life (by means of which

he keeps himself within the framework of *art* ...) ... against this same conscious current [is] 'pure psychic automatism,' which is the guiding principle of Surrealism."

113. See the unsigned review in *La Critique sociale*, no. 4 (December 1931), p. 186, probably by Souvarine, of Aragon's poem in the issue of *La Littérature de la révolution mondiale:* "[His] breathless *Front rouge* expresses only the obstinate misunderstanding evidenced by the Stalinist bureaucracy of the living conditions of the workers and peasants in all countries."

114. See Aragon, *Aragon parle avec Dominique Arban* (Paris, 1968), pp. 7 and 73. The last words of Nadeau, in his *History of Surrealism*, p. 230, would agree with the position that metaphor had no political significance: "Until further notice, we must resign ourselves to considering Surrealism as a literary school ... / Then after it will come, perhaps, those who will truly put an end to metaphors." For an opposite evaluation of the place of metaphor in politics, see Alvin W. Gouldner, "The Metaphoricality of Marxism and the Context-Freeing Grammar of Socialism," *Theory and Society,* 1 (1974), pp. 415–40.

115. Savitry frequented Montparnasse between 1920 and 1927 and was good friends with Desnos. Aragon wrote for the catalogue of his first exhibition, organized by Zborowsky in 1929. His biography was written by Elsa H. Savitry in 1971.

116. See Aragon, *Aragon parle*, p. 86, n. 1. Béhar, *Breton*, p. 233, has puzzled over Breton's apparent sympathy for Stalin's Russia and sought to resolve the question by examining the archives of the French Communist Party that were recently returned to France by the Soviet Union. However, he found nothing useful.

117. D. B. Riazanov, called by *Izvestia* (March 10, 1930) "the outstanding Marxist scholar of our times," was arrested in February 1931. Souvarine admired Riazanov, and in the pages of *Critique sociale*, no. 2 (July 1931), p. 50, he powerfully indicted the Stalinist bureaucracy for their actions against him: "In 1924 Riazanov spoke the following words of approbation at the Académie Socialiste at the moment when it adopted the name Communiste: 'I am not Bolshevik, nor Menshevik, nor Leninist. I am only a Marxist, and as a Marxist, I am a Communist.' This statement, already considered subversive at the time, is nowadays considered in a Russia claiming to be Soviet, as a crime of high treason to the dictatorship (*lèse-dictature.*)" The Surrealists perceived the utopian aspect of the Trotskyists' belief in the existence of a French "workers' party" and made very astute criticisms of the limits of Marxism. See "Lettre au P.C.I., section française de la Quatrième Internationale, à propos des élections présidentielles," in Pierre, *Tracts*, vol. 2, p. 240, and "La Plate-forme de Prague," April 1968, ibid., p. 280, where Surrealists regret the need of Marx and Engels to dismiss important thinkers like Stirner, Proudhon, Bakunin, and Fourier, adding that they perceived the necessity "to distinguish, in Marx's thought, that which legitimated Stalinism from that which made Stalinism impossible."

118. See Breton, *OC,* vol. 1, p. 822. The First Manifesto has a collage "poem" with correct syntax. See ibid., pp. 341–3. William James already formulated what later became Surrealist practice in his *Principles of Psychology* (New York, 1890), chapter 9, "The Stream of Thought," p. 264: "Nonsense in grammatical form sounds half rational, sense with grammatical sequence upset sounds nonsensical; e.g., 'Elba the Napoleon English faith had banished broken to he Saint because Helena at' " (for "The English banished Napoleon to St. Helena, because he had broken faith at Elba"). That a sentence – the fundamental Surrealist element (and the only one ordered syntactically) – can imply a whole discourse emerges from the work of A. J. Greimas, *Sémantique structurale* (Paris, 1966). See Hawkes, *Structuralism and Semiotics*, p. 91, who notes that Greimas shows that "the semantic structure of sentences will imprint itself on much larger entities. As Culler says, one of the chief functions of this scheme 'is to make the structure of the sentence roughly homologous to the plot' of a text." An insight of a structural character seems to underlie the replaceability of the components: a favorite comparison of Saussure's was of the language system with a game of chess. The form or substance of the pieces is irrelevant to their basic definition by their relations to the other pieces and to the board. The Dada perception of game structure preceded and probably influenced the Surrealists. Duchamp and Man Ray invented unusual chess

pieces, and in Hans Richter's film *8 × 8* of 1957 all three along with other ex-Dadaists and Surrealists played and danced a game of "lawn chess."

119. Clifford Geertz found a similar breakdown of the distinction between metaphor and metonymy in Lévi-Strauss's *Tristes Tropiques,* which he called "an ideal-typical Russian/Czech formalist poem: meaning constructed by projecting the analog axis of paradigmatic substitution, Jakobson's 'metaphor,' onto the digital one of syntactic combination, his 'metonymy.'" See Geertz, *Works and Lives* (Stanford, Calif., 1988), p. 33. Cf. Barthes's discussion of paradigm or system in relation to syntagma or metonymy, in "L'Imagination du signe," *Arguments,* no. 27–8 (1962), pp. 118–20.

120. Piaget's analysis of the first stages of the child's developing intelligence revealed to him that nonverbal behavior always preceded the stage of verbal logic. Borrowing his terminology from Saussure, his fellow Swiss, he analyzed the child's first mental images and visual representations in terms of concrete "symbols" – the turning of a stone into a candy, of a stick into a rifle, a flute, or a telescope. Gombrich considered a similar case in his "Meditations on a Hobby-Horse" (1951). Freud in *The Ego and the Id* stated that visual images are more primitive than verbal ones.

121. See Claude Cahun, "La Poésie garde son secret" (1934; the title comes from a chapter in Ernst's collage novel, *La Femme sans têtes*), in Nadeau, *Histoire du surréalisme,* vol. 2, p. 388. Aragon argued in "Réalisme socialiste et réalisme français" (1937), that Socialist Realism in France of the time had to base itself on the great tradition of French realism, and in "Du nouveau dans l'art soviétique?" (1957) he claimed to descry among execrable Russian realist paintings new talents and a new experimentalism. Both articles were reprinted in Aragon, *Ecrits.*

122. See Aragon, "Pour qui écrivez-vous?" *Commune* (December 1933), p. 329.

123. See his book *Neue Kunst in Russland, 1914–1919* (Munich, 1920), cited in Herta Wescher, *Collage* (New York, n.d.), pp. 100–101.

124. See Pierre Reverdy, *Gant de Crin* (Paris, 1926), and *Le Livre de mon bord* (Paris, 1930–6), where he states that the poetic image is "absolutely unadaptable to any concrete real object." In fact, as I have tried to show in Chapter 2, this volume, the Surrealists often produce *textes à clé* in which appears a dialectical relationship between the images conveyed by the texts of dreams or poems and the concreteness of selected features of external reality. Of course, they knew that concrete allusions even to raw sexual facts could easily be missed by an audience unfamiliar with their "poetics"; for their practice of seeking unusual poetic images often resulted in extraordinary associations that obscured the sexual allusions. In seeking to interpret Surrealist images we will find the connection between metaphor and image an essential guide. Gérard Legrand in an entry for the *Dictionnaire général du Surréalisme* (Berlin, 1982), s.v. "image," p. 213, justifiably criticized Pierre Caminade's effort to separate image from metaphor in *Image et métaphore* (Paris, 1970). Legrand believes that this separation would lead to an "abstract rhetoric." We find perhaps an instance of that in Paulhan's "La Querelle de l'image," *Clef de la poésie* (Paris, 1944), pp. 71–80 and 72–3. Paulhan claims that critics agree on the nature of Surrealist works as only "leading, in the word of Breton's Manifesto, 'to the production of the most beautiful images.'"

125. Cf. J. Burbank, and P. Steiner, eds., *Structure, Sign and Function: Selected Writings of J. Mukarovsky* (New Haven, Conn., 1978) for the notion of the dialectical transformation of the "immanence" and "autonomy" of the artwork into social, cultural, and historical productions. Mukarovsky (p. 9) says that "the work of art bears the character of a sign. It can be identified neither with the individual state of consciousness of its creator nor with any such states in its perceiver, nor with the work as artifact. The work of art exists as an 'aesthetic object' located in the consciousness of an entire community. The perceivable artifact is merely, by relation with this immaterial aesthetic object, its outward signifier; individual states of consciousness induced by the artifact represent the aesthetic object only in terms of what they all have in common."

126. See Eluard, *OC,* vol. 1 (Paris, 1968), p. 1387, concerning *Les Dessous d'une vie, ou la pyramide humaine* of 1926. Breton made his comments in *Entretiens,* pp. 109–10. In *OC,* vol. 1, p. 982ff., Eluard, while advocating the

independence of artist and poet, indicates that poetry affected the artistic development of Picasso: "In 1910, a painter, Pablo Picasso, discovered in the work of a poet a new means of inspiration. Since then, painters have constantly distanced themselves from description, from the imitation of subjects proposed to them.... In their collaboration painters and poets wish themselves independent. Dependence debases, prevents comprehension and love. There is no model, for the artist who searches for what he has never seen."

127. Naville's article *"Mieux et moins bien,"* published in *La Révolution surréaliste,* no. 9–10 (October 1927), pp. 54ff., expresses disdain for the pessimism of Artaud as a retreat into fantasy and criticizes the pessimism of idealists (Breton's group) involved in contemplation or skepticism rather than serious politics. He speaks for a Marxist pessimism that stimulates actions directed against bourgeois society and for "la vie." Naville's criticism of his old colleagues extended to their literary and artistic interests, as demonstrated in his treatment of a painting by his erstwhile friend Tanguy, *Lost Animals,* which he owned. At some point Naville overpainted it with a portrait of his wife, Denise. The original painting was reproduced – presumably with Naville's permission – in *La Révolution Surréaliste,* no. 8 (December 1, 1926), p. 12, and one might suppose that Naville overpainted it after that date. See Marcel Jean, "Tanguy in the Good Old Days," *Art News,* 54 (September 1955), p. 56. Naville never responded to my letter inquiring about the painting.

128. See Breton, *Manifestoes,* pp. 257–58. Legrand, *André Breton en son temps,* p. 119, n. 1, writes that "around 1960, Breton regretted that this vow had not finally been realized," so perhaps Breton, assuming that he did not again change his mind, had meant the label idea to be taken seriously. See Marcel Jean, *The History of Surrealist Painting* (New York, 1960), pp. 230–1, on the vulgarization of Surrealist images in the thirties through success.

129. In Breton, *Le Surréalisme et la peinture,* p. 280.

130. As Haim Finkelstein has rightly observed, very few such objects were actually produced and circulated.

131. Cf. Maurice Blanchot, "Réflexions sur le surréalisme," *La Part du feu* (Paris, 1949), p. 99: "Surrealism is one of those attempts whereby man claims to discover his totality, an incomplete totality.... (It) seeks a kind of existence different from the 'given,' from the ready made (it doesn't quite know if this 'other' existence can be attained by analysis, by experimental conditions like the unconscious, the dream, abnormal states, by appealing to a secret knowledge buried in history, or if it must be arrived at by a collective effort to change life and the course of things). At the same time Surrealism aims at an absolute event in which man is manifested with all his possibilities."

132. See Gorin, "Vers un art social et collectif universel," *Abstraction-Création,* no. 4 (1935), p. 11.

133. See Adorno, "Looking Back on Surrealism," in Irving Howe, ed., *The Idea of the Modern in Literature and the Arts* (New York, 1967), p. 223. Adorno's view has recently been revived in Foster, *Compulsive Beauty.*

134. See Peter Bürger, *Theory of the Avant-Garde* (Minneapolis, Minn., 1984), pp. 53–4. Cf. Jack Spector, review of Bürger's *Theory,* in *Art Criticism,* 2, no. 1 (1985), pp. 70ff. Bürger's view of the avant-garde's aim of destroying the autonomy of art applies to Surrealism in the twenties much more than in the thirties. Like Bürger, Renato Poggioli's book of the same title fails to distinguish the phases of Breton's career.

135. See Breton, *La Clé des champs,* p. 130.

136. Not long before his death Breton signed the tract "Ni aujourd'hui, ni de cette manière" (April 1966; Pierre, *Tracts,* vol. 2, p. 251), turning down the Trotskyists' invitation to the Surrealists to reconstitute a radical group and insisting on the independence of art and the artist. The will to revolution was again promoted as personal rather than a collective choice. And after Breton's death (in November 1966), the Surrealists explained their refusal to join the Trotskyists in "Les Surréalistes à la section française de la IVe Internationale." See ibid., pp. 253–5.

137. See Andrew Arato, introduction to "Esthetic Theory and Cultural Criticism," *The Essential Frankfurt School Reader* (New York, 1982), p. 191.

138. See the important article by Paul O. Kisteller, "The Modern System of the Arts," *Journal of the History of Ideas,* 22 no. 4 (1951), pp. 496–527, and 8, no. 1 (1952), pp. 17–46.

139. See the *Manifesto,* in Breton, *OC,* vol. 1, p. 316.

4. SURREALISM AND PAINTING

1. Freud, *The Interpretation of Dreams*, vol. 6, *The Dreamwork*, "The Means of Representation of Dreams."

2. See the unpublished letter sent from the Hôtel des Grands Hommes, on January 22, 1919, to Tzara in Zürich. He still admired Ingres in 1921; for in "Liquidation," published in *Littérature* (March 1921), he gave the artist a high score of 17, above Aragon, Ernst, and Picasso, and equal to Arp. Aragon and Eluard also gave Ingres high marks. Curiously, the name of Moreau, an artist admired early on by Breton, does not appear on the list. Picabia placed on the cover of *391*, no. 14 (November 1920) a "Copie d'un autographe d'Ingres" – a legal document concerning his marriage – and comically appended his own name at the end of the letter, so the signature reads "Francis Ingres."

3. A week later Breton wrote to Aragon: "Advertising ceases to be a means and becomes an end. Death of art (for art's sake)" (in Bonnet, *Breton*, p. 153). The qualification, which also appears in a letter to Aragon of April 19 (ibid., p. 153), softens the effect of the phrase in the letter to Tzara.

4. Tzara was not always hostile to art per se; for example, he wrote in "Note 1 sur quelques peintres," written in 1917 on the occasion of the first Dada exhibition in Zurich, first published in his *OC*, vol. 1, pp. 553–4: "With the force of a waterfall Picasso ... poured out experiments with the wisdom of an archangel in an atmosphere of electricity.... In his researches he maintained the attitude of a painter confronting nature, like Rembrandt long ago: he doesn't philosophize.... De Chirico's inner state and his representations of them are externalized. His lines are stiff, his imagination covers us with a green ice; he conducts abstraction along a path of irony that is poisoned and mystical."

5. Freud, who actually spoke of the omnipotence of thought, which he distinguished from the image, parallels the Cartesianism of a Binet, who, in his *L'Etude expérimentale de l'intelligence* (Paris, 1922), argued that words and images are only a kind of clothing for thought, that thought is the interpretation of an image, that it often stands in contradiction to the image, and that it sometimes appears without the help of any image at all. Contrary to a recent theory by Foster, *Compulsive Beauty*, emphasizing the role of trauma in Surrealism, the crucial idea for Breton's group seems to me to remain the "omnipotence of dream." See my review of *Compulsive Beauty* in *Art Journal*, 53, no. 3 (Fall 1994), pp. 108–11.

John MacGregor, *The Discovery of the Art of the Insane* (Princeton, N.J., 1989), p. 274, exaggerates when he claims, "The first manifesto of Surrealism of 1924 contains little that does not derive from *The Interpretation of Dreams* and other early works of Freud." But Freud's book had not yet been translated in 1924. Bonnet, *Breton*, p. 342, observes rightly that "although Freud had aided [Breton] to crystallize his thought ... [Breton] never claimed to be a disciple ... doubtless he still had [in 1924] only an indirect and inadequate acquaintance with *The Interpretation of Dreams*."

6. In his *"Entrée des médiums"* of 1922 Breton spoke of a "psychic automatism," which he compared to the dream state; and Francis Gérard's article, "L'Etat d'un surréaliste," in *La Révolution surréaliste*, no. 1 (December 1924), pp. 29–30, treats automatism in writing without even mentioning art. On the other hand, the English scientist Francis Galton, after writing on word association as access to the unconscious (an anticipation of Jung) in "Psychometric Experiments" (1879), discussed "the automatic construction of fantastic figures through ... allowing my hand to scribble at its own will, while I am giving my best attention to what is being said by others.... I find that a very trifling accident, such as a chance dot on the paper, may have great influence on the general character of any one of these automatic sketches." See his *Inquiries into the Human Faculty* (London, 1907 [1883]), pp. 124–5. In their illustrated article, "Automatic Drawing," published in *Form: A Quarterly of the Arts*, 1, no. 1 (April 1916), pp. 27–30, Austin O. Spare and Frederick Carter cited Leonardo but not Galton. I am grateful to Carolyn Lanchner for providing me with a reproduction of the MOMA's copy of this rare document.

7. Breton shared his interest in gesture with his enemies Dermée and the group of L'Esprit Nouveau, all of whom adhered to the French tradition of understanding art in terms of touch and movement. Cf. Victor Basch, "L'Esthétique nouvelle et la science de l'art," writing for the post-Cubist periodical of Jeanneret and Ozenfant *L'Esprit nouveau*, no. 1 (1920), pp. 8–12; Basch allied aesthetics and

physiological psychology and believed that form in art comes from our tactile and motor sensations. Other writers, including Henri Wallon and Bergson in France and the psychoanalyst Gustav Bally in Germany, made similar points, and a pervasive literature in the last decades of the nineteenth century by French psychologists included Janet's and Binet's discussions of automatism and automatic behavior and Bernheim's notion that imagistic suggestion engaged an automatic process. Dermée, *Les Affaires et l'affiche* (Paris, 1920–22), p. 32, influenced by Bergson, Ribot, and Janet, expressed the idea that automatism was the basis of all creative activity in the arts, and he claimed priority to Breton in "La Querelle de Surréalisme," *L'Esprit nouveau*, no. 28 (1925), pp. 2324–5. In "Poésie = Lyrisme + Art," *L'Esprit nouveau*, no. 3 (n.d. [ca. 1920–21]) p. 327, Dermée wrote, "Lyricism is a flux shaken from the deepest source of our conscious being; it is normal . . . the waves formed from our subconscious creations flow along the stone banks constructed by automatism." Breton doubtless despised Dermée for making the claim ("La Querelle," p. 2362) that there is "a lyric quality in modern business."

8. Admittedly some artists, like the Cubist Gleizes, proposed a revolutionary modernism, claiming that "realism was bourgeois and had to be overcome," and that "the avant-garde had long since escaped the bourgeoisie." See "Vers une époque de bâtisseurs," *Clarté*, 1, no. 13 (March 20, 1920), p. 3. After World War I he continued his earlier "communism" in terms of a new collectivism that rejected individualism and anarchy, as well as bourgeois competition, and, perhaps echoing Ruskin, discovered in the Gothic period a model for the unification of political, spiritual, social, and artistic realms. See his articles in *Clarté* in 1920 and the articles between 1913 and 1924 published in *Tradition et Cubisme: Vers une conscience plastique* (Paris, 1927).

9. Like the other Dada artists, Francis Picabia absorbed Cubist collage, but the witty and literate artist went much further and, like the subtly ironic Duchamp, insinuated verbal associations, as in puzzles, or even like Chinese ideographs. For Picabia, whose protean relation to Breton and Surrealism still needs much work, see William A. Camfield, *Francis Picabia: His Art, Life and Times* (Princeton,

N.J., 1979), as well as Sanouillet, *Dada à Paris*.

10. A major critic of the voice as the primary instrument of communication, Derrida, believed that the reliance on it commits one to a falsifying "metaphysics of presence," based on the illusion of coming "face to face once and for all with objects." See Terence Hawkes, *Structuralism and Semiotics* (Berkeley, 1977), p. 145. Breton's concerns, on the other hand, ally him to Greimas's study of the fundamental structure of syntax and his notion that man is the "talking animal."

11. The emphasis on automatism as a technique made more difficult the definition of a Surrealist painting; indeed Morise, in a review of a De Chirico exhibition for *La Révolution surréaliste*, no. 4 (July 1925), p. 31, stated that "there is no Technique, there does not exist a science of good painting." And Joyce Mansour, in *Bief*, no. 12 (April 15, 1960), n.p., denied that there was "a Surrealist way to paint. It is not the painting technique that is Surrealist but the painter: it is the painter's vision of life." For the view of the automatic *déclic* as a limit to artistic expression, see Camille Puyo, *Notes sur la photographie artistique* (Paris, 1896), p. 8: "Cet automatisme apparaît donc au photographe pictorial comme l'adversaire qu'il doit vaincre, s'il veut . . . aller plus loin que le photographe classique . . . dans . . . l'interprétation du sujet."

12. For Symbolism, see G.-Albert Aurier, "Le Symbolisme en peinture: Paul Gauguin," *Mercure de France*, vol. 2 (Paris, 1891), pp. 159–64: "The easel painting is nothing but an illogical refinement invented to satisfy the fantasy or the commercial spirit in decadent civilizations. In primitive societies, the first pictorial efforts could be only decorative." (The Symbolist notion of the "decorative" had little in common with the Surrealists'.) Berenson, the connoisseur of Italian Renaissance painting, spoke of the "originality of incompetence," by which he designated precisely the feature of Romanticism pursued in automatism.

13. See Albert Boime, *The Academy and French Painting in the Nineteenth Century* (New York, 1971).

14. See Richard Shiff, *Cézanne and the End of Impressionism: A Study of the Theory, Technique, and Critical Evaluation of Modern Art* (Chicago, 1984). Cf. Walter Benjamin, "The Work of Art in the Age of Mechanical Reproduction," in *Illuminations*, trans. Harry Zone (New

York, 1969). For Roland Barthes, see especially his *S/Z* (Paris, 1970; New York, 1974), and, for postmodern views see, for example, Douglas Crimp, "The Photographic Activity of Postmodernism," *October*, 15 (Winter 1980), pp. 91–102. Rosalind Krauss, an editor of *October*, has been interested in the subject of originality of the avant-garde.

15. For a comparison of Dada photomontage to pictorial automatism, see Aaron Scharf, *Art and Photography* (Harmondsworth, 1968, 1974), pp. 277–8. For the photography of invisible mental fluids, see H. Baraduc, *L'Ame humaine, ses mouvements, ses lumières et l'iconographie de l'invisible fluidique* (Paris, 1896), and *Méthode de radiographie humaine. La force courbe cosmique. Photographie des vibrations de l'éther. Loi des Auras* (Paris, 1897).

16. Krauss, in Krauss and Livingston, *L'Amour fou* alters Scharf's observation by attributing to Breton the (involuntary) idea that photography (rather than photomontage) could be the basis for a theory of Surrealist art. Her argument does not convince me; nor does she offer to distinguish Dadaist from Surrealist photography, a point that led to controversy with her collaborator in *L'Amour fou*, Sara Livingston, as to whether Man Ray's photography is Dadaist or Surrealist.

Cocteau, in the "Photographie" section of *Les Feuilles libres*, no. 26 (April–March 1922), published "Lettre ouverte à Man Ray, photographe américain"; on pp. 134–5 he says (anticipating the Surrealist debates about painting and photography after 1925): "Since Picasso, I have followed with curiosity and sadness the researches that have rejected painting while making use of photography. Right off the prints of Max Ernst fascinated me. But Max Ernst plays tricks – he tastefully cuts and pastes. His work remains witty. Your plates [on the other hand] do not show objects photographed with a lens, but placed directly by your hand between the light and the sensitized paper... all this brings about a metamorphosis of the motif, the result being a masterpiece that makes no sense.... [After Daguerre and Nadar] you have come once more to deliver the painter." Only Picasso and Braque have the genius to continue painting in the tradition of Raphael.

17. See Breton, "The Surrealist Situation of the Object" (1935), in *Manifestos of Surrealism*, pp.

272–3. Even later, in his introduction to *Toyen* (Paris, 1953), Breton observed: "At the inception of Surrealism as an organized movement the proposition was advanced, with rather excessive timidity, that photography and the cinema had dealt a death blow to imitative painting.... The continued improvement in methods of mechanical recording not only makes that kind of painting increasingly irrelevant, it also gives immediate prominence to the prophetic nature of those works which have become the first, historically, to break completely with imitative painting" (see Breton, *Surrealism and Painting*, p. 207).

18. See "Le Maître de l'image," a eulogy of the poet Saint-Pol-Roux, in Breton, *OC*, vol. 1, p. 901.

19. See Part Three of *Le Paysan de Paris*, p. 247.

20. See "Il y aura une fois," *LSASDLR*, 1, no. 2 (July 1930), pp. 2–4. Cf. Jean Dutourd, *L'Ame sensible* (Paris, 1959?), who cites Stendhal: "La chose imaginée est la chose existante." Maxime Alexandre, in "Liberté, Liberté chérie," *La Révolution surréaliste*, no. 7 (June 1926), p. 31, claimed that "there is evidently no other reality than poetic images. This city in which I move... is a poetic image, [as is] this sky, this woman's mouth." More recently the postmodern theorist Baudrillard has gone even further, stating that the image, or "simulacrum," has supplanted the thing itself and that the very nature of what we call the "real" has changed.

21. The contrast between the modernist artists and Surrealism corresponds to that between Gestalt psychology, which emphasizes the pleasure of perceptual and intellectual resolution, and psychoanalysis, which aims to bring emotional conflict to light.

22. See *Apollinaire on Art*, ed. LeRoy C. Breunig (New York, 1960), p. 327. In 1914 Apollinaire, ibid., p. 422, quoted this from an article in *Lacerba* by Soffici: "De Chirico's painting is not painting as that word is generally understood today. It could be defined as a language of dreams."

23. Breton's article was first published in *Littérature*, no. 11 (January 1920), as a comment on an Italian brochure probably of 1919 illustrating 12 paintings, later as a preface to an exhibition of 55 paintings at Paul Guillaume's gallery in 1922, and again in *Les Pas perdus* (1924).

24. See Breton, *OC*, vol. 1, p. 32.

25. The reality of hallucination was maintained by

Rimbaud (*Une Saison en Enfer*) and by Moréas (his Symbolist Manifesto of 1886). Among philosophers the continuity of perception and imagination was assumed not only by Taine, but by Aristotle, Descartes, Berkeley, Ribot, the neo-Kantians, and Merleau-Ponty; their discontinuity was assumed by Plato, Vico, Fichte, and Bachelard, as well as the poets Baudelaire and Breton. See Edward S. Casey, *Imagining: A Phenomenological Study* (Bloomington, Ind., 1976), p. 130.

26. This comes from Taine's *L'Intélligence* (Paris 1870), a book to which Breton referred several times in "Caractères de l'évolution moderne" (1923), the manifesto of 1924, and *Surrealism and Painting* (1928).

27. See Breton, *Surrealism and Painting*, p. 14. Many in the Surrealist generation were in revolt against the positivism to which they were exposed by their early education. The moral of the soup in Taine's narrative, as applied to De Chirico, illustrates the antipathy to materialistic positivism. See Hippolyte Taine, *On Intelligence* (London, 1871), part 2, book 1, chapter 1. Cf. Kandinsky, letter of September 13, 1923: "Intellectual workers are being repressed. Spirit, art, science, religion, morality are to be 'superseded' and humanity is going once again to start haggling over belly-stuffing goods until it either becomes idiotic or begins to despair. The materialistic soup will have to be gulped down to the last drop." Cited in Shapiro, *Painters and Politics,* p. 209. Taine here transmits a tradition – extending from the *Idéologie* of Condorcet to the voluntaristic philosophy of Maine de Biran – emphasizing that psychological mechanisms could serve as a source of knowledge.

28. See the *Vases communicants* of 1934.

29. An illustration of a collage fashioned by Aragon and Breton titled "Ci-gît Giorgio de Chirico" appeared in *La Révolution surréaliste,* no. 119 (March 1928), p. 8. *Documents* directly opposed that judgment by including illustrations of post-1928 work by De Chirico in Georges Ribemont-Dessaigne's article in vol. 2, no. 6 (1930), pp. 336–45.

30. Aragon's review, "Le Feuilleton change d'anteur. Préface-pamphlet," is in Aragon, *Ecrits sur l'art moderne,* pp. 20–2. The exhibition, "Oeuvres anciennes de Georges de Chirico," was held in the Galerie Surréaliste in February–March 1928.

31. Aragon, "Au bout du quai, les Art Décoratifs.' "

La Révolution surréaliste, no. 1 (December 1, 1924), pp. 26–7. The index of *La Révolution surréaliste* incorrectly refers this article *Ecrits sur l'art moderne* to issue no. 5, where the front cover lists it, although it appears only in issue no. 1.

32. In a paragraph lauding Duchamp-Villon's architectural sculpture in *Les Peintres cubistes* (1913) Apollinaire deplored the fact that contemporary architecture had lost the feeling for uselessness one finds in architectural monuments from the Pyramids to the Eiffel Tower. The witty Duchamp soon after demonstrated how to transform ordinary functional items – urinals, hat racks, or bicycle wheels – into what one might call "meta-art" – objects useful chiefly as comments about art and its appreciation. In a more recent ironic turn, Duchamp's objects preserved in museums have – as "meta-meta-art" – regained their aura as mementos of their era.

33. As one might expect, they tried – unsuccessfully – to buy early De Chiricos from the artist, as noted by J. T. Soby, *De Chirico* (New York, 1955), pp. 134, 160; in addition, Breton bought at least seven Picabias at the 1926 Duchamp sale. However, they also bought Fauve works by Braque, Derain, and Vlaminck; two Soutines; and even a Modigliani portrait and nude.

34. Breton said that Doucet "wasn't really a connoisseur of painting. He had 'taste,' but it was the taste of a dressmaker." For Breton's relations with Doucet, see J.-F. Revel, "J. Doucet, couturier et collectionneur," *L'Oeil,* no. 84 (December 1961), pp. 44–51. Doucet employed Breton, Reverdy, and Aragon as advisers and suppliers. They wrote him reports on the artistic scene and advised on the purchase of manuscripts and paintings, as well as outlining an ideal library for him. Doucet followed the good advice and acquired an excellent collection; for example, on Breton's recommendation he bought the *Demoiselles d'Avignon* for 25,000 francs.

35. See Behar, *Breton,* on Breton's need to survive by selling some of the pictures he had bought cheaply or had received as gifts from artist friends.

36. See Malcolm Gee, *Dealers, Critics and Collectors of Modern Painting: Aspects of the Parisian Art Market between 1910 and 1930* (New York, 1981), p. 49, who observes that the Surrealists, who claimed to be collectivist,

were, in fact, individualist, interested in hyperexceptional individuals like Picasso, as were other modernists.

37. See "Protestation," *La Révolution surréaliste*, no. 7 (June 1926), p. 31. Reaching into prehistory Breton later in *Surrealism and Painting*, p. 20, deplored the person who "first enclosed a landscape or a human figure within the boundaries of a canvas, [and] had the idea of saying 'This is mine' (meaning also 'I did this')." Duchamp had already mocked with caustic wit the possessive aspect of bourgeois creativity. Meyer Schapiro later rephrased the idea semiotically.

38. See *Archives*, no. 3, meeting of November 27, 1926, p. 80: "Breton: – On this point we ought to allow ourselves a degree of latitude with regard to our friends. I find it possible to accept the collaboration of someone on *La Révolution surréaliste* who would not be acceptable from a revolutionary standpoint."

39. For a recent semiotic analysis of this Cubist collage see Frascina, *"Art and Semiotics."*

40. See Yvette Gindine, *Aragon: Prosateur surréaliste* (Geneva, 1966), p. 62.

41. Aragon, *Le Paysan de Paris*, p. 248.

42. A dynamic French psychiatry concerned with suggestion and hypnosis maintained that images could have an influence on the public – e.g., in advertising. See Rosalind Williams, *Dream Worlds: Mass Consumption in Late Nineteenth Century France* (Berkeley, 1982). Théodule Ribot, *La Psychologie de l'attention* (Paris, 1889), p. 3, had already written that mental representations tend to translate themselves into action. Bernheim, in his *De la suggestion dans l'état hypnotique et dans l'état de veille* (Paris, 1884), p. 18, speaks of "the brain's ability to receive or call up ideas and its tendency to transform them into acts" ("les objets, les êtres, les phénomènes peuvent être à la fois eux-mêmes et d'autres"). Of course, a countertradition, expressing a Cartesian viewpoint, maintained that images, particularly those of the Surrealists, deceive; for example, Jean Cazaux, *Surréalisme et psychologie: Endophasie et écriture automatique* (Paris, 1938), distinguishes Surrealism from *littérature,* and defines *endophasie* as the "langage intérieur" of writers of the late nineteenth century or of Joyce's interior monologues. He states that automatic writing does not have the aim of literature to create something that will arouse or communicate a state of mind to the reader.

And Charles Baudouin, in *Psychanalyse de l'art* (Paris, 1929), pp. 41–2, addresses what he considers the Surrealist error: "The images stirred up by the subconscious have significance surely – even a profound one at times – but strictly personal and uncommunicable." Sollers's *H* and Derrida's experimental writing seem to follow the line of Joyce.

43. See Charbonnier, *Entretiens avec Masson*, p. 96.

44. Naville threatened to close the Surrealist Central because the absence of Breton and others from the office put an extra burden on him. Breton, in turn, countered, declaring "I am no longer interested in anything at the *Révolution surréaliste*." This was on March 25, 1925; Breton displaced Naville and Péret (who still edited no. 3) as director of *La Révolution surréaliste,* starting with no. 4 (July 1925). See *Archives du Surréalisme*, vol. 1, p. 97.

45. Naville here follows Breton, who in the manifesto vaunted his "mauvais goût."

46. Naville seems to develop an idea about the difficulty of representing the content of dream in images, which Crevel expressed in his article, "Le Sommeil: Je ne sais pas de couper," in issue no. 2, p. 26: "As day progressively brings me further and further from the nocturnal dream, and causes the (reveried) condition to evaporate, I am compelled, in order to recreate it, to pursue more and more images and words. Thus is born the temptation of art." Naville's emphasis on cinema echoes the important discussion (based on The Surrealist Manifesto) of Jean Goudal, "Surréalisme et cinéma," *Revue Hebdomadaire*, 34, no. 8 (February 21, 1925), pp. 343–57, who found cinema's "conscious hallucination" a way to fuse dream and reality, and its rapid succession of images a way to deny logic but not meaning.

47. M. Bonnet, "Introduction" to the catalogue of the Breton exhibition at the Pompidou in Paris, 1991, p. 40, denies Krauss's affirmation in *Le Photographique* (1990), p. 108, that in Surrealism sight receives "an absolute supremacy over the other senses." On the contrary, Bonnet notes the "preeminence always accorded by Breton to the auditory in automatic writing" and that in fact sight and sound were inseparable in Surrealist imagery.

48. The window image responds to Morise's remark in "Les yeux enchantés", p. 26: "This universe [the unexplored domains of Surreal-

ism], on which a window has been opened, from now on can and must belong to us."

49. Breton does not mention that Diderot already used this phrase. German idealists descended from Kant likewise emphasized the mental "interior."

50. See Aragon's list "Les Présidents de la république du rêve," in *Une Vague de rêves,* p. 112, which includes besides these two painters the writer Roussel, the assassin Germaine Berton, the poet Reverdy, the Surrealist Vaché, and "Siegmund [*sic*] Freud."

51. Breton, *Surrealism and Painting,* p. 5.

52. Ibid., p. 10, contemptuously cites Braque's "rule that corrects emotion." For Descartes's view that the passions, while not morbid, needed to be controlled, see the *Traité des passions,* art. 6.

53. He seems to evoke Platonic reminiscence in *Surrealism and Painting,* p. 43: "To see, hear means nothing. To recognize . . . means everything."

54. See the *Aesthetics,* vol. 1 (Oxford, 1975), pp. 315–16, translated by T. M. Knox.

55. Breton, *Surrealism and Painting,* p. 25. Breton could also have found this abhorrence of materialism among abstract artists like Kandinsky, who observed: "Our *nouveaux riches* are bad, and the immediate future is in their hands, whatever the government calls itself. Thus intellectual workers are being repressed. . . . The materialistic soup will have to be gulped down to the last drop." Letter to Katherine Dreier of September 13, 1923, Dreier Correspondence, Beinecke Library, Yale University. See Shapiro, *Painters and Politics,* p. 209.

56. Naville's article in issue no. 3 had appeared in "Beaux-Arts," a section that disappeared after issue no. 5 and was replaced by Breton's series of articles on painting.

57. Exponents of Surrealist photography have introduced confusion into the scholarship by claiming that the article appeared in the very first issue of *La Révolution surréaliste,* and that that issue included not one single illustration of a painting. In fact, the article was published in issue no. 5, and the first issue, in addition to five photos plus the cover by Man Ray, reproduced four paintings, as well as a collage, and drawings by Ernst, De Chirico, Morise, Masson, and a psychotic. Dawn Ades in *Dali and Surrealism* (London, 1982), p. 73, and again in "Photography and the Surrealist Text," in Krauss and Livingston, *L'Amour fou,* p. 159,

locates Morise's article in issue no. 1 and claims twice that "not a single painting was reproduced in the first issue." The mixup about Morise's article (and others – proving how inattentively the periodical has been read) has contaminated the scholarship on Surrealism: the article is incorrectly located by Jean, *Autobiography of Surrealism;* by Jean-Charles Gâteau, *Paul Eluard* (Paris, 1988), p. 136; and even by Bonnet, in Breton, *OC,* vol. 1, p. 1702, n. 1.

For Cocteau's views see his "Lettre ouverte à Man Ray, photographe américain," *Les Feuilles libres,* no. 26 (April–May 1922), pp. 134–5: "Since Picasso, I have followed with curiosity and sadness the researches which, rejecting painting, have employed photography. Already the plates of Max Ernst enchanted me . . . he cuts and pastes with taste. Your plates are objects in themselves, not photographs through a lens, but directly interposed by your poetic hand between the light and the sensitized paper . . . a metaphor arises from the motif, resulting in a masterpiece without meaning. . . . You have once again freed the painter."

58. See *La Révolution surréaliste,* no. 4 (July 1925), pp. 31–2. Morise worries over De Chirico's seeming desertion of his great early style in favor of the antique:

> De Chirico seems to want to persuade us that mind inhabits matter. The statues, monuments, things that appeared in his old paintings as unintelligible *signs* return with human proportions.
>
> My profound friendship, eternally astonished and incapable of measuring your greatness, invites me to put you on this pedestal, Chirico. We will see whether the statue of the Commander. . . .

59. Published in *La Révolution surréaliste,* no. 8 (December 1926). Passage cited in Breton, *OC,* vol. 2, p. 288.

60. See R. Desnos, "Qu'est-ce que la peinture surréaliste?" *Cahiers d'art* no. 8 (October 1926), p. 213. In December 1925 Desnos wrote a one-page note, "Le Sens révolutionnaire du Surréalisme," for *Clarté,* p. 338.

61. The "definition of Surrealism" refers to automatism in writing. Desnos agreed with Eluard and others that one cannot find its counterpart in painting.

62. One might expect more easily to find a parallel to automatic writing in drawing (Masson, Miró, Arp) than in painting, which requires the knowledge and control of such technical procedures as paint mixing and canvas preparation. However, Breton attributed automatism to certain techniques developed in the twenties and thirties. Aside from the already mentioned *décalcomanie* (Domínguez's method of pressing paper or canvas onto another surface covered with wet paint) and *fumage* (Paalen's method of passing a sheet of paper randomly over a smoky candle flame), there were frottage (Ernst), *grattage* (scraping paint randomly from a surface), *coulage* (dripping paint randomly), *écrémage* (skimming a sheet of paper over the surface of water on which paint has been poured), "promorphic woodcuts" that incorporated forms inherent in natural debris (Arp), and *impressions de relief* in which foreign objects like nails, pieces of rubbish, and so on are incorporated between paper and stone before a lithographic print is pulled (Dax).

63. Breton's metaphors seem almost to describe a work by Robert Rauschenburg made of a bed quilt and another by Jasper Johns with a ladder extending below the frame. Both artists emulated Duchamp's ironic paraphrasing of other artists.

64. Picasso allowed his dove to serve as a peace emblem for the Stalinists and drew a controversial posthumous portrait of Stalin in 1953.

65. This letter is quoted by François Chapon in his article on the correspondence between Breton and Doucet, published in *André Breton*, catalogue of the show at the Pompidou in 1991, pp. 118–19.

66. The "Hommage," published in *Journal littéraire*, no. 9 (June 21, 1924), p. 11, was signed by 12 Surrealists and the musicians Auric and Poulenc. In the same issue Aragon published "Pour Arrêter les bavardages," p. 10, a defense of the raucous behavior of the Surrealists: their boisterous applause for Picasso and booing of Satie at the June 15 performance had provoked police intervention. In another letter to Doucet, in Chapon article in *Andre Breton*, p. 119, dated December 12, 1924, Breton anticipated a celebration of the *Demoiselles* comparable to that of Cimabue's *Virgin* and claimed that the work "defies analysis ... with it, we bid farewell to all past paintings. ... I know that the thought embodied in this painting is among the thoughts that have sustained my position, my beliefs, my hope."

67. The image of light recurs in Breton, as in one of the dreams discussed in Chapter 2, this volume.

68. Breton's omission of Magritte is puzzling; for while he did not see the exhibitions held in Brussels – one in 1927 ("La Peinture de René Magritte") at the Galerie le Centaure, the other in 1928 ("René Magritte") – he had become acquainted with Magritte after the artist's arrival in Paris in September 1927 and surely saw his work exhibited in "L'Exposition surréaliste" held at the Galerie Goemans in Paris, 1928.

69. André Breton, *Les Pas perdus*, expressed himself clearly with regard to Cézanne: "dont ... je me moque absolument," etc. (see *OC*, vol. 1, p. 300).

70. See Léger's articles (in F. Léger, *Fonctions de la peinture* (Utrecht, 1970): "L'Esthétique de la machine: L'Objet fabriqué, l'artisan et l'artiste," *Bulletin de l'effort moderne* (Paris, 1924), pp. 53–62, and "La Rue: Objets, spectacles," *Cahiers de la République des Lettres* (Paris, 1928), pp. 68–9. The ideas of Léger and the Purists anticipated and perhaps affected the formal emphasis of the highly influential periodical *Cahiers d'art*, which, while reporting on and even including articles sympathetic to Surrealism, essentially resisted whatever failed to measure up to the canons of plastic art in the line of Cézanne and Cubism. *Cahiers d'art* had an immense importance for what one might call the New York academy of modernism. Barr's exhibitions at the New York Museum of Modern Art in 1936 and the "International Style" formalism he concocted with his Harvard friends H. R. Hitchcock and Philip Johnson seem especially indebted to the periodical. Cf. Helen Searing, "International Style: The Crimson Connection," *Progressive Architecture* (February 1982), pp. 85–91, and in the same issue, R. G. Wilson, "International Style: The MOMA exhibition," pp. 92–104. Barr's exhibitions impressed sympathetic and adverse critics alike, and determined the essential intellectual content of many later exhibitions at the MOMA.

71. See *Cahiers d'art*, 5, no. 2, (1930), p. 69–77, for E. Tériade, "Documentaire sur la jeune peinture. Part 4. La Réaction littéraire," especially p. 74.

72. Breton, *OC*, vol. 1, p. 341. Breton's "Poem"

placed near the end of the manifesto uses a technique resembling the Dada cutouts, but in contrast to the Dadaists he carefully selected his texts and invested them with greater coherence both through maintaining a minimum syntactical structure and through evocative associations.

73. This effect of collage is well known to art historians. Cf. David Rosand, "Paint, Paste and Plane," in Jeanine Plotteal, ed., *Collage* (New York, 1983), p. 124: "The painter's gesture ... no longer dominates the order of things ... the sign of his active and creating presence no longer controls the notion and impression of composition." I think formalists like Cooper, Rubin, and Christopher Green exaggerate the extent of Surrealist opposition to late Cubism; in fact the Cubists had become irrelevant to Surrealism after the transformation of collage in the early twenties by Ernst and Schwitters. The latter does not figure in early Surrealist discussions, and what little Breton has to say about him later in *Surrealism and Painting* is not significant. Rubin, *Dada and Surrealist Art*, p. 99, connects Schwitters to Cubism, Dadaism, and post–World War II painting.

74. See Aragon, "Du Décor," in *Le Film* (September 16, 1918), in Aragon, *Ecrits sur l'art moderne*, pp. 5–9.

75. See ibid., pp. 12–16; see also p. 319, where arguments are advanced to date the essay 1923.

76. With Rimbaud and Lautréamont, Breton evokes as he had in 1921 the same late-nineteenth-century poets whose "automatic writing is a photography of thought" that anticipated and perhaps inspired Ernst.

77. Breton here seems to refer to the issue brought up in relationship to De Chirico and the bowl of broth, discussed earlier.

78. Breton, *Surrealism and Painting*, p. 26.

79. For instruments conceived in terms of the actions they perform and by implication of their potentially anthropomorphic character, see Michel de Certeau, *The Practice of Everyday Life* (Berkeley, 1984), p. 147: "cutting, tearing out, extracting, removing, etc., or else inserting, installing, attaching ... assembling, sewing together ... [and] those substituted for missing or deteriorated organs, such as heart valves ... prosthetic joints...." It seems to me that Magritte's *Les Vacances de Hegel* showing a glass of [rain]water balanced on an open umbrella, recycles the umbrella in a con-

densed version of Ernst's image: the half-full glass sits with a potential of "vacance" on the empty concavity in a Hegelian dialectical play on emptiness and fullness, and between having a vacation and suffering its being rained out.

80. See Masson, "A Joan Miró, pour son anniversaire" (1973), in Françoise Will-Levaillant, ed., *André Masson. Ecrits* (Paris, 1976), p. 87. *La Révolution Surréaliste*, no. 2, pp. 6–7, published a text by Artaud based on "des tableaux de M. André Masson," and issue no. 4, p. 5, included a poem to Masson by Eluard.

81. Breton, *Surrealism and Painting*, pp. 35, 36. R. Krauss, *L'Amour fou*, p. 20, makes a serious error in describing Masson as "the painter whose 'chemistry of the intellect' Breton was most drawn to." Bataille fits this description better than Breton.

82. After the break with Picasso in the forties, Breton became very close to Miró – for example, in connection with *The Constellations*.

83. Breton, *Surrealism and Painting*, p. 40. Margit Rowell, in the Pompidou Breton catalogue, says that Breton prized Miró's *Danseuse espagnole* (1928) as an expression of Miró's wish to "assassiner la peinture."

84. Miró signed the protest of the Surrealists against the attack on Aragon's poem "Front rouge" (1932). See Pierre, *Tracts*, vol. 1, p. 208. Rowell in her *Joan Miró* (Boston, 1986), Introduction, p. 12, mistakenly claims that "[Miró] never signed a manifesto."

85. See "Yves Tanguy et les objets d'Amérique," May 27–June 15, 1927, Paris, Galerie Surréaliste." For Arp, see note 90, this chapter.

86. Breton, in the First Manifesto, *OC*, vol. 1, p. 340, advocated the artist's return to childhood: "The mind which plunges into Surrealism relives with exaltation the best part of its childhood." While this might seem analogous to the psychoanalytic project of searching for clues in early memories, in fact it has more to do with Romantic presumptions of innocent origins; and Breton sees the events of childhood not as a source of adult neurosis, but as a means to replenish the imagination.

87. Breton, *Surrealism and Painting*, p. 43.

88. Breton alludes to the battle of wits between the psychologist Théodore Flournoy and his patient, the seer Helen Smith, over the truth of her claims to come from Mars, but he distinguishes this case from Tanguy, since the artist made no claims for the concrete reality of his images.

89. Although this vision pervades the works on exhibit, it refers specifically to Tanguy's *Un grand Tableau qui représente un Paysage* of 1927 illustrated in the book. Breton and Eluard in their *Dictionnaire abrégé du Surréalisme* of 1938, p. 397, say that this painting

> indicates that Tanguy is trying to abolish the connection of art to nature. There is not even a horizon. There is only, physically speaking, our immense suspicion which surrounds everything.
>
> Figures of our suspicion, beautiful, pitiful shadows prowling round our cave: we know that you are shadows. The powerful subjective light that floods Tanguy's canvases makes us feel less alone and surrounds us with seething life.

Such a formulation corroborates Golding's opinion that the Surrealists' contempt for nature presented a barrier that prevented Picasso's complete agreement with them even during the period of his closest rapprochement.

90. Most of the material pertaining to Arp had already been published in Breton's preface to Arp's exhibition of 46 works at the Galerie Surréaliste from November 21 to December 9, 1927.

91. This phrase became the nuclear idea and title for the *Vases communicants.*

92. Breton, *Surrealism and Painting*, p. 46. Cf. Breton's article in *Minotaure*, no. 8 (June 1936), entitled "Decalcomania of Desire," recommending a technique, paradoxically described as personal and expressive, for producing "landscapes" by pressing wet gouache between sheets of paper.

93. Breton, *Surrealism and Painting,* p. 47. The Surrealists' sensitivity to the poetry of Arp's painting was reciprocated by the artist, who, in an interview with Pierre Schneider, published in "Arp Speaks for the Law of Chance," *Art News,* 57 (November 1958), observed: " 'It was the poetic side that attracted me to Surrealism. The one I was fondest of was Eluard.' / S.: 'What about Breton?' / A.: 'His poems interested me, not his theoretical writings. *Nadja, L'ère* [*sic!*] *de l'eau.*' / S.: 'Did you break with the Surrealists later?' / A.: 'I've never broken with anyone.' "

94. See Dali, *Oui,* vol. 1, pp. 30–1.

95. This was noted by Ades, *Dali and Surrealism,* p. 61. This not only shows how early Dali was familiar with Breton, but proves his willingness to illustrate someone else's dream.

96. See Breton, "Première Exposition Dali," in *Point du jour* (Saint-Amand, 1970), p. 67. Cf. the revelations through windows presented in the First Manifesto and *Nadja,* and also "D'une Décalcomanie sans objet préconçu (Décalcomanie du Désir)," *Minotaure,* no. 8 (June 1936), p. 18, describing a technique "Pour ouvrir à volonté sa fenêtre sur les plus beaux paysages du monde et d'ailleurs."

97. See Breton, *OC,* vol. 1, p. 808.

98. See R. Arnheim, *Visual Thinking* (Berkeley, 1969), p. 141. Foucault, on the other hand, with almost alchemical zeal, sublimated its contents into a long philosophical meditation.

99. Bataille's analysis of expenditure, which has ties to Mauss's essay on the gift and to Freud's equation, feces = a gift = money, might apply to the "Surrealist economy." Surrealist sublimation parallels the transformation of desire into the wonder of genuine art that Hegel describes in his *Aesthetics,* vol. 1. Bataille's "The 'Old Mole' and the Prefix '*Sur*' " applies Nietzsche's criticism of "bourgeois spiritual elevation" to the "Icarian" sublimation he finds in the Second Manifesto.

100. See Gandelman, *Reading Pictures,* chapter 8, "The Scatological Homunculus." Cf. Barthes's version of anal aggression: "The text is (should be) that uninhibited person who shows his behind to the Political Father," in *The Pleasure of the Text* (New York, 1975), p. 53. This "father" approaches Bataille's subversive image of the "Solar Anus" directed at Breton, the "Sun King" of Surrealism.

101. In his *Entretiens* (1950), p. 290, Breton later expressed regret that in the *Vases communicants* he had "sacrificed too much to the materialism then in vogue," an allusion both to Bataille and the Marxists.

102. As Haim Finkelstein shows in his book on Dali (1996), the key term in 1925 for Dali and Lorca was "putrefaction" (of the bourgeois), and from 1928 on scatology was important. *Documents,* no. 4 (September 1929), first illustrated Dali's *Bathers,* a proto-"Big Toe," and *Female Nude* with its swollen "masturbatory" hand.

103. Similarities between Dali's earlier imagery and Bataille's are easily demonstrated: the photos of digits in Dali's article "Liberation of the Fingers" (1929) and those of grotesque toes in *Documents,* and Dali's image of people

trapped before his canvases "like flies by *Tanglefoot* paper" and the big close-up photo of such flies in *Documents*.

104. Salvador, Dali, *Diary of a Genius* (New York, 1965), p. 25.

105. For their famous scene of feathers falling out a window onto a courtyard in their film *L'Age d'or*, Buñuel and Dali were, in my opinion, inspired by the passage just before Nadja's first appearance: "Finally . . . the tower of the manor of Ango explodes and . . . feathers snow down from the pigeons, melt on hitting the ground of the great court, which was a moment before covered with the debris of roofing tiles and is now covered with real blood!" Of course, Dali borrowed more often from other artists.

106. See "Picasso in His Element" (1933), in the second edition of Breton, *Surrealism and Painting*, p. 105.

107. The article appeared in *Minotaure*, no. 3–4 (December 1933), pp. 69–76. Cf. Dali, in response to Tériade's questions about chance, spontaneity, and the absence of the model in modern art, in ibid., p. 18: "We know that the Surrealists have gone beyond the cannibalism of flesh to that of bone, and are on the verge of devouring objects. . . . It is enough to say that for me the model could only exist as an intestinal metaphor. Not only the model, but objectivity itself has been eaten." Jacques Lacan, *De la psychose paranoiaque dans ses rapports avec la personnalité* (Paris, 1980 [1932]), p. 258, presents a developmental schema by Abraham that Dali probably made free use of, in which cannibalism of the oral stage corresponds to narcissistic incorporation of the object (manic depression); incorporation continues in the primary stage of anal sadism (paranoia). Dali's orality (hunger, cannibalism) could be interpreted in terms of object relations theory (Winnicott).

108. Dali, in a text attributed to him, wrote in 1934 of *L'Immaculée conception:* "If the First and Second Manifestoes expounded the manifest [a pun intended?] content of the Surrealist dream, the *Immaculate conception* expounds its latent content." See Breton, *OC*, vol. 1, p. 1632. Bonnet connects the text to Ernst's *La Femme 100 têtes* on which Breton wrote in 1929. Ibid., p. 1631.

We should note that Eluard had by 1924 contributed poetry to issue no. 35 of *Les Feuilles libres* (January/February 1924), dedicated to the drawings and texts of the psychotic. A comment directly anticipating *L'Immaculée conception* appears on p. 306: "We divide the psychoses according to their causes: dementia precox (coinciding with puberty), senility, by intoxication . . . illness (typhoid fever, syphilis, general paresis) and trauma. According to its manifestations, we can distinguish dementia as hebephrenic or manic, catatonic or stupid, paranoiac or delirious."

109. Dali's "Rêverie," *LSASDLR*, no. 4 (December 1931), pp. 31–6, offers a guided and controlled daydream experience, into which played memories of former dreams and fantasies, and evocations of daydreams within the daydream. "I had to invent several histories which were to create the dream conditions." This corresponds to the controlled dreams of Hervey de Saint-Denis that Breton discussed.

110. Dali says that he found the images comical and laughed as he painted them, but none of the Surrealists laughed with him. However, Breton recalled in 1941 that "Dali insinuated himself into the surrealist movement in 1929." Breton, *Surrealism and Painting*, pp. 73–4.

111. Dali had already introduced the theme of masturbation in his nude bathers of 1928 with their swollen hands and phallic fingers. In 1929 he produced a bumper crop of paintings on the theme. Later the Surrealists, in their "Recherches expérimentales – L'Objet; Sur les possibilités irrationelles de pénétration et d'orientation dans un tableau: Georgio de Chirico: L'Enigme d'une journée . . . " published in *LSASDLR*, no. 6 (May 1933), p. 13, asked this question: "At which spot would one masturbate?" Dali's response would have been interesting, but unfortunately he did not take part in the "research."

112. Ironically, almost a decade later Dali became the target of similar criticism for acting with commercial motives identical to those attributed by the Surrealists to De Chirico.

113. Ades's surmise (*Dali and Surrealism*, p. 76) that this figure represents Dali himself is consistent with the interpretation of the gesture as mockery and revolt against this artistic "parent." Dali represented himself by more than one figure.

114. At this time Dali often made deformed enlargements of body parts, inspired by the work of Miró and Picasso. Dali, as already noted, had

written an essay entitled "The Liberation of the Fingers."

115. Perhaps a comical version of penis envy is intended, or of "psychasthenia" (a term that Breton applied to Bataille), as presented in P. Janet, *Psychological Healing* (London, 1925), vol. 1, p. 579: "the sentiments of incompleteness which are so characteristic of psychasthenics." Lacan (perhaps on the basis of Bataille's analysis of *Le Jeu lugubre*) considered Dali's phallic images a response to castration anxiety.

116. Dali avoided going over the edge of psychotic simulation by his sense of humor – for example, the self-mockery of his long thinly "phallic" mustaches and his self-portrait as Duchamp's "Mona Lisa" (*L.H.O.O.Q.*).

117. His adoption of a quasi-Fascist aerodynamism and his pseudo-Nazi doting on a swastika can, in part, be attributed to his anti-Breton stance, that is, to his resistance to the radical politics of the dominant figure. However, Dali must also have known that his outrageous public stances had sociopolitical implications, rendering the Surrealist movement less credible in revolutionary circles.

118. See Breton and Eluard, *Dictionnaire*, in Breton, *OC*, vol. 1, p. 794.

119. The Oedipal themes of the *William Tell* series may well reflect Dali's struggle against the dominant personality of Breton – as it had reflected his struggles with his father and others. At first Dali may have chosen the "paternal" Breton over Bataille as an "umbrella" of protection. Carter Ratcliff, "Swallowing Dali" (September 1982), pp. 33–9, and "Dali's Dreadful Relevance" (October 1982), pp. 57–65, both in *Artforum*, considers Dali a "saint of consumerism" who drags "high-art sensibility through the low-culture mud" and wins the uneasy support of Breton in the late twenties. He notes that Dali places in doubt "images of sincere feelings of engaged, radical intellectuality."

120. In discussing paranoia Breton refers to Bleuler and Kraepelin, but ignores Freud's analyses of narcissism, homosexuality, and the Oedipus complex, as well as Freud's view of the artist as a daydreamer trying to turn the results of play into real success. He does refer to the psychoanalytic concept of sublimation, however, a term attractive to him in these years.

121. Breton, *Surrealism and Painting*, p. 130. For the claim that Breton understood and went

beyond Freud's analysis of humor, see the remarks of Etienne-Alain Hubert, in Breton, *OC*, vol. 2, p. 1759.

122. "Leonardo da Vinci proved an authentic innovator of paranoiac painting by recommending to his pupils that, for inspiration, in a certain frame of mind they regard the indefinite shapes of the spots of dampness and cracks on the wall, that they might see immediately rise into view, out of the confused and the amorphous, the precise contours of the visceral tumult of an imaginary equestrian battle. Freud, in analyzing the famous vulture (which appears in that strangest of all pictures, Leonardo's Virgin of the Rocks) [actually *St. Anne, the Virgin and Child* in the Louvre] involuntarily laid the epistemological and philosophical cornerstone of the majestic edifice of imminent 'paranoiac painting.' " See Dali, in "Dali, Dali!" the catalogue for the Dali exhibition in the Julien Levy Gallery (New York, 1939), reprinted in *Oui*, 2 (1971), pp. 101–3. Haim Finkelstein notes that Ernst's frottage is closer to Leonardo's method than Dali's double or multiple images. Cf. also Janson, "The Image Made by Chance in Renaissance Thought," *Sixteen Studies* (New York, 1973), pp. 53–74, on the cloud horseman in Mantegna's *Saint Sebastian*. See Breton's *L'Amour fou*, p. 99, for a discussion of "Leonardo's lesson" as offering "possibilities of extension to all other domains besides painting"; and Ernst, "Au delà de la peinture," *Cahiers d'art*, no. 6–7 (1936), p. 607, linking his frottage to Leonardo.

123. See "A propos de L'Enigme de Guillaume Tell," *XXe Siècle*, 36 (June 1971).

124. Breton, in "The Most Recent Tendencies in Surrealist Painting" (1939), in *Surrealism and Painting*, asserts that Surrealist paintings "show a marked return to *automatism*" (p. 124), and as contrasts to Dali's paranoiac criticism he cites with approval Paalen's *fumage* and Dominguez's "decalcomania."

125. Breton's remarks are in *Surrealism and Painting*, p. 146 (1939 edition) and p. 74 (1941 edition). Breton apparently based himself on Dali's own statement for his exhibition "Dali! Dali!" held in the Julien Levy Gallery in New York in 1939 that Leonardo's walls were the source of paranoiac criticism.

126. See the unpublished sentences in *Archives du Surréalisme*, vol. 1, p. 161, in Breton's hand. This text was for the announcement about Le

Bureau de Recherches Surréalistes in *La Révolution surréaliste,* no. 2 (January 1925), p. 31, but was not included.

127. For an illustration see *La Révolution surréaliste,* no. 29 (January 15, 1925), p. 7.

128. Both Desnos and Naville signed the invitation to the *vernissage* of Miró's exhibition at Galerie Pierre on June 27, 1926. Allusions to shipwrecks and floating bottles containing a message appear in Aragon's *Les Aventures de Télémaque* (Paris, 1922), and earlier in his *Anicet.* In *La Révolution surréaliste,* no. 4 (July 1925), p. 18, Desnos invested bottles with special significance: "*Enigma.* / What rises higher than the sun and descends lower than fire, which is more liquid than wind and harder than granite? / Without reflection, Jeanne d'Arc-en-ciel [a punning conflation of "Joan of Arc" and "rainbow"] replies: / *A bottle.*" Later, in his *La Liberté ou l'amour* (1927), Desnos dwelled on shipwrecks; for example, he says that the steamer "LOVE is incessantly reborn from its shipwrecks" (p. 39). This remark may reflect his stormy affair during the years up to 1930 with the actress Yvette Georges. They both took drugs, and she died in 1930 of an overdose. He also describes a phantom ship and "the Pilot of the cataclysm that lures the yacht Corsaire into a shipwreck" (p. 41). In the same issue (pp. 4–5) Naville provided a Surrealist text that begins, "The tiresome boat sails over my lost body and goods" ("mon corps perdu et biens" is a play on "perdu corps et biens," meaning "lost with all hands") and that alludes repeatedly to ships.

129. For Masson's interest in the ambivalent image of this calligramme, see Françoise Will-Levaillant, *André Masson* (Paris, 1976), p. 250, n. 38, citing a letter of 1939.

130. This practice is in keeping with the observations of a philosopher that the Surrealists read and quoted. See Berkeley, *A Treatise Concerning the Principles of Human Knowledge* (1710), in E. A. Burtt, ed., *The English Philosophers from Bacon to Mill* (New York, 1939), p. 513, "Introduction," no. 10: "I can imagine a man with two heads, or the upper parts of a man joined to the body of a horse. I can consider the hand, the eye, the nose, each by itself abstracted or separated from the rest of the body. But then whatever hand or eye I imagine, it must have some particular shape and color."

131. These practices recall those of some Symbolists. For the deep commitment to the clarity of sentential logic by the French, see the essay by Antoine de Rivarol, a young man from the Midi, who won a prize from the Berlin Academy in 1784 for his "De l'universalité de la langue française," in which he claims that "French first names the subject of the discourse, then the verb, which is the action, and finally the object of this action: there you have the logic that is natural for all.... What is not clear is not French." Voltaire expressed a similar view in his *Dictionnaire philosophique* ("Français").

132. The failure of the visual representation of mental space is discussed by the Kleinian Bion in *Attention and Interpretation* (London, 1970), p. 12, where he indicates an essential difference between the manageable limits of the geometer's space and the potentially infinite domain of mental images. (Perhaps we can make an analogy here to the relation between beauty and the sublime.) The attempt of Bion's patients to represent mental space through the points, lines, and space of the geometer meets such limitations that Bion postulates mental space as "a thing-in-itself" that is unknowable but that can be represented by thoughts. Bion compared their position to that of the geometer who had to await the invention of Cartesian coordinates before he could elaborate algebraic geometry. Bion suggests that in such cases the process of projection of parts of the self that Melanie Klein describes takes place in a mental space that has no visual images to fulfill the functions of a coordinate system; neither faceted solids nor the multidimensional, multilinear figure of lines intersecting at a point are possible: "The mental realization of space is therefore felt as an immensity so great that it cannot be represented even by astronomical space because it cannot be represented at all." The feminist psychoanalyst Luce Irigaray develops a similar position.

133. The original – "Il s'agit d'aboutir, etc." – is put into imperative form for the cover.

134. See *Archives du Surréalisme,* vol. 1, p. 66, Breton's remarks on December 2, 1924.

135. "Le Surréalisme en 1929" offered this "Définition humoristique du Surréalisme": "bewildering objects ... fantastic painting ... automatic writing."

136. For Breton's awareness of the *Chambre*, see *Archives du Surréalisme*, vol. 1, p. 66.

137. See later for the association of Uranus and ambition.

138. In "Le Message Automatique" (1933) Breton discusses the disruption of the "message" by visual images, which he considers less coherent than the verbal, and he finds that auditory images have more value for poetry than visual ones and prefers metaphor to the excesses of visual hallucination.

139. For Breton on Ernst see *OC,* vol. 1, p. 299. Breton asked Ernst to do Nadja's portrait, but he refused because Mme. Sacco, the *clairvoyante,* predicted that someone with a name like Nadja would harm the woman Ernst loved. This seemed a perfectly valid reason to Breton, who – presumably in order to sustain the mystery of her charm – apparently never tried again to enlist either artist or photographer to portray her. Desnos published the drawings and poem in *Les Feuilles libres,* no. 35 (January–February 1924), devoted to work presumably by madmen. He anticipates the collaboration of Breton and Eluard, *L'Immaculée conception* – an attempt to simulate the utterances of psychotics.

140. See Dr. A. Hesnard, *Les Psychoses et les frontières de la folie* (Paris, 1924), with a preface by Prof. H. Claude (a psychologist singled out in *Nadja,* where his photo appears, as stupid and overbearing toward his patients). See also Matthews, *Surrealism, Insanity and Poetry* (p. 145), and the "Foucaultian" analysis of Jan Goldstein, *Console and Classify: The French Psychiatric Profession in the Nineteenth Century* (New York, 1987).

141. Hesnard, *Psychoses,* pp. 52–3, no. 1. One should note that this language seemed rich in poetic meaning for the Surrealists. And they would have found a measure of support in Wittgenstein, who argues that words have meaning not from being attached to things, but from being part of a set of conventions. Wittgenstein considers the case of an arbitrary, meaningless squiggle and says that it is possible to endow this, too, with meaning by imagining it is "a strictly correct letter of some foreign alphabet." Meaning comes from the mark's belonging to an organized sequence of signs in a language. The American psychiatrist Harry Stack Sullivan also took a position akin to the Surrealists in his explorations of the meanings within psychotic language.

142. Lucien Lévy-Bruhl, applying his notion of representation by the "loi de participation" (which rests on the idea that "objects, beings, phenomena can be at the same time themselves and others"), wrote in *Les Fonctions mentales dans les sociétés inférieures* (Paris, 1910), pp. 77–81: "The collective representations of primitives are not, like our concepts, the product of an intellectual labor, properly speaking. They contain . . . affective and motor elements, and above all imply, rather than conceptual inclusions and exclusions, participations more or less precisely defined, but, in general, intensely felt"; for example, a portrait "participates" in the life of the person/thing portrayed. And Durkheim, in *Les Formes élémentaires de la vie religieuse* (Paris, 1912), wrote: "We say that an object, whether individual or collective, inspires respect when the representation expressing it in the mind is gifted with such a force that it automatically causes or inhibits actions, without regard for any consideration relative to their useful or injurious effects." (There is an unexpected parallel to the contemporary view of the Christian Aristotelian Maritain's analysis of the relation of *puissance* to *acte.*) Cf. Victor Turner, *Dramas, Fields, and Metaphors: Symbolic Action in Human Society* (Ithaca, N.Y., 1974).

143. Suggested by Artaud, sketched out by Desnos, and edited by Fraenkel, the "Lettre aux Médecins-Chefs des Asiles des Fous" was published in *La Révolution surréaliste,* no. 3 (April 1925), p. 29. Here the Surrealists hardly differed from most sophisticated Parisians, who, as scions of Molière (*Le Malade imaginaire,* etc.), were only too ready to mock the pretensions of doctors: Jules Romains's popular comedy, *Knock, ou le triomphe de la médecine* (1923), played four years in Paris and satirized the power of doctors to impose upon human credulity by group manipulation.

144. Hesnard, *Psychoses,* p. 161, defines the "very essence of madness": "The psychotic (*aliéné*) is he who recognizes a stranger (*aliéné*) in what is in fact himself." Cf. Emil Kraepelin (a psychiatrist that Breton admired as early as 1916), "Disturbances of Judgment and Reasoning," *Clinical Psychiatry* (New York, 1980 [1907]), pp. 53–4: to patients with thoughts of

persecution it can seem that "newspaper articles and popular songs contain references and even indirect insults." Soupault wrote in "L'Ombre de l'ombre," *La Révolution surréaliste,* no. 5 (October 1925), pp. 24–5: "There is no difference between an actual news item and stray events that strike our mind."

145. Cf. the earlier discussion of his essay on Ernst (1921), where he compares automatic writing to a "photography of thought." *Nadja*'s photographs served as visual condensations and concretions of sites and portraits associated with the text. The photographs replace verbal descriptions but not reproductions of Surrealist paintings, tribal masks, and Nadja's sketches, which are also reproduced.

146. Breton mocked spirit "materialization" in his essay on Duchamp (1922). See *Kandinsky: The Development of an Abstract Style* (Oxford, 1980), Washton-Long, p. 125, for the spirit photographs in A. Aksakov, *Animism and Spiritism,* a French translation of which appeared in 1890.

147. Aube was the name selected by André and Jacqueline Lamba for their daughter, born in 1936 and married to the painter and poet Yves Elléouët. In 1977 and 1978 she exhibited lyrical collages in the manner of Ernst.

148. This optical phenomenon is analogous to the reading of the initials "A" and "B" in the numerals of the year 1713.

149. Breton, *OC,* vol. 1, pp. 719–21.

150. Ibid., p. 721. Perhaps Dali's *Illumined Pleasures* (1929) owes one of its details to this image and Breton's comments on it: the incongruous organism fashioned out of the frontal and profile heads of a woman and man on a vase that flows out into a roaring lion's head.

151. Nadja's identification with the siren has a pathetic signficance: this creature is known for the tormenting frustration of its seductively beautiful face and breasts above coupled with an impenetrable fish form below. At first glance she seems to be a twin-tailed siren (their tips are in fact divided in two), but one of the tails belongs to the male monster. Another illustration of a siren, in a drawing on a postcard, reveals that a similar uncertainty caused her to botch the drawing of its second tail.

152. These sentences combine traits of the Gorgon's petrifying look and the Sphinx's challenge.

153. One may consider the gloved hand a metaphor for the (regretted) absence of direct touch or contact between Nadja and Breton, and perhaps it also alludes to coquetry as in Klinger's famous and much appreciated *Paraphrase über den Fund eines Handschuhes.* See José Pierre, "Le Gant et son rôle dans l'oeuvre de Klinger et de Chirico," *Le Surréalisme, même,* no. 1 (1956), pp. 131–9. Allusions to gloves and hands abounded among the Surrealists: a disturbing, single, empty glove was left at the Bureau de Recherches Surréalistes; a flaming hand emerges from the water in one of Nadja's hallucinations; a glove of cut paper in one of her collages contains a cutout representation of her head; and hands appear in the paintings by Ernst and De Chirico used as illustrations for the book. Breton raised the image of a "gigantic hand covered in armor" ("Limites, non-frontières de Surréalisme" [1937], in *La Clé des champs,* p. 24) to the level of a symbol of automatic writing, while Dali created the ironic monumentality of the Great Masturbator's swollen hand, and Picasso, during his "Surrealist phase" of the mid-1930s produced a drawing that he called *The Hand That Speaks.*

154. Breton does not refer to Nadja's linking of "13" and "AB." As indicated in note 148, the seemingly cryptic significance for him of the year 1713 – composed of numerals resembling the form of his initials (17 = A; 13 = B) – long intrigued him, and years later he alluded to 1713 in a *poème-objet.* In his essay of 1950, "Pont-neuf," in *La Clé des champs,* p. 280, after quoting from *Nadja,* Breton referred to the date "13 mars 1313." Breton – associating his A/17 with Arcane – titled a book written near the end of World War II (1944) *Arcane 17,* the seventeenth card in Tarot, The Star that lights the road of imagination and magic; and the nameless thirteenth card indicates death but, through its red color, also signifies a beginning.

155. Several psychoanalysts pursued the matter. For Freud's interest in the paranormal, see his correspondence in 1908 with Ferenczi about his colleague's efforts to test the prophetic powers of a "seer."

156. For a discussion of "the open window" as giving access to subconscious reality, see Jennifer Mundy, "Surrealist Painting: Describing the Imaginary," *Art History,* 10, no. 4 (December 1987), pp. 492–508.

157. See Baudelaire, "Les Fenêtres" (1863) in *Petits poèmes en prose,* in Baudelaire, *OC,* p. 174. Closer to Surrealism are De Chirico's paintings of many darkened windows, or a lighted one filled with the forbidding figure of the father's torso in *The Child's Brain,* and the figure in the window in the Man Ray photo illustrating Breton's article "La Dernière grève," *La Révolution surréaliste,* no. 2 (1925), p. 1.

158. Breton insisted on the uncanny truth of "instances of unusual happenings which apparently concern only the two of us and dispose me, for the most part, in favor of a certain finalism which might permit us to explain the particularity of any thing, happenings, I say, of which Nadja and I have been the simultaneous witnesses or of which only one of us has been the witness." *Nadja,* p. 135. I think that Breton may have given nonverbal cues to Nadja that would explain her seemingly preternatural ability to share his thoughts; for example, full of Berkeley's text, he probably stared at the fountain with Nadja observing him. Freud observed in his "The Uncanny" (1919), in *On Creativity and the Unconscious* (New York, 1950), p. 146: "All obsessional neurotics I have observed are able to relate analogous experiences. They are never surprised when they invariably run up against the person they have just been thinking of, perhaps for the first time for many months. If they say one day 'I haven't had news of so-and-so for a long time,' they will be sure to get a letter from him the next morning. And an accident or a death will rarely take place without having cast its shadow before on their minds. They are in the habit of mentioning this state of affairs in the most modest manner, saying that they have 'presentiments' which 'usually' come true." Of course, Breton asserted his own sanity very firmly at one point after he had gained all he could from Nadja, when he said "I have, for quite some time, ceased to understand Nadja. To tell the truth, perhaps we never understood one another."

159. The "philosopher of Surrealism" Alquié in *Entretiens* of Cerisy (Paris, 1968), pp. 293–5, countered Clara Malraux's remark "but Breton declares that Nadja lived opposite this house," implying that she might have been familiar with the lights and curtains of the window concerned. Alquié acknowledges that "this would, in effect, much diminish the mysterious nature of the event." Arguing subtly, Alquié maintained that Breton did not intend to state a fact but only to indicate what Nadja in her confusion believed, so that we cannot easily decide its truth value; hence, the event retains its mystery for us. Breton believed in the uniqueness and spontaneity of the window episode, but the critical reader who has observed similar coincidences described in Breton's earlier writings will wonder, as mentioned earlier, whether Nadja knew the parts and – with seductive manipulation – performed them for their creator. Nadja acknowledged having read Section no. 31 of *Poisson soluble,* which juxtaposes black (curtains) and red (Satan, "the color of fire"), and which includes a character – Helen – who announces "the window is open" (Nadja believed she actually had once played the role of Helen). Satan, "the author of the play" (hence, presumably signifying Breton to Nadja), states: "I went to the Opera one day, and there, profiting from the general lack of attention, I first *caused several reddish lights to appear on the façade of the building*" (in Breton, *OC,* vol. 1, p. 392; my emphasis). Breton liked to think that through circuitous paths of the imagination (literature, prophecy), one could forsee events outside the domain of a linear determinism.

160. Benjamin appreciated the Parisian arcades in this sense, and Bachelard spoke of the "topoanalytique" study of the visual hallucinations of landscapes and decor in dreams. See M. Guiomar, "Le Roman moderne et le Surréalisme," in Alquié, *Entretiens,* p. 74. Can the Dublin of Joyce's *Ulysses* (first published in Paris, 1922), an Irish counterpart to Breton's Paris, have influenced Breton, as well as Aragon in his *Paysan de Paris,* despite an apparently mutual antipathy between the two men and Joyce?

161. Aragon says that the role of the poet consists in divulging the diffuse presence (of the divine), scattered in the world of the concrete, and in imagining the divine through simple promenades filled with reflections. See Yvette Gindine, *Aragon, Prosateur surréaliste* (Geneva, 1966), p. 60, relating the *Paysan de Paris* (p. 140) to Schelling's *Introduction to the Philosophy of Mythology.* One could also trace the idea of what one might designate a philosophical *flâneur* back to Rousseau's *Promenades.*

162. In the years between 1870 and 1914, 132 public monuments were inaugurated in Paris, perhaps a parallel to Italian building in those years. See G. Pessard, *Statuomanie parisienne. Etude critique sur l'abus des statues* (Paris, n.d. [1911–12?]); M. Agulhon, "La 'Statuomanie' et l'histoire," *Ethnologie française,* 8 (1978), pp. 145–73; and C. Martinet, "Les Historiens et la statue," *Le Mouvement social,* no. 131 (April–June 1985), pp. 121–30.

163. "Si le Surréalisme était maître de Paris, . . ." *Le Figaro littéraire* (March 17, 1951). Reprinted in Pierre, *Tracts,* vol. 2, pp. 71–2.

164. Breton, *OC,* vol. 1, p. 698. Even some reputable French scientists shared with Breton the belief in the possibility of mental telepathy. Dr. J. Grasset, author of *L'Hypnotisme et la suggestion* (Paris, 1903), who like Breton admired Flournoy's book *Des Indes à la planète Mars* of 1900, studied the telepathic medium Helen Smith, about whom he wrote (p. 494): "When one has witnessed the birth of wireless telegraphy, one ought no longer deny the possibility of mental suggestion, even at a distance."

165. Breton used a French translation with an engraving showing the philosophers before a fountain. This edition dates to 1750, the first English edition to 1713. Breton, *OC,* vol. 1, p. 1546, explains Breton's choice of this book by its date: Breton, always on the hunt for "marvelous" coincidences, made the visual pun on 1713/AB. As discussed earlier Breton apparently shared this with Nadja: within a heart she drew over her face in one of her collages, Nadja inscribed both the number 43 – suggesting the letters of her lover's name – and "Nadja." Other friends of Breton's understood his interest in playing games with the letters of his name: Man Ray drew a portrait "à André Breton" in 1936 in which the lowercase letters "a" – in Man Ray's signature and "à" and the uppercase letter in "André" – take the form of haystacks in a landscape.

166. See Berkeley, *Dialogues,* p. 288. Breton seems to have recalled this incident a year later in the part of *Surrealism and Painting* published in *La Révolution surréaliste,* no. 9–10 (October 1927), p.42: "Fountain (*jet d'eau*) supports egg that neither rises nor falls. Woman cherishes man who loves woman who fears man."

167. For his knowledge of Lenin's book, for which an ad appeared in *LSASDLR,* no. 4 (December 1931), see Breton, *Entretiens* (Saint-Amand, 1969 ed.), p. 128. Lenin refers to the *Three Dialogues* on p. 30 of the edition of Moscow (1976), vol. 14. The preface by Boiffard, Eluard, and Vitrac to *La Révolution surréaliste,* no. 1, (December 1924), quoted a remark of Berkeley's. Lenin's *Materialism and Empiriocriticism* cites a passage of Diderot that provided the subject not only of Crevel's essay *Diderot's Harpsichord* (1932), but, I believe, of Dali's *Six Apparitions of Lenin on a Keyboard* of 1931.

168. Boutroux, *De L'idée de loi,* p. 41, describes Berkeley's refutation of a Newtonian metaphysics that presumes our ability to know material things. Freud considered the problem of linking perceptions and ideas in *Le Moi et le ça,* p. 191: "By the intermediary of verbal representations, internal intellectual processes become perceptions. . . . When thought is in a state of overload, ideas are actually perceived as coming from outside and for this reason considered real." Aragon in *Une Vague de rêves,* p. 102, wrote: "*Absolute nominalism found in Surrealism a brilliant demonstration, and it seems to us finally that the mental material of which I spoke, was constituted by the vocabulary: there is no thought without words.*" The famed psychologist Binet had at the beginning of the century likewise maintained the identity of thought and words.

169. In Lenin, *Matérialisme* (Paris, 1976), p. 30.

170. A more formal version of Breton's approach appeared in "psychocritique," Charles Mauron's psychoanalytic version of literary criticism.

171. See Breton, *OC,* vol. 2, "Notice" to the *Vases communicants,* for an extensive discussion of Freud's relevance to the book.

172. In fact, Didier Anzieu, *L'Auto-analyse de Freud et la découverte de la psychanalyse* (Paris, 1975 [1959]), has shown that Freud omitted all references to his own sexuality in analyzing his "specimen dream" entitled "Irma's Injection."

173. Cf. J.-B. Pontalis, "Les Vases non communicants," *La Nouvelle Revue française,* 302 (March 1, 1978), pp. 26–45, who says that for Breton dreams and reality were in mystical communication; for Freud they were in a relation of distorted displacement, and the Surrealist position would seem antirational. Breton, on the contrary, attempting at this time to reconcile Surrealism with Marxist materialism, without sacrificing the weight and significance of dreams and images in the

"real world," asserted that the "vase" dream and reality were equipollent and could be connected dialectically.

174. The term "psychoaesthetics" had already appeared in the criticism of Baudouin.

175. See the "Discours sur le peu de réalité" and also the last issue of *La Révolution surréaliste*, no. 12 (1929), p. 22, with its call for responses to "A Surrealist Inquiry. The True Phantoms" (he seems never to forget Taine's bowl of soup!): "We can distinguish in the possibilities we have of getting out of our normal personality, the *physical conditions:* illnesses of the nerves, of the personality, of the senses or of memory and their consequences: dreams, somnambulism, madness, visions and hallucinations, cryptaesthesia, etc. What is the relation of these *phantoms* with *things:* more real, as real, unreal?"

176. "Cil-anse" is pronounced like "sil-ence."

177. The synaesthetic association of the visual to sound – and to silence – engaged non-Surrealists like Kandinsky, who published in *Cahiers d'art*, 6 (1931), p. 351, the remarks: "The painter needs discreet, silent, almost insignificant objects.... How silent is an apple beside Laocoon. A circle is even more silent." This path from Cézanne's apples to Kandinsky's circles bypasses the issues of Surrealist painting.

178. The image and relevant text were first published in *LSASDLR*, no. 3 (December 1931), p. 21. In his *Anthologie de l'humour noir* of 1939, (p. 272), Breton later speaks of a "little parallelogram-shaped box" charged with "solutions" from which Jarry could load up his "revolver ... the paradoxical hyphen between the exterior and interior worlds." (This passage may have inspired the portrait by Matta of Breton – who wrote about Matta that very year – entitled *A Poet of Our Acquaintance* (1944), in which a starkly frontal and menacing figure points a handgun at us.) Curiously, French thinkers like Lévi-Strauss and Foucault were later fascinated by a similar figure of a quadrilateral with a dot at the center of crossed diagonals. Foucault devised a four-cornered system, a "quadri-lateral of language" (proposition, articulation, designation, and observation), a sweeping scheme that he applied to all literature from fiction to science. See Foucault, *The Order of Things* (New York, 1970 [1966]), pp. 116–20. Greimas and others employed similar schemata, reminiscent of

the square of traditional logic. During the seventies a "graphomania" for such diagrams seized a number of American followers of French structuralism and poststructuralism.

179. The unacknowledged source of the pun may have been Leiris's "silence" phonically decomposed into "(d)anse" and "cils" in his "Glossaire," *La Révolution surréaliste*, no. 6 (March 1, 1926), p. 21: " 'SILENCE' (on y entend la danse des cils) ["SILENCE" (we hear/mean by that the dance of the eyelashes)]. There may also be a connection to the eyelashes, handles, and absent mouth (silence) of Dalí's *Great Masturbator*.

180. See "Enquête," *Minotaure*, 3–4 (1933), p. 101.

181. See Louis Huart, *Physiologie de la grisette* (Paris, 1841), p. 61, which presents the ingredients of Lautréamont's phrase: in a chance encounter on a Paris street during a rain, a young man could use the offer of his umbrella to seduce a young seamstress or milliner. Cf. also Daumier's *Dido and Aeneas*, in which the hero-seducer offers to shelter the queen from the rain in a cave.

182. Taking phantoms seriously was not new to Breton: as we have seen, he had already talked about the phantoms of De Chirico and of Taine in *Le Surréalisme et la peinture*.

183. The torso-envelope first appeared in *La Révolution surréaliste*, no. 9–10 (October 1927), p. 44. It is perhaps significant that a *cadavre exquis* illustrated on p. 8 of the same issue has vase-legs with prominent handles, or *anses;* moreover, the two vases are joined or "communicate" via the trouser above them.

184. Breton apparently owed some of his charisma to his unusual combination of personal authority with the denial of a higher authority.

185. W. Spies's attribution of Freudian sources for the early Ernst does not convince me. At least one detail of Ernst's *Oedipus Rex* (1922) – the arrow that pierces the walnut – comes right out of Sophocles, *Oedipus the King* (1197/1200) according to my colleague Lowell Edmunds. Albert Camus, in *L'Homme révolté* (Paris, 1951), p. 118, called the Surrealists "salon nihilists: Absolute revolt, total insubordination, regular sabotage, humor and cult of the absurd, Surrealism, in its initial intuition, defines itself as putting everything continually on trial."

186. Sartre, *Situations*, vol. 2, pp. 214–15.

187. See Bonnet, *Breton*, p. 12, and Breton, *OC*, vol. 1, p. xxix.

188. In *L'Amour fou,* p. 160, Breton reports: "An illustrated history of France, doubtless the first that I ever saw, at about four years old, showed the very young Louis XV massacring, *for pleasure,* birds in an aviary... without doubt I retain with regard to this image a certain ambivalence."

189. See Breton, *L'Amour fou,* illustration 2. The phrase "praise of crystal" is on pp. 16–17. This photo by Brassai bears the text: "The home I live in, my life, what I write...." On p. 16, he states that "the work of art, by the same token as any moment of human life considered in its most serious import, seems to me devoid of value if it does not show the hardness, rigidity, the regularity, the luminosity on all its surfaces both exterior and interior, of crystal.... I never cease to advocate creation and spontaneous action," qualities of which crystal is "the perfect expression." Earlier, in his "Discours sur le peu de réalité," he wrote of "Crete, where I must be Theseus, but Theseus forever enclosed within his labyrinth of crystal" (see Breton, *OC,* vol. 2, p. 265). I wonder whether a deep ambivalence about the firmness of his father may be linked to Breton's famous assertion (which betrays more than a grain of classical castration anxiety) that he never wished to be seen nude by a woman unless in a state of erection. This would naturally and invariably have led to a case of *post coitum triste.*

190. See Roland Barthes, *Image – Music – Text* (New York, 1977), p. 124.

191. The theme must have charmed Breton: a vampire loses his eternal life for a night of love – owing to his passion he overstays the love bed and, oblivious to the time, fails to regain the safety of his coffin before dawn and the lethal sunlight.

192. See Breton, *OC,* vol. 2, pp. 136ff. Arp frequently made images of disabled machines rendered useless (except for a biological afterlife) by softening and deformation, like Dali's watches. Cf. Dali, *Oui,* p. 130: "The minute hands acquire a real value only when they cease to show the time."

193. Lenin researched his *Materialism and Empiriocriticism* only to prove the reactionary thrust of certain "unmaterialist" physicists; consequently, he ignored the emergence of relativistic ideas in physics and non-Euclidean geometry. He only began to accept relativity in 1922, a year before his death.

194. Earlier he associated the gift of a bidet to Suzanne with a bridge, and we recall the bridge of the "dew with the cat's head."

195. See Jean Paulhan, *Le Pont traversé* (Paris, 1922), in which communication through dreams plays an important role. Paulhan wrote a series of articles for *Littérature* in 1920 when Breton, Aragon, and Soupault were editors.

196. Dali has painted a barely visible toenail at the tip of the nose. A similar head without the nail on the nose appears in Dali's *The Lugubrious Game* also of 1929. In his *Bather* of 1928 he likewise imposed a toenail on a form that has nothing to do with a foot.

197. For Breton's remark on onanism, see note 201.

198. Cf. Otto Fenichel, *The Psychoanalytic Theory of Neurosis* (New York, 1945), pp. 244–5, who observes that in "nymphomaniacs" the "vagina unconsciously signifies a mouth." See also E. Glover, "The Significance of the Mouth in Psychoanalysis," *British Journal of Medical Psychology,* 4 (1924), and the writings of the anthropologist Desmond Morris on primate sexuality. Dali assigned a vaginal mouth to some of his male figures, as in *The Lugubrious Game.* The ants swarming on the ventral side of the grasshopper opposite the "erased" mouth of the Masturbator suggest a favorite Dali association between ants and pubic hair, one that seems to have inspired Eluard, who made a collage in 1935 in which a Great Anteater (a play on the Great Masturbator?) straddled by one naked woman licks at the pubic area of another, and Breton, perhaps with a similar idea (since he liked cunnilingus), assembled a Great Anteater from pieces of wood gathered by his wife in 1962. See illustrations in Roger Cardinal and Robert S. Short, *Surrealism: Permanent Revolution* (London, 1970), pp. 154–5.

199. Dali illustrated the cover of *La Femme visible* with the eyes of Gala in a photograph cropped like Nadja's eyes and with two vague and shadowy irises reflected beneath them in the manner of the four replications of Nadja's eyes.

200. Clinical psychologists have often noted a connection between urination fantasies and ambition in children. This may apply to the concern about urination expressed at one point by Breton, who had complicated attitudes toward his own ambition and career,

grounded in memories of an uncomfortable experience at age six when his mother consulted a doctor about his involuntary nocturnal emissions. (See *Recherches sur la sexualité* [Paris, 1990], session of February 1928, p. 80.) Can there be an etymological link between urine (derived from the popular form *aurina* after the Latin *aurum* applied to the golden stream of urine, akin perhaps to Lenin's famous comic symbol of the victorious world revolution, "pissotières en or"), and the "or du temps" that Breton so ardently sought? Note that Breton saw himself under the sign of Uranus – linked at once to *ouranos* (Greek; "heaven") and *ouron* (Greek) / *urina* (Latin) – a zodiacal sign symbolizing great individuality and a Promethean ambition to seek the new.

201. A mockery of Surrealism as masturbatory had already appeared in Naville's "Mieux et moins bien," part of which appeared in *La Révolution surréaliste* (October 1927), pp. 54–61, which connected the Surrealists' aesthetic radicalism and their morally reprehensible failure to act in support of Bolshevism: "Glib talkers, [whom we can call] pen pushers [*plumitifs*] in the way we say emetics [*vomitifs*], masturbators of pure poetry." (Understandably, this passage was omitted from the issue, but published in Pierre Naville, *La Révolution et les intellectuels* [Paris, 1928], p. 58). Breton expressed his view of masturbation in the "Recherches sexuelles" published in *La Révolution surréaliste*, no. 11 (March 1928), p. 33: "Onanism . . . must be accompanied by images of women. It is suited to every age, has nothing sad about it, is a legitimate compensation for certain sad things in life." Giacometti denigrated his Surrealist period as masturbatory when he developed his final sculptural style.

202. See chapter 5, section 6, of *Materialism and Empiriocriticism*. The great French mathematician Henri Poincaré (1854–1912) anticipated aspects of the special theory of relativity and wrote remarkable memoirs at the beginning of the century on the unconscious mentation of mathematicians. During this period popular books on the occult grappled with the new and difficult mathematical and scientific concepts. See, e.g., G. de Pawlowski, *Voyages au pays de la quatrième dimension* (Paris, 1923), with its allusions to parapsychology and the supernatural.

203. See André Thirion, *Révolutionnaires sans révolution* (Paris, 1988), p. 294: "Serious emotional events threw some of us into confusion. Breton has described with extraordinary precision and an incredibly evocative power what the first months of the spring of 1931 were like for him. These images form the framework of the central section of the *Vases communicants*."

204. The allusion to length seems directly linked to the exposure of an erection mentioned earlier.

205. Above all see *La Critique sociale,* edited by Souvarine, a periodical that published Bataille, Bernier, and others critical of Breton's Surrealism. Trotsky and his Left Opposition published penetratingly analytic as well as ad hominem criticisms of Stalin, but, unable to see beyond Leninist Bolshevism (as Rosa Luxembourg for one did), they never gave up their belief in the USSR as a Communist paradigm.

206. In an essay of 1954, in *Surrealism and Painting*, p. 307, he compared the mediumistic art of Joseph Crépin to the "Palais idéal": both "do not, properly speaking, contain either an 'interior' or an 'exterior,' or rather, this interior and this exterior are, so to speak, imbricated together."

207. See *Archives du Suréalisme*, p. 184.

208. Such fixed images suggest a sublimation that covers a flux, as in the psychoanalyst's notion of the "Monday morning crust." In a similar vein Bergson, in his *Introduction to Metaphysics* (New York, 1913), pp. 8ff., observes that "when I direct my attention inward to contemplate my own self . . . I perceive at first, as a crust solidified on the surface, all the perceptions that come to it from the material world. These perceptions are clear, distinct . . . [But] there is beneath these sharply cut crystals and this frozen surface, a continuous flux."

209. As noted earlier Breton had already written in his "Discours sur le peu de réalité": "Crete, where I must be Theseus . . . forever enclosed within his labyrinth of crystal" (see *OC*, vol. 2, p. 265). See K. Barck, "Lecture de livres surréalistes par Walter Benjamin," *Mélusine,* 4 (June 1981), p. 283, for Benjamin's notion of "life in a house of glass," which Benjamin traced to *Nadja;* but he might have come across it in his native Germany: poets, architects (like Taut and Scheerbart), and artists (like Feininger) dreaming of a futuristic So-

cialist architecture after World War I often spoke of glass and crystal houses.

210. For the theme of transparency, see Romy Golan, "Mise en suspens de l'incrédulité. Breton et le mythe des Grands Transparents," in *Breton. La Beauté convulsive,* Catalogue of the exhibition at the Centre Pompidou (Paris, 1991), p. 354. Golan cites the remark in *Arcane 17:* " 'la grande ennemie de l'homme, c'est l'opacité' " (ibid.), and he quotes (ibid.) Breton as wishing for a " 'vitrification de l'être' " (ibid.). Note that Picabia is quoted in "Jésus-Christ Rastaquouère," *Littérature,* no. 9 (March 1923), p. 24, as follows: "that subjective objectivity that directs men toward transparency." For crystal as an image of French scientific order and logic, see the article by the geologist Albert de Lapparent, "L'Evolution des doctrines cristallographiques," *Revue de l'Institut Catholique de Paris,* no. 1 (January–February 1901), pp. 1–24, and no. 2 (March–April 1901), pp. 123–43.

211. The machine penetrating "la forêt vierge" functions like Duchamp's machines for turning a "vierge" into a "mariée." Breton wrote an essay on the "desiring machine" (a concept developed by Deleuze and Guattari in the sixties) of Duchamp in 1934, the same year he was at work on *L'Amour fou.* Perhaps sensing an analogy to the "lyricism" (a word Breton applied both to the poet and the artist) of Lautréamont's image of a sewing machine and an umbrella in the space of a dissecting table, Breton characterized Duchamp's *Bride Stripped Bare by Her Bachelors, Even* as "a mechanistic, cynical interpretation of the phenomenon of love" (*Surrealism and Painting,* p. 94). But he adds (ibid.) that "one very soon abandons oneself to the charm of a kind of great modern legend where everything is unified by lyricism" and concludes with high praise of the work's originality and of the validity of its "statement of the relationship between the rational and the irrational" (p. 99). For background on responses to the railways, see Wolfgang Schivelbusch, *The Railway Journey: The Industrialization of Time and Space in the Nineteenth Century* (New York, 1977), pp. 129–49.

212. Tzara's poem "Speaking or Intelligible Wood Sign of Easter Island" (in *Of Our Birds,* 1923) contains the phrase "the wide sound of speed is slowness."

213. Ibid., p. 680.

214. One is surprised not to find illustrations of any of Klee's subtle evocations in drawings of the twenties of forms on the verge of disintegration.

215. These insects fascinated Ernst, as well as Breton and Eluard, both of whom once bred them at home.

216. See the beginning of section 3, p. 38.

217. Browning wrote the famous line "A man's reach should exceed his grasp" in "Andrea del Sarto" (1855), in Robert Browning, *The Poems* (New Haven, Conn., 1981), p. 646, lines 97–8. Hugo wrote "L'Avenir, fantôme aux mains vides, / Qui promet et qui n'a rien," in *Les Voix intérieures,* vol. 2, *Sunt lacrymae Rerum,* in Victor Hugo, *Poésie* (Paris, 1885), vol. 3, p. 231.

218. The title refers to the famous sentence that concludes chapter 1: "La Beauté convulsive sera érotique-voilée, explosante-fixe, magique-circonstancielle ou ne sera pas."

219. There is a striking anticipation of the *explosante-fixe* in Goethe's category of "fixed lightning." Goethe found that by either blinking his eyes or looking with a flickering light, he could see the Laocoon as a "fixierte Blitz" (a phrase uncannily anticipating photographic fixing) or as a "petrified wave." See "Über Laokoön," *Schriften zur Kunst,* in the *Werke* (Hamburg ed., 1967), vol. 12, p. 60.

220. Cf. Legrand, *Breton,* p. 119. Bonnet, *OC,* vol. 2, pp. 1709–10, cites Legrand's text with approval.

221. Cf. Man Ray's manipulated photos of eyes (Nadja's) and of breasts repeated on a vertical axis.

222. See Breton, *OC,* vol. 2, p. 1693.

223. See Nietzsche, *Gay Science,* p. 341; *Beyond Good and Evil,* p. 56.

224. Perhaps he also had in mind another photo of Man Ray's in which glass spheres implicitly represent testicles. The argot equating balls and testicles (which holds in French as in English) supports the equation of milky and spermatic spheres. Man Ray had made a similar glass container illustrated in *La Révolution surréaliste,* no. 1, called "Roulement habile" – a pun on *à bille,* meaning a clever ball bearing, which places the balls inside the glass cylinder rather than outside. *Rouler* can mean to deceive – a fitting term for the prankster artist.

225. Eugénie Sokolincka offered a lecture to the

Fourth Conference of French-Speaking Psychoanalysts in June 1929 held at the Sainte-Anne Hospital. It was published as "La Technique psychanalytique," *Revue française de psychanalyse,* 3, no. 1, 1929, cited in Roudinesco, *Histoire,* vol. 1, pp. 288–9.

226. Here he may have had in mind Charcot's theories, e.g., in his article "Métalloscopie, métallothérapie, aesthésiogénie," *Archives de Neurologie* (1880–1). The teaching of "éléctricité statique" in the *lycées* regularly included experiments on electrically charged gold leaves. See *Plan d'etudes ... dans les lycées et collèges* (Paris, 1896–7), p. 142.

227. See Aragon's review of Emile Savitry's show at the Galerie Zborowski, Paris, March 5–19, 1929: "[Savitry] belongs among those who paint in order to serve essentially subversive aims. Notice: nothing but Surrealism is subversive at this time."

228. See "Le Phénomène de l'extase," *Minotaure,* no. 3–4 (December 1933), pp. 76–7; and the same issue, p. 68, included photos by "XXX" of "sculptures involontaires" (rolled bus tickets, bits of soap and bread, with special lighting effects that convey an illusion of plasticity). The "involuntary sculptures" were used to illustrate *Oui* (1971), an anthology of Dali's articles.

229. See the *Larousse du XX° siècle,* s.v. "objet d'art."

230. Benjamin may have been influenced by the Surrealist attitude (as well as Baudelaire's essay on *le joujou*) in "Russian Toys," in *Moscow Diary* (Cambridge, Mass., 1987), pp. 123–4, where he opposes the magic of the toy to the fetishism of the commodity.

231. See especially Nerval's "Vers dorés," which present ideas analogous to those in the poetry of Breton and Eluard: "Chaque fleur est une âme à la Nature éclose; / Un mystère d'amour dans le métal repose." But cf. the imagery of Lamartine and Hugo.

232. Breton often associated fur and ceramics. For his involvement in Oppenheimer's "Fur-Lined Cup and Saucer," see Chapter 5, this volume. An ingrained impulse guided Breton's continual contrasting of the hard and the soft, for example, his antipodal tastes for crystal architecture and the amorphous pile of the postman Cheval.

233. Freud, in the chapter "Dream Symbolism" in his *Introductory Lectures* already equated "shoe, slipper [and] female genital."

234. Dali described it in "Objets surréalistes," *LSASDLR* (December 1931), p. 16: "A woman's shoe, inside of which has been placed a cup of lukewarm milk [resting] in the middle of paste of ductile form and excremental color.... Many accessories (pubic hairs glued to a sugar cube, a small erotic photo) complete the object." Quoted in "Objets du fétichisme," *Nouvelle revue de psychanalyse,* no. 2 (Autumn 1970), pp. 31–9.

235. See Freud, "Fetishism" (1927), *SE,* vol. 21, p. 152, and Guy Rosolato, "Le fétichisme dont se dérobe l'objet," in "Objets du fétichisme," *Nouvelle revue de psychanalyse,* no. 2 (Autumn 1970), pp. 31–9.

236. Gonzalez wanted to use space "as though one were dealing with a newly acquired material.... There is a union of real forms with imaginary forms ... and according to the natural law of love, to make them inseparable." See the catalogue *Julio Gonzalez* (New York, 1956), p. 42. It is noteworthy that such a statement could come from an artist with no overt connection to Surrealism, despite working closely with Picasso during the years he was most sympathetic to Surrealism.

237. Sculptural automatism seemed forclosed, presumably owing to the importance of technical control. However, some psychiatrists did in fact discuss it one year after the appearance of the *Champs magnétiques.* See M. Laignel-Lavastine and J. Vinchon, "Un Cas de sculpture 'automatique,'" *Bulletin de l'Académie de Médecine,* 83 (1920), pp. 317–9, and their "Délire mystique et sculpture automatique," *Revue neurologique,* 27 (1920), pp. 824–8.

238. See Breton, *Entretiens,* p. 163.

239. Léger's view of a dancing woman from below that renders her figure unreadable may have suggested Man Ray's "Explosante-fixe."

240. Sarane Alexandrian, in his *Surrealist Art* (New York, 1970), pp. 115–18, makes unsubstantiated claims for the importance of the *Dolls* to the Surrealists; cf. the similar view later adopted by Rosalind Krauss followed by Hal Foster. See my review of Foster's *Compulsive Beauty.*

241. One can read in some pieces of this period the rotating and penetrating motions of the sewing machine and the pouring of blood on the operating table. And one of Giacometti's drawings (see *LSASDLR,* [December 1931], no. 3), with its phallic shape penetrating the

intersection of crossed diagonals on a rectangle, directly recalls Lautréamont's image.

242. Dali probably owed his deforming and softening of eating utensils like the spoons in *Paranoiac Metamorphosis of Gala's Face* (1932) to Giacometti's *Spoon Woman* (1927).

243. See *LSASDLR*, no. 3 (December 1931), pp. 35–6. This was originally a lecture he gave in Barcelona on September 18, 1931.

244. Crevel's play on the words *jouer / jouir* anticipates a similar usage later developed by Barthes, and the words "make love" prefigure Derrida's "play of signifiers." This association of the objects with love and life did not convince Adorno, who – perhaps thinking of the term "exquisite corpse" – criticized Surrealism for its concentration on the *nature morte* and death.

245. See Hegel, *Aesthetics*, vol. 1, pp. 315–16.

246. The text, originally in *Cahiers d'art*, no. 5–6 (1935), was republished in André Breton, *Je vois, j'imagine* (Milan, 1991), p. 23.

247. Breton is playing formally on the "huppe" or "houppe" (an "o" with an "huppe"; a bird's crest that he compares to the fountain shape in *Nadja* and to the sign "ˆ") and playing phonically on the homonymy of "o" and "eau."

248. I would suggest that Breton practiced a similar self-exploration in his disussion in chapter 4 of *Vases Communicants* of his poem "La Nuit du tournesol."

249. One can consider Duchamp's last work, a sealed room in the Philadelphia Museum of Art, which is accessible only by a peephole (recalling Dali's peeping man looking into an "art box" in *Illumined Pleasures* of 1929), as an ironic comment on exhibition(ist) spaces and on voyeurism.

250. See Tzara, "D'un certain automatisme du goût," *Minotaure*, no. 3–4 (December 14, 1933), pp. 81–4. In his *Trauma of Birth* (New York, 1929 [1924]), p. 156, Otto Rank found the "real root" of art in the "autoplastic imitation of one's growing and origin from the maternal vessel." Breton, *OC*, vol. 1, pp. 1634–5, has noted the influence of the theory of intrauterine life advanced in Rank's book (translated in 1928 as *Le Traumatisme de la naissance*) on the section "L'Homme" of *L'Immaculée conception* (1930) and on Dali's *La Femme visible* (1930). In general, the impact of Rank's theories on art in Paris (in Germany and the United States as well) deserves much greater scholarly attention, especially since the psy-

choanalyst lived in Paris during the twenties and traveled in art circles.

251. Kiesler doubtless found the idea for the staging of the play congenial; for Tzara had stated, "The scene represents a closed boxlike space from which no actor can leave." (Did Tzara's idea inspire Sartre's *Huis clos*?) Kiesler already designed curving walls for the gallery Art of This Century (1942).

252. See the interesting catalogue for the exhibition "1936. Surrealism. Objects, Photographs, Collages, Documents," held in the Zabriskie Galleries, New York and Paris, February to April 1986. The juxtaposition of Breton's introduction to the Paris show, of the English poet and critic Herbert Read's to the London show (emphasizing Freud), and of Hugnet's to the New York show (inanely defending the beauty and taste for Surrealist objects) demonstrates with unintended irony the replacement of political by aesthetic "revolution."

253. See, for the English version, *Surrealism and Painting*, pp. 275–80.

254. See "Max Ernst," in *Les Pas perdus*, in Breton, *OC*, vol. 1, pp. 245–6. In her essay for the catalogue of the "L'Amour fou" exhibition, Rosalind Krauss claims that implicit in Breton's writing is a theory of Surrealist photography rather than painting. Nowhere in the essay does she consider other media or the historical context of Breton's evolving ideas.

255. For a view of Surrealist photography in terms of a linguistic system, see Franco Vaccari, *La Photographie et l'inconscient technologique* (Paris, 1981), p. 65.

256. Although he did not allude to it in his essay on Duchamp (1922) Breton would not have disagreed with Duchamp's view, as reported by Léger. The artists were visiting a Salon de l'Aviation with Brancusi before World War I, and as Léger notes, "Suddenly he [Duchamp] said to Brancusi: 'Painting is finished, who can do anything better than this propeller?'" In Dora Vallier, "Braque La peinture et nous. Propos recueillis," *Cahiers d'art*, 29 (1954), pp. 13–24. Admittedly, after the adulation of the airplane as a weapon against the Ethiopians by the Fascist Count Ciano, its use as a means to terrify enemy populations by the Nazis, and recently the helicopter's deadly service in suppressing local rebellions, Duchamp's remark has lost its innocence.

257. These subjects appealed to Léger in the post-Cubist thirties.

258. See "Surrealist Situation of the Object" (1935), in Breton, *Manifestoes,* p. 272; and Breton and Eluard, *Dictionnaire abrégé du Surréalisme,* in Breton, *OC,* vol. 2, p. 822: "Man Ray . . . 'Il peint pour être aimé.' Peintre pré-surréaliste et surréaliste."

259. For opposed views of Man Ray's status as a Surrealist, see the essays of Livingston and Krauss in *L'Amour fou.*

260. In "Surrealism and Painting," published originally in *La Révolution surréaliste,* no. 9–10, (October 1927), p. 41.

261. For Breton's quote on Man Ray, see ibid. R. Krauss, who wishes to keep Surrealism and Cubism apart, here ignores the role of collage and photomontage in Surrealist photography. Morover, she calls "the strategy of doubling" "photographic." (Elsewhere she makes much of "iteration" and ties it to a heterogeneous group including Saussure, Lacan, Barthes, and Derrida.) See the *Amour fou* catalogue, "Photography in the Service of Surrealism," p. 28. But doubling appeared in Cubist painting prior to the photographs she cites, e.g., the double breasts in Picasso's *Woman in an Armchair* (1913) and *Woman with Guitar Player* (1914).

262. Dali, "La Fotografia, pura creació de l'esperit" (September 1927), cited in Ades, *Dali and Surrealism,* p. 47. Vaccari, *La Photographie et l'inconscient,* discusses the photographic unconscious without mentioning Dali. The notion appears in Benjamin and, with differences, in Krauss, *The Optical Unconscious.*

263. See Ades, *Dali and Surrealism,* p. 55, citing Dali's essay "Photographic Fact."

264. For the view that Art Nouveau photographs influenced Surrealist photography, see Deborah Silverman, *Art Nouveau in Fin-de-siècle France* (Berkeley, 1989).

265. Current aestheticians tend to deny the old claim still made by Arnheim that photography stands in direct relation to reality. Feminist artists like Cindy Sherman and Sherrie Levine use ironically photographic self-portraits, in which they become the subject as well as the object, and photos of photos in criticism of conventions of beauty and "originality."

266. See Vaccari, *La Photographie,* pp. 29–30, citing *The Work of Art in the Age of Mechanical Reproduction.*

267. We are close here to the notion of the pregnant moment.

268. A scene in *Nadja* describing the throwing of objects from a window may well have inspired similar scenes in both *Un Chien andalou* and *L'Age d'or.*

269. See Roland Barthes, "The Third Meaning: Research Notes on Some Eisenstein Stills," *Image, Music, Text,* pp. 66–7; and on film vs. photograph, "The Rhetoric of the Image," ibid., p. 45.

270. Cf. ibid., p. 66, n. 1: "There are other 'arts' which combine still (or at least drawing) and story, diegesis – namely the photo-novel and the comic-strip.... And there is an autonomous 'art' (a 'text'), that of the *pictogram* ('anecdotalized' images, obtuse meanings placed in a diegetic space) ... ethnographic pictograms, stained glass windows, Carpaccio's *Legend of Saint Ursula, images d'Epinal,* photo-novels, comic-strips." For a parallel in poetry to this potential unfolding of a still, see Eluard, *Donner à voir* (1939; in Breton, *OC,* vol. 1, pp. 969–70): "An image can be made up of a multitude of terms, can be a whole poem, even a long one. It is then subjected to the necessities of the real, it develops in time and space, it creates a constant atmosphere, a continuous action. To cite only the poets of this century, Raymond Roussel, Pierre Reverdy, Giorgio De Chirico, Salvador Dali, Gisèle Prassinos, Pablo Picasso have thus brought to life the infinity of their universe, sometimes by developing a single image." The comparison between the "sister arts" of poetry and painting in terms of time and space goes back at least to the baroque in the theory of *ut pictura poesis* – rewritten by the Surrealists in terms of an *ut pictura somnium.*

271. Cf. Jean Wahl, "Art et perception," *Minotaure,* no. 6 (Winter 1935), p. 20: "Anti-transcendental and transcendental theory of space: if the object exists, under what conditions could it be considered as present? / Presence-absence of space: perception. / Presence-absence in time: memory." Also see Henri-Charles Puech, "Signification et représentation," ibid., p. 52.

272. I have adapted this notion of figurative metaphor, a visual means functioning like language "to suggest through formal resemblance, a revealing similarity," from Robert Klein, "Considérations sur les fondements de l'iconographie" (1963), in *La Forme et l'intelligible* (Paris, 1970), p. 360. He in turn apparently relies on Richard Bernheimer,

The Nature of Representation (New York, 1961).

273. A typically simplistic view was held by Herbert Read, *History of Modern Painting* (New York, 1968), p. 132: "Surrealism was above all a question of *poetic* creation; and indeed painting and sculpture were to be conceived as essentially plastic transformations of poetry." Unfortunately he does not get beyond such clichés: he nowhere explores the interplay between the imagery of Surrealist poetry and painting, or the nature of Surrealist art criticism.

274. The critic Michael Riffaterre, *Semiotics of Poetry* (Bloomington, Ind., 1984 [1978]), p. 85, is typical of this position in his assertion of the autonomous nature of Surrealist poetry: "Yet the incompatibility [in *gazon de lait*] is there only if the text is used as a reference to reality. The incompatibility vanishes once the text is read the way texts are built to be read, as a reference to its own models, to words further back down the line." And p. 141: "The lesson surrealists meant to teach by their automatic writing – that beneath the words there is nothing but more words."

275. See Adorno, "Looking Back on Surrealism." He applied similar metaphors of death to Walter Benjamin, who espoused Surrealism and spoke of "dialectical images."

276. Cf. Adorno, *Philosophy of Modern Music,* p. 51.

277. See Souvarine, *Staline* (Paris, 1985 [written between 1930 and 1935]), p. 472: "In 1933, the advent of Hitler in Germany intensified the pacifist tendencies of Bolshevism. Everything previously regarded as detestable now became excellent, and vice versa." Cf. also Thirion, *Révolutionnaires,* p. 406.

278. The influential "Théorie générale de la magie" (1920–3) of Mauss and Hubert developed the basis for understanding the role of images in fetishism and *envoûtement* by showing how magical practices depend on the "laws" of similarity and contiguity enunciated in Frazer's *Golden Bough.*

279. See Jacques Lacan, "Problème du style," *Minotaure,* no. 1 (June 1933), p. 69. See also Rank's classic essay "Doppelgänger," *Imago,* 3 (1914), in Rank, *Psychoanalytische Beiträge zur Mythenforschung* (Leipzig, 1919), pp. 267–354.

280. Lacan, *The Four Fundamental Concepts of Psychoanalysis,* pp. 85–9, comparing ana-

morphic deformation to paranoiac ambiguity, uses Dali's painting as an example. He claims Dali's deformations of skulls and soft watches have the effect of turning ordinary objects in a state of repose into an erection. Dali's images symbolize phallic phantoms making up for a lack. Like Holbein's image in *The Ambassadors,* Dali's phallic self-representations imply his response to a threat of castration.

281. See *Minotaure,* no. 7 (June 1935), pp. 58–9.

282. Masson observed in 1963 that "the name *Minotaure* was given to the periodical by Bataille (at its origin, as a project, an organ of the Surrealist dissidents ...)." See Will-Levaillant, *Masson ... Ecrits* (Paris, 1976), p. 73 and n. 34.

283. Victor Hugo, *Les Contemplations* (Paris, 1834), lines 175–6.

284. Lacan first described the mirror stage in a lecture at the International Congress of Psychoanalysis in 1936, then under the same auspices in 1949. See *Ecrits* (New York, 1977), p. 4: "The *mirror stage* is a drama whose internal thrust is precipitated from insufficiency to anticipation – and which manufactures for the subject, caught up in the lure of spatial identification, the succession of phantasies that extends from a fragmented body-image to a form of its totality that I shall call orthopaedic – and, lastly, to the assumption of the armour of an alienating identity, which will mark with its rigid structure the subject's entire mental development."

285. See Frois-Wittmann, *L'Art moderne et le principe du plaisir,* p. 79, who points out a distinction between the "heroic period" of psychoanalysis that dwelled on "individual traumas" and the more recent concept of the superego, which (p. 80) "represents the morals, most often collective, placed within the child by the educator." Breton also made much of ego, superego, and id (Freud's tripartite model of 1923) in his book on black humor. In Germany around 1930 Wilhelm Reich and others interested in radical sociopolitical change also attempted to fuse psychoanalysis and Marxism.

286. See Dali, *Secret Life,* p. 304. Gombrich mocked simplistic polarities like this in *Meditations on a Hobby Horse.*

287. See Caillois, "La Mante religieuse," in *Minotaure,* no. 5 (May 1934), pp. 23–6.

288. He could also have mentioned a book impor-

tant for Dali, Lacan's study of paranoia, which contains a relevant diagram by Freud's disciple Abraham of developmental stages including oral aggression.

289. Caillois cited the second and third lines of Breton's contribution to "Je m'écoute encore parler," in Breton, Char, and Eluard, *Ralentir travaux* (1930), in Breton, *OC*, vol. 1, p. 774: "I hug the women who wish only to be another's / Those women who in love hear the poplars go by / Those who in hate are thinner than praying mantises / The destruction box was invented for me / A thousand times more beautiful than playing cards." (One can presumably interpret the "destruction box" the poem associates with the female insects that devour their mates as an image of the *vagina dentata*.) In their writings the Symbolists De Gourmont and Maeterlinck perhaps had in mind femmes fatales like Salome and Messalina – the first wrote of the murderous habits of the queen bee after mating in *La Vie des abeilles* (1905), and the second described the cannibalism practiced on her mate (and other "suitors") by the female mantis, in his *Physiologie de l'amour*, vol. 14. Caillois was more justified in ignoring Grandville's image (1842), which compares a "praying" insect to a devout woman who believes that "to die is to be reborn to a better life" (see his *Scènes de la vie privée et publique des animaux* [Paris, 1842], in Grandville, *Das Gesamte Werk* [Munich, n.d.], vol. 2, no. 1073, p. 26, n. 31). For a survey of the visual material, see William L. Pressly, "The Praying Mantis in Surrealist Art," *Art Bulletin*, 55, no. 4 (December 1973), pp. 600ff.

290. See Sewell, *Work and Revolution in France*, chap. 9, p. 219.

291. For Caillois, see "Mimétisme et Psychasthénie Légendaire," *Minotaure*, no. 7 (1935), pp. 5–10. One wonders whether the prominence given to this article, and one by Bataille appreciating the sadistic rites of the Aztecs (in turn "crushed like insects" by Cortez) in the ten-year anthology of Krauss's periodical *October*, indicates an emerging postmodern insectolatry. For camouflage see A. Ducasse, J. Meyer and G. Perreux, eds., *Vie et mort des français: 1914–1918. Simple histoire de la grande guerre* (Paris, 1962), pp. 510–11, chapter by Alice Barthe. A French painter named Victor Lucien Guirande de Scevola claimed to have been the inventor of military camouflage

and acknowledged that he was inspired by Cubism.

292. See Ed. Claparède, "Le Sommeil réaction de défense," *Minotaure*, no. 3–4 (December 1933), pp. 22ff. He considers sleep a form of psychological suicide; and the *Totstellreflex*, the simulation of death in animals, he calls "a very inept attempt at self-defence ... since – as is often the case of the immobilized animal – it does not prevent its being apprehended by its adversary." The issue is doubtless complicated by the fact that some predators rely on visual, others on olfactory or auditory cues.

293. Apparently Caillois derives from Lacan as well as from the very influential anthropologist Mauss, who wrote, "There remains in the 'primitive' an overwhelming tendency to imitate, combined with a belief in the efficacy of this imitation, a tendency still quite strong in 'civilized' man." See Mauss and H. Hubert, "Esquisse d'une théorie générale de la magie," *L'Année sociologique*, 7 (1902–3), pp. 61–73, on imitation among the "primitives."

294. For this text and illustrations, see Breton, *Je vois*, p. 29. A phallic candle runs from top to bottom of the "great" head, an open cage with a pair of spectacles for eyes; whereas on the "small" head (color reproduction in the Pompidou catalogue, *André Breton*, p. 299), a mantid camouflages itself on a dried flower, its wings simulating eyes and brows, its body a nose.

295. For the Heraclitus quote, see Breton, *Surrealism and Painting*, p. 283. Bataille's periodical *Contre-Attaque*, which lasted from 1935 to 1936, and to which the Surrealists briefly rallied, contained articles on Hegel's dialectics, the utopian socialism of Fourier, and the revolutionary implications of de Sade. A populist and pacifist article advocated an autonomous peasant movement in support of the revolution. P. Klossowski, in D. Hollier, ed., *Le Collège de sociologie* (Paris, 1979), pp. 586–7, claimed that Walter Benjamin first drew Fourier to the attention of the group around Bataille, who in turn cued in Breton's group. Breton, "Giorgio De Chirico," *OC*, vol. 1, p. 251. Aragon, *Le Paysan de Paris*, p. 155.

296. The editors of *Cahiers d'art*, wishing to show all contemporary styles, included Surrealism as far back as the twenties, although they sometimes viewed it as not much more than an academic parody of Picasso (see vol. 3, no.

2 [1928], p. 69). Breton's text of 1935, "Du temps que les surréalistes avaient raison," was accepted by the periodical, but not published, as noted in Breton, *OC,* vol. 2, p. 1563. In their 1938 *Dictionnaire abrégé du Surréalisme* Breton and Eluard placed the issues of *Cahiers d'art* of 1935 and 1936 under the rubric "Revues surréalistes"; yet Dawn Ades's extensive survey of the periodical literature, *Dada and Surrealism Reviewed* (London, 1978), fails to mention *Cahiers d'art.* On fashion see Richard Martin, *Fashion and Surrealism* (New York, 1987), and my review in *Art Journal,* 47, no. 4 (Winter 1988), pp. 372–5.

297. The Situationist International of 1957, which advocated freedom and spontaneity and worker control of the factories, borrowed much of its program of opposition to capitalism, bureaucracy, and consumer society largely from the Surrealists. Cf. the Situationist Guy Debord's *Société du spectacle* (Paris, 1967).

298. The disaffected Jean Arp commented: "The navel bottle, a useful, monstrous object combining bicycle, whale, brassiere, and absinthe spoon, the glove that one can wear in place of the decrepit head – all that ought to suggest to the bourgeois the unreality of the universe, the futility of his vain aspirations, [and] of his very profitable patriotism. All that was evidently naive on our part since the normally constituted bourgeois has at his disposal about as much fantasy as an earth worm, and since in place of his heart (*coeur*) one finds an immense foot corn (*cor*) that pinches only when the barometer, that is, the stock market, is in decline." Cited by Claude Abastado, *Introduction au Surréalisme* (Paris, 1971), p. 110.

299. See Pierre, *Tracts,* vol. 1, p. 512. The Trotskyist Péret was furious at this, knowing that the USSR was betraying the Spanish revolutionaries.

300. On all these matters see ibid., vol. 1, for these years.

301. Cf. "Trait d'union" (1955), in *Perspective cavalière* (Paris, 1970), pp. 9–12, in which Breton asserts his wish to subvert "reality" by pleasure and opposes it to Freud's program to bring pleasure under the control of the reality principle.

302. See J. L. Sert, "The Architect Remembers," in Ellen C. Oppler, *Picasso's "Guernica"* (New York, 1988), p. 198. Aragon hesitated to write on Picasso (who was barely tolerated by the Social Realists of the party) until Stalin's death in 1953; thereafter he published extensively on him. In a lecture given in Paris in October 1937, he linked Picasso and the triumph of his "bleeding" homeland over the "foreigners," without alluding to *Guernica.* See Aragon, *Ecrits,* p. 62.

303. He called his contribution to the London exhibition of June 1936 "Poetic Evidence," never mentioned Breton, and selected a Dali for the show that Breton hated.

304. For Breton's art-critical generosity see Dore Ashton's remarks, cited in the catalogue for the exhibition "Paris–New York" held at the Centre Pompidou, Paris, 1977, p. 109. In May 1939 the Surrealists signed a collective statement, "Le Nationalisme dans l'art." See *Minotaure,* no. 12–13 (May 1939), pp. 70–1.

305. The first issue of *Clé,* a monthly bulletin representing this viewpoint, appeared in January 1939. Trotsky is reported to have explained that he "could not afford to be sectarian in ideological matters when allies were so hard to come by." See René Etiemble, "The Tibetan Dog," *Yale French Studies,* no. 31 (May 1964), p. 130. Robbe-Grillet, like Breton and Trotsky, opposed the "fine art lovers" and the subscribers to Zhdanov's Social Realism, both of whom wished to subvert "the principal condition for the existence of art, liberty" (see "Sur quelques notions périmées," p. 40); but more expressly than they, he supported the autonomy of art.

306. Published in *Clé,* no. 2 (February 1939). See Pierre, *Tracts,* vol. 1, p. 524. In *Clarté* (1922, p. 293), Alexander Blok anticipated the revolutionary emphasis on the artist. He wrote that a new movement is replacing humanism: "Already we can discern the new role of the individual, a new human race. The goal of this movement... is the *artist-human being,* who alone will be capable of *living* and of *acting* avidly."

307. It is significant that Benjamin formed his idea of the Surrealist "shock" during the late twenties, rather than the mid-thirties. For the international situation from the viewpoint of Germany, see John Willett, *Art and Politics in the Weimar Period: The New Sobriety, 1917–1933* (New York, 1978).

308. Eugene Lunn, in an important study, states: "In the late thirties, Benjamin and Adorno

disputed whether Surrealists merely mirror the experience of a reified world out of control (to which they surrender in its domination of the data of the 'unconscious') or seriously and effectively counter that world (through shocks to habitual logic and mental associations)." See his *Marxism and Modernism: An Historical Study of Lukacs, Brecht, Benjamin and Adorno* (Berkeley, 1982), pp. 57–8.

309. Meyer Schapiro told me that the philosophers Sidney Hook and A. J. Ayer and he, highly skeptical about the validity of dialectical materialism, invited Breton one evening around 1942 to debate the theory. Schapiro, who had once sent Trotsky copics of Breton's major writings, stood on the side of the opponents of what we might term the dialectical Surrealists. Breton was supported by Jan Van Heijenoort, Trotsky's apologist and former assistant, and the Surrealist critic Nicolas Calas, who had little to say. Breton himself contributed little but watched the contestants like a judge. Schapiro claims that after the long argument Breton became convinced to give up belief in the theory, and that he never again used it in his writings. When I called Van Heijenoort about 1986 at Stanford (where, as a professor of mathematics, he was engaged in editing Gödel's papers), he claimed that in contradiction of Schapiro, Breton was not convinced by the arguments of Schapiro and Hook, and continued to believe in the validity of dialectical materialism until his death. More details of the debate emerge in remarks quoted in James Thompson and Susan Raines, "A Vermont Visit with Meyer Schapiro (August 1991)," *Oxford Art Journal*, 17, no. 1 (1994), pp. 10–11. As I understand it, the debate originated in the heated controversy between Trotsky and Max Eastman over the validity of dialectical materialism and spread to other New York radicals like Hook, Schapiro's friend. The Trotskyist Heijenoort, an advocate of dialectical materialism, assuredly exaggerated the importance of the idea for Breton, and Schapiro's account seems inaccurate in two counts: he says that dialectical materialism "had some merit in Hegel's philosophy" and that "all [Breton's] previous writings which were not strictly poetic had some reference to dialectical materialism.... [After the debate the term] disap-

peared from the vocabulary of Surrealism." But the term, a concoction of Engels adopted by Lenin and Trotsky, had little to do with the idealist Hegel. (Admittedly Lenin's reading of Hegel as a materialist and discussion of the phrase "dialectique matérialiste" – part of his exposition of Hegel – was known to the Surrealists. See the French translation of Lenin's "En lisant Hegel," reprinted in *LSASDLR*, no. 6 [May 15, 1933], pp. 1–5, esp. the sections numbered 20 and 107.) And Breton rarely used the term before the debate: he generally refers in his political writings of the thirties to "dialectics" and to "materialism" rather than to "dialectical materialism" (or at most to "historical materialism" in his lecture in June 1935 to a congress of writers). Even the *Dictionnaire abrégé du Surréalisme* edited by Breton and Eluard in 1938, during one of the most politically active periods, has an entry not for dialectical materialism but for "Dialectique," and neither of the citations under this word by Engels and Lenin mentions dialectical materialism. In one instance (the Second Manifesto), however, he did use the phrase to criticize Bataille for his "obnoxious return to anti-dialectical materialism." He wrote it at a moment of insecurity and crisis both political and artistic. For further discussion, with limited bibliography, see Philip Pomper, translator and annotator, *Trotsky's Notebooks, 1933–5: Writings on Lenin, Dialectics, and Evolutionism* (New York, 1986).

310. See Breton, *Entretiens*, p. 287.

311. See Erik Erikson, "Wholeness and Totality: A Psychiatric Contribution," in C. J. Friedrich, ed., *Totalitarianism* (New York, 1964).

312. A number of brilliant but mystical or reactionary writers have mourned the joint loss of authority and a center. Yeats wrote in *The Second Coming* (1921), "Things fall apart; the center cannot hold, / Mere anarchy is loosed upon the world"; Hans Sedlmayr, an eminent but reactionary art historian, railed against modern art as contributing to the general "loss of the center" in contemporary Western culture in *Verlust der Mitte. Die bildende Kunst des 19. und 20. Jahrhunderts als Symptom und Symbol der Zeit* (Salzburg, 1948); Allen Tate, a reactionary literary critic who decried modernist synaesthesia (the "mélange des genres"), stated that "when the center of life disappears, the arts of poetry become the art of poetry."

See his *Reactionary Essays* (New York, 1936), p. 35. Cf. note 147, this chapter. And Rudolf Arnheim, a Gestalt psychologist, emphasized *The Power of the Center* (Berkeley, 1982) as distinct from the Cartesian grid that has become a Holy Grail of postmodernism.

313. The group around Georges Lefebvre (a historian of the French Revolution) founded the Cercle Descartes in 1938 to combat doctrines that lead "to the discrediting of reason," "to defend 'the true mission of the University.'" See François Azouvi, "Descartes," in *Bibliothèque illustrée des histoires: Vol. 3. Les France* (Paris, 1990), p. 776. The French Stalinist leader Thorez lectured on Descartes in 1946 at the Sorbonne.

314. Cf. Tzara's *Monsieur Anti-tête* in which the *sana mens* of the classical hero is jettisoned.

315. See Foucault, *Les Mots et les choses*, p. 398.

316. See Derrida's essay "Ellipsis" in *Writing and Difference*, p. 297. I sense the recent emergence of a postmodern version of liberalism in which there is a return to a center, but a passive or empty one that is formed from the neutralization or leveling of distinctions; this has led in gender matters to androgyny, in politics to neutrality or inertness, in moral matters to indifference.

317. Breton steadfastly refused to speak English: he lectured in French at Yale in 1942 and confined himself to Francophone communities in the United States and Canada (Quebec). He once quoted a passage in English from an article by Aragon for a Hollywood periodical, in order to condemn and ridicule Aragon's vanity and chauvinism.

318. A number of French critics have taken a similar view of the power of language. Cf. Jean-François La Harpe, *Du fanatisme dans la langue révolutionnaire ou de la persécution suscitée par les Barbares du dix-huitième siècle, contre la religion chrétienne et ses ministres,* 3d ed. (Paris, 1797). François Furet, *Penser la Révolution française* (Paris, 1978), pp. 71–2, proposed the semiological theory that, in the French Revolution, "speech substitutes itself for power" and "the semiotic circuit is the absolute master of politics." Recently the American logician W. Quine has developed a notion of "semantic ascent."

319. See Breton, *Surrealism and Painting*, p. 8.

320. See "Max Ernst," p. 156, for both quotations. The statement occurs in an imaginary dia-

logue with President De Brosses, who in the eighteenth century introduced the notion of the fetish to France.

321. See Breton, "Joseph Crépin" (1954), in *Surrealism and Painting*, pp. 298ff. There is a clear analogy between Breton's "sacred" and Benjamin's "aura."

322. See ibid., pp. 313ff.

323. The exhibition was organized by Cercle et Carré, the group of Seuphor and Torrès Garcia. The group Abstraction-Création was active in Paris between 1932 and 1936. And in 1930 Theo van Doesburg founded a periodical dedicated to *art concret* (abstract art).

324. See Pierre Francastel, *Art et technique* (Poitiers, 1972 [1956]), p. 207: "Cézanne introduced the notion of the reality of the 'motif,' that is the positive character of the empty spaces created by the intervals between objects. With him there appears the unity of all parts of the figural image." In Cézanne's self-portraits of the 1870s – even before the use of an analytic brush stroke that created even greater coherence – the hair shapes play into the wallpaper patterns. Critics faulted the Cubists early on for taking a comparable approach to "negative space." One pointed out this "mistake" in 1912: "From the truth that depth must be expressed in genuinely plastic terms . . . they conclude that it must be represented with as much solidity as the objects themselves. . . . The intervals between forms – all the empty parts of the picture, all the places in it occupied by nothing but air find themselves filled up by a system of walls and fortifications." See Jacques Rivière, "Present Tendencies in Painting," 1912, in E. Fry, *Cubism* (New York, 1966), p. 79.

325. See "The Triumph of Gaulish Art" (1954), in Breton, *Surrealism and Painting*, p. 325: "It is permissible to interpret Mondrian's paintings as being panoramas of fields of tulips seen from a bird's-eye view." One notes that Surrealist color usage bears little relation to the sensual harmonies and tensions of colorists like Matisse or Kandinsky. Moreover, the Surrealists, wishing to make art into a form of automatic writing, turned often for their text illustrations to black and white. Owing to their rejection of harmony and composition (regarded as functions of bourgeois sensuality), color functioned for the detachment of forms, for symbolic purposes (heraldic devices, Tarot cards, Rimbaud's vowels, Eluard's poetry),

and for its power to designate a physical object to fill up the void of the canvas. In his article "Picasso in His Element" (1933), *Surrealism and Painting,* p. 104, Breton states that color is "first and foremost, the power to fill with reality the void left by the form ... to stand surety for every aspect of [the physical object's] existence." One might add that here color helps distinguish the existent object from the colorless phantom.

326. See "D'une Décalcomanie sans objet préconçu (Décalcomanie du Désir)," *Minotaure,* no. 8 (June 1936), p. 18, with illustrations including two he made in collaboration with Jacqueline.

327. See the last of the *Entretiens* (1952), p. 305, and also "The Triumph of Gaulish Art," *Surrealism and Painting,* pp. 324–36 (before his allusion to Mondrian cited in the preceding note), where he refers to Gestalt theory and Rorschach in support of the claim that "the mind – normal or abnormal – invariably interprets freely any fortuitous (or systematically non-figurative) shape, and in most cases derives from such interpretation a naturalistic significance which invariably carries symbolic overtones."

328. See "Ni aujourd'hui, ni de cette manière," in Pierre, *Tracts,* vol. 2, p. 251. It was published in April 1966; Breton died in September.

329. The war over student graffiti goes back at least to August 31, 1929, when "Le Semainier," a commentator writing in *L'Illustration* (p. 214) on "graffiti," characterized the defacement of school desks as "vandalism." He recommended that "in order to destroy this old ancestral instinct it would be necessary to combat systematically and quite early, at the time when the student imagines that his bench and his desk were invented to allow him to do wood engraving. We have to suppress severely his passion for scribbling and soiling everything." The illustration appeared in *Le Rire,* no. 271 (April 12, 1924), under the heading "La Plus belle affiche electorale."

330. Breton had found in "the entirely new art" of Gorky nature treated "like a cryptogram upon which the artist's previous tangible imprints have just left their *stencil,* in the quest for the rhythm of life itself." See Breton's essay "Gorky" (1948), in *Surrealism and Painting,* p. 200. Derrida in his *Of Grammatology* cites the scholar E. R. Curtius's discussion of the "world as text" in "The Book of Nature,"

European Literature and the Latin Middle Ages, (New York, 1953), pp. 319–26.

331. The poster, a linogravure, originated in the Atelier (populaire) de l'École Nationale des Beaux-Arts.

332. See "Pas de Pasteurs pour cette Rage!" in Pierre, *Tracts,* vol. 2, p. 276. As the editors note, the tract was distributed at an international gathering when the student uprising was already on the decline. A collective declaration introducing a special issue of the Surrealist journal *L'Archibras, hors série,* no. 4 (June 18, 1968), defended the students and virulently attacked the state, the university, and its police.

333. The editors terminate the *Tracts* in their note (vol. 2, p. 431) to the introduction to *L'Archibras* (see the preceding note), commenting that one might consider the collective declaration a "swan song" of the Surrealist movement.

334. See D. LaCapra, *A Preface to Sartre* (Ithaca, N.Y., 1978), p. 223, criticizing Jameson's claim that the May 1968 events were "a corroboration of Sartre's theory": "One of the more promising features of the anticapitalistic and antibureaucratic protest during the May–June 1968 events was the attempt to assert the need for more 'supplementarity' and even 'carnivalesque' forms of relationship in modern institutional life. To this extent, these events may have been more 'advanced' than the analysis in Sartre's *Critique* that is often seen as their theoretical analogue."

335. See "Ecriture et Révolution," in one of the anti-Surrealist issues of *Tel quel: Théorie d'ensemble* (Paris, 1968), p. 78.

336. See "Beau comme BEAU COMME," in Pierre, *Tracts,* vol. 2, p. 271. They also criticized Sollers for accepting Aragon's literary approach to Lautréamont.

337. At the annual meeting of the College Art Association in Seattle 1993, I conducted a session entitled "Surrealism – The Unfinished Project."

5. THE SURREALIST WOMAN AND THE COLONIAL OTHER

1. For a discussion of "feminine stereotypes" see Mary Ellman, *Thinking about Women* (1968), chapter 3, which lists "formlessness, passivity, instability, piety, spirituality, irrationality and compliancy."

2. See Breton, *Entretiens,* p. 139.

3. Apollinaire claimed that de Sade was a liberator of women, as noted by F. Laugaa-Traut, *Lectures de Sade* (Paris, 1973), p. 180. But see A. Carter, *The Sadeian Woman and the Ideology of Pornography* (New York, 1980); Nancy Miller, "*Juliette* and the Posterity of Prosperity," *L'Esprit créateur* (Winter 1975), p. 416; and C. Claude, "Une Lecture de femme," *Europe* (October 1972), pp. 64–70.

4. See Breton, *OC,* vol. 1, p. 322.

5. Susan Rubin Suleiman, *Subversive Intent: Gender, Politics, and the Avant-Garde* (Cambridge, Mass., 1990), applies feminist psychoanalysis to the avant-garde, especially to Surrealism, where woman's body as object is central, but she is not subject as artist: "The real drama exists between the son and the father . . . not between the son and the mother. The mother's body functions as mediation in the Oedipal narrative, whose only true (two) subjects are male" (p. 86). "I want to emphasize a more positive and empowering aspect of the 'woman'/avant-garde/marginality trope for female subjects . . . there is a way in which the sense of being 'doubly marginal' and therefore 'totally avant-garde' provides the female subject a kind of centrality, in her own eyes" (p. 86). Critics have noted that Suleiman fails here to discuss the pre-Oedipal mother–child relation, though she does so in another context.

6. Surrealist poetry often included medical and zoological metaphors for women, and Surrealist painting produced by either automatism or collage deformed or dismembered the female body. See Maurice Blanchot, *Lautréamont et Sade* (Paris, 1949), for a comparison of the First Manifesto to Lautréamont's disturbing zoological images.

7. For woman as Nature and as the Other opposed to culture, see Ludmilla Jordanova, *Sexual Visions: Images of Gender in Science and Medicine between the 18th and 20th Centuries* (London, 1989). In his "Reminiscences," first published in 1913, Kandinsky described the white canvas as "a pure chaste virgin nature. . . . And then comes the willful brush which first here, then there, gradually conquers it . . . like a European colonist, who pushes into the wild virgin nature, hitherto untouched, using axe, spade, hammer, and saw to shape it to his wishes." See the version in R. L. Herbert, ed., *Modern Artists on Art* (Englewood Cliffs, N.J., 1964), p. 35.

8. I agree with Margaret D. Carroll, "The Erotics of Absolutism," *Representations,* 25 (Winter 1989), pp. 3–29, n. 28, when she criticizes as a simplification Krauss's assertion that "characterizations of surrealism as antifeminist [are] mistaken." Rudolf E. Kuenzli cogently criticizes Krauss for her instrinsic misogyny in "Surrealism and Misogyny," in Mary Ann Caws, Rudolph E. Kuenzli, and Gwen Raaberg, *Surrealism and Women* (Cambridge, Mass., 1993 [1990]), pp. 17–26.

9. Henri Clouzot wrote in *L'Illustration* (26 January 1929), "Comment la femme française est venue à l'art moderne." He states that all admit that women have "omnipotence in the domain of morals, of dress, of furniture arrangements" (p. 85). Woman's taste is based on "raisons personnelles": dealers in art are advised to tempt her with "sensible presentations (understand what I mean: sensible in the sense of appealing to her feeling rather than to her reason)."

10. J. C. Flügel, *The Phychology of Clothes* (London, 1930), p. 111, observes that at the end of the eighteenth century "there occurred one of the most remarkable events in the whole history of dress, one under the influence of which we are still living . . . : men gave up their right to all the gayer, more elaborate, and more varied forms of ornamentation, leaving these entirely to the use of women, and thereby making their own tailoring the most austere and ascetic of the arts. Sartorially, this event has surely the right to be considered as 'The Great Masculine Renunciation.' Man abandoned his claim to be considered beautiful." Parenthetically, the Surrealists never applied their concept of convulsive beauty to men, who at most would have been drawn into the woman's convulsion and the fusion of "l'amour fou."

11. See Pierre, *Tracts,* vol. 1, pp. 78ff. Written by Aragon, it was signed by thirty-two Surrealists, all men.

12. Breton attended Kojève's celebrated seminars on Hegel, which emphasized the role of desire, in Paris for several years (1933 and later). Breton, as we recall, had already introduced the theme of desire in recounting Taine's story of the ("real") broth. Human desire differs from the animal in seeking not a real object, but another desire, or mutuality. Kojève applied this concept of desire to sexual relations between man and woman: the desire is not for

the other's body but for the other's desire. Human history is the story of desired desires. See Roudinesco, *Histoire,* vol. 2, pp. 149, 154. Catherine A. MacKinnon, "Feminism, Marxism, Method, and the State," in Nannerl O. Keohane, Michelle Z. Rosaldo, and Barbara C. Gelpi, eds., *Feminist Theory: A Critique of Ideology* (Brighton, 1982), p. 27, criticizes the sexual objectification of the term "desire" in the thought of Sartre and of Deleuze and Guattari. All these writers ignore the spiritual concept of desire as represented, for example, in the thought of Louis-Claude de Saint-Martin (the exact antithesis of his contemporary de Sade and of Lautréamont's sharkish Maldoror), whose *L'Homme de désir* (1790) addresses the human desire for spiritual regeneration: "Swim continually within prayer as in a vast ocean without bottom or shores whose immensity permits you to walk freely and calmly." And, no mystic, but anticipating the Surrealist quest of the quotidian marvelous, he wrote in a letter: "I learn every day how to read in the marvels that I have in common with all men."

13. See Breton, "Le Discours sur le peu de réalité," in *Point du jour,* p. 16.

14. The survey by Whitney Chadwick, *Women Artists and the Surrealist Movement* (London, 1985), contains good illustrations and astute observations from a traditional feminist perspective, mingled with a number of regrettable errors; for example, she mistakenly generalizes about the exclusion of women from the Surrealist "research" on sexuality. Perhaps she had in mind the meeting held in January 1928 at which Aragon questioned the validity of the conclusions drawn by the participants owing to the "predominance of the masculine point of view." However, women did attend later meetings and expressed themselves with great candor. See *Recherches sur la sexualité,* vol. 4, in *Archives du Surréalisme.* Robert J. Belton, "Speaking with Forked Tongues: 'Male' Discourse in 'Female' Surrealism?" in Caws, Kuenzli, and Raaberg, eds., *Surrealism and Women,* p. 50, rightly questions Chadwick's generalization that "almost without exception, women artists viewed themselves as having functioned independently of . . . surrealist doctrine."

15. Cf. Breton's "Introduction aux 'Contes Bizarres' d'Achim d'Arnim" (1933), in *Point du jour,* p. 143, citing the ideas of Ritter, Arnim's editor: "It is the earth which [to Ritter] some-how directs through the woman. 'We love only the earth and through woman the earth loves us in turn.' That is why love and women are the clearest solution of all enigmas. 'Know woman, and everything else will fall into place.'"

16. At the first meeting on January 27, 1928, as reported in the *Recherches sur la sexualité,* Breton answered his own question, "Is love necessarily reciprocal?" in the affirmative, adding, "I thought the opposite for a long time, but recently I've changed my mind." He alludes here doubtless to his relation with Suzanne Muzard.

17. For the disaffection of feminists with Marxism see, among other writings, Heidi Hartman, "The Unhappy Marriage of Marxism and Feminism," in Lydia Sargent, ed., *Women and Revolution: A Discussion of the Unhappy Marriage of Marxism and Feminism* (Boston, 1981).

18. See his article "Woman" for the *Dictionnaire général du Surréalisme et de ses environs.*

19. See Fourier's remark cited in Richard Bienvenu, ed., *The Utopian Vision of Charles Fourier* (Boston, 1971), p. 176, that "woman in a state of liberty will surpass men in all the mental and bodily functions which are not related to physical strength."

20. In a response to the thesis of *Acrane 17,* Roszika Parker and Griselda Pollock, *Old Mistresses: Women, Art and Ideology* (New York, 1981), wrote that "although the Surrealists identified masculinity and patriarchy as the repressive order, they intended to subvert it by appropriating the feminine" (p. 138). They observe that the Surrealists adopted an "essentialist" position and "endorsed traditional definitions of Woman as Nature, Woman as silent enigma, Woman as Sphinx, Woman as child" (p. 138). This critique is corroborated directly by the Surrealists' poetry and painting, and indirectly in the uneasiness they felt toward homosexuality. See also Mary Ann Caws, "Singing in Another Key: Surrealism through a Feminist Eye," *Diacritics* (Summer 1984), pp. 64–5, and the feminist writings on Surrealism of Whitney Chadwick.

21. See "Et suivant votre cas. La Série des jeunes femmes," *Littérature,* 7 (December 1922), pp. 8–9.

22. One might compare Breton's egoistic use of Nadja to Théodore Flournoy's of Helen Smith, a personality that intrigued Breton: each au-

thor, at first exhilarated, submitted for a time to the seductive fantasy of the woman, until a point of saturation led to boredom and the wish to terminate the association. Breton's critics never let him off the hook on his behavior toward Nadja: they branded him a hypocrite for abstractly castigating the mental hospitals and psychiatrists and advocating humane consideration of the mentally ill while disengaging himself from Nadja, once she had served her purposes such as providing a model for his character in the book. For a sympathetic treatment justifying Breton's behavior, see Breton, *OC,* vol. 1, pp. 1512–17.

23. A nineteenth-century French writer said, "The Black seems to me the female race." See C. L. Miller, *Black Darkness: Africanist Discourse in French* (Chicago, 1985), p. 244. The character of Musidora, played by Jeanne Roques (born in 1897), was the heroine of the film series *Vampires* of Louis Feuillade, who also created *Fantômas.* His films were greatly admired by the Surrealists.

24. "Nadja," the only name given, was not a real one; Suzanne Muzard is called "X" in *Nadja* and in the *Vases communicants* (though her name appears in her joint response with Breton to the "Enquête sur l'amour" published in *La Révolution surréaliste,* no. 12 [December 1929], p. 71), and "ma femme" in "Union libre." Jacqueline Lamba, the central figure of *L'Amour fou,* is never named.

25. Berton does not appear as an autonomous "heroine" but as a solitary icon surrounded by portraits of men. Berton's victim was a royalist; Corday's was an admired Jacobin, whose death was the subject of paintings from David to Picasso.

26. See the later discussion of the collective tract on Violette.

27. Aragon, *Le Paysan de Paris,* pp. 237–48. Aragon summed up his dependence on the woman he loved in his response in "Recherches sur la sexualité," *La Révolution surréaliste,* no. 12 (December 1929), p. 71: "I can absolutely not do without the presence of the one I love. Possibly that is a weakness." After deserting to Stalinist Socialist Realism he continued to see the world through the eyes of Elsa, moving from one fascination to another. I am told by an editor who worked with the author in his old age that, after Elsa's death, Aragon, then an old man, altered his sexual behavior and indulged his taste for young men.

He constantly referred nostalgically to the old days with Breton, and at times appeared to have forgotten Elsa's name.

28. In *La Révolution surréaliste,* no. 1 (December 1, 1924), p. 12, Aragon wrote: "Absolute liberty offends, disconcerts. The sun has always hurt the eyes of its adorers." Issue no. 5 (October 1925) has a full-face, square photo of Breton surrounded by twenty-eight photos (each one-fourth the size and also square), mainly of the Surrealists (Freud and Picasso are also represented), with a quotation from Baudelaire that develops Aragon's allusion to sunlight: "Woman is the being who projects the greatest shadow or the greatest light into our dreams." Jean, *Autobiography of Surrealism* (New York, 1980), p. 156, and Biro and Passeron, *Dictionnaire général du Surréalisme* (1982) under "Femme," both mistakenly locate the photo in issue no. 1 instead of no. 5.

29. See Aragon, Breton, "Le Cinquantenaire de l'hystérie," *La Révolution surréaliste,* no. 11 (March 1928), pp. 20–2. Georges Didi-Huberman, *L'Invention de l'hysterie* (Paris, 1982), p. 272, discusses Charcot's "invention" as a "tyranny" and also an "esthetic," and concludes with the poignant question, "What is then the special nature of this hatred which experiments with, invents and produces images, – of this *hatred turned into 'art'?*"

30. Delaunay wrote a letter in 1917 in which he called the prewar Parisian avant-garde an "epoch of poor painting, hysterical, convulsive, destructive"; and in denigrating *Parade* he used the phrase "hysteria – painting of a sick mind." See Silver, *Esprit de corps,* pp. 147–8. Tzara stated in "Proclamation without Pretension" (1918) that "art is a PRETENSION. . . . Hysteria born in the studio." Cited in M. A. Caws, ed., *Tristan Tzara* (Detroit, 1973), p. 157.

31. In *La Nouvelle Revue française* (September 1, 1920), pp. 455–8.

32. Jan Goldstein, "The Uses of Male Hysteria: Medical and Literary Discourse in Nineteenth Century France," *Representations,* 34 (Spring 1991), p. 156, observes that hysteria only extended the purview of the male artist, who could assume "female modalities" without sacrificing "male prerogatives." The simulation of mental illnesses in the section "Les Possessions" of *L'Immaculée conception* (1930) by Breton and Eluard had a similar intent.

33. Dr. René Held makes the claim and speaks of

the Surrealist "theatricalization of repressed desires" in *L'Oeil du psychanalyste: Surréalisme et surréalité* (Paris, 1973), pp. 79–80.

34. See "Le Lierre," in *Ralentir Travaux,* a collaboration with Eluard and Char published in 1930 – but these words are Breton's. See Breton, *OC,* vol. 1, p. 772.

35. When Breton asks, "Who's there?" he is still talking to himself: actual exchange with Nadja never occurs, for she is a "special" being, incapable of ordinary dialogue – like Desnos during his "sleeps." Cf. Denise Riley, *Am I That Name? Feminism and the Category of Women in History* (Minneapolis, Minn., 1988), and the writings of Luce Irigaray.

36. Cf. "Laugh" (1975; reprinted in H. Adams and L. Searle, *Critical Theory since 1965* [Tallahassee, Fla., 1986], p. 312), by Hélène Cixous, who counterposes woman's namelessness to Lacan's "nom du père": "A woman is never far from 'mother' (I mean outside her role functions: the 'mother' as no-name and as source of goods)." See also Kristeva's Kleinian modification of Lacan in "Place Names," in *Desire in Language* (New York, 1980), p. 291: "Naming, always originating in a place (the *chora,* space, 'topic,' subject-predicate), is a *replacement* for what the speaker perceives as an archaic mother – a more or less victorious confrontation, never finished with her."

37. For Sartre, see his *What Is Literature?* (New York, 1949), p. 190. For Foucault, see his "Nietzsche, Genealogy, History," in *Language, Counter-Memory, Practice* (Ithaca, N.Y., 1977), pp. 139–64.

38. From Engels, *The Origin of the Family, Selected Works,* vol. 3, p. 233.

39. See Breton, *Poisson soluble, in OC,* vol. 1, p. 391: "You are the ultimate uselessness, the laundress of fish."

40. Sartre once remarked, "Surrealism is haunted by the ready-made, the solid; it abhors genesis and births . . . it is the surging up *ex nihilo,* the abrupt appearance of a completely formed object which enriches the collection." See Sartre, "What Is Literature?" p. 190. Cf. note 37, this chapter.

41. At the first meeting on January 27, 1928, as reported in *Recherches sur la sexualité,* p. 50, Breton explained why he wished to close the brothels: "Because they're places where everything is paid for, and also they resemble asylums and prison." Freud also elaborated on the significance of the male's inconsistent view of woman as pure as a mother and defiled as a prostitute.

42. See the *Vases communicants,* p. 84. Prostitutes not only made money but, throughout the period of France here under discussion, were promoted by some public officials: allegedly, they performed a hygienic service that helped preserve the health of men. See Alain Corbin, *Les Filles de Noce: Misère sexuelle et prostitution, 19e et 20e siècles* (Paris, 1978), pp. 491–3.

43. Masson and his friends visited Parisian brothels and believed in the "sacred harlot." See Masson, *La Mémoire du monde* (Geneva, 1974), pp. 19–23.

44. See D. Riazonov, *Communisme et mariage* (Paris, 1929), pp. 52–3. After citing Engels's remark that "monogamy did not at all come out of individual love," Riazanov asserts that "individual marriage constitutes the conquest of . . . woman by man," adding, "We advance toward the social revolution in which the economic bases of present-day monogamy will disappear as inevitably as its complement prostitution."

45. See "Note sur l'argent," *La Révolution surréaliste,* no. 12 (December 1929), p. 27. Thirion anticipated Walter Benjamin, who, in his *Passagen-werk* (Frankfurt, 1983), p. 475, observed, "Love of the prostitute is the apotheosis of *empathy* in merchandise."

46. Cf. Tamar Garb, "Renoir and the Natural Woman," *Oxford Art Journal,* 8, no. 2 (1985), pp. 3–15.

47. Cf. the French postcard of 1907 on the same theme, illustrated in Edward Fuchs, *Geschichte der erotischen Kunst* (Berlin, 1908), p. 401.

48. Sorel, in *Reflections on Violence* (London, 1961 [1906]), p. 66, mentions that "Henri Turot, editor of *La Petite République,* wrote a book on the 'proletariat of love,' by which he meant the lowest class of prostitutes."

49. See Silver, *Esprit de corps,* for the period of World War I.

50. See Derrida's critique of the incest aporia in "Structure, Sign and Play" (1966) in Jacques Derrida, *Writing and Difference* (Chicago, 1978), pp. 278–93.

51. See Susan Buck-Morss, "Le Flâneur, l'homme-sandwich et la prostituée: Politique de la Flânerie," in *Walter Benjamin et Paris* (Paris, 1986): "The figure of the prostitute is the allegory of the transformation of the object, of the world of things" (p. 383); "If prostitution is the symptom of the 'disintegration of love,' it

also deprives sexuality of its illusion of having an aura" (p. 389). In a dream (recounted in Chapter 2) Breton, having earned money from his art dealings with Doucet over Picasso's *Demoiselles d'Avignon,* castigated himself by linking his cash gains with the word "brothel" – the locale of the painting commonly alluded to in Parisian art circles.

52. Breton wrote in *Entretiens,* p. 139, that *"Le Paysan de Paris* and *Nadja* provide a good account of the mental climate [of the young male Surrealists in Paris] in which the taste for wandering about attained its extreme limits. Free rein was given to an uninterrupted quest to reveal what lay hidden beneath surface appearances. The unexpected encounter which tends always, explicitly or not, to take on the features of a woman, marks the culmination of this quest."

53. This text, signed by thirty Surrealists, is quoted in the Surrealist tract on Rimbaud, *"Permettez!"* of October 1927. Breton collaborated on it. See Pierre, *Tracts,* vol. 1, p. 86.

54. See Bienvenu, chapter 6, "Attractive Work," *Utopian Vision,* pp. 271–328; and Herbert Marcuse, *Eros and Civilization* (Boston, 1966), p. 217.

55. This statement became a feminist battle cry in the nineteenth century, serving as the epigraph to Flora Tristan, *L'Emancipation de la femme* (Paris, 1845). Engels alluded to it in *Anti-Dühring* (Peking, 1976 [1876–8]), p. 334, where Fourier is called a great satirist who "handles dialectics with the same mastery as his contemporary Hegel."

56. See *Disque vert,* 2nd year, 3rd series (1924), pp. 92–3, where he mentions Socrates and Gide.

57. Only during their pre-Surrealist Dada days did some, for the sake of scandal and outrageous humor, momentarily relinquish their conservative clothing; for example, Breton on one occasion put on a dress. The drab male garb of the bourgeois became an apt sign of an impersonal power structure, while the fashionably dressed woman, a Victorian "bird in a gilded cage," became an attractive and valuable symbol of property.

58. See Adolf Loos, "Ladies' Fashion" (1902). The views, already referred to earlier, of the psychoanalyst J. C. Flügel, *Psychology of Clothes,* p. 111, complemented those of Loos.

59. Cf. Claire Pajaczkowska, "The Heterosexual Presumption," in *The Sexual Subject* (London, 1992), pp. 184–96.

60. Certain of Breton's images are distinctly bisexual – e.g., the phallic-vaginal slipper in *L'Amour fou.* Foster, *Compulsive Beauty,* takes Breton to task for not emphasizing much more such transgressive gender blurring – as Foster found in the perverse "dolls" of the marginal Surrealist Hans Bellmer.

61. The questionnaire on sexuality in issue no. 12 asked, "What do you hope for from love?" Suzanne Muzard responded, "Not to find any reason to live without it," to which Breton added, "No other answer than this one could be considered as mine."

62. In *"Le Lierre,"* in *Ralentir travaux,* in Breton, *OC,* vol. 1, p. 772.

63. In *Arcane 17* Breton explained that the *femme-enfant* "has always captivated poets, for time has no hold on her." At the March 3, 1928, session of the *Recherches sur la sexualité,* p. 135, Breton, asked what he thought of a woman with her pubic hair shaved, said, "Very beautiful, infinitely better. I've never seen it, but it must be magnificent." The smooth pubis of the young girl also fascinated Bellmer, creator of *La Poupée.*

64. See Jean, *Autobiography,* p. 190.

65. See "Union libre." Breton did not need to draw on the etymology of *glaïeul* (from Latin *gladiolus,* little sword), since the shape of the flower shows the attribute. Breton, *OC,* vol. 2, pp. 1317–18, observes that this poem did not allude specifically to Suzanne or to any specific woman, but was "un hommage à la femme en général."

66. See "The Structuralist Activity," in V. W. Gras, ed., *European Literary Theory and Practice* (New York, 1973), p. 158: first Barthes observed that "the goal of all structuralist activity, whether reflexive or poetic, is to reconstruct an 'object' in such a way as to manifest thereby the rules of functioning . . . of this object. Structure is therefore a *simulacrum* of the object, but a directed, *interested* simulacrum, since the imitated object makes something appear which remained invisible or, if one prefers, unintelligible in the natural object. Structural man takes the real, decomposes it, then recomposes it." He apparently had in mind the Surrealist fetish-object, for later he suggests that Surrealism may have produced the first "structural literature." For a different view of a similar theme, see Louis Althusser, "Ideology and Ideological State Apparatuses," in *Lenin and Philosophy and Other Essays,* trans. Ben Brewster (New

York, 1972). Althusser speaks of the "necessity for the duplication of *the Subject into subjects* and of the *Subject itself into a subject-Subject*," after explaining that "God is the Subject" and that "God duplicates himself."

67. See Chapter 4, this volume. This practice is in keeping with an old observation by Berkeley, *A Treatise Concerning the Principles of Human Knowledge* (1710), in E. A. Burtt, ed., *The English Philosophers from Bacon to Mill* (New York, 1939), p. 513, "Introduction," no. 10: "I can imagine a man with two heads, or the upper parts of a man joined to the body of a horse. I can consider the hand, the eye, the nose, each by itself abstracted or separated from the rest of the body. But then whatever hand or eye I imagine, it must have some particular shape and color." Gabriele Schwab, "The Multiple Lives of Addie Bundren's Dead Body: On William Faulkner's *As I Lay Dying*," in J. F. Mitchell, ed., *The Other Perspective in Gender and Culture* (New York, 1990), p. 210, compares (without allusion to Surrealism) dead bodies of young girls or brides in twentieth-century literature to the "exquisite cadaver": "Their dead body functions as a symbolic object for a necrophilic male economy."

68. Nabokov's well-known novel described with perverted romanticism the sexual escapades of the child Lolita, and Hans Bellmer with refined sadism mutilated the body parts of dolls, turning them into contorted exquisite corpses. For *Finnegans Wake*, in which Joyce mocked the Dada and Surrealist "sugar dadaddies" and "old geesers" who have commerce with young girls, see Dougald McMillan, *Transition, 1927–1938* (London, 1975), p. 211.

69. The endlessly varied and generally bizarre innovations in Surrealist clothing fashions during the thirties were designed almost exclusively for women – the men generally wore uniformly simple and conservative clothing – likewise served as a means to dominate the woman's body. Flügel, alluding to a historic example, saw the issue of women's fashion in terms of a struggle with men for power and space, or *Lebensraum*. See Flügel, *Psychology of Clothes*, chapter 1, "The Fundamental Motives," p. 47: "Indeed, the crinoline has been looked upon as a symbol of feminine domination … and there were many jokes of the period which related to the difficulty that men experienced in finding space to stand in a room that was occupied by a number of women thus attired." Daumier caricatured the aggressive intrusion of female clothing into the public space of the omnibus.

70. Anticipating postmodernism, the semiotician Barthes sought to show that literary creation is played out on the frontier between metaphor (paradigm or system) and metonymy (syntagme). See R. Barthes, "L'Imagination du signe," *Arguments*, no. 27–8 (1962), pp. 118–20. Cf. Philippe Sollers, *Critique*, 22, no. 226 (March 1966), p. 216, who considers poetry "this ceaseless superposition of similarity onto contiguity."

71. The Surrealists created eight poems and eight drawings illustrating the Violette Nozières incest episode.

At the sixth session devoted to Surrealist sexual researches, held on March 3, 1928, and published in *Recherches sur la sexualité*, p. 138, Queneau got these responses to his question, "What do you think of rape?": "Péret: Completely opposed; Tanguy: Very, very nice; Breton: Horror of it; Queneau: It's the only thing that interests me; Duhamel: It doesn't interest me; Prévert: I find it legitimate; Unik: I'm opposed to it."

72. The Surrealists' wives picketed once or twice for the early release of their "heroine," the assassin Germaine Berton, but did not pursue further contact.

73. The photos of the shut-eyed contemplators recall the image of this half-length portrait reproduced in *Littérature*, n.s., no. 1 (March 1922), titled there "The Child's Brain," discussed in Chapter 2. The man, massive and bare-chested, stands with closed eyes before an open book. Breton, long intrigued by the painting, later published an engraving with the eyes altered to show them "open" and a detail of the head from the area of the eyes to the mustache, in an untitled collage of 1937 illustrated in Breton, *André Breton, je vois, j'imagine* (Paris, 1991), p. 71. The potential of the gaze for domination descends from the Jesuits' eye of God and reappears in discussions by Hegel, by Sartre, for whom "seeing and being-seen correspond to dominating and being dominated," and more recently by Foucault and feminists like Mulvey and Pollock.

74. For Jouffroy, see *Un Rêve plus long que la nuit*, p. 162. For an illustration, see Pierre, *Tracts*, vol. 1, p. 255.

75. Perhaps these images illustrate variants on

Magritte's obsession with the story of his mother, drowned when he was a child, and whose body when recovered was exposed but whose head was entangled in her clothing. Martha Wolfenstein, Mary Gedo, and Ellen Spitz have discussed this event; cf. also my review of Spitz's book in *Journal of Aesthetics and Art Criticism* (Winter 1986).

76. Stephen Heath, "Difference," *The Sexual Subject* (London, 1992), p. 79: "the look of the man, the image of the woman, 'the satisfaction of the woman who knows she is being looked at' (Lacan). Everything turns on the castration complex and the central phallus, its visibility and the spectacle of lack. . . . What the voyeur seeks, poses, is not the phallus on the body of the other but its absence as the definition of the mastering presence, the security, of his position, of seeing, his phallus . . .; the desire is for the Other to be spectacle not subject. . . . Fetishism too, which often involves the scopophilic drive, has its scenario of the spectacle of castration." Heath comments on Magritte's *Representation* (1937) showing a female torso filling a mirror and without clear indication of her sex organ: "The history of the nude in western art from classical times is one of the omission of a sex for the woman . . . what is thus represented . . . is the fully intact, the body smooth without break, the scopophilic defence of 'beauty' " (p. 79). One is not far from the Medusa, a young girl transformed into a monster and whose decapitated head is "phallicized" (Freud) by turning her hair into serpents. Cf. Freud, "The Medusa's Head" (1922). I covered this topic in my lecture for the College Art Association (New York, February 1994), "Medusa on the Barricades."

77. For discussion of *Le Viol* as a superimposition of images comparable to Galton's composite portraits, see my *Aesthetics of Freud* (New York, 1972). For the eroticization of displaced and/or deformed female body parts, see the work of Picasso, who, for example, in his *Woman in an Armchair* (notebook of summer 1927 in the Musée Picasso, Paris), shows a vertical and toothed "vaginal" mouth on the head (akin to the mouth of the left figure in the *Three Dancers* of 1925) and its genital counterpart, a horizontal oral vagina in the pubis. Cf. Robert Rosenblum's important article, "Picasso and the Anatomy of Eroticism," in T. Bowie and C. Christensen, eds., *Studies in Erotic Art* (New York, 1970), pp. 337–50.

78. See Michael Collins, *Towards Post-Modernism: Design since 1951* (London, 1987).

79. See Breton, *Entretiens,* p. 112. The casts both reduced women to anonymity and emphasized the sexual character of their bodies.

80. See Breton's "Les Visages de la femme," written in October 1933 as a preface to a Man Ray album of photos of women, published in 1934, reprinted in *Point du jour:* "Bright faces gathered outside time (*hors du temps*), faces of living women" (p. 161). "The portrait of a person one loves should be not only an image on which one smiles, but also an oracle that one questions. One would need all the sparkling curiosity, all the unfailing audacity that characterize the intellectual demeanor of Man Ray . . . to form this unique individual in whom we can see the last avatar of the Sphinx" (p. 163).

81. Cf. Renate Bridenthal and Claudia Koonz, *Become Visible: Women in European History* (Boston, 1977), and the writings of Luce Irigaray on the invisibility of women. Many writings have engaged the issue; for example, Mirra Bank, *Anonymous Was a Woman* (New York, 1979), considers it in the context of traditional American folk art.

82. On its semiotic complexity: this work (like other Surrealist photomontages) refutes the oversimple equations index = photograph and painting = icon by some semiologists following Peirce. These photos, while indexically linked to the subjects who posed for them, here also serve a mock iconic (and symbolic) function in their disposition like angels framing a Madonna. On the other hand, the painting of the nude (rather than the photos) actually serves a linguistic, aniconic function as a symbolic replacement for a missing noun, as appears in the following discussion. For another example, see Man Ray's photo of Breton ca. 1925 posed before De Chirico's *Enigme d'une journée* (1914) so as to seem inside the painting. That painting was the subject of a February 11, 1933, session published in "Recherche expérimental. Sur les possibilités irrationnelles de pénétration et d'orientation dans un tableau," *LSASDLR,* no. 6 (May 15, 1933), pp. 13–16. The eleven participants answered questions such as "Where would one masturbate or defecate in the picture?" From his first contact with the Paris Surrealists, Magritte, as though rising to the challenge of their poetic concept of the image, produced ingenious variations on the theme of word and image.

83. In *Nadja*, Breton – like a Rousseau promenading in irregular "natural" gardens rather than in symmetric Cartesian ones – remarked, "I have always incredibly desired to meet at night in a forest a beautiful and nude woman" (Breton, *OC*, vol. 1, p. 668). Romantic (particularly German Romantics like Moritz von Schwind to whom Freud refers) and Symbolist artists found this theme attractive, and Henri Rousseau's famous version *Le Rêve* (1910) under the name *Le Divan dans la forêt* was proposed in 1927 as the cover to a series of volumes including *Nadja*. See Breton, *OC*, vol. 1, p. 1507. Magritte also compared the human body to a forest in his painting *La Clef des songes* of 1936.

84. An awkward alternative would elide the nude as the substantive and make "la cachée" the object of the verb.

85. Cf. David Sylvester, "La Grande icône surréaliste," in *André Breton*, Centre Pompidou, 1991 (originally in *Res*, 7–8 [Spring 1984]), a poetic evocation of the "invisibility" of the woman's image, which is compared to the physical disintegration of the painting.

86. In his *Philosophy of Surrealism*, p. 154, Alquié interprets Magritte's female as a passive object explored by the active male ("our" inevitably means male) gaze: "For every object, even in the open, seems at first to hide its true reality from us; it is revealed only by our uneasy attention." For a feminist view see Laura Mulvey, *Visual and Other Pleasures* (Bloomington, Ind., 1989) and "Visual Pleasure and Narrative Cinema" (1973) in *Screen*, 16 (1975), 20, which contrasts the passivity of woman as icon to the activity of the male figure.

87. See "Première exposition Dali" (November 1929), in *Point du jour*, pp. 67–70. Dali himself, in "L'Ane pourri," *LSASDLR*, no. 1 (July 1930), p. 9, described "the very essence of nature which, according to Heraclitus, loves to conceal itself." The last phrase about hallucination is akin to Dali's paranoiac-critical method. Breton already suggested the psychological premises for the hallucinatory aspect of Dali's artistic persona in his discussion of Taine's case of "progressive hallucination" (the bowl of soup) in *Surrealism and Painting*.

88. In the "Manifesto," *OC*, vol. 1, p. 322, Breton's macho self-image comes through with special clarity in his remark, already cited, "And besides, isn't [it] the essential thing that we are our own masters, and the masters of women as well as of love?"

89. See the *Interpretation of Dreams*, chapter 6, "The Dreamwork, Section E, "Representation by Symbols in Dreams." Rarely does a complete nude by Magritte display pubic hair, and wherever hair is shown it has significance that requires interpretation. "Forest" may sometimes signify the female body in Magritte's painting: he divided *Le Masque vide* (1928) into four areas, on one of which he wrote: "corps humain (ou forêt)."

90. This image recalls Breton's Section 13 of *Poisson soluble* describing how chalk "wrote the word love on the slate of [a young girl's] mouth."

91. For Breton's quote on ties, see the *Vases communicants*, p. 47. In *Nadja* Breton already equated beauty and love with the moment of orgastic climax as a convulsion. His images of this convulsion include the lurching of starting and stopping trains, as well as earthquakes that echo the tremors of desire of "the human heart" in the manner of Lautréamont's phrase "beautiful as a seismograph." Breton connected a *tremblement de terre* and love in his "Introduction au discours sur le peu de réalité" (1924), in *Point du jour*, in *OC*, vol. 2, pp. 265–80. Leiris published a dream in *La Révolution surréaliste*, no. 5 (October 1925), p. 10, in which Breton and Robert Desnos had this dialogue: "A.B. to R.D.: 'The *sismotérique* (earthquake) tradition . . .'; R.D. (transforms himself into a pile of dishes)." For further discussion of convulsion in *Nadja* see Breton, *OC*, vol. 1, p. 1564. Breton (perhaps like Dali) seems to draw on the predilection of Art Nouveau to place images of the industrial age in the same context as unruly organic forms.

92. See W. J. T. Mitchell, *Iconology* (Chicago, 1986), p. 109: "The fundamental ideological basis for [Lessing's] laws of genre [are] the laws of gender. The decorum of the arts at bottom has to do with proper sex roles."

93. In the *Interpretation of Dreams*, chapter 6, Section E, "Representation by Symbols in Dreams," no. 6 (added in 1911).

94. In the 33rd lecture of the *Introductory Lectures on Psychoanalysis*, n.s., Freud linked women's shame to penis envy and to their instinct to cover or disguise their "lack." Ernst Grosse, *The Beginnings of Art* (New York, 1900 [1893]), maintained the contrary view: explaining shame in terms of patriarchal possession of the

woman as property, he stated that shame did not lead to, but resulted from, the invention of clothing.

95. Breton's article "La Beauté sera convulsive" appeared in *Minotaure*, 5 (May 1934), p. 15; it was later included in *L'Amour fou*, without this photograph.

96. Cf. Picabia's *Machine Turn Quickly* of 1916, which meshes the cogs of two wheels designated "femme" and "homme." Léger's *Man with a Wheel* of 1919 is not sexual, but does – like Man Ray's photo – unite a figure and a wheel.

97. See Mary Ann Caws, "Ladies Shot and Painted: Female Embodiment in Surrealist Art," in Susan Suleiman, ed., *The Female Body in Western Culture* (Cambridge, Mass., 1986), pp. 262–87, for an interesting comparison of the original photograph and its cropped version. She does not comment on the facing photograph by Man Ray, discussed later.

98. In the fourth meeting, on February 15, 1928, documented in *Recherches sur la sexualité*, Breton, fascinated by the question, asked his colleagues whether they would copulate with a woman during her menstruation (most would not). He did not state his own preference in the matter.

99. Such display has seemed to refute the theory of castration fear, on which Laura Mulvey relied. See Griselda Pollock, "What's Wrong with 'Images of Women'?" in *The Sexual Subject* (London, 1992), pp. 141–2. Perhaps changed conditions of male–female relations that have diminished in Western countries the apotropaic potential of "private parts," and the role of what I would call the new "public intimacy business" (MTV, Madonna) compel a reformulation of the Freudian terms. One might note a connection between the veiled-erotic (a term used by Breton in his *L'Amour fou*) and Freud's theory of castration anxiety, which postulates that women invented weaving as a genital cover.

100. Cf. the suggestive drawing of a woman as a bridge by Man Ray.

101. Bearing the date July 14, 1923, and published originally in *Littérature* (October 15, 1923), the poem was reprinted as a separate text in 1949. See Breton, *OC*, vol. 1, pp. 1205–6. Breton cited part of this phrase among the examples of a Surrealist image in the First Manifesto.

102. The poem was dedicated to Aragon, so we may regard the vaginal allusion as a covert anticipation of Aragon's frank *Le Con d' Irène* (Irene's Cunt). Published anonymously (and never acknowledged by its author), the novel may have repulsed Breton, who always ignored this masterpiece of erotic writing. Musset already linked *femme* and *rosée*. One might well compare the *pont* to a *tête de pont* in the military metaphor, meaning a bridgehead or a debarkation, a typical male image found abundantly in Renaissance painting.

103. Breton's close friend in his last years, the perceptive critic Legrand, almost alone recognized the image of the "rosée à tête de chatte" as a "glaringly obvious reference to sexuality," adding that through the sexual allusion Breton may well have suggested "a metaphor for the very birth of the poetic image." See Gérard Legrand in an entry for the *Dictionnaire général du Surréalisme*, p. 215. Characteristic misconstruals of it can be found in Marcel Raymond, *De Baudelaire au Surréalisme* (Paris, 1966), p. 287; Gérard Genette, *Figures* (Paris, 1966), who affirms the "literalness of the image" and misquotes it, substituting "se balançait" for "se berçait"; and Alain Bosqet, "Les Poèmes," *La Nouvelle Revue française*, no. 172 (April 1967), p. 819, who writes: "We are here in the presence of the purest fantasy, which it would be pointless to analyze. We have the intuition, about which we feel some uncertainty, that the dew might, seen under the microscope, offer some analogy to snowflakes, which could in certain circumstances have a contour similar to that of a cat's head. Etc."

104. See Lacan, *Ecrits*, p. 287: "[The phallus] is chosen because it is the most tangible element in the real of sexual copulation, and also the most symbolic in the literal (typographical) sense of the term, since it is equivalent there to the (logical) copula."

105. A standing nude, similar but much larger, stands between the legs of Magritte's *Le Vieux Canonnier* of 1947, a male fish whose amputated (castrated?) lower left leg is replaced by a phallic dowel that crosses the nude's body. The idea that the woman has a version of the penis – the clitoris – has a long history in France antedating Freud; for example, Diderot writes in "Rêve d'Alembert," *OC*, vol. 2, pp. 150–1: "Le clitoris est un membre viril en petit."

106. See Richard Krafft-Ebing, *Psychopathia Sexualis* (New York, 1908), p. 219: "This preference for certain particular physical characteristics in persons of the opposite sex – by the side of which, likewise, a marked preference for certain psychical characteristics may be demonstrated – following Binet ['Du Fétichisme dans l'amour,' *Revue Philosophique* 1887] and Lombroso [Introduction to the Italian edition of the second edition of this work], I have called 'fetishism'; because this enthusiasm for certain portions of the body (or even articles of attire) and the worship of them, in obedience to sexual impulses, frequently call to mind the reverence for relics, holy objects, etc., in religious cults." The anthropological study of the fetish in terms of cults from De Brosses in the eighteenth century to Frazer appears also in Salomon Reinach, in lectures before 1900 and in writings like *Cultes, mythes et réligions* (Paris, 1912), cited by Freud.

107. Derrida criticized the logocentrism on which the Surrealists depended (but not entirely); and feminists, as though to counter the notion of penis envy, reversed the negative evaluation of the "empty space" of the vagina. See Lucy Lippard, ed., *From the Center: Feminist Essays on Women's Art* (New York, 1976).

108. For an allusion to the group of males in "Je ne vois pas" as "a men's club," see Kuenzli, *Surrealism and Women*, p. 18. For Freud the threat came ultimately from the father; for Melanie Klein it came from the phallic mother.

109. What is not seen is her "penis" as a body part; what is seen is her whole body as a long shape. For the standard Freudian view of the anxiety caused by the woman's missing penis, and the consequent voyeuristic search, see Fenichel, *Psychoanalytic Theory*.

110. Can one also compare this to the potently ceremonial ring and cigar shared by Freud's first circle of nine psychoanalytic colleagues – all male?

111. See *Recherches sur la sexualité* (Paris, 1990), fourth meeting, 15 February, 1928, p. 100: "Genbach: A woman came to me and said: 'Your *cravate* pleases me, I want to suck your *queue*.' / Breton: Did you accept? / Genbach: Absolutely."

112. For Breton, see the *Vases communicants*, p. 47, and the discussion in Chapter 4, this volume. For De Chirico's remark, see his "Meditations of a Painter" (1912): "The giants have hidden behind the rocks... Medusa with eyes that do not see."

113. See the following by Tzara: "Note on Negro Art," all in *Sic* (1917), in *OC*, vol. 1, p. 394–5: "Du noir puisons la lumière" and "L'Art, dans l'enfance du temps, fut prière"; an essay on primitive art; and "Note sur la poésie nègre," *Sic* (1918), in *OC*, vol. 1, pp. 400–1, which concludes, "Poetry first of all lives to function as dance, religion, music and work."

114. R. Krauss fails to specify her referent – Bataille's group – in "Using Language to Do Business as Usual," in N. Bryson, M. A. Holly, and K. Moxey, eds., *Visual Theory* (Cambridge, 1991), p. 81: "By the 1930s a surrealizing kind of primitivism had joined with revivals of Nietzsche and of Sade, with developments in French sociology and psychoanalysis, to posit the productiveness of the violent and the sacrificial, and to find in the heterological and the 'irrational' a way of getting behind the ideological facade of Western rationalism in order to found a new critique."

115. "The Colonial Exposition" of 1931 was first intended to be an inter-Allied show of unity against both the defeated German enemy and that other "barbarous" threat from the East – Soviet Russia. Difficulties in realizing the original intention resulted in mainly emphasizing the beneficent power of French colonialism. The Communists, although concerned primarily neither about Africans nor Orientals, but with their own power struggle against Western capitalism, took the occasion to encourage groups like the Surrealists to criticize the imperialists as mercenary and racist. See Charles-Robert Ageron, "L'Exposition Coloniale de 1931, Mythe républicain ou mythe impérial?" in P. Nora, ed., *Les Lieux de mémoire, Vol. 1, La République* (Paris, 1984), pp. 561–91. For the Communist counterexhibition that vaunted the model of Soviet liberation and for the attendance at the exhibitions, see Nicolas Bancel, Pascal Blanchard, and Laurent Gervereau, *Images et colonies. Imagerie et propagande coloniale sur l'Afrique française de 1800 à 1962* (Paris, 1993), pp. 268–9. See also Herman Lebovics, "Donner à voir l'empire coloniale. L'Exposition Coloniale Internationale de Paris en 1931," *Gradhiva*, no. 7 (Paris, 1990), pp. 18–28. The Surrealists issued two critical tracts: "Ne visitez l'Exposition Coloniale" (May 1931), pp. 194–5, and

"Premier bilan de l'Exposition Coloniale" (July 1931), pp. 198–200, both in Pierre, *Tracts*, vol. 1.

116. Bataille's colleague Carl Einstein wrote on African art for *Documents*, no. 5, (1930), and Leiris (who had switched from Breton to Bataille) eventually went on archaeological expeditions and published his results among other places in *Minotaure*.

117. See the nineteenth-century entries for "Sauvage" and "Civilisation." Larousse sanctioned the ideas of the notorious ethnologist Gobineau, a source for Nazi racial theories: see the entry "Aryas."

118. See the entry "Conquête." The enfeeblement resulting from excessive "civilization" preoccupied the generation, from Rimbaud to the "decadents" of the fin de siècle, that saw France's defeat in 1870–1. See Saint-Simon on the superiority of the European race to all others, able to maintain peace by sublimating its warlike instincts and turning outward to expansive, militant colonizations and inward to public works, in "De la réorganisation de la société européenne," *Oeuvres choisies*, vol. 2, p. 289. From F. Manuel, *The New World of H. Saint-Simon* (Cambridge, Mass., 1956), pp. 196, 236.

119. One of the courses offered at the Collège Libre des Sciences Sociales, taught in 1902–4 by the former governor of Indochina, was called "Principles of Colonialization." See T. N. Clark, *Prophets and Patrons: The French University and the Convergence of the Social Sciences* (Cambridge, Mass., 1973).

120. See Gwendolyn Wright, *The Politics of Design in French Colonial Urbanism* (Chicago, 1991), p. 29.

121. Crevel fiercely mocked a psychoanalyst for claiming a scientifically grounded distinction between the unconscious found in white Westerners and that of blacks. J. Viot, in "N'Encombrez pas les colonies," *LSASDLR*, 1 (July 1930), pp. 43–4, praised the fetish for its mystery, magic, and vitality, and – ironically restating the judgment of Christian critics of the fetish – insisted that there is no trace of religion in fetishism: "[Primitives] have no religion. Without religion, there is no God. Because God cannot do without praise."

122. The quotation reads: "Un peuple qui en opprime d'autres ne saurait être libre" ("A people that oppresses others cannot itself be free").

123. See *La Critique sociale*, no. 9 (September 1933), p. 151.

124. For a recent critique of psychological repression as an aspect of colonialist oppression, see Homi Bhabha, "Of Mimicry and Man: The Ambivalence of Colonial Discourse," *October*, no. 28 (1984), pp. 125–33. The Surrealists were less concerned with racial issues than with Marxist anti-imperialist ones; for example, Georges Sadoul, like his friend Aragon an ardent defender of the Communist Party of the Soviet Union, criticized the 1931 Colonial Exhibition in "Le Bon pasteur," *LSASDLR*, no. 4, pp. 23–6, mainly for providing the Soviet Union's enemies with a religious platform: "Contre les Soviets la France et l'Allemagne se réconcilent au pied de la croix. M. Paul Reynaud, l'homme des casques d'acier, a inauguré l'exposition coloniale en allant à la messe et le chancelier Brüning... alla se recueillir... à Notre-Dame des Victoires."

125. The editors of *Cahiers d'art* had in common with the Surrealists a taste for African and Oceanian art. The *Cahiers*, no. 2–3 (1929), p. 108, illustrated objects from the collections of Breton and Eluard. On Picasso, see Malraux, *La Tête d'obsidienne* (Paris, 1974), and especially Patricia Leighten, *Re-Ordering the Universe: Picasso and Anarchism, 1897–1914* (Princeton, N.J., 1989), who offers on p. 92 the interesting idea that Picasso's painting *Mother and Child* (1907) based on African masks represented an anti-Christian version of a Madonna and Child. When the artists associated with the *Blauer Reiter Almanach* equated tribal, peasant, Gothic, and modern art, they were neither ironic nor political, but rather were seeking an essential inner spirit that transcended the variety of its manifestations.

126. The Surrealist elevation of the fetish object over the human figure of Christ is implicit in Eluard's "L'Art sauvage" (1929), in *Variétés* (Brussels, June 1929), pp. 36–7: "The image becomes sacred / Everything that resembles this image becomes sacred / Primitive man, like the poet, is surrounded by nothing but mirrors. / Through the fetish man creates spirits." On old French postcards one sometimes finds staged photos of white missionary nuns surrounded by black children. In the absence of native mothers in the photos the nuns seem like surrogates, "mothers superior" bringing the innocents Christian charity.

127. Not coincidentally during the twenties, the journal *Le Monde colonial illustré* promoted a closer integration of metropolitan and colonial economies. Höch, perhaps reacting against the formal and racial motivations of male German Expressionists like Pechstein and Nolde for adapting primitivist art, during her Dada phase created "self-portraits" in which she grotesquely collaged an African mask over her own face; thereby, she simultaneously mocked colonialism and the bourgeois image of the pretty and domesticated woman.

128. See *Anthologie des philosophes français contemporains*, 5th edition, preface by Arnaud Dandieu (Paris, 1931), p. 98. In certain remarks one feels that he might have been speaking of the women seers promoted by the Surrealists.

129. See his *Essay on the Creative Imagination* (Chicago, 1906), p. 118.

130. The exceptional Museum für Völkerkunde in Frankfurt am Main sees as its purpose not the preservation of older art of the "Third World," but the presentation of work now being created by living artists. A more important index of the maturing of Western culture is the emergence in the established institutions of scholarship of minority scholars who take seriously both their cultural traditions and the work of living minority artists.

131. The Surrealists stole cult objects from churches; for example, Aragon was arrested for theft of figures from French churches (he lightheartedly presents and discusses two news items reporting his arrest for theft of church property in *Traité du style*, pp. 165ff.) and Breton was reprimanded by his Trotskyite friends in Mexico after he bragged about stealing from the churches. There was a strong streak of anticlericalism among the Surrealists (Péret, the defrocked priest Genbach), but their attempts to justify these acts as anticlerical do not convince.

132. Cf. the "walking heads" of Prinzhorn's *Bildnerei der Geisteskranken* (Berlin, 1922) – perhaps an inspiration for those made by Surrealist artists – that remind one of Freud's explanation of the fetish as a displacement of the glance of the child seeking the missing penis (and the later associations thereby induced), since the eye passes from the foot upwards. In this context see A. Ehrenzweig, *Psychoanalysis of Artistic Hearing and Vision*

(London, 1953), pp. 190–1, who uses Freud's fetish-glance analysis without here alluding to Freud. He derives the cephalopods in schizophrenic and fantastic art from a loss of constancy of localization so that "sectional glances at a human figure might grow together in a 'wrong' way. If the eye were to leap from viewing the face directly to the feet, an irrational composite image might fit the feet directly to the face." (Can the sculptor of the cephalopods on Romanesque façades have mingled in them his alternating glances at the foot and the face of authority figures, thereby expressing obliquely and with wit his mixture of anxiety and awe? Certainly the sculptors had to glance constantly from the ground up to the capitals – and the vaults above them – they were to adorn.)

133. For the fetishes see the issue of *Variétés*, "Le Surréalisme en 1929." The "muse" was a photograph on the cover of *La Révolution Surréaliste*, no. 9–10 (October 1927), of a seated woman pen in hand and with eyes upturned, labeled "L'ECRITURE AUTOMATIQUE."

134. See "Recherches expérimentales. A. Sur la connaissance irrationnelle de l'objet," *LSASDLR*, no. 6 (1933), pp. 10–12. The questions concerned issues like the sexual perversion suggested by various items like a piece of rose velvet, a crystal ball, and a painting by De Chirico. All the male respondents associated the velvet to the woman, and Breton (and Caillois) associated it to the "perversion" "fétichisme."

135. See "Recherches sur la sexualité," *La Révolution surréaliste*, no. 11 (March 1928), pp. 32ff.

136. Barthes argues that "the fetish, unique amongst signs (more correctly, 'signifiers'), exists, paradoxically, to deny the existence of the very thing to which it refers – the absence of the female penis; in this it masquerades as entirely self-sufficient, not really a *sign* at all, but an *object* purely and simply. Again, the comparison with the art object is obvious. The fetish, in short, is *pure presence*, its function being precisely to deny absence, to fill the 'lack in being' – and how many times have I been told that photographs 'lack presence,' that paintings are to be valued precisely *because of their presence!*" It seems to me that this formulation is a reflex of the crisis of belief in the West that has impelled many to turn to the myriad versions of the

fetish served up daily by the popular media. Derrida claims only to have drawn on Heidegger for his similar notion of "erasure." Roland Barthes, "The Structured Activity," in V. W. Gras, ed., *European Literary Theory and Practice* (New York, 1973), p. 158.

137. See E. Ann Kaplan, "Is the Gaze Male?" (1975), in A. Snitow, *Power of Desire* (New York, 1984), p. 312: "But psychoanalysts agree that, for whatever reason – the fear of castration (Freud), or the attempt to deny the existence of the sinister female genital (Horney) – men endeavor to find the penis in women (K. Horney, "The Dread of Woman" [1932], in *Feminine Psychology* [New York, 1967], p. 136). Feminist film critics have seen this phenomenon (clinically known as fetishism) operating in the cinema; the camera (unconsciously) fetishizes the female form, rendering it phallus-like so as to mitigate woman's threat. Men, that is, turn 'the represented figure itself into a fetish so that it becomes reassuring rather than dangerous' (hence, overvaluation, the cult of the female star)." Cf. L. Mulvey, "Visual Pleasure and Narrative Cinema," *Screen*, 16, no. 3 (Autumn 1975), pp. 6–18.

138. Work on the *Invisible Man* of 1929–33 had already begun; it was perhaps a takeoff on H. G. Wells's famous *The Invisible Man* of 1897.

139. Examples could be presented showing that the guillotine of the 1793 Terror cast its shadow in France across the nineteenth century right down to the thirties.

140. See the session on sexuality of January 31, 1928, in "Recherches sur la sexualité," in *Archives du Surréalisme*, vol. 4, p. 70, where Aragon asked, "What excites you the most?" to which Breton answered, "The eyes and breasts." And at the sixth meeting, held March 3, 1928, ibid., pp. 135–6, Breton asked, "Apart from ejaculating in the vagina, mouth and rectum of the woman, where would you like your ejaculation to take place, in order of preference?" and in his own answer said: "1. On the eyes. 2. In the hair." But in the session of November 1930, ibid., p. 150, a troubled time just before the definitive rupture with Suzanne, he responded differently. When two participants of the session said their preferred sexual representation was of the eyes, Breton "protested violently" and asserted that "the eyes are not sexual."

141. Mauss, *Sociologie et anthropologie* (Paris,

1950), pp. 367–8, cited, though in disagreement, the theory of the dance authority Curt Sachs that masculine societies get their pleasure from displacement, whereas "uterine" prefer to dance in place. Interestingly, Lévi-Strauss, who knew and admired Mauss's work, in an article of the forties published in *Structural Anthropology* (Paris, 1958), p. 237, analyzed the Oedipus myth in terms not of the hero's swollen foot, but of his difficulty in walking straight.

142. See Marie-Claire Dumas, *Robert Desnos ou l'exploration des limites* (Paris, 1980), pp. 406–7. Examples of swollen-footed males recur among the Surrealists: in *La Révolution surréaliste,* no. 12 (December 1929), p. 52, appeared an illustration by Miró of a couple: the man, with tiny erection and large foot, reaches for a female figure. One wonders about the secret implications for the Surrealists of exposing their own feet. Jacqueline Breton quoted Breton as saying, "I never wish to be seen without my shoes on." (I was told this in November 1993 by Mary Ann Caws, who reported her own conversation with Jacqueline.) We remember his remark about not wishing to be seen naked without an erection by a woman.

143. See *L'Amour fou,* pp. 15–16.

144. See Heine, "Rétif de la Bretone et la femme féique. Un monument gravé à la gloire du pied féminin," *Minotaure,* no. 6 (Winter 1935), pp. 53–6.

145. Women seem always to duplicate Eve's original Fall, often to the amusement of men. Montesquieu, in "Essai sur le goût dans les choses de la nature et de l'art," *OC,* vol. 2 (Paris, 1958), p. 1262, wrote, "When a woman falls, all the circumstances that add to her embarrassment increase our amusement." Linda Nochlin made the witty observation that, unlike a man, when a woman falls, she falls on her back.

146. For a discussion of the phrase see my article "The State of Psychoanalytic Research in Art History," *Art Bulletin,* 70, no. 1 (March 1988), pp. 49–76. A mutation of the theme appears in the recent involvement of postmodern and feminist and gay critics with the chasm (*abîme; mise-en-abîme*).

147. I discussed this image of Liberty in my lecture (1994), already cited, "Medusa on the Barricades."

148. See Marcel Mauss, *"Les Techniques du*

corps," and *Journal de psychologie,* no. 3–4 (March–April 1936), in Mauss, *Sociologie et anthropologie,* pp. 365–86. From a lecture given in 1934. Perhaps with Mauss in mind, Foucault, in *Discipline and Punish: The Birth of the Prison,* chapter 1, "Docile Bodies," p. 151, discusses the control of troops in the seventeenth century by obligatory marching rhythms.

149. Breton later quoted the phrase in his essay "Gradiva," *La Clé des champs,* p. 33: "On the bridge that unites dream and reality, 'gathering lightly her dress in her left hand': GRADIVA."

150. Breton claimed that the Surrealists found Jensen's book more interesting than Freud's analysis of it, and in 1937 Breton dedicated an article to Gradiva without mentioning Freud's study. However, it was through the latter that they got to know the former, which was not available in French. Sylvère Lotringer, "The Fiction of Analysis" (1977), repeats Breton's point.

151. A number of writers, basing themselves on Werner Spies, maintain that Ernst knew Freud's study as early as 1923. In *The Return of La Belle Jardinière* (New York, 1971), p. 48 (*Die Rückkehr der schönen Gärtnerin* [Cologne, 1971], pp. 53–4), Spies claims to have found details of Ernst's painting of 1923, *At the First Plain Word* – the brick-red masonry, the screenlike wall – which seem to him compellingly similar to descriptions in Freud's study of *Gradiva.* The implication that Ernst, who read German, knew the *Gradiva* book so long before 1931 is very exciting; however, the point is not made explicitly, and despite the fact that Spies has had more access to the Ernst archives than any other scholar, no documentary proof is adduced to support the scanty internal evidence offered. E. M. Legge, *Max Ernst: The Psychoanalytic Sources* (Ann Arbor, Mich., 1989), pp. 105–11, elaborates Spies's speculation (only once does she hesitate about Spies's conclusion, noting that the painting features not the famous foot of Gradiva, but a *hand*), claiming (p. 107) that Ernst and Eluard's collaboration on *Les Malheurs des immortels* already evidences knowledge of Gradiva, but she too relies entirely on internal evidence. Unfortunately for the thesis of early knowledge, there is a universal silence about the names of Gradiva and Jensen before 1931 in the writing and correspondence of all the Surrealists interested in Freud – Ernst, Eluard, Breton (who knew Eluard the whole time intimately and collaborated with him), and Aragon.

152. Writing for *La Critique sociale,* no. 5 (March 1932), p. 229, Jean Bernier reviewed the French translation and mentions Jensen's text only in terms of Freud's analysis of it. Both Spies, *Return,* and Legge, *Max Ernst,* refer exclusively to Freud's analysis.

153. Lisa Appignanesi and John Forrester, *Freud's Women* (London, 1992), claim that in the Gradiva essay Freud actually considered the woman as the model psychoanalyst.

154. See Joan Copjec, "Transference: Letters and the Unknown Woman," *October,* 28 (Spring 1984), pp. 61–90. In a section called "Gradiva. The Spirit of Pompeii," she states that the crucial point of the story is the separation of Zoë and Gradiva: "Where the journey had begun, full of anxiety, as the investigation of sexual difference (of whether or not a woman's manner of walking was different from a man's), it ends with an alleviation of anxiety's symptoms ('without knowing why, he felt that he was breathing more easily')." The fetishized foot helps Hanold bring back his Zoë/Gradiva: "*Rediviva* indeed. What is resurrected from the prehistoric past is the phallus-copula which makes that past simultaneous and disavows its difference. This is no cure, but the resistance side of the transference."

155. Having been mistress, wife, and mother, Jacqueline began to feel restless, unfulfilled. Tensions with Breton early in 1936 led to her leaving briefly with their infant daughter Aube. Breton, perceiving her need to express herself artistically, encouraged Jacqueline to paint, praising her work and advising her, "It is *necessary* that you work unceasingly." But later tensions that led to their divorce suggest that Breton did not sustain this high-minded attitude.

156. The Surrealists were also fascinated with life-size female mannequins (e.g., those at the Musée Grévin), cousins of Pygmalion.

157. See *Minotaure,* no. 6 (1935), p. 65: "And the son who touches us trembles once more / To see again in the womb as a hard thing what he had seen before as soft." De Chirico, increasingly emulating the old masters, painted a version (now in the National Gallery, Rome) after Raphael's *La Gravida* in 1919.

158. See the articles in *Documents* on the bound foot in China, the "pieds pudiques" in Spain before the nineteenth century, and Bataille's article "The Big Toe," in the issue of November 1929. Willfully going contrary to received scientific opinion Bataille makes the big toe rather than the thumb the feature that distinguishes the human from the animal.

159. The Third Republic inaugurated secondary schools for girls through the Loi Camille Sée of December 22, 1880, but in contrast to the boys' schools its curriculum lasted only five years and included no ancient languages and only a comparatively rudimentary study of mathematics. See Charles Fourier, *L'Enseignement français*, vol. 2, *De 1789 à 1945* (Paris, 1965).

A drawing by H. Mirande published in *Le Rire* in 1924 makes humorous allusion to the clichéd equation of phallus and power: an unhappy little boy with a raised shirt shows his penis, holds on to a "phallic" post with his right hand, and stands near a kettle with a long spout. To his mother he complains: "Mama, Louisette always wants to be the leader. . . . But I'm the boy!"

160. See the *Comité français des Expositions et Comité National des Expositions Coloniales, Cinquantenaire, 1885–1935*, p. 43.

161. Hugo's visionary "Discours sur l'Afrique" (1877) presented colonization as an incentive for developing and spreading working-class culture, but his dream of domesticating matter and nature through imagination and science was easily adaptable to the needs and ambitions of the industrial bourgeoisie.

162. See Bonnet, *Breton*, p. 231, n. 159.

163. After 1934 Claude Cahun signed several times as did Valentine Hugo, Dora Maar, and Joyce Mansour. Other signatures by women appeared occasionally right through the sixties.

164. The catalogue included a phrase written by each artist. Valentine Hugo wrote: "The dream is valuable not only for evasions it permits. It is the very basis of a reality that is new and always in process of evolving"; Meret Oppenheim wrote, "Springtime arrives in a thousand leaves of fine butter." And Léonor Fini quoted a phrase (triply misspelling *sadistisches*) from Prinzhorn's book on psychotic drawing: "Sadistiches Motiv, sadistiches Motiv, sadistiches Motiv." All three quotes are from Pierre, *Tracts*, vol. 1, pp. 292–3.

165. Prassinos (born in 1920), according to Breton (in *Anthologie de l'humour noir, OC*, vol. 2, p. 1168), created a "permanent revolution in beautiful images." She wrote and published long past her "marvelous" childhood and continued to be respected among the Surrealists.

166. Cf. Gloria Orenstein, "Women of Surrealism," *Feminist Art Journal*, 2, (Spring 1973), pp. 15–21.

167. In the present state of visual documentation, it is easier to see the influence going from the men to the women than the reverse: Valentine Hugo's *Dream of 21.12.29* seems clearly derived from the eye slicing of the film *Un Chien andalou* of 1929, shown in Paris while she was there; Rita Kernn-Larsen, *Self-Portrait (Know Thyself)* seems to derive from Picabia's *Hera*, in which leaves metamorphose into lips; and Remedios Varo's *Alchemy or the Useless Science* (1958) can be compared to Ernst's *Paramyth* (1948), illustrated in Breton, *Surrealism and Painting*, p. 166. Cf. Chadwick, *Women Artists*, p. 90, for special qualities she finds in the female Surrealists. Recently a case has been made for the role of Mexico in freeing the late work of some of the women from their dependence on Surrealism. See Holly Barnet-Sanchez and others, *Leonora Carrington: The Mexican Years, 1943–85* (Albuquerque, N.M., 1991).

168. Freud, in an essay of 1925, "On Narcissism," described a narcissistic woman as representative of all women. The great majority of Freud's patients were upper-class women according to B. Brody, "Freud's Case-Load," *Psychotherapy: Theory, Research and Practice*, 7 (1970), pp. 8–12. Chadwick, *Women Artists*, p. 92, cites Simone de Beauvoir, *The Second Sex*, on the image of the mirror (and consequently of self-portraiture) as the key to the feminine condition. Sarah Kofman, "The Narcissistic Woman: Freud and Girard," *Diacritics*, 10 (1980), pp. 37–8, thinks of a woman's "taking of narcissistic pleasures in herself [not] as a compensation for a natural deficiency, but rather as a compensation for social injuries." It seems to me that the male structuring of the myth of Narcissus has forced the woman into invisibility: Narcissus sees his reflection, whereas Echo only hears her disembodied voice – significantly, calling to him. In fact the term "echolalia" in current literary theory refers to an echoing back and forth between signs and the fact that mean-

ing, in the absence of a fixed authority or presence, is determined relationally.

169. Madeleine Gagnon, *Body One* (Paris, 1980 [1977]).

170. Laura Mulvey made an important attack on beauty from a feminist point of view in "Destruction of Pleasure as a Radical Weapon," a section of her "Visual Pleasure and Narrative Cinema," *Screen*, 16, no. 4 (Winter 1975–6), pp. 119–30.

171. The chapter, in Apollinaire's *Le Poète assassiné*, suggests that the futurist manifestos of Boccioni could provide a model for the design of women's clothing. The use of costume and makeup by the Surrealist men was ruled out by their anxiety about tainting their heterosexuality; only the overtly gay Crevel put on makeup and drag.

172. Frida Kahlo, who will be discussed later, is an exception. Her personal experience of bodily trauma led her to create an art that unites mutilation with tenderness, penetration with caress – qualities that attracted MTV star Madonna (see her *Bedtime Stories*, mentioned earlier).

173. In Belton's interview with her, in *Surrealism and Women*, p. 69, Oppenheim said that "I have become known as a maker of surrealist objects, but they were the least of my endeavors. I thought of myself as a picture-maker." RB: "It's ironic, then, that the *Déjeuner* is considered your masterpiece." MO: "That's the Museum of Modern Art for you! But to return to the dogmatism of Breton and others – it was he who named it *Déjeuner en fourrure*, playing on the associations with queer sexuality in Manet's *Déjeuner sur l'herbe* and Sacher-Masoch's *Vénus en fourrures*. The word-games of critics, the power struggles of men! . . . I was thinking only of the contrast of material textures. Later, Breton asked me to participate in the Ratton show. I simply made up the object according to the idea. I didn't care about any title at all. I don't really care that it is now known by Breton's title." Anxious to distinguish herself from Surrealism and its acceptance of Freudian sexuality, Oppenheim turned to Jungian theories. See note 175, below.

174. Freud, in chapter 1 of *Three Contributions to the Theory of Sex, SE*, vol. 7, pp. 149–50, described fur as a fetish "with the hairiness of the *mons veneris*."

175. Oppenheim herself refused to talk of her works in terms of Freudian sexual symbolism and preferred the Jungian psychology of the collective unconscious, as she told Belton, *Surrealism and Women*, p. 69. Roughly contemporary to the *Luncheon in Fur*, Edith Sitwell's *Canticle of the Rose: Poems 1917–49* (New York, 1949), reveals a comparable fascination with hair and fur in phrases like "hairy sky" and "furred . . . light."

176. Her piece "Feast on the Body of the Nude Woman" was shown at the opening of the E.R.O.S. exhibition held in the Galerie Cordier. A greatly expanded version of the idea appeared in the feminist Judy Chicago's *The Dinner Table* of 1979. Oppenheim, no feminist, claimed to be what one might call an "androgynist."

177. Breton wrote the introduction to *Toyen* (Paris, 1953). See also Breton, *Surrealism and Painting*, pp. 207–14.

178. The grouping in both instances of male commentators around the work of a woman recalls the role of Magritte's nude as the centerpiece for the photos of the Surrealist men.

179. See Nezval, "Toyen," *Cahiers d' art* (1936). Nezval evidently became acquainted with the expression through Breton's article in *Minotaure*, no. 5 (1934), but he also came into direct contact with the poet when Breton gave a lecture on Surrealism in Prague in 1935. By 1938 Nezval was making anti-Semitic statements; he soon turned to Stalinism and became an enemy of Surrealism.

180. "Interview de René Balance," *Haïti-Journal*, December 12–13, 1945; Breton, *Entretiens*, p. 237.

181. Artaud, long separated from Surrealism, sought a spiritual "révélation-révolution" in Mexico, where he gave several lectures. Paalen, who had good relations with Breton, founded the periodical *Dyn* in Mexico, which had six issues from 1942 to 1944.

182. Breton, *Surrealism and Painting*, p. 144.

183. In Diego Rivera, "Frida Kahlo and Mexican Art," *Bulletin of the Mexican Cultural Seminary*, no. 2 (Mexico City, October 1943), pp. 89–101.

184. See Octavio Paz, *Essays on Mexican Art* (New York, 1993 [1987]), p. 262. "[Kahlo's] procedure that turns [verbal metaphor] into poetic fuel is characteristic of Surrealist painting" (p. 244). "It is absurd to deny the influence of Surrealism on Frida's painting,

as certain nationalistic critics have tried to do" (p. 261).

185. See Laura Mulvey and Peter Wollen, *Frida Kahlo. Tina Modotti* (London, 1982), catalogue of the exhibition held at the Whitechapel Art Gallery.

186. *New York Times Book Review,* April 24, 1983, p. 23. Terry Smith, in several interesting articles and in the chapter "Frida Kahlo: Marginality and Modernity," of his *Making the Modern* (Chicago, 1993), pp. 247–81, makes the largest claims of all for Kahlo's significance. Her recent apotheosis suggests that, like Paula Modersohn-Becker, Kahlo has transcended problems originating in her being a woman. (I disagree with Pollock's assessment of the failure of Paula's nude self-portraits in her article "What Is Wrong with Images of Women?" *Screen Education,* no. 24 [Autumn 1977], pp. 25–33.)

187. Rivera, who had provided the house where Trotsky resided at the time that Breton met him, painted monumental murals with overt political content. He returned to the Communist Party in the last years of his life (he died in 1957), after making the obligatory humiliating confessions.

188. Breton, doubtless with the postwar international tensions in mind, asserted in his essay "Rufino Tamayo," in 1950 on the occasion of an exhibition of the artist's work in the Venice Biennale, that Tamayo's "essentially Mexican" art, through its "technical research" achieved a universal language, "which remains the sole basis for [international] unification." Among Paz's numerous writings, I cite only *Aigle ou soleil?* (Paris, 1958), *Le Labyrinthe de la solitude* (Paris, 1959), and *Marcel Duchamp* (Paris, 1977).

189. See Breton, "Bois de Posada," *Minotaure,* no. 10 (1937), p. 18. Posada's death's head caricatures particularly appealed to Breton.

190. For an argument against seeing her as a Surrealist or in the bourgeois terms of a suffering woman, and instead for appreciating her as "a committed Third World cultural nationalist," see Janice Helland, "Culture, Politics, Identity in the Paintings of Frida Kahlo," *Woman's Art Journal,* 11 (Fall 1990–Winter 1991), pp. 8–13.

191. For feminist comments on the odalisque see Marilynn L. Board, "Constructing Myths and Ideologies in Matisse's Odalisques," *Genders,* 5 (Summer 1989), pp. 21–49.

192. On the sexist implications of female imagery see Linda Nochlin, "Eroticism and Female Imagery in 19th Century Art," in Thomas B. Hess and Linda Nochlin, eds., *Woman as Sex Object* (London, 1973), pp. 9–15.

193. See A. Solomon-Godeau, "Going Native," *Art in America,* 77 (July 1989), pp. 118–29, quoting Gauguin's admission of a "longing to rape," in *Noa Noa* (London, 1972), p. 23. See also Gill Perry, "Primitivism and the 'Modern' " (especially the section " 'Pillaging the Savages of Oceania': Gauguin and Tahiti"), in *Primitivism, Cubism, Abstraction: The Early 20th Century* (New Haven, Conn., 1993).

194. The English, with their tradition of supernaturalism, either derided the silliness of the French or claimed that they had anticipated it all with Shakespeare, Coleridge, Blake, Lewis Carroll, and others. The big London Surrealist exhibition of 1936 had only a momentary impact, despite Herbert Read's exultant review; and a later attempt to have another major exhibition fell through, as noted by Denis-J. Jean, "An Invitation Refused: André Breton and Surrealism in England in 1959," *Dada and Surrealism,* no. 5 (1975), pp. 77–9. Most Americans, ignoring the linguistic and cultural context of Surrealism, called it "Super-realism"; however, two who did contact Breton in the sixties were Franklin Rosemont, who initiated a movement in Chicago, and the black poet Ted Joans, who moved between New York and Paris. Joans actually claimed to have found in Surrealism a "weapon" with which to defend himself against a racist society.

195. The French language was always a paramount concern for the Surrealists, who militated against institutionally orthodox writing. But while they welcomed nonstandard language as a contribution to their effort to subvert the classical language, they considered Creole poetry essentially an inflection of their metropolitan French. This was not the case with prose: the Surrealists wrote clear and incisive prose, and they welcomed the excellent French of the best colonial poets (gained through the standard and universal education common then, as it is today, to French language schools for the educated middle class). In 1963 Senghor, then president of Senegal, paid tribute to his alma mater (in "Lycée Louis-le-Grand, haut-lieu de la culture française"), which had educated him

into classical ways of thinking and writing. See *Louis-le-Grand, 1563–1963. Etudes, souvenirs, documents* (Paris, 1963), pp. 247–9.

196. See Césaire, *Discours sur le colonialisme*, p. 21: "In the relation between the colonizer and the colonized there is room only for forced labor, for intimidation, pressure, the police ... for *rudeness* between the brainless elites and the degraded masses." His *Soleil cou coupé* (Paris, 1948) takes its title from Apollinaire's *Zone*, in *Oeuvres poétiques*, p. 44, which concludes with complex irony: "You walk toward Auteuil you want to go home on foot / To sleep among your fetishes from Oceania and Guinea / They are Christs of another form and another faith / They are inferior Christs with obscure hopes / Farewell Farewell / Sun neck cut off (Soleil cou coupé)." Césaire writes, "Europe, notable name for Crap," and while writing in French, he created his own hopeful vision based on returning to his African origins: "I open through my mouth the flood gates of reconstruction to perfect a rebel island still to be born / Hope, Hope ..."

197. Senghor, who tried to distinguish an African Surrealism from the European brand, advanced the idea that the image is a manifestation of the invisible (a notion rejected by Breton).

198. For Senghor, see his "Chants d'ombres" (1945), in *The Collected Poetry* (Charlottesville, Va., 1991, p. 269). The problem persists; for example, as reported in *Le Monde hébdomadaire* (April 2–8, 1959) a participant at Le Deuxième Congrès des Ecrivains Noirs held in Rome (the first was in the Sorbonne in 1956) spoke of the need to " 'de-Westernize black culture and to return to the African sources in order to make possible, through the recovered independence, the renewal of the African creative spirit,' according to the terms proposed by the Martinique novelist Edouard Glissant." Two groups of black intellectuals, Catholics and Marxists, proposed this platform; thus, both were intimately linked to the "master" culture from which they wished to disengage. In 1956 Césaire wrote to the leader of the French Communist Party, Maurice Thorez: "What I want is that Marxism and Communism be placed in the service of blacks and not that blacks be put in the service of Marxism and Communism."

For resistance to the controlling images of the French, Italian, Portuguese, Belgian, and English colonial *régimes*, see Pascal Blanchard and Armelle Chatelier, eds., *Images et colonies. Actes du colloque (B.N.)* (Paris, 1993).

199. See Eugène Revert, *La Martinique. Etude géographique et humaine* (Paris 1949), p. 487: "Irrationality, the marvelous are everywhere in Martinique and illuminate things and persons with a very special light."

200. Unfortunately over the years this official doctrine – for all its virtue in supporting a sense of racial pride and identity – left Senegalese artists dependent on the state, and with the end of Senghor's presidency (1960–80) financial support for the policy dwindled, ironically forcing artists into the tourist market.

201. The following are a few of the many writings relevant to French art and colonialism: Christopher M. Andrew and A. S. Kanya-Foster, *France Overseas: The Great War and the Climax of French Imperialist Expansion* (London, 1981); E. Said, *Orientalism* (New York, 1978); L. Nochlin, "The Imaginary Orient," *Art in America*, 71, no. 5 (May 1983), pp. 119–31, 186–92; R. Golan's Ph.D. dissertation at the Courtauld Institute on colonialism in the twenties; Kenneth Silver, *Esprit de Corps;* and Barthes's analysis in *Mythologies* of a negro soldier in the French army admiring the flag.

202. Hans-Jürgen Lüsebrink, "Les Troupes coloniales dans la guerre: Présences, imaginaires et représentations," in *Images et colonies,* pp. 74–85, cites General Mangin's tribute to the many thousands of non-Caucasian colonials who had died in World War I: " 'A greater France has come out of the War, so united and strong that it remains now in peace the surest safeguard of the people's liberty. The blood spilled together on the battlefield has created between the metropolitan troops and those of the colonies a fraternity crowned by victory." As a lieutenant-colonel in 1910 this same general had stated: "All Frenchmen will understand that France does not end at the Mediterranean or on the Sahara ... that it comprises an empire more vast than Europe which, in a half century will have 100 million inhabitants."

203. For this "Appel aux travailleurs intellectuels," published first in Henri Barbusse, *L'Humanité* (July 2, 1925), see Pierre, *Tracts* vol. 1, p. 51. For the replies of Aragon, Artaud, Crevel, and Eluard to the questionnaire, "Que pensez-

vous de la guerre du Maroc?" published in *Clarté* (November 30, 1925), see Pierre, *Tracts,* vol. 1, p. 395. Cf. Chapter 3, this volume, for some details of the Moroccan War. For the opposition to chauvinism and colonialism in France, see Stuart Roberts, *History of French Colonial Policy, 1870–1925* (London, 1929); Thomas Power, *Jules Ferry and the Renaissance of French Imperialism* (New York, 1944); and Zeldin, *France, 1848–1945,* pp. 923–42. Gene Lebovicz's recent writings on the French united front touch on the Surrealist response to French colonialism.

204. One of the great debates in modern historiography – whether there is a link between industrialization and imperialism – originated in the Marxist critique of capitalism. See Lenin, *Imperialism: The Highest Stage of Capitalism* (New York, 1939 [1917]), and Hobson, *Imperialism: A Study.* For the relations between metropolis and colony, see the authors A. Hopkins, D. C. M. Platt, R. Robinson, J. Gallagher, R. Owen, and J. Strengers. For France as well as England see Winfried Baumgart, *Imperialism: The Idea and Reality of British and French Colonial Expansion, 1880–1914* (New York, 1982).

205. Marx expressed his ideas in *Capital,* vol. 1, chapter 33, "The Modern Theory of Colonisation," in E. Kamerka, *The Portable Karl Marx* (New York, 1983), p. 503, which is really concerned with the expansion of Western capitalism – especially in the United States – and the expulsion of the laborer: "We are not concerned here with the condition of the colonies. The only thing that interests us is the secret discovered in the new world by the political economy of the old world."

206. See Georges Michael, *"Où en est la France? Le Colonialisme intercapitaliste,"* *Clarté,* no. 38 (1923), pp. 469–70.

207. The fetish has provided a link between woman and the "primitive" in studies by psychoanalysts and Marxists. See the articles in "Objets du fétichisme," *Nouvelle Revue de Psychanalyse* no. 2 (Autumn 1970), pp. 1–255.

208. See Leiris's article on "Alberto Giacometti" on the artist's sculpture published in *Documents,* 1, no. 4 (1929), pp. 209–10. For *Minotaure* see Chapter 4, this volume.

209. The Colonial Exhibition of 1906 (another followed in 1922) was appropriately held in Marseille, a big port with close ties to the colonial trade. Aragon's chatty "Souvenirs de

voyages: L'Exposition Coloniale de Marseille" appeared in *Littérature,* no. 8 (January 1923), pp. 3–4, and tells about touristic Breton's purchase of an armadillo from one of the natives and his sale of it to another "Monsieur." Henri Béhar, *André Breton* (Mesnil-sur-L'Estrée, 1990), p. 140, reports that Breton called the exposition "the saddest zoological garden he knows of." Neither poet had any sympathy or insight into the native cultures, nor had they yet acquired the appropriate Marxist anticolonial rhetoric.

210. On the "Exposition internationale des arts décoratifs et industriels modernes" of 1925 see Kenneth Silver, "Matisse's Retour à l'ordre," *Art in America,* 75, no. 6 (June 1987), p. 117. For the "Exposition Coloniale Internationale," see the catalogue published in Paris in 1931. The president of the 1931 exposition was Maréchal Lyautey, who had already organized the important exhibition of Moroccan art in 1917.

211. Gender distinctions among the native populations received little emphasis, except for picturesque specialties like the dances of Balinese women and the *fantasias* of Moroccan horsemen.

212. Significantly, most illustrations, with ethnographic smugness, ignore tribal art (except for two drawings on pp. 74 and 81), while putting on show the natives as exotic specimens. What is meant on p. 162, in speaking of "highly characteristic and truly beautiful native architecture and fine arts," is not tribal art, but that of the Dutch East Indies, Surinam, Java, and Sumatra. An ad for "Art nègre" by Galerie Percier, rue de la Boétie (p. 302), showing a photo of an African head, is the only photo of tribal art in the book. This gallery did not advertise in *La Révolution surréaliste,* *LSASDLR,* or *Documents.*

213. See "Adresse au visiteur," *Exposition,* pp. 17–21, signed André Demouchey, who quotes Lyautey admiringly. This concept of the peaceful battle sits uncomfortably in a book, where on p. 268 appears a full-page ad for a "Cartoucherie française," and matching this cartridge ad the facing page carries an ad by a gun manufacturer. Cf. Christopher M. Andrew and A. S. Kanya-Forstner, *France Overseas: The Great War and the Climax of French Imperial Expansion* (London, 1981).

214. Posters for the expositions in Marseille and Paris invariably present healthy and happy

men and women dressed in their native costumes.

215. Lévi-Strauss, *Tristes Tropiques*, Weightman translation (Paris, 1955), p. 168; orig. ed., p. 132, found in Third World cities "filth, promiscuity, disorder, physical contact; ruins, shacks, excrements, mud; body moisture, animal droppings, urine, purulence, secretions, suppuration – everything that [European] urban life is organized to defend us against, everything we loathe."

216. Among their purchases of modern art Eluard and Breton bought *papiers collés* directly from Picasso and Braque after World War I, and paintings from Derain. See the catalogue of the exhibition at the Librairie José Corti, March 1930; René Gaffé, *A la verticale* (Brussels, 1963); and Robert Lebel, "Breton et la peinture," *L'Oeil*, no. 143 (November 1966), pp. 11–19. Aside from Oceanic and African figures Breton collected katchina dolls (also admired by Ernst) and exalted the art of the Hopi – e.g., in his *Ode à Fourier* (written while in the United States), and in an unsigned note published in *Bief*, no. 7 (June 1, 1959), praising a book on the Hopi (Pierre, *Tracts*, vol. 2, pp. 180–1 and 380–1). See also Benjamin Péret, *Anthologie des mythes, légendes et contes populaires d'Amérique* (Paris, 1959).

217. Breton wrote an article published in 1947 and included in *Surrealism and Painting*, pp. 308–12, on the Haitian artist Hector Hyppolite, whom he met in 1945 and whose realizations of voodoo and African magic he applauded as authentic.

218. In the thirties and later the Surrealists discovered fresh recruits among the Francophone intelligentsia of Haiti and Martinique.

219. See Patricia Leighten, "The White Peril and *L'Art nègre*: Picasso, Primitivism, and Anticolonialism," *Art Bulletin* (December 1990), p. 609: "The preferences of some modernists (in 1905–9) for 'primitive' cultures was as much an act of social criticism as a search for new art." Also see C. Miller, *Blank Darkness: Africanist Discourse in France* (Chicago, 1985), and J. Suret-Canale, *Afrique noire* (Paris, 1964), and *L'Ere coloniale, 1900–45* (New York, 1971).

220. See Norman Bryson, "The Politics of Arbitrariness," in Norman Bryson, M. A. Holly, and K. Moxey, eds., *Visual Theory* (New York, 1991), p. 100; the remarks occur in the context of a rebuttal of Krauss's effort to apply Saussure's theory of linguistics to visual images. "The modernist project of taking non-European art away from its context and absorbing it into the mainstream of European art assumes, and is a part of, the ideology of colonialism, past and present.... If the question whether images are grounded in natural resemblance or in convention can only be answered historically, we should be prepared to look and see what historical processes may be shaping our own discussion of the issue." In "Le Mythe, aujourd' hui," *Mythologies* (Paris, 1957 [1956]), pp. 201–2. Barthes examined a poster of a black in the uniform of the French colonial army. He asserts that the "universal" military uniform, by sanitizing and depoliticizing the image of the black soldier, illustrates his thesis that "myth is speaking/speech (*parole*) depoliticized" (p. 230). But his Marxist point concerns the denial of Western history. By making the image enter into the framework of French radicalism, he remains within the framework of linguistic imperialism: he neither hears nor expects to hear the voice of the black subject. For Soyinka's position, see his "The Critic and Society: Barthes, Leftocracy and Other Mythologies," in Henry Gates, ed., *Black Literature and Literary Theory* (London 1984), pp. 27–57.

221. See Roger Vailland, "Colonisation," a review of André Gide's *Voyage au Congo*, *Le Grand Jeu*, no. 1 (1928), pp. 77–8.

We certainly approve of André Gide's protesting the treatment inflicted on the negroes of French West Africa [this federation, created in 1895, included Mauritania, Sudan, Upper Volta, Guinea, Nigeria, the Ivory Coast, and Dahomey]. Mr. Brion recalls to us the cruelty of the Spanish toward the Indians, a cruelty that is necessarily part of any colonization. French and Spanish colonizers perforce educate, even while abusing their pupils: they teach Catholicism to the very negroes who will eventually massacre them, their oppressors. We are for the blacks, yellowskins and redskins against the whites. We are for all those who have been condemned to prison for having the courage to protest against the colonial wars.

We fraternize with you, dear negroes, and hope that you will soon arrive in Paris.

222. As Derrida had already observed in the sixties: "One can assume that ethnology could have been born as a science only at the moment when a decentering had come about: at the moment when European culture ... had been *dislocated*, driven from its locus, and forced to stop considering itself as the culture of reference." See Jacques Derrida, "Structure, Sign and Play," *Writing and Difference* (Chicago, 1978 [1967]), p. 282. More recently English-speaking intellectuals like E. Said, G. Spivak, and H. Bhabha, all born in Third World countries, have become part of the Western establishment and from within have waged a war of subtle subversion of its cultural hegemony. For an anxious critique (addressed especially to the Palestinian-American Said) of those who attack the West while remaining safely outside it, see James Clifford, *The Predicament of Culture: Twentieth-Century Ethnography, Literature, and Art* (Cambridge, Mass., 1988).

Select Bibliography

Breton

By Breton

(There is also unpublished archival material in the Bibliothèque Jacques Doucet and other published material in the Bibliothèque Nationale.)

Oeuvres complètes, Bibliothèque de la Pléiade: Gallimard, ed., and annotated by M. Bonnet et al., vol. 1, to 1930 (Paris, 1988); vol. 2, to 1941 (Paris, 1992).
L'Amour fou (Paris, 1937).
Anthologie de l'humour noir (Paris, 1966 [1939]).
Arcane 17 (Paris, 1947).
"Caractères de l'évolution moderne" (1922). Lecture published in *Les Pas perdus* (1924).
La Clé des champs (Paris, 1967).
"Crisis of the Object," *Cahiers d'art* (May 1936).
"Décalcomanie du désir," *Minotaure,* no. 8 (June 1936).
Entretiens (Paris, 1969).
Je vois, j'imagine (Paris, 1991).
Manifestoes of Surrealism, translated by Richard Seaver and Helen R. Lane (Ann Arbor, Mich., 1969).
Nadja (Paris, 1962 [1928]).
Les Pas perdus (Paris, 1924).
Point du jour (Paris, 1970).
Qu'est-ce que le Surréalisme? (Brussels, 1934).
Le Surréalisme et la peinture (Paris, 1965 [1928]).
Trajectoire du rêve (Paris, 1938).
[Unsigned note on the Hopi], *Bief,* no. 7 (June 1, 1959).
Les Vases communicants (Paris, 1955 [1932]).

Collaborations

Breton, André, and Louis Aragon, "Trésor des jésuites," in *Variétés* (Brussels, 1929).
Breton, André, René Char, and Paul Éluard, "L'Ecole buissonnière," in *Ralentir travaux* (Paris, 1930).
Breton, André, and Paul Eluard, eds., *Dictionnaire abrégé du Surréalisme* (Paris, 1938).
Breton, André, and Paul Eluard, *L'Immaculée conception* (Paris, 1930).
Breton, André, and Philippe Soupault, *Les Champs magnétiques* (Paris, 1919).

On Breton

Balakian, Anna, *André Breton: Magus of Surrealism* (New York, 1971).
Béhar, Henri, ed., *André Breton par lui-même* (Paris, 1970).
Béhar, Henri, *André Breton* (Mesnil-sur-L'Estrée, 1993).
Bonnet, Marguerite, *André Breton. Naissance de l'aventure surréaliste* (Paris, 1975).
"Breton et le Surréalisme," special no. of *La Quinzaine littéraire* (March 16–31, 1971).
Eigeldinger, Marc, ed., *André Breton* (Neuchâtel, 1970).
Fontainas, André, review of Breton, "Clair de terre," *Mercure de France* (July 15, 1924).
Isou, Isidore, *Réflexions sur André Breton* (Paris, 1948).
Legrand, Gérard, *André Breton en son temps* (Paris, 1976).
Remy, Ariel, "Beau comme la rencontre fortuite . . . entre Breton et Freud." Unpublished thesis (Strasbourg, 1991).

Other Surrealists

The major Surrealist periodicals are *Littérature; La Révolution surréaliste; Le Surréalisme au service de la révolution;* and *Minotaure.* Others include *Paris-Journal; Aventure; Action, Cahiers de philosophie et d'art; L'Oeuf dur;* and *Monuments,* after an initial phase associated with Bataille.

Aragon

By Aragon

Anicet (Paris, 1921).
Aragon. Ecrits sur l'art moderne, ed. Jacques Leenhardt (Paris, 1981).

Aragon parle avec Dominique Arban (Paris, 1968).
Les Aventures de Télémaque (Paris, 1922).
Les Collages (Paris, 1965).
Le Con d'Irène (ca. 1925). Published anonymously.
Je n'ai jamais appris à écrire ou l'incipit (Paris, 1969).
Le Mouvement perpétuel (Paris, 1925).
Le Paysan de Paris (Paris, 1924).
La Peinture au défi (Paris, 1930). Reprinted in *Les Collages* (Paris, 1965).
Une Vague de rêves (Paris, 1924).

On Aragon

Gindine, Yvette, *Aragon, Prosateur surréaliste* (Geneva, 1966).

Artaud

Artaud, "Cinéma et réalité," *La Nouvelle Revue française* (November 1, 1927), pp. 561–7.
"A la grande nuit ou Le bluff surréaliste," in *Cahiers du Sud,* 1 (June 1927), pp. 59–66.

Carrington

Barnet-Sanchez, Holly, and others, *Leonora Carrington: The Mexican Years, 1943–85* (Albuquerque, N.M., 1991).

Crevel

Crevel, René, *Le Clavecin de Diderot* (Paris, 1932).

Dali

By Dali

Diary of a Genius (New York, 1964).
Oui (Paris, 1971).

On Dali

Ades, Dawn, *Dali and Surrealism* (London, 1982).
Alain, Roger, *Hérésies du désir: Freud, Dracula, Dali* (Vallon, 1985).
Finkelstein, Haim, *The Metamorphosis of Narcissus* (New York, 1996).
Laurent, Jenny, "From Breton to Dali: The Adventures of Automatism," *October,* 51 (Winter 1989), pp. 105–14.
Ratcliff, Carter, "Swallowing Dali," *Artforum* (September 1982).
"Dali's Dreadful Relevance," *Artforum* (November 1982).

Salvador Dali rétrospective, 1920–80, in the Pompidou Museum (Paris 1980).

De Chirico

Ribemont-Dessaignes, G., "Giorgio de Chirico," *Documents,* 2, no. 6 (1930).
Soby, James T., *Giorgio de Chirico* (New York, 1955).
Vitrac, R., *Georges de Chirico* (Paris, 1927).

Desnos

Desnos, Robert, *Deuil pour Deuil* (Paris, 1924).
"Qu'est-ce que la peinture surréaliste?" *Cahiers d'art,* no. 8 (October 1926).
La Liberté ou l'amour! (Paris, 1927 [1925]).
"Le Sens révolutionnaire du Surréalisme," *Clarté,* no. 78 (November 30, 1925).
Dumas, Marie-Claire, *Robert Desnos ou l'exploration des limites* (Paris, 1980).

Duchamp

Cabanne, Pierre, *Entretiens avec Marcel Duchamp* (Paris, 1967).
De Duve, Thierry, ed., *The Definitively Unfinished Marcel Duchamp* (Cambridge, Mass., 1992).
d'Harnoncourt, Anne, and K. McShine, eds., *Marcel Duchamp* (New York, 1973).
Paz, Octavio, *Marcel Duchamp* (Paris, 1977).
Spector, Jack J. "Duchamp's Androgynous Leonardo: Queue and Cul in *L.H.O.O.Q.,*" *Source,* 11 no. 1 (Fall 1991).

Eluard

Eluard, Paul, "L'Art sauvage," *Variétés* (Brussels, June 1929).
Donner à voir (1939), in Breton, *Oeuvres complètes,* Pléiade vol. 1 (Paris, 1968).
Mourir de ne pas mourir (Paris, 1924).
Oeuvres complètes, vol. 1 (Paris, 1968).
Gateaux, Jean-Charles, *Paul Eluard, ou le frère voyant, 1852–1952* (Paris, 1988).

Ernst

Ernst, Max, *Beyond Painting and Other Writings* (New York, 1948).
Legge, Elizabeth M., *Max Ernst: The Psychoanalytic Sources* (Ann Arbor, Mich., 1989).
Spies, Werner, *The Return of La Belle Jardinière* (New York, 1971).

Kahlo

Helland, Janice, "Culture, Politics, Identity in the Paintings of Frida Kahlo," *Woman's Art Journal,* 11 (Fall 1990–Winter 1991), pp. 8–13.

Mulvey, Laura, and Peter Wollen, *Frida Kahlo. Tina Modotti* (London, 1982), catalogue of the exhibition held at the Whitechapel Art Gallery.

Rivera, Diego, "Frida Kahlo and Mexican Art," *Bulletin of the Mexican Cultural Seminary,* no. 2 (Ministry of Public Education, Mexico City, October 1943), pp. 89–101.

Smith, Terry, *Making the Modern* (Chicago, 1993).

Magritte

Foucault, Michel, *Ceci n'est pas une pipe* (Montpellier, 1973).

Magritte, René, *Ecrits complets* (Paris, 1979).

Masson

Charbonnier, Georges, *Entretiens avec André Masson* (Paris, 1985 [1958]).

Will-Levaillant, Françoise, ed., *André Masson, le rebelle du Surréalisme: Ecrits* (Paris, 1976).

Masson, André, *La Mémoire du monde* (Geneva, 1974).

"Le Peintre et ses fantasmes," *Les Etudes philosophiques,* no. 4 (October–December 1956), pp. 634–6.

Miró

Rowell, Margit, *Joan Miró* (Boston, 1986).

Péret

Péret, Benjamin, ed., *Anthologie des mythes, légendes et contes populaires d'Amérique* (Paris, 1959).

Anthology of Sublime Love (Paris, 1956).

Picabia

Camfield, William A., *Francis Picabia: His Art, Life and Times* (Princeton, N.J., 1979).

Picabia, Francis, ed., *391. Revue publiée de 1917 à 1924,* new ed. by M. Sanouillet (Paris, 1975).

Soupault

Soupault, Philippe, *Profils perdus* (Le Mesnil-sur-L'Estrée, 1963).

"Soupault," *Europe,* no. 769 (May 1993), especially Henri Béhar, "Philippe Dada," pp. 7–14.

Tanguy

Breton, André, Introduction to the exhibition catalogue "Yves Tanguy et les objets d'Amérique," Paris, Galerie Surréaliste (May 27–June 15, 1927).

Jean, Marcel, "Tanguy in the Good Old Days," *Art News,* 54 (September 1955).

Toyen

Breton, André, "Introduction," *Toyen* (Paris, 1953).

Nezval, Vitêzslav, "Styrsky Toyen," *Cahiers d'art,* no. 5–6 (1935).

Tzara

Caws, Mary Ann, ed., *Tristan Tzara* (Detroit, 1973).

Tzara, Tristan, "Note on Negro Art," *Sic* (1917), in Tzara, *Oeuvres complètes,* vol. 1, pp. 394–5.

"Note sur la poésie nègre," *Sic* (1918), in Tzara, *Oeuvres complètes,* vol. 1, pp. 400–1.

ABOUT DADA AND SURREALISM (INCLUDING ARTICLES AND TRACTS)

Ades, Dawn, *Dada and Surrealism Reviewed* (London, 1978).

Alexandrian, Sarane, "L'Espace du rêve," *Nouvelle Revue de psychanalyse,* no. 5 (Spring 1972).

Le Surréalisme et le rêve (Paris, 1974).

"Almanach surréaliste du demisiècle," special no. of *La Nef* (Paris, 1950).

Alquié, Ferdinand, ed., *Entretiens sur le Surréalisme,* lectures in 1966 at Cerisy (Paris, 1968).

Philosophy of Surrealism (Ann Arbor, Mich., 1965 [1955]).

Appignanesi, Lisa, and John Forrester, *Freud's Women* (London, 1992).

Archives du Surréalisme (all published by Gallimard in Paris). Vol. 1, *Bureau de Recherches Surréalistes. Cahier de la permanence, October 1923 to April 1925,* ed. P. Thévenin (1988); vol. 2, *Vers l'action politique, July 1925–April 1926,* ed. M. Bonnet (1988); vol. 3, *Adhérer au Parti communiste?* ed. M. Bonnet (1992); vol. 4, *Recherches sur la sexualité, Jan. 1928–August 1932,* ed. J. Pierre (1990 [sic]).

Berl, Emmanuel, *Mort de la morale bourgeoise* (Paris, 1929).

Biro, Adam, and René Passeron, eds., *Dictionnaire général du Surréalisme et de ses environs* (Paris, 1982).

Bonnet, Marguerite, "L'Orient dans le Surréalisme: Mythe et réel," *Revue de littérature comparée*, no. 4 (October–December 1980).

Bürger, Peter, *Theory of the Avant-Garde* (Minneapolis, Minn., 1984).

Cahun, Claude, *La Poésie garde son secret* (Paris, 1934).

Caillois, Roger, "La Mante religieuse," *Minotaure*, no. 5 (May 1934), pp. 23ff.

Cardinal, Roger, and Robert S. Short, *Surrealism: Permanent Revolution* (London, 1970).

Cazaux, Jean, *Surréalisme et psychologie: Endophasie et écriture automatique* (Paris, 1938).

Chadwick, Whitney, *Myth in Surrealist Painting, 1929–1939* (Ann Arbor, Mich., 1980).

Daumal, René, "Lettre ouverte à André Breton sur les rapports du Surréalisme et du Grand Jeu," *Le Grand Jeu*, no. 3 (October 1930), pp. 191–5.

Doesburg, Theo van, Jean Arp, Kurt Schwitters, and Tristan Tzara, "Manifeste art prolétarien," *Merz*, 2, no. 1 (April 1923).

Drieu la Rochelle, "La véritable erreur des Surréalistes," in *Nouvelle Revue Française* (August 1925), pp. 166–71.

"Ecriture et Révolution," *Tel quel: Théorie d'ensemble* (Paris, 1968).

Foster, Hal, *Compulsive Beauty* (Cambridge, Mass., 1993).

Foucault, Michel, *Death and the Labyrinth: The World of Raymond Roussel* (New York, 1986 [1963]).

Gershman, Herbert, S., "Futurism and the Origins of Surrealism," *Italica* (June 1962), pp. 114–23.

The Surrealist Revolution in France (Ann Arbor, Mich., 1969).

Hollier, Denis, *Against Architecture: The Writings of George Bataille* (Cambridge, Mass., 1989).

Howe, Irving, ed., *The Idea of the Modern in Literature and the Arts* (New York, 1967).

Hulak, Fabienne, director, *Folie et psychanalyse dans l'expérience surréaliste* (Nice, 1992).

Ilie, Paul, *The Surrealist Mode in Spanish Literature: An Introduction of Basic Trends from Post-Romanticism to the Spanish Vanguard* (Ann Arbor, Mich., 1968).

Janis, Harriet, "Paintings as a Key to Psychoanalysis," *Arts and Architecture*, 63, no. 2 (1946).

Janover, Louis, *Surréalisme: Art et politique* (Paris, 1980).

Jean, Marcel, ed., *Autobiography of Surrealism* (New York, 1980 [1978]).

Jean, Marcel, and Arpad Mezei, *Histoire de la peinture surréaliste* (Paris, 1959. English ed., New York, 1960).

Krauss, Rosalind, and Sarah Livingston, *L'Amour fou* (Washington, D.C., 1985).

Lemaitre, Georges, *From Cubism to Surrealism in French Literature* (Cambridge, Mass., 1941).

Lewis, Helena, *The Politics of Surrealism* (New York, 1988).

Martin, Richard, *Fashion and Surrealism* (New York, 1987).

Matthews, J.-H., *The Imagery of Surrealism* (Syracuse, N.Y., 1977).

Surrealism, Insanity and Poetry (Syracuse, N.Y., 1982).

Maxence, Jean-Pierre, *Histoire de dix ans (1927–1937)* (Paris, 1939).

Mead, Gerald, *The Surrealist Image: A Stylistic Study* (Berne, 1978).

Melzer, Annabelle, *Latest Rage the Big Drum: Dada and Surrealist Performance* (Ann Arbor, Mich., 1980).

Morise, Max, "Les Yeux enchantés," in the "Beaux-Arts" section of *La Révolution surréaliste*, no. 5 (October 1925).

Motherwell, Robert, *The Dada Painters and Poets* (New York, 1951).

Nadeau, Maurice, *History of Surrealism* (New York 1965 [1945]).

Naville, Pierre, "Beaux-Arts," *La Révolution surréaliste*, no. 3 (1925), p. 27.

La Révolution et les intellectuels. Que peuvent faire les surréalistes? (Paris, 1927 [1926]).

Nesbit, Molly, "Ready-Made Originals," *October* no. 37 (Summer 1986).

Orenstein, Gloria, "Women in Surrealism," *Feminist Art Journal*, 2 (Spring 1973), pp. 15–21.

Paulhan, Jean, *Les Fleurs de Tarbes, ou la terreur des lettres* (Paris, 1941).

Paz, Octavio, *Aigle ou soleil?* (Paris, 1958).

Le Labyrinthe de la solitude (Paris, 1959).

Pelles, Geraldine, "Psychology and the Surrealist Theory of Art," unpublished M.A. thesis, Columbia University, 1949.

Pierre, José, "Le Gant et son rôle dans l'oeuvre de Klinger et De Chirico," *Le Surréalisme, même* no. 1 (1956), pp. 131–9.

Position politique de la peinture surréaliste (Paris, 1975).

Pierre, José, ed., *Tracts surréalistes*, 2 vols. (Paris, 1980 and 1982).

Pressly, William L., "The Praying Mantis in Surrealist Art," *Art Bulletin*, 55, no. 4 (December 1973), pp. 600ff.

Raymond, Marcel, *De Baudelaire au Surréalisme* (Paris, 1966).

Ribemont-Dessaignes, Georges, *Déjà jadis: Ou du mouvement Dada à l'espace abstrait* (Paris, 1958).

Richter, Hans, *Dada: Art and Anti-Art* (New York, ca. 1965).

Rivière, Jacques, Interview with Roger Vitrac, *Journal du Peuple* (April 21, 1923).

Robert, "Pour une définition du Surréalisme," *Revue de l'Université d'Ottawa* (April–June 1973), pp. 297–306.

Rubin, William, *Dada, Surrealism and Their Heritage* (New York, 1968).

Sadoul, Georges, "Souvenirs d'un témoin," *Etudes cinématographiques,* no. 38–9 (Paris, 1965).

Sanouillet, Michel, *Dada à Paris* (Paris, 1965).

Short, Robert, *Dada and Surrealism* (London, 1980).

Somville, Léon, *Les Devanciers du Surréalisme* (Geneva, 1971).

Spector, Jack J., Review of Hal Foster, *Compulsive Beauty, Art Journal* (Fall 1994).

Review of Richard Martin, *Fashion and Surrealism, Art Journal,* 47, no. 4 (Winter 1988), pp. 372–5.

"Le Surréalisme en 1929," special no. of *Variétés* (Brussels, June 1929).

Surrealist collective tract, "beau comme BEAU COMME," in Pierre, *Tracts,* vol. 2, pp. 267–72.

"Hands off Love" (1927), in Pierre, *Tracts,* vol. 1, pp. 78–84.

"The Moscow Trial: Appeal to Men" (August–September 1936), in Pierre, *Tracts,* vol. 1, pp. 304–6.

"Le Nationalisme dans l'art," *Minotaure,* no. 12–13 (May 1939).

"Ni aujourd'hui, ni de cette manière" (April 19, 1966), in Pierre, *Tracts,* vol. 2, pp. 250–2.

"Permettez!" (October 1927), in Pierre, *Tracts,* vol. 1 (on Rimbaud).

"Que pensez-vous de la guerre du Maroc?" *Clarté* (November 30, 1925), in Pierre, *Tracts surréalistes,* vol. 1, p. 395 (replies of Aragon, Artaud, Crevel, and Eluard).

Tériade, E., "Documentation sur la jeune peinture. Part 4, La Réaction littéraire," *Cahiers d'art,* 5, no. 2 (1930).

Thirion, André, *Révolutionnaires sans révolution* (Paris, 1988).

Vailland, Roger, *Le Surréalisme contre la révolution* (Paris, 1947).

LANGUAGE, SEMIOTICS, AND WRITING

Barthes, Roland, *Image–Music–Text,* trans. S. Heath (New York, 1977).

Mythologies (Paris, 1970 [1957]).

The Pleasure of the Text (New York, 1975).

S/Z (Oxford, 1990 [1973]).

Besançon, Julien, *Les Murs ont la parole* (Paris, 1968).

Bryson, Norman, Holly, M. A., and Moxey, K., eds., *Visual Theory* (New York, 1991).

Burgin, Victor, *Graffitification* (1977).

Clifford, James, *The Predicament of Culture: Twentieth-Century Ethnography, Literature, and Art* (Cambridge, Mass., 1988).

Clifford, James, and George Marcus, eds., *Writing Culture* (Berkeley, 1986).

Derrida, Jacques, *Of Grammatology* (Baltimore, Md., 1976).

Writing and Difference (Chicago, 1978 [1967]).

Eco, Umberto, *A Theory of Semiotics* (Bloomington, Ind., 1976).

Erlich, Victor, *Russian Formalism: History-Doctrine* (The Hague, 1965 [1955]).

Ernest, Ernest, *Sex Graffiti* (Paris, 1979).

Foucault, Michel, *Language, Counter-memory, Practice,* ed. Donald F. Bouchard (Ithaca, N.Y., 1977).

Gandelman, Claude, *Reading Pictures, Viewing Texts* (Bloomington, Ind., 1991).

Kristeva, Julia, *Desire in Language* (New York, 1980 [1977]).

Saussure, Ferdinand de, *Cours de linguistique générale* (Paris, 1971).

Young, Robert, ed., *Untying the Text: A Poststructuralist Reader* (Boston, 1981).

MARXIST, SOCIALIST, AND ANARCHIST CRITICISM

Althusser, Louis, *Lenin and Philosophy and Other Essays,* trans. Ben Brewster (New York, 1971).

Bienvenu, Richard, *The Utopian Vision of Charles Fourier* (Boston, 1971).

Engels, Friedrich, *Anti-Dühring* (Peking, 1976; [1876–8]).

The Origin of the Family (Chicago, 1902).

Ickowicz, Marc, *La Littérature à la lumière du matérialisme historique* (Paris, 1929).

Jameson, Fredric, *Marxism and Form* (Princeton, N.J., 1971).

The Political Unconscious: Narrative as a Socially Symbolic Act (London, 1981).

Jay, Martin, *Marxism and Totality* (Berkeley, 1984).

Joll, James, *The Anarchists* (Boston, 1964).

Kriegel, Annie, *Les Communistes français: Essai d'ethnographie politique* (Paris, 1968).

Lafargue, Paul, *Droit à la paresse* (1883).

Laqueur, Walter, and G. L. Mosse, eds., *The Left-Wing Intellectual, 1919–39* (New York, 1966).

Lenin, V. I., "En lisant Hegel," *LSASDLR,* no. 6 (May 15, 1933), pp. 1–5.

Imperialism: The Highest Stage of Capitalism (New York, 1939 [1917]).

Materialism and Empiriocriticism (Moscow, 1976 [1908]).

Lunacharsky, Anatoly, *On Literature and Art* (Moscow, 1973 [1965]).

Lunn, Eugene, *Marxism and Modernism: An Historical Study of Lukacs, Brecht, Benjamin and Adorno* (Berkeley, 1982).

Naville, Pierre, *Psychologie, Marxisme, Matérialisme* (Paris, 1946).

Trotsky vivant (Paris, 1979).

Pianca, Jean-Michel, "Et Guerre au travail," *Mélusine,* 5 (1983).

Pomper, Philip, ed., *Trotsky's Notebooks, 1933–5* (New York, 1986).

Poznanski, Renée, "Intelligentsia. Trois écrivains russes confrontés aux événements révolutionnaires de 1917," unpublished doctoral thesis, Institut d'Etudes Politiques de Paris, 1978.

Riazonov, D., *Communisme et mariage* (Paris, 1929).

Serge, Victor, "Un Portrait de Lénine par Trotsky," *Clarté,* no. 75 (June 1925), pp. 255–71.

Trotsky, Leon, *Lénine. Suivi d'un texte d'André Breton,* ed. M. Bonnet (Paris, 1970).

Littérature et révolution, preface by Maurice Nadeau (Paris, 1964).

PHILOSOPHY

Benjamin, Walter, *Reflections,* ed. P. Demetz (New York, 1978).

Bergson, Henri, *Essai sur les données immédiates de la conscience* (Paris, 1889).

L'Evolution créatrice (Paris, 1966 [1907]).

Matière et mémoire (Paris, 1968 [1896]).

La Pensée et le mouvant (Paris, 1934).

Boutroux, Emile, *De l'Idée de loi naturelle dans la science et la philosophie* (lectures at the Sorbonne given in 1892–3; new ed., Paris, 1925).

Bréhier, Emile, *Contemporary Philosophy* (Chicago, 1969 [1932]).

Brunschvicg, Léon, *Relation entre mathématique et physique* (Paris 1923).

Camus, Albert, *L'Homme révolté* (Paris, 1951).

Le Mythe de Sisyphe, Essai sur l'absurde (Paris, 1942).

Croce, Benedetto, *Ce qui est vivant et ce qui est mort de la philosophie de Hegel* (Paris, 1910).

Dandieu, Arnaud, Preface, *Anthologie des philosophes français contemporains,* 5th ed. (Paris, 1931).

Foucault, Michel, *Discipline and Punish: The Birth of the Prison* (New York, 1979).

Hamelin, Octave, *Essai sur les éléments principaux de la représentation* (Paris, 1907).

Système de Descartes (Paris, 1911).

Hegel, Georg William Friedrich, *Aesthetics,* vol. 1, trans. T. M. Knox (Oxford, 1975).

Esthétique de la peinture figurative (Paris, 1964).

Lupasco, Stéphane, *Logique et contradiction* (Paris, 1947).

Poincaré, Henri, *Science and Hypothesis* (New York, 1905).

Popper, Karl, *Conjectures and Refutations* (New York, 1968).

Sartre, Jean Paul, *What Is Literature?* (New York, 1965).

Les Mots (Paris, 1964).

Valéry, Paul, *The Living Thoughts of Descartes* (New York, 1947).

Véra, A. *Introduction à la philosophie de Hegel,* 2nd ed. (Paris, 1864).

Wismann, Heinz, ed., *Walter Benjamin et Paris* (Alençon, 1986).

PSYCHOLOGY, SOCIOLOGY, PSYCHOANALYSIS (ESPECIALLY FREUD)

Anzieu, Didier, *Le Groupe et l'inconscient* (Paris, 1984).

Arnheim, Rudolf, *The Power of the Center* (Berkeley, 1982).

Visual Thinking (Berkeley, 1969).

Baudouin, Charles, *Psychanalyse de l'art* (Paris, 1929).

Bernheim, Hippolyte, *De la suggestion dans l'état hypnotique et dans l'état de veille* (Paris, 1884).

Borel, A., and Gilbert Robin, "Les Rêveurs. Considérations sur les mondes imaginaires," *L'Evolution psychiatrique,* 1 (1925), pp. 191–2.

Bourget, Paul, *Essais de psychologie contemporaine,* vol. 1 (Paris, n.d. [1885]).

Chabaneix, P., *Le Subconscient chez les artistes, les*

savants et les écrivains, preface by Emmanuel Régis (Paris, 1897).

Damourette, J., and E. Pichon, "La Grammaire en tant que mode d'exploration de l'inconscient," *L'Evolution psychiatrique,* 1 (1925).

Debord, Guy, *Société du spectacle* (Paris, 1967).

Didi-Huberman, Georges, *L'Invention de l'hysterie* (Paris, 1982).

Le Disque vert, special issue entitled "Freud et la psychanalyse" (Brussels, 1924).

Dufresne, Roger, *Bibliographie des écrits de Freud en français, allemand et anglais* (Paris, 1973).

Durkheim, Emile, *L'Education morale* (Paris, 1938).

Les Formes élémentaires de la vie religieuse (Paris, 1912).

Le Suicide (Paris, 1897).

Ehrenzweig, A., *Psychoanalysis of Artistic Hearing and Vision,* 2nd ed. (New York, 1965).

Ettinger, Tom, "Picasso, Cubism, and the Eye of the Beholder: Implicit Stimuli and Implicit Perception," unpublished doctoral dissertation, New York University, May 1994.

Fenichel, Otto, *Psychoanalytic Theory of Neurosis* (New York, 1945).

Ferenczi, Sandor, *Final Contributions* (New York, 1980).

Flournoy, Théodore, *Des Indes à la planète Mars* (Paris, 1900).

Flügel, J. C., *The Psychology of Clothes* (London, 1930).

Freud, Sigmund, *Cinq leçons de psychanalyse* (Paris, 1922).

Délire et rêves dans la Gradiva de Jensen (Paris, 1931).

Introduction à la psychanalyse (Paris, 1922).

La Psychanalyse, intro. E. Claparède (Geneva, 1921).

Psychologie collective et analyse du moi (Paris, 1924).

Psychopathologie de la vie quotidienne (Paris, 1923).

Le Rêve et son interprétation (Paris, 1925).

La Science des rêves (Paris, 1926).

Un Souvenir d'enfance de Léonard de Vinci (Paris, 1927).

Totem et tabou (Paris, 1923).

Trois essais sur la théorie de la sexualité (Paris, 1923).

Goldman, L., *Structures mentales et création culturelle* (Paris, 1970).

Goldstein, Jan, *Console and Classify: The French Psychiatric Profession in the Nineteenth Century* (New York, 1987).

Grasset, J., *L'Hypnotisme et la suggestion* (Paris, 1903).

Held, René, *L'Oeil du psychanalyste: Surréalisme et surréalité* (Paris, 1973).

Hesnard, A. *Les Psychoses et les frontières de la folie,* preface by H. Claude (Paris, 1924).

Hollier, Denis, ed., *Le Collège de Sociologie* (Paris, 1979).

Horney, Karen, *Feminine Psychology* (New York, 1967).

Jaccard, Roland, ed., *Histoire de la psychanalyse* (Paris, 1982).

Janet, Pierre, *De l'angoisse à l'extase,* 2 vols. (Paris, 1928).

L'Automatisme psychologique (Paris, 1910 [1889]).

Psychological Healing: A Historical and Clinical Study, vol. 1 (London, 1925).

Jung, C. G., "L'Analyse du rêve," *L'Année psychologique,* 15 (1909).

Klein, Melanie, *Contributions to Psychoanalysis: 1921–1945* (London, 1948).

Kofman, Sarah, "The Narcissistic Woman: Freud and Girard," *Diacritics,* 10, no. 3 (1980), pp. 36–45.

Kris, Ernst, *Psychoanalytic Explorations in Art* (New York, 1964 [1952]).

Lacan, Jacques, *Ecrits* (New York, 1977).

Laforgue, René, and A. Allendy, *Psychanalyse et les névroses,* preface by Henri Claude (Paris, 1924).

Laignel-Lavastine, M., and J. Vinchon, "Un Cas de sculpture 'automatique,'" *Bulletin de l'Académie de Médecine,* 83 (1920), pp. 317–19.

"Délire mystique et sculpture automatique," *Revue neurologique,* 27 (1920), pp. 824–8.

Lasswell, Harold, *Psychopathology and Politics* (Chicago, 1977 [1930]).

Le Bon, Gustave, *The French Revolution and the Psychology of Revolution* (New Brunswick, N.J., 1980).

Psychologie des foules (Paris, 1895).

Lévy-Bruhl, Lucien, *Les Fonctions mentales dans les sociétés inférieures* (Paris, 1910).

Maeder, A., "Le Mouvement psychanalytique," *L'Année psychologique,* 18 (1912).

Mahoney, Patrick, *Freud as Writer* (New York, 1982).

Maury, L. F. A., *Le Sommeil et les rêves* (Paris, 1878).

Mauss, Marcel, "Essai sur le don," *L'Année Sociologique,* 1 (1923–4).

Politzer, Georges, *Critique des fondements de la psychologie* (Pittsburgh, Pa., 1994 [1928]).

Prinzhorn, Hans, *Bildnerei der Geisteskranken* (Berlin, 1922).

Régis, E., and A. L. M. Hesnard, *La Psychanalyse* (Paris, 1914).

Ribot, Théodule, *La Psychologie de l'attention* (Paris, 1889).

La Psychologie des sentiments (Paris, 1896).

Roudinesco, Elisabeth, *Histoire de la psychanalyse en France,* vol. 1 (Paris, 1986).

Ryner, Han, "La Psychanalyse," *Revue de l'époque,* no. 5 (February 1920).

Saint-Denys, Hervey, *Les Rêves et les moyens de les diriger* (Paris, 1867).

Souriau, Paul, *La Suggestion dans l'art* (Paris, 1893).

Spector, Jack J., *The Aesthetics of Freud* (New York, 1972–8).

"The State of Psychoanalytic Research in Art History," *Art Bulletin,* 70, no. 1 (March 1988), pp. 49–76.

Taine, Hippolyte, *De l'intelligence* (Paris, 1870).

Turner, Victor, *Dramas, Fields, and Metaphors: Symbolic Action in Human Society* (Ithaca, N.Y., 1974).

OTHER TOPICS (COLONIALISM, EDUCATION, FEMINISM, MODERNISM, PHOTOGRAPHY)

Actes du quatrième colloque d'Histoire de l'Art Contemporain tenu à Saint-Etienne... , in *L'Art face à la crise. 1929–39* (Saint-Etienne, 1980).

Agache, A., *Les Citations de la révolution de mai* (Paris, 1968).

Andrew, Christopher M., and A. S. Kanya-Foster, *France Overseas: The Great War and the Climax of French Imperialist Expansion* (London, 1981).

Apollinaire, Guillaume, *Alcools* (Paris, 1913).

Calligrammes (Paris, 1918).

Les Mamelles de Tirésias. Drame surréaliste (Paris, 1917).

Les Peintres cubistes (Paris, 1913).

Apollonio, Umberto, ed., *Futurist Manifestos* (New York, 1973).

Bachelard, Gaston, *Lautréamont* (Paris, 1939).

Bancel, Nicolas, Pascal Blanchard, and Laurent Gervereau, *Images et colonies. Imagerie et propagande coloniale sur l'Afrique française de 1800 à 1962* (Paris, 1993).

Bank, Mirra, *Anonymous Was a Woman* (New York, 1979).

Baraduc, H., *L'Ame humaine, ses mouvements, ses lumières et l'iconographie de l'invisible fluidique* (Paris, 1896).

Méthode de radiographie humaine. La Force courbe cosmique. Photographie des vibrations de l'éther. Loi des Auras (Paris, 1897).

Barrès, Maurice, *De Hegel aux cantines du Nord* (Paris, 1904).

The Undying Spirit of France (New Haven, Conn., 1917).

Baudelaire, Charles, *The Painter of Modern Life* (London, 1964).

Baumgart, Winfried, *Imperialism: The Idea and Reality of British and French Colonial Expansion, 1880–1914* (New York, 1982).

Besançon, Julien, *Les Murs ont la parole. Mai 1968* (Paris, 1968).

Blanchot, Maurice, *Lautréamont et Sade* (Paris, 1949).

Boime, Albert, *The Academy and French Painting in the Nineteenth Century* (New York, 1971).

Bowie, Theodore, and C. Christensen, eds., *Studies in Erotic Art* (New York, 1970).

Breunig, L. C., ed., *Apollinaire on Art* (New York, 1972 [1960]).

Bridenthal, Renate, and Claudia Koonz, *Become Visible: Women in European History* (Boston, 1977).

Caws, Mary Ann, Rudolf E. Kuenzli, and Gwen Raaberg, eds., *Surrealism and Women* (Cambridge, Mass., 1993).

Céline, Louis-Ferdinand, *Death on the Installment Plan* (New York, 1966 [1933]).

Cendrars, Blaise, *Or* (Paris, 1925).

Césaire, Aimé, *Discours sur le colonialisme,* 5th ed. (Paris, 1970).

Cahier d'un retour au pays natal (New York, 1947 [1939]).

Blanchard, Pascal, and Armelle Chatelier, eds., *Images et colonies. Actes du colloque* (Paris, 1993).

Chadwick, Whitney, *Women Artists and the Surrealist Movement* (London, 1985).

Chapoutot, Henri, *Villiers de l'Isle-Adam, l'écrivain et le philosophe* (Paris, 1908).

Clark, T. N., *Prophets and Patrons: The French University and the Convergence of the Social Sciences* (Cambridge, 1973).

Debord, Guy, *La Société du spectacle* (Paris, 1967).

Décaudin, Michel, *La Crise des valeurs symbolistes* (Paris, 1957).

Dermée, Paul, *Les Affaires et l'affiche* (Paris, 1920–2).

Durville, Hector, *Télépathie, télépsychie. (Actions à distance),* 2nd ed. (Paris, 1919).

Flint, R. W., ed., *Marinetti: Selected Writings* (New York, 1972).

Fourier, Charles, *L'Enseignement français,* vol. 2, *De 1789 à 1945* (Paris, 1965).

Fry, Edward, *Cubism* (New York, 1966).

Fuchs, Eduard, *Geschichte der erotischen Kunst* (Berlin, 1908).
Illustrierte Sittengeschichte, vol. 3 (Munich, 1910).

Furet, François, *Penser la Révolution française* (Paris, 1978).

Gabory, Georges, *Essai sur Marcel Proust* (Paris, 1926).

Gee, Malcolm, *Dealers, Critics and Collectors of Modern Painting: Aspects of the Parisian Art Market between 1910 and 1930.* Ph.D. dissertation, Courtauld Institute, 1977 (Garland, N.Y., 1981).

Gide, André, *Traité du Narcisse* (Paris, 1891).

Giedion, Siegfried, *Mechanization Takes Command* (New York, 1948).

Gossot, H., F. Brunot, and S. Herbinière, *L'Enseignement du premier degré de 1887 à 1962: De la théorie à la pratique* (Paris, 1962).

Greenberg, Clement, *The Collected Essays and Criticism,* 2 vols. (Chicago, 1986).

Grosse, Ernst, *The Beginnings of Art* (New York, 1900 [1893]).

Guisan, Gilbert, *Poésie et collectivité, 1890–1914. Le Message social des oeuvres poétiques de l'unanimisme et de l'Abbaye* (Lausanne, 1938).

Harrison, Charles, ed., *Primitivism, Cubism, Abstraction: The Early 20th Century* (New Haven, Conn., 1993).

Hess, Thomas B., and Linda Nochlin, eds., *Woman as Sex Object* (London, 1973).

Hobson, John Atkinson, *Imperialism: A Study* (London, 1938).

Hugo, Victor, "Discours sur l'Afrique" (1879), *Oeuvres complètes,* Edition Nationale (Paris, 1895), vol. 4, pp. 465–71.

Hunt, Lynn, *The Family Romance of the French Revolution* (Berkeley, 1992).

Keohane, Nannerl O., Michelle Z. Rosaldo, and Barbara C. Gelpi, eds., *Feminist Theory: A Critique of Ideology* (Brighton, 1982).

Kern, Stephen, *The Culture of Time and Space* (Cambridge, Mass., 1983).

Lebovics, Herman, "Donner à voir l'empire coloniale. L'Exposition Coloniale Internationale de Paris en 1931," *Gradhiva,* no. 7 (Paris, 1990).

Lefebvre, Henri, *Introduction à la modernité* (Paris, 1962).

Leighten, Patricia, *Re-Ordering the Universe: Picasso and Anarchism, 1897–1914* (Princeton, N.J., 1989).

Levin, Miriam R., *Republican Art and Ideology in Late 19th Century France* (Ann Arbor, Mich., 1986).

Lippard, Lucy, ed., *From the Center: Feminist Essays on Women's Art* (New York, 1976).

MacGregor, John, *The Discovery of the Art of the Insane* (Princeton, N.J., 1989).

McMillan, Dougald, *Transition, 1927–1938* (London, 1975).

Marcuse, Herbert, *Eros and Civilization* (Boston, 1966).

Martin, Marianne, *Futurist Art and Theory (1909–15)* (New York, 1978).

Michaud, Guy, *Message poétique du Symbolisme* (Paris, 1947).

Miller, C. L., *Black Darkness: Africanist Discourse in French* (Chicago, 1985).

Mitchell, J. F., ed., *The Other Perspective in Gender and Culture* (New York, 1990).

Mitchell, W. J. T., *Iconology* (Chicago, 1986).

Moutote, Daniel, *Egotisme français moderne: Stendhal, Barrès, Valéry, Gide* (Paris, 1980).

Mulvey, Laura, *Visual and Other Pleasures* (Bloomington, Ind., 1989).

Nochlin, Linda, *The Politics of Vision: Essays on 19th Century Art and Society* (New York, 1989).

Nora, Pierre, ed., *Les Lieux de mémoire.* vol. 1, *La République* (Paris, 1984).

Parker, Roszika, and Griselda Pollock, *Old Mistresses: Women, Art and Ideology* (New York, 1981).

Paulhan, Jean, *Clef de la poésie* (Paris, 1944).

Perloff, Marjorie, *The Futurist Moment: Avant-Garde, Avant-Guerre, and the Language of Rupture* (Chicago, 1986).

Pevsner, Nikolaus, *Academies of Art: Past and Present* (New York 1973) [1940]).

Plotteal, Jeanine, ed., *Collage* (New York, 1983).

Power, Thomas, *Jules Ferry and the Renaissance of French Imperialism* (New York, 1944).

Praz, Mario, *Romantic Agony* (New York, 1967).

Rees, A. L., and Frances Borzello, *The New Art History* (London, 1986).

Reverdy, Pierre, *Gant de crin* (Paris, 1926).
Le Livre de mon bord (Paris, 1930–6).

Revert, Eugène, *La Martinique. Etude géographique et humaine* (Paris, 1949).

Riley, Denise, *Am I That Name? Feminism and the Category of Women in History* (Minneapolis, Minn., 1988).

Robbe-Grillet, Alain, *Pour un nouveau roman* (Paris, 1957).

Romains, Jules, *La Vie unanime* (Paris, 1908).

Said, Edward, *Orientalism* (New York, 1978).

The World, the Text, and the Critic (Cambridge, Mass., 1983).

Salmon, André, *La Terroire noire. Chronique du mouvement libertaire* (Paris, 1959).

Samaltanos, Katia, *Apollinaire, Catalyst for Primitivism, Picabia, and Duchamp* (Ann Arbor, Mich., 1984).

Sargent, Lydia, ed., *Women and Revolution* (Boston, 1981).

Schapiro, Meyer, *Modern Art* (New York, 1978).

Scharf, Aaron, *Art and Photography* (Harmondsworth, 1974 [1968]).

Screen, *The Sexual Subject*, A Screen Reader in Sexuality (London, 1992).

Sedlmayr, Hans, *Art in Crisis* (London, 1958) (*Verlust der Mitte. Die bildende Kunst des 19. und 20. Jahrhunderts als Symptom und Symbol der Zeit*, 1948).

Die Revolution der modernen Kunst (Hamburg, 1955).

Senghor, Leopold, "Lycée Louis-le-Grand, haut-lieu de la culture française," in *Louis-le-Grand, 1563–1963. Etudes, souvenirs, documents* (Paris, 1963), pp. 247–9.

Chants d'ombre, illustrated by A. Masson (Geneva, 1976 [1945]).

Sewell, William H., *Work and Revolution in France* (Cambridge, 1980).

Shapiro, Theda, *Painters and Politics* (New York, 1976).

Shiff, Richard, *Cézanne and the End of Impressionism* (Chicago, 1984).

Silver, Kenneth E., *Esprit de Corps* (Princeton, N.J., 1989).

Simmel, Georg, *The Conflict in Modern Culture and Other Essays* (New York, 1968; [1914; German ed. published in 1918]).

Sorel, Georges, *Reflections on Violence* (New York, 1941 [1906]).

Souriau, Paul, *La Suggestion dans l'art* (Paris, 1893).

Suleiman, Susan Rubin, *Subversive Intent: Gender, Politics, and the Avant-Garde* (Cambridge, Mass., 1990).

Suleiman, Susan Rubin, ed., *The Female Body in Western Culture* (Cambridge, 1986).

Suret-Canale, J., *Afrique noire* (Paris, 1964). *L'Ere coloniale, 1900–45* (New York, 1971).

Swartz, M. J., Victor Turner, and A. Tuden, eds., *Political Anthropology* (Chicago, 1966).

Tate, Allen, *Reactionary Essays* (New York, 1936).

Thomas, Karin, ed., *Um 1968. Konkrete utopien in Kunst und gesellschaft* (Düsseldorf, 1990).

Valéry, Paul, *Cahiers*, ed. Judith Robinson (Paris, 1973–4).

Willener, Alfred, *The Action Image of Society: On Cultural Politicization* (New York, 1970).

Williams, Rosalind, *Dream Worlds: Mass Consumption in Late Nineteenth Century France* (Berkeley, 1982).

Wright, Gwendolyn, *The Politics of Design in French Colonial Urbanism* (Chicago, 1991).

Zeldin, Theodore, *France: 1848–1945*, vol. 1, *Ambition, Love and Politics* (Oxford, 1973); vol. 2, *Intellect, Taste and Anxiety* (Oxford, 1981).

PERIODICALS AND TRACTS

Antliff, Mark, "Cubism, Celtism and the Body Politic," *Art Bulletin* (December 1992), pp. 655–68.

Barthes, Roland, "L'Imagination du signe," *Arguments*, no. 27–8 (1962), pp. 118–20.

Bernier, Jean, Review of Jensen's *Gradiva*, *La Critique sociale*, no. 5 (March 1932).

Breunig, L. C., "Apollinaire et Freud," *La Revue des lettres modernes*, no. 183–8 (1968).

Bryson, Norman, and Mieke Bal, "Semiotics and Art History," *Art Bulletin*, 73, no. 2 (1991), pp. 174–208.

Copjec, Joan, "Transference: Letters and the Unknown Woman," *October*, 28 (Spring 1984), pp. 61–90.

Crimp, Douglas, "The Photographic Activity of Postmodernism," *October*, 15 (Winter 1980).

Flournoy, Théodore, "Esprits et médiums," *Bulletin de l'Institut Général Psychologique*, no. 3 (1909), pp. 357–90.

Foster, Hal, "L'Amour faux," review of the Corcoran exhibition, *Art in America*, 74, no. 1 (January 1986), pp. 46–128.

"Armor fou," *October*, 56 (Spring 1991).

Freinet, Célestin, "Pestalozzi, éducateur du peuple," *Clarté*, no. 37 (1923).

Gandelman, Claude, "Proust's Draft Copy-Books: Sketches of His Dreams," *American Imago*, 34, no. 4 (Winter 1977), pp. 297–312.

"The Artist as 'Traumarbeiter': On Sketches of Dreams by Marcel Proust," in "Boundaries: Writing and Drawing," *Yale French Studies*, no. 84 (1994), pp. 118–35.

Le Semainier, "Graffiti," *L'Illustration* (August 31, 1929).

Léger, Fernand, "L'Esthétique de la machine: L'Objet fabriqué, l'artisan et l'artiste," *Bulletin de l'effort moderne* (1924), in Léger, *Fonctions de la peinture* (Utrecht, 1970), pp. 53–62.

"La Rue: Objets, spectacles," *Cahiers de la République des Lettres* (Paris, 1928), in Léger, *Fonctions de la peinture* (Utrecht, 1970), pp. 68–9.

Leighten, Patricia, "The White Peril and L'Art nègre: Picasso, Primitivism, and Anticolonialism," *Art Bulletin* (December 1990), pp. 609–30.

Martin, Marianne, "Futurism, Unanimism and Apollinaire," *Art Journal*, no. 28–29 (1969).

Michel, André, "L'Art français sous la 3ème République," *Journal des débats* (November 11, 1920).

Petitjean, A.-M., "Analyse spectrale du singe," *Minotaure* (1935).

Revel, J.-F., "J. Doucet, couturier et collectionneur," *L'Oeil*, no. 84 (December 1961).

Reverdy, Pierre, "L'Image," *Nord-Sud*, no. 14 (April 1918).

Ribemont-Dessaignes, Georges, Review of "Einstein et l'Univers par Ch. Nordmann," *Littérature*, n.s., no. 1 (March 1922).

Rivière, Jacques, "Introduction à la métaphysique du rêve," *La Nouvelle Revue française* (November 1, 1909 [1908]).

Robbe-Grillet, Alain, "Nouveau roman, homme nouveau," *Revue de Paris* (1961).

Romains, Jules, "La Foule au cinématographe," *Puissances de Paris* (Paris, 1911).

Romains, Jules, and Maublanc, René, "La Vision extra-rétinienne et le sens paroptique," *La Nouvelle Revue française* (1920).

Schneider, Pierre, "Arp Speaks for the Law of Chance," *Art News*, 57 (November 1958).

Solomon-Godeau, Abigail, "Going Native," *Art in America*, 77 (July 1989), pp. 118–29.

Soupault, Philippe, "Scénario automatique," *Sic*, no. 24 (December 1917).

Spare, Austin O., and Frederick Carter, "Automatic Drawing," *Form: A Quarterly of the Arts*, 1, no. 1 (April 1916), pp. 27–30.

Spector, Jack J., Review of Bürger's *Theory of the Avant-Garde, Art Criticism*, 2, no. 1 (1985), pp. 70ff.

Tynianov, Y. N., and R. Jakobson, "Problems in the Study of Literature and Language," *Novy Lef*, 12 (1928), pp. 36–7.

Valéry, Paul, "Littérature," *Commerce* (Summer 1929).

Exhibition Catalogues

Les Affiches de Mai 68 ou L'Imagination graphique, Bibliothèque Nationale (Paris, February–March 1982).

André Breton: La Beauté convulsive, Centre Georges Pompidou (Paris, 1991).

Leonora Carrington: The Mexican Years, 1943–1985, Mexican Museum (San Francisco, 1991).

De Chirico Exhibition, ed., William Rubin, Museum of Modern Art (New York, 1982).

1936. Surrealism. Ojects, Photographs, Collages, Documents, Zabriskie Galleries (New York and Paris, February–April 1986).

BIBLIOGRAPHY

INDEX